THE YEAR 1200 I

THE YEAR 1200

A Centennial Exhibition at
The Metropolitan Museum of Art

FEBRUARY 12 THROUGH MAY 10, 1970

I Catalogue written and edited by
KONRAD HOFFMANN

THE CLOISTERS STUDIES IN MEDIEVAL ART I

The Metropolitan Museum of Art

DISTRIBUTED BY NEW YORK GRAPHIC SOCIETY LTD.

Design: Peter Oldenburg
Color separations: Electronics Corp.
Color illustrations: Vinmar Lithographing Co.
Typesetting: Finn Typographic Service, Inc.
Printing and binding: Jenkins-Universal Corp.

CONTENTS

FOREWORD

Thomas P. F. Hoving

During my months of research in 1963 and 1964 on the Bury St. Edmunds cross I became fascinated with, enamored of, and at times frustrated by that exceptional period of international style that was evident in almost every great artistic center of the civilized world around the year 1200. It was then, as I traveled through the museums of Europe and the United States searching for manifestations of that vibrant and humanistic figure style of the years 1180–1220, that the idea hatched in my mind to have someday a distinguished scholarly (and popular!) exhibition on the development and scope of Style 1200.

Here the exhibition is, and a great triumph it is, not only of scholarship but of popular instruction as well. Thanks to the perseverance and unparalleled expertise of Dr. Florens Deuchler, Dr. Konrad Hoffmann, and their staff, *The Year 1200* is one of the most important exhibitions ever to be assembled in the Western Hemisphere. Each of its more than three hundred objects has been chosen from hundreds to explain in the most lucid manner possible not only the period overall but, where applicable, the figure style. This is one of great dignity and corporeality, of nervous energy, of stunning classicality, exemplifying the continual search for the most harmonious way of showing man and his anthropomorphic creations in their full naturalistic stature. Around 1200, for practically the first time since ancient Greek and Roman times, draperies curl and caress the bodies underneath; limbs themselves are proudly and successfully shown as organic entities; strength becomes a thing of muscles rather than size alone; physiques are neither camouflaged nor ignored, but studied and presented to our eyes in an almost overpowering intensity. Faces become truly alive, eyes shine with an inner light, gestures seem to develop an entirely new expressive poetry of their own. Drama is supreme.

Neither Romanesque nor Gothic, nor indeed Transitional, this exciting style is an important artistic manifestation in its own right, a fact recognized up to now by a relatively small group of historians. We hope that this distinguished exhibition will make the autonomous importance of Style 1200 even more clear, and that the exhibition itself will become one of the foundation blocks for further study and appreciation of this most fascinating and excellent moment of man's creative history.

ACKNOWLEDGMENTS

It was at the time of my arrival in this country, late in October 1968, that my staff and I really started the preparation of this exhibition. We realized, very quickly indeed, that we had an exceedingly short time at our disposal. It now seems to me a kind of unexpected miracle that we have achieved such an exciting result. This miracle has come to pass for two reasons. The first was the generosity and willingness with which our European and American colleagues lent their finest objects. The second was the extraordinary efforts of my *équipe* at the Museum. The success of the exhibition is a direct result of a fine collaboration with all of the lenders, and perfect teamwork within the Medieval Department.

I am therefore deeply indebted to all the people involved in the realization of *The Year 1200*. First of all I want to thank Thomas P. F. Hoving, Director, and the Board of Trustees, who generously entrusted me with the difficult task of gathering the material now on display. Konrad Hoffmann, who upon my invitation came to New York in January 1969 to write this catalogue, became my closest adviser. I thankfully acknowledge his great help. I also thank Jane Hayward, who was instrumental in the preparation of the stained-glass section (nos. 200–237), Andrew Watson, who coordinated and prepared the section on The Book (nos. 294–310), Margaret Frazer, responsible for the Byzantine objects (nos. 53, 75, 76, 77, 130, 134, 239, 288–293, 336), Harvey Stahl, who dealt with French illuminated manuscripts, (nos. 242–248, 250, 253, 254, 256, 258, 262, 274–278, 286, 327). Individual entries were contributed by François Avril (no. 252), Carlo Bertelli (nos. 338, 340), Adelheid Heimann (no. 257), and Jeffrey Hoffeld (no. 259). William H. Forsyth, Carmen Gómez-Moreno, and Vera Ostoia gave much valuable advice. Bella Bessard, Sabrina Longland, and Ian McGee helped in different ways. Last but not least I thank Michael Botwinick, who became a genuine *deus ex machina* for a perfect coordination.

It is a personal pleasure to mention the help we all received from Linda Papanicolaou; we are all indebted to her for her good humor and perfect sense of order. We are also indebted to Diane Rothman, another member of this department's staff, always willing and totally dependable.

A great deal of external work and organization was handled by Ronnie Rubin of the Centennial Office, and her office, under the able direction of George Trescher, willingly gave all the assistance we asked for. To William Wilkinson, Registrar, and his staff, our thanks for the careful work that brought so many of these magnificent objects to New York.

The Museum's and my thanks go to the members of the European Advisory Committee and the American Advisory Committee, which met in Switzerland and New York in 1968 and 1969, and to our colleagues Carlo Bertelli, Bruno Malojoli, and Cesare Brandi in Italy, Father Floridus Röhrig in Austria, Léon Pressouyre in France, and William Wixom in this country. I also wish to thank personally my friends Francis Wormald, Louis Grodecki, Hanns Swarzenski, and John Plummer for the many enlightening talks we had and their clarifying ideas.

The mere mention of these names does not convey either the magnitude of their efforts or the fullness of my thanks, nor do these brief words really bring to light all of the people who deserve recognition for their help. The ultimate satisfaction for all of us lies in the galleries, in these pages, and in whatever we hope to give to art history and the public through this exhibition.

FLORENS DEUCHLER
Chairman of the Department
of Medieval Art and The Cloisters

ADVISORY COMMITTEES ON THE EXHIBITION

American HARRY BOBER, The Institute of Fine Arts, New York University
ROBERT BRANNER, Johns Hopkins University
SUMNER McK. CROSBY, Yale University
ROBERT HARRIS, Smith College
DOROTHY MINER, The Walters Art Gallery
CARL NORDENFALK, Princeton, Institute for Advanced Study
JOHN PLUMMER, The Pierpont Morgan Library
MEYER SCHAPIRO, Columbia University
CARL D. SHEPPARD, University of Minnesota, Minneapolis
WHITNEY STODDARD, Williams College
HANNS SWARZENSKI, The Museum of Fine Arts, Boston
KURT WEITZMANN, Princeton, Institute for Advanced Study

European JUAN AINAUD DE LASARTE, Museos de Arte de Barcelona
JOHN BECKWITH, Victoria and Albert Museum, London
CARLO BERTELLI, Gabinetto Fotografico Nazionale, Rome
PETER BLOCH, Staatliche Museen, Preussischer Kulturbesitz, Berlin
JACQUES DUPONT, Inspecteur général honoraire, Monuments Historiques, Paris
MME. GERMAINE FAIDER-FEYTMANS,
 Conservateur honoraire, Musée de Mariemont, Bruges
HERMANN FILLITZ, Universität, Basel
MARIE-MADELEINE GAUTHIER,
 Centre national de la recherche scientifique, Paris
CESARE GNUDI, Pinacoteca Nazionale, Bologna
LOUIS GRODECKI, Université de Paris
HANS R. HAHNLOSER, Berne
HUBERT LANDAIS, Musées Nationaux de France, Paris
PETER E. LASKO, University of East Anglia, Norwich
JOSÉ M. PITA ANDRADE, Universidad de Granada
FRANCIS SALET, Musée de Cluny, Paris
WILLIBALD SAUERLÄNDER, Universität, Freiburg i. Br.
ERICH STEINGRÄBER, Bayerische Staatsgemäldesammlungen, Munich
JEAN TARALON, Monuments Historiques, Paris
MARCEL THOMAS, Bibliothèque Nationale, Paris
D. H. TURNER, Department of Manuscripts, British Museum, London
ANDREW WATSON, University College, London
GEORGE ZARNECKI, The Courtauld Institute of Art, London

LENDERS TO THE EXHIBITION

AUSTRIA

Graz, Universitätbibliothek
Dr. Erhard Glas, Director

Klosterneuburg, Chorherrenstift
DDr. Floridus Röhrig, Can. Reg.

Vienna, Kunsthistorisches Museum
Dr. Erwin Neumann, Leiter der Sammlung für Plastik und Kunstgewerbe

Vienna, Österreichische Nationalbibliothek
Hofrat Dr. Dr. Franz Unterkircher, Handschriftensammlung

BELGIUM

Brussels, Musées Royaux d'Art et d'Histoire
Pierre Gilbert, Conservateur-en-chef; René De Roo, Jean Squilbeck, Conservateurs

Brussels, Collection Lucien Féron Stoclet

Grimbergen, Collection Jean Pincket

Huy, Collégiale de Notre-Dame
M. le chanoine Devos

Liège, Musée diocésain
Léon Dewez, Conservateur

Mariemont, Musée
Guy Donnay, Conservateur

Tongres, Basilique de Notre-Dame
M. le chanoine L. Kortleven

Tournai, Cathédrale de Notre-Dame
Msgr. A Faux, Doyen

DENMARK

Copenhagen, National Museum
Dr. P. V. Glob, Rigsantikvar; Harald Langberg, Keeper; Fritz Lindahl, Assistant Keeper

ENGLAND

Cambridge, Fitzwilliam Museum
David Piper, Director

Hereford, Cathedral Library
Canon J. M. Irvine, M.A., Chapter Librarian

London, The British Museum
Sir Frank Francis, Director; R. L. S. Bruce-Mitford, Keeper, Department of British and Medieval Antiquities; D. H. Turner, Janet Backhouse, Assistant Keepers, Department of Manuscripts

London, Guildhall Museum
Norman C. Cook, Director

London, Lambeth Palace Library
E. G. W. Bill, Librarian

London, Victoria and Albert Museum
John Pope-Hennessey, Director; John G. Beckwith, Deputy Keeper, Department of
Architecture and Sculpture; Robert Charleston, Keeper, Department of Ceramics

London, Collection Peter Wilson

Oxford, Ashmolean Museum, Department of Western Art
Hugh Macandrew, Susan Booth, Assistant Keepers

Oxford, Balliol College
E. V. Quinn, Librarian

Oxford, Bodleian Library, Department of Western Manuscripts
R. W. Hunt, Keeper

Oxford, Corpus Christi College
T. H. Ashton, Librarian; P. J. Law, Assistant Librarian

Oxford, New College
G. V. Bennett, Librarian

Rochester, The Precinct of the Cathedral
H. S. Wharton, M.A., Chapter Clerk

Winchester, The Deanery of the Cathedral
Canon W. D. Maundrell, Vice Dean

York, The Deanery of the Cathedral
The Very Reverend Alan Richardson, Dean

York, Yorkshire Museum
George Willmot, Keeper

FRANCE

Direction des Musées Nationaux de France
Jean Châtelain, Directeur général des musées de France; Hubert Landais, Inspecteur général
adjoint au Directeur

Direction de l'Architecture
Jean Taralon, Inspecteur général des Monuments Historiques

Angers, Paroisse de Saint-Serge

Bourges, Cathédrale
Mgr. Le Guenne, Archiprêtre; Jean Favière, Conservateur du Musée du Berry

Carpentras, Bibliothèque Inguimbertine
Henri Dubled, Conservateur des Archives Communales et du Musée Municipal

Dijon, Musée Archéologique
Paul Lebel, Conservateur

Dijon, Musée des Beaux-Arts
Pierre Quarré, Conservateur-en-chef

GREECE

Athens, Benaki Museum
 Prof. Manolis Chatzidakis, Director

IRELAND

Dublin, National Library of Ireland
 P. Henchy, Librarian
Dublin, Collection Mr. and Mrs. John Hunt

ITALY

Anagni, Cattedrale

Parma, Galleria Nazionale
 Dr. Augusto G. Quintavalle, Director

NETHERLANDS

Amsterdam, Rijksmuseum
 Dr. A. van Schendel, Director

NORWAY

Oslo, Museum of Applied Arts
 Lauritz Opstad, Director

SPAIN

Barcelona, Museos de Arte
 Juan Ainaud de Lasarte, Director
Santiago de Compostela, Cathedral

SWEDEN

Stockholm, Royal Library
 Dr. Uno Willers, Director; Dr. Harry Järv, Keeper of Manuscripts
Stockholm, Central Office and Museum of National Antiquities
 Dr. Sven B. F. Jansson, Dr. Monica Rydbeck

SWITZERLAND

Lausanne, Cathédrale
 J. P. Vouga, Département des travaux publiques
Lucerne, Collection Ernst E. Kofler-Truniger
Saint-Maurice, Abbaye
 M. le chanoine J. M. Theurillat
Sursee, Collection Dr. Franz Wicki

UNITED STATES

Baltimore, The Walters Art Gallery
Richard H. Randall, Jr., Director; Dorothy Miner, Librarian and Keeper of Manuscripts

Berkeley, Lowie Museum of Anthropology, University of California
William R. Bascom, Director

Boston, Museum of Fine Arts
Perry T. Rathbone, Director; Hanns Swarzenski, Curator of Decorative Arts

Buffalo, Albright-Knox Art Gallery
Gordon M. Smith, Director

Cambridge, Fogg Art Museum, Harvard University
Agnes Mongan, Acting Director and Curator of Drawings

Chicago, The Art Institute
Charles Cunningham, Director; Allen Wardwell, Acting Curator of Decorative Arts

Cleveland, The Cleveland Museum of Art
Sherman E. Lee, Director; William D. Wixom, Curator of Medieval and Renaissance
Decorative Arts

Colorado Springs, The Colorado College Museum
Mark Lansburgh, Lecturer in Art and Curator

Detroit, The Detroit Institute of Arts
Willis F. Woods, Director

Durham, The Art Museum, Duke University
Robert C. Moeller III, Director

Lawrence, Museum of Art, University of Kansas
A. Bret Waller, Director; Jack Schrader, Curator of Northern Renaissance Art

New Haven, Yale University Art Gallery
Andrew Carduff Ritchie, Director; Sumner McKnight Crosby, Curator of Medieval Art

New York, The American Numismatic Society
George C. Miles, Director; Leslie A. Elam, Secretary of the Society; Margaret Thompson,
Chief Curator; Henry Grunthal, Curator of European and Modern Coins

New York, Collection Mrs. Ernest Brummer

New York, Collection H. P. Kraus

New York, The Robert Lehman Collection
George Szabo, Curator

New York, The Pierpont Morgan Library
Curt F. Buhler, Acting Director; John Plummer, Research Fellow for Art: Medieval
and Renaissance Manuscripts

New York Public Library
J. W. Henderson, Research Chief

New York, Collection Mr. and Mrs. Germain Seligman

New York, Collection Georges E. Seligmann

New York, Collection George Stricevic

THE YEAR 1200 |

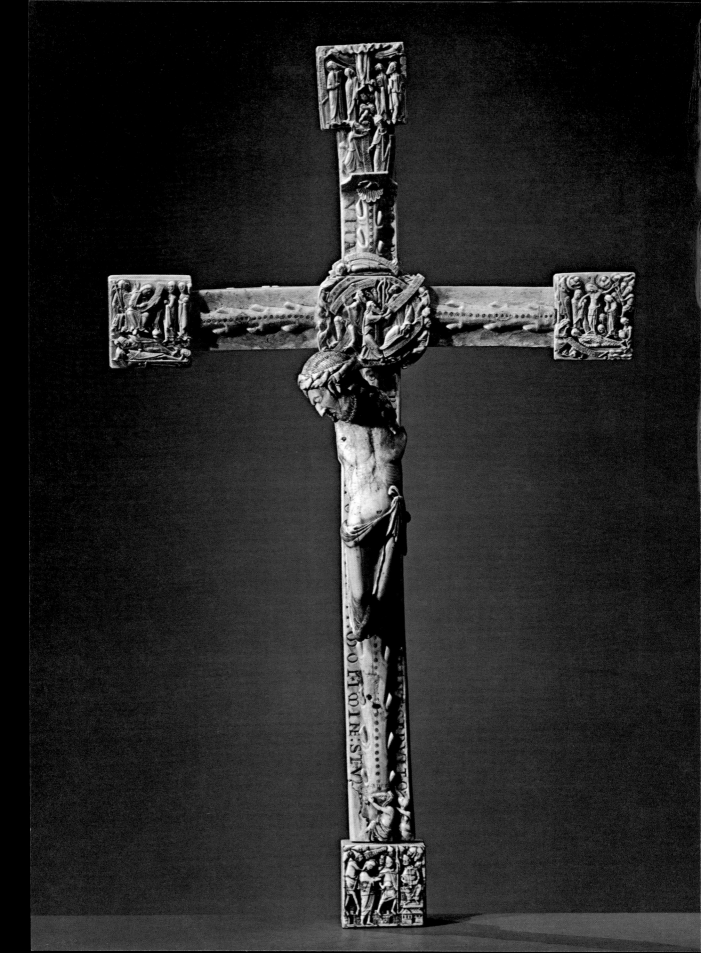

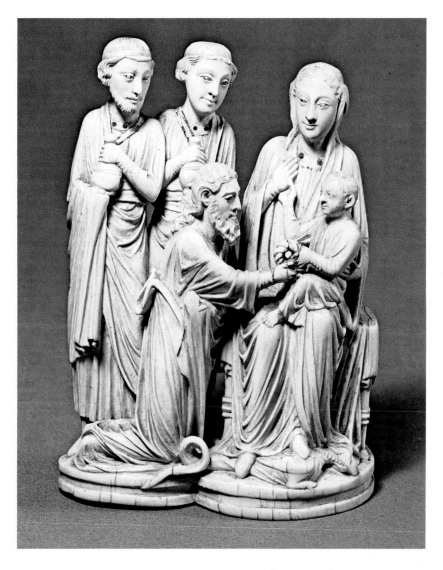

Cross

Walrus ivory
England, Bury St. Edmunds (?), 1150–1190
The Metropolitan Museum of Art, The Cloisters Collection
(Exhibition no. 60)

Adoration of the Magi

Ivory
Denmark or England, 1240–1250
Copenhagen, National Museum
(Exhibition no. 74)

Corpus (shown on cross)

Walrus ivory
England, 1170–1190
Oslo, Kunstindustrimuseet
(Exhibition no. 61)

Presentation scene from shrine of the Virgin, Tournai

Silver gilt, copper gilt, enamel, filigree
Mosan, Nicholas of Verdun, 1205
Tournai Cathedral

(Exhibition no. 100)

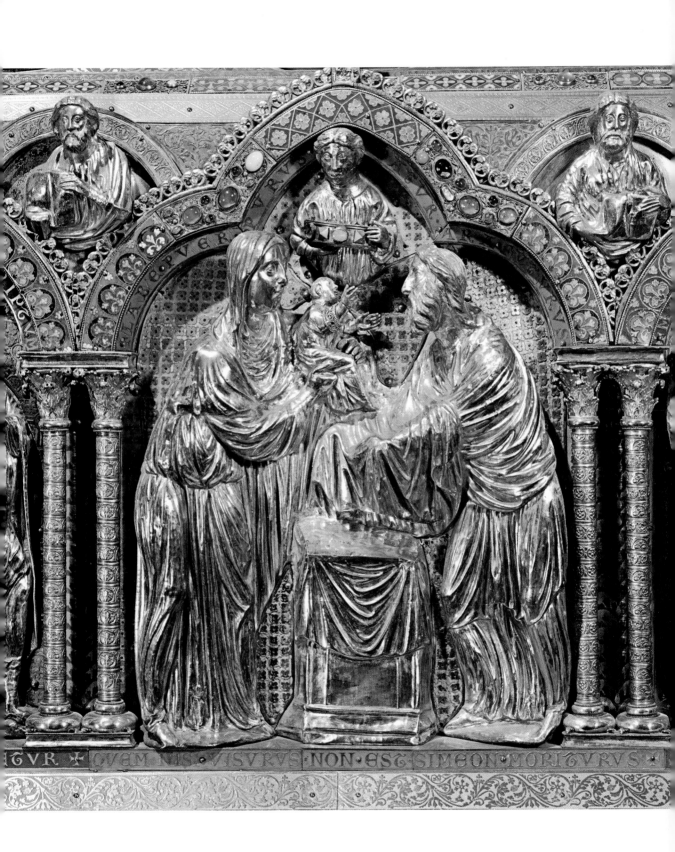

TVR ✠ QVAM NIS · VISVRVS · NON · EST · SIMEON · MORITVRVS ·

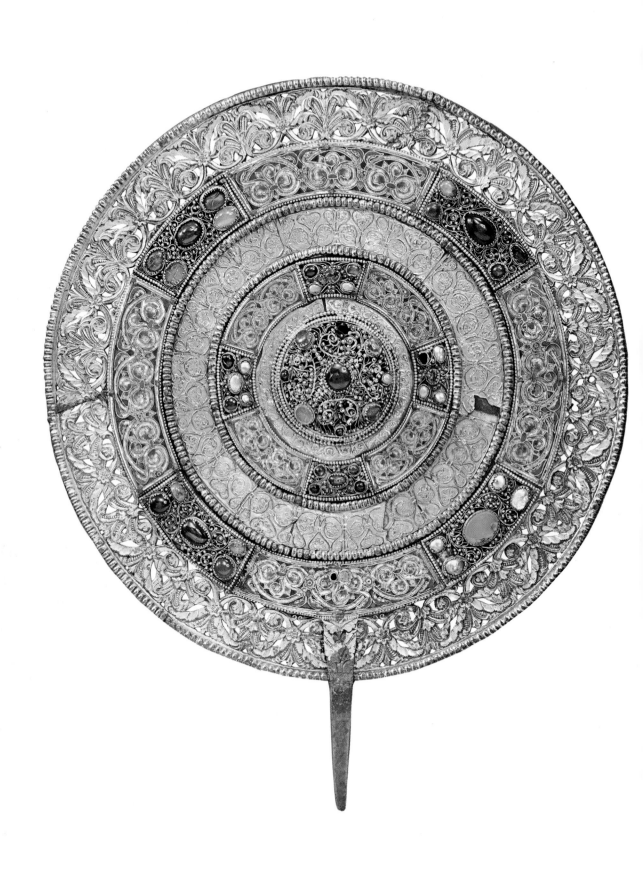

Flabellum

Silver, filigree, enamel
Rhenish or Mosan, about 1210
The Metropolitan Museum of Art, The Cloisters Collection
(Exhibition no. 118)

Fibula

Gold, filigree, jewels
Germany, Mainz, 1200–1220
Mainz, Mittelrheinisches Landesmuseum
(Exhibition no. 123)

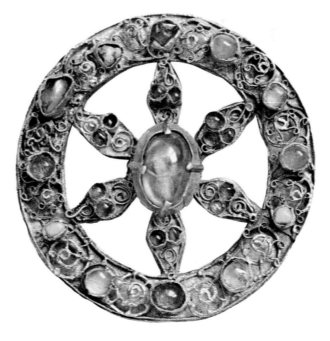

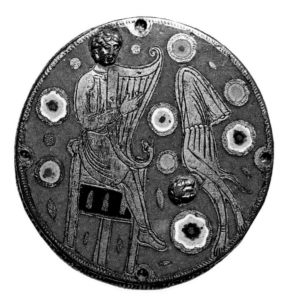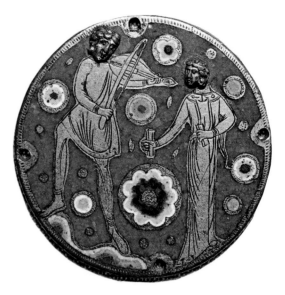

Medallions

Champlevé enamel
France, Limoges, 1200–1220
Copenhagen, National Museum
(Exhibition no. 155)

Adoration of the Magi

Champlevé enamel
France, Limoges, about 1190
Paris, Musée de Cluny
(Exhibition no. 141)

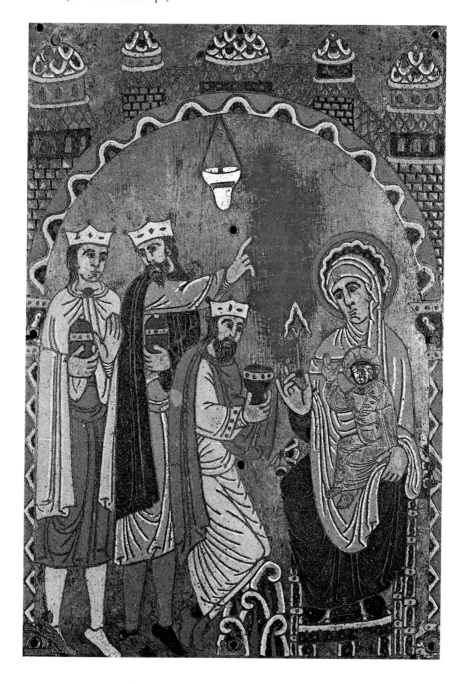

Samson and the Lion

Champlevé enamel
Mosan, Nicholas of Verdun, 1181
Klosterneuburg, Stiftskirche
(Exhibition no. 179)

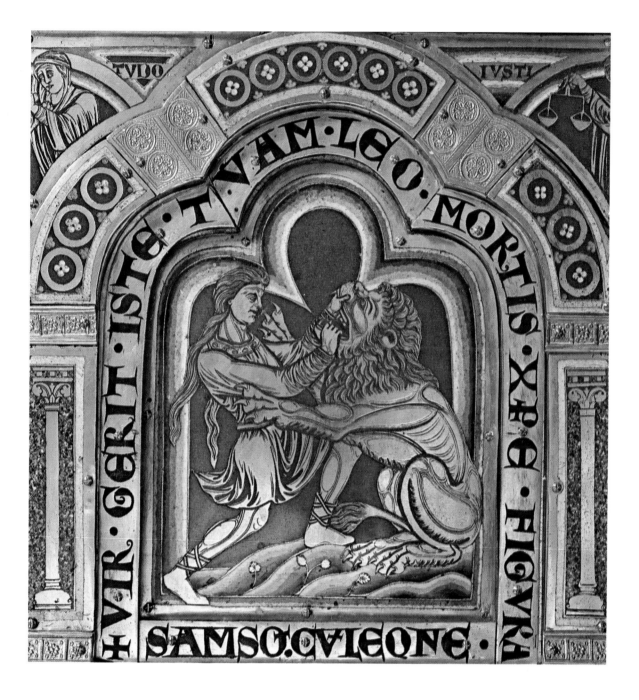

Fragment of a border

Pot metal
England, Canterbury Cathedral, about 1220
Dublin, Coll. John Hunt

(Exhibition no. 230)

Scene from legend of the Seven Sleepers of Ephesus

Pot metal
France, Rouen Cathedral, about 1210–1220
Anonymous loan

(Exhibition no. 207)

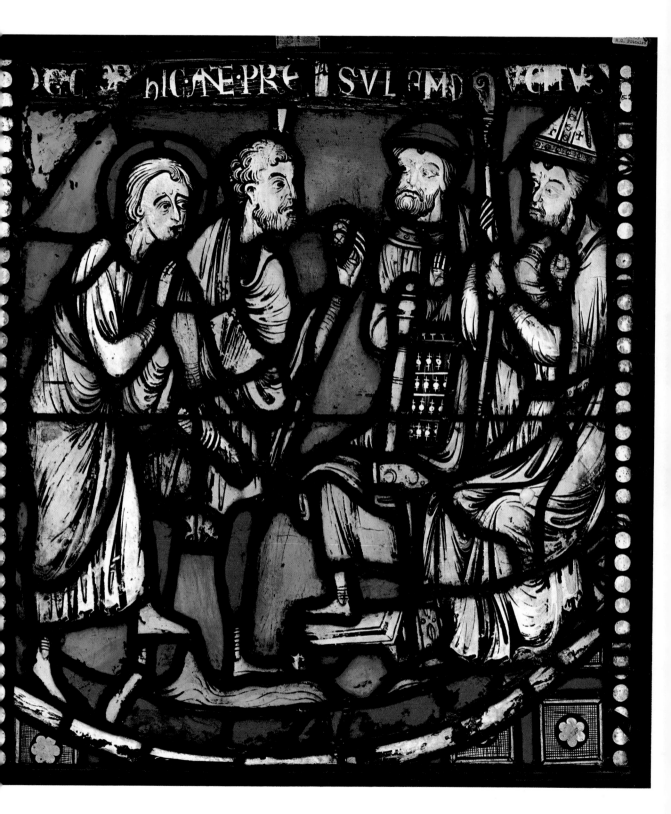

Standing saint, New Testament codex

Vellum
Northern France, 1205–1210
Baltimore, The Walters Art Gallery

(Exhibition no. 249)

Speculum Virginum,
allegorical harvesting scenes

Parchment
Germany, middle Rhineland, about 1190
Bonn, Rheinisches Landesmuseum

(Exhibition no. 266)

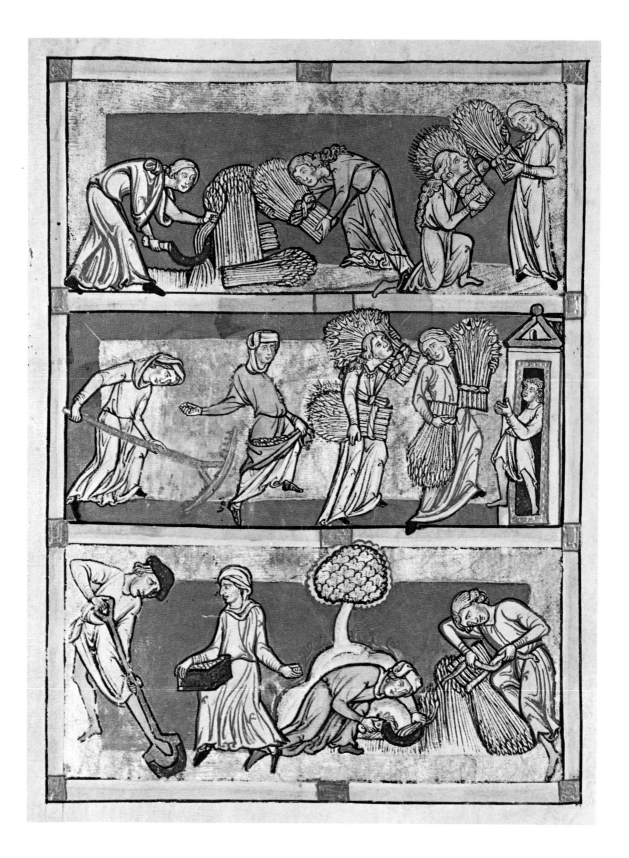

INTRODUCTION

Konrad Hoffmann

THE EXHIBITION *The Year 1200* is dedicated to a relatively short, precisely defined period. In this respect it differs from most exhibitions of medieval art held during recent decades in Europe and in this country (Boston, 1940: *Arts of the Middle Ages;* Baltimore, 1947: *Early Christian and Byzantine Art;* Baltimore, 1962: *The International Style;* Cleveland, 1967: *Treasures from Medieval France;* Essen, 1956: *Werdendes Abendland;* Council of Europe exhibitions: Barcelona, 1961 (Romanesque art); Aachen, 1965 (Carolingian art); Paris, 1968 (Gothic art). After these broad surveys it seems justified and meaningful to aim at a more specific selection and, consequently, a sharpened focus. This exhibition is the first to concentrate on the art of the late twelfth and early thirteenth century. In the earlier development of medieval art one would hardly find another phase of such short duration that could boast of a similarly concentrated, many-sided, and international character of its artistic production. In spite of or just because of its short chronological limit the period exhibited in *The Year 1200* has an unequivocal art-historical profile. According to conventional stylistic periodization, the arts around 1200 had to be called both "early Gothic" and "late Romanesque." However, despite the general heuristic value of traditional stylistic terminology, the labels Romanesque and Gothic are not sufficiently precise to encompass the concrete art-historical situation prevailing toward the end of the twelfth and the beginning of the thirteenth century. The artistic movement inaugurated by Nicholas of Verdun's Klosterneuburg retable of 1181 and culminating in the sculptural decoration of Chartres (transepts) and Reims Cathedrals clearly deviates from the preceding Romanesque. In mid-twelfth-century Romanesque art the human figure was subordinated to an abstract geometric scheme wherein the body was subdivided in a pattern of flat compartments. In contrast to Romanesque isolation and ornamentalization, Nicholas presented a unified image of the human body: the limbs are shown in harmonious relationship to each other, both anatomically and proportionally, and the drapery folds constitute a continuously running, clearly discernible course. The single figure is conceived of as an independent being, not only with regard to its corporeal organism. In its free mobility, spatial suggestiveness of posture, and overlapping of limbs, as well as in the variety of gestures and

expressive physiognomies, man now appears as an animated individual. With Nicholas of Verdun, the criteria mentioned—unification, mobility, spatial conception, and animation of the human figure—mark the departure from Romanesque tradition. In drapery arrangement a hallmark of Nicholas's artistic vision may be seen in the so-called *Muldenfalten* (hairpin drapery loops) that were to become a stylistic leitmotif of the period until the Reims Visitation group (before 1225) and Villard de Honnecourt's sketchbook of about 1230.

The 1200 style deviates from the succeeding phase of High Gothic as clearly as it does from the preceding Romanesque. In Reims Cathedral, a glance at the Annunciation placed directly beside the Visitation illustrates this point. The absence of both *Muldenfalten* and contrapposto in the Annunciation, together with the edged hardening and linearization of the folds and the geometrical stylization of the figures, points to a basic transformation. The newly achieved unification of the human figure was retained from the 1200 style, to be sure, but in the drapery system one notes a reappearance of abstract tendencies. The evidence seems incompatible with the assumption of a continuous stylistic development. Between Romanesque and Gothic there emerges a phase with a characteristic style in its own right. It is time to recognize this art-historical situation. And it is mostly as a demonstration of this evidence that the exhibition *The Year 1200* is planned to serve. For a clear evaluation of the problem a correct terminology is necessary.

From the preceding remarks it is evident that Nicholas of Verdun and his artistic heritage cannot be subsumed under the heading "late Romanesque" without sacrificing a consistent notion of Romanesque style. The application of the label "early Gothic" to our period is invalidated by the fact that in the history of architecture the Gothic style is thought to start with Abbot Suger's St.-Denis, of about 1140. Consequently the term "early Gothic," in the development of French art, at least, has a wider meaning than the four decades around 1200 (whereas, conversely, it would have a shorter range when transferred to England and Germany). The expression "transitional style," finally, which is used so often to describe the art of our period, seems to be misleading, too, because the 1200 style in essential respects and in its profile proper is not an intermediary between Romanesque and High Gothic, but deviates equally from both.

In view of its close indebtedness to classical art, such denominations as "style antiquisant" and "neoclassicism" have been proposed for the art around 1200. In using this terminology, however, one should consider the fact that the 1200 style is not to be explained by classical sources, either specifically or exhaustively. In any case, this "classicizing style" is not to be confused with the so-called "proto-renaissance" of Provençal and northern Italian Romanesque sculpture, even less

so with the general notion of the twelfth-century renaissance chosen by C. H. Haskins to characterize the cultural life of this century. Classical art, to be sure, was an important factor in the formation of the characteristic 1200 style. It should be understood, however, as an instrument rather than a goal in itself for the artist of the period.

A dynastic nomenclature would have the advantage of closely connecting the stylistic phenomenon with historical facts. As the dates of political history vary, however, from country to country, we could not find a generally valid denomination. Partial aspects of the 1200 style, therefore, can be covered only by such notions as "Plantagenet style," "Philip Augustus style," and "Staufischer Stil." Clearly distinguishable in stylistic terms, our style is still in search of a satisfying name. For the time being, the phrase "Style 1200," derived from the title of this exhibition, may serve as an auxiliary notion indicating its chronological center. Yet with regard to the history of styles, the problem of definition and periodization is only roughly sketched by these remarks. In constituting finally the notion of the art around 1200 a reflection on the different positions in earlier art-historical writing would seem to be a revealing contribution. For the notion of late Gothic Jan Bialostocki recently presented a detailed survey of this kind. Such a study should clarify which concepts, aspects, and motifs were instrumental in isolating the art of 1200 in previous scholarship.

Setting aside the problems of method and definition, one already notes a fresh process of artistic liberation that took place during the last quarter of the twelfth century. The strictly geometrical determination of both the single figure and the entire composition prevailing around the middle of the century gave way to an emphasis on spatial and corporeal dynamism, on outward as well as psychological animation of the frozen figure type. By their provenance the objects assembled in this exhibition indicate that during the period around 1200 the artistic center was in northwestern Europe. The area in question includes the northern French provinces, especially Ile-de-France and Champagne, the adjacent Meuse valley, England, and in Germany mostly the Rhineland, Westphalia, and Saxony.

Characteristically enough, the center of gravity was shifted to the north from the Mediterranean, the scene of the proto-renaissance of Romanesque sculpture. The northern regions were well prepared for this changeover by an intense inclination toward classical antiquity predominant in literature and intellectual life and aptly called proto-humanism (John of Salisbury), corresponding to the southern proto-renaissance. Moreover, there existed in this region, a vivid tradition of classicizing style that can be traced in the so-called minor arts back to the Carolingian age. It is in this sense that Hanns Swarzenski speaks of a Reims tradi-

tion, the continuity of which he demonstrates from the ninth-century Reims scriptorium (the Utrecht Psalter) via Mosan production of the eleventh and twelfth centuries to early thirteenth-century cathedral sculpture. In terms of general development, the late twelfth century witnessed the interaction of monumental sculpture, indebted in its turn to the Provençal proto-renaissance, with the classical heritage embodied in the agitated and suggestive style of the "Reims tradition."

In the northern area, the development of sculpture from the west portal to the transept porches of Chartres Cathedral is essentially a process of its integration into the architecture. From this point of view, the period of around 1200 may be divided roughly into two halves. During the last two decades of the twelfth century a spirited dynamic style prevailed, full of striking contrasts and pathos, spreading from the "minor arts" into the sphere of contemporary cathedral sculpture (as at Senlis, Laon). From 1200 onward, conversely, architectural sculpture initiates a style of calm monumentality that quickly was adopted by the "minor arts." In the œuvre of Nicholas of Verdun itself one may detect this development by comparing the Klosterneuburg retable to the Tournai shrine. Besides an increase in the architectural conception one observes a mitigation of the earlier agitation and the tendency toward monumentality in figure style.

The period from 1180 to 1220 thus turns out to be determined by a clearly discernible process of stylistic development that appears with slight variation in different regions and media. The "Sturm und Drang" is followed by a phase of classicistic outlook, represented by such works as the Ingeborg Psalter, the Westminster Psalter, and the northern transept porch sculptures of Chartres Cathedral. Whereas the development between 1180 and 1220, within the period of *The Year 1200,* may be interpreted as a logical, immanent process in terms of a tendency toward articulation, clarification, and consolidation, the isolated position of the entire period with regard to its wider historical context between Romanesque and Gothic remains enigmatical. Apparently the stylistic change occurring about 1180 cannot be explained by an immanent development of forms. There is a gap between the achievements of Nicholas of Verdun and the preceding stage. Nicholas had sources of inspiration, to be sure. Impulses toward a deliberately agitated representation of human figures did occasionally occur earlier in Mosan twelfth-century art. In this connection the Liége baptismal font of Reiner of Huy should be mentioned as a highly surprising anticipation that prompted no immediate consequence.

Moreover, during the first half of the twelfth century an international wave of Byzantine influence popularized the motif of the "damp fold" (Koehler), and by this stylistic device paved the way for the conception of the autonomously func-

XXXVI

tioning body. For a correct understanding of the artistic situation of about 1200 it is important to realize that in Byzantine art itself the latter half of the twelfth century produced a markedly dynamic style, as recognized only recently in its full historical significance. An early key monument of this stylistic trend is the fresco cycle in Nerezi of the 1160s, whereas its final phase of vividly agitated forms is apparent in the fresco decoration produced in the last decade of the century in Kurbinovo and Laghoudera. It is significant that here, too, the excitement of form and drapery is paralleled by, and indicative of, a fresh emphasis on an expressive range of human emotion. The impact exerted by this phase of Byzantine art on Western developments has recently been demonstrated by Kitzinger and Weitzmann.

In Byzantium, likewise, a change toward a calmer classicism took place around 1200, a parallel to the Western pattern of development rather than its actual source. The agitated style dominating in Byzantine art during the second half of the twelfth century and exported to the West forms part of what has been called the "perennial Hellenism" of Byzantine art. It is this classical element that attracted Western artists then as already in the case of previous *renovatio* movements.

Besides, artists and humanists in northwestern Europe had immediate access themselves to works of ancient art, both in Rome (Magister Gregorius) and in their native countries, France and England, which had been thoroughly Romanized and still could boast of many standing classical monuments (Adhémar). One finally has to consider the multiple possibilities of recourse to earlier classicizing phases of Western medieval art. In the context of this exhibition the latest illustrated copy of the Utrecht Psalter graphically demonstrates the extent of such an inspiration. Cases of indebtedness to remote periods of classicizing art both in Byzantium and the West have been pointed out in architectural sculpture (Sauerländer, 1959), miniature painting (Kitzinger, 1960), and goldsmiths' work (Mütherich, 1940). All these sources provided models of ornamentally agitated forms to the imagination of artists.

The choice of models was dictated by stylistic affinity, as evident, for example, in the predilection for the courtly ceremonial precision and uniformity of standing saints of tenth-century Byzantine ivory triptychs (Macedonian renaissance) that attracted the attention of French sculptors (Notre-Dame, Paris) at the threshold of High Gothic stylization only. Taken together with the effect of the Mediterranean Romanesque proto-renaissance, all these more or less indirect connections to ancient art demonstrate the complexity that characterizes the relationship of the art around 1200 to classical antiquity. Contact with classical art became possible only in the context of the structural principles of early Gothic cathedral architec-

ture, which constituted the technical, aesthetic, and conceptual frame for the rise of columnar statues as axially autonomous beings.

The changing constellation of architecture, "minor arts," and classical and Byzantine orientation marks the art-historical essence of *The Year 1200*. From this it follows that there should not be expected in this period any high degree of uniformity. Different impulses were given by single individuals and schools, resulting in different accomplishments; simultaneously, Romanesque traditions survived in many places untouched by more recent developments. Old and new elements were combined in various forms, characteristic of a period of experimentation. It is only the center of these manifold activities that is covered by the exhibition. Interesting as they are in themselves, the effects produced by the French achievements on Italian and Spanish soil could not be included adequately. The Italian contribution essentially starts only after 1220, the chronological limit observed in our exhibition. Similarly, the south Italian and Sicilian court art of Frederick's renaissance forms a complex subject in itself that, tied up with very special historical conditions, had to remain outside the scope of the exhibition. With regard to the northwestern part of Europe, it sometimes proved difficult to observe the limiting year, especially when dealing with England and Germany. In German art most of the major works were produced not before the third or fourth decade of the thirteenth century; they represent a peculiar interpretation of Style 1200 achievements, unaffected by more recent French developments, indulging, instead, in a deeply Byzantinizing mannerism evident in the early *Zackenstil* (zigzag pattern). Works such as the Goslar Evangelistary and the Wolfenbüttel sketchbook, the Braunschweig tomb, the sculptures of Strasbourg, Freiburg, and Bamberg, and the Hildesheim baptismal font are belated echoes of Style 1200, originating in stylistically isolated provinces. In our panorama, moreover, the Scandinavian contribution is missing, both the impressive sculptural groups of the early thirteenth century, closely indebted to the Franco-English development, and the dragon doorways of the stave churches that continue local twelfth-century traditions.

Well aware of all these ramifications, our exhibition has had to concentrate on that group of monuments that demonstrate the decisive breakthrough of about 1180–1190 and the subsequent developments, subdivided by Homburger into three high points: about 1180 the leading role is with the Meuse valley and apparent in goldsmiths' work, changing about 1200 to England and the technique of painting, whereas around 1220 French sculpture is thought to dominate the scene. If only for technical difficulties it was impossible to present in ideal purity and completeness this pattern of artistic processes. Thus, no French early thir-

teenth-century columnar statue is included to demonstrate the final accomplishment of the axially conceived independent human figure in the state of organic animation. In order to facilitate orientation, the most important of the material not shown in the exhibition is presented in the second of our publications, *The Year 1200: A Background Survey*. This supplementary volume also illustrates the historical perspective that is the central tenet of the exhibition. Between the strictly determined stylistic conventions of Romanesque pictorial geometry and High Gothic there was a short interval, inside what is called early Gothic in terms of French development, that won new territory and flexibility to artistic imagination and inaugurated a fresh attempt at a more naturalistic and individualizing ideal of beauty.

About 1220 there began a countermovement that amounted to a narrowing of the recently opened wider horizons of artistic vision. The conventional habit of thinking in terms of the categories of Romanesque and Gothic prevented the recognition of the marked changes in direction that in fact occurred about 1180 and 1220. How are we to explain these stylistic changes in terms of history? Evidently, an answer to this question may be found only if we do not consider the art-historical development as an isolated phenomenon, but rather view it together with the creative achievements observable in many areas of twelfth-century culture and life.

A fresh impetus is characteristic of the century that witnessed the rise of both scholasticism and mysticism. A richness of poetic expression and devices unheard of before came to the fore in vernacular literature as well as in the refined Latin lyric and prose; these were to gain a novel depth and charm in the writings of John of Salisbury, for example, and Alanus de Insulis. Manifold themes and fields of imagery first were made accessible; classical legends and mythology inspired poetic imagination, for example, in the Berlin *Eneide* (no. 271). Love poetry embodied a new notion of courtly affection and a female ideal that was foreign both to classical antiquity and the previous vernacular. A definite stylistic change has often been noted in the formal structure of twelfth-century poetry. In the lyrics of the vagantes and Goliards, as well as in the quickly developing genre of parody and satire, a recently acquired freedom of critical distance first became effective. With regard to historical reality, the Crusades established an intensified contact with eastern Europe, Byzantium, and the Near East. In Europe itself, the great pilgrimage routes enhanced occasions of exchange between people from different countries and classes, parallel to the ascendancy of active international trade routes. From all this a widened horizon resulted, together with a greater mobility and a broader basis of culturally active levels of society, as opposed to the exclusive monopoly of

court and monastery in previous times. A marked social differentiation became effective, both on the side of the feudal lords (and their code of conventions) and on the part of the developing middle class. It is in this period that, together with the economic rise, the beginnings of urban organization, civilization, and culture in our modern sense are to be found.

Fresh stimuli occurred in science and technology, connected with both the influx of Greek and Arabic writings and the intensified practical demands. In his book *Medieval Technology and Social Change,* Lynn White has analyzed these relationships and their meaning for social history. School training was transferred from monasteries and cathedral school to universities. In the realm of political constitution, a far-reaching trend toward centralization made itself felt both in the monarchies and the Church, accompanied by a more systematic approach to practice as well as theory.

All these various aspects of creative activity during the twelfth century, summarized under the heading of a "12th-century Renaissance" by C. H. Haskins, are not mentioned here simply to evoke an abbreviated panorama of cultural events. Not all of these phenomena exactly coincided with the period of *The Year 1200,* to be sure. But, in one way or another, they contribute to our understanding of the historical situation, only in the climate of which the stylistic change of around 1180 could become possible. Thus, for example, the specific flowering of civic life in the Meuse valley, a fountainhead of the artistic renewal, is of special interest in this context. The interaction between the events of social history and the data of the art-historical situation needs to be studied more closely. Mere parallelisms drawn between the various fields, without an investigation of the actual process of transmission, remain unsatisfactorily abstract. The connection of the scholastic method with the development of Gothic architecture, for example, may be closely followed up in the contemporary institution of the cathedral schools, especially the leading one at Chartres with John of Salisbury as a teacher. Similarly, the sculptor's attempt at animation and tangible rendering of the human figure is to be understood in the light of the contemporary views on the relationship between body and soul (Koehler, 1943; Panofsky, 1951; Ladner, 1965). The reception of Aristotle's teachings brought to an end the dualistic theories of Augustine and the early medieval tradition; instead it emphasized the notion of the organism, which at the time was applied by John of Salisbury also to the realm of political theory. The relevance of the flourishing technology to the rise of Gothic architecture is well known; it even has been overrated occasionally.

The Crusades made accessible products of various previously "exotic" areas to Western twelfth-century artists; they could draw inspiration not only from classi-

cal, Early Christian, and Byzantine works, but also from Sasanian textiles and vessels and Islamic forms, not to mention a newly awakened interest in native (Celtic, Germanic) traditions.

During the twelfth century an especially strong visual sensitivity and interest came to the fore. Who would expect, in a high medieval chronicle, a descriptive passage like the one Giraldus Cambrensis devoted to an old Irish manuscript? — "When you consider these pictures in a superficial and ordinary manner they will appear as blots rather than coherent shapes, and you will fail to perceive any subtlety where there is nothing but subtlety. But when you concentrate the visual power of your eyes upon a more thorough examination, and with a sustained effort penetrate the secrets of art, you will be able to perceive intricacies so delicate and subtle, so close-knit and involved, so knotted and interlaced, and so much illumined by colors which have preserved their freshness up to our day that you will attribute the composition of all this to the industry of angels rather than humans." In this passage not only the sympathetic understanding of the formal structure of an archaic work of art is surprising, but also the psychological reflection on the optical concentration required from the beholder. In a study entitled "On the Aesthetic Attitude of Romanesque Art," Meyer Schapiro has collected passages from twelfth-century writings that indicate a purely formal interest in works of art, as opposed to the more common emphasis on subject matter, meaning, and didactic or religious function. The trend toward visibility turns out to be a basic factor in the pattern of twelfth-century culture and life, traceable in many sectors. The demand for visual experience presupposes an individual point of view, interest in empirical demonstration and suggestion, and an increased relevance of the work of art to the beholder. These connections are evident, in the religious sphere, in the new custom, starting in the first decade of the thirteenth century, of elevating the Eucharist during transsubstantiation, in order to show it to the community, which, consequently, often was satisfied with "visual communication." At the same time reliquaries changed shape to facilitate the concrete visibility of their contents. Relics were often shown from the rood-loft inside the church, a new species of ecclesiastical furniture. In a broader sense, the tendency to render things visible to the senses is at the root of contemporary medieval religious and philosophical thought, too. It is in this sense that "clarificatio" and "manifestatio" were central notions of scholasticism, aiming at the spiritual articulation of traditional dogma. Similarly, it was the ambition of mystics to make faith evident to man's senses (Frey, 1946; Ringbom, 1969, on works of art as "materia meditandi"). F. Ohly recently discussed a special type of exegesis, starting in twelfth-century theology, that basically takes advantage of painted images as means of visual demonstration

(Hugo of Folieto; Hugo of St. Victor; Adamus Scotus). Stefan Otto analyzed the function of the image concept in twelfth-century theology.

The all-pervading desire for vividness has been adduced, in different ways, to explain the genesis of the Gothic cathedral. It is with the Gothic cathedral that a unified visual perception of a whole interior became possible to the beholder. Most especially, however, one will understand the sculptural decoration of cathedrals, concentrating on the rich display of façades, in terms of their social function only, both in pilgrimage churches and city cathedrals. In the rising civic environment, visual demonstration acquired a fundamentally new relevance for the population. The façades of the cathedrals were optical propaganda both of the royal ideology and of the Church, taking into account the curiosity of citizens and pilgrims. Iconographically, too, the choice of new subjects like the Old Testament kings, precursors of both Christ and the French kings, points to the fact that the new art served definite social purposes. The emphasis on Marian subjects, intended to refute heretic doubts about Christ's incarnation, moreover matched contemporary interest in secular feminism. What matters most in our context, however, is the insight into the increased social function of the work of art that started in the twelfth century. It is in this historical frame of reference that the period of *The Year 1200* should be looked upon. The intensification of visual experience, both in the popular form of naïve curiosity and in the refined version of aesthetic sensitivity and reflection, and the newly acquired social significance of artistic production are nothing but two aspects of the same process. The demand to render the supernatural visible to the senses is the basic feature of both twelfth-century piety and its heretic opponents, and this tendency obviously is incompatible with what was the source of artistic vision in the Romanesque. These new claims of suggestivity newly required from a work of art are a historical parallel to the revival of rhetoric, which also strives for convincing images. The shift of emphasis onto the social factor may be interpreted as a symptom of secularization. In looking at the glorified bodies of the Blessed appearing directly above the earthly, rural, and feudal occupations of the months on cathedral portals, people visually, at least, participated in an ideal perfection superimposed on their daily life. Unfortunately, we have no information whatsoever about the assembly rooms of heretical cults and their decorations, although these must have existed simultaneously with the rise of the cathedrals. Similarly, nothing is known about the beginnings of secular art, such as the imagery of contemporary castles. We should take into consideration these areas in our attempt at understanding the art of around 1200 as vividly as this art itself was destined to appear to contemporary people.

It is the aim of our exhibition to break with the vague clichés often applied to

the art and life of the Middle Ages. A specific phase of its artistic development is presented here, to be understood in the context of its original environment. In its liberating force the period around 1200, often referred to as an anticipation of the Renaissance, was a basic step in the direction of man's understanding of himself. The artistic renewal forms part of the endeavors to cope with this vision and contributed to its progressive realization. In looking at the Museum's presentation of these objects, we should remember the special interest men of the twelfth century paid to the problems of visual presentation and arrangement of an ensemble. In a contemporary document it is stated, for example, that in 1169 Abbot Wibald of St. Trond monastery, near Liége, "laid the foundations for a higher building where he himself was to dwell and to rest; and putting his whole mind to the job, he distinguished the house by its wonderfully fine workmanship. For he constructed in it large and airy windows that provided a long vista to anyone standing in the house, and offered to the beholder's eyes a full view of almost half the city."

Aiming at a evocation of Style 1200 in its total environment, the present exhibition follows a splendid tradition of American medieval studies that have analyzed the interconnections among politics, social life, intellectual history, and art on a broad basis. Lodging all these precious objects in its galleries, the Metropolitan Museum can assert, echoing C. H. Haskins's methodological appeal given in an article on "Sport in the Middle Ages": "The whole breadth of the Middle Ages is ours."

A NOTE ON CROSS REFERENCES:

References to
material in *The Year 1200: II A Background Survey*
will be found in this catalogue in this fashion: II, ill. 145

SCULPTURE

1. Fragments of a Deposition

Northern France
About 1180
Stone
Christ: H. 48 cm. (18⅞ in.)
Lille, Palais des Beaux-Arts

The fragment of Joseph of Arimathea (with Christ's hand on his shoulder) has been recognized by Vanuxem as belonging with the torso of Christ (unpublished research, 1969). Both are made of a white stone native to Cambrai. A subtle rhythm characterizes the conception of the figure, especially discernible in the wrap of the loincloth and treatment of the hair. The soft modeling of the body, apparent in the modest articulation of the ribs, harmonizes with the expressive curvature of the torso. The derivation of the Senlis figure style from Cambrai sources, suggested by Vanuxem (1945) was rightly contested by Sauerländer, who pointed to the retardataire features in the Cambrai and Lille fragments. The sources of the stylistic peculiarities of the fragment should be sought in northern French and Mosan miniature painting. Besides some northern French manuscripts (Oxford, Corpus Christi College, Ms. 157, fol. 77; Paris, Bibliothèque Mazarine, Ms. 341, fol. 125, Swarzenski, 1967, fig. 317); one might compare the bronze figure of Christ in the mid-twelfth-century Deposition group in the Victoria and Albert Museum (Swarzenski, 1967, fig. 341; for other illustrations of Mosan crucifixions, Usener, 1934). Compare, moreover, a fragmentary English morse ivory crucifix in London (Swarzenski, 1967, fig. 280) and a bronze crucifix in Angers (Cleveland, 1967, III 19, p. 83).

BIBLIOGRAPHY: J. Vanuxem, "Les portails détruits de la cathédrale de Cambrai," *Bulletin Monumental,* 1945, pp. 89–102; J. Vanuxem, "La sculpture du XIIe siècle à Cambrai et à Arras," *Bulletin Monumental,* 1955, pp. 7–35; Sauerländer, 1958, pp. 133–134; Barcelona, 1961, no. 340; Paris, 1962, no. 21

2. Head of a priest

France
About 1180
Stone
Mantes, Dépôt Lapidaire

This head and no. 3 are believed to have come from the central portal of the Mantes Collegiate Church (Aubert). The veil and its border decoration identify the head as that of an Old Testament priest. Sauerländer, referring to the Christophores cycle of the Senlis cathedral portal, the immediate prototype of the Mantes doorway decoration, proposed Samuel or Simeon. The protruding cheekbones and the treatment of the beard are seen not only in some archivolt figures still preserved in Mantes cathedral, but also in the type of head produced in the Senlis atelier (Sauerländer, 1958, fig. 68). The variation of the beard seen on no. 3 is explained as the work of two masters working side by side. The sculptor of the priest's head remained closer to the style of Senlis, where he might actually have worked before coming to Mantes; the masklike appearance and the soft

fluidity of the head represent stylistic inventions of a generation earlier. The artist was also influenced by the decoration of the earlier north portal of the Mantes façade derived from the Porte des Valois in St. Denis.

BIBLIOGRAPHY: Aubert, 1938, p. 9; Sauerländer, 1958, p. 150, fig. 90

3. Head of Moses

Ile-de-France
About 1180
Stone
H. 43.2 cm. (17 in.)
Mantes, Dépôt de la Collégiale Notre-Dame

This impressive head was shown by Aubert to come from one of the jamb figures of the central west portal of the collegiate church in Mantes. The long beard and the high cap and cheekbones contribute to the striking verticalism. The modeling of the beard, the full lips, the detailed rendering of the eyeballs and lids, and the articulation of the cap indicate the exceptional subtlety of the sculptor's conception and technique. The rhythmically intertwined beard strands contribute to the sublime expression. The piece combines a continuously swelling surface with a rigid structure, a sense of playful movement with a hieratic effect, that recall Burgundian Romanesque figures of fifty years earlier (Aubert). Fragments of beards resembling the one on our head appear on some of the archivolt statuettes still in the central portal in Mantes. Slightly later versions occur in the archivolt figures of St. John's Portal of Sens Cathedral, whose dependence on Mantes was demonstrated by Bony. In contrast to the rather stiff relief style of the Mantes Coronation of the Virgin tympanum, developed from the slightly earlier northern portal of the collegiate church, the distinctive achievements of Senlis sculptors come to the fore only in the jamb figures and achivolt statuettes of the central portal in Mantes (Sauerländer, 1958). Pointing to the stylistic roots of the Mantes sculptures in the St.-Denis Porte des Valois and a group of Mosan

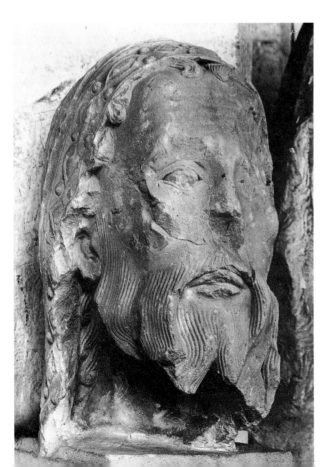

and northern French miniatures, engravings, and ivories, Sauerländer convincingly suggests a date around 1180 for the central portal of Mantes, thereby correcting Bony's dating of 1195. Paralleling our head in style are five medallion heads carved on the front of a sarcophagus preserved in the church of St. Pierre in Lisieux, intended probably for Archbishop Arnold de Lisieux (d. 1181); especially revealing is a profile comparison of our head with the profile head of this sarcophagus (Sauerländer, 1961, figs. 16, 23). The relationship is an additional support for the dating of the exhibited head.

BIBLIOGRAPHY: M. Aubert, "Têtes gothiques de Senlis et Mantes," *Bulletin Monumental,* XCVII, 1938, pp. 8–9; J. Bony, "La Collégiale de Mantes, les circonstances historiques," *Congrès Archéologique,* 104, 1946, p. 202; Sauerländer, 1958, p. 148 f.; Paris, 1962, no. 35; Cleveland, 1967, III, no. 37; Providence, 1969, p. 167; Pressouyre, 1969

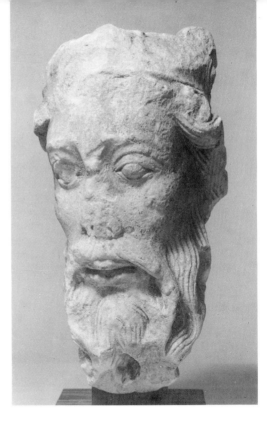

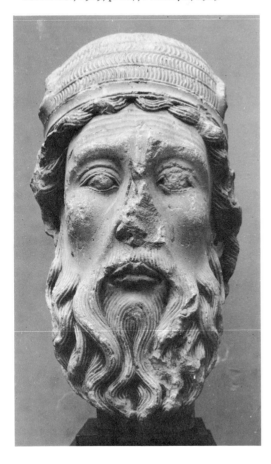

4. Head of an Old Testament king

French
About 1180
Limestone
H. 25.7 cm. (10⅛ in.)
Durham, North Carolina, Duke University,
 Art Museum

This head seems indebted to the expressive formulas for portrait types in middle Byzantine art, especially in the ivories that profoundly influenced the sculpture of Notre-Dame in Paris (Sauerländer, 1959). Although it is said by R. Moeller (Durham, 1967) to have come from the west portal of the collegiate church in Mantes, it is smaller than one indubitably from that portal (no. 3) and so could not well have belonged to the same cycle of jamb figures, despite its closely similar elongated proportion and many-layered, wavy beard. The head would also seem to be too large to have been part of an archivolt statuette at Mantes. Furthermore, it clearly deviates in style from other remnants of Mantes sculpture, namely two heads connected with the slightly earlier

north porch of the façade (Sauerländer, 1958, figs. 92, 94). In its refined, alert modeling and undulating outline the head anticipates effects of Giovanni Pisano (H. Keller, *Giovanni Pisano,* Vienna, 1942). Another product of the Mantes workshop, datable about 1180, is the central head of the five medallions of the Lisieux sarcophagus (Sauerländer, 1961, fig. 23); it illustrates the reduction in size of the monumental head encountered here. The exhibited head, while reminiscent of mid-twelfth-century heads in a certain stiffness, anticipates, in its qualities mentioned earlier, and in its animated expression, a head of the early thirteenth century, no. 15. The psychological perception evident in the present head parallels developments in French psychology (Koehler, 1943) and literature (A. M. Colby, *The Portrait in 12th Century French Literature,* Geneva, 1965), elucidating the meaning of "early Gothic humanism."

BIBLIOGRAPHY: Durham, 1967, no. 10; Providence, 1969, no. 57

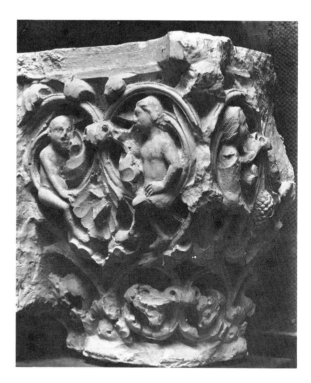

5. Capital fragment

France
About 1180
Stone
32 x 42 x 42 cm. (12⅝ x 16½ x 16½ in.)
Reims, Musée de Reims

This fragment is a rare example of Reims twelfth-century sculpture. Symmetrically placed, a naked man and woman (identifiable as Adam and Eve) emerge from a scroll pattern on one side; a similar group originally decorated the damaged back. The piece is distinguished by the compact modeling of figures and plants. The deep undercutting produces a rich play of light and shadow on the surface. While following the botanical grammar of Romanesque capitals (Paris, 1962, no. 7) the spatial implications and the whirling effect anticipate the culmination of Gothic floral capitals in the thirteenth-century Reims cathedral (Nordenfalk, 1935; Behling, 1964; Jalabert, 1965). Reviving the classical type of inhabited scrolls our piece testifies to the Reims tradition of *style antiquisant.* The close connections of this region with Mosan goldsmiths' work are seen in the crest of the Siegburg shrine of St. Anno, in which Sauerländer found parallels for the intermingling of figures and floral ornament (Sauerländer, 1963, p. 215; for the Anno Shrine: Mütherich, 1940, figs. 10, 11; also no. 113). A more linear interlacing of figures and floral medallions may be followed in Reims twelfth-century sculpture from the magnificent fragments of the tomb of Raoul de Vert in St. Remi (Saxl, 1954, figs. 4, 5) to the pilasters of the Porte Romane in the cathedral (Sauerländer, 1956, fig. 1). For a brilliant development of this type in French sculpture of about 1200 the trumeau relief of Sens cathedral (Aubert, 1946, p. 280).

BIBLIOGRAPHY: Baltrusaitis, 1960, p. 58; Paris, 1962, no. 123; Sauerländer, 1962, p. 228; Sauerländer, 1963, p. 215

6. Fragment of a floral capital

France
About 1180
Stone
32 x 42 cm. (12⅝ x 16½ in.)
Reims, Musées de Reims

Similar to other capitals preserved in Reims (see no. 5), this piece presents a magnificent intertwining of branching stems, though it lacks the human figures seen on the other examples. The dynamic and continuous movement, the characterization of the leaves' flabby surface, the variety of details, and the clear compositional arrangement are striking. It is in the Porte Romane of Reims Cathedral (Sauerländer, 1956, fig. 1) that one finds stylistic parallels in a coherent ensemble; a date in the eighth or ninth decade of the twelfth century becomes probable from this relationship. In comparison with no. 5 one notes here a closer placement of the forms to the ground of the relief; this difference indicates a slightly earlier origin. Carl Nordenfalk (1935) showed how the increasing naturalism of floral ornament—in classical art and that of early thirteenth century Reims alike—is linked to its degree of spatial independence from the background. The progression can be followed in Reims from the early twelfth century onward. The emphasis in our fragment on delicate lines is a heritage from local precedents such as the magnificent tomb of Raoul le Vert, fragments of which are preserved in St. Remi (Saxl, 1954, figs. 4–5). Reims was a natural place for the formation of this type of capital since it knew both remnants of classical sculpture and the contemporary art of the adjacent Meuse valley. A slightly later adaptation is apparent in capitals of Laon Cathedral (Jalabert, 1965, pl. 57B).

BIBLIOGRAPHY: Paris 1962, no. 124

7. Columnar figure: apostle

France
About 1180
Limestone
97.9 x 24.1 cm. (38½ x 9½ in.)
Cleveland, Museum of Art, 19.38

Carrying a book in his left hand, the upright figure of a youthful saint is attached to a column. The vigorous modeling of the body and the intensely stretched drapery folds contrast with the relief-like combination of figure and column, indicated also by the way the halo follows the surface of the column. The sculpture was only recently recognized as from the cloister of Notre-Dame-en-Vaux in Châlons-sur-Marne (Pressouyre) A large number of fragments, both of columnar figures and capitals, have been found there since 1961. The figure not only matches the Châlons statues in size but agrees in proportion, drapery, and technique. Apparently an apostle, our statue is tentatively identified as St. John. Among the Châlons fragments it is especially the two columnar figures secondarily installed in the church of Saony (Marne) that have been compared with our figure (Sauerländer, 1963, pl. XLII, fig. 23). Our statue is distinguished by a vividly lifelike expression not incompatible with the impression of cool restraint. Its stylistic connections with the ateliers of St.-Denis (Porte des Valois) and those of Senlis and Mantes in the 1170s have been pointed out by Sauerländer, together with fea-

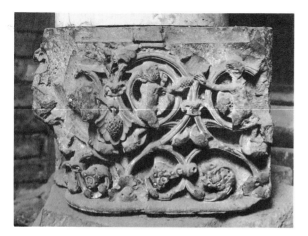

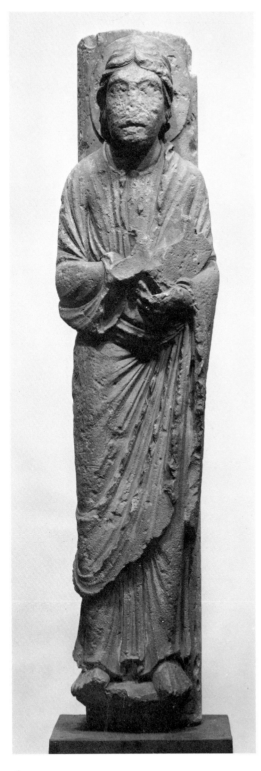

tures characteristic of Champagnesque sculpture well into the thirteenth century. The common St.-Denis inspiration explains certain similarities with the apostle from St. Martin in Angers (no. 8). The strong Mosan connotations apparent in the Châlons statue result from the sources of the Porte des Valois as well as from direct connections with north French ateliers that had been closely associated with Mosan art since the middle of the twelfth century.

BIBLIOGRAPHY: Sauerländer, 1963; L. Pressouyre, "Fouilles du cloître de Notre-Dame-en-Vaux de Châlons-sur-Marne," *Bulletin de la Société National des Antiquaires de France,* 1964, pp. 23–38; Cleveland, 1967, III, 27; Paris, 1968, no. 19

8. Madonna and Child with four saints

France
1175–1190
Stone
H. 195.6 to 139.8 cm. (77 to 55 in.)
New Haven, Yale University Art Gallery,
 Gift of Maitland F. Griggs

These statues come from the choir of St. Martin in Angers (where they are now replaced by modern copies). A sixth figure, long known to have belonged to the ensemble, has disappeared. The polychromy was applied around 1768. The heads were removed during the French Revolution. Two of the statues appear to be the apostles Andrew and John, the other two have been identified as local bishop saints, Maurille (or Aubin) and Loup. From the unusual cutting of the St. Martin choir vault ribs G. H. Forsyth concluded that the figures were installed in the choir of the church only secondarily. He postulated the west portal of St. Martin as their original site, with the Virgin and Child destined for the tympanum, but this portal, as a matter of fact, was never completed. Although noting the different sizes of the statues,

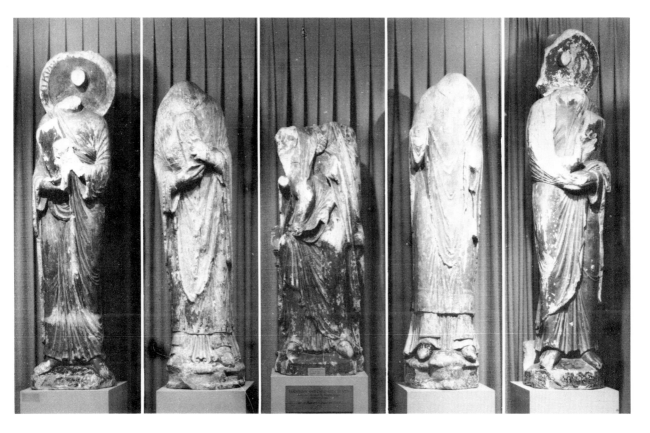

Ludwig Schreiner rejects Forsyth's theory but presents no definite reconstruction of the portal's original appearance.

Stylistically, the figures combine a strict adherence to their actual block shape with vividly linear drapery that reveals the straightened limbs underneath. The most accomplished examples of this treatment are the statues of the apostles; the two bishops are conceived differently in a sequence of flat layers covering the block. In the Madonna group the mobility of the Child's posture and its fluid drapery betray the artist's tendency to overcome the conventional formulas employed in the other statues. In the remaining sculptural decoration of St. Martin some of the keystones are comparable for their style as well as for their type of head, which may help us visualize the heads of the present statues. The stylistic derivation of the cycle is complex and was the subject of controversy in the earlier literature.

Whereas in the Anjou region the stylistic impact of the Chartres Cathedral Portail Royal is evident well into the 1170s, in works such as the western portals of Angers Cathedral and the south porch of Le Mans Cathedral, the stylistic peculiarities of our cycle have been traced not only to Chartres (via Angers Cathedral) but also to local traditions (the refectory portal of St. Aubin, Angers) and Burgundian sources. The Porte des Valois in St.-Denis and the Senlis and Mantes Coronation portals have been indicated as further sources. Taking into consideration other Angevin works partly dependent on our cycle (the Madonna in Saumur, Ste. Trinité in Vendôme, parish church in Chiqué), and the building history of St. Martin, Schreiner could not date these statues more precisely than by suggesting the period 1175-1190.

BIBLIOGRAPHY: G. H. Forsyth, *The Church of St. Martin Angers,* Princeton, 1953; Schreiner, 1963, p. 7 f.

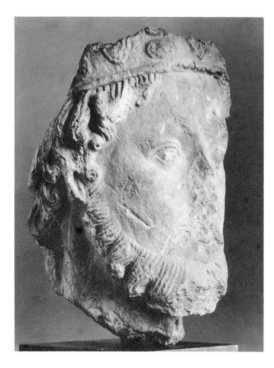

9. King's head

France
1180–1190
Limestone
H. 33 cm. (13 in.)
New York, The Metropolitan Museum of Art,
 Bequest of Mrs. H. O. Havemeyer, 29.100.28

This fragment is distinguished by precise draw-ing in the rendering of the eyelids, the separate curls of hair, and the rough parallel strokes of the beard. The dating results from the heavy im-pression, the frontal stare, the treatment of the beard, and the type of crown. The head resembles one from the collegiate church in Mantes (Sauer-länder, 1958, fig. 94). Perhaps our piece also originally belonged to the north portal of this church's façade, generally dated 1175–1180. The relationship of this group to the Porte des Valois in St.-Denis (Sauerländer, 1958, p. 152, fig. 93) supplies further comparative material for an attempt to fix the origin of our head.

BIBLIOGRAPHY: *Art News,* 1930, p. 40, ill. p. 53

10. Angel

France
1190–1200
Stone
Laon, Cathedral

This kneeling figure came from the gable of the left porch in the west façade of Laon Cathedral, part of a symmetrically arranged composition attached to the portal with the Adoration of the Magi tympanum. The continuous flow of drapery together with the fine differentiation of single folds testifies to the versatility of the artist. In motif as well as style the figure resembles the kneeling angels in the Coronation of the Virgin tympanum of the cathedral's central portal. Whereas no definitive chronology, either abso-lute or relative, can be established for Laon sculp-ture, a date in the last decade of the twelfth

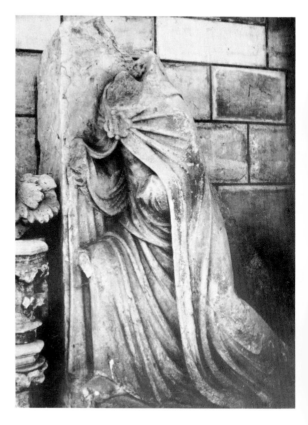

century is generally assumed, especially as the impact of the Laon style is discernible in Chartres from 1194 onward. From detailed comparisons Sauerländer establishes the Coronation tympanum as a precedent for the lateral doorways of Laon Cathedral façades. Compared to the angel in the Coronation tympanum, our figure is distinguished by a more subtle integration of movement and drapery. With regard to later adaptations of Laon techniques the figure has been compared both to the Abraham in the north transept of Chartres (Sauerländer, 1966, p. 56, fig. 95) and to the row of damned in the fragmentary Last Judgment from Braisne (Sauerländer, 1963, p. 210). One may observe another variation of this figural type in the first kneeling king of the Adoration tympanum in the sculptural decoration of the Laon façade itself (Sauerländer, 1956, fig. 18), which, in its complicated arrangement of drapery, apparently holds an intermediary position between the kneeling angel of the Coronation and our fragment. Sauerländer indicates the Porte Romane of Reims cathedral, of about 1180, as their main stylistic source. There is, however, no close prototype in Reims for our figure, which, in its soft and charming interpretation of Mosan as well as classical models, seems to anticipate achievements of the "international style" of 200 years later.

BIBLIOGRAPHY: Sauerländer, 1963, p. 210; Sauerländer, 1966, p. 56; Deuchler, 1967, p. 139

11. Angel

France
1190–1200
Stone
Laon, Cathedral

To judge from its outline this fragment comes from the left half of the archivolt of one of the three portals of Laon Cathedral. Despite its damaged state the figure is impressive in its relaxed posture and its varied drapery, combining pre-

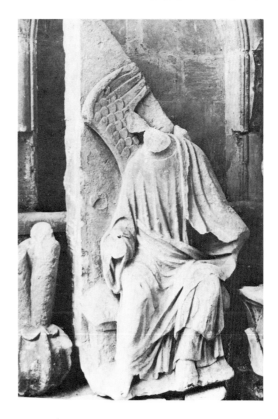

cisely drawn folds and clinging, wrinkled areas. The slightly diagonal axis was originally emphasized by the highly lifted wings. A variety of stylistic trends has been observed in the sculptures of the Laon façade, attributable to the rather long building period. In the Coronation of the Virgin tympanum, datable to about 1190–1200, there is already a restrained linearism that sets Laon sculpture apart from the vitality of Senlis; apparently this was derived from the Porte Romane of Reims cathedral. Stylistically our fragment may be attributed to the phase of the northern portal. Although the seated posture and drapery of St. Joseph, in the Adoration of the Magi tympanum, appears to be a slightly earlier version (Sauerländer, 1956, fig. 18), the same calm mood prevails in both works. An earlier version can be seen in the angel at the tomb in the lintel of the Mantes left portal (Sauerländer, 1963, fig. 31).

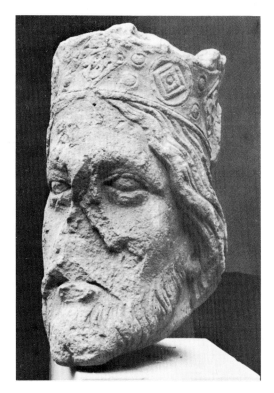

54); a comparison of these works shows the progression from tenderly dissolving forms to an official type of High Gothic sculpture characterized by uniformity and stiffness. Other pieces in this exhibition, nos. 13 and 16, testify to the wide range of formal possibilities prevailing in the Sens workshop around 1200.

BIBLIOGRAPHY: Sauerländer, 1964; Sauerländer, 1966, p. 66, fig. 110; Pressouyre, 1969

13. Apostle's head

France
About 1200
Stone
H. 40 cm. (15¾ in.)
Sens, Salle synodale

The piece is distinguished by soft modeling, graceful linearism of hair and beard, and pathos of the eyes and mouth. It has been associated with the sculptural decoration of the Sens cathedral's

12. Head of a king

France, Sens
1190–1200
Stone
Sens, Palais Synodal

This elongated oval head, which comes from the central west-façade portal of Sens Cathedral, is distinguished by a precise articulation. Spatial emphasis is apparent in the deep hollows of the eyes and the obliquely recessed hair. The rebuilding of the cathedral began in 1184 with dedications of various parts of the west façade occurring in the first decade of the thirteenth century, and this activity brackets the carving of the head. Adaptations and developments of this Sens workshop type can be seen in the figure of St. Martin in the south transept of Chartres Cathedral (Sauerländer, 1966, figs. 110–112) and in the head of a bishop's tomb in the Hospice d'Aligre in Lèves (Sauerländer, 1966, fig. 115; Paris, 1962, no.

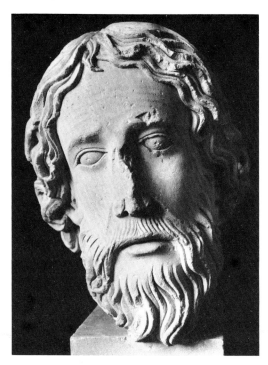

main portal, for which a date in the last decade of the twelfth century is apparent from both documentary and stylistic evidence. For another fragment said to come from a Sens portal, displaying the same touching melancholy, see no. 12. Iconographically, the central doorway of Sens was the first to represent the twelve apostles by expanding the traditional scheme of previous Ile-de-France portals that contained only eight columnar statues (Katzenellenbogen, 1963, 1967). Another head preserved in Sens and coming probably from the St. John portal illustrates the stylistic connections with the Mantes atelier (Paris, 1962, no. 39).

The richness of subtle gradations in the treatment of the stone, the loose rhythm of the hair strands, and the apparent indebtedness to classical models make the exhibited head a major representative of the classicizing trend around 1200. Greenhill finds contrasts in mood and conception between the present head and no. 15. Sauerländer compares our head to the noble and eloquent profile head of Dives on the Vasque of St. Denis, attributed by him to the same Sens atelier. (For comments on the psychological aspects of this group: Ladner, 1965.)

BIBLIOGRAPHY: Paris, 1962, no. 38; Sauerländer, 1961, fig. 12; Sauerländer, 1963, fig. 215; Sauerländer, 1966, fig. 35; Greenhill, 1967, fig. 8

14. Apostle

France
1200–1210
Stone
H. 198.2 cm. (78 in.)
Paris, Musée Lapidaire du Carnavalet

This extremely elongated figure combines a stiff posture with an animated surface of precisely drawn folds. The right leg supports the weight of the body, the classical contrapposto motif corresponding to the classical drapery that clings closely to the body. Found in 1880 in the bed of the Seine near the Pont du Diable in front of Notre-Dame, the torso has been thought to come from a portal of the cathedral. The oblong object in the figure's left hand has been tentatively identified as a cross, the traditional attribute of the apostle Andrew. Noting a broad scar on the back of the figure, Greenhill concludes that the statue was originally attached to a supporting column figure from which it was probably separated during the French Revolution. Taking into consideration both the iconographical identity of our figure as an apostle and its apparent dating around 1200, Greenhill connects it with the last Judgment portal of Notre-Dame, the jambs of which have been dated to the very beginning of the

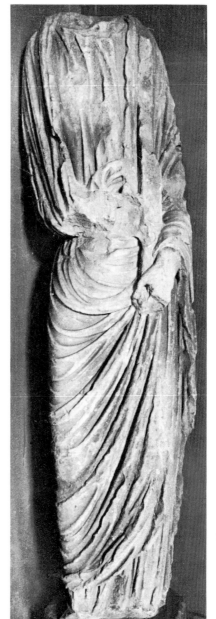

thirteenth century by Sauerländer. Discussing the art-historical conclusions from her proposed reconstruction, Greenhill stresses the mediatory role of the Paris atelier that was instrumental in spreading the classicistic trend of the northern French and Mosan transitional style. The verticality, the contrapposto, and the drapery treatment of our figure may be looked upon as successors to late twelfth-century inventions, such as a fragment in the Cluny Museum (found with our torso in 1880: Paris, 1962, no. 11; Sauerländer, 1958, p. 133, fig. 77). A schematized derivation of our figure is to be seen in the David jamb figure of the central portal in the Chartres north transept (Katzenellenbogen, 1959, fig. 50). The foreshadowing of the exhibited figure was sensed by Hamann-MacLean, who, in ascribing it to the Sens workshop active in Paris after 1208, recognized it as a source of Reims cathedral sculpture. Greenhill mentions another fragment, in the reserve of the Cluny Museum (Greenhill, 1967, figs. 11–12), differing slightly from our figure in its broader proportion and treatment of drapery (directly reminiscent of Sens precedents); this piece, too, is plausibly connected with Notre-Dame. The nature of the alleged classical models employed by the Paris sculptor is not yet known. Greenhill associates the exhibited figure with the head, no. 15.

BIBLIOGRAPHY: Hamann-MacLean, 1965, p. 233, n. 24; Greenhill, 1967; Haussherr, 1968, p. 304; Pressouyre, 1969

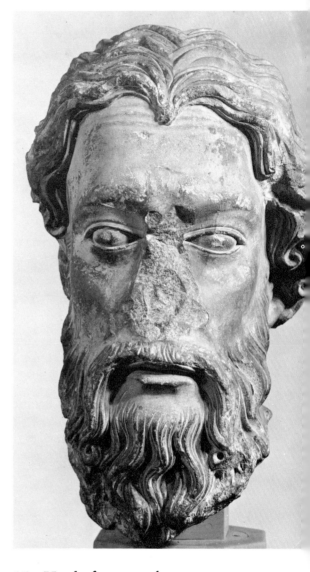

15. Head of an apostle

France
1200–1210
Limestone
H. 43.2 cm. (17 in.)
Chicago, The Art Institute, Buckingham Fund, 44.413

This subtly rhythmic head, with its superb undulating treatment of hair and beard, is traditionally attributed to a portal of Notre-Dame in Paris. Greenhill has proposed a combination of the

head with a headless torso (no. 14) in the Musée Carnavalet, as a reconstructed columnar figure from the Judgment Portal of Notre-Dame. Admittedly, the pieces agree in dimension, style, and even character of break, but the proposal fails because the stones themselves are of different composition. Not only is the Parisian origin of the head still unproved, Greenhill's conclusion concerning the stylistic impact of the Judgment Portal in the formation of the High Gothic style has to be approached cautiously. This head has been compared (Greenhill) with a fragment from Sens (no. 13) to show the differences rather than the interrelations between the succeeding ateliers (Sens and Paris). Pressouyre, on the other hand, convincingly connected the head with the Sens workshop. As well as possible antique prototypes one has to consider Byzantine ivories as sources, in accordance with Sauerländer's derivation of Notre-Dame's portal sculpture from this area (Sauerländer, 1959, pls. 18–19). It is most probably in these ivories that the verticality, animated surface, and the treatment of the beard find their closest precedents.

BIBLIOGRAPHY: Boston, 1940, no. 175; Chicago, 1945, pls. X-XI; Greenhill, 1967 (with ref. to Sauerländer letter of 1958 proposing a date shortly after 1200); Cleveland, 1967, IV, 1, p. 124; Pressouyre, 1969

ing to similarities in detail (drawing of the eyes and wings of the nose) in the trumeau figure of St. Stephen and two fragments from Sens Cathedral, Erlande-Brandenbourg suggests a Sens origin for our head. This attribution seems correct, despite the fact that the three pieces, as well as an abbot's tomb in Nesle-la-Reposte (Pressouyre, 1967), lack the dynamism of our head. This dynamism is derived from the sculptor's indebtedness to a Roman imperial bust, perhaps that of Antonius Pius, to which Panofsky showed resemblances in the slightly later statue of St. Peter in the north transept of Reims cathedral (Panofsky, 1960, p. 63, n. 1, figs. 35–36). It was perhaps a similar, or even the same classical piece, available in Ile-de-France, that inspired both the Sens and Reims sculptor at the beginning of the thirteenth century. It is interesting to note that the Reims statue, in its overall curling of the hair, more closely follows the Roman prototype than our head, where the curls are limited to the first row framing the forehead. The strong classical connotations of our head further support the Sens localization insofar as this atelier has been recognized in recent research as the leading center of classicizing trends in French sculpture around the turn of the century.

BIBLIOGRAPHY: Erlande-Brandenbourg, 1967

16. Head

France
About 1200
Stone
29.5 x 24.5 x 24.5 cm. (11½ x 9⅝ x 9⅝ in.)
Paris, Musée Rodin

With only slight mutilations and modern restorations disturbing its original appearance, the piece, from a columnar statue at a church portal, is distinguished by a striking vitality. The sensitive drawings of the eyes and lips, contrasting with the broad treatment of the dense beard curls, points up the sculptor's masterly technique. Point-

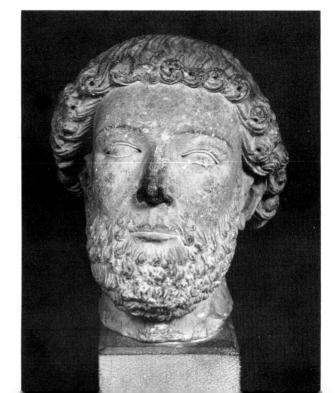

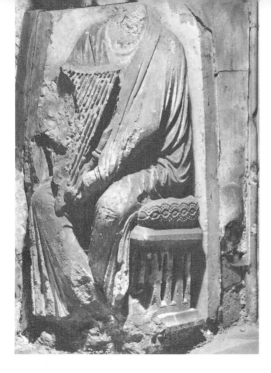

17. Harpist

France
1200–1215
Stone
Rouen, Musée des Antiquités

This figure of a seated man holding a harp before his chest comes from the archivolts of the Rouen Cathedral, west façade, central portal; these were removed in the sixteenth century. Wrapped in smoothly fluid drapery, the figure is distinguished by an ornamentally closed outline and a marked accent of diagonal movement, underlined by the position of the harp. Currently labeled "King David," the statue more probably represents one of the twenty-four apocalyptic elders, a subject often found in archivolt decorations of early Gothic French cathedrals. The time-honored popularity of this old pictorial formula (Steger, *David, Rex et Propheta,* Nuremberg, 1961) is attested to by the fact that similar harpists occur in different narrative contexts of contemporary art (no. 86; the plaque from the Shrine of the Three Kings, Swarzenski, 1967, fig. 523). A discussion of the stylistic sources (Mantes) as well as a reconstruction of the figure's original context will be published by H. Krohm (dissertation, Columbia University, 1969), who points to the

fire of 1200 as the *terminus ante* for the portal decoration.

BIBLIOGRAPHY: Cochet, *Catalogue du Musée des Antiquités de Rouen,* Rouen, 1875, p. 85, no. 107; Sauerländer, 1966, p. 91 f.

18. Annunciation

France, Toulouse
About 1180–1196
Marble
H. Angel 189 cm., Virgin 164 cm.
(74½, 64½ in.)
Toulouse, Musée des Augustins

The original site of this monumental group, installed in the Toulouse Convent of the Cordeliers in 1210, is no longer known. The dating of the group derives from its stylistic similarity to the chapter house portal figures of the Abbey of La Daurade in Toulouse, dated in written sources between 1180 and 1196. The figures of the pres-

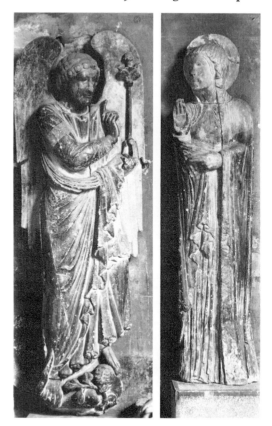

ent group are characterized by solid, blocklike structures and heavy cascades of drapery with sharply undulating edges. The immobile positions of the heads, the summary treatment of the hair masses, and the restrained gestures and facial expressions indicate the lasting effect of Romanesque Provençal sculpture. On the other hand, the erect bearing and rhythmical articulation of the bodies depend on northern French portal sculptures. This influence is especially evident in the figure of the angel; the dynamic tension of his diagonally drawn-up mantle, the parallelism between his right arm and the bolster of drapery underneath, and the delicate holding of the scepter with two fingers. The angel stands upon a dragon biting a leafy branch. An Annunciation group in Lérida, Spain, which apparently was modeled after the present sculptures, shows the angel standing similarly with the Virgin standing upon a lion (Porter, 1923, pl. 553). From this comparison the original iconography of our group may be reconstructed and interpreted in terms of Christ (lion) defeating the devil (dragon). An antecedent for this conception may be found in the Annunciation relief in St.-Jouin-des-Marnes of about 1140, an Aquitanian piece geographically adjacent to Provence (Guldan, 1966, pl. 46, pp. 180–181 with further examples).

BIBLIOGRAPHY: P. Mesplé, *Toulouse, Musée des Augustins: Les Sculptures romanes,* Paris, 1961, nos. 248–249; Paris, 1962, no. 31; Cleveland, 1967, III, 34, p. 112 f; Sauerländer, 1958, p. 131, no. 42; Sauerländer, 1962, p. 228

19. Tomb figure, Eleanor of Aquitaine

France
1204–1210
Stone, polychromy
L. 217 cm. (85 in.)
Fontevrault, abbey church

Like the closely related tomb figures of Henry II, her second husband, and her son Richard the Lion Heart, all buried in the Fontevrault abbey church, Eleanor is represented lying in state on a four-posted bed that is covered by a thin cloth. Her head supported by a pillow, the crowned queen wears a long mantle over her flowing robe. The book held in her hands is an extremely rare detail (Panofsky, 1964, p. 57). The figure is characterized by its lengthy proportions and ornamentally arranged drapery folds that seem to be incised only on the surface. The antagonism between this linearism and the solid sculptural substratum of the figure is explained by the amalgamation of different stylistic trends. On one hand, the drapery technique may be viewed as a western French peculiarity, apparent earlier in the figures from St. Martin in Angers (no. 8) and recurring in the Virgin group of Cunault (Schreiner, 1963, fig. 75). On the other hand, the impact of contemporary sculpture from the north transept porch of Chartres Cathedral has been rightly assessed by Schreiner, especially in comparison with the prophets and the tympanum with the Chartres Coronation of the Virgin. Schreiner fur-

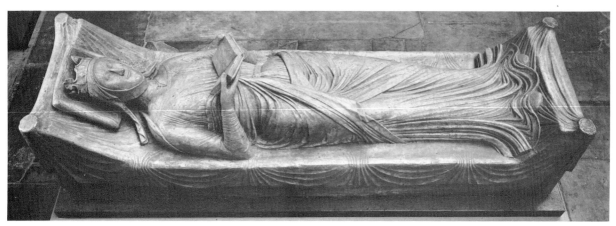

thermore points to the Coronation of the Virgin portal of Laon Cathedral and to the tympanum Virgin of the north portal in Bourges in an attempt to derive the strict constraint, the closed outline, and the technique of the Fontevrault tomb. While Eleanor's tomb is datable by her death in 1204, the two other tomb figures could still have been worked toward the end of the twelfth century. This would explain the increased elegance and rhythmic fluidity to be observed in the drapery of Eleanor as opposed to the simpler arrangements in the two other gisants. A date in the later part of the first decade of the thirteenth century for Eleanor's tomb would harmonize furthermore with the chronology of the Chartres and Laon sculptures adduced for comparison. With regard to iconography, Erlande-Brandenburg considers the queen's closed eyes another indication of the artist's adherence to western French tradition.

BIBLIOGRAPHY: Paris, 1962, no. 49; Schreiner, 1963, pp. 67–77; A. Erlande-Brandenburg, "Le 'Cimetière des Rois' à Fontevrault," *Congrès Archéologique*, 122, 1964, pp. 482–492

20. Capital: Doubting Thomas

France
1190–1210
Limestone, polychromy
H. 61 cm. (24 in.)
Rochester, Memorial Art Gallery of the
 University, R. T. Miller Fund

Four figures are represented: Thomas, Christ, an unidentified apostle, and Peter (holding his key). Stepping to the left, his legs crossed, his right arm swung across the doubter's chin, the figure of Christ dominates the group. An indebtedness to twelfth-century northern French prototypes is evident in the movement of the Christ figure and in the drapery motifs generally. The noble expression of Christ's face, its inclined position harmonizing with the open mouth and flowing hair, recalls the Byzantine ivories that had influenced the northern French models. The derivative character of the sculpture is clear in the uneven qual-

ity of its parts: compared with Christ and Peter, the treatment of the figures is provincial, yet the entire capital, its rich original polychromy more or less intact, is interesting in its evidence of stylistic amalgamations and overlappings that occurred in late twelfth- and early thirteenth-century ateliers in reaction to Ile-de-France innovations. This object was recently recognized as coming from the church of St. Martin in Candes by L. Pressouyre (unpublished research), where a modern replica is to be seen *in situ* (Schreiner, 1963, fig. 64). The style of the Candes reliefs has been derived from Laon ateliers by Schreiner.

BIBLIOGRAPHY: *The Rochester Memorial Art Gallery Handbook,* 1961, pp. 41, 49; Schreiner, 1963, pp. 106–112

21. Saint Germain d'Auxerre

France
1210–1225
Stone
H. 168 cm. (66⅛ in.)
Paris, St.-Germain-l'Auxerrois

This impressive life-size figure was discovered in 1950 under the Virgin's Chapel of St.-Germain-l'Auxerrois. The late thirteenth-century date of the church's portal precludes identification of the piece as the trumeau figure known to have been removed with the tympanum in 1710. A close relationship exists with the Coronation of the Virgin portal at Notre-Dame Cathedral, testifying to the Parisian origin of the figure. Slight irregularities in the course of the drapery folds, and the position of the head, contribute to the impression of spontaneity.

The standing bishop, as a type, occurs in French sculpture in a nimbused statue of the late twelfth century in the Musée du Berry, Bourges (Paris 1962, no. 25); comparison with our piece emphasizes the animation achieved by the early thirteenth-century sculptor. For an English interpretation of the subject, see no. 197.

BIBLIOGRAPHY: Paris, 1962, no. 50; Sauerländer, 1962

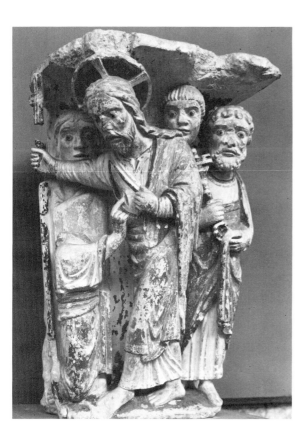

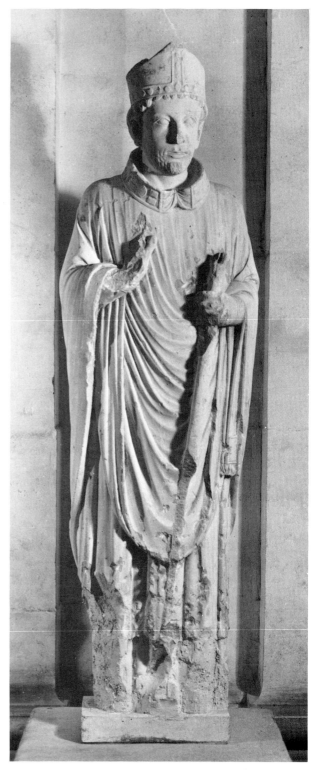

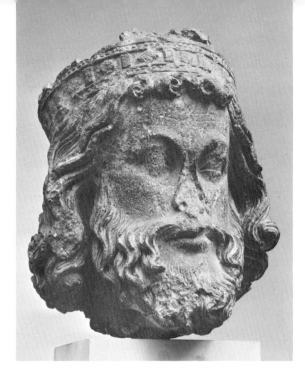

are clear when the head is compared with figures of the Chartres archivolt (Sauerländer, 1959, fig. 60). Compared with the king from the Paris archivolt, the superior quality of our head is evident, especially in the delicate articulation of the hair and beard. While like a Burgundian head (no. 24) deriving from the Chartres Master of the Kings Heads it differs from it by its precise modeling and the courtly smile, both anticipating the sculpture of Reims. The motif of the upturned eyes has a broad ancestry in classical art (H. P. L'Orange, *Apotheosis in Ancient Portraiture*, Oslo, 1947).

23. Head

France
1225–1230
Limestone
25.4 x 17.8 x 17.2 cm. (10 x 7 x 6¾ in.)
Seattle, Art Museum, Eugene Fuller Memorial
 Collection, Fr. 11.11

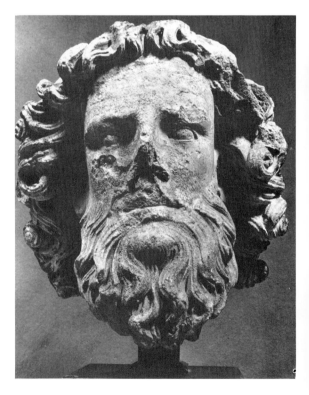

22. King's head

France
1210–1220
Limestone
H. 34.3 cm. (13½ in.)
New York, The Metropolitan Museum of Art,
 Fletcher Fund, 47.100.55

This oval head with lively, curling hair and beard in a dissolved omega form, has a special elegance, its appeal heightened by the expressive upward glance. The sources of this piece are to be found among the works of the so-called Master of the Kings Heads in Chartres Cathedral (especially the figure of Solomon). Closer analogies are visible in the Coronation of the Virgin portal of Notre-Dame in Paris. Especially striking is a comparison with a standing king from the archivolt statuettes (Sauerländer, 1959, fig. 59), where the same framing hair, smooth surface, and narrow mouth recur. It is from this portal that our head is said to come, and a date in the second decade of the thirteenth century may therefore be assigned to it. In the course of development of French early Gothic sculpture, the Coronation portal holds an intermediary position between the north transept of Chartres Cathedral and the façade decoration of Amiens. These connections

Strikingly vertical, this magnificent head manifests a baroque pathos. The deep hollows of the eyes and the convolutions of the hair create an agitated effect. The marked protrusions of the brows, eyes, and chin are integrated in the continuous swelling of the surface. From its general appearance, as well as its sculptural technique—the deep hollows of eyes, the omega-shaped beard, and the hair that stands off from the face—it is evident that this head originated in a Burgundian upper Rhenish workshop. Calmer versions of this type of head are in Dijon (Sauerländer, 1966, figs. 191–192) and Besançon (Paris, 1962, no. 61), while two damaged heads in Beaune more closely agree with our object in its touching expression (Sauderländer, 1966, figs. 197–198). The same dynamic spirit seen in our piece occurs in heads from Strasbourg Cathedral (Sauerländer, 1966, fig. 199), obtained, however in these by a greater emphasis on graphic devices. Starting with works of the Chartres Master of the King's Heads, this Burgundian group culminates in the overwhelming temperament of our head.

BIBLIOGRAPHY: Boston, 1940, no. 176

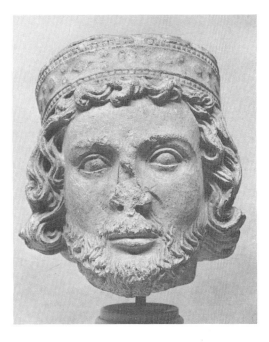

24. Head of a king

> France
> About 1215–1220
> Limestone
> H. 15.7 cm. (6⅜ in.)
> Brunswick, Bowdoin College Museum of Art,
> 1915.100

Of broad proportion, this head is distinguished by a serene expression and restrained surface treatment. Animated by the precise drawing of the eyes and mouth and the relief of the curling beard, the head is framed by a narrow cap of wavy hair. Though retaining the graceful modeling and sensitivity of about 1200, the head undoubtedly originated in the second or third decade of the thirteenth century, as demonstrated by the subtle smile and the deep undercutting of

the hair. It is difficult to localize this head. Similar examples are found in the transept portals of Chartres Cathedral (Sauerländer, 1959, figs. 65, 69), yet the impression of formality and the serene mood would seem to connect the head with the change toward High Gothic standardization apparent in the Amiens portals (Sauerländer, 1959, figs. 67, 71). The martial aspect of the curly beard and the type of smile are reminiscent of Roman imperial busts, especially a type of Nero portrait.

25. Head of St. Peter

> France
> 1220–1230
> Stone
> 27 x 20 cm. (10 x 7⅞ in.)
> Dijon, Musée Archéologique

The similarity of this head to console figures in Notre-Dame in Dijon (Schürenberg, 1937), suggests it probably comes from the west façade portal of this church. Convincingly identified by

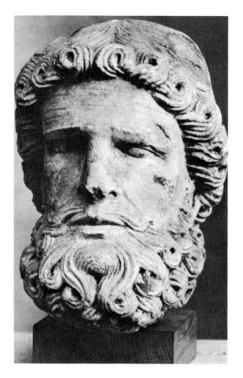

its features as an image of Peter, the head is a fragment of an apostle cycle as it appeared originally on the portal of Sens Cathedral (Katzenellenbogen, 1963; 1967). Displaying a clear structural organization, the piece combines a sharp linear articulation in the forehead, eyebrows, and the broadly etched mouth, with an exuberant frame of deep-cut curling hair and beard. A dynamic conception is apparent in the tension of the omega-shaped beard and the expression of the eyes. Panofsky (1930) pointed out both its indebtedness to the Solomon figure of the Chartres Master of the King's Heads and its influence in the sculpture of Strasbourg Cathedral. Other Dijon heads differ in their less symmetrical treatment of the beard. Taking into consideration further material from other Burgundian church decorations of the same time—Besançon, Beaune, and Semur-en-Auxois—Sauerländer gives a differentiating review of the intricate relationships. In the scholarly dispute about our piece and its art-historical position two aspects are yet unsolved: on one hand, the problem of regional style in early thirteenth-century Burgundian sculpture, suggested by Schürenberg and rejected by Sauerländer; on the other hand, the relation of our head to models and sculptural techniques from classical antiquity and Byzantine art.

BIBLIOGRAPHY: Panofsky, 1930; Bauch, 1930; Schürenberg, 1937; Sauerländer, 1966, p. 116, fig. 191; Paris, 1968, no. 37

26. Head of a youth

France, Burgundy
1225–1230
Stone
H. 35 cm. (13¾ in.)
Semur-en-Auxois, Musée Municipal

Slightly inclined, this head is framed by a magnificent mass of swirling hair. The rounded forms of face and hair, the soft modeling of nose and mouth, and the mournful expression are similar to those seen in sculptures in Strasbourg Cathedral, especially an angel from the Judgment pillar (Sauerländer, 1966, fig. 210) and the tympanum of the Death of the Virgin. The calm effect, more emphasized here than in the Strasbourg heads,

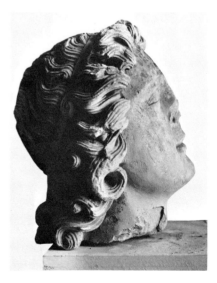

may be described as a Burgundian characteristic. The impressive profile of this head (Sauerländer, fig. 211) clearly indicates the sculptor's knowledge of a classical model; both the technical devices and the touching sentiment are reminiscent of Hellenistic sculpture. While no specific prototype may be identified, similar Hellenistic connotations have been discovered in other contemporary pieces of sculpture (Kantorowicz, 1965, pp. 264–283). The head may have been derived from a profile view on a coin, similarly revived in the contemporary Augustal coins of Frederick II. In the course of development of French sculpture the sources of this striking formulation are to be sought in such Sens works as the Dives medallion of the Vasque of St.-Denis (Sauerländer, 1961, fig. 9), thereby affirming the Sens origin of the present head.

BIBLIOGRAPHY: Sauerländer, 1966, p. 124, figs. 209, 211

27. Relief

France
1225–1230
Stone with traces of polychromy
56 x 85 cm. (22 1/16 x 33½ in.)
Semur-en-Auxois, Musée Municipal

Within a deep frame two scenes overlap, on the left, Christ at supper with Simon the Pharisee, on the right, the Flagellation. The fragment, of unknown provenance and function, is distinguished by its animated facial expressions and vivid gestures. Notable is the double action of Simon, touching Christ on the shoulder (a gesture repeated by the flagellator) while pointing down toward Mary Magdalen, who anoints Christ's feet. The drapery of the prostrate Magdalen parallels the broad swing of the folds of the tablecloth. As the connection of our sculpture to the church of Notre-Dame in Semur-en-Auxois, the

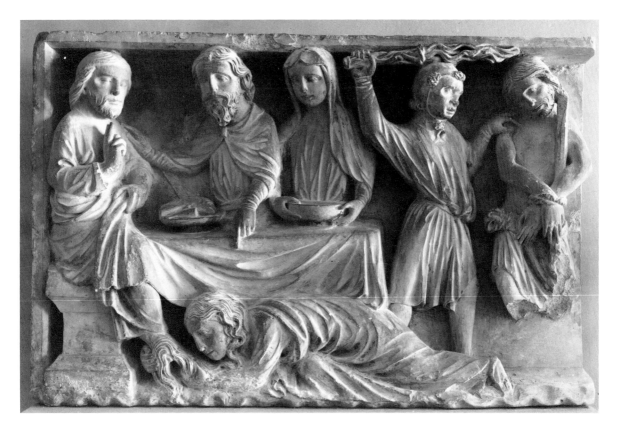

building of which started about 1220, is uncertain, its art-historical position depends on stylistic comparisons. Sauerländer, rejecting the dating in the third quarter of the thirteenth century (Paris, 1962), compares the relief's general mood to that of the Death of the Virgin tympanum of Strasbourg (datable about 1235), noting particularly the similar pathos in the profile expressions of the Magdalen and the mourning girl in front of Mary's deathbed. Another link to upper Rhenish art is the iconographic similarity of our relief with a Hagenau stained-glass window showing the penitent woman in a similar position while anointing Christ's feet (Sauerländer, 1966, fig. 206). Comparing the inclined head of our flagellated Christ to that of the Christ in the Strasbourg Death of the Virgin and the Crucifix in Nevers (fig. 184), Sauerländer classifies our piece as an ultimate manifestation of the Sens-Laon-Chartres trend traced by him as the source of Burgundian and Strasbourg sculpture in the third decade of the thirteenth century. From these relationships our relief can be dated about 1225–1230, notwithstanding its obvious difference in quality from the Strasbourg sculptures. By a broad common descent, further similarities, for example that of the executor in the stoning of the Jews (no. 106), and the parallels mentioned may be explained (Swarzenski, 1967, figs. 534, 542). For an antecedent of the prostrate sinner see the enamel Crucifixion of the Bleidenstadt book cover (Koetzsche, 1967).

BIBLIOGRAPHY: Paris, 1962, no. 103; Sauerländer, 1966, p. 122 f.; Haussherr, 1968, p. 307

28. Female figure

Germany, Strasbourg (St. John the Baptist
 Chapel?)
About 1230
Stone
H. 128 cm. (50⅜ in.)
Strasbourg, Musée de l'Oeuvre Notre-Dame

The popular designation of this figure, "La Petite Eglise," should probably be corrected, according to Zschokke's suggestion, to the Queen of Sheba.

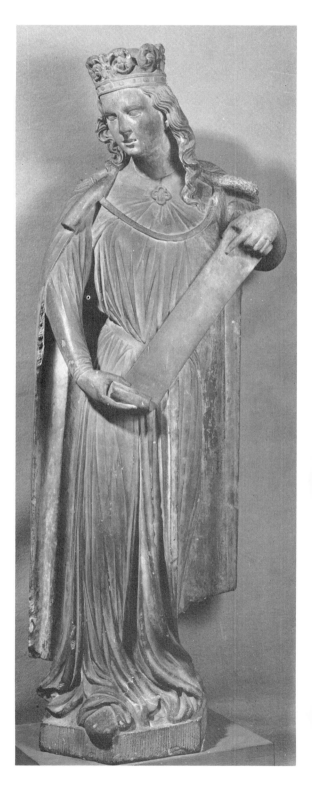

Strikingly gracious in movement, proportion, drapery folds, and facial expression, the youthful, crowned woman, holding a scroll diagonally across her upper body, represents a figure type whose origins can be sought in the cathedral ateliers of Sens and Chartres. In company with no. 34 it illustrates the range of Sens influence. The interplay between limbs and garments, the niche-like mantle and graceful linear swing appear in both works, although the present figure displays a more complicated articulation than either of its French sources (Sauerländer, 1966, fig. 16) or no. 34. The expressive torsion of the elongated body, rooted in French pre-Gothic conventions of spiritual stylization (Sauerländer, 1966, p. 27), was to become a trait of the Strasbourg atelier. As the beginning of the Chartres-inspired workshop in Strasbourg is assumed to be around 1225, the dating of this figure, as given above, becomes evident. The systematic radial organization of the folds issuing from the belt was to become dominant in the sculptures of Bamberg and Magdeburg.

BIBLIOGRAPHY: Zschokke, 1950; Paris, 1962, no. 85; Sauerländer, 1966, p. 27; Haussherr, 1968

29. Fragment of a statuette

England
About 1180
19 x 8.8 cm. (7½ x 3½ in.)
Stone
London, Victoria and Albert Museum,
A. 26–1950

This fragment, showing the lower half of a slightly bent figure, was found some twenty years ago at Bridlington Priory, Yorkshire. Its small size — it originally measured about one foot in height — and the uncarved back imply an architectural setting, probably a niche. As the iconographical identity of the figure is unknown, any idea about an original counterpiece is hypothetical. A thin layer of ornamentally swinging folds encloses the thigh in an elliptic form and stands off from the body at the left. The subtle grading of relief levels, the linear rhythm of the thinly incised folds,

and the unstable pose of the elongated figure indicate its stylistic character.

The contrast with contemporary French sculpture is striking. The fragmentary columnar statues from St. Anne's portal of Notre-Dame, Paris, now in the Cluny Museum (Paris, 1962, no. 11), illustrate the French technique of active interpretation of body and drapery, as opposed to the linear unison of both to be seen here. Zarnecki convincingly compares the fragment to a Visitation group in a psalter in the Royal Library, Copenhagen. The saints mentioned in this calendar relate to an Augustinian house in the York area, possibly Bridlington itself. The indebtedness to Byzantine drapery formulas apparent in the illumination reveal the artistic origin of our sculpture. A common Byzantine inspiration also allies the Bridlington statuette with late twelfth-century stucco sculpture in lower Saxony.

BIBLIOGRAPHY: Zarnecki, 1953, pp. 47–48, figs. 115–116

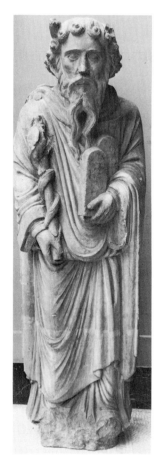

type of portal seen in French cathedrals, where the main decoration is a series of columnar figures. As well as the figures, which mostly appear to be Old Testament forerunners of Christ and Apostles, a fragment of the tympanum (Virgin and Child) and four voussoirs (see no. 31) from the arches suggest the portal's original positioning.

Sauerländer has pointed out the close stylistic connection between the York cycle and the portal statues of Mantes and Sens, datable from 1180 to 1195. Compared with the French models, the Moses figure is characterized by a more concentrated plastic compactness, with shorter, heavier proportions, and a more intense frontal stare. These features, suggesting a frozen stiffness, do not exclude a striking classicism apparent in the fluid and richly differentiated treatment of drapery. The interest in classical art was not newly imported from Ile-de-France, but had been current in English art from the second quarter of the twelfth century as a response to influences from Byzantine models (Saxl-Wittkower, pls. 24–27), becoming particularly marked from 1150–1200. This, as well as the curiously ambivalent conception of classical antiquity observable in English twelfth-century writings (Panofsky, 1963), must be considered if one is to understand the stylistic aspects of the York figures.

Zarnecki (1963) compares the figures with the prophet statuettes placed at the angles of a stone cistern in the Amiens cathedral. This comparison, as well as his reference to a Pontigny Bible (Lansburgh Collection, Colorado Springs, Colorado), supplies a convincing link between the York figures and the immediately preceding tradition of Mosan and northern French art. The direction in which the English artist deviates from this tradition is vividly illustrated by a comparison of Moses' head with a graffito drawing on a stone in the west wall of the north aisle in All Saints' Church, Campton, Bedfordshire (V. Pritchard, *English Mediaeval Graffiti*, Cambridge 1967, p. 1, fig. 1).

30. Moses

English
About 1200
Stone
H. 176 cm. (69¼ in.)
York, Yorkshire Museum

Together with nine other statues, this figure originally formed part of a richly sculptured portal at St. Mary's Abbey, York. The abbey was destroyed in 1539. The backs of all the figures still contain traces of the columnar shafts to which they were attached. Some parts of their original richly painted and gilded surfaces were still to be seen at the time of their excavation. The York portal is the principal indication that England adopted the

BIBLIOGRAPHY: Zarnecki, 1953, p. 48; Stone, 1955, p. 95; Sauerländer, 1959; Barcelona, 1961, no. 607, p. 338; Zarnecki, 1963, p. 156; Paris, 1968, no. 25

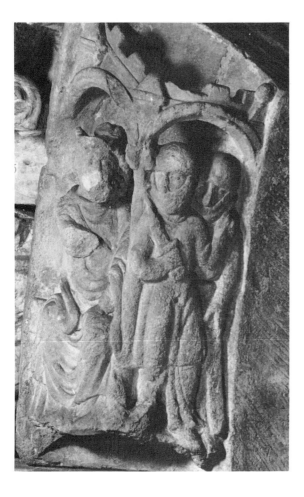

31. Two voussoirs

England
About 1210
Stone
York, Yorkshire Museum

These voussoirs are two of the four that remain from the doorway of St. Mary's Abbey, York. The first is recognizable as Herod ordering the Massacre of the Innocents. The second shows a standing figure, possibly Christ, carrying a book. The voussoirs' fragmentary state precludes identification of their narrative context or reconstruction of the arches they originally decorated. On the Herod carving the figures stand beneath crenelated arcades. This spatial device provides a stage for the compact bodies. French influence combined with local style is evident on both voussoirs. The grouping of heavy figures in a narrow field is seen as early as a Chichester relief of the early twelfth century (Stone, 1955, pl. 40). Zarnecki compared the massacre relief to a miniature painting in a contemporary English psalter (Oxford, Bodleian Library, Ms. Gough Liturg.), pointing to Byzantine influence in both works. The second relief presents a more subtle sculptural treatment, apparent in the deep-cut folds of Christ's drapery. In type, gesture (position of the book), and drapery, the figure of Christ may be compared to another York figure (no. 31).

BIBLIOGRAPHY: Zarnecki, 1953, pp. 49–50, figs. 126, 127

32. Fragment from an abbot's tomb

England, Holywell Priory
Early 13th century
Stone
64 x 59 x 22 cm. (24¼ x 23¼ x 8¾ in.)
London, Guildhall Museum

Only the torso remains of this figure, which was of very high quality; from the fragment one can reconstruct a tomb slab with a deeply carved, molded profile. The deceased is represented in the vestments of an abbot, his hands in liturgical gloves. He is blessing with his right hand (broken); in his left he originally held a crosier. This composition emphasizes the diagonal line formed by the left arm (for an earlier example, the mosaic tomb slab of Bishop Fournold, d. 1184, in the Museum of Arras, Panofsky, 1964, fig. 194). The drapery molds the outlines of the arms in dense, fine folds, and is gathered into broken crosslines over the body. It is apparent that the artist was interested in representing characteristics of the different materials used in the vestments.

The subject of the standing bishop can be traced uninterruptedly through the twelfth century in a series of representations on seals of English dioceses (Saxl, 1954, pls. III–IV). A tombstone fragment from the cloister of Durham represents the monumental interpretation of this subject at about the middle of the twelfth century (*ibid.*, pl. XCII). In this sculpture, which is earlier by two generations than the piece exhibited, one notes as stylistic differences the strongly block-shaped body with very firm outlines, the clothing modeled in layers, and the deep drapery folds. Our piece represents the impact of French sculpture of the beginning of the thirteenth century in England. A further development of figure types on tombstones is represented in France by the bronze slab of Bishop Evrard de Fouilloi (d. 1220) in the cathedral of Amiens (Andersson, 1949, p. 65, fig. 18) and in the stone figure of St. Germain d'Auxerre from the church of St. Germain l'Auxerrois in Paris (no. 21; Paris, 1962, no. 50; for an earlier step in the same development, *ibid.*, no. 25). Statues in St. Mary's Abbey, York, show the range of interpretations given to French models by English artists of the time.

33. Virgin and Child

England
1210–1220
Wood
47.5 x 24.1 cm. (18½ x 9½ in.)
London, Victoria and Albert Museum,
 A 79–1925

Seated on a low throne, the base and seat of which are decorated with similar protruding profiles, the Virgin holds the Child on her left knee. Characteristic of the group's early thirteenth-century date are the oblique placing of both Mary's and the Child's legs (examples for this position of the Virgin's legs are found earlier in the twelfth century: Borchgrave d'Altena, 1961, figs. 22–23), and the dynamically free gesture of the Child extending his right arm to his mother's breast, two blessing fingers raised vertically in

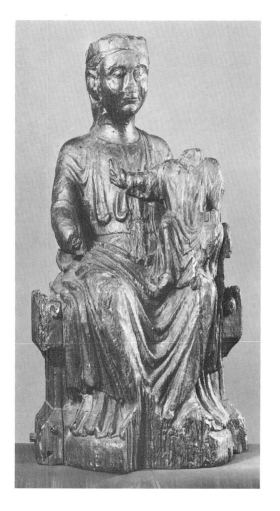

placid, somewhat uninspired piece of carving whose principal interest is in showing the wood-carver experimenting with new ideas."

BIBLIOGRAPHY: Stone, 1955, p. 104 f., pl. 78; Borchgrave d'Altena, 1961, p. 31, fig. 24

34. Female figure

England
About 1220–1225
Stone
128 x 48 cm. (50⅜ x 18¾ in.)
Winchester, Cathedral

The iconographical identity and original setting of this famous figure are not known, although its provenance suggests that it stood in one of the four niches of the porch of the prior's house (T. D. Atkinson, *Archaeologia*, LXXXV, 1935, p. 161). Surrounded by a mantle that forms a niche, the upright body, in lively contrapposto position, is covered by dense folds of fine texture, slightly swelling above the belt and elegantly gliding above the base. Originally, the figure had metal attachments for the neck fastenings and the belt, as well as a small object in the left hand. In general type, proportion, and troughlike drapery folds, the figure presupposes a knowledge of early thirteenth-century sculpture of Ile-de-France, especially that of the north porch of Chartres Cathedral. A dating of the piece in the second to third decade can be derived from this relationship. The striking resemblance of the sculptural treatment to classical works of the fourth century B.C. has not yet been given a convincing explanation (for a discussion of this phenomenon, Panofsky, 1960, p. 62 f.). A slightly earlier version of this type of female figure, of a rather provincial quality, following, however, an important model, occurs in the decoration of the Kelloe Cross (Saxl, 1954, pl. XCVI). The quatrefoil fragment of Christ in Majesty in the refectory of Worcester Cathedral (Saxl, 1954, pl. XCIC–c) is further testimony to this French-born stylistic trend. Similar stylistic achievements

front of her body. The simple heavy folds of Mary's robe are regularly distributed. The smoothly undulating folds gliding toward her right arm, as well as the U-shaped drapery on her breast, are reduced versions of slightly earlier French achievements in sculpture and miniature painting (compare with the Virgin and Child in the Westminster Psalter: Borchgrave d'Altena, 1961, fig. 21), particularly in the facial expressions. For the position of the group in English art, the iconographical type may be compared to the tradition of twelfth-century seals (Saxl, 1954, pls. V, VI). Stylistic relationships to the Canterbury stained-glass windows have been proposed by Stone, who gives a too-critical judgment of our group's artistic merits: "On the whole it is a

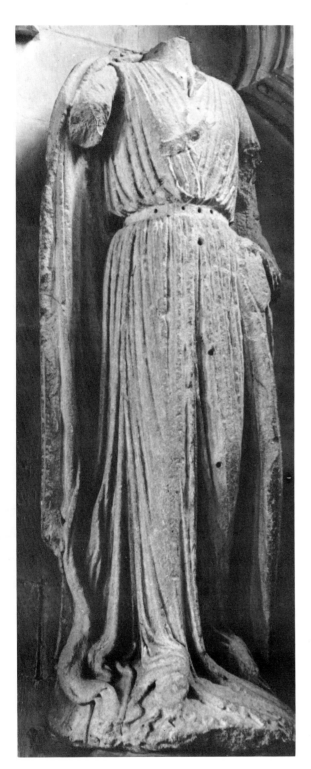

are found in English wall painting, as in the figure of Mary from the Annunciation scene in Hardham, Sussex (Tristram, 1955, pl. 29; for a general survey, Demus, 1968).

BIBLIOGRAPHY: Stone, 1955, pp. 112–113; Roosen-Runge, 1961; Panofsky, 1963, p. 282, no. 33; Paris, 1968, no. 50; Haussherr, 1968, p. 321

35. Virgin and Child

Mosan
1215–1220
Oak with traces of original paint
122 x 50.4 cm. (48 x 20½ in.)
New York, The Metropolitan Museum of Art,
 Bequest of George Blumenthal, 41.190.283

This group belongs to the type known as Sedes Sapientiae, in which Mary is interpreted as the Throne of Solomon or Seat of Wisdom. Mary, crowned and sitting in a cathedra, may once have held a scepter in her right hand (missing). The Christ Child sits on her left knee holding an orb in his left hand and raising his right one (missing) in blessing. The Virgin tramples a dragon under her right foot in memory of God's words to the serpent: "And I will put enmity between thee and the woman, and between thy seed and her seed; it shall bruise thy head, and thou shalt bruise his heel" (Gen. 3:15).

The general treatment of the throne recalls the profile of the end of the choir stalls at Anchin abbey, dating from the end of the twelfth century (Destrée, fig. 4), and drawings of Villard de Honnecourt (Hahnloser, 1935, figs. 27, 28). But the type of ornament that decorates the throne—a rosette with a double line of swirling acanthus leaves—is without direct equivalent in Flemish ornamental art.

The flat face and wide-set eyes framed by flowing hair are found in the Virgins at Odilienburg and the Brussels Museum (Borchgrave d'Altena, 1961, figs. 47, 72). The cord holding the mantle, the long floating girdles of the belt, and the round fibula (only traces of which are left) at the collar opening also occur in the Odilienburg piece. The

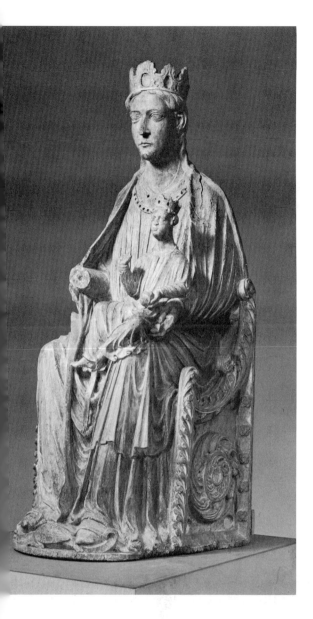

1961, fig. 49). The undulating lines of the hem of the garment, flowing smoothly over the feet and base, are another stylistic characteristic of this group.

The symmetrical position and the drooping shoulders point to a date around 1200 (compare the Virgins in Liège; Borchgrave d'Altena, 1961, figs. 69, 70), but other elements such as the Child sitting slightly at an angle with widespread legs, and the fleurons of the two crowns suggest a later origin for our piece.

The fluid folds that replace the schematized convention of the earlier Mosan drapery, and the emphasis on verticalism, reveal the influence of Chartres style around 1215–1220, while the drapery's angular sharpness reflects the metal techniques prevailing at that time in the workshops of Nicholas of Verdun and Hugo of Oignies. The stylistic similarity of our piece to the Sedes Sapientiae on the back of the phylactery in Namur, which originally came from the Oignies priory (Destrée, fig. 1), coincides with the alleged provenance of our Virgin.

BIBLIOGRAPHY: Destreé, 1925, pp. 24–28; Devigne, 1932, pp. 40, 41, pl. VII, no. 30; Schnitzler, 1934, pp. 101, 102; Cassart, 1954, pp. 497–506

36. Virgin and Child

Mosan
Early 13th century
Wood
H. 129 cm. (50¾ in.)
Liège, Musée Diocésain

In this group, the steep proportion is striking, especially compared with the broad and freely moving Virgin in the church of St. John in Liège. (Borchgrave d'Altena, 1961, fig. 69). Produced in the same region at approximately the same date, both groups illustrate the wide range of modes available to artists working in the same milieu. A close adherence to the twelfth-century's tradition of hieratically conceived cult images probably explains the specific features of our group. A similar combination of twelfth-century

open mantle, which does not cover the right arm, but falls from the shoulders in a curved sweep and is slung over the right knee, is similar to those of the Virgins at Gassicourt and St.-Omer (Vitry-Brière, pl. XLVII, no. 5; Borchgrave d'Altena, 1961, fig. 40). The particular way of wrapping the Child in the Mother's coat is a less frequent feature but appears in the Virgins at Odilienburg and Laeken (Borchgrave d'Altena,

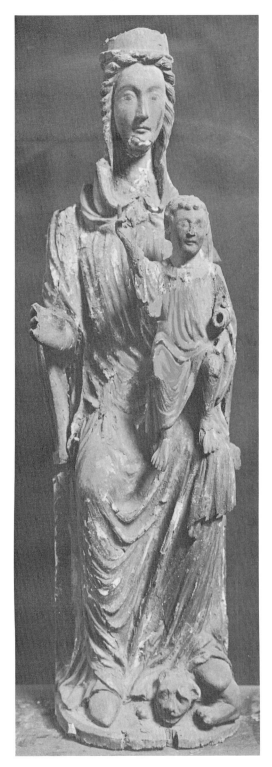

proportions and early thirteenth-century drapery style is to be seen in the contemporary northern French Vièrge dorée, in the Museum of Fine Arts, Boston (Swarzenski, 1961). The stiff gestures of both figures, the ornamentally framing hair of the Virgin, the immobile expression of the faces, together with the angular sharpness of the folds, as seen in Mary's knees, further indicate the archaistic position of our piece. Lacking documentary evidence, it cannot be proved that the style of this group is indebted to a twelfth-century cult image it was perhaps intended to replace. The motif of the dragon under Mary's feet, popular only from the middle of the twelfth century on, is not an indication of the age of the Madonna that this model replaced, as it may not have included it. (Christ's supremacy over the dragon is also indicated by his placement directly above it.)

BIBLIOGRAPHY: *Art Roman*, 1966; no. 57; Barcelona, 1961, no. 1144

37. Infant Christ

France or Flanders
1210–1220
Wood with traces of polychromy
H. 32 cm. (12½ in.)
Lawrence, The University of Kansas,
 Museum of Art, 61.2

From this fragment, one may reconstruct a magnificent Sedes Sapientiae group. The upright position of the child, supported by the Virgin's hand at his left thigh, the free movement of his legs, with the deep folds between, establish a close tie with the Virgin and Child in St. John's church in Liège (Borchgrave d'Altena, 1961, fig. 69). Our fragment is distinguished by a superb fluidity of drapery. A rare motif is the horizontal folds under the child's chest; a similar arrangement may be seen in the slightly later Virgin of Gassicourt (Swarzenski, 1960, fig. 19). In comparing the fragment with the many thirteenth-century Madonna groups of Flanders and northern France illustrated in Borchgrave d'Altena (1961), its

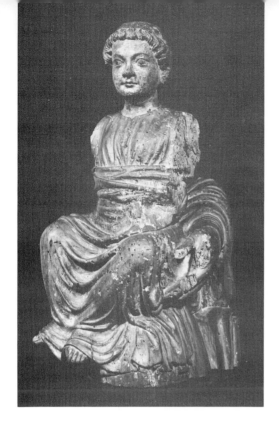

outstanding quality is immediately recognized. The cutting of the hair, leaving only a small, curled, row above the forehead, suggests the figure once wore a crown. Such crowns, lost in most cases, were probably often used on twelfth-century statuettes (for the still completely preserved pieces in the Aachen Mary Shrine, II, ills. 130–132, and the Hoven Madonna: Borchgrave d'Altena, figs. 28–29). The motif of Mary holding the child with one hand on his leg or thigh, common in contemporary sculptural groups, derives from Byzantine models.

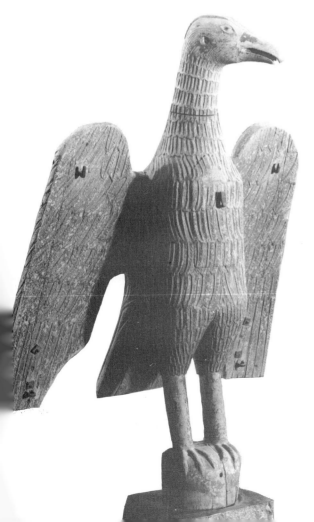

38. Eagle lectern

Germany (?)
About 1200
Wood
H. 96.5 cm. (38 in.)
Colorado Springs, Colorado College, Lansburgh
Collection

Standing on a broad knob, this eagle, with symmetrically extended wings, originally served as a lectern for a Bible. Such lecterns were popular as independent objects as well as in an ambo or pulpit. The eagle, identified in many cases by accompanying inscriptions from the gospels, represents St. John, the most venerated of the four evangelists (Schapiro, 1954). In Italy, eagle lecterns for pulpits were generally of stone; other contemporary eagles were mainly carved on gems, making it difficult to find comparative material for the present piece. The broad shaping and clear articulation, together with the dense and precisely drawn feathering, suggest a south German origin rather than the French attribution it has sometimes been given.

31

39. Book cover (back)

Germany
1220–1230
Wood, leather
22.7 x 10.5 cm. (9 x 4⅛ in.)
Vienna, Kunsthistorisches Museum, Sammlung
für Plastik und Kunstgewerbe, 4981

The back cover of a breviary written between 1217 and 1235 for Abbot Berthold in Weingarten Abbey, Germany, the panel presents three medallions in pierced work separated by horizontal floral motifs. Traces of coloring remain. The border was once covered by metal decoration with precious stones. Inscribed on the border, between smooth moldings, are the names of the persons represented in the medallions. In the upper medallion Mary sits frontally, holding a serpent in her left hand; in the center medallion the kneeling donor, Abbas Bertholdus, venerates the Virgin above; in the lower medallion a monk, Udalricus, works on a book cover. Trees flank each figure. Stylistic and iconographical similarities can be observed among the decorations of the cover and the initials in the codex, as well as in related Weingarten manuscripts (Swarzenski, 1943, p. 72 f.). The composition of Mary enthroned frontally between trees derives from Byzantine representations of Paradise that formed part of Eastern Last Judgment iconography from the twelfth century onward. A contemporary image of the Virgin enthroned between trees, from the same scriptorium as our breviary, occurs in the Pierpont Morgan Library Ms. 711 (Swarzenski, 1943, p. 74, fig. 124). The motif of the serpent alludes to Mary as the second Eve (Guldan, 1966). A formal prototype for an enthroned female figure holding a serpent is provided by a late twelfth-century Mosan statuette of Prudence (Swarzenski, 1967, fig. 382). The representation of the abbot kneeling before Mary adheres to the tradition of dedication images (compare Abbot Suger prostrate before Mary in a St. Denis stained glass window, Grodecki, 1961, fig. 7); it recurs in the dedicatory miniature of a manuscript commissioned by Abbot Berthold (Swarzenski, 1943, pl. LXIII i). Very few analogies

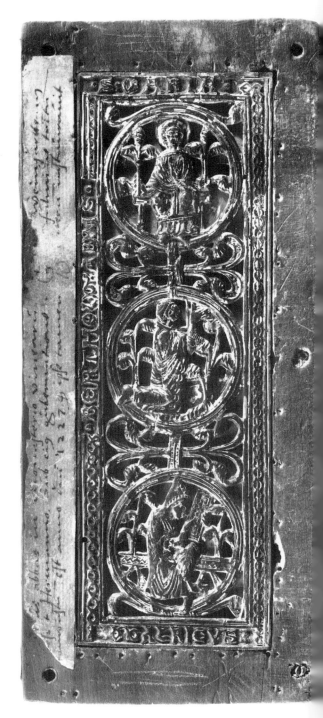

can be cited for the image of the carving monk. Roughly contemporary with our piece, the Namur book cover by Hugo of Oignies (Steenbock, 1965, no. 118) shows the artist in the act of dedicating a book to the enthroned Christ.

The front cover of Abbot Berthold's breviary probably showed a correspondingly organized plaque with representations of Christ, St. Martin (the abbey's patron), and the illuminator of the codex (as suggested by Steenbock).

BIBLIOGRAPHY: Swarzenski, 1943, pp. 21, 71 f., 105 f.; Vienna, 1964, no. 94; Steenbock, 1965, no. 117

40. Virgin and Child

Middle Rhenish
1220–1230
Linden wood, traces of original paint
H. 41 cm. (16⅛ in.)
Berlin-Dahlem, Stiftung Preussische
 Kulturbesitz, Staatliche Museen, 1789

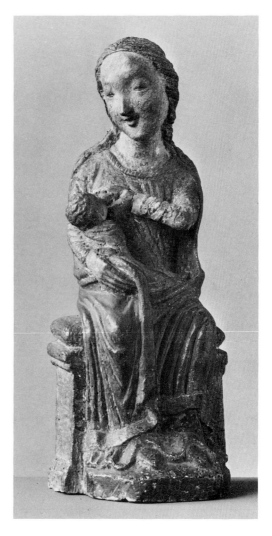

Sitting on a low throne with a half-circular protruding pedestal, Mary holds the Child with her right arm while giving him her breast. The group is distinguished by fine sculptural modeling, noticeable especially in the precisely drawn drapery folds, the impression of movement, the graceful, fluid outline, and Mary's benign expression. The impact of early thirteenth-century sculptural achievements is clearly recognized in the undulating edge of Mary's robe where it covers her feet. The second-decade dating takes into consideration the possibility of a stylistic delay seen in the group's provincial origin. This provincialism may be detected in the oversized head. A contemporary lactans group of more stretched bodily articulation and higher artistic quality in Friesach, Austria (J. Zykan, *Osterreichische Zeitschrift für Kunst und Denkmalpflege,* XVIII, 1964, p. 60 f., fig. 73) and a group in Brussels (Adolphe Stoclet Collection, Brussels, 1956, p. 198 f.) have been ascribed to a Veronese atelier, probably in consequence of a related statue in the Archepiscopal Palace in Verona. The Veronese localization extended to our statuette by Zykan is not convincing. Inspired by Byzantine types, a strong tendency toward humanization of the Madonna image took place in twelfth-century sculpture of upper Italy (H. Swarzenski, "A Masterpiece of Lombard Sculpture," *Boston Museum of Fine Arts Bulletin,* 57, 1959, pp. 64–75), the Rhine (Cologne: Maria im Capitol; Brussels: casket; Swarzenski, 1959, figs. 7, 8), and the Meuse (Liège, Madonna of Dom Rupert: *Art Mosan,* 1961, n. 26, p. 197, compare with the English ivory Madonna of the eleventh century

33

in the Victoria and Albert Museum: Saxl, 1953, fig. 1). It was this tendency that revived the classical lactatio motif in Madonna groups (Guldan, 1966, p. 342, no. 30). In both the dynamic linear organization of the body and the iconographical motif the best-known predecessor of our group is the Liège Madonna of Dom Rupert.

BIBLIOGRAPHY: *Bildwerke der Christlichen epochen von der spätantik biszum klassizismus, Skulpturenabteilung,* Munich, 1966, no. 182

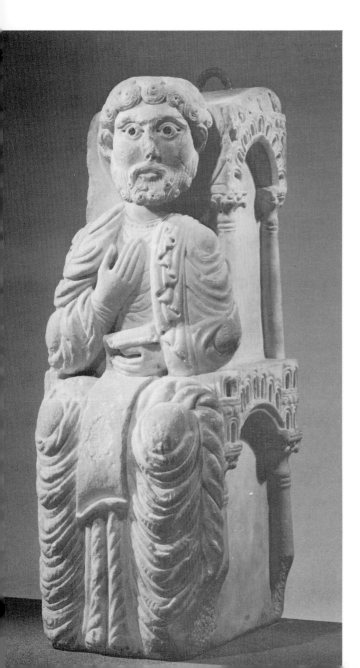

41. Prophet (?)

Italy, Lucca
1180–1190
Marble
H. 63.5 cm. (25½ in.)
New York, The Metropolitan Museum of Art,
 The Cloisters Collection, 47.101.19

The bearded figure, in high relief, looks slightly to the left and holds an unrolled scroll between his knees. He is seated against an architectural fragment. On the right side are two arched niches supported by columns, indicating that the statue was to have been seen from front and side. The damaged condition of the marble indicates that the statue formed the right end of a larger composition. The original context is not known.

The style of this piece evolved from the art of the sculptor Biduino, and his workshop, active in the Pisa-Lucca area around 1180. Among Biduino's works, the architraves from St. Angelo in Campo and St. Leonardo al Frigido (Gómez-Moreno, 1965, figs. 2, 7) stand out as the direct antecedents of the expressive facial features and the block treatment of the prophet's body. Even more closely related are three Lucchese reliefs (C. Ragghianti, "Arte in Lucca, Spicilegio," *Critica d'Arte,* VII, 1960, pp. 58–61, figs. 51, 53, 54) and a figure holding a flask at The Cloisters (Hoving, 1965, fig. 1). Technically, all these pieces are characterized by an extensive use of the drill and a predilection for perforated decorations. The rope-like treatment of the folds, the vigorous geometry of the drapery, and the bulkiness of the figures are outstanding features of this group.

The numerous points of similarity between the two Cloisters figures suggest that they are from the same monument; each piece is slightly cut off at the bottom, which explains the absence of feet. Technique, style, and the alleged provenance from St. Agostino, Lucca, point to a Lucchese origin for the present sculpture.

BIBLIOGRAPHY: Boston, 1940, no. 150; Hoving, 1965, pp. 349–361, fig. 3

42. Crucifix

Northern Italy
1190–1200
Wood
191.9 x 205.8 cm. (75½ x 81 in.)
New York, The Metropolitan Museum of Art,
Fletcher Fund, 47.100.54

Clad in a long-sleeved, belted tunic, Christ is represented alive. The clothed figure, as a type, can be connected to the famous Lucchese cult image, the Volto Santo, which, according to legend, was carved by Christ's disciple Nicodemus, and reached Italy in the eighth century. Although the veneration of this image in Lucca can be traced to the eleventh century, the Volto Santo now in Lucca was shown by Francovich to be a copy of the original work, made by a follower of Benedetto Antelami at the beginning of the thirteenth century. The strong sculptural articulation and consequent balance of Christ's body, achieved by the sharply drawn folds in the Antelami Volto Santo and its copies, is absent from our piece, the alleged provenance of which points to northern Italy. Instead, our crucifix shows a rigid symmetry in a system of folds forming elliptic areas. Consequently, the sculpture can be placed among the large number of crucifixes now to be found in Spain, Italy, France, England, and Germany, all of which copy in varying degrees the pre-Antelami Lucchese Volto Santo. A date for our piece in the

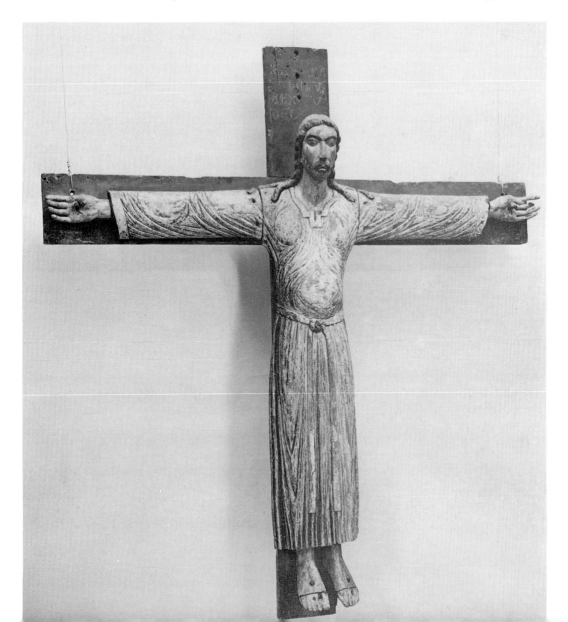

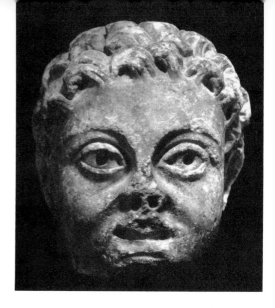

last decade of the twelfth century is evident from the solid mass of the body, organized by a strict geometrical pattern. Therefore, the cross precedes the Antelami version of the Lucca prototype only by a short interval.

A date in the second half of the twelfth century was assigned to our piece by Francovich, who, however, wrongly supposed a French origin for it. The Italian provenance and origin of our cross is remarkable in view of the astonishingly small number of Italian copies of the Volto Santo. For the iconographical and liturgical aspects of the type, see Haussherr. Walter Cahn's suggestion that the numerous Spanish crosses of our type may be based on another legend, that of the so-called Crucifix of Beirut, should also be taken into consideration (*Gesta*, VIII, 1969, p. 64).

BIBLIOGRAPHY: Stanley Casson, "Byzantinism," *Burlington Magazine*, 59, 1931, pp. 209–213 (dated in ninth to tenth century, localized in England or northern Germany; Francovich, *Bollettino Storico Lucchese*, 8, 1936, p. 17 f., p. 26, n. 5; R. Haussherr, "Das Imervard Kreuz und der Volto-Santo-Typ," *Zeitschrift für Kunstwissenschaft*, XVI, 1962, pp. 129–170, esp. p. 151, n. 53

43. Head of a boy

Italian
Early 13th century (?)
Marble
H. 13 cm. (5⅛ in.)
Berkeley, California, University of California,
Robert H. Lowie Museum of Anthropology

Once considered to be a classical Roman work, this small head has recently been called Italian late Romanesque and dated around 1200 (Wright). While the Hellenistic sources are readily recognized, no direct analogies among Italian sculptures of the Middle Ages can be identified. Noting the sharp linear articulation and geometrical regularity of the head, Wright speaks of "the aim of animation, purely medieval in nature, proceeding from the eyes which are cut off from the organic unity of the face by disciplined linear outlines and dominated by the uncanny effect of the

black glass inset." Because central and south Italian sculpture of the early thirteenth century is still an obscure subject, the head's original context can only be guessed. Perhaps it formed part of an entablature like the one showing similar masklike heads in St.-Gilles, which is based on a Gallo-Roman model (Panofsky, 1960, figs. 27–28). For Italian examples, our head's open mouth and intense glance may be compared to a female head in the lapidarium of the Palazzo Venezia, Rome (Wentzel, 1955, figs. 32–33). The marble baptismal font in Catania, Castel Urgino (*ibid.*, fig. 25) contains a similarly classicizing youth with comparably stylized hair.

BIBLIOGRAPHY: D. H. Wright, *Selection 1966. The University Art Collection*, The University Art Museum, Berkeley, p. 42 f., no. 33

44. Relief

Italy
1190–1210
Marble
86.4 x 31.8 x 4.8 cm. (34 x 12½ x 1⅞ in.)
Seattle, Art Museum, 49.It 14.1

This relief shows a symmetrically arranged floral pattern with intertwined birds and human figures. The original context is not known, and the dating derives from the style. The relief has a remarkable vigor in the depth of its undercutting

and in the precise articulation of such details as the bird's feathers and the flabby surface of the curling leaves. Although the heads of the human figures are weakly executed, they do not really

diminish the quality. Derived from prototypes of classical architectural sculpture, the relief is most probably from a south Italian workshop active in the last decade of the twelfth century or perhaps later. Besides antique models, Byzantine decorative reliefs were available to artists in Campania and other regions. Although the species of classicizing floral decoration called inhabited scrolls was revived toward the end of the twelfth century in most of the artistic centers of Europe, an Italian feature may be recognized here in the comparatively regular and dense filling of the relief. Compare the linear rhythm apparent in contemporary French works such as the trumeau relief in Sens Cathedral (Aubert, 1946, p. 280). A Rhenish interpretation of a model similar to our artist's source may be seen in a relief in the Schnütgen Museum (Cologne, 1968, no. 56). In Italian Romanesque sculpture, the type of tendrils that form the medallions in the exhibited piece became popular with the decoration of Modena Cathedral at the beginning of the twelfth century (Jullian, pl. XVI, fig. 3).

BIBLIOGRAPHY: Crichton, 1950

45. Annunciation

Italy, Tuscany
About 1200
Maremma marble
67.4 x 61 x 12 cm. (26½ x 24 x 4¾ in.)
New York, The Metropolitan Museum of Art,
 The Cloisters Collection, 60.140

On a square plaque, surmounted by a frieze of monumental incrustation, the Annunciation is depicted under a city wall with two niches. The angel, seen in profile, raises his right hand in a gesture of address as he approaches Mary from the left. The Virgin displays the palm of her right hand in a sign of surprise and holds a book in her left.

Thomas Hoving has shown that this piece was originally one of seven panels decorating the pulpit of San Piero Scheraggio in Florence. The

While the relief generally follows Byzantine tradition in composition, Mary's book is specifically a Western motif in use since the tenth century (Pächt, Wormald, Dodwell, p. 63). The inlay of dark serpentine, or *verde di Prato,* that fills the borders and the eyes is very common in twelfth-century Tuscan art. Stylistically, our relief is characterized by fluid treatment of drapery and mobility of figure, qualities that are more pronounced in the Annunciation, Baptism, and Presentation than in the other reliefs of the cycle. The combined use of both incrustation and figural sculpture coincides with the stylistic observations, resulting in a dating to the early thirteenth century.

BIBLIOGRAPHY: Hoving, 1961

pulpit must have been dismantled sometime between 1410 and 1755 (C. Richa, *Notizie istoriche delle chiese fiorentine divise ne'suoi quartieri,* Florence, II, 1755), and during this period our piece became separated from the other six, which were transferred in 1782 to San Leonardo in Arcetri. Originally the Annunciation was set between the Tree of Jesse and the Nativity, followed by the Adoration, Presentation, Baptism, and Deposition. The accompanying inscription of Latin verses is not preserved in full. On the other hand, in the inscription of the Deposition there is plaster fill between the first two words ANGELI PENDENTEM. Hoving shows that the existing word ends with a U, not an I, and thus suggests that the original inscription was ANGELUS, and therefore a direct reference to the angel of our Annunciation.

The series of towers, gates, and crenelations that crown the two broad arches appear also in the Adoration of the Magi; the ornamental background is similar in the Adoration and Presentation as well.

46. Capital

Southern Italy
Early 13th century
Marble
47 x 43.2 x 40 cm. (18½ x 17 x 15¾ in.)
Chicago, The Art Institute, Buckingham Fund, 44.405

An eagle stands at each corner upon a row of upright palmettes. The wings are spread and meet under a rosette at the center of each side. The ornamental patterns of the feathers are deeply undercut. The capital combines the classical type with single forms, testifying to the "renaissance" movement in southern Italian art of the early thirteenth century. The delicate linear modeling of the wings and planes suggests the sculptural achievements of early Gothic ateliers. The heraldic conception of the eagle and the schematized treatment of the wings suggest both Eastern and northern inspiration (for Byzantine and other Oriental influences in southern Italian representations of animals: Volbach, 1943).

From the eleventh century on, the decoration of capitals with one or more eagles is seen in Italian, French, and German architectural sculp-

ture (RDK, I, 1937, cols. 180 f. s.v. "Adlerkapitell;" particularly for France, J. Evans, "Die Adlervase des Sugerius," *Pantheon,* 1932, pp. 221–223). In southern Italy, at the period of our capital, a marked predilection for the eagle motif is found in objects in several media sponsored by the imperial court of Frederick II (H. Wentzel, "Mittelalter und Antike in Kleinen Kunstwerken des 13. Jh.," *Studies till H. Cornell,* Stockholm, 1950; Nau, 1968, pp. 21–56). A survey of southern Italian capitals of the period is given by Jacobs, 1968.

BIBLIOGRAPHY: Chicago, 1945, no. 3

cacy of drapery folds, and serenity of expression tend to confirm this.

BIBLIOGRAPHY: G. Francovich, *Benedetto Antelami*, Florence-Milan, 1953, p. 415 f.; V. Viale, *Opere D'arte preromanica e romanica del Duomo di Vercelli*, Vercelli, 1967, p. 17 f., Paris, 1968, no. 56

48. Labors of the Months: Turnip-picker, Archer

Italy
1230–1235
Marble
Ferrara, Cathedral

These allegorical fragments originally formed part of the Porta dei Mesi on the south façade of Ferrara Cathedral, the sculptural decoration of which was dismantled in the eighteenth century. Iconographic and stylistic resemblances connect these pieces with the Antelami cycle of months at the cathedral of Parma. Evidently the Ferrara Labors of the Months and the corresponding zodiacal signs were added at the porch to the early twelfth-century portal (Krautheimer-Hess). Popular in twelfth- and thirteenth-century encyclopedia programs, the subject had already appeared on the archivolt of the Portail Royal at Chartres. A similar placement is also found on the porch of the Pieve in Arezzo (Francovich, pl. oo). The sculptor of the Ferrara portal was strongly influenced by the artistic achievements of Benedetto Antelami as well as early thirteenth-century French cathedrals, especially the portals of the Paris and Chartres cathedrals, and north Italian late Romanesque sculpture.

BIBLIOGRAPHY: T. Krautheimer-Hess, "The Original Porta di Mesi at Ferrara and the Art of Nicolo," *Art Bulletin*, XXVI, 1944, pp. 152–174; Francovich, 1952, p. 45 f.; J. Richter, "Les sculptures des mois à Trogis et à Ferrare," *Bulletin Monumental*, CXXIII, 1965, pp. 25–35; Paris, 1968, no. 53; I. C. Webster, *The Labors of the Months in Antique and Medieval Art to the End of the Twelfth Century*, Princeton, 1938, no. 40; L. Pressouyre, "Marcius Cornator," *Mélanges d'Archéologie et d'Histoire*, 77, 1965, p. 415 f.

47. Wise man

Italy
About 1220–1240
Stone
Vercelli, Museo Leone

This figure was originally part of the lectern in the cathedral of Vercelli. A certain hardness is noticeable if the sculpture is compared with the two angel figures from the same complex (Francovich, figs. 473, 474), which was demolished in 1570. From a fourteenth-century source it is evident that the lectern contained the representation of a lady, given as an ex-voto after a miracle in 1237. The dating of the figure derives from this document as well as the style. Once ascribed to Benedetto Antelami and assistants, the figure is now associated with French models of the beginning of the century. The elegance of form, delicacy of drapery folds, and serenity of expression

49. Capital with four heads

Southern Italy
About 1220
Limestone
H. 36.2 cm. (14.4 in.)
New York, The Metropolitan Museum of Art,
The Cloisters Collection, 55.66

This fragment is decorated around its base with a flat row of vertical acanthus leaves that sprout from the astragal. A human head decorates each of the four corners, three swirling leaves fill the spaces between. The similarity to a capital in the cathedral in Troia, Apulia, indicates the provenance of our piece; the destruction of this city in 1229 by Frederick II is the terminal date for both capitals (H. Wentzel, "Ein gotisches Kapitell in Troia," *Zeitschrift für Kunstgeschichte,* 17, 1954, pp. 185–188). Their original function was probably as part of a canopy structure, possibly part of a wall tomb.

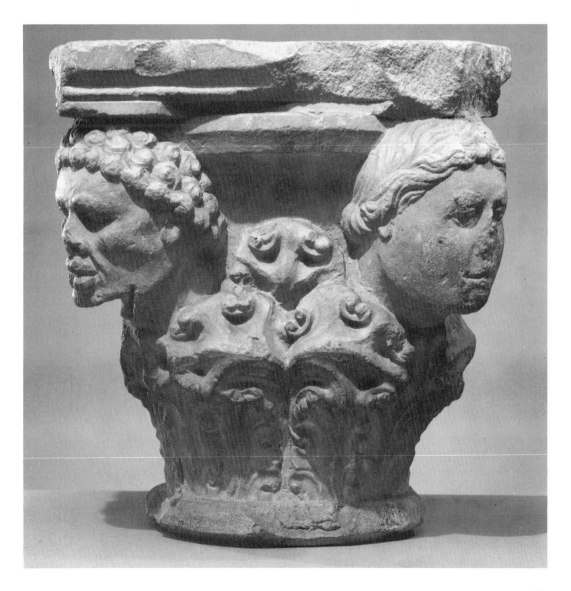

SCULPTURE

The type of capital, with heads replacing vo-
lutes at the corners, was widespread in classical
antiquity and survived into the Middle Ages
(E. v. Mercklin, *Antike Figuralkapitelle,* Berlin,
1962, pp. 60–70, figs. 292–340, for southern
Italian pieces). The four heads representing a
Moor, a Moslem, and an unidentifiable man and
woman, are distinguished by a compact sculp-
tural modeling that combines the tradition of
Italian Romanesque art with that of classical
Roman portrait sculpture. The head of the Moor,
conceived with the same conciseness as the corre-
sponding head on the Troia counterpiece, indi-
cates the artist's knowledge of contemporary
French sculpture. Wentzel convincingly com-
pared the Moor's head to the curly-headed figure
crouching under the feet of the Queen of Sheba
on the north transept portal of Chartres Cathedral
(Panofsky, 1960, p. 65). A later example of the
Apulian blending of classical and French achieve-
ments may be seen in the sculptural decoration of
the Capua tower gate (For contemporary capitals
of the region, Jacobs, 1968).

BIBLIOGRAPHY: V. K. Ostoia, "To represent what is
 as it is," *Metropolitan Museum of Art Bulletin,* 1965,
 pp. 367–372

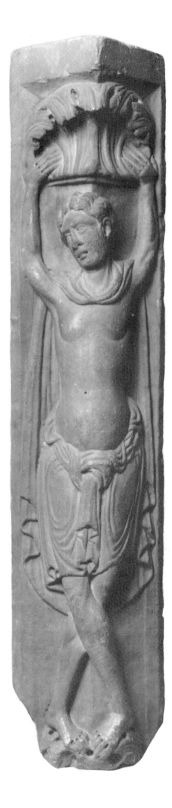

50. Supportive figure

Southern Italy
Early 13th century
Marble
H. 63 cm. (24¾ in.)
Vienna, Kunsthistorisches Museum, Sammlung
 für Plastik und Kunstgewerbe, no. 7367

Supporting a conchlike floral capital with up-
raised arms, the cross-legged male figure stands in
front of a corner pilaster, probably a pulpit frag-
ment. The slender, elongated body is nude except
for a loincloth with a large center knot; a mantle
falls behind the shoulders. An interest in playful,
undulating movement is to be noted in the folds
of the loincloth, as well as in the curved outline

of the capital. The upraised arms, the head touchingly turned to the right, and the modeling of the features, especially the open mouth, give an effect of gracious mobility and sensibility. In general conception and in sculptural details this figure follows classical models. Strong similarities to ancient prototypes are noticeable in a supportive figure of the candelabra in the Cappella Palatine, Palermo (Crichton, 1954, fig. 89). Similar supporting figures with arms reaching to capitals are seen on the pulpit and Easter candelabra in Salerno (Crichton, 1954, fig. 85a). A caryatid similar to the exhibited piece occurs in twelfth-century French architectural sculpture probably from a church portal in Cambrai (Paris, 1962, no. 20). In view of indications of dependence on other French models by Sicilian sculptors, the verticalism and the linearism apparent in the present piece may have a French derivation too.

The motif of the crossed legs was fully developed by contemporary artists interested in its spatial implications, as in the Samson Master's use of it in a seated figure of a violinist (Cologne, 1964, no. 54). The motif is also seen in a contemporary manuscript illumination (Swarzenski, 1943, pl. LVI b). A later north Italian example

of classicizing supportive figures is seen in the fragment of a column base in Bologna (Barcelona, 1961, no. 318).

BIBLIOGRAPHY: Vienna, 1964, no. 101, fig. 19

51. Adoration of the Magi

Spain, Castile
1180–1190
Stone
First king H. 1.24; second king H. 1.34; Virgin and Child H. 1.36; Joseph H. 1.29 m. 48¾; 52¾; 53½, 50¾ in.)
New York, The Metropolitan Museum of Art, The Cloisters Collection, 30.77.6–9

This relief was taken from a niche in the south portal of the church of Nuestra Señora de la Llama at Cerezo de Riotirón, Burgos. As monumental representations of this scene were usually designed for tympana, it is doubtful that this location was its original setting. Furthermore, the arch did not contain the third king, although he must have been in the original composition. The backward movement and glance of the second

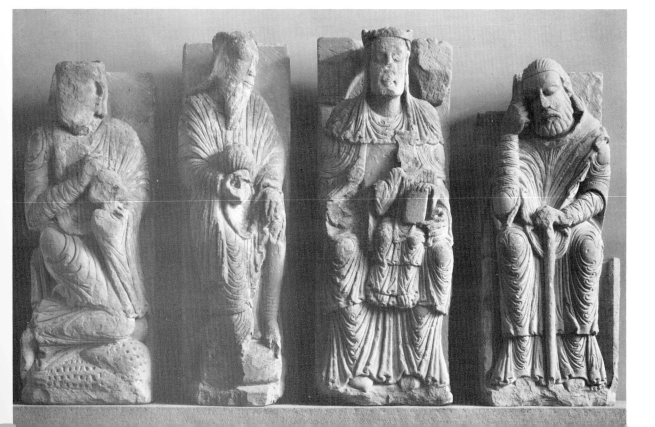

king presuppose the third, to whom he is show-
ing the star, as in the tympanum at St. Trophime,
Arles. Therefore, the original group would have
lacked symmetry, as in the tympanum of St.
Alban-sur-Rhône (Hamann, 1955, fig. 460), a
provincial example of such compositional irregu-
larity. If one takes the Adoration of Benavente
(Porter, 1928, pl. 135) as a parallel, the possi-
bility arises that the angel—warning Joseph—
is missing as well. The motif of the kneeling
king follows the middle twelfth-century formula,
which succeeded the Early Christian one.

The monumental conception of the figures, the
drapery style, and emphasis on depth in the folds,
are hallmarks of Spanish late Romanesque sculp-
ture. The configuration of the Virgin's head re-
sembles that of God the Father in the tympanum
of St. Domingo at Soria (Porter, VI, 1923, pl.
796). The particularly rich contrast of forms in
the second king points to antecedents in Proven-
çal sculpture (St. Gilles, Arles). The relationship
to tympana dated by inscriptions (Benavente:
1181; Gredilla de Sedano, Moradillo de Sedano:
around 1188; Porter, 1928, pls. 154, 155) indi-
cates the chronological position of our group.

BIBLIOGRAPHY: Porter, 1928, p. 28, pl. 112; Rori-
mer, 1963, pp. 23–25

52. Choir screen (two units)

Spain, Santiago Cathedral
1180–1200
Stone
Santiago de Compostela, Cathedral

The choir screen of Santiago Cathedral, removed
in the sixteenth century, has been reconstructed
in part from surviving fragments by Pita And-
rade. Originally erected, according to written
sources, in the time of Archbishop Suarez de
Deza (d. 1203), the screen was the work of
Master Mateo and his assistants, who worked at
the same time on the cathedral's Portico de la
Gloria. The placement of the screen in the nave
followed a Romanesque tradition that was espe-
cially popular in Spain. The architectural model
for the reconstruction was the tomb of an un-
known lady in the church of Santa Maria Magda-
lena in Zamora (P. M. Palol-M. Hirmer, *Early
Medieval Art in Spain,* New York, 1966, fig.
189), which is geographically adjacent and artis-
tically related to Santiago. In the Barcelona ex-
hibition of 1961 only one unit was reconstructed;
the second one has been formed since then. The
full extent of the screen and its sculptural deco-
ration has not yet been ascertained, as the icono-

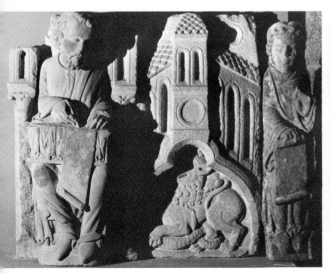

graphical program of the monument remains unknown. However, it is evident that the groups of fighting animals under its trefoil arches are indebted to an imagery, inspired by Eastern prototypes, that was widespread in Spanish Romanesque art. In both the architectural and figural sculpture the modeling is excellent, notably in the heads of the enthroned prophets and apostles which, in 1611, were inserted in the Portico de la Gloria. Descriptions of the individual fragments and their states of preservation are to be found in the Barcelona catalogue of 1961.

53. Plaque: The Presentation

Byzantium
1175–1200
Stone
10.7 x 8.8 cm. (4¼ x 3½ in.)
Athens, Benaki Museum, 32502

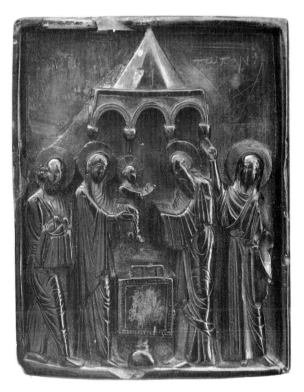

The Virgin, standing to the left of the altar table, holds out the Child to Simeon, who extends his draped arms to receive him. Joseph approaches the altar behind Mary, holding his offering in his draped hands. The prophetess Ann, on the far right, raises her right hand in a gesture of speech, the open scroll of her prophecy held in her left. A pyramidal ciborium with three arcades across the front rises over the central group. The arrangement of the figures is consistent with that of many Middle Byzantine Presentations (bronze door of St. Paul's in Rome, E. Josi, *La porta bizantina di San Paolo,* Rome, 1967, fig. 16; illustrated New Testament, Paris, B. N. gr. 74, fols. 105v and 109v: H. Omont, *Evangiles avec peintures byzantines du XI siècle,* I, Paris, n.d.; D. C. Schorr, "The Iconography of the Presentation in the Temple," *Art Bulletin,* XXVIII, 1946; Schiller, I, 1961, p. 100 f.). Probably originally a portable icon, the plaque may have been mounted with others to form a group of feast scenes (Athens, 1964, p. 189 f.) or a simple diptych or triptych with saints (see the ivories at Paris and Berlin, Goldschmidt-Weitzmann, II, 1936, nos. 4, 39, 72a). The closest stylistic parallels occur in work of the fourth quarter of the twelfth century. The emphasis on Simeon's and Joseph's legs, for example, resembles the similar treatment of the legs of Isaiah or Habbakkuk in a psalter in Athens (Nat. Lib. Ms. 7: Bubere, 1917, figs. 43, 45) or Abraham in the Sacrifice of Isaac at Monreale (Kitzinger, 1960, fig. 47), and the simple incised folds over Mary's and Ann's legs resemble those of the women in a steatite of the Crucifixion in Athens (Athens, 1964, no. 110).

BIBLIOGRAPHY: Schlumberger, 1896–1905; *Benaki Museum, Guide,* Athens, 1936, p. 32; Athens, 1964, no. 107

54. Madonna and Child

Northern France (?)
1180–1190
Ivory
Dublin, Coll. Mr. & Mrs. John Hunt

Mary sits in a lively contrapposto movement on a low, cushioned throne that has carved ends. She holds the Child against her upper body and he reaches toward her chin in the Byzantine "Eleousa" gesture. The deep folds of the drapery closely follow the outlines of the bodies. The iconography and linear animation of the group point to a Byzantine inspiration. In the third quarter of the twelfth century contact with Eastern sources produced similar results in different countries. The linear articulation of our piece is similar to that of French groups from St. Martin-des-Champs, now in St.-Denis (Paris, 1962, no. 6), an English ivory statuette in the Victoria and Albert Museum (Saxl, 1954, pl. x), and the Mosan Madonna of Dom Rupert in Liège (Panofsky, 1924, pl. 50). The solid bodies, the dynamic action of the child independent of the mother's block outline, and the heavy, broad folds that hang between the widely separated legs of both figures are all developments datable between 1180 and 1190. The enchanting intimacy that characterizes the group distinguishes it from the few other enthroned Madonnas produced in the late twelfth and early thirteenth century; two more examples of this small group are in the exhibition (nos. 55, 73).

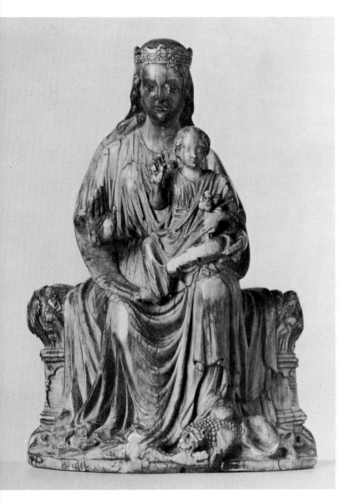

tramples a basilisk with her right foot. This representation is a more elaborate version of the widespread motif of a dragon beneath Mary's foot seen in contemporary French, Mosan, and German examples of the Sedes Sapientiae type (compare no. 35). Iconographically, the combination of lion and basilisk under Mary's feet is a transference from representations of Christus Victor, illustrating Psalm 91: "Thou shalt tread upon the lion and adder: the young lion and the dragon shalt thou trample under feet." (For the iconographical problem, E. Guldan, *Eva-Maria,* Cologne, 1965.) The animals are important for the compositional arrangement of the group. The upward movement of the drapery, swinging in a broad curve between the Virgin's legs, is caused by her raised foot. This type of drapery occurs in a more compact form on the enthroned Mary of the Pentecost miniature in the Ingeborg Psalter, fol. 32 V. (Deuchler, 1967, fig. 36). For the classicizing aspect of this form, Kitzinger's comparison with enthroned Madonna groups of early Byzantine ivories seems very convincing (Kitzinger, 1966, figs. 25, 26); these works could have been available to artists of the early thirteenth century.

BIBLIOGRAPHY: Koechlin, 1924, no. 5; Goldschmidt, III, no. 133

55. Seated Virgin and Child

Northern France
About 1210
Ivory
11.8 x 8.4 cm. (4¼ x 3½ in.)
Hamburg, Museum für Kunst und Gewerbe

On a low, broad throne decorated with trefoiled arcades, the crowned **Virgin and Child** sit in a frontal pose. It is not certain that the parallelism between the figures originally extended to their gesture of benediction, since the Virgin's right hand is evidently a restoration. Mary rests her left foot on the back of a crouching lion and

56. The Deposition

Northern France or England
1200–1205
Walrus ivory
Dublin, Coll. Mr. & Mrs. John Hunt

On this fragment Joseph of Arimathea embraces the body of Christ. Joseph's compassionate look, the fallen position of Christ's head, and his limp arms contribute to the strong emotional appeal of the work. The position of Christ's feet indicates that they were fastened to the Cross with one nail, a method of attachment that was initiat-

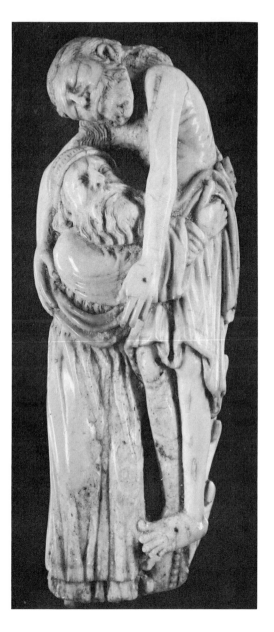

position. The emotional interpretation of the Deposition, taken from Byzantine prototypes, began in Western art around the middle of the twelfth century, as seen in the Mosan St. Trond lectionary (Swarzenski, 1967, fig. 340), where the Eastern influence is clear in both style and iconography. A French interpretation of the Deposition, also with Eastern inspiration, can be seen in the miniature of Ms. 44 of the Pierpont Morgan Library (Boston, 1940, no. 29, pl. XX; for iconographical development, Pächt-Wormald-Dodwell, pp. 92–93; Bober, 1963, p. 50). Stylistic comparison can be made with a fragment of a cross of a slightly earlier date, and of English origin, now in Oslo (no. 70, Goldschmidt, III, no. 128a, pl. XLVI). Similarities can be observed in the treatment of the body and drapery as well as in the touching expression of Christ's inclined head.

57. Virgin of Ourscamp

Northern France
About 1220
Ivory
36 cm. (14⅜ in.)
Paris, Musée du Petit Palais

Mary sits on a narrow seat holding the child obliquely on her left thigh, his right foot resting against her right knee. The group is characterized by conservative elements: rigidity of posture, frontal pose, and immobile facial expressions. Remarkable technical skill is seen in the soft modeling of Mary's face and the way in which her mantle adheres to her head and follows the outline of her body. The gestures are indicative of the early Gothic mood of tenderness. The fluid drapery covering the legs parallels achievements of Mosan sculpture from the early thirteenth century, exemplified in the Virgin and Child from St. John in Liège (see also, no. 36). A French ivory statuette of around 1230 is very similar to our group (Koechlin, 1924, no. 8). Although this period is mainly noted for the monumental sculpture of its cathedrals, the mi-

ed in the early thirteenth century. The vigorous modeling and the spatial arrangement of the figures also suggest this date for the fragment. The individuality of our piece is apparent when it is compared with an ivory fragment from about 1100 in the Schnütgen Museum (Cologne, 1968, no. 9); on this Christ's body retains an upright

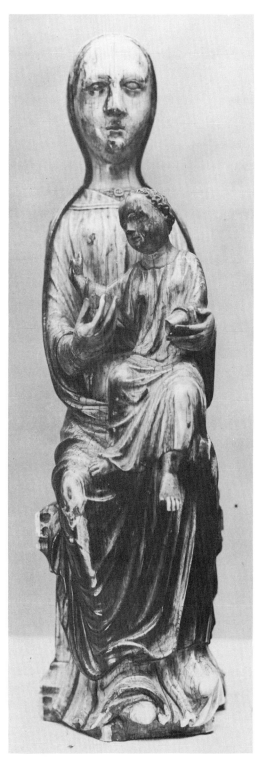

nor arts produced in Mosan were of high quality. The Copenhagen Adoration of the Magi (no. 74) is a result of the Mosan influence in Denmark, while a Cleveland statuette (*Handbook,* p. 53) shows the development of this style at a slightly later date in northern France.

BIBLIOGRAPHY: L. Grodecki, *Ivoires Français,* Paris, 1947, p. 80 f., pl. XXI; *Handbook, Cleveland Museum of Art,* Cleveland, 1967, p. 146

58. Ascension

England
About 1180
Ivory
13.6 x 7.6 cm. (5½ x 3 in.)
London, Victoria and Albert Museum,
 A15–1955

This relief creates an impression of movement through the figure's agitated gestures and the artist's treatment of the entire surface in an irregular rhythm of dark and light. A forced mannerism is particularly apparent in the movements of Christ. Note especially Christ's raised right leg and the disciples' heads that turn nervously in different directions. The drapery treatment is notable; the garments adhere to, yet seem to be independent of, the bodies. The male half-figure beneath Christ's foot, raising his hands in an orant-like gesture, emphasizes the central vertical axis between Christ and Mary; at the same time, this figure may be regarded as the apex of a broad triangle that intersects with a narrower triangle formed by Christ and the angels.

The relief testifies to the survival of late antique models transmitted by northern French ivories of the ninth century. In development prior to the late twelfth century, influence from Byzantium should be taken into consideration.

Iconographically, the *dextrarum iunctio* between Christ and the Hand of God is traditional

(H. Schrade, "Zur Ikonographie der Himmel-fahrt Christi," *Vorträge der Bibliothek Warburg, 1928–29,* Leipzig-Berlin, 1930, pp. 109–115), but the significance of the cup held up by the angel on the left is now unknown. The position of Christ's legs originates from realistic depictions of the Ascension, these of a type showing strong affinity with representations of Moses climbing Mount Sinai (H. Buchthal, "The Minia-ture of the Paris Psalter," *Studies of the Warburg Institute,* Vol. 2, London, 1938, p. 35).

BIBLIOGRAPHY: Beckwith, 1956

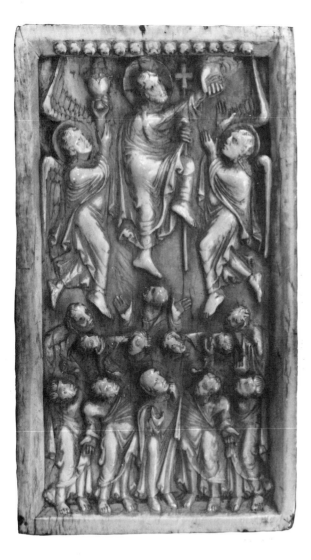

59. Crosier

England
About 1180
Ivory
London, Victoria and Albert Museum

This object consists of a slightly oval volute ta-pering gradually from base to tip, and cut back to a narrower diameter where it originally met the staff. The piece combines three christological scenes, the Nativity, the Annunciation to the Shepherds, and the Agnus Dei, as well as three episodes from the legend of St. Nicholas: his birth, the infant saint's abstinence from his mother's milk on fast days, and the saint giving money to the impoverished nobleman of Myra for his three dowerless daughters, represented re-clining disconsolately under a blanket (compare the St. Nicholas scenes on the roughly contem-porary Tournai font in Winchester Cathedral; Zarnecki, 1953, figs. 38, 39). Although this par-ticular combination of scenes from the lives of Christ and of St. Nicholas seems to be unique, it corresponds to numerous hagiographical cycles that establish a parallelism between Christ and the saint. Furthermore, the choice of the St. Nich-olas episodes appears to be fitting for a bishop's crosier, as St. Nicholas himself held this rank. Representations of the saint became popular after the transfer of his relics from Asia Minor to Bari in 1087. The localization and date assigned to this crosier in earlier literature varies from Eng-land and France to Germany, and from the early eleventh century to the late twelfth. Dale has commented on its eclecticism. Besides reminis-cences of Anglo-Saxon illumination in the pose of the Annunciation and of the St. Alban's Psalter type of facial expression and concentric spiral folds in the drapery of the Nicholas scenes, Dale detected similarities to the Portail Royal at Char-tres. The group on the outer curl of the crosier is decisive for the dating as it shows the most ad-vanced treatment, connected by Dale with the sculpture and stained-glass window of Canter-bury Cathedral that was reconstructed after the fire of 1174 until 1180.

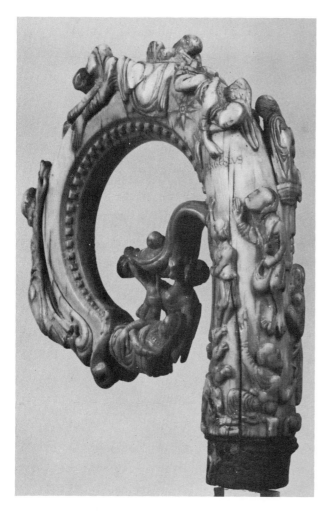

A late twelfth-century English poem, "Vita Thurstini archiepiscopi Eboracensis" (Lehmann-Brockhaus, 1956, no. 5496), allegorizes the crosier:

Mysterium baculi discernit pontificalis
Prima quid, altera quid, tertia pars quid agat.
Curva trahit baculi pars ad bene vivere pravos;
Recta regit rectos; pingit acuta pigros.

BIBLIOGRAPHY: W. S. A. Dale, "An English Crosier of the Transitional Period," *The Art Bulletin*, 38, 1956, pp. 137–141.

60. Cross

England, Bury St. Edmunds (?)
1150–1190
Walrus ivory
57.7 x 36.2 cm. (22⅝ x 14¼ in.)
New York, The Meropolitan Museum of Art,
 The Cloisters Collection, 63.12; 63.127

On the front, a tree with severed branches is attached to the cross. Several holes indicate the position of the original Christ figure, which in all likelihood is no. 61. Both faces of the cross show a central medallion held by angels, and square plaques at the ends of the arms (the bottom plaque is now missing; the thin walrus plaque representing Christ before Caiaphas was presumably one of those that adorned the original base). As a typological prefiguration of the Crucifixion, the scene of Moses and the Brazen Serpent (U. Graepler-Diehe, *Festschrift Usener,* Marburg, 1967, p. 167 f.) in the front medallion would have appeared behind the head of the missing Christ like a halo. The three original terminal plaques represent episodes of the Deposition and Lamentation (right), the Women at the Sepulcher and the Resurrection (left), and Christ's Ascension (top), the missing bottom plaque may have depicted the Harrowing of Hell. Adam and Eve are seen rising from their tomb beneath the tree-cross. Pilate and Caiaphas, in an exceptionally rare scene, dispute the title inscription of Christ's cross that here replaces the traditional wording "Iesus Nazarenus Rex Judeorum" with the rare formula IESUS NA[Z]ARENUS REX CONFESSORUM, also given in Greek and pseudo-Hebrew (fully analyzed by Longland, 1968). On the back of the cross the central medallion shows the personification of Synagogue piercing the Lamb of God, while the terminal plaques contain the symbols of the Evangelists. Twenty prophets appear on the horizontal bar and the upright, either as busts or as full or three-quarter figures. (The lowermost figure, Jonah, is now missing). All the prophets, the explanatory Old and New Testament figures added to the two medallion scenes and the Lamentation, and the protagonists in the christological representations carry scrolls, the in-

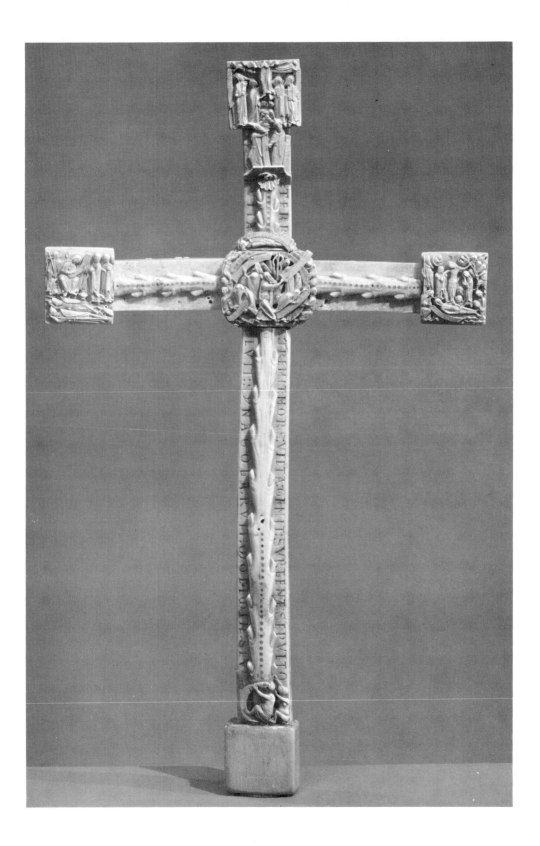

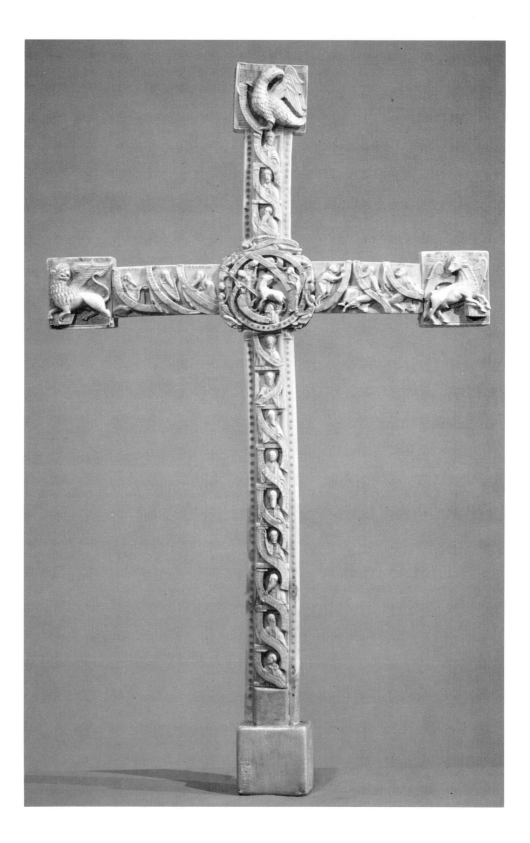

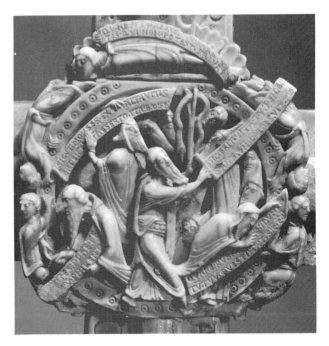

scriptions of which comment on the passion theme (for transcriptions, translation, and discussion: Hoving, 1964). While the predilection for Old Testament prototypes is common in mid-twelfth-century imagery, the appearance of Christ crucified and the Lamb surrounded by the symbols of the Evangelists on the two faces of the cross follows an early medieval tradition (O. K. Werckmeister, *Der Deckel des Codex Aureus*, Strasbourg, 1963, p. 73, n. 604).

As no documentary history of the object is known, its date and localization depend on stylistic analysis. Whereas doubts about the English origin of the cross have never been substantiated in the literature, its chronological position has not yet been finally ascertained. The modeling, proportions, physiognomy, and drapery treatment of the single figures indicate a mid-twelfth-century date (Swarzenski, 1967, fig. 338: "Second half twelfth century"). Comparisons with the Bury St. Edmunds Bible (1130–1140) (Cambridge, Corpus Christi College, Ms. 2; C. M. Kauffmann, "The Bury Bible," *Journal of the Warburg and Courtauld Institutes*, XXIX, 1966, pp. 60–81) and other English manuscripts (Hoving, 1964) would seem to limit the carving of the cross in any case to the third quarter of the century. A characteristic feature of the drapery style is the so-called "damp fold"; this, based on Byzantine models, became popular in the second quarter of the twelfth century (Koehler, 1943; Garrison, 1955). The angels holding the medallions may be compared to corresponding figures on the St. Nicholas crosier (no. 59; for their classical source: Dodwell, 1954, pl. 41 c–g). The motif of the blindfolded Synagogue was rare before 1150 (W. Seiferth, "The Veil of Synagogue, Horizons of a Philosopher," *Essays in Honor of D. Baumgardt*, Leiden, 1963, pp. 378–390), while Synagogue killing the Lamb, an extremely rare scene reminiscent of contemporary representations showing her in the act of killing an Old Testament sacrificial animal (Panofsky, 1960, p. 99, n. 1), recurs in the Gospel book of Duke Henry the Lion, painted around 1175 in lower Saxony under strong English influence (Longland, 1969, p. 173, fig. 17). From this scene and the inscriptions most

prominently placed on the front and narrow sides of the cross (TERRA: TREMIT: MORS: VICTA: GEMIT: SURGENTE: SEPULTO VITA.CLUIT: SYNA-GOGA: RUIT: MOLMINE: STULT[O]CHAM: RIDET: DUM: NUDA: VIDET: PUDIBUNDA: PARENTIS IUDEI: RISERE: DEI: PENAM: MOR[TIS]) a specific anti-Judaic message becomes apparent in the

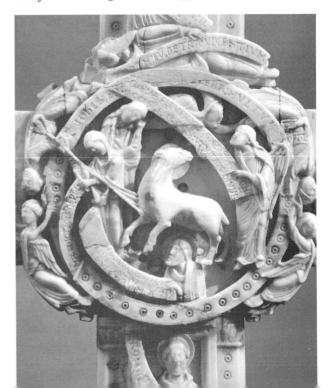

cross; Hoving connects this with Abbot Samson's struggle against the Jews in the 1180s (for the wider historical context, H. G. Richardson, *The English Jewry under Angevin Kings,* London, 1960; for iconography, B. Blumenkranz, "La polémique antijuive dans l'art chrétien du moyen-age," *Archivio Muratoriano,* LXXVII, 1965, pp. 21–43). Tempting as this historical connection with the Bury St. Edmunds monastery appears, it seems to be at variance with the stylistic evidence pointing to an earlier origin of the object. Hoving's mediating suggestion that the inscriptions may have been added under Abbot Samson some thirty years after the cross was carved seems improbable in view of the fact that the Caiaphas-Pilate group discussing the titulus has an anti-Jewish tendency in itself already. The Bury St. Edmunds localization has been doubted on philological grounds (Longland, 1968, 1969).

BIBLIOGRAPHY: W. Mersmann, "Das Elfenbeinkreuz der Sammlung Topic-Mimara," *Wallraf Richartz-Jahrbuch,* XXV, 1963; T. P. F. Hoving, "The Bury St. Edmunds Cross," *The Metropolitan Museum of Art Bulletin,* XXII, 1964, pp. 317–340; J. Beckwith, *The Adoration of the Magi in Whalebone,* London, 1966, p. 26, fig. 34; S. Longland, "Pilate Answered: What I Have Written I Have Written," *The Metropolitan Museum of Art Bulletin,* XXVI, 1968, pp. 410–429; Longland, "A Literary Aspect of the Bury St. Edmunds Cross," *Metropolitan Museum Journal,* 2, 1969, pp. 45–79; Longland, "The 'Bury St. Edmunds' Cross," *The Connoisseur,* 172, 1969, pp. 163–173

61. Corpus from a cross

England
1170–1180
Walrus ivory
H. 19 cm. (7½ in.)
Oslo, Kunstindustrimuseet

In a highly expressive curve, emphasized by the long falling hair, Christ's head rests on his right shoulder. The tense posture is echoed in the arrangement of the loincloth, drawn up in a knot on the left hip. The missing arms were originally fastened by tenons into the lower of the two holes

in the shoulders. A parallel position for the missing legs may be reconstructed, with the feet resting side by side. There are cracks on the face, traces of rose color on the loincloth, green on the crown of thorns, and dark brown on the hair and the beard. The flesh is uncolored. The impressive carving of the face, with its regular row of beard curls, slightly curved mouth outline, and thinly incised eyelid lines, was once ascribed to a Norwegian artist of the mid-thirteenth century. The piece has now been reattributed. Pointing to the

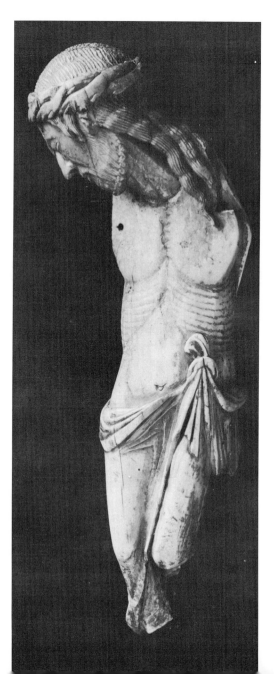

characteristic "damp folds" on the right leg and thigh and comparing the piece to figures in English book illuminations and ivory carvings and no. 60, Blindheim considers the corpus English and dates it to the third quarter of the twelfth century. It has been suggested that the object originally formed part of no. 60, the corpus of which is missing. The close stylistic similarities of the carvings are noted by Blindheim, and the pertinent measurements confirm the plausibility of the suggestion.

BIBLIOGRAPHY: Goldschmidt III, no. 128; H. Schnitzler, *Festschrift E. Meyer,* Hamburg, 1959; M. Blindheim, "En romansk Kristus-figier av Hvalrosstann," *Arbok, 1968/1969, Kunstindustrimuseet, Oslo,* Oslo, 1969, pp. 22–32; Longland, 1969

62. Rest on the Flight into Egypt

England
About 1180
Ivory
7.8 x 3.9 cm. (3⅛ x 1½ in.)
New York, The Metropolitan Museum of Art,
 Dodge Fund, 40.62

The relief's fragmentary state precludes a reconstruction of its original appearance and context, and the meaning of the flanking supports (trees, parts of an arcade?) is unclear. The Virgin holds the Child and sits frontally on the ass, protected by Joseph, who puts his arm around Mary's shoulders, holding the reins in his other hand. The psychological intimacy of the group is focused in the subtle facial expression of Joseph, combining anxiety and astonishment. The delicate treatment of Mary's drapery, covering her body in thin layers of parallel swinging curves, is notable. The motif of the ass eating grass, together with the static conception of the group, suggests that it represents the Rest on the Flight into Egypt, a scene that gained popularity only in late medieval art, as opposed to the earlier traditional representations of the Flight into Egypt proper. As a

parallel for Joseph standing behind the ass, H. Swarzenski (Swarzenski, 1950, pp. 25, 26) referred to the twelfth-century fresco from Audignicourt (Aisne). The motif of Joseph's arm around the Virgin's shoulder is reminiscent of contemporary representations of the Sponsus-Sponsa group (Wentzel, 1952; Pächt, 1956), where the Sponsa of the Canticle refers to Mary, the artist having transferred the gesture from Sponsus-Christ to Joseph.

The elongated figures, together with the pointed features, support an English rather than northern-French origin for this piece. Certain similarities to the St. Nicholas crosier and the ivory relief of the Ascension (see nos. 59 and 58) have been observed by Beckwith, leading him to suggest a late twelfth-century date as opposed to Hanns Swarzenski's dating around the middle of the century. A comparison with the Bury St. Edmunds Cross (no. 60), especially in regard to the fine multiple drapery, the resemblance of Joseph's features to those of some of the bearded prophets, and, finally, to the continuously stretched body surfaces of the animals shown in profile, further supports the English origin of the relief and its proposed dating.

BIBLIOGRAPHY: Goldschmidt, IV, no. 19; Beckwith, 1956, p. 119; Swarzenski, 1967, pl. 139, no. 314

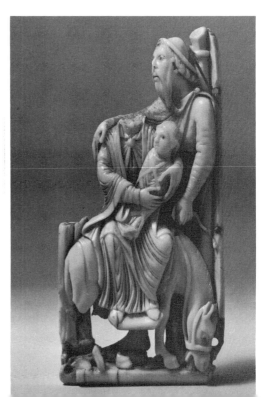

63. Capital

England
1180–1190
Walrus ivory
5.4 x 3.1 cm. (2⅛ x 1¼ in.)
London, Trustees of the British Museum

This miniature capital is formed by a regular sequence of upright leaves. At each of the four corners a seated nude youth grasps the tail of an upward-climbing salamander. The circular carving indicates that the capital originally supported a flabellum or similar liturgical object, perhaps a small crucifix (Dalton; Goldschmidt). For a later, unknown use the upper edges were squared and two holes were added. The piece is distinguished by the inventive variations of posture of all the figures. The iconographical motif is traceable to classical prototypes—element cycles—and appears to be a variation of this imagery, which was widespread in twelfth-century capitals and manuscript initials. The curling rhythm connects the capital with English work of the last quarter of the century (compare the dragons on a mirror case, no. 86); the same rhythmic interpretation can be seen in the floral decoration of a tiny bronze-gilt knob, of English or Mosan origin of around 1200 (Boston, *Museum of Fine Arts Bulletin*, 55, 1957, p. 83, fig. 35).

BIBLIOGRAPHY: Dalton, 1909, no. 72; Goldschmidt, IV, no. 24; Swarzenski, 1967, fig. 456

64. Flagellation of Christ

England
1200–1210
Walrus ivory
6.9 x 7.1 cm. (2 11/16 x 2 13/16 in.)
Copenhagen, National Museum

Circular medallions often appear in late twelfth- and early thirteenth-century ivory carving; decorated with animals and secular scenes, they were used mainly as chess pieces (II, ill. 153). While there are medallions with Old Testament episodes, very few examples exist with New Testament subjects.

This medallion probably originally formed part of a Passion cycle decorating a liturgical vessel. Following a widespread pictorial type depicting scenes of martyrdom (Herod at the Slaughter of the Innocents, Saul at the Stoning of Stephen, and others; see W. S. Heckscher, *Rembrandt's Anatomy of Dr. Nicolaas Tulp*, New York, 1957, p. 87 f.), the composition shows Pilate sitting at the left, his legs crossed in a pose traditionally associated with judges, commanding the flagellation. Christ, with a cross-nimbus, his arms fettered around the column in front of his body, occupies the center of the plaque. Following the circular shape, the executioner's head is turned back. The soldier's bent left leg corresponds to the outline of Christ's right leg. The medallion is distinguished by careful modeling, variation of

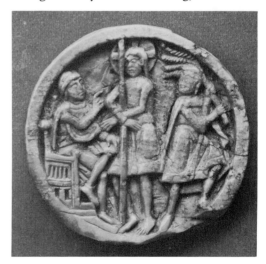

relief layers, and interest in complicated movements. In spite of this explicit stylistic evidence, a precise localization or grouping with related pieces cannot be made.

Iconographically, scenes of the Flagellation may be followed from the early medieval period (Goldschmidt, III, no. 302, pl. LX) through twelfth-century Mosan enamels, (Brussels, 1964, no. 41, fig. 38); for a reduced version, also with Pilate enthroned at the left (Brussels, 1964, p. 39, fig. 35). For a broad historical analysis of the compositional devices to be found in medieval representations of the Flagellation and their classical prototypes, see the article on the Frick flagellation by M. Meiss ("A New Early Duccio," *Art Bulletin,* 1951, pp. 95–103).

usual in medieval representations of Judas, and has unfavorable connotations not present in a frontal face. The motif of Christ grasping his right arm with his left is unusual; it is perhaps meant to suggest Judas' separation from the vessel protected by Christ's gesture. The arresting treatment of form provides no clue for a specific localization of the object. An early thirteenth-century dating, however, may be taken for granted in view of the mentioned stylistic and technical peculiarities. The type of an upward-staring, pathetically conceived figure occurs earlier in medieval representations, apparently stemming from classical prototypes (for French examples from the ninth and eleventh centuries that easily might have been known to the English carver, Swarzenski, 1967, figs. 167–168).

65. Judas at the Last Supper

English
1200–1220
Walrus ivory
H. 8.5 x 7 x 4.5 cm. (3⅜ x 2¾ x 1¾ in.)
London, Victoria and Albert Museum, A34-1949

The original appearance and context of this fragment are not easily reconstructed. The back is chipped out and shows old cracks. In addition to the two holes in the table, there is a large hole in the back. The upper body of Judas is seen in profile as he receives the morsel from Christ's hand. The distorted upward movement of his head, paralleled by the broad curve of his right arm, and the drastic reductions of forms contribute to the impressive effect. The summary treatment of the hair cap and beard, the protruding nose, and the curve of the arm harmonize with the suggestion of Judas' passionate desire to receive the bread. In these features the fragment is a masterpiece of expressive visualization, taking seemingly primitive elements into the service of a highly accomplished task (E. Müller, "Von Ausdruck des Primitiven in der Plastik des Späten Mittelalters," *Kunst,* I, 1948, p. 17). The profile is

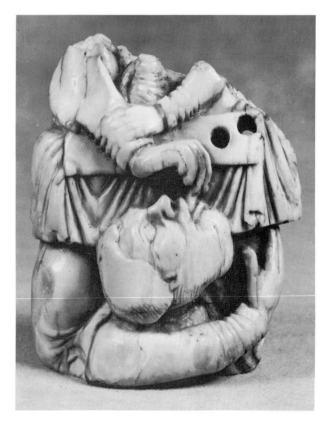

compared by Dalton to the mid-thirteenth-century sculptures of the chapterhouse doorway at Westminster, the fluidity of Mary's drapery points to an earlier, perhaps second-decade, date for our sculpture. A closer resemblance is seen in the *Zackenstil* drapery treatment of Saxon manuscript illumination of the "Haseloff school" (Haseloff, 1897). Although the exhibited sculpture is linked by Swarzenski to the Copenhagen Adoration (no. 74), the drapery differs and our piece more closely resembles early thirteenth-century Mosan and northern French art. Because of the exchange between England and Scandinavia in early Gothic sculpture, the French influences could have been transferred to Denmark through English examples, with the Danish Adoration and our example showing different responses to the same French models.

BIBLIOGRAPHY: Dalton, 1909, no. 248, pl. LIV; Koechlin, 1924, no. 5B, pl. II

66. Adoration of the Magi

England
Early 13th century
Ivory
H. 9 x 7.4 cm. (3 9/16 x 1 9/16 in.)
London, Trustees of the British Museum

The Virgin and Child, a frontal Eleousa type, are flanked by the Magi represented as attributes. This arrangement, also seen in Spanish apse frescoes (Cook, 1955, pl. 23), and the Cologne shrine of the Three Kings (II, ill. 111), differs from the usual narrative renditions of the Adoration. The sharply drawn drapery folds are a severe interpretation of *Muldenfaltenstil* achievements, seen in the undulating edges of Mary's mantle. The features of the kneeling king are similar to those of half-length kings seen in late twelfth- and early thirteenth-century Norwegian ivory chess pieces derived from English models (Goldschmidt, IV, pls. LXIV, LXV). Although

67. Fragment of a reliquary

Germany
Late 12th century
Walrus ivory
a. 16.5 x 6 x 4 cm. (6½ x 2⅜ x 1 9/16 in.)
b, c. 10 x 4.5 x 3.6 cm. (3⅞ x 1¾ x 1⅜ in.)
Darmstadt, Hessisches Landesmuseum

This object, consisting of three pieces connected by pins, shows the front of a three-naved basilica with a two-storied middle tower decorated with blind arcades, windows, and a triangular gable. A fully preserved reliquary from the same Cologne workshop, now in the Brussels Museum (Goldschmidt, III, no. 53), suggests that our piece originally had a similarly organized back, probably displaying the enthroned Virgin. On our fragment, the enthroned center figure of Christ in a deep niche is framed by an arcade, the arch decorated by sprouting leaves. The four animalia accompany Christ in two superimposed niches on both sides. At the outer edges of the side panels armed figures of soldiers, possibly members of the Thebaid Legion, especially venerated

68. Seated Christ

Rhineland
About 1200–1220
Walrus ivory
15 x 15 x 2 cm. (5 11/16 x 2 x 1⅛ in.)
New York, The Metropolitan Museum of Art,
 The Cloisters Collection, 65.174

Seated in an aedicula, the round arch supported by columns, Christ raises his right hand in blessing and holds a book with his left. The elongation of the figure, accentuated by the blessing hand and the upright position of the book, harmonizes with the steep proportion of the framing arcade. In spite of an abraded surface, the excellent quality of the fragment is still evident in the smoothly flowing drapery that combines an ornamental

in Cologne, are represented as guardians of the building and the relics enclosed. The plasticity of the entire building and the details of the forms (note especially the predilection for polygonal forms) recall contemporary church architecture of Cologne and the lower Rhine region. The iconographical program of the reliquary may consequently be understood as the Majesty type, traditional in church tympana. The transposition of Christ to the ground-floor level of the portal perhaps refers to the biblical concept of Christ as the door (John 10:7). At the same time the disposition of Christ, and perhaps Mary, enthroned on the façades may be derived from the compositional scheme of Mosan and Cologne reliquary shrines.

In spite of its traditional frontal posture and blessing gesture, the Christ-figure is vividly conceived. The elegantly flowing drapery of his mantle is a calm rendering of the more agitated style known to the artist from various contemporary models, both Western and Byzantine. (A broad survey of twelfth-century types of Christ enthroned is given in Rademacher, 1964, especially the material for the attribute of the book, characterizing Christ as the teacher).

BIBLIOGRAPHY: Goldschmidt, III, no. 52, pl. XV; Cologne-Hüpsch, 1964, no. 15, fig. 17

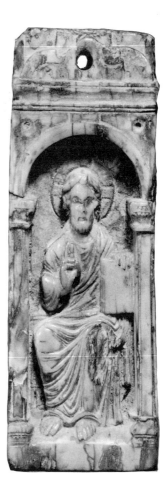

pattern with a firm sculptural articulation of the body. The sensitivity of Christ's expression is influenced by Byzantine-inspired French sculpture. The artist has paid particular attention to the architectural details of the columns' bases and capitals. The piece is a fragment of a reliquary shrine comparable in size, type, and style to no. 67 (Goldschmidt, III, nos. 52–54). The hole at the center of the top, and the three on each side, contained pegs for securing the piece within a shrine.

69. Samson and the lion

Germany
Late 12th century
Walrus ivory
D. 5.36 cm. (2⅛ in.)
Hannover, Kestner-Museum 416

The vivid impression of movement in this plaque results from the backward turn of the lion's head and the flowing drapery. The impressive agility in the bodies, as well as in the drapery, points to Western, possibly English, inspiration. The accompanying inscription stresses the aspect of fortitude in Samson's victory over the lion: SANSON HVNC FORTEM FORTIS VIC . . . ATQUE

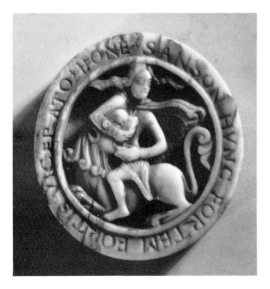

LEONE. Although the idea was very popular in the Middle Ages, the source of the line is unidentified. This plaque, one of a large number of similar plaques and sets of chessmen, was produced in a Cologne atelier toward the end of the twelfth century. Such finely drawn figures are often found in Cologne ivory carving of the time. The subject of Samson had a special popularity, seen in its depiction on Mosan candlesticks (no. 119). (For equivalent representations in other narrative contexts, Swarzenski, 1967, figs. 450, 452). At the time and place our plaque was carved, Nicholas of Verdun may have worked his Samson lion group in the crest of the Three Kings Shrine (Swarzenski, 1967, fig. 525). Another German Samson group with Western derivation is seen on a stamp of the St. Lawrence arm reliquary, formerly in the Welfenschatz (Swarzenski, 1932, p. 391, fig. 333, right part).

BIBLIOGRAPHY: Goldschmidt, III, no. 233, pl. LVI; Hannover, 1966, no. 110

70. Casket with love scenes (Tristram and Isolde?)

Germany (?)
About 1200–1220
Ivory
9.9 x 14.9 x 9.8 cm. (3⅞ x 5⅞ x 3⅞ in.)
London, Trustees of the British Museum

On the front, two couples appear in arcaded niches above crenelated walls; on the ends, couples (one of them crowned) flank a tree, schematized towers and crenelated walls completing the scenes. In one of these reliefs the wall opens to show the roots of the tree. Two battling knights in a symmetrical scene of towers and trees appear on the back of the casket. By their stiff postures and ceremonial fighting gestures, they recall the mass-produced Cologne ivory chessmen. Towers appear again on the lid plaque, which shows a couple lying in bed, attended by a servant. The oblique position of the bed and the free rhythm of the cloth remind one of contemporary repre-

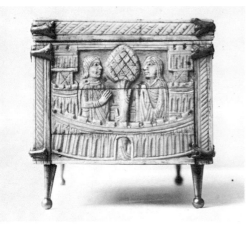

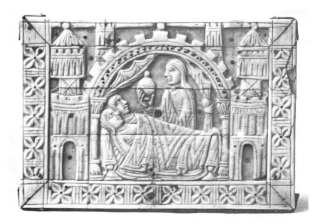

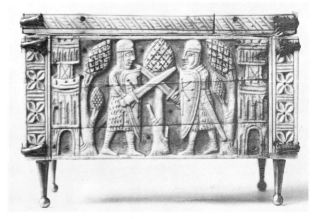

sentations of the Nativity; this scene has iconographical analogies in miniatures of the Berlin *Aeneid* codex (no. 271) and in the Bussen mirrorcase (no. 111). If the decoration of the casket is to be considered a direct illustration of the Tristram-Isolde story, it would be derived from an illustrated text like the Berlin codex (Weitzmann, 1959; Stammler, 1962).

The localization of the piece to a German workshop is uncertain; perhaps it originated in England or Scandinavia. However, relationships to contemporary Cologne massproduced ivory carving may be noted in the repetition of the limited decorative elements, particularly the simple star motif in the border panels, reminiscent of the border plaques on the Darmstadt tower reliquary (no. 71). An uninventive repetition is observable also in the four similarly represented couples. The historical significance of this piece is in its early date; as a *Minnekästchen* it precedes the majority of this genre by almost a hundred years (Kohlhaussen, 1928).

BIBLIOGRAPHY: R. Forrer, "Tristan et Iseult sur un coffret inédit du XIIe siècle," *Cahiers d'Archéologie d'Alsace,* 1933; R. S. Loomis, *Arthurian Legends in Medieval Art,* London/New York, 1938, p. 43, figs. 19–23

71. Tower reliquary

Germany, Cologne
Early 13th century
Bone
H. 36.5, largest D. 26 cm. (14½ x 10¼ in.)
Darmstadt, Hessisches Landesmuseum, 54.226

Each story of this two-storied polygonal tower shows standing figures in arcades: on the lower story, Christ, eleven apostles, and the Adoration of the Magi; on the upper story, eleven Old Testament figures, Pope Sylvester, and an unidentified figure whose inscription is lost. The sloping roof between the stories presents sixteen half-length angels emerging from crenelated towers; the

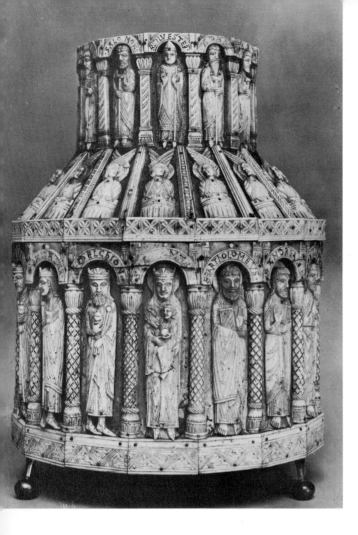

that the box contained relics of St. Sylvester, or that it was made for a church dedicated to this saint, cannot be substantiated. Similarly, the presence of the Adoration of the Magi, especially popular in Cologne after the transfer of the relics of these kings from Milan, does not permit any specific conclusion.

The use of the tower form for reliquaries, traditional from early Christian times (W. Beeh, "Zur Bedeutungsgeschichte des Turmes," *Jahrbuch für Asthetik und Allgemeine Kunstwissenschaft*, VI, 1961, pp. 177–206) is explained by the sepulchral connotations of tower structures since classical antiquity. As a centrally planned building with an overall sculptured surface, our reliquary recalls the appearance of the twelfth-century Armenian church of Zwarthnotz. A marked predilection for centralized buildings is to be noted further in Rhenish late Romanesque architecture (Bandmann, *Wallraf Richartz Jahrbuch*, XV, 1953). The Hochelten reliquary, no. 339, now in the Victoria and Albert Museum, bears testimony to the Cologne workshop's adaptation of another type of centralized structure. Another tower reliquary of the same atelier, of smaller size, is preserved in the Darmstadt Museum.

BIBLIOGRAPHY: Goldschmidt, III, no. 67: Cologne-Hüpsch, 1964, no. 17

crowning lantern is missing. In the spandrels of the lower story are small towers. The colonettes of the columns are ornamented with imbricated leaves in high relief, the bases and capitals decorated with upright leaves. Pilasters, similarly decorated, support the arcades of the upper story. Stylistically the type of the slender figures, with precisely drawn drapery, derives from the middle twelfth-century Cologne tradition of ivory carving. A steady contact with French and Mosan development can be assumed in the atelier. At the same time, however, advanced Western models were used for the purposes of mass production, impeding the inventiveness and quality of the workshop. For this reason too, a precise chronology of the Cologne Romanesque ivory production is difficult to establish, as is the liturgical destination of our piece. The suggestion

72. Reliquary

Germany, Cologne
First half of the 13th century
Bone
23.5 x 13.4 cm. (9¼ x 5¼ in.)
New York, The Metropolitan Museum of Art,
 Gift of J. Pierpont Morgan, 17.190.230a, b

Eight apostles stand in niches bordered by colonnades holding scrolls inscribed with their names. The triangular plaques of the pyramidal lid contain alternating half-figures of the animalia and unidentified figures. The base of the lower story is decorated with a zig-zag pattern; above the figures is a sequence of schematized arcades. A

rough geometrical pattern fills the background of the lid plaques. The fine, dense folds of the drapery are a drastic simplification of thirteenth-century sculptural achievements. Iconographically as well as stylistically this reliquary has three close counterpieces (no. 71 and Goldschmidt, III, pp. 68–70). The similarity of these four objects points to the mass production prevalent in Cologne ateliers of the first half of the thirteenth century. The elongated figures and linear stylization of the standing apostles is seen in Rhenish-Belgian ivory-carving of the early twelfth century (Deposition fragment in the Schnütgen Museum, Cologne, 1968, no. 120). The representation of only eight apostles, traditional in octagonal reliquaries, is seen in works of other German ateliers (the lower Saxon St. Oswald reliquary, H. Reuther, "Das Oswaldreliquar in Hildesheim und seine architektonischen Vorbilder," *Nieder deutsche Beiträge zur Kunstgeschichte,* IV, 1965, pp. 63–76). The source of these Western pieces is an Early Christian type transmitted in a Byzantine tradition (R. Ruckert, "Zur Form der byzantinischen Reliquiare," *Münchener Jahrbuch,* 1957, pp. 73–6).

BIBLIOGRAPHY: Goldschmidt, IV, no. 305

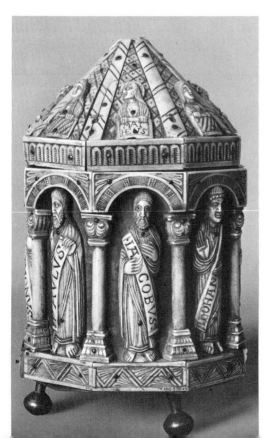

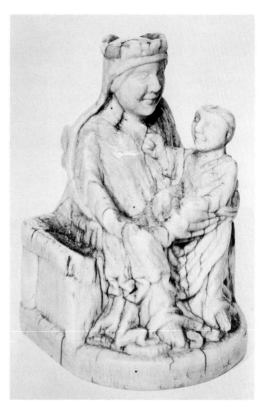

73. Virgin and Child enthroned

Germany
1220–1230
Ivory
H. 5.6 cm. (2½ in.)
Princeton University, Art Museum, 49.120

The Virgin sits on a solid throne with a low tapering back that terminates in a horizontal bar below the height of her shoulder. Wearing a crown over her veil, which falls in a sweeping curve, she holds the Child loosely on her left leg. Judging from similar representations, the Virgin originally held an apple in her missing right hand. Stylistically, the group is distinguished by its cubic solidity, emphasized by the heavy proportions. In comparison with an ivory group in Essen (H. Schnitzler, "Eine unbekannte spätromanische Elfenbeinmadonna," *Pantheon,* XXVI, 1940, pp. 294–295), the more fluid drapery of our figure indicates a date around 1220–1230.

Weitzmann suggests a German origin for the piece, pointing out both its Western derivation and similarity to a group of Saxon sculptures (Freiberg, Halberstadt) that translates the French idiom into a characteristically Byzantinizing manner. But a definite localization of late Romanesque ivory production, the Cologne workshop excluded, has not yet been agreed upon. A north Italian origin is assigned to a rather similar statuette of the Madonna in Berlin, of around 1200 (*Bildwerke der Christlichen Epochen von der Spätantike bis zum Klassizismus,* Munich, 1966, no. 224, pl. 22). Since other ivory statuettes of the Virgin of this time are bigger and most are used as reliquaries (Goldschmidt, III, nos. 133–136), the surprisingly small size of our piece and the lack of an opening are unusual. A hole in the underside of the throne indicates that the statuette was attached by a pin to a base, probably a reliquary.

BIBLIOGRAPHY: Weitzmann, 1951, no. 2, pp. 2–6

74. Adoration of the Magi

Denmark or England
1240–1250
Ivory
H. 17 cm. (6¾ in.)
Copenhagen, National Museum

Seated on his mother's lap, the Child receives a wreath from one of the kings, thereby joining the classical ceremonial of presenting gold wreaths to a ruler with the biblical narrative (R. Klauser, "Aurum Coronarium," *Reallexikon für Antike und Christentum,* I, 1950, cols. 1010–1020). While the style is undoubtedly French in origin, an English or Danish origin cannot be excluded in view of the widespread French influence. The work is regarded as Danish by Swarzenski, who suggested English prototypes. This influence is plausible given the interrelations between English and Scandinavian sculpture in the mid-thirteenth century (Andersson). A similar linearization and relief-like interpretation occurs in the

Virgin from the English Annunciation in the chapter house of Westminster Abbey (Swarzenski, 1960, fig. 15). The Scandinavian work closest to the exhibited group is an ivory crucifix from the Herlufsholm Abbey (Swarzenski, 1967, fig. 544), reflecting in the technique of the loincloth northern French works of *Muldenfaltenstil.* The subtlety and precision of the single drapery folds is typical of northern French and Mosan work of about 1200–1210, but a later date is suggested by other points such as the systematic organization of the drapery and its seeming thinness, the conception of the figures as isolated from one another, and the physiognomical details of the kneeling king. Mary is shown trampling a dragon, a motif seen in Mosan Sedes Sapientiae groups and also occurring earlier in an Italian Adoration relief in Arezzo (G. Vezin, *L'Adoration et le cycle des mages dans l'art chrétien primitif,* Paris, 1950, p. 88, pl. XX) and in an eleventh-century German ivory plaque (Goldschmidt, II, no. 153c, pl. XLIV).

BIBLIOGRAPHY: Goldschmidt, III, no. 125; Andersson, 1949; Swarzenski, 1960, p. 73 f., fig. 14

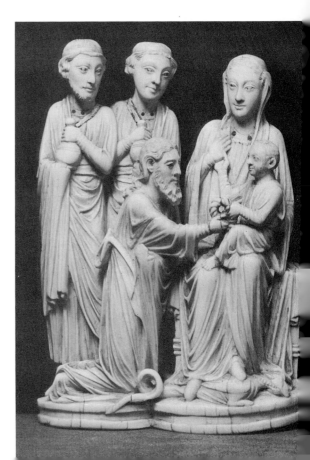

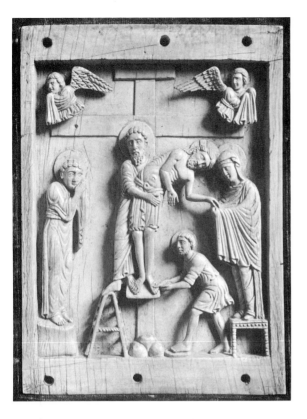

75. Plaque: Deposition

North Italy
1180–1200
Ivory
11.8 x 16 cm. (4¾ x 6¼ in.)
Boston, Museum of Fine Arts

Joseph stands on a short ladder, supporting the body of Christ as it falls from the cross. Mary, standing on a stool at the right, takes Christ's hand in hers, while Nicodemus removes the nails from his feet. Two half-figures of angels above the cross arms and John, standing on the left, mourn the dead. The portrayal of the Deposition in Byzantine art followed the composition of the Crucifixion from which, as early as the ninth century, it drew the figures of John and Mary (Millet, 1916, p. 467 f.). Mary soon assumed a major role in reaching up for the arms of Christ and, later, in actually receiving the full weight of his

body from Joseph (fresco at Toqale, Cappadocia: Jerphanion, 1925, I, pl. 69; fresco at Aquileia: Demus, 1968, pl. XXII; II, ill. 244, no. 291). In the present plaque, Mary stands on the stool that apparently was used by Nicodemus to disengage Christ's arms from the cross, as she does in many late Byzantine and Italo-Byzantine Depositions (Millet, 1916, figs. 501–502).

The plaque was probably made by a north Italian carver of the late twelfth or early thirteenth century who used Byzantine models extensively (Keck, for the strong influence of Byzantine ivories on the lintel sculpture at San Michele degli Scalzi and the Baptistry at Pisa, Venturi, 1930, III, p. 964). Our artist copied a plaque similar to one in the Hildesheim Treasury (Goldschmidt-Weitzmann, II, no. 220). He closely followed the mid-twelfth century Byzantine mode of draping his figures simply in sharp parallel folds and using round individual curls for St. John's hair (compare steatite of St. Theodore, George, and Demetrius in the mosaic icon of Christ in Florence, Museo Nazionale: L. Marcucci, *Dipinti Toscani del secolo XIII,* Rome, 1958, no. 25).

BIBLIOGRAPHY: Keck, 1930; E. J. Hipkiss, "A Carved Ivory Plaque," *Boston Museum of Fine Arts Bulletin,* XXXIII, 1935, pp. 20–21; Goldschmidt-Weitzmann, II, nos. 219, 220

76. Casket

Byzantium
1170–1190
Ivory
11.5 x 39.5 x 19 cm. (4½ x 15½ x 7½ in.)
New York, The Metropolitan Museum of Art,
 Gift of J. Pierpont Morgan, 17.190.235

The side panels contain scenes of hunting or heraldically confronted animals surrounded by bands of simple bead or twisted moldings and of rosettes in medallions. Two panels with erotes representing warriors and musicians decorate the flat, sliding top, which is framed with friezes of twisted bands, rosettes in medallions, and stylized palmettes. The naked erotes, like those of no. 77,

derive from the standard iconographic repertory of Byzantine caskets (Goldschmidt-Weitzmann, I, no. 88) and the figure of Hercules seated on a basket on the right of the left panel stems ultimately from the Greek statue of Hercules set up in the Hippodrome in Constantinople (N. Choniates, *De Signis Constantinopolitanis,* Bonn, I, 1838, p. 858 f.). The figures are rather primitively carved with the outlines of muscles and ribs carefully incised. The similar treatment of the animals and the sharp, angular foliage of the friezes indicate that the casket was made in the second half of the twelfth century, perhaps in a provincial workshop.

68

The hunting animals stem from late antique hunting scenes in mosaics (I. Lavin, "The Hunting Mosaics of Antioch and their Sources," *Dumbarton Oaks Papers,* XVII, 1963, pp. 179–286), metalwork (A. Minto, "Spalliera in bronzo decorata ad intarsia del R. Museo Archeologico di Firenze," *Critica d'Arte,* I, 1936, pp. 127–135), and glass (F. Fremersdorf, *Figürlich geschliffene Gläser: eine Kölner Werkstatt des 3. Jahrhunderts,* Berlin, 1951). The confronted animals, on the other hand, come from Eastern decorative arts (textiles, von Falke, 1922, p. 7 f.; Cott, 1939, passim). They were used extensively in Byzantine and Italian medieval art; for example, the mosaics of the Norman Stanza at Palermo (Demus, 1949, p. 180 f.; pl. 115) and many marble ambo and choir-screen plaques (Buchwald, 1962–3, figs. 22–27; Volbach, 1944, pp. 172–180).

BIBLIOGRAPHY: P. C. Nye, "Oblong Caskets of the Byzantine Period," *American Journal of Archaeology,* XXIII, 1919, p. 401; Goldschmidt-Weitzmann, I, no. 57

tory of Byzantine caskets, but the use of erotes as actors is unusual. The warriors derive from representations of the story of Joshua, the dancing figures from antique representations of maenads and musicians, and the group on the cover plaque from antique decorative friezes. The drum on the front of the lid, on the other hand, is a medieval instrument. A scene from the Labors of Hercules, his struggle with the Nemean lion, is pictured on the left side of the lid. Similar combinations and permutations of the casket's diverse subject matter are frequent throughout the history of Byzantine ivory-casket production, for example, on a tenth-century casket in the Metropolitan Museum (Goldschmidt-Weitzmann, I, no. 12).

The present casket should be compared to the example from Anagni, 340, whose Rhenish artist took his figures directly from tenth-century Byzantine models, one of which had the same shape as the present casket and was decorated with some of the same figures. The poorly articulated chest and shoulders of the erotes appearing frontally on the present casket, their roughly drawn faces, and their stereotyped draperies reveal an artist dissociated from the tenth-

77. Casket

Byzantium
1150–1200
Ivory
23 x 28.8 x 19 cm. (8 x 11⅜ x 7½ in.)
The Metropolitan Museum of Art, Gift of
 J. Pierpont Morgan, 17.190.239

The panels of the body are decorated with erotes represented as warriors and framed by rosettes in medallions, small rosettes on ribbed strips, and a bead and reed molding. The sloping sides of the pyramidal lid contain a foliate scroll enclosing erotes represented as dancers, musicians, and mythological figures. The top plaque, framed by simple moldings and rinceaux, depicts erotes playing with a female panther and a hound. The casket closely resembles two other twelfth-century examples (Goldschmidt-Weitzmann, I, nos. 47–49, p. 18 f.). The themes of war and mythology stem from the traditional iconographic reper-

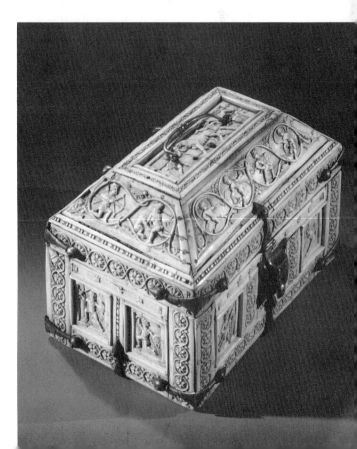

century models of 340. The angular treatment of the astragal and rosette bands is similar to, but less accomplished than, the incisive delineation of foliage in a late twelfth-century ivory plaque (II, ill. 219) and on a casket in Florence (Goldschmidt-Weitzmann, II, 1936, no. 68). The fig-

ures on the present casket, however, are individually active and amusing, and each erote balances the movement of his companion so that every side of the casket becomes an accomplished decorative frieze.

BIBLIOGRAPHY: Goldschmidt-Weitzmann, I, no. 47

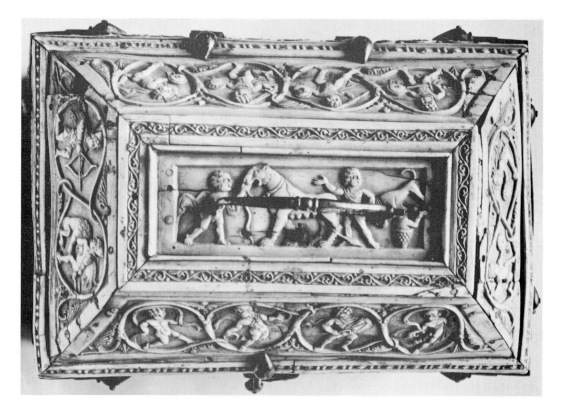

78. Reliquary cross

France
About 1180
Silver gilt, filigree, jewels
43 x 33 cm. (17 x 13 in.)
Rouen, Musée des Antiquités

An overall curled filigree, set with gems and pearls, decorates both sides of the main cross. Two smaller crosses are set into the front and back; on the front, a late Ottonian, mid-eleventh-century cross in the tradition of Lothar's cross (Schramm-Mütherich, 1962, no. 106), on the back, a fifteenth-century addition. Although the floral filigree points to the style of the end of the twelfth century, the cross was traditionally thought to have been a gift of Empress Matilda around 1167 to the Cistercian monastery of Valasse near Rouen, founded by her in 1157. The discrepancy between the style of the filigree and the date of the empress' gift can be explained if one assumes that her gift was the small eleventh-century cross. Noting the lack of preserved goldsmiths' work of this time (for slightly later examples, Paris, 1965, pls. 95, 108, 116–118, 120, 124), Steenbock looked for the source in filigree ornament in lower Saxon manuscript illumination, especially that of the Gmunden Gospels (Corvey, 1966, no. 192). The Gmunden ornament presupposes knowledge of northern French or Mosan goldsmiths' work similar to and contemporary with our cross. Steenbock suggested that the cross was completed for the dedication of the Valasse abbey church in 1181.

BIBLIOGRAPHY: Barcelona, 1961, no. 422; Paris, 1965, no. 213; Steenbock, 1967, pp. 41–51.

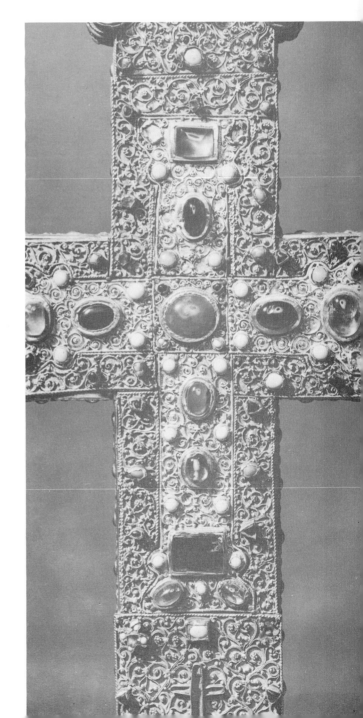

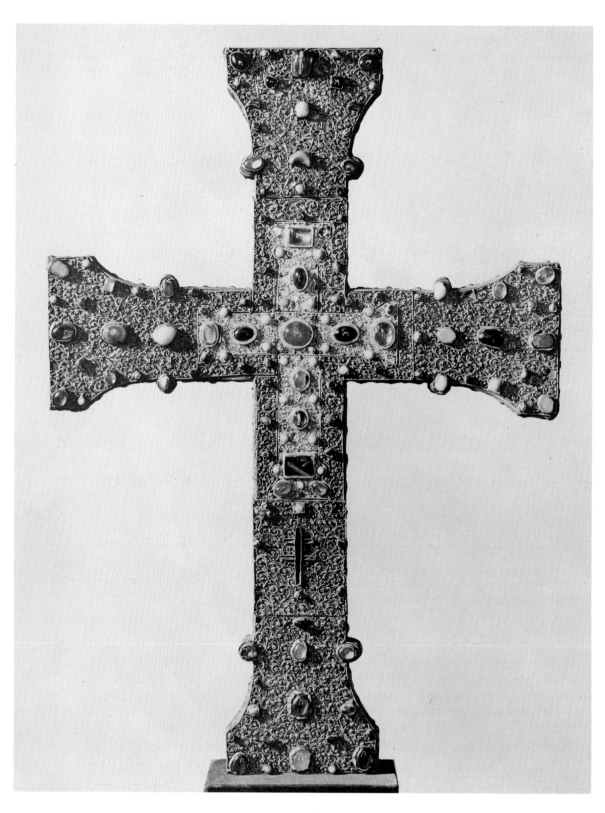

72

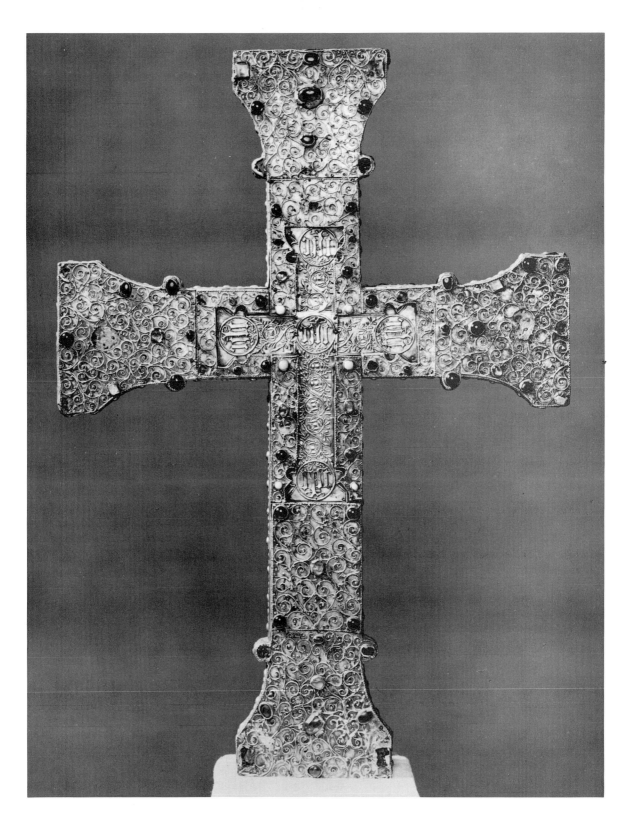

73

79. Chimeras

France, Limoges
Early 13th century
Copper gilt
3 x 9.5 cm. (1⅝ x 3 3/16 in.)
Seattle, Art Museum, Donald E. Frederick
Memorial Collection, 49.Fr. 6.1

Constrained within a narrow border two fantastic animals, their tails ending in stylized leaves, are playfully interlaced. The variation in the position of their wings and the curling of their tails produce a subtle rhythmical pattern. The contrast between the smooth wings and the scaly surface of the bodies shows the artist's keen interest in characterization of material qualities. This plaque probably once decorated a secular casket (comparable to pierced-work circular medallions with similar animals produced in Limoges in the thirteenth century). In the floral treatment of the tails and the dynamic tension of the bodies our piece resembles a medallion in the Cluny Museum, although differing from the marked human physiognomy of the animals' heads on the Cluny piece (Gauthier, 1950, pl. 41). In proportion and ornament, a definitely later stage of stylistic development is represented by medallions in the Kofler-Truniger Collection (Schnitzler-Bloch, pp. 60–61, pl. 40). Northern French and Mosan models are presupposed for the style as well as the motifs of our plaque (compare ornamental plaques and crests in Nicholas of Verdun's and Rhenish goldsmiths' works of the later twelfth and early thirteenth century: Falke-Meyer pl. 72). While the type of fantastic animal is based on literary sources of classical antiquity, the ornamental intertwining testifies to the survival of an early medieval animal tradition that underlies much Romanesque imagery in capitals, initials, and metalwork (Pächt, 1963). But whereas the occurrence of fantastic animals in twelfth-century ecclesiastical art may often be interpreted as moral allegory, an ever increasing tendency toward aesthetic interest and curiosity is evident in the production of objects like our plaque (Schapiro, 1948; Sedlmayr, 1950, pp. 159–161, for thirteenth century demonic imagery from cathedrals).

80. Mourning Virgin

Northern France
About 1200–1210
Bronze gilt
H. 10.2 cm. (4 in.)
Baltimore, The Walters Art Gallery

This statuette was originally part of a Crucifixion group. Raising her left hand to her cheek, the Virgin stands, looking downward, in a contrapposto movement, the right leg forward. Her head is surrounded by a niche-forming veil, her body is covered by drapery that falls in heavy undulating folds that follow the movements of the figure. A companion statuette, of broader proportion and more relaxed posture, is preserved in the Kunstgeschichtliches Seminar of Freiburg University (Meyer, 1957). While the classical appearance of both statuettes is very striking, specific models are not known. In the words of Panofsky: "It is . . . significant, that just those figures which are the nearest to classical antiquity in spirit are often the most difficult to derive from any specific model" (Panofsky, 1960, p. 63). Pointing to a Demeter type (Reinach, *Répertoire de la statuaire grecque et romaine,* Paris, 1897–1910, II, p. 241, no. 6), as well as bronze figurines of Juno (Vienna) and Selene (Berlin) (K. A. Neugebauer, *Antike Bronzestatuetten,* Berlin, 1921, figs. 59–60) as possible sources of inspiration for the mourning Virgin, Panofsky made the reservation "that the diagonal folds of drapery

the bronze statuettes (Swarzenski, 1960, pp. 72–76, figs. 16–17). The figures, therefore, can be looked upon as representatives of the classicistic trend in northern France before its culmination in the Reims Visitation of about 1225 (Panofsky, 1960, fig. 40). At the same time, however, their genesis should be traced to a mid-twelfth-century bronze statuette of the mourning Virgin also from northern France (Cleveland, 1967, III, no. 22). Despite the obvious differences in proportion and posture, a dynamic linear interpretation of a classical prototype is already apparent in the earlier figure, appropriately called a "medieval Korei" by W. D. Wixom (Cleveland, 1967).

BIBLIOGRAPHY: Meyer, 1957, p. 17 f.; Swarzenski, 1960, p. 72 f.

81. Madonna and Child

France, Limoges
About 1220
Copper
H. 22.5 cm. (8¾ in.)
Brussels, Musées Royaux d'Art et d'Histoire, 427

Mary, sitting frontally on a high throne, displays an apple in her elevated right hand. The Child, portrayed in flat relief against her body, raises his right hand in the same gesture as hers. The throne, resting on a four-legged circular base, shows the figures of Mary and the archangel Gabriel on its sides. It is thus a stage for the Annunciation scene, with the two figures widely separated, a treatment also seen in many monumental renderings of the subject on triumphal arches in churches. The group of Mother and Child is characterized not only by the parallelism of gesture, but similarities in the regularly flowing draperies. Despite the archaistic frontality and stiffness, details, such as the undulating fold between Mary's feet and the sleeve falling from her raised arm, suggest the advanced style of the models that the artist imitated and simplified. The sculptural modeling of Mary's upper body, and the wavy outline of her loosely falling hair,

drawn across the chest presuppose a still different model and that the medieval artists, although the impression of their works may be as 'classical' as that of any Renaissance production, were unfamiliar with the sartorial technicalities of Greek and Roman costume" (Panofsky, 1960, p. 64, n. 5). Comparing the similarly fluid and classicized drapery style, as well as the noble pathos of the mourning Virgin in the Anchin Missal of about 1200 (Douai, Municipal Library, Ms. 90; no. 250; Deuchler, 1967, fig. 238), the same date and northern French localization may be given for

line on which the horse stands, the elegantly raised bridle, and the horse's tail form part of a gracious linear pattern that intersects the overall ornamentation of the plaque. The lack of specific attributes and the great variety of horsemen in medieval art make an identification of the plaque's original context and the subject difficult (for some twelfth-century examples, see Swarzenski, 1967, figs. 236, 319, 320). The type of ornament, sculptural treatment of the horse's body, easy posture of the rider, and his pensive

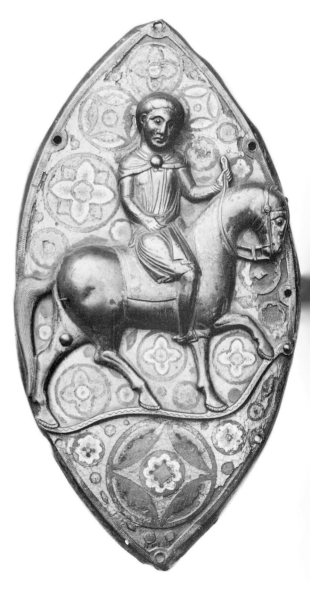

point to a date around 1220, or shortly after. The piece originally served as a reliquary, continuing an early medieval tradition of cult images of Virgin and Child (H. Keller, "Zur Entstehung der sakralen Vollskulptur in der ottonischen Zeit," *Festschrift für Hans Jantzen,* Berlin, 1951, pp. 71–91).

BIBLIOGRAPHY: Brussels, 1964, no. 117

82. Equestrian

France, Limoges
1200–1220
Copper, champlevé enamel
24.8 x 12.8 cm. (9¾ x 5⅛ in.)
New York, The Metropolitan Museum of Art,
 Gift of J. Pierpont Morgan, 17.190.854

On this oval plaque a horse and rider are seen in profile against a background of floral designs enclosed in circles. A delicate rendering of details is apparent in the lines of the horse's tail. The

expression, assign our piece to an advanced position in the Limoges production of the early thirteenth century. Similar representations of riders may be found in different contexts of Limoges work; a roughly contemporary reliquary shrine with the three Magi riding is in Laval (Corrèze), (Paris, 1965, no. 402, pl. 57). A later development is represented by the equestrian St. Evilasius on the late thirteenth-century reliquary of St. Fausta in the Cluny Museum (Gauthier, 1955, pl. 53). At the same time the Limoges atelier produced circular medallions with riding falconers, which differ in their vivid conception from the quiet mood of our plaque (Gauthier, 1950, pl. 24).

BIBLIOGRAPHY: E. Rupin, p. 429

83. Virgin and Child

France, Limoges
1220
Copper gilt, champlevé enamel, pearls
21.5 x 10.5 cm. (8½ x 4⅛ in.)
Cleveland, Museum of Art, 62.29

This relief is distinguished by its classicizing drapery, firm modeling, and early Gothic linearism apparent in the closed outline that avoids overlapping of the Child. The Virgin's drapery is decorated with bands set with enamel pearls; these also appear on her crown. The relief was set originally against a blue enamel background, as were a series of apostle reliefs very similar to our group. The enamel bands appear on the apostle group as well as on the garment of a reliquary statuette of a standing deacon saint, probably Stephen (exhibited in Cleveland, 1967, with St. Paul of the apostle cycle and the present relief). The close resemblances between the heads of this saint and our Virgin may indicate that both works were done by the same artist. The dates assigned to these works vary considerably. The standing saint has been linked with the decora-

tion of the Grandmont altarpiece around 1189, while the apostle series has been thought to be as late as the third quarter of the thirteenth century. The evident similarities of the present Virgin with monumental sculpture in Paris and Chartres Cathedral (Wixom, Cleveland, 1967, who also points to a stained-glass window from Soissons Cathedral) limit the chronological range and allow the above dating. Further similarities can be seen with the appliqué relief of the Virgin and Child from the shrine of St. Viance (Gauthier, 1950, pl. 49). The ornamental features, dated by

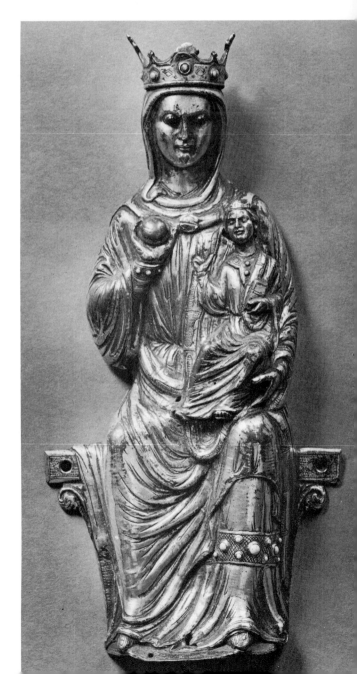

Gauthier to the third quarter of the thirteenth century, appear too late since they represent a later stylistic stage. Further repetitions and variations upon the type of our piece have been grouped together by Gauthier and Wixom. A stylistically and compositionally differing contemporary type of Virgin (Hildburgh, 1955), with the archaic motif of the frontally seated Child, was juxtaposed by Gauthier (1950, pl. 47) to the deacon saint mentioned above.

BIBLIOGRAPHY: Cleveland, 1967, IV, p. 148, 17

84. Sleeping youth

Northern France
1220–1230
Gilt bronze
H. 3.8 cm. (1½ in.)
London, Coll. Peter Wilson

The figure, in a crouching position, cradles its head in its folded arms. The drapery folds of the mantle cut like furrows into the core of the sculpture, and a sequence of narrow curves outlines the regular pattern of the hair strands. Nothing specific is known about the subject or the statuette's original context.

A drawing of a sleeping youth in Villard de Honnecourt's sketchbook (dated around 1240),

often compared to our piece (Swarzenski, fig. 547), differs stylistically and therefore cannot be decisive for its dating. The drawing's strong linear rhythm in the hair strands, the recesses of the folds that are elongated into teardrop shapes, and the ornamental treatment of individual parts of the clothing are all more developed than those of our figure, even allowing for the difficulties of comparing works in different media. Villard mentions an actual model for some of his other sketches, but such a prototype cannot be found for his sleeping youth. Although no direct causative relationship seems to exist, ultimately, between the bronze and the drawing, on the basis of the postures it is possible to identify both figures as parts of Gethsemane groups, where, indeed, one often encounters apostles sleeping in similar attitudes. However, no miniature sculpture of the Mount of Olives dated in the early thirteenth century is known, and no artistic or practical purpose for such an object is imaginable. The same difficulty presents itself for every other possible explanation of the part played by the figure in a narrative scene; for instance, as a disciple from a Transfiguration (Swarzenski, pl. 176, for comparable representations), as Joseph in a Nativity (Bober, 1963, pl. IV), or as one of the guardians in a Resurrection (Bober, p. 38, pl. XVII, c-d).

BIBLIOGRAPHY: Bober, 1963, p. 38; Scheller, 1963, p. 93, n. 14; no. 29; Swarzenski, 1967, no. 548

85. Reliquary of St. Thomas Becket

England
1175–1180
Silver gilt, niello, ruby
5.7 x 7 x 4.4 cm. (2¼ x 2¾ x 1¾ in.)
New York, The Metropolitan Museum of Art,
17.190.520

The oblong front and back plaques show the murder and burial of the saint, the front and back roof plaques contain half-figures of angels. The angel above the martyrdom scene holds a child symbolizing Becket's soul. The end plaques are filled with floral ornament as are the roof plaques

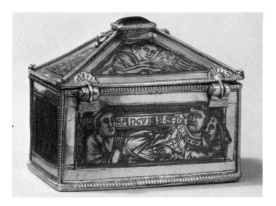

directly above them. The inscription reads IUTUS SANGUIS EST SANCTE TOME SANCTUS TOMAS ACCIDITUR. The reliquary's magnificent craftsmanship is evident in the beaded bands, hinges, and the floral decoration of the two lid plaques. The figural plaques show a delicate design, precise physiognomy, and modeling of bodies by means of sharply drawn drapery folds. Breck's identification of the piece as the Thomas reliquary presented in 1176 to Chartres by John of Salisbury is partly based on a wrong reading of the inscription and remains hypothetical. One of the earliest Thomas Becket reliquaries, this object is attributed to an English workshop, active in the 1170s, on stylistic grounds evident in its resemblances to contemporary English works like the Kennet and Malmesbury ciboria, the Bargello crosier, and the Victoria and Albert Museum casket (Swarzenski, 1967, pls. 196–197). The enthroned kings of the Hildesheim Oswald reliquary (Swarzenski, 1967, fig. 484) are contemporary niello pieces reflecting strong English influences. A stylistically related small gold pendant with Becket relics, datable to 1174–1183, has recently been acquired by the Metropolitan Museum (T. Hoving, "A Newly Discovered Reliquary of St. Thomas Beckett," *Gesta, International Center of Romanesque Art*, 4, 1965, p. 28 f.).

BIBLIOGRAPHY: J. B. Breck, "A Reliquary of Saint Thomas Beckett made for John of Salisbury," *Metropolitan Museum of Art Bulletin*, XIII, 1918, p. 220 f.; Rosenberg, 1925, p. 11 f.; Borenius, 1932, p. 78 f.; Swarzenski, 1943, p. 50 f., fig. 71; Swarzenski, 1967, fig. 490

86. Mirror case

English
1180–1190
Bronze gilt
D. 11.1 cm. (4⅜ in.)
New York, The Metropolitan Museum of Art,
 The Cloisters Collection, 47.101.47

The disc is decorated in low relief with a subtle rhythmical pattern of four lizard-like dragons and vines; in the center is a rosette. On the edge, part of a hinge is preserved between two acanthus scrolls that hold ring attachments. On the back, the mirror of polished silver is set within a scalloped border. The floral details, the expressive elongation of the crawling beasts, and the continuously undulating movement of the surface are reminiscent of miniature painting and enamels of northern France and England in the late twelfth century. Comparing the case with a Cloisters bowl (no. 169) and a bowl in Stockholm (Swarzenski, fig. 458), Hanns Swarzenski suggests an English origin for the case, although a date shortly after his proposal of 1175 seems preferable. It is difficult to determine the decoration's possible iconographic meaning. The importance and function of mirrors in medieval art and literature are discussed in G. F. Hartlaub's *Zauber des Spiegels*, Munich, 1951.

BIBLIOGRAPHY: Boston, 1940, no. 272; Rorimer, 1948, p. 239; Swarzenski, 1967, fig. 460

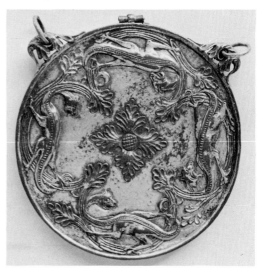

87. Head of a crosier

England (?)
Late 12th century
Bronze gilt
H. 12.4 cm. (4⅞ in.)
Boston, Museum of Fine Arts, Grace M. Edwards
 Fund, 47.1437

The graceful volute, ending in a vigorously mod-eled serpent's head with open mouth and deeply incised eyes, is ornamented at the base with an engraved band of a schematized floral motif. France, as well as England, has been suggested as the place of origin. Although reminiscent of early Limoges crosiers in its multiple spirals, a similar volute in Florence, attributed to England, is perhaps of thirteenth-century origin (Chamot, 1930, no. 15, p. 31). A crosier in the Kofler-Truniger Collection, with only one spiral and an octagonal shaft, has been tentatively attributed to France and dated to the beginning of the thir-teenth century (Schnitzler-Bloch, p. 47, E 145, pl. 83, with further references to pertinent ma-terial).

BIBLIOGRAPHY: Boston, *Museum of Fine Arts Bulle-tin,* 55, 1957, p. 83, fig. 34; Paris, 1962, no. 162

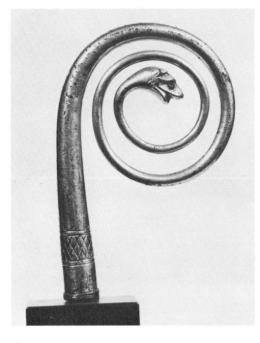

88. St. Thomas Becket châsse

England
Around 1200
Copper, gilt
17.8 x 25.4 x 11.4 cm. (7 x 10 x 4½ in.)
Lent Anonymously

Resting on lion's feet this rectangular reliquary has a sloping roof surmounted by a crest. The front roof plaque contains three medallions with engraved half-length figures of Christ, Peter, and Paul, the lower front presents four medallions with half-length figures of bishop saints (Alfege, Anselm, Dunstan, Thomas) and, on each end, a medallion with a king represented (St. Edmund and St. Edward). A schematic floral decoration, consisting of circular petals and symmetrically disposed curling branches, covers the punched ground surrounding the medallions. The Eng-lish origin of the châsse is evident from the choice of bishops represented, the place of honor being taken by St. Thomas and St. Dunstan. While St. Thomas shares the attributive mar-tyr's palm with the adjacent St. Alfege (?), only his crosier terminates in a cross, the others end in volutes. In the combination of a bish-op's cycle with representations of the apostles, Peter and Paul, flanking Christ, a reference is to be noted to the idea of the bishop's "apostolic succession." The medallions, with their sharp, nervous strokes contrast with the soft ornamental pattern of the surrounding decoration. Stylisti-cally the clear separation between figural medal-lions and ornamental background is a striking deviation from late twelfth-century English prac-tice of intertwining both elements in a decorative unit (Swarzenski, 1932, p. 334 f.). A similar combination appears in the niello stamps of the St. Lawrence reliquary arm of the Welfenschatz, the English derivations of which were convinc-ingly demonstrated by Swarzenski (1932, p. 380 f.). A comparison of the heads and gesticulating arms of Christ and Paul on our reliquary with the apostle (Swarzenski, 1932, p. 381, fig. 326 b) il-lustrates this connection. The comparable floral ornament on a book clasp of the late twelfth cen-tury tentatively localized to Durham (Swarzen-

ski, 1967, fig. 487) suggests that our reliquary may be similarly dated. From the casket's emphasis on episcopal and royal tradition, as well as the special role of St. Thomas, an origin in Canterbury may be deduced. The foliate decoration is similar to that of the Canterbury manuscript, no. 257. (For other representations of St. Thomas: nos. 85, 164; T. Borenius, 1932; Hoving, 1965).

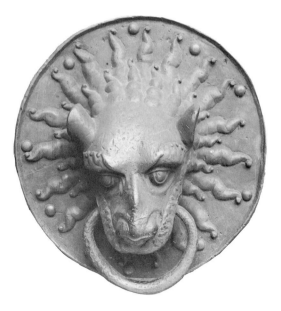

89. Door knocker

England
1210–1220
Bronze
D. 37.2 cm. (14⅝ in.)
London, Trustees of the British Museum

This lion-head plaque, with its concentrated expression and imaginatively treated hair (resembling later schematic representations of the sun), displays sculptural virtuosity. Its English origin is probable in view of its provenance from Brazen Head Farm, Essex. Door knockers were common in church decoration from the eleventh century on. Their meaning and function, as well as the significance of the lion's head, are discussed in Hahnloser. Lion-head door knockers not only resemble other ecclesiastical objects, particularly aquamanilia, in their apotropaic and judicial functions, they also correspond to lion monuments, erected as symbols of authority and protection in contemporary civic communities (Deér, 1959, p. 66 f.).

A group of late twelfth- and early thirteenth-century door knockers has been studied by Zarnecki, and our piece may be compared to the last of his series, a knocker of about 1210 in the church of Luborzyca, Poland. In their remarkable sculptural volume both pieces deviate from earlier Romanesque ones, on which the heads are flatter. The treatment of the hair on our piece may be understood as succeeding the engraved floral designs on earlier knockers (seen also on the Polish example). The animated rendering of the lion's head on our piece closely parallels the changing conception of human figures in the sculpture of this transitional period.

BIBLIOGRAPHY: H. R. Hahnloser, "Urkunden zur Bedeutung des Türrings," *Festschrift E. Meyer,* 1957, p. 135 f.; E. Meyer, "Romanische Bronzen der Magdeburger Giesshütte," *Festschrift F. Winkler,* 1959, pp. 22–28; G. Zarnecki, "A Group of English Medieval Door-knockers," *Miscellanea Pro Arte: Festschrift H. Schnitzler,* Düsseldorf, 1965, pp. 111–118

90. Chalice: "Coupe de Charlemagne"

England
1210–1220
Silver gilt
25 x 17.6, D. foot, 11 cm. (9¾ x 6¾, 4¼ in.)
St. Maurice, Abbaye

This magnificent chalice derives its name from a late medieval tradition that it was a gift of Charlemagne. The foot repeats an identical seated figure in each of its three medallions. The bowl and lid each show five christological scenes in medallions; half-figures of angels appear in the

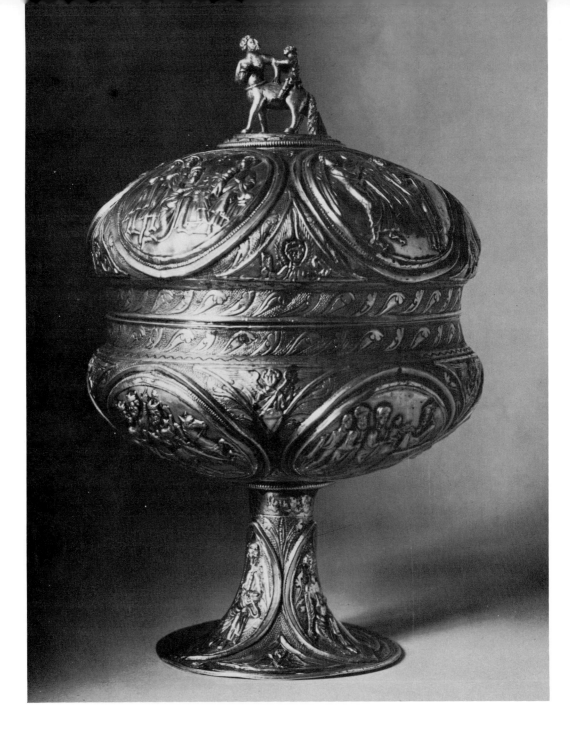

punched ground of the spandrels. The edges of the bowl and lid are decorated with diagonally placed floral branches. The scenes on the bowl are: the Journey of the Magi, the Magi before Herod, the Slaying of the Innocents, the Presentation, and the Baptism. The scenes on the lid are:

the Annunciation, the Visitation, the Annunciation to the Shepherds, the Nativity, and the Adoration of the Magi. In an integration of classical mythology with liturgical symbolism the figures of Chiron and Achilles surmount the lid (these were originally placed inside the bowl). (For the

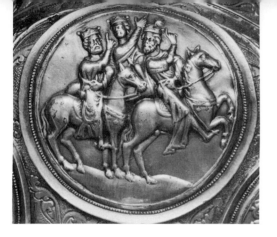

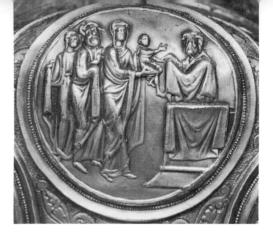

meaning of the Chiron group, Adhemar, 1939; Buchthal, 1952, p. 75). The stylistic similarity between the figures in the medallions and figures on a group of early thirteenth-century English psalters (nos. 260, 261) led Homburger to claim an English origin for the chalice. (The figure of the enthroned Herod addressing the Magi is similar to the seated kings that appear on two buckles in this exhibition, nos. 102, 103). Our chalice is unlike other late twelfth-century chalices in its lack of typological imagery and enameling. In shape and design it resembles the Limoges ciborium of Master G. Alpais (Gauthier, 1950, frontispiece) and the Sainte coupe in Sens (Paris, 1965, no. 817), both of which were made a few years earlier, around the turn of the twelfth century.

BIBLIOGRAPHY: J. Berthier, *La coupe dite de Char-lemagne du Trésor de Saint-Maurice,* Fribourg, 1896; O. Homburger, "Früh- und hochmittelalterliche Stücke im Schatz des Augustinerchorherrenstifts von St. Maurice und in der Kathedrale zu Sitten," *Früh-mittelalterliche Kunst in den Alpenländern;* Olten-Lausanne, 1954, p. 352 f.; Barcelona, 1961, no. 564; Zarnecki, 1963, 157; Aachen, 1965, no. 682

91. Crosier

England
1220–1230
Bronze, jewels
Rochester, Cathedral

Mary and the angel of the Annunciation stand within the volute, which is covered with engraved floral and geometric patterns and set with

small cabochons. The outer edge of the crosier is decorated with short branches. Classified among the numerous late thirteenth-century pieces in Marquet de Vasselot's corpus of Limoges crosiers, the stylistic peculiarities of the Annunciation group hardly fit any parallel in contemporary Limoges production. This example, lacking the enamel and complex volutes of the Limoges examples (nos. 157, 158), is comparable in shape to an English ivory crosier (no. 59). A large number of Limoges enamels were imported into England in the thirteenth century (Chamot, 1930, pl. 6) and undoubtedly this crosier was produced there in imitation of a Limoges prototype. The influence of French-inspired monumental sculpture of 1220–1230 is apparent in the modeling of Mary's body.

BIBLIOGRAPHY: de Vasselot, 1941, p. 251, no. 94

92. Corpus from a crucifixion

Ireland (?)
1180–1200
Bronze
Dublin, Coll. Mr. and Mrs. John Hunt

Although Irish works of the late twelfth century are rare, making comparisons difficult, this is evidently a strongly conservative piece. An impressive and unusual stylization is seen in the parallel lines of the chest and the regular course of the drapery. The flat modeling of the upper body contrasts with the intense modeling of the legs and loincloth, while the manner of draping part of the cloth between the legs is apparently unique. Known in much earlier works are the protruding eyeballs and nose and the prominent crown. For all its retrospective features, the dating of the piece derives from the contrapposto disposition of the legs.

93. Statuette: the Sea

Mosan
About 1180–1190
Bronze
9 x 5.6 x 3.5 cm. (3½ x 2½ x 1¾ in.)
London, Victoria and Albert Museum, 630-1864

Mounted on a circular base on which the word MARE is engraved, a bearded, elderly man leans on a capital-like support. Looking at his raised right hand, he turns his head to the right in an abrupt movement. The position of his left hand corresponds to that of his right. His left leg, crossed over his right knee, and the mantle stretched over his right arm, form a zigzag movement across the body, intersecting the diagonal line running from the right hand down the right leg. The agitated posture of the figure is emphasized by the pointed beard and nervous facial expression. Angular sharpness and precision characterize the drapery folds, which flow in broad sculptural strands. The figure is to be seen

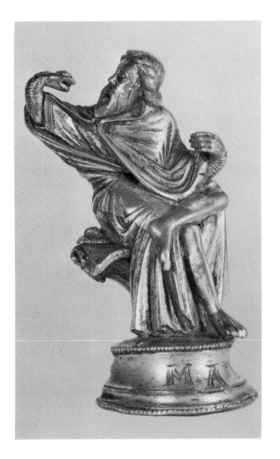

tations of river gods leaning on an urn with water streaming from it (for a Carolingian representation of a Sea of this type, Swarzenski, 1967, fig. 8). The motif of the crossed leg may be followed in representations of both Sea and Rivers of Paradise (Swarzenski, 1967, pl. 69, fig. 161, illustrating both). The complicated movements inherent in the figure type (for earlier Mosan examples, Swarzenski, 1967, figs. 222, 423) meet the stylistic tendency of Mosan art of about 1160–1180, when the range of such postures was fully exploited in different iconographical contexts (for example, the apostles at the lower left in an ivory Transfiguration plaque, Swarzenski, 1967, fig. 390). A different spirit that strives toward a monumental conception of the figure is revealed only in works dating from the turn of the century, such as the Oxford bronze statuette of Moses (no. 98; Swarzenski, 1967, figs. 537, 538).

BIBLIOGRAPHY: Mitchell, 1918, p. 59 f.; Swarzenski, 1967, figs. 394, 395

as part of a four-element cycle that was probably attached to the foot of a cross or the base of a candelabrum. Compare, for location and posture, the cross-legged, upward-looking figure of St. John the Evangelist that appears at the base of the cross of St. Bertin (Swarzenski, 1967, fig. 396). Remnants of a similar cycle of four elements are preserved in statues personifying Earth and Fire in the Bayerisches Nationalmuseum, Munich (no. 94; Swarzenski, 1967, figs. 391–393). Their different size precludes an immediate correlation of the London and Munich statuettes.

Iconographically, the personification of the Sea began to occur in Carolingian times in combination with the figure of Earth in different contexts of northwestern French and Mosan art (for a general survey, see the richly documented entry "Erde" in RDK, V, 1967, cols. 9997 f.). In spite

94. Earth, Water, Air, Fire

Mosan
About 1180
Copper gilt
10.3 x 6.5 x 5.7 (4⅛ x 2½ x 2¼ in.)
Munich, Bayerisches Nationalmuseum

Earth presses her breast to feed a serpent; Water holds two jugs (for Temperance in the same pose, Swarzenski, 1967, fig. 420). The attributes of Air and Fire are missing. The mantles, diagonally stretched in front of the figures, form an elliptical curve in both Earth and Air. In Air the diagonal accent is repeated in the crossed legs, seen also in no. 93. The serpent curled around the arms of Earth reveals a similar interest in movement and

85

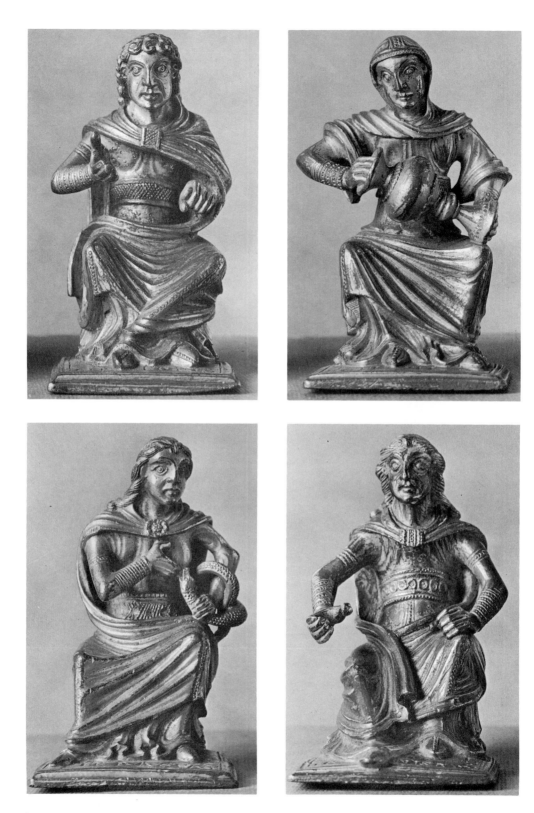

86

spatial devices. The curls on the forehead, the beaded bands in the fibulas, bracelets, and girdles, all testify to the artist's interest in variations of the surface. The concept of active, frontally seated figures, and sharply drawn stretched drapery connect our statuettes with the evangelists at the foot of the St. Bertin cross (Swarzenski, 1967, figs. 396–398), which were perhaps derived from Abbot Suger's great cross in St. Denis where similar representations of the elements appear.

The original context of the exhibited cycle is not known, although liturgical objects of Mosan artistry from the middle of the twelfth century include such personification as those seen in the Hildesheim chandelier (Falke-Meyer, pl. 21). The style of our statuettes, slightly more advanced than that of the figures of the St. Bertin cross and the Bargello evangelists (Swarzenski, 1967), figs. 385–386), suggests the dating given above. The culmination of this stylistic tendency is represented in the Oxford prophet statues of the circle of Nicholas of Verdun (no. 98).

BIBLIOGRAPHY: H. R. Weihrauch, *Die Bildwerke in Bronze,* Munich, 1956, p. 6, nos. 7–10; Swarzenski, 1967, figs. 391–393

95. Candlestick

Mosan
Late 12th century
Bronze, copper gilt
20.3 x 13.2 cm. (8 x 5⅜ in.)
Belgium, Coll. Jean Pincket

The upturned heads of three small dragons serve as feet. The base is formed by three larger dragons, separated by floral medallions framed by broad bands, which issue on each side from a dragon's mouth. The knob is decorated by medallions with foliate scrolls. Two serpents climb the ribbed shaft, which rises from a low row of plants, and turn their heads down beneath the wax pan. Two types of support from earlier Mosan candlesticks are present on this example: the half-length dragon as caryatid, seen here as

the feet (Hildesheim candlestick, Falke-Meyer, pl. 21, fig. 48), and the dragons in downward movement on the base (monumental example in Reims, Falke-Meyer, fig. 60, smaller examples, *ibid.,* figs. 62–70). A very similar candlestick, differing in the floral decoration of the base, was once in the convent of the Soeurs Noires in Namur (Falke-Meyer, fig. 71). While the Mosan origin given results from a great number of correlated pieces as well as references in written sources, evidence for a precise localization has been advanced so far. A very few fixed dates being known, one only can establish a relative chronology among the great number of Mosan bronze works of the later twelfth century. Taking into consideration the different types that were in existence side by side at a given time in a workshop, dating efforts are furthermore impeded by possible repetitions and survivals.

BIBLIOGRAPHY: Falke-Meyer, no. 73; fig. 72

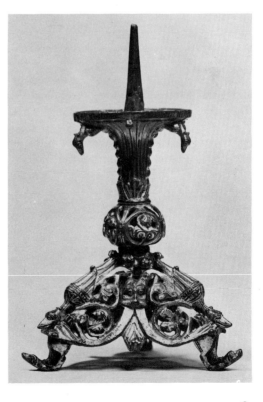

96. Lion aquamanile

Mosan
Late 12th century
Bronze
H. 23 cm. (9 1/16 in.)
Mariemont, Musée de Mariemont

The lion is characterized by a blocklike solidity and a tension noticeable in the straightened back legs and concentrated movement of the neck and head. The vivid rhythm of the mane is achieved by a dense system of lines ending in droplike curls. The lion grasps a half-figure of a man in his teeth. The vessel originally had a curved handle in the shape of a dragon, and precious stones once were set in the mane. Given a Mosan origin by Falke-Meyer, this late Romanesque lion was grouped by them with lion aquamanilia in Maastricht, Nürnberg, and Vienna (Falke-Meyer, figs. 323, 324, 326). The Vienna lion, dated to the beginning of the thirteenth century by Falke-Meyer, has a smoother surface and lacks the tension evident in the posture of the exhibited piece. A closer parallel is found in an earlier lion monument in Braunschweig (for a discussion of its relation to lion aquamanilia, Swarzenski, 1932, p. 316, 135). The date proposed for the Maastricht lion, about 1150 (Swarzenski, 1967, fig. 470), would seem to be too early. The motif of the human figure in the lion's mouth (reappearing in some later aquamanilia, Falke-Meyer, figs. 343, 355, 364; E. Meyer, "Romanische Bronzen der Magdeburger Giesshütte," *Festschrift F. Winkler,* 1959, pp. 21–28; Zarnecki, 1965, pl. LXXIV, LXXV) forms part of the widespread imagery of allegorical moral struggles in medieval art. Pointing to contemporary representations in a Regensburg manuscript (Boeckler, 1924, pl. LXXIII, fig. 87) referring to man's fate after death, Stammler (1962, pp. 86–93) supported Goldschmidt's (1895) allegorical interpretation of such scenes.

In the Mariemont lion the delicate modeling of the mane's curled strands may be seen as a precursor of the Mosan development that was to culminate in such lion aquamanilia as nos. 1 and 120 and the Samson candlestick, no. 119.

BIBLIOGRAPHY: Falke-Meyer, no. 349, fig. 325; Barcelona, 1961, no. 1122; Mariemont, 1963, no. 45

97. Reliquary of the True Cross

Mosan
Early 13th century
Wood, copper gilt, engraved enamels, jewels
H. 57.5, L. 30.5 cm. (22 11/16, 12 in.)
Brussels, Musées Royaux d'Art et d'Histoire,
1035

On the central, deeply recessed plaque, a double-branched cross rests on a stylized hill surrounded by tendrils. The frame is decorated with floral shoots and jewels and, at each corner, plaques with the animalia. In the tympanum a half-length figure of Christ with raised arms appears between symbols of the sun and moon, customary in representations of the Crucifixion. The reliquary is crowned by a trefoil arch with a rock-crystal knob at the center. An inventory of the relics preserved inside is inscribed on the back of the reliquary. Christ's drapery is similar to that seen on the enthroned Christ on the gabled front of St. Mary's Shrine, Aachen (Schnitzler, 1959, pl. 51), and on the standing figures of saints from the Mettlach cross triptych (II, ills. 136, 137; Schnitzler, 1959, pl. 16).

Christ's bust appearing above a cross occurs in earlier Mosan cross reliquaries (Swarzenski, 1967, figs. 375, 376, 425). As in the Tongres reliquary (no. 178) the accompanying symbols of the Evangelists elucidate the iconographical meaning and source of the composition. The bust of Christ above the cross is to be understood as illustrating the Second Advent, where, according to the vision in Matthew 24:30, the sign of the Son of man, traditionally identified with the cross, precedes Christ the Judge. Accordingly, the type of Christ figure is an adaptation from elaborate judgment scenes like those on the cross reliquary in the Alastair Bradley Martin Collection, New York (Swarzenski, 1967, fig. 376), with the Weighing of Souls and Resurrection of the Dead. With its abbreviated version of the judgment iconography, the exhibited reliquary combines the Early Christian scheme of the cross on the mountain, the accompanying floral motifs evoking the idea of paradise.

The trefoil arch as a framing device was common in Mosan works, as seen in panels of the

Klosterneuburg altarpiece (no. 179) and arcades of the Cologne shrine of the Three Kings (II, ill. 111). But, unlike the Cologne shrine, our piece assigns no architectonic function to the trefoil arch. A rectangular plaque, combined only superficially with an arch, stems from the early medieval tradition of book covers (Steenbock, 1965).

BIBLIOGRAPHY: Falke-Frauberger, no. 87; Collon-Gevaert, 1961, pl. 50; Barcelona, 1961, no. 1124; Brussels, 1964, no. 102

98. Moses and a prophet

Mosan, workshop of Nicholas of Verdun
1200
Bronze
Prophet, 23.4 x 21.9 cm. (9¼ x 8¾ in.)
Oxford, Ashmolean Museum

These old Testament figures display an extraordinary dynamism in posture, drapery treatment, and expression. Especially noticeable are the sharp spine of the legs and the pathetic gestures of Moses, whose right arm is integrated into the movement of drapery folds that run across the body in broad curves. In the prophet statue a circular movement results from the closed curve of the right side and the diagonal swing of drapery. Although nothing is known about the original destination of our figures, close resemblances to the art of Nicholas of Verdun are evident, especially to his prophet statuettes of the Cologne Shrine of the Three Kings (II, ill. 111). The connections with earlier Mosan bronzes are apparent in comparisons of the Moses with the Earth of the Munich Elements cycle (no. 94), or the St. John from the St. Bertin Cross (Swarzenski, 1967, fig. 396), whereas the prophet recalls no. 93. While the vivid dynamism appears earlier among small Mosan and Rhenish engravings (the Heribert shrine, Swarzenski, 1967, fig. 411), comparable renderings in bronze occur only around 1190 (the Cologne shrine: II, ill. 111) and 1200 (Milan candlestick: II, ill. 154). Swarzenski places the prophet statue with northern French miniature

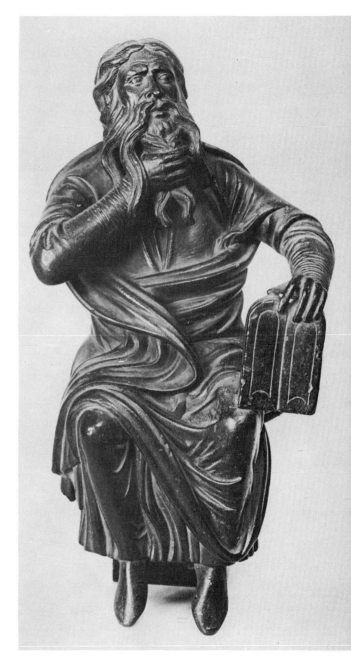

paintings of the very beginning of the thirteenth century, the Ingeborg Psalter (Deuchler, 1967) and the Anchin Missal (no. 250). For the iconographical meaning of Moses holding his beard, see H. W. Janson, *Festschrift U. Middeldorf*, Ber-

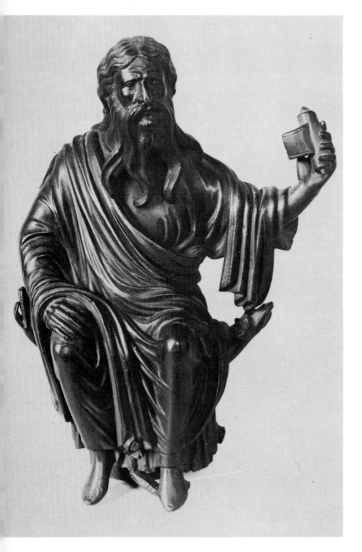

the early thirteenth century (Berlin, 1966, no. 185–186), is doubtful.

BIBLIOGRAPHY: Swarzenski, 1967, figs. 537–539

99. Crucifix

Mosan or German
Late 12th century
Bronze gilt
Dublin, Coll. Mr. and Mrs. John Hunt

With the head slightly lowered, the body in an upright position, harmonizing with the horizontal arms, the soft, continuous modeling of the body is combined with a few sharply drawn lines such as those marking the chest. Adopting a drapery scheme often used in twelfth-century crucifixes, the artist emphasized the folds radiating from the knot at the upper left. A similar tendency toward a straight outline of the body is seen in many Mosan crucifixes of the third quarter of the twelfth century (Usener, 1934; Cologne, 1968, no. 45; Manchester, 1959, no. 97). Compared with these examples the present crucifix displays a modification of this severe scheme, and this, with the emphasis on sculptural articulation and linear beauty of the loincloth, points to a later origin. The drapery technique of the loincloth seems to foreshadow that of an early thirteenth-century aquamanile (no. 124), also stemming from Mosan tradition. Iconographically, Christ's crown, his open eyes (A. Grillmeier, *Der Logos am Kreuz,* Munich, 1956), and the separate nailing of the feet are traditional motifs indicative of the concept of Christ's victory over death; this gave way during the course of early medieval art to the conception of the dead or suffering Christ (R. Haussherr, *Der tote Christus am Kreuz,* (dissertation), Bonn, 1963).

BIBLIOGRAPHY: J. Hefner-Alteneck, *Kunstkammer in Hohenzollern Sigaringen,* Munich, 1866, pls. 27A-C; Meyer, 1957

lin, 1967 (see also the figure of Eli in Chartres: Sauerländer, 1966, fig. 137; and Cambridge, St. John's College, Ms. 8, f. 91: Dodwell, 1954, pl. 37a). The authenticity of two similar bronze statuettes of an apostle and a prophet, thought to be products of a northeastern French atelier of

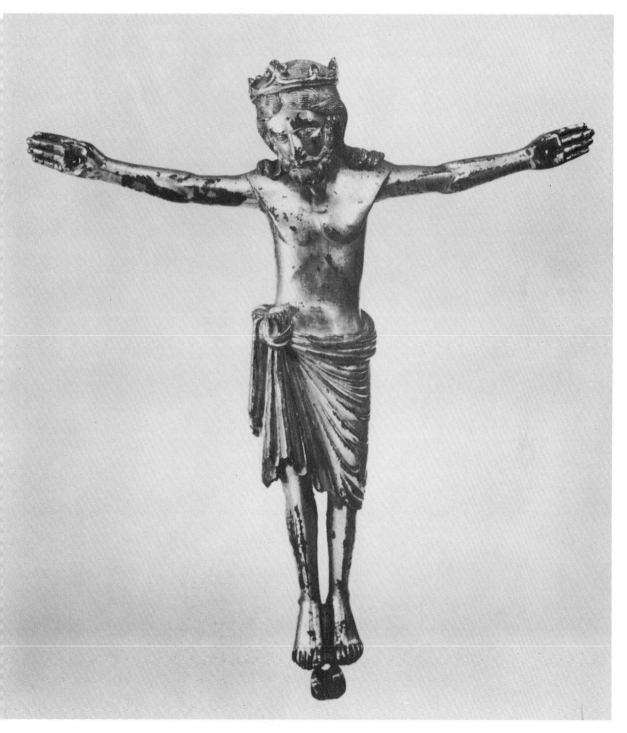

100. Shrine of the Virgin

Mosan, Nicholas of Verdun
1205
Wood core, silver gilt, copper gilt, enamel
 filigree
90 x 126 x 70 cm. (35½ x 49⅝ x 27½ in.)
Tournai, Cathedral

The shrine, in the shape of a sarcophagus, has a hip roof with two trapezoidal and two triangular sloped gables. At each end a profiled socle with semicircular projections serves as a base for colon-nettes that support three trefoil arches at each side and one arch at each end. At the ends, set against variously enameled walls, these arcades frame the Adoration of the Magi and Christ between two angels with instruments of his Passion. Perhaps the Adoration was originally intended as the main façade (for the analogous problem of the original placement of the St. Elisabeth's shrine: Dinkler-Schubert, 1964). Six childhood scenes appear on the two sides: the Annunciation, Visitation, Nativity, Flight into Egypt, Presentation at the Temple, Baptism. The spandrels of the

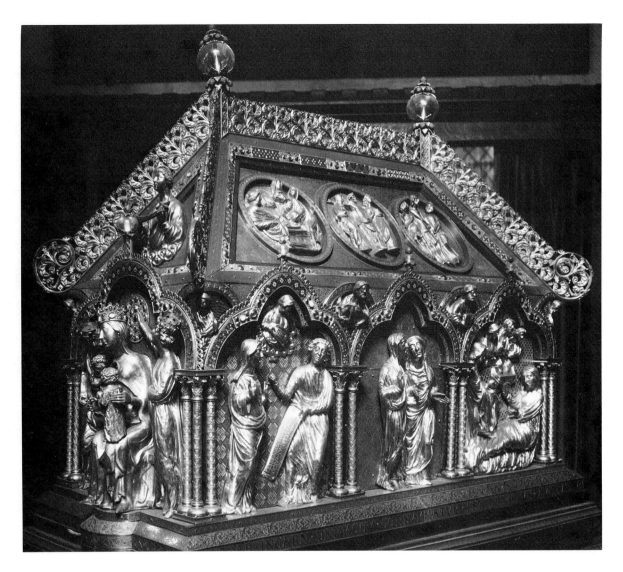

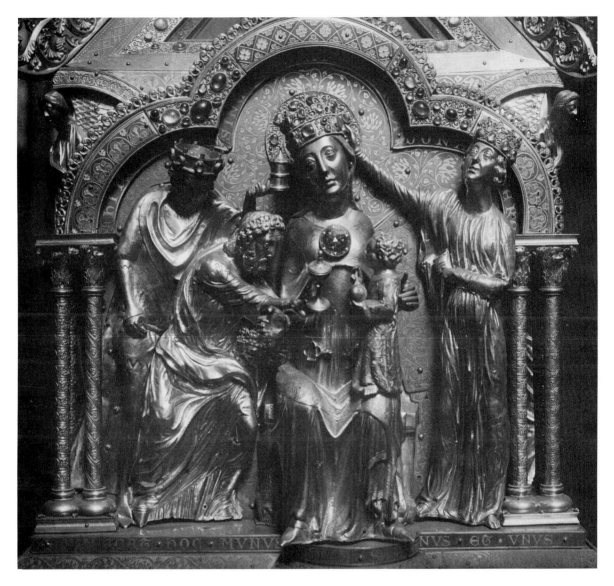

arcades contain half-figures of prophets and, at the corners, angels. Six relief medallions with scenes from the Passion and Resurrection fill the side roofs: the Crucifixion, Flagellation, Holy Women at the Sepulcher, Noli me Tangere, Christ in Limbo, Doubting Thomas. The ground is decorated with a rich variety of vine scrolls. At the lower corners of the roof are symbols of the evangelists, the triangular gables of the ends show half-figures of angels.

Some fourteenth-century additions and, probably, reworking are discernible, especially in the Adoration group and the Flagellation relief. A restoration in 1890, following heavy damages, was concerned with preserving the shrine's original appearance, the work involving the arcades (enamel and filigree plaques, cabochons), crests (copied from the Shrine of the Virgin in Aachen), knobs, and inscriptions. In the single scenes, the hands of the enthroned Christ figure as well as

93

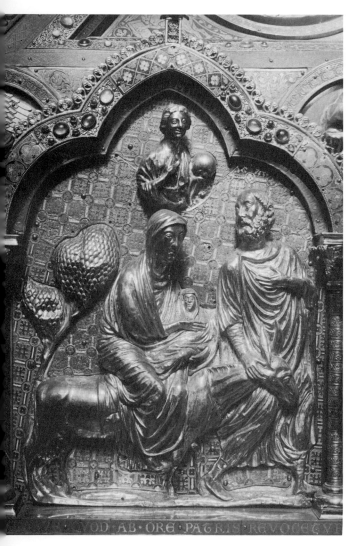

Joseph's and Mary's arms in the Nativity are modern, as is the half-figure of the angel above the Annunciation. The best-preserved scene, almost intact, is the Presentation at the Temple. Relatively well preserved are the Flight into Egypt and the Baptism. Of the relief medallions on the roof, the Crucifixion has been partly restored while the Thomas scene and the Descent into Limbo are entirely modern. (A detailed report on this restoration was made by L. Clagett (1961), the art historian supervising the work of the goldsmith F.

Mondo.) The inscription running around the base, first recorded in the seventeenth century, names not only the artist and the date of origin, but also the amount of gold and silver needed for the shrine: HOC OPUS FECIT MAGISTER NICOLAUS DE VERDUN. CONTINENS ARGENTI MARCAS CIX AURI MARCAS VI ANNO AB INCARNATIONE DOMINI MCCV CONSUMMATUM EST OPUS AURIFEBRUM. Despite its modern reworking, the shrine remains an impressive document of the last phase in Nicholas of Verdun's stylistic development. Compared to his earlier Cologne Shrine of the Three Kings (II, ill. 111), the trend toward "Gothic" peculiarities is easily recognized in the elongation of figures and in the rhythmic compositions. The use of the trefoil arch as a framing device links the Tournai shrine with the Cologne shrine and with Nicholas' other earlier masterpiece, the Klosterneuburg altarpiece (no. 179; II, ills. 100–104). However, there is evident a steady increase of spatial suggestion, culminating in the stage-like placement of the Tournai figure groups. In certain scenes that occur in all three works, particularly the Cologne and the present shrine, one can closely follow the transformation of Nicholas' art. Christ between angels bearing his "arma" (R. Berliner, "Arma Christi," *Münchener Jahrbuch,* 1955, p. 55 f.) is to be found in one of the Klosterneuburg plaques and on the Cologne shrine; and the Adoration of the Magi, distributed on the two façades here is superimposed (together with the Baptism) on the front of the Cologne shrine (for a juxtaposition of the Tournai Flight into Egypt with the Klosterneuburg Moses' Return from Egypt: Swarzenski, 1967, pl. 220). The motif of the Child standing on the Virgin's knee in the Adoration, mostly ascribed to the fourteenth-century reworking since it was popular only during this period in Madonna statues, can be taken as Nicholas' original intention in view of some late twelfth-century instances of this type, for example, the tomb of St. Junien.

BIBLIOGRAPHY: Cologne, 1964, no. 12; Paris, 1968, no. 372; Demus, 1965

101. Reliquary (ostensory)

Mosan, Arras
1210–1230
Crystal, enamel
H. 37 cm. (14½ in.)
New York, The Pierpont Morgan Library

Mounted on a vaulted circular foot, this reliquary, designed for the showing of relics and thus classifiable as an ostensory, consists of a base, crystal cylinder, top, and knob. The use of rock-crystal is evidence of the widespread twelfth-

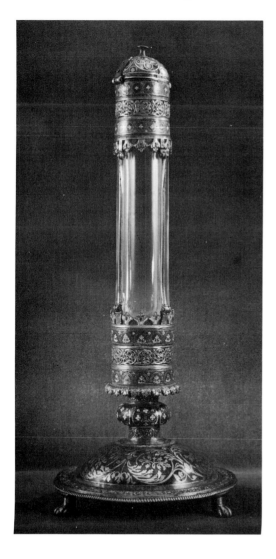

century tendency to make relics as well as the eucharist visible (Sedlmayr, 1950, p. 311 f.; Meyer, 1950). This ostensory is the oldest preserved example of its kind; the next oldest comparable ostensory is in Walcourt, a work of the circle of Hugo of Oignies (Braun, fig. 162). The broad, curling floral ornament on the foot of the exhibited piece, with its heavy, flabby leaves (compare no. 117), as well as details of its enamel, indicate a connection with a Mosan workshop between the time of Nicholas of Verdun and Hugo of Oignies. Apparently indebted both for its general shape and use of crystal to Eastern prototypes (Grabar, 1951), this object reflects in proportion, size, and mixture of techniques, the specific taste of the early thirteenth century, as opposed to the appearance of unanimously "High Gothic" features in later ostensories (Braun, 1940, fig. 11).

BIBLIOGRAPHY: Falke-Frauberger, p. 89; Mitchell, 1921, p. 166; Braun, 1940, p. 302 f., fig. 291

102. Clasp

Mosan, workshop of Nicholas of Verdun
Around 1210
Gilt bronze
5 x 7.5 cm. (2 x 3 in.)
New York, The Metropolitan Museum of Art,
The Cloisters Collection, 47.101.48

On the right half, a crowned male figure sits on a bench, right hand on knee, left raised and holding an orb. His feet rest on a lion. A male attendant, on one knee, places a hand on the king's shoulder. On the left half is a seated woman, her hair covered by a veil. She, too, has an attendant half-kneeling near her. Paralleling the king's position, the woman rests her feet on a basilisk. The animal's head is that of a monkey, the body resembling a dragon. Acanthus leaves decorate the four corners of the clasp, accentuating its X-like design. The cylinder at the clasp's center is decorated by a series of stylized leaves pointing toward the woman.

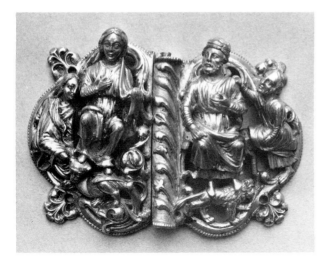

Compositionally, the seated couple corresponds to late twelfth-century groups of the Coronation of the Virgin (compare especially the tympanum at Senlis, 1180–1185). In spite of this formal similarity, the identification of the two seated figures and the allegorical meaning of the whole composition are difficult to establish. The absence of a crown on the female figure prevents the identification of the couple as Solomon and the Queen of Sheba.

Many stylistic features, such as the drapery drawn across the knees and the ornamental motifs, point to the art of Nicholas of Verdun and his school (compare, for the foliage, Swarzenski, 1967, pls. 222, 223). The combination of acanthus and berry motifs with interwoven figures and monsters had reached, by 1200, a particularly rich development in the Milan candlestick (Homburger, 1949; II, ills. 154–156). The similarity of the rounded features of the female figure to those of the Three Marys of the Tournai shrine, also the simplified style of the drapery, indicate a date around 1210 for our piece.

Close stylistic and functional similarities connect this clasp to no. 103. Both pieces are historically important as examples of chivalric jewelry, of which little survives.

BIBLIOGRAPHY: Boston, 1940, no. 218; Andersson, 1949, p. 61, fn. 1; Evans, 1953, pl. 41, p. 45; Steingräber, 1957, p. 34; Rorimer, 1963, p. 44, fig. 72

103. Clasp

Mosan or English
1210–1220
Silver gilt
5 x 9.5 cm. (1 x 3¾ in.)
Stockholm, Museum of National Antiquities

On the right portion a standing female figure welcomes a mounted knight who is followed by a walking man. The horse and rider are circled in part by a floral branch. On the left portion a seated couple is flanked by small figures, the heads of which, much eroded, are barely recognizable. The magnificent drapery is deeply modeled on all the figures, creating a gentle rhythmical articulation of the surface. A close similarity to no. 102 has long been recognized. The seated couple is flanked by small attendant figures in both examples, and the seated man appears almost identical in both cases (see also the figure of Herod on no. 90). The carefully rendered fruit on the left portion of the present buckle is reminiscent of the slightly earlier Rhenish shrine knobs on no. 117. While no. 102 has been associated, more or less directly, with the artistic heritage of Nicholas of Verdun, our object has been called Lotharingian or English by Swarzenski. In her short upper body and linearistic elegance the standing female figure recalls French-inspired early thirteenth-century statues such as no 34. The close connections between England and Scandinavia in this period (no. 169) would seem to support an English localization of our object.

The iconographical meaning in the present example and no. 102 is not clear; both apparently adapt compositional schemes traditional in earlier Christian contexts. The representation of the rider welcomed by the standing woman was tentatively called "Entry into Jerusalem" by Swarzenski. The resemblance is due to the pictorial formula derived from classical adventure imagery (E. H. Kantorowicz, "The King's Advent," *Art Bulletin,* 26, 1944, pp. 207–231). Comparably, a secularized transposition of traditional religious images is to be found in contemporary love lyrics.

BIBLIOGRAPHY: C. R. af Ugglas, *Gotländsa Silverskatter från Valdemarstågets tid,* Oslo, 1936, p. 20, pl. XXI; Swarzenski, 1967, no. 535; Paris, 1968, no. 399

104. Pyx

Mosan
Early 13th century
Rock crystal mounted in silver repoussé, filigree, gems
H. 28.2 cm., D. foot 11.5 cm. (11, 4½ in.)
Brussels, Musées Royaux d'Art et d'Histoire, 2875

Rising from a circular foot decorated with eight gems set in filigree, an octagonal stem, encircled by a ribbed knob, supports a cylindrical rock-crystal vase mounted between richly jeweled bands of filigree. Above an openwork gallery of filigreed ribbon, a conical roof supports a spherical capital. A crucifix at the top of the vessel, not original, was added in the fourteenth century. In structure pyxes resemble chalices and ostensoirs, objects that also serve as containers of the Eucharist. The present example follows a later development in its accumulation of architectural motifs, mostly of ciborium type. (For a general survey and interpretation of these types see V. H. Elbern's study of early medieval chalices: Elbern, 1963.) The use of transparent material for the vase reflects the twelfth century's concern with visual participation of the believer in the divine service, especially the transubstantiation of the Eucharist (Sedlmayr, 1950, p. 39 f.). At the

same time, however, the Early Christian type of small closed pyx continued to be produced in quantity in Limoges ateliers. Technically and stylistically, our piece is not connected with Limoges. The repertory of the goldsmith's decorative formulas seen here, especially those of the knob, and the refined plantlike stylization of the filigree edging are reminiscent of Mosan works of 1215–1225.

BIBLIOGRAPHY: Brussels, 1964, no. 182

105. Virgin and Child

Mosan
1210–1220
Gilt bronze
6.9 x 6.4 x 3.3 cm. (2¾ x 2½ x 1¼ in.)
Frankfurt am Main, Liebieghaus, N. 942

This type of Virgin, sitting with widely separated legs and holding the child on her left knee, is often seen in works of the early thirteenth cen-

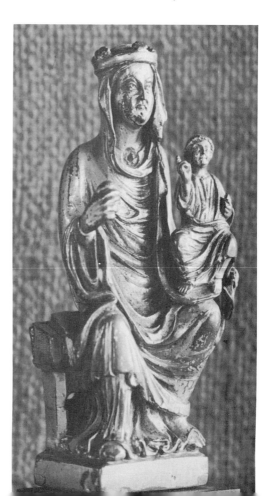

tury. Our statuette is distinguished by the vigorous treatment of the body and drapery. The folds, in varied layers of relief depth, display a strong rhythmical pattern. No linear articulation of Mary's waist is attempted. The artist, apparently familiar with the works of Nicholas of Verdun, treated his classical elements with a heavy hand. This interpretation of Nicholas' style may be called an extreme alternative to that pursued by Hugo of Oignies. (Without pertinent stylistic parallels, a German origin can only be suggested.) Comparable posture and facial expressions are sometimes seen in Mosan groups of the thirteenth century, for example, in the Virgin in Leau (Borchgrave d'Altena, 1961, figs. 63 and 94). Reminiscent of, and perhaps inspired by, a classical matrona-type, available to the artist in provincial Roman sculpture (Adhémar, 1939), the exhibited Virgin may be linked to the twelfth-century type of stiff, frontal Madonnas, popular in the Auvergne (Borchgrave d'Altena, 1961, figs. 37 and 41).

BIBLIOGRAPHY: *Kleinplastik aus dem Liebieghaus,* Frankfurt am Main, 1960, no. 19

106. Reliquary statuette of St. Stephen

Mosan
1220–1230
Silver gilt, copper gilt, semiprecious stones, glass
H. 43.2, base 23.2 x 15.3 cm. (17, 9¼ x 6 in.)
New York, The Metropolitan Museum of Art, The Cloisters Collection, 55.165

The saint, wearing deacon's garments, stands on a large molded base against a plaque with a patterned background framed by a triple arch: two large leaves intersect the arches. Two beaded bands frame a broad strip of floral filigree set with jewels; the same type of filigree appears on the collar and sleeves. He originally held a book

containing his relics. On the back of the plaque Stephen's martyrdom is represented in a two-storied composition. In the lower section, two executioners with Jewish hats and exaggerated noses hurl stones at Stephen from a supply held in slings around their necks. At the left, the nimbused figure of Saul is seated with crossed legs, his left hand in a gesture of command, his right holding a sword. In the upper part of the plaque, Christ stands upon a row of undulating lines flanked by two angels (compare the Chartres south porch typanum, Katzenellenbogen, 1959, fig. 72); the one to the left bears a censer, the one to the right presents the nude crowned figure of the saint's personified soul to Christ. The continuous floral ornament of the border is set with rosettes. Three limp leaves appear at the intersection of the arches forming an ornament similar to that of the corners of the base and that seen enclosed in the diaper pattern behind the statuette. Stylistically, the statuette's drapery combines the vividness and variation seen in Nicholas of Verdun's Tournai shrine (no. 100) with the verticalism and monumentality of French cathedral statues, especially those of Chartres. In the engraving the sure drawing with sharp, jagged lines is reminiscent of the Klosterneuburg altar plaques (no. 179). Of the various styles developed by Nicholas' Mosan successors, the Stephen reliquary most closely follows that of his later work, lacking both the quiet classicism of the Mettlach cross reliquary and the mannerism of Hugo of Oignies.

Iconographically, the artist characterized the figure of Saul as the saint (nimbused) that he became afterward, distinguishing him by a sword that fits both his judicial function in the martyrdom scene and points to his own future martyrdom. A nimbused Saul also occurs in Stephen's martyrdom on a roughly contemporary Limoges châsse in Gueret (Gauthier, 1950, pl. 10). The Jewish hats of Stephen's executioners appear also on the Halberstadt paten (Panofsky, 1924, pl. III). Seen in his original state holding a book (for a Limoges statuette of Etienne de Muret similarly posed, Gauthier, 1950, pl. 46), St.

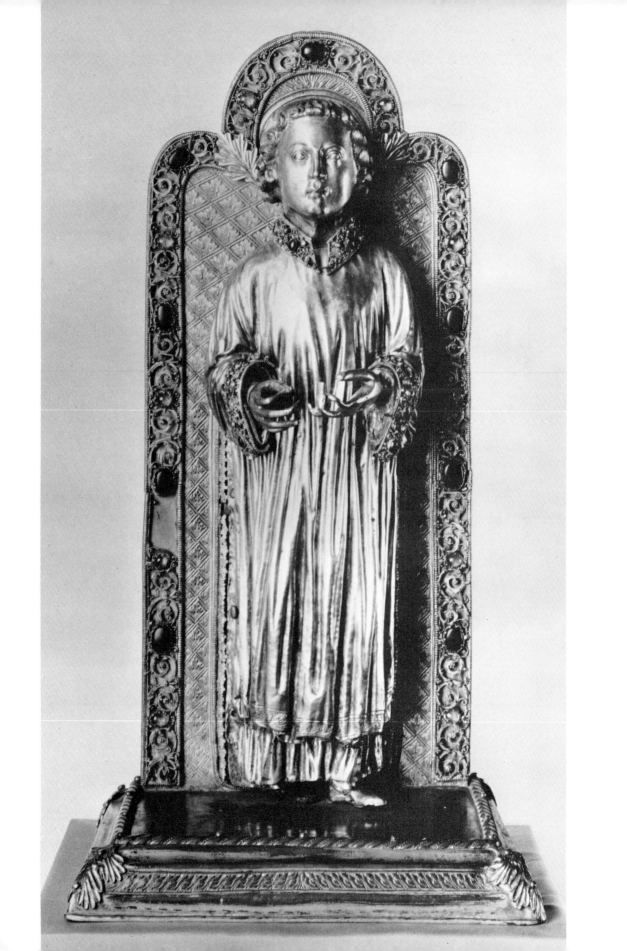

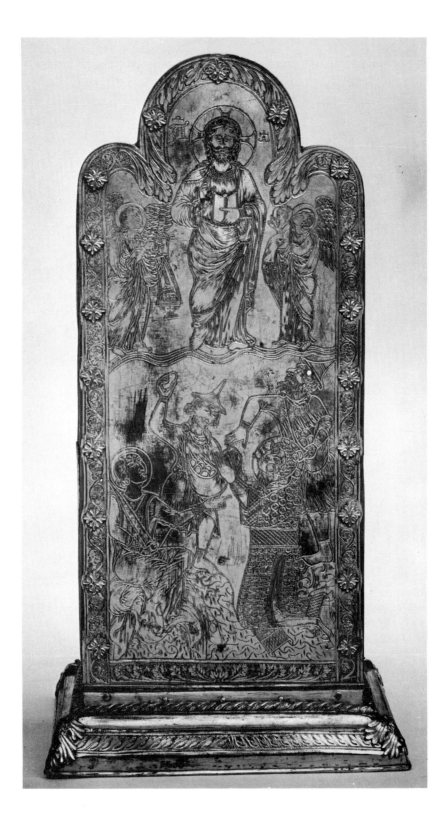

Stephen apparently was to correspond to Christ's posture (nobody else is shown frontally), gesture, and positioning (at the center of the triple arch). A notable difference between the hieratically conceived standing figures of Stephen and Christ and the lively realism of the martyrdom scene is apparent (for earlier instances, M. Schapiro, *The Parma Ildefonsus,* New York, 1964, p. 24, n. 75). The motif of the angel carrying the soul is derived from the imagery of tomb stones (Ely Cathedral: Zarnecki, 1953; with regard to the framing triple arch, the tombstone of Presbyter Bruno, d. 1194, in Hildesheim; Panofsky, 1964, fig. 240). The crown of the martyr's soul revives an Early Christian tradition (A. J. Brekelsmans, "Märtyrerkranz. Eine symbolgeschichtliche Unteruchung im frühen Schrifttum," *Analecta Gregoriana,* vol. 150, Rome, 1965). The artist's inventiveness is demonstrated by his placing of some of the deadly stones around Stephen's halo beneath the crowned soul above (for the comparable representation in the fifth-century S. Maria Maggiore mosaic of Moses saved by a mandorla from the stones of his persecutors: O. Brendel, "The origin of the mandorla," *Gazette des Beaux-Arts,* 1943).

Reliquary statuettes of saints contributed to the development of medieval sculpture from the tenth century on (H. Keller, "Zur Entstehung der Sakralen Vollsculptur in ottonischer Zeit," *Festschrift Hans Jantzen,* Berlin, 1951, pp. 71-91; for the objections raised against Keller's interpretation by H. Schrade, "Zur Frühgeschichte der mittelalterichen Monumentalplastik," *Westfalen,* 1957, pp. 33–64). Conversely, in the thirteenth century monumental sculpture exerted an influence on reliquary statuettes, as seen in our piece. The spacious base provides a stage for the saint, similar to a public monument the type of which emerged about the same time.

BIBLIOGRAPHY: M. B. Freeman, "A Saint to Treasure," *The Metropolitan Museum of Art Bulletin,* 1956, pp. 225–245; Rorimer, 1963, pp. 138–140

107. Arm reliquary

Mosan
1220–1230
Bronze, silver, gold
H. 63.3 cm. (24½ in.)
New York, The Metropolitan Museum of Art, The Cloisters Collection, 47.101.33

The thumb and two fingers of the hand are raised, as they are also in early thirteenth-century French examples (Rouen: Swarzenski, 1932; Crespin: Paris, 1965, no. 9, pl. 125). (Compare the fully raised hand of no. 110.) Large holes in the inner side of the arm's metal cover reveal spaces in the wooden core, intended for relics. Originally the holes may have been closed by rock crystals, as in two Cologne arm reliquaries (Cologne, 1964, nos. 3–4, figs. 6–7). The sleeve, of silver-gilt plate, has a border of fifteen nielloed silver plaques alternating with fourteen of silver-gilt filigree set with semiprecious stones. Similar filigree appears on the bracelet. A gilt-bronze plaque on the edge of the sleeve is engraved with foliate designs. On the niello plaques a great variety of foliate scrolls and grotesque animals appear, as well as five figural compositions, the latter placed on the upper part of the border. On the cuff, two half-figures of flying, censer-bearing angels emerge from clouds; below, the standing figures of Peter and Paul are similarly conceived as a pair. The fifth plaque represents a standing man ringing bells above his head while an angel flies over him. The combination of vigorous design and linear stylization seen in the floral motifs, the physiognomy and drapery style of the figures, and the type of filigree all relate this reliquary to Mosan art of the third decade of the thirteenth century, the time of Hugo of Oignies. In some of the foliate scrolls the precise drawing of the petals is reminiscent of the slightly earlier Cologne Passion plaques (no. 198). The broad heart-shaped scroll engraved on the base may derive from early medieval patterns (for the design tradition in Mosan art, Swarzenski, 1967, figs. 212, 214, 215). Of the animal plaques the most impressive shows a basilisk and a dragon fight-

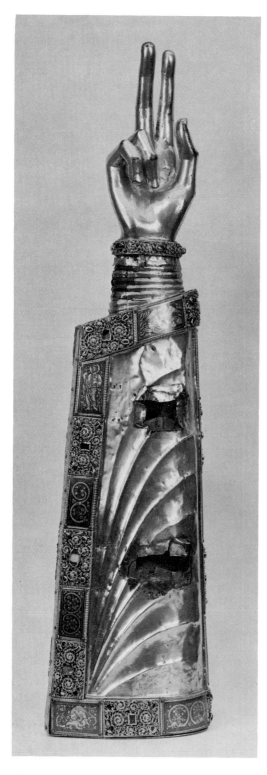

ing; similar scenes can also be seen on the Engel-berg Cross (Grimme, 1968, p. 88, pl. XIV) and the Three Kings Shrine crest (Swarzenski, 1967, fig. 252). The standing Peter and Paul, reminis-cent of monumental sculpture (Chartres, north porch) of advanced *Muldenfaltenstil,* have close similarities in style and motifs to those on con-temporary works like the Namur chalice (Swar-zenski, 1967, fig. 533), the Manchester book cover (Swarzenski, 1967, fig. 532), and the St. Matthias (Peter only) and Mettlach Cross reli-quaries (Schnitzler, 1959, pls. 10, 17; II, ills. 136, 137). Iconographically, the representation of Paul holding a model of a city or church is unique. The representation of a man ringing bells below an angel, an unusual feature, may be connected with the tradition of the Annunciation to the Shepherds. With regard to type, movement, and drapery, an engraved figure of the Three Kings Shrine (Swarzenski, 1967, fig. 523) can be viewed as an antecedent.

BIBLIOGRAPHY: Braun, 1940, pls. 119–123, figs. 443–470; Boston, 1940, no. 212 (with too early dating to the 12th century); Rorimer, 1963, p. 140 f.

108. Gargoyle

Mosan
About 1230
Bronze gilt
4.5 x 12.3 cm. (1¾ x 4¾ in.)
Munich, Bayerisches Nationalmuseum, 61.18

A man with animal head in a hooded robe is rep-resented with his hands at his chest and his knees bent. The figure was probably originally attached to a small table fountain (for a later example, Cleveland, 1967, p. 250, VI, 8). Above the screw holes near the base are the goldsmith's marks in the form of a triangle and the number XV. An impressive emphasis is placed on the bodily vol-ume and the deep modeling of the drapery folds. A vital artistic temperament is betrayed both by the strikingly reduced shape and the energetic movement of the figure, the tension of which seemingly unloads itself in the wide-open mouth.

Stylistically, the gargoyle recalls the vigorous modeling of no. 84. The conception of this figure obviously is indebted to the monumental gargoyles of contemporary French cathedrals, the apotropaic meaning of which is based on old traditions of placing tutelary signs at the top of monuments (Sedlmayr, 1950, p. 160; Schade, 1962, p. 32 f.; Schapiro, 1963).

BIBLIOGRAPHY: *Münchener Jahrbuch der Bildenden Kunst*, XXIII, 1962, p. 265

109. Chalice

Probably northern Netherlands
Early 13th century
Silver gilt
H. 15.5, D. 13 cm. (6⅛, 5⅛ in.)
Amsterdam, Rijksmuseum, 595

The wide, smooth-surfaced cup rests on a shaft decorated above and below the knob with rows of roundels formed by spirals of filigree. The circular foot, with a background of punched ornament, contains four oval medallions with seated figures of the Evangelists in repoussé, and, in the spandrels between these, small heads of winged cherubs. The knob, divided into an upper and lower half, is decorated with openwork roundels. In three medallions on the lower half appear busts of Christ and two angels; on the upper half, symbols of Matthew, Mark, and John. For lack of space and reasons of symmetry, the ox, symbol of Luke, was omitted. The remaining openwork medallions are filled with vine scrolls. The icono-

graphical scheme (Christ and the Evangelists) and the use of decorative plant forms have their sources in the iconographical tradition of Early Christian chalices (Elbern, 1963, pp. 117–188, especially p. 167 f.).

The provenance of our piece from a Utrecht church does not necessarily indicate its place of origin, which is probably the northern Netherlands. In any case, its workmanship must have been influenced by the early thirteenth-century examples from the region of Maas. The distribution of Mosan chalices is shown by the existence of a large number made around 1220 in the neighboring German art centers: Rhineland, Westphalia, and lower Saxony (Meyer, 1932). Compared with these pieces, the Amsterdam chalice, in its type of vine ornament, sculptural character of its knob similar to that of a ciborium, and width of its cup, shows indications for a dating in the early thirteenth century.

In the development of chalice shapes, our example represents the type without handles, which originated in the mid-twelfth century and is found frequently in the early thirteenth century (for a survey of the surviving chalices of the later twelfth and early thirteenth centuries,

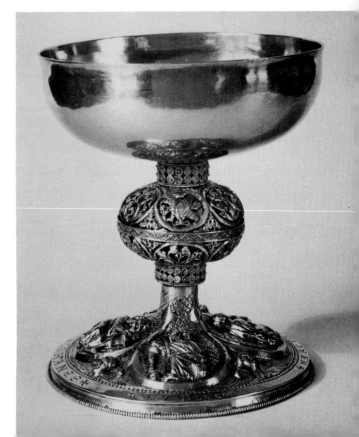

Braun, 1932, p. 85 f.). The general proportions and particularly the shape of the knob of this chalice should be compared with the chalice in the church of the Holy Apostles in Cologne (Braun, pl. 8, fig. 22) and another in Basel (Braun, pl. 13, fig. 40).

BIBLIOGRAPHY: Meyer, 1932, p. 177, n. 2; W. J. A. Visser, *Archief van de Geschiedenis van het Aartsbisdom,* Utrecht, LVIII, 1934, p. 42; Amsterdam, 1952, no. 4; Barcelona, 1961, no. 1134, pl. LXVIII

110. Arm reliquary

German
About 1180
Silver gilt, champlevé enamel
H. 50.8 cm. (20 in.)
Cleveland, Museum of Art

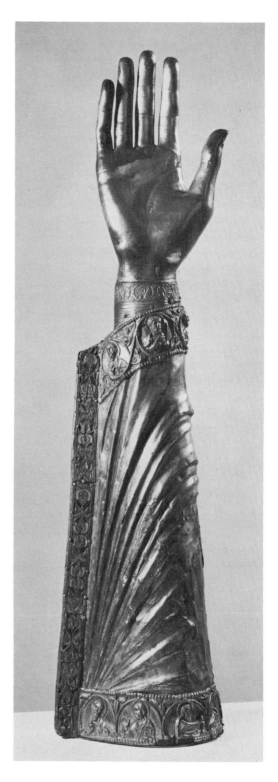

The slender arm is firmly modeled with deep relief; the hand is delicately articulated. Western French inspiration is evident in details of the decoration. The bracelet and the vertical border of the arm show a floral pattern; half-figures of Christ and the apostles appear in the upper and lower borders, in medallions above, in half-circles below. Set on a punched ground, which stems from Mosan goldsmiths' work, the palmette frieze of the bracelet was compared by Swarzenski to border ornaments in English book illuminations of the late twelfth century, especially those of the Bury Bible, Cambridge, Corpus Christi College, Ms. 2 (for a recent discussion of this manuscript, C. M. Kauffmann, 1964). Swarzenski convincingly derives the motif of medallions formed by branching stems from English miniature painting. The type of half-length figure in a half-circle, as seen in the lower border, is indebted to Byzantine prototypes, employed earlier by Mosan artists on the Paris arm reliquary of Charlemagne (Deér, 1959).

The combination of Mosan and English influences was thought to constitute a specific achievement of a Braunschweig workshop considered by Swarzenski to be the result of Duke Henry the Lion's strong personal and political interest in the

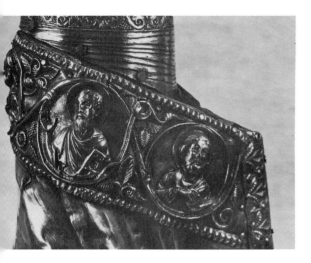

1932, pp. 316–339), is a phenomenon to be considered when one deals with the problem of attribution and chronology of our arm. Based on very old beliefs and superstitions in the magical power of the arm (L'Orange, 1953; Homburger, 1953), the erect hand of a reliquary arm, reminiscent of contemporary ritual oaths (seen also in the Rouen arm mentioned above), is explicitly defined as a symbol of protection in the inscription of the arm reliquary from Crespin: "Protegat hec dextra nos semper et intus et extra que Landelbrii sacra continet ossa benigni."

BIBLIOGRAPHY: Swarzenski, 1932, p. 316 f.

minor arts. Perhaps he ordered a large group of arm reliquaries in competition with Frederick Barbarossa's gift of a reliquary casket with the arm of Charlemagne to Aachen in 1165. Braunschweig had a tradition of arm reliquaries, the earliest known specimens dating from the eleventh century. Falke localized the present arm, together with many other pieces, to Hildesheim (Falke, 1936). Swarzenski pointed out the similarities connecting this piece and the arm in the Rouen Museum (Swarzenski, 1932, p. 328, fig. 271). (The later arm in the church of Crespin, mentioned by Swarzenski, is reproduced in Paris, 1965, pl. 125, no. 9; it has a different type of filigree work, indicative of a thirteenth-century origin.)

The remarkable diversity of technique, forms, and types apparently practiced side by side in one workshop at the same time (Swarzenski,

111. Mirror case with handle

Germany
Late 12th century
Bronze gilt
H. 8.8 cm. (3½ in.)
Frankfurt am Main, Museum für
 Kunsthandwerk

Found in 1900 at Bussen in Swabia, this case is a rare instance of an early secular object. Two embracing lovers form the handle, while the case shows a couple lying under a tree and a man playing a harp. The contrast between the erect bearing of the couple on the handle and their smooth, almost amorphous faces is striking. The energetically drawn folds of their garments correspond to the heavy cloth covering the couple on the medallion. Opposing Hanns Swarzenski's early thirteenth-century dating given in the 1954 edition of his *Monuments of Romanesque Art,* Heinrich Kohlhaussen assigned a mid-twelfth-century date to the piece by comparing the long sleeves of the female on the handle with those on a figure in an upper-Rhenish miniature dated 1154. However, in view of the continuous use of this stylistic detail in the later twelfth century (the tombs in Saxony, Panofsky, 1924, pl. 20; for an exhaustive survey of this motif see Stammler, 1962, p. 84, n. 13), our case cannot be precisely dated, and may well belong to the last decades of the cen-

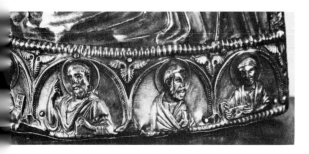

tury. The choice of a medallion-like composition for the love scene relates it to secular subjects carved on circular ivory medallions that were produced, mainly in Cologne, from the turn of the twelfth century. In spite of the scarcity of comparative material presented by Kohlhaussen, his Swabian localization is persuasive. The resemblance of this object to mirror cases of classical antiquity is perhaps explained by the artist's familiarity with a provincial Roman mirror found in his region.

With regard to the iconographical meaning, a direct literary illustration (Tristan and Iseult, as proposed by Swarzenski) seems as improbable as that of a Christian allegory. There is no detail referring to King Solomon and the Sponsa, and Sauerlandt's interpretation of the harpist as David is unconvincing. The tree motif with a loving couple recurs in a capital from Eschau (Alsace) of the mid-twelfth century, as well as in an early thirteenth-century miniature of Dido and Aeneas in the Berlin codex of Heinrich von Veldeke's "Eneide" (see no. 271) and the contemporary representation of a married couple enthroned (Scheller, 1963, no. 9, fig. 34).

BIBLIOGRAPHY: Kohlhaussen, 1959, figs. 12, 13; Swarzenski, 1967, fig. 469 a, b

112. Portable altar

Lower Saxony
1190–1200
Ivory, copper, rock crystal
London, Trustees of the British Museum

The choice of agate or other stone as a center for portable altars was traditional from early medieval times. Of the different media employed here (ivory, engraving, and miniature painting) the inclusion of a miniature was apparently especially popular among lower Saxon twelfth-century workshops. (For a miniature similarly covered by rock crystal at the center of the upper plaque of the Eilbertus portable altar: Swarzenski, 1967, fig. 241.) The donor's inscription placed at the lower edge of the altar indicates its Hildesheim destination: THIDERICUS ABBAS III DEDIT, referring to the late twelfth-century abbot of St. Michael's monastery in Hildesheim. The decoration includes engravings of the animalia, one in each corner, with two ivory carvings between them on the vertical axis, above, the Crucifixion, below, the Virgin and Child seated between two local saints; at the center of the sides a miniature of a standing bishop saint, above and below on the left, engravings of Saints Peter and Stephen, and above and below on the right, engravings of John the Baptist and St. Lawrence. The ivory figures show agitated gestures and firm sculptural modeling. The fluidity and smoothness of drapery is particularly notable on the Virgin, foreshadowing stylistic achievements of early thirteenth-century Madonna statuettes (no. 55). The Virgin and Child seated between standing local saints

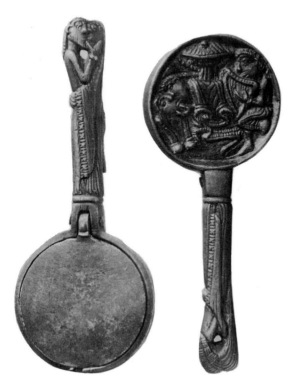

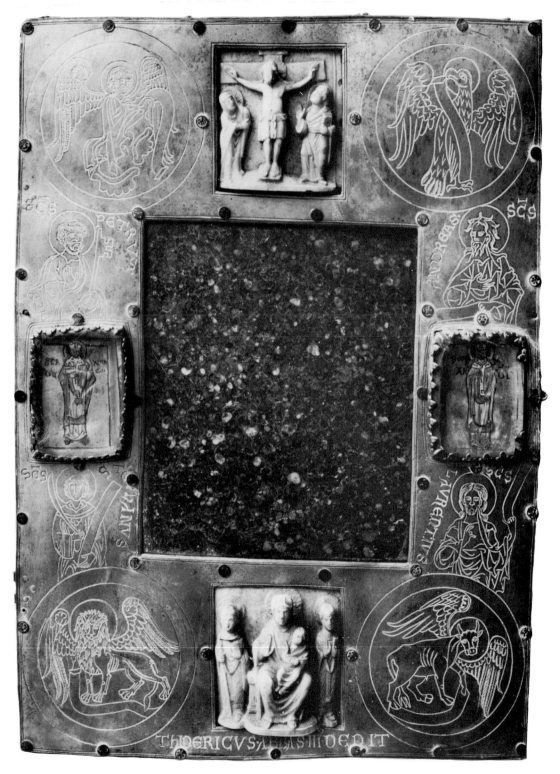

may also be seen on the front plaques of reliquary shrines. In the precise, jagged drawing of the engraved saints one meets an excellent early example of lower Saxon Byzantinism of the turn of the century. A more conservative element appears in the treatment of the ox, the rigidly stylized drawing of which is traditional. Linear virtuosity occurs in the impressive ornamental display of the angel's mantle, the sketchy feathering of the eagle, and the dense mane of the lion, the latter recalling the local predilection for lion aquamanilia (no. 120). As to the object's chronological position, a clue may be drawn from its apparently most advanced element, the miniatures of the standing bishops. Together with the brilliant Byzantinizing engraving, most especially of John the Baptist, they point to the very end of the twelfth century. The style of the miniatures is closely paralleled in sculpture in the Magdeburg tomb of Archbishop Wichmann (Panofsky, 1964, fig. 201).

113. Fragment of a crest

German
1190–1200
Bronze
London, Victoria and Albert Museum,
7237–1860

In this magnificent piece two men fight a dragon whose tail becomes part of an interlacing scroll. The inhabited scroll, stemming from late classical decorative art, was broadly revived during the last decades of the twelfth century, especially by Nicholas of Verdun. This crest recalls contemporary achievements in the monumental sculpture of the so-called Samson Master (Cologne, 1964, no. 39, figs. 36–37; Mütherich, 1940, p. 92 f.). The impressive vigor in the modeling of the bodies, the variety and intensity of the movements and intertwinings, and the playful mood of a burlesque *all'antica* are all striking. It is evident that the object formed part of a shrine close

in style, date, and place of origin to the Anno and Albinus shrines of Siegburg and Cologne, both of which are similar in their continuous frieze-like disposition of the action. (Opposed to this is the system of medallions enclosing simple figures or groups in the crest of the Three Kings Shrine, Swarzenski, 1967, fig. 525; II, ills. 111–121). The crests of both the Anno and Albinus shrines were attributed by Mütherich (1940, p. 62 f.) to the same master, either Nicholas of Verdun himself or a leading member of his workshop, and a date in the late 1180s or in the 1190s may be inferred from this connection. The slightly earlier date of the Anno shrine becomes evident when one compares its crest with that of the Albinus shrine and our fragment, both of which are more advanced in the articulation of organic movement as well as in the dissolving of the frieze (for comparative material, Swarzenski, 1967, pls. 222–223). For similar representations of a man leaning backward on a dragon, compare an engraved figure from the Three Kings Shrine (Swarzenski, 1967, fig. 523, below) and one of the Jews stoning Stephen on the Halbershadt paten (Swarzenski, 1967, fig. 534; II, ill. 152). With regard to style, technique, and the allegorical significance of such scenes of men and dragons, the sources of this crest are to be sought in earlier Mosan candlesticks (for representations of secular episodes of force at the top of monuments, Schapiro, 1963). An antecedent of the delicate treatment of leaves is found in the Hildesheim chandelier, by the master of the Stavelot altarpiece (Falke-Meyer, pl. 21).

BIBLIOGRAPHY: Swarzenski, 1967, fig. 527

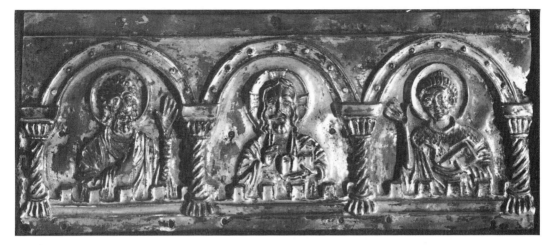

114. Plaque

Germany
Late 12th century
Copper gilt
17.8 x 7 cm. (7 x 2¾ in.)
Lent anonymously

The half-figures of Christ blessing and two apostles acclaiming appear behind a crenelated wall under arcades supported by small spiral columns. The compositional type of busts within arcades and the expressive modeling of the figures imply Byzastine models (Goldschmidt-Weitzmann, no. 99). Nearly identical plaques are found on a reliquary from Enger in the Kunstgewerbemuseum, Berlin (Corvey, 1966, no. 287, pl. 233), a tower reliquary in the treasury of Minden Cathedral, and a pyx in Lippstadt (E. Meyer, "Eine Spätromanische Goldschmiedewerkstatt in Osnabrück," *Westfalen,* XV, 1931, p. 69 f.; for reservations about Meyer's chronology, Swarzenski, 1932, p. 306 n. 115). All these pieces testify to the intense Byzantinism in lower Saxon art of the late twelfth and early thirteenth century. While the Berlin reliquary provides a model for reconstructing our plaque's original context, it differs in that the crenelated wall is divided into three parts. Our plaque, furthermore, lacks a precise characterization of the apostles, identifiable in the Enger reliquary as Peter and Paul. The motif of the crenelated wall, absent in the Byzantine models, apparently was adapted from a type of imperial seal often seen in the eleventh and twelfth centuries (Deér, I, 1961, figs. 12, 14, 21, 28a; Goldschmidt, III, pls. VIII, nos. 29b, c, pl. XVI, no. 53d, pl. XXXIII).

BIBLIOGRAPHY: Swarzenski, 1932, p. 306 f., fig. 250; New York, 1968, no. 98

115. Head reliquary

German
Late 12th century
Bronze gilt; eyes: silver, niello
H. 31 cm. (12¼ in.)
Hannover, Kestner-Museum, 1903.37

Head reliquaries appeared in medieval art in the ninth century. This life-size head of an unidentified saint rests on a long conical neck. Curled locks of hair frame the face in a rhythmic pattern. The head had been compared to the Cappenberg bust of Frederick Barbarossa of around 1165 (Schramm-Mütherich, p. 409, no. 173) and to the Hildesheim Rivers of Paradise font of the third decade of the thirteenth century (Falke-Meyer, fig. 283). However, the treatment of the hair places the head later than the Cappenberg bust, while the rigid structure and immobile expression separate it from the vivid physiognomy of the Hildesheim font as well as from the spirited classicism of the Aachen head (no. 124). A better comparison may be made with a late

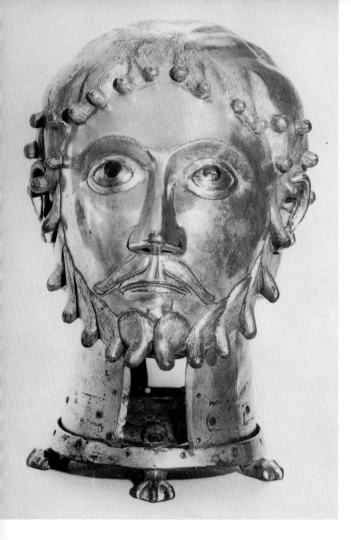

116. Chalice and paten

Lower Saxony
About 1200
Niello
H. chalice 6.5 cm. D. paten: 11.4 cm.
(2½, 4½ in.)
Iber, Kirchengemeinnde Iber Kr. Einbeck

Mounted on a seventeenth-century foot, the cup shows four christological representations enclosed in medallions: Annunciation, Nativity, Descent from Cross, and Resurrection, with half-figures of scroll-bearing prophets in the spandrels: Isaiah twice, with his prophecy, 7.14: *Ecce Virgo concipiet et pariet,* referring to the Annunciation, while the Nativity is commented upon by 9.6: *Puer natus est nobis filius datus est;* Hosea 13.4 (Descent from Cross): *Ero mors tua o mors;* St. Paul (Resurrection): Rom. 6.9: *Christus resurgens a mortuis.* A similar choice of scenes, sometimes substituting the Crucifixion for the Descent, and the Marys at the Tomb for the Resurrection, is to be found on a number of late twelfth- and early thirteenth-century chalices (Meyer, 1932, p. 163 f.). As on the feet of these chalices Old Testament scenes mostly are included as typological counterpieces to the Christ episodes that appear on the cup, a corresponding reconstruction may be suggested for the original decoration of our chalice's decoration. Johannes Sommer, who discovered the chalice in the parish church of the small lower Saxon village of Iber, situated between Hildesheim and Einbeck, convincingly analyzed its close relationship to late twelfth-century lower Saxon goldsmiths' work.

While certainly later than the niello engravings of the St. Oswald reliquary in Hildesheim (II, ills. 145–148), the engravings of the chalice recall in some of their details the decoration of the Welfenschatz St. Lawrence reliquary arm, dated around 1190 by Georg Swarzenski (1932). The resemblance also applies to the decorative formulae used, especially the floral ornament. While undoubtedly correct in dating the chalice slightly after the reliquary arm, Sommer is less convincing in his attempt to localize the chalice, together with an important group of more or

twelfth-century head reliquary in the Düsseldorf church of St. Lambertus (Falke-Meyer, fig. 320; H. Schnitzler, "Der Kirchenschatz von St. Lambertus," *Die Stifts und. Pfarrkirche St. Lambertus in Düsseldorf,* 1956, p. 170 f.). Both heads show the same frontal stare, linear articulation, conical neck, and treatment of hair and may be regarded as roughly contemporary. The reliquary head of St. Oswald (Swarzenski, 1932, fig. 320; II, ills. 145–148), produced in the same milieu as these two pieces, is a variation of this type. In spite of regional differences, a comparison may be suggested with the reliquary head of St. Mauritius in Zurich, dated 1206.

BIBLIOGRAPHY: Swarzenski, 1932, p. 315; Hannover, 1966, no. 17; Corvey, 1966, no. 284; Swarzenski, 1967, fig. 362

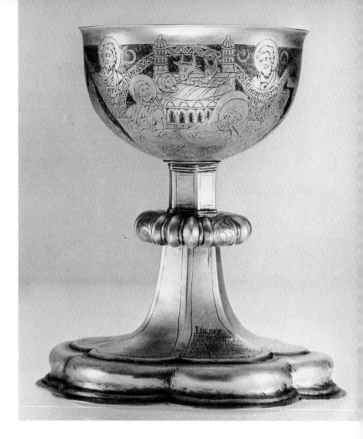

less related objects, to a Hildesheim atelier, thus reviving Falke's opposition to Swarzenski's reconstruction of a major Braunschweig workshop sponsored by Duke Henry the Lion. Iconographically, one notes the unique motif of the enthroned Virgin of the Annunciation answering the angelic message by a gesture of oath (for the seated Virgin in the Annunciation: Pächt-Wormald-Dodwell, pls. 116–118). The reclining Mary of the Nativity was convincingly compared by Sommer to the brilliant stucco fragment of the same scene from the Hildesheim church of St. Michael. The Descent from the Cross is reminiscent of a later rendering in the St. Mark shrine (no. 182) in their common Byzantine inspiration. In this scene the figure of the man drawing the nails from Christ's body is especially expressive, shown from the back, his head turned in profile. In the medallion of the Resurrection a comparison with the Louvre armilla (no. 174) may elucidate the direction of change chosen by the late twelfth-century lower Saxon artist in transforming his Western (northern French and Mosan) starting point.

The magnificent paten shows a central medallion of a blessing half-length figure of Christ, surrounded by the animalia in a quatrefoil pattern with curled branches in the spandrels. The dynamic approach and artistic temperament imposed upon a refined and spiritualized Byzantine Pantocrator type is apparent in the broad rhythm of both Christ's gestures and drapery. Although only slightly earlier, the so-called St. Bernward's paten, a Hildesheim product (Swarzenski, 1967, fig. 482), strikingly illustrates the extent to which the artistic achievements of our master surpassed the immediately preceding generation of his native region. The density of form and directness of perception are especially fascinating in the frontal representations of the ox and lion (compare with Villard de Honnecourt's lion, Hahnloser, 1935, pl. 48, drawn some thirty years later). A contemporary analogy of the Christ figure, probably from Nicholas of Verdun, is seen in the impressive gold medallion from the shrine of the Three Kings, now in the treasury of Cologne Cathedral (Cologne, 1964, no. 1). A com-

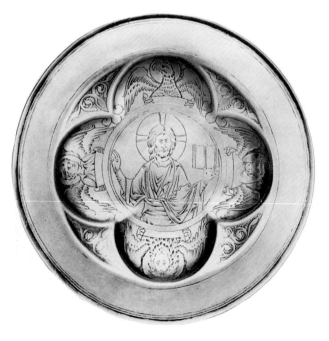

parison reveals the lower Saxon component of the Iber paten in the beginning of sharpening the drapery edges that apparently announces the rise of the *Zackenstil*.

BIBLIOGRAPHY: Sommer, 1957; Sommer, 1966; R. Haussherr, *Niedersächsisches Jahrbuch für Landesgeschichte*, 38, 1966, pp. 257–261

117. Knob

Rhineland
About 1200
Rock crystal, bronze gilt
H. 10.2 x 7.3 x 7.3 cm. (4 x 2⅞ x 2⅞ in.)
Cologne, Schnütgen Museum, 570

This object is distinguished by the delicate and comparatively realistic modeling of the plant's leaves that support the crystal and curl downward at the top, as well as the superb rhythm of the berries whose densely punched surface contrast with the broad planes of the leaves. Naturalistic interpretations and rhythmic integration are

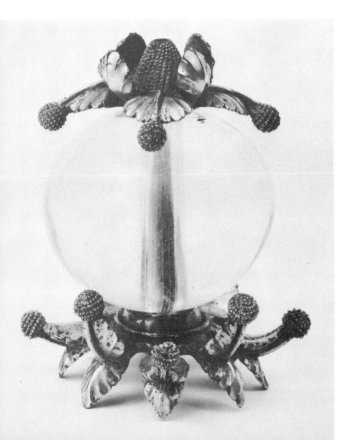

characteristic of Rhenish goldsmiths' work of the twelfth century. The majority of knobs on Rhenish shrines of this period consist entirely of solid metal (no. 193). However, the shining radiance of rock crystal led to its choice in several cases (Cologne, 1964, figs. 10, 12). Comparable mountings and large crystal balls are to be seen on the Honoratus shrine in Siegburg (Cologne, 1964, fig. 13). The striking richness in the decoration of our object is seen in comparison with the other examples. The precise and at the same time lifelike modeling of the leaves is a phenomenon corresponding to the firm, straight drapery of certain German crucifixes (Cologne, 1964, figs. 28, 29).

118. Flabellum

Rhenish or Mosan
About 1200
Silver, jewels, gilt, filigree, enamel
D. 29, L. of handle 6.4 cm. (11½, 2½ in.)
New York, The Metropolitan Museum of Art,
 The Cloisters Collection, 47.101.32

This object is decorated with silver-gilt filigree set with semiprecious stones, strips of polished tin, enamels, and gilt bronze. The outer band is of copper gilt, pierced and chased in leaf design, the second and fourth bands include four panels of cloisonné enamels in two shades of blue with details in red, green, and yellow, alternating with sections of gold filigree, each mounted with five jewels. The third and fifth bands are made of paper-thin silver embossed with an interlacing scroll and leaf design. All panels are bordered with gilt beading. The central boss has a hinged top of gold filigree *à jour* mounted with eight jewels, including rubies, amethysts, and turquoise. The compartment beneath the boss once contained a relic.

As a form, the flabellum derives from fans of feather or parchment (*muscatoria*), which were used in Early Christian times to keep flies from

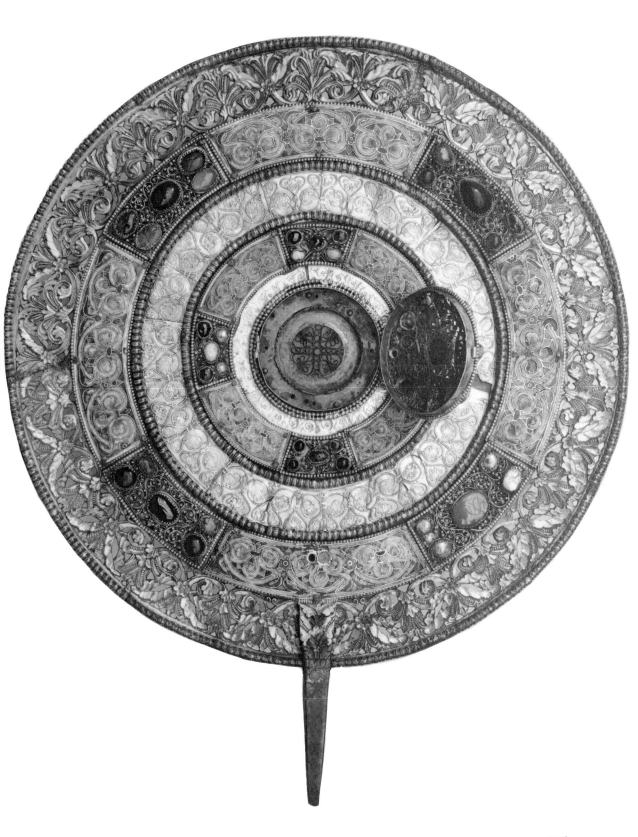

the sacrament and from the priest during the Mass. Miniatures from thirteenth-century manuscripts illustrate such scenes (Missel de Jumièges, Rouen, Bibl. Mun. ms. 299, fol. 152; Missel de St.-Corneille-de-Compiègne, Paris, B. N., ms. lat. 17.318, fol. 173). Several flabella made in parchment still exist, such as those of ninth-century origin from Tournus (Eitner, 1944), and the twelfth century (Green, 1951). In the late Middle Ages parchment flabella were succeeded by ones of metal. These usually bore a cruciform decoration and were carried in pairs; later, thought too heavy to carry, they served as altar crosses or reliquaries. (Compare statues of apostles in the St.-Chapelle and in the cathedral in Cologne, holding similar discs.) The apparent companion piece to our example is in the Hermitage (Darcel-Basilewsky, pl. XXX).

Whereas the flabella in the Kremsmünster abbey and the National Museum, Copenhagen, illustrate gospel scenes, our flabellum, like the ones in the Seillière Collection and the Hildesheim Treasury, is limited to pure ornament. It surpasses all other contemporary metal flabella in its exceptional quality and richness.

BIBLIOGRAPHY: Darcel-Basilewsky, p. 76, no. 193; Braun, 1932, pp. 655, 656, 660; Boston, 1940, no. 243; Rorimer, 1963, pp. 137, 138; Deus, 1967, pp. 79–80

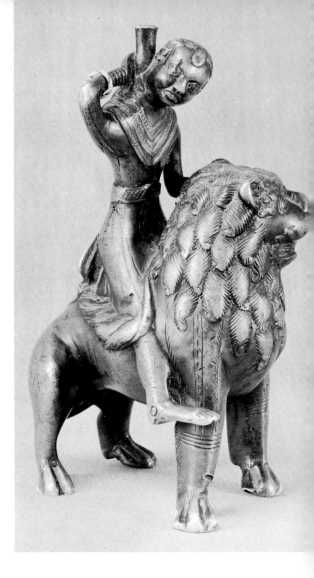

119. Samson Candlestick

North Germany
About 1200
Bronze
20 x 13.5 x 7.5 cm. (7⅞ x 5¼ x 2⅞ in.)
Hamburg, Museum für Kunst und Gewerbe, 1958.10

Samson sits astride a lion, grasping its mane with his left hand. Bending forward in the posture of a caryatid, he supports the candlestick with his raised right hand. An impression of movement is created, not only by the lion and rider looking in opposite directions, but by the bending of Samson's left leg into the lion's side. The compact body of the animal is accentuated by the vivid molding of the strands of the mane, treated as ornamental imbricated scales. The lion's tail swings over his body, following a line parallel to that formed by the rider, and merges into the bulging roll of the latter's clothing.

Quite a large group of so-called Samson candlesticks exists datable into the late twelfth and thirteenth centuries. The earliest example, in the Louvre (Falke-Meyer, pl. 90, fig. 216), already shows Samson's left leg pressing into the lion's side, which indicates a derivation of the type from antique combat scenes, as in representations of Mithras. Like the Louvre example, our piece

presents the theme of a hero in combat, while maintaining the traditional stance of a rider. Some of the candlesticks show the riding Samson in the act of tearing open the lion's mouth—another link to classical scenes of combat—for example, on the crest of the shrine of the Three Kings in Cologne (Swarzenski, 1940, pp. 67–74; II, ill. 111). Documentary evidence and the presence of original gilding on several of the pieces indicate that these candlesticks were meant for use in churches. Nicholas of Verdun's representation of the scene on the Klosterneuburg Altar (1181), shows Samson subduing the lion as a prefiguration of Christ's victory over the Devil, in the scene of Christ's Descent into Hell, no. 179. When one speaks of the special popularity enjoyed by the Samson groups, beginning with the late twelfth century, it is well to keep in mind the contemporary interest in representations of actual combats. The Wolfram candlestick in Erfurt Cathedral indicates the possibility of autobiographical associations for pieces similar to ours. Such a possibility can be considered for the present candlestick. Although its provenance is not definitely known, its style points to the Mosan tradition of bronze casting.

BIBLIOGRAPHY: Falke-Meyer, no. 253, fig. 217; Meyer, 1960, no. 14, Barcelona, 1961, no. 1081

in strong relief, and the free treatment of details, indicate a date in the early thirteenth century for both pieces. They are late examples of the Mosan tradition of the twelfth century. One can also see a close relation of these lions to that of the Samson candlestick (no. 119).

The conception of the animal is striking when compared with earlier lion aquamanilia. The ornamental rhythm in the arrangement of the hair tufts on the lion's mane, the outline of the dragon on the lion's back, which serves as a handle, and the intense look of the lion's eyes all indicate a strong differentiation in form.

The placing of two small vipers under the lion's feet is unusual. One is reminded of the contemporary representations of Terra or Luxuria, with two snakes suckling at her breast. It is possible that the artist took the idea from this composition. But, at the same time, he has represented the lion's victory over the serpents. The source of the allegorical meaning is no longer known.

The representation of a seated lion, which one meets in various connections in the later Middle Ages (for example, in the Marzocco in Florence), is a rare occurrence in the early thirteenth century, not only among aquamanilia. As an isolated example one can mention a stone sculpture from south Italy in the Museum of Fine Arts, Boston,

120. Lion aquamanile

North Germany, Wismar
1200
Bronze
H. 21 cm. (8¼ in.)
New York, The Robert Lehman Collection

This aquamanile and its companion piece (Falke-Meyer, no. 373, fig. 351), differ from the large group of medieval lion aquamanilia by their sitting position. The modeling of the body shapes

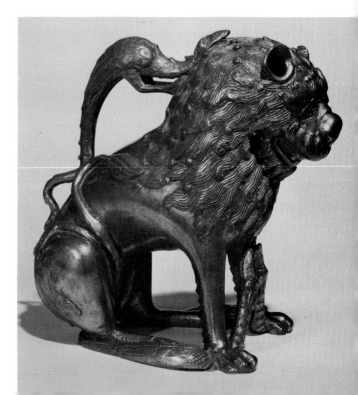

which is related to the Oriental tradition of seated lions through Byzantine art (Swarzenski, 1941, pp. 32–35). A single example of a fountainhead figure in the shape of a seated lion spitting out water appears in the Carolingian Utrecht Psalter, fol. 14v. (Panofsky, 1960, p. 49 f., fig. 15). This Carolingian drawing, which perhaps follows a late antique prototype, could have exerted influence through the medieval copyists' tradition of perpetuating types (compare with the copy of the Utrecht Psalter made about 1200; no. 257).

BIBLIOGRAPHY: Falke-Meyer, no. 372, fig. 350; New York, 1968, no. 100

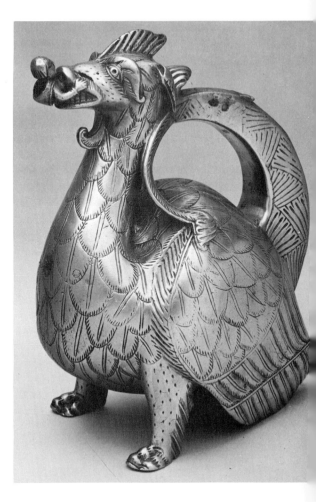

121. Dragon aquamanile

German
12th century or beginning of the 13th
Bronze
H. 22.5, L. 18.5 cm. (8¾, 7¼ in.)
New York, The Metropolitan Museum of Art,
 The Cloisters Collection, 47.101.51

The dragon is supported in front by its legs, in the rear by its wing tips. The tail forms the handle. The upper half of a small hooded figure projects from the dragon's mouth and forms the spout; the figure holds his head up and grasps the jaws of the beast as if to prevent being swallowed.

Our piece represents a more elaborate version than those in which the open mouth is used as a spout, with the liquid guided by the animal's protruding tongue (Vienna Museum; Victoria and Albert; Falke-Meyer, figs. 229, 230a). Iconographically, examples with human figures may be seen as illustrating the struggle between man and beast (see aquamanilia in the Minden cathedral, Falke-Meyer, fig. 363; and in the Hermitage, Swarzenski, 1967, fig. 34). However, the precise meaning is unclear. For an earlier instance in a different context, see the early eleventh-century ivory group of a lion devouring a man, in Swarzenski, 1967, fig. 135. A similar hooded figure is found in the mouth of a twelfth-century Mosan-Lorraine lion in the Museum of Mariemont, Belgium (no. 108; Falke-Meyer, fig. 325; Mariemont, 1963, no. 45), and on a twelfth- or thirteenth-century Mosan-Lorraine dragon in the Hamburg Museum (Meyer, 1960, pp. 64–65).

One may compare our dragon with a German lion aquamanile in the Kestner Museum, Hannover, for both the position of the human figure and size of its hood (Falke-Meyer, fig. 343). The modeling of the thick lips, the bulbous nose with accentuated line decoration, and the deep-drilled nostrils are almost identical with those of our aquamanile. These characteristic features, and the conception of human figures serving as spouts, belong to Mosan-Lorraine prototypes.

However, the incised lines and points of the legs, and the stylization of the engraved feathers and scales, are more representative of lower Saxon works. Similar patterns appear on the candlestick in the Diocesan Museum at Münster (from Hildesheim, according to Falke-Meyer, fig. 180) and on the wings of the angels on the baptismal font in the Dom of Hildesheim (1220–1230) (Falke-Meyer, fig. 248). Saxony, in addition to Lorraine, was a major center of bronze casting in the twelfth and thirteenth centuries.

BIBLIOGRAPHY: Boston, 1940, no. 284, pl. XXXII; Rorimer, 1963, pp. 142–144, fig. 71

122. Lion aquamanile

North Germany
Early 13th century
Bronze
29 x 28 cm. (11 6/16 x 11 in.)
Mariemont, Museum

The abrupt sideward turn of the head (seen also in contemporary candelabra, Falke-Meyer, pls. 90–95), the elegant fluidity of the tail and the dragon handle, and the treatment of the mane distinguish this aquamanile from no. 96. A precise dating and localization of this object (and for the others assembled by Falke-Meyer) is difficult. A Mosan origin for a small group of bronze lions was tentatively indicated by Falke-Meyer, and the assumption that the majority of those pieces were produced in lower Saxony and other workshops in northern Germany is borne out at least by their provenance.

A particular motif of the group called "Gothic" by Meyer is the separation of the lion's beard hairs from his mane by a small band (as in the present example) which later replaces the beard entirely. The exaggerated proportion of certain parts of the animal's body (trunk, neck) and the alert expression indicate early Gothic artistic achievements. From this time on aquamanilia were more often used outside liturgical functions.

BIBLIOGRAPHY: Falke-Meyer, no. 419, fig. 393

123. Fibula

Germany, Mainz
Early 13th century
Gold, filigree, jewels
7 cm. (2¾ in.)
Mainz, Mittelrheinisches Landesmuseum, 2633

At the center of this circular object a large cabochon is joined to six oval arms that connect it to an outside band of filigree and small precious stones. This form is typical of fibulas in late classical and medieval art. Originally a very complex structure, borrowed from monumental prototypes such as ceiling decorations, the design became more simplified. (For a more elaborate treatment, compare an Ottonian fibula: Steingraber, fig. 6). The early Gothic origin of our piece is evidenced in the dissolution of the formerly solid surface into a linear radial articulation, seen also in rose windows of this period. Inspired by Mosan models, slightly antedating the work of Hugo of Oignies, this fibula may have been produced in a middle-Rhenish atelier, suggested not only by its provenance but also by the local tradition of jewelry production in Mainz from early medieval times. Roughly contemporary, dissimilar buckles (nos. 102, 103) illustrate the wide range of types available to patrons and artists around 1200. Closer to 123 is a fibula in Aosta (Steingräber, fig. 21).

BIBLIOGRAPHY: E. Meyer, "Zur Geschichte des hochmittelalterlichen Schmuckes," Festschrift für A. Goldschmidt, Berlin, 1935; Steingräber, 1956, p. 28 f., fig. 22

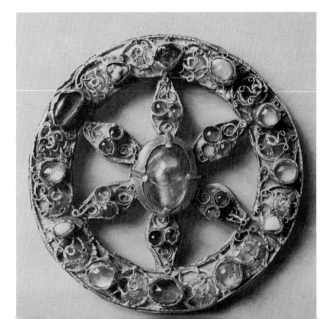

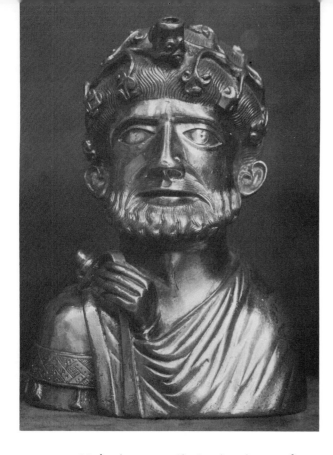

shrine in Aachen (II, ills. 128, 129), and especially to the crucifix in the Diocesan Museum in Cologne (Cologne, 1964, no. 26), appears more acceptable than the early twelfth-century dating proposed by Falke-Meyer and Swarzenski. Consequently, our piece cannot be the oldest medieval vessel in the shape of a bust. Rather, it follows a type already known in twelfth-century Mosan tradition (Falke-Meyer, figs. 307–315). In turn, the Romanesque vessels probably had forerunners in late antique Roman anthropomorphic bronze vessels, used as incense containers (Falke-Meyer, figs. 304, 305).

The imitation of antique prototypes, as seen in the aforementioned aquamanilia, invalidates Schnitzler's suggestion that our bust is specifically connected with the classicized court art of Frederick II, or his coronation in 1215 at Aachen (Schnitzler, p. 21).

BIBLIOGRAPHY: Falke-Meyer, p. 52 f., figs. 306a, b, no. 328; Schnitzler, 1959, no. 12, pls. 46, 47; Barcelona, 1961, no. 1093; Cologne, 1964, no. 25; Swarzenski, 1967, pl. 163, fig. 358

124. Aquamanile in the shape of a bust

Germany, Aachen
1210–1220
Hollow bronze with traces of gilding; silver eyeballs
H. 18.3 cm. (7¼ in.)
Aachen, Domkapitel

The bearded head is crowned with a wreath made of two grapevine branches with stylized grape leaves. The branches end in curls that meet under the spout, placed above the forehead; their intertwined stems form a handle attached to the nape of the figure's neck. The mantle, or chlamys, is tightly drawn over the left arm; from its folds, a strongly modeled hand emerges and holds one of the two strips tied in a knot over the right shoulder.

The sharply drawn features and drapery style connect the bust with the early thirteenth-century goldsmith work of Aachen. Accordingly, Schnitzler's reference to the stylistic relation of the bust to the dedication relief on Charlemagne's

125. Chalice, paten, straws

Germany
1230–1250
Silver, parcel gilt, niello, jewels
Chalice: 20.3 x 17.5 cm. (8 x 6⅛ in.) Paten: D. 22.4 (8¾ in.) Straws: L. 21.5 cm. (8½ in.)
New York, The Metropolitan Museum of Art, The Cloisters Collection, 47.101.26–29

Richly decorated with applied filigree set with jewels, the cup rests on a knob that is connected to a broad circular foot. A cycle of four typological pairs of scenes from the Old and New Testaments appears in medallions on the foot and knob. The backgrounds of the applied reliefs are cut out and show the silver-gilt surface of the chalice. The Old Testament scenes of the foot are encircled by inscriptions that refer to the New Testament scenes on the knob:

Moses at the Burning Bush (Annunciation): NON ARDENS RVB[VS] ANGELICI RESERACIO VERBI.

Aaron's Rod (Nativity): FLORIDA VIRGA NV-
CEM FERT VIRGO CVNCTA FERENTEM.

Noah's Ark (Baptism of Christ): ARCHA NOE
PRO DILVVIO PAPTISMA FIGURA.

Moses and the Brazen Serpent (Crucifixion):
SERPENS IN LIGNO XRM NOTAT I CRVCEM
PAAVM.

The cup is articulated by beaded silver-gilt
arcades with spiral colonnettes framed by filigree
and jewels. Represented in niello, the enthroned
Christ and the twelve apostles stand in dialogue
groups. The incised inscription around the rim

of the base refers to the Last Supper: QUI MAN-
DVCAT CARNEM MEAM ET SANGVINEM MEVM IN
ME MANET EGO IN EO DICIT DOMINUS. The cen-
ter of the silver-gilt paten is ornamented by a
quatrefoil crosslike decoration with an incised
floral design in the spandrels. The top lobe of the
cross shows the half-figure of Christ holding a
chalice and the host; at the left Abel offering a
lamb; at the right Melchisedech in bishop's robes
and miter raising a chalice; at the bottom the
nimbused half-figure of St. Trudpert holding a
palm in his right hand. On the outer rim four

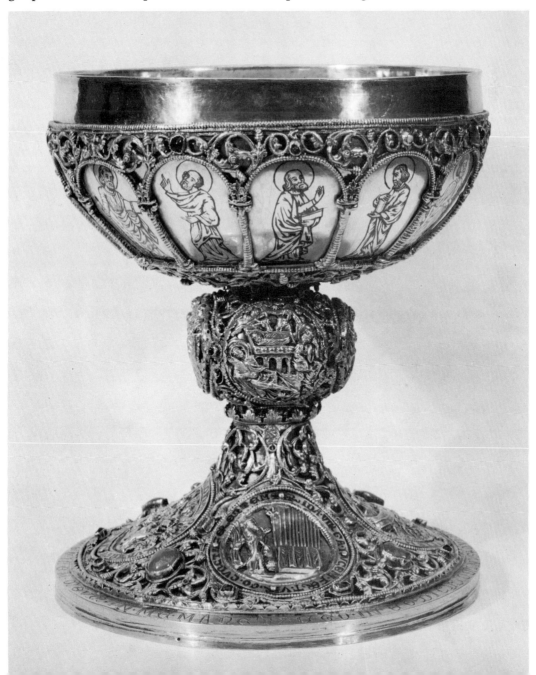

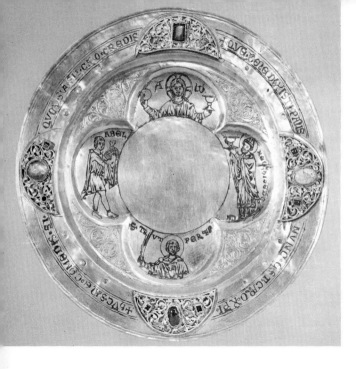

segments with applied silver-gilt filigree set with jewels appear as extensions of the central quatrefoil scheme. Between the segments, applied silver strips display the nielloed inscription: QUE BENEDIXISTI PANIS NVNC EST CARO XRI ✠ HVC SANE COMEDIS SI QUOD SVASIT CARO CREDIS.

The representation of St. Trudpert on the paten indicates that the whole set (chalice, paten, straws) came from the monastery of St. Trudpert near Freiburg. The provenance of the pieces does not necessarily imply an upper Rhenish origin, as no metalwork production is known there before the Villingen flabellum of 1268. The strong sculptural modeling of the figures, apparent both

in the reliefs and the niello engravings, the delicate filigree, and the limp, heavy floral ornament point to a date between 1230 and 1250. The finely engraved tendrils in the four gores of the paten are in a style closely related to that of Hugo of Oignies. Without attributing our pieces to Hugo himself, we suggest Mosan origin; a group of chalices, produced in northern Germany after Mosan prototypes, provides stylistic as well as iconographical parallels (Meyer, 1932). A very similar chalice from Weingarten (known from an eighteenth-century engraving, Swarzenski, 1943, fig. 102) depicts Aaron's Rod, Noah's Ark, and the Brazen Serpent on the foot, the corresponding New Testament scenes (Nativity, Baptism) and the inscriptions also agreeing with our piece (Braun, 1932, no. 85). Of the typological pairs, the combination of Moses at the Burning Bush and the Annunciation is the least frequent (E. M. Vetter, "Maria im brennenden Dornbusch," *Münster*, 10, 1956, pp. 237–253).

On the paten, the artist transformed a representation of Cain and Abel offering into a eucharist image, replacing Cain by the king-priest Melchisedech. (For an iconographical survey of medieval patens, Elbern, 1963).

The two eucharistic straws, with their fine filigree handles, represent a liturgical object rarely preserved, the consequence of the church's increasing hostility toward the faithful drinking wine at communion (T. Borenius, "The Eucharistic Reed or Calamus," *Archaeologia*, XXX, 1930, pp. 99–116, esp. pl. XVII, fig. 3).

BIBLIOGRAPHY: Braun, 1932, p. 86, no. 169; J. Sauer, "Unbekannte Kunstwerke aus dem Kloster St. Trudpert," *Zeitschrift des Freiburger Geschichtsvereins*, 46, 1935, pp. 52–82

126. Reliquary cross

Germany
About 1230
Wood, silver gilt, niello, jewels, pearls
H. 34.3 cm. (13½ in.)
Aachen-Burtscheid, Pfarrkirche

This Byzantine type of two-armed cross was widely imitated in Mosan and Rhenish gold-

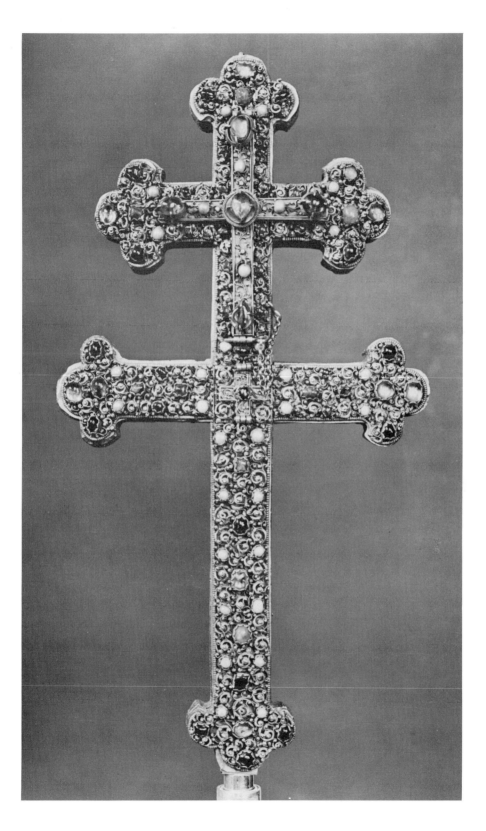

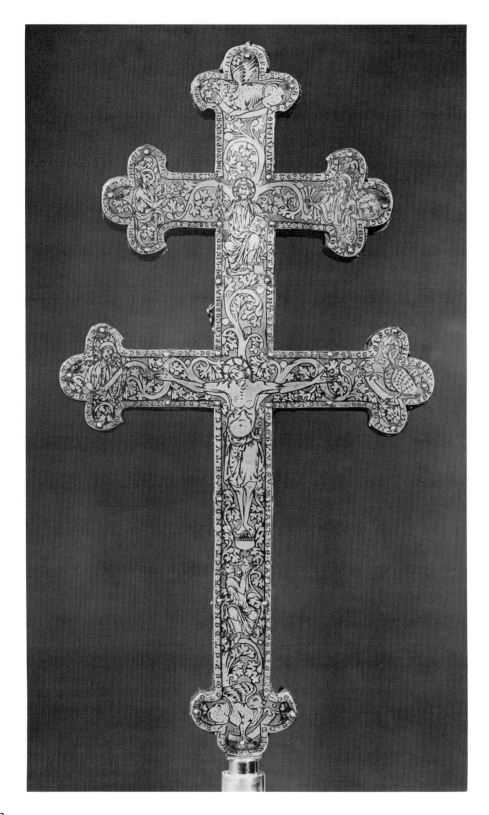

smiths' work of the twelfth and thirteenth centuries (Frolow, 1961, 1965). Two crosses are attached to the front at the center, the upper one contains the relics; both are heavily restored. The uninterrupted connection between the bars and their trilobed ends distinguishes our piece from the reliquary crosses of Hugo of Oignies (Brussels, Namur, Walcourt) as well as from the famous cross from Clairmarais, now in St. Omer. A similar composition (and, on the reverse, figural iconography) is to be seen on the slightly later northern French Blanchefosse Cross (Paris, 1965, no. 125, pls. 122–123), and a cross in Rouvres (Paris, 1965, no. 805, pl. 124). The front of our cross is entirely covered by curl filigree set with precious stones and small pearls; four stones are at the end of each arm.

The back of the cross is decorated in niello by a continuous, freely branching stem, referring to the traditional concept of the cross as the Tree of Life. At the center the crucified Christ is represented, his arms broadly stretched out, his feet crossed according to the recent type of one-nail attachment. The personification of the Church, glancing upward, collects the blood streaming from Christ's feet in a chalice. At the intersection of the upper cross bars the enthroned Christ in Majesty is seen between two angels who appear in the trilobe ends, and who present the crown of thorns and the three nails (R. Berliner, "Arma Christi," *Münchener Jahrbuch,* 1955, pp. 35–153). The four major trilobe endings show the animalia. On the border a continuous and uninterruptedly running inscription lists the relics enclosed.

The close association between the themes of the Crucifixion and Christ in Majesty, noticeable in the imagery of the cross, stems from Early Christian and early medieval art (E. Grube, "Majestas und Crucifix. . ." *Zeitschrift für Kunstgeschichte,* XX, 1957, pp. 268–287).

The vigorous drawing of the mobile figures and their drapery is characteristic of a style deeply indebted to northern French cathedral sculpture. Schnitzler convincingly attributes the cross to the second master working in the 1230s on the Aachen Shrine of the Virgin (II, ills.

130–132). It is probably through French ateliers that Byzantine prototypes became known to the Aachen goldsmith, contributing to his serene interpretation of forms and movement.

BIBLIOGRAPHY: Schnitzler 1959, no. 13, pls. 48, 49

127. Chalice

Northern Europe
1222
Silver
H. 18.4, D. 13.4 cm. (7½ x 5⅜ in.)
New York, The Metropolitan Museum of Art,
 The Cloisters Collection, 47.101.30

The cup has a central knob, pierced and polished. The interior of the cup and the bands around the knob and above and below it have been gilded. The knob is decorated with six intertwined dragons and a central band of interlaced foliate scroll. Unlike late twelfth-century chal-

ices, our cup is distinguished by its spare orna-
mentation, a type that continued in Germany
well into the thirteenth century. Around the foot
is engraved: AD HONOREM B. MARIE VIRGINIS F.
BERTINVS ME FECIT A° MCCXXII. Frater Bertinus
has not yet been identified, consequently the lo-
calization of the piece depends on stylistic judg-
ment, varying in earlier literature from "Mosan"
and "northern French" to "English," "Scandina-
vian," and "Icelandic." The cup generally resem-
bles the Pelagius chalice in the Louvre (E. Moli-
nier, *L'orfèvrerie religieuse et civile du V^e à la fin
du XV^e siècle*, Paris, 1902, p. 195), the chalice
from Swalbald, now in the Copenhagen Museum
(Th. Kielland, *Norsk Gudsmedkunst; middelal-
deve*, Oslo, 1927, pl. 59), the chalice from the
tomb of Bishop Absalon (d. 1201) in Sovo (P.
Norlund, *Gyldne altie*, Oslo, 1926, p. 115, fig.
96), and an Icelandic piece in the Victoria and
Albert Museum (H. P. Mitchell, "A Medieval Sil-
ver Chalice from Iceland," *Burlington Magazine*,
II, 1903, pp. 70–73). Although the actual place
of origin is uncertain, the elegant fluidity in the
combination of animals and plants, and the solid
foliage of the central band indicate a knowledge
of Mosan art of the early thirteenth century. A
great number of chalices produced in the first half
of the thirteenth century in northern Germany,
often intended for export, testify to the wide
range of interpretations that were given to Mosan
prototypes (Meyer, 1932).

BIBLIOGRAPHY: E. A. Jones, "Some old foreign
silver in the collection of Mr. W. R. Hearst," *Con-
noisseur*, 1930, pp. 220, 221

128. Cross

Italy (?)
1180
Copper gilt, engraving
31.7 x 25.1 cm. (12½ x 9⅞ in.)
Durham, North Carolina, The Duke
 University Museum of Art

On the front and back, half-figures of angels
appear at the ends of the horizontal bar; a half-
figure angel appears at the top on the front and a

half-figure of God the Father on the back. The
living Christ is represented on the front and the
dead Christ on the back. The cross is edged with a
beaded band bordering a row of punched circles.
The drawing is especially fine in the V-shaped
folds of the loincloth and the linear rhythm of
the arms and hair. The engraving in its sharp
modeling and use of the V-motif is clearly in-
debted to the German tradition of metalwork
initiated by Roger of Helmarshausen. An Italian
origin is assigned to the cross and comparable
pieces by R. Moeller (Duke, 1967), but the
limited knowledge concerning Italian Roman-
esque engravings precludes a more detailed local-
ization. Similarities can be seen in the expert
handling of forms and drapery with contempo-
rary Italian miniature and panel painting. Byzan-
tine influences can also be seen in the sharply cut
edge of the loincloth and the manneristically

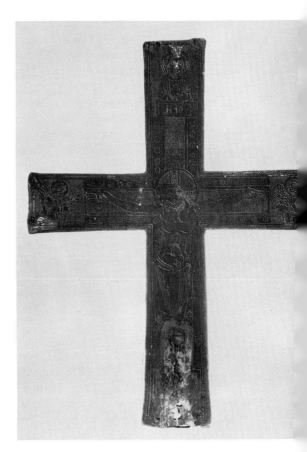

exaggerated anatomical drawing of Christ's chest. Early Christian traditions are evident in the representation of the living Christ on the cross (R. Haussherr, *Der tote Christus am Kreuz,* Bonn, 1963) as well as in the combination of angels with the crucifix. (For the motif of God the Father appearing on top of the cross, W. L. Hildburgh, "A Medieval Bronze Pictorial Cross," *Art Bulletin,* XIV, 1932, pp. 79–102).

BIBLIOGRAPHY: Duke University, 1967, p. 86 f. no. 34

129. Personification of Prudence

North Italy
1170–1180
Bronze, cast and chiseled
H. 11.2 cm. (4 7/16 in.)
Baltimore, The Walters Art Gallery, 54.52

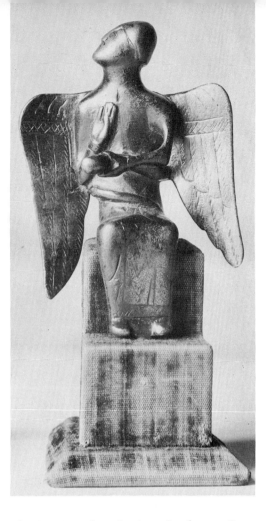

Worn by handling, the statuette's original surface remains only in the feathering of the wings. Frontally seated and clad in a long garment with an ornamented lower border, the angel stares stiffly upward. In his left hand he holds the head of a serpent that curls around his waist; his right hand, turned outward, is held before his chest. The attribute of the serpent suggests that the figure represents Prudence (as seen in contemporary art: Swarzenski, 1967, figs. 382, 418; no. 106; Swarzenski, 1943, p. 71, n. 1; Boeckler, 1930, pl. 956). Representations of the virtues in the guise of angels, based on a traditional theological combination of both concepts, often occur in twelfth-century art (no. 177). The motif of the encircling serpent derives from a pictorial tradition of classical art (for the moralizing adaptation of an astronomical Serpentarius in twelfth-century initials: Dodwell, 1954, pl. 37a–b; for the Laocoön tradition: L. D. Ettlinger, in *Essays in Honor of E. Panofsky,* New York, 1961, p. 121 f.); this tradition was revived in Italian medieval art in different iconographical contexts (F. Saxl, *A Bibliography on the Survival of the Classics,* II, Warburg Institute, London, 1938, no. 408, p. 104 f.). The summary treatment of form seen here, the lack of bodily articulation, and the exaggerated gestures are conservative stylistic traits. Taking into consideration the delay customary among Italian adaptations of northern models, the given date seems plausible. A Veronese origin has been suggested for the statuette by Boeckler, who compared its style to that of the figures on the San Zeno bronze door; and, indeed, northern influence has been demonstrated in bronze casts of twelfth-century Veronese workshops. The range of contemporary stylistic possibilities is strikingly illustrated by a comparison with such Mosan pieces as no. 94 and, for the agitated posture, no. 93.

BIBLIOGRAPHY: A. Boeckler, *Die Bronzetür von S. Zeno,* Marburg, 1931; Boston, 1940, no. 262, pl. IX; *4000 Years of Modern Art,* Baltimore, The Walters Art Gallery, 1953, no. 56

130. Two Plaques

Italy, San Clemente a Casauria
About 1190
Bronze
Castle: 26.2 x 27.3 cm. (10½ x 10¾ in.)
 Interlace with frame: 39 x 39 cm.
 (15¼ x 15¼ in.)
Baltimore, The Walters Art Gallery, 54.1057,
54.1058

These plaques come from the large bronze door
at the entrance to the church of the monastery of
San Clemente a Casauria; two more of the plaques
are in Berlin (Volbach, 1930, pp. 155–156). The
first plaque portrays a three-turreted castle in
high relief inscribed: CASTRUM FARE DABRILE
(the castle of Fare d'Abrile), a possession of the
monastery. The second is decorated with a raised
interlace design surrounded by a band of incised
lozenges and preserves its original frame deco-
rated with incised geometric designs. These are
two of the door's five decorative elements, which
includes, in its seventy-two plaques, other abstract
patterns, twenty castles, and four figures. The
present castle plaque and another castle plaque
were not replaced in the nineteenth-century res-
toration.

The door was commissioned by Abbot Joel,
who is named in an inscription on one of the
plaques with the enthroned St. Clement: IOHEL
ABBAS. SCS. CLEMENT (Calore, p. 205; Bindi,
1889, p. 442 f.). Joel probably became abbot in
1182 and, according to a privilege of Pope Celes-
tine III, he was still abbot in 1191 (Muratori, p.
769 f.). He undoubtedly commissioned the door
in connection with his completion of his prede-
cessor's building program for the façade. Joel's
enumeration of his monastery's possessions on
the door of his church derives from a tradition
established as early as the ninth century with
Charlemagne's bronze door of the atrium of St.
Peter's in Rome (J. B. de Rossi, *Inscriptiones
Christianae Urbis Romae*, II, Rome, 1888, pp.
221, 233). His use of castles is found again in an
early thirteenth-century fresco in the portal of
SS. Anastasio and Vincenzo alle Trè Fontane in
Rome (S. d'Agincourt, *Denkmäler der Archi-
tectur, Sculptur und Malerei*, III, ed. von Quast,
Berlin, 1840, pl. LCVII, p. 109 f.; M. Armellini,
Le Chiese di Roma, II, Rome, 1942, p. 1168). The
three-turreted castle was a common symbol with
political and judicial connotations for a city or
monastery in medieval art (Bandmann, 1951,
p. 98 f.), and the interlace belongs to an Italian

tradition stemming from eighth-century Lango-bardic art (R. Kautzsch, "Die Langobardische Schmuckkunst in Oberitalien," *Römisches Jahrbuch für Kunstgeschichte*, V, 1941, figs. 24, 33).

The panels represent the style of works produced in the Abruzzi during the twelfth and thirteenth centuries, such as the ambo at Sta. Maria at Bominaco and the more elaborate ambo of San Clemente itself (Bertaux, 1904, pl. XXV and fig. 258) with their emphasis on pattern and richness of design. The high yet planar relief of the panels is also characteristic of the twelfth-century wooden doors from Sta. Maria in Cellis and San Pietro ad Albe Fucense, both now in the museum at L'Aquilla (Bertaux, 1904, figs. 253, 254).

BIBLIOGRAPHY: L. A. Muratori, *Rerum Italicarum Scriptores*, II, Mediolani, 1726, pp. 766–1018; W. K. H. Schulz, *Denkmaler der Kunst des Mittelalters in Unteritalien*, II, Dresden, 1860, p. 23 f.; Bindi, 1889, p. 442 f.; P. L. Calore, "La Ricomosizione delle Porte di San Clemente a Casauria," *Archivio Storico dell'Arte*, VII, 1894, pp. 201–217

131. Bird

South Italy
1200–1210
Bronze gilt
H. 27.5 cm. (10¾ in.)
New York, The Metropolitan Museum of Art,
 The Cloisters Collection, 47.101.60

The bird clasps a ball with a large, deep hole in the base. From this hole, Goldschmidt concluded that it originally crowned a staff, perhaps a royal scepter. The ornithological evidence would seem to indicate a falcon rather than an eagle (Hinkle), the pictorial tradition of which, however, undoubtedly inspired the artist. Whereas the antique type of eagle scepter (for its origin: H. Vetters, "Der Vogel auf der Stange-ein Kultsymbol," *Arte del Primo Millennio*, ed. E. Arslan, Viglongo, 1951, pp. 125–133) can be followed from tenth-century representations of medieval rulers in manuscripts and seals, the stylistic peculiarities, especially the naturalistic modeling of the head, and the deep-set eyes, point to a late twelfth- to early thirteenth-century date. Goldschmidt con-

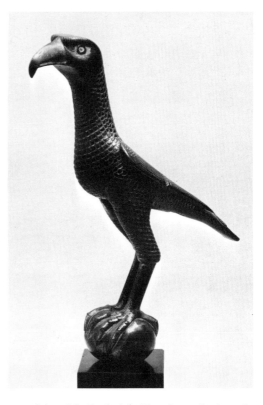

nected it with Frederick II and sought its origin in south Italian art, opposing Hanns Swarzenski's Milanese localization (*Zeitschrift für Kunstgeschichte*, 1937, p. 245). The eagle motif was already very popular in the last quarter of the twelfth century in the decorative sculpture of Campania and Apulia. While many monuments, such as the pulpit and the ambo in the Salerno cathedral, adopt the classical type of eagle with dramatically widespread wings (appearing also on Frederick's Augustal coins in 1231), our artist modeled the bird's body with great simplicity. The apparent stylization, inherent in the slenderness of the body and the marked contrast between smooth planes and feathered areas, connects our piece with the heraldic eagle design, traditional in oriental textile decoration.

BIBLIOGRAPHY: A. Goldschmidt, "A Scepter of the Hohenstaufen Emperor Frederick II," *Art in America*, 1942, pp. 166–173; H. Wentzel, *Mittelalter und Antike in kleinen Kunstwerken des 13. Jh.*, *Studies till. H. Cornell*, Stockholm, 1950, p. 92, n. 29; Rorimer, 1963, p. 145 f., fig. 73; Hinkle, 1966, p. 6, n. 60

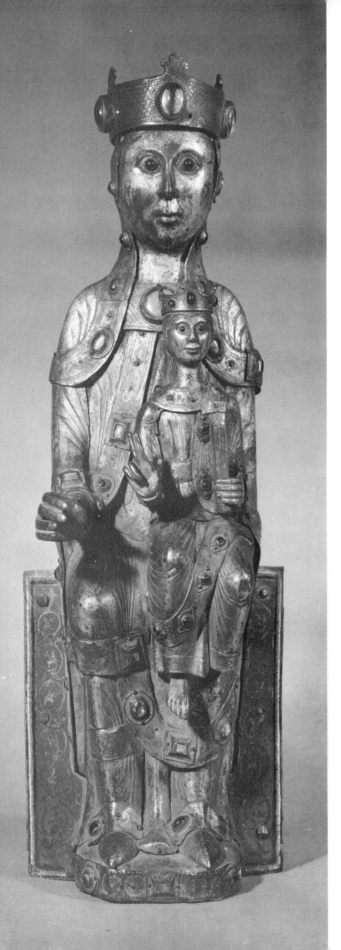

132. Virgin and Child

Spain
1180–1200
Copper gilt, champlevé enamel, glass paste
H. 37.5 cm. (14⅝ in.)
New York, The Metropolitan Museum of Art,
 Gift of J. Pierpont Morgan, 17.190.125

Frontally enthroned, the Virgin holds the Child on her left knee. The statuette has a wooden core covered with thin strips of gilded copper and simulated gems. Two enamel plaques with a scroll pattern appear on the front of the throne; the sides are each decorated with a large lozenge-shaped champlevé plaque with a rosette at its center. The back is decorated with small circular stamps that are repeated on the base. The hieratic conception and rigid verticality seen here, traditional in Romanesque cult images, is also present in the well-known Salamanca statuette of the "Virgin de la Vega." Both these works are the earliest examples in a group of copper and enamel images of the Virgin and Child assembled by Hildburgh, who, in his reexamination of the intricate cross relationships between southern French, especially Limoges, and Spanish goldsmiths' work of the second half of the twelfth century, attributed them to Spain instead of Limoges. The provenances of the Salamanca statuette and the stylistic evidence of the group as a whole are in line with this attribution.

BIBLIOGRAPHY: Hildburgh, 1955, p. 144 f., pl. LVII
 a-e

133. Astrolabe

Spain (?)
13th century
Brass
D. 10.7 cm. (4⅜ in.)
London, Trustees of the British Museum

Medieval interest in this kind of instrument used to determine the position of stars was apparent in the early treatise of Hermannus Contractus, the Reichenau monk of about 1040 (Gunther, pp.

404–422). New insights were gained from Greek and Arabic sources in the twelfth century (Saxl, 1957, pp. 73–84, 85–95). The earliest preserved astrolabes have been attributed to Italy and Spain, the countries most thoroughly exposed to Arabic science. The exhibited piece has been placed as the earliest astrolabe produced in Spain, the undoubted source of all Western astrolabes. Gunther dates it "circa XIVth century" and describes it thus: "This early instrument has a distinctly oriental appearance. The substantial unadorned bracket with its simple contour of lobes and ogees of a piece with the rim, the suspension by two rings of a ◇-shaped section and a shackle, and the shape of the star-pointers, all suggest strong Moorish influence. The instrument seems not to have been finished, since star names have not been inscribed. Rete (short form for 'rotula mobilis' the movable part) for 12 stars (unnamed). The Capricorn circle is connected to the Zodiac by an E. W. bar and three ties. Star-pointers have 4-lobed bases, each lobe being marked with a dot, a decoration which may have been derived from the perforate base characteristic of the pointers in Moorish instruments. . . . A table for ' ħl ' is engraved on the interior of the mother. The three changeable tablets are for latitudes 23° and 30°; 36° and 41°; 45° and 48°. On the Back are concentric Calendar scales, with the first of Aries coincident with March 15. The month of May is spelt 'MADIVS.'"

As in other astrolabes, the divergent circular systems of the engraving on the mother and the rete contribute to the formal attraction of the piece, reminiscent of Gothic characteristics in contexts as diversified as triforia or rose windows in their common trellislike effect. While more direct connections with contemporary Gothic tracery may be observed in the Sloane astrolabe

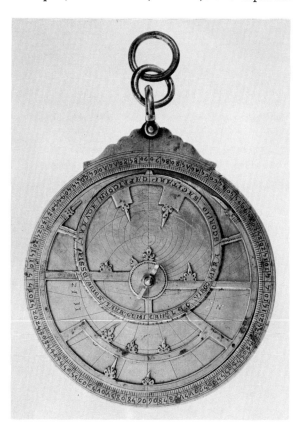

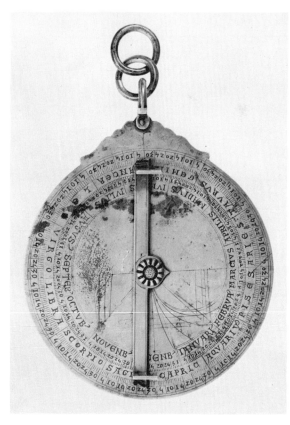

(Gunther, pl. CXXVI), the elaborate decoration of the present example reflects the interrelation among science, technological innovations, and aesthetic experience in the High and Late Middle Ages (Schapiro, 1939, p. 339, n. 73; White, 1962).

BIBLIOGRAPHY: R. T. Gunther, *The Astrolabes of the World,* Oxford, 1932, no. 161

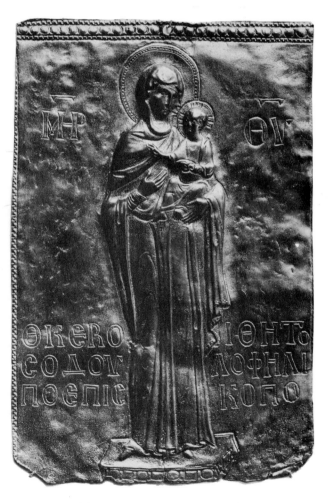

134. Plaque: Virgin and Child

Byzantium
1170–1200
Copper repoussé
21.5 x 14.5 cm. (8½ x 5¾ in.)
London, Victoria and Albert Museum,
 818.18 91

Standing on a jeweled pedestal, the Virgin turns slightly to the right and holds the Child with her left arm. The plaque, said to come from Torcello, is inscribed with a dedication to Mary by an unidentified Bishop Philip (Athens, 1964, no. 560). The Virgin is the Hodegetria type, an important and popular image from an icon supposedly painted by St. Luke. She was one of the first images represented in mosaic in the apse of Hagia Sophia after the iconoclastic controversy of 843. She was also adopted by Photius and subsequent patriarchs as the image on seals (Der Nersessian, 1960, p. 71 f.; Beckwith, 1961, p. 63, n. 15; G. P. Galavaris, "Observations on the Date of the Apse Mosaic of the Church of Hagia Sophia in Constantinople," *Actes du XIIᵉ Congrès International d'Etudes Byzantines,* II, Belgrade, 1964, pp. 107–110). The image is iconographically similar to the Hodegetria on several tenth-century Byzantine ivories (Goldschmidt-Weitzmann, II, nos. 46, 48, 49, 51). The drapery style, however, is closer to the Virgin Blacherniotissa on a late twelfth-century bronze plaque (K. R. Miatev, 1932, pp. 39–45), where the drapery also softly surrounds the face and falls over the legs in slenger oblong folds.

BIBLIOGRAPHY: K. R. Miatev, "Relief en Bronze de la Vierge du Musée de Plovdiv," *Seminarium Kondakovianum,* V, 1932, pp. 39–45; D. T. Rice, *The Art of Byzantium,* London, 1959, no. 159; Athens, 1964, no. 560

135. Shrine of St. Calmine

France
1180–1200
Champlevé enamel, copper gilt
46 x 82 cm. (18 x 32¼ in.)
Mozac, Church

Although unusual in size and quality, this shrine agrees with many other Limoges châsses in establishing a parallel between Christ and a locally venerated saint. The Crucifixion is depicted at the center front of the châsse. Directly above, on the roof, Christ in Majesty appears. Each plaque is flanked by scenes of three apostles standing under arcades. The Virgin and St. Austremoine, in mandorlas, occupy the gabled side plaques. On the back, three engravings represent St. Calmine

and Namadie, his wife, constructing the monasteries of St. Chaffie (in Mozac, Tulle, and Monastier). The back roof shows the burial of the saintly couple with the figure of the donor, Abbot Peter of Mozac, kneeling in front of an altar. The donor mentioned in the accompanying inscription: PETRUS ABBAS MANZIACUS FIAT CAPSAM FRECIO has been identified with both Abbot Peter III de Marsac (1168–1181) by Souchal, and Abbot Peter V (1252–1267), or Peter IV (elected

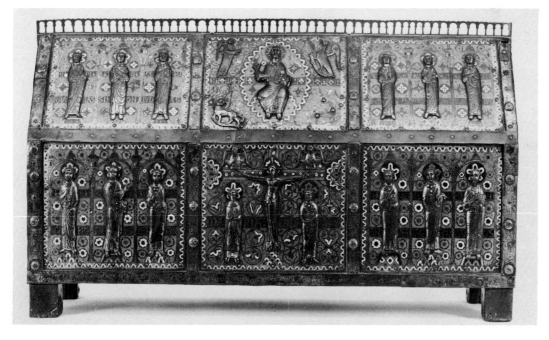

in 1243), by Marquet de Vasselot and Gauthier. Pointing to the existence of applied figures *en ronde bosse* on twelfth-century enameled works of Limoges ateliers, G. Souchal determined that it was Peter III, thereby dating the shrine around 1180. Comparing the building scenes of the shrine on one hand to a mid-thirteenth-century engraving of the same subject on the châsse of St. Fausta in the Cluny Museum and, on the other, to the Monreale mosaic of the erection of the Tower of Babel, and to the enameled building scenes of the Cologne shrine of St. Heribert, she convincingly demonstrates the earlier dating of the object. The regular drapery and straight contours of the standing figures are hieratically conceived and opposed to the lively realism of the accompanying genre scenes. A subtle modeling of the bodies, particularly evident in the figure of Christ, together with an unusually rich and inventive ornamental repertoire give this châsse a special position among Limoges objects.

BIBLIOGRAPHY: Rupin, nos. 100–107; Gauthier, 1950, pls. 38–39; Souchal, 1963, pp. 307–318; Paris, 1965, no. 445, pl. 59

136. Majesty of Christ

France, Limoges
Late 12th century
Enamel, gilt
28.8 x 13.7 cm. (11 5/16 x 5⅜ in.)
Paris, Musée de Cluny

This plaque, originally a book cover, shows Christ enthroned in a mandorla with the animalia in the spandrels. The plaque is bordered by a beaded band, as are the two framing ornamented strips of the mandorla, in highly chiseled relief. Sitting on a rainbow, his feet resting on a stool, Christ is blessing and holding a book on his knee with his left hand. Compared with the accompanying symbols, the figure of Christ is monumental in conception and size. The plaque is one of the earliest instances in Limoges production to show the heads of figures in appliqué relief; the hands and feet of Christ are reserved. Particularly striking are the three oval groups of

swinging folds in Christ's garment, set one against the other in dark and light blue, combined with a green and red edge (the green forming a shield-like pattern with the radial folds of Christ's right knee). While the lower part of the garment displays a fascinating sequence of nervously undulating bands in white, red, and light blue, the green mantle gathered over Christ's left arm presents a magnificent assembly of irregular lines, in contrast to the strict geometrical outline of his shoulders and upper arms. The raised wings of the ox and lion in the lower corners echo this pattern.

The steep verticalism seen in Christ's legs, drawn up to the center of the plaque, and the circular folds covering his body, stem from the mid twelfth-century organization of figures seen in a Danish bronze Virgin (Swarzenski, 1967, fig. 250), combined with the Byzantine technique of sharp linear modeling seen in miniature painting and enamels alike. Byzantine influence is most evident in Christ's features (Goldschmidt's comparison of the Halberstadt Christ with Byzantine ivories: 1900, p. 225 f.). The representation of the eagle with a scroll, as opposed to the other animalia carrying books, is an iconographical detail often found in southern French art, especially Limoges pieces (Schapiro, 1954; for a general discussion of the Majesty type: Van der Meer, 1938).

BIBLIOGRAPHY: Gauthier, 1950, pl. 8

137. Châsse

France, Limoges
Late 12th century or early 13th
Wood, copper gilt, champlevé enamel
22 x 19 cm. (8¾ x 7½ in.)
Brussels, Musées Royaux d'Art et d'Histoire, 2064

This object has preserved its original crest with three superimposed knobs, the center one carrying a cross. The front plaque depicts the Three Marys at the Tomb. On the sloping roof, three quatrefoils contain Christ between two angels.

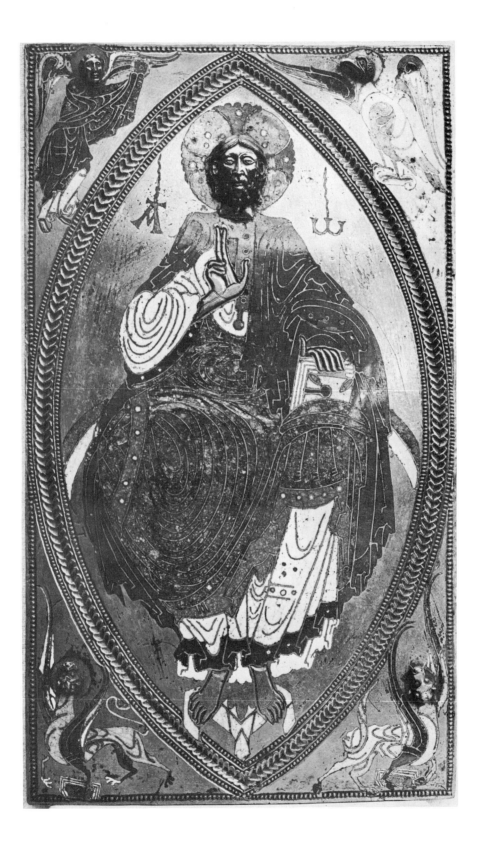

The gabled end plaques each contain a standing saint under an arcade crowned by a central tower. Stylistically, the figures are reduced and stiffly articulated, harmonizing with the formal composition of the scene. Stylized quatrefoil flowers are strewn ornamentally over the back plaques. Christ, carrying a cross-staff and book between two angels, may be understood as an abbreviated version of the Ascension, complementary to the Resurrection depicted underneath (for the ascending Christ carrying a book: T. Michels, "Der himmelfahrende Christus mit Buchrolle," *Römische Quartalschrift,* 1932). A reliquary shrine with nearly identical decoration and iconography is in the Kofler-Truniger Collection (Schnitzler-Bloch, II, p. 14, E 7, in which publication it is mistakenly suspected that the piece is identical with the present châsse). Analogies for the three Marys scene are found on a Limoges casket in Issoire (Rupin, figs. 475, 476).

BIBLIOGRAPHY: Brussels, 1964, no. 107

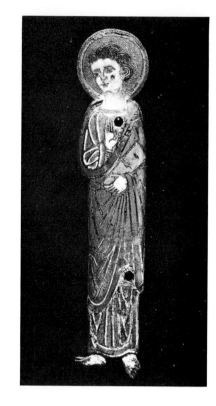

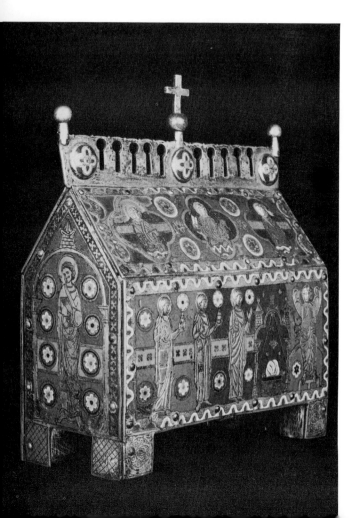

138. Saint John

France, Limoges
Late 12th century
Copper, champlevé enamel
H. 14.6 cm. (5¾ in.)
Baltimore, The Walters Art Gallery, 44.258

This standing figure was originally part of a Crucifixion scene. Two holes indicate an attachment of the relief to a metal plaque, probably of a book cover. The traditional garments (tunic and pallium), gesture of reverence, and book suggest comparisons to engraved Crucifixions of later twelfth-century Limoges book covers (Steenbock, 1965, figs. 169, 174). The type of drapery folds, reminiscent of Byzantine cloisonné enamels, and the straight, immobile posture of the saint indicate an early origin. The technique of flat relief appears contemporary with that of the Mozac châsse of 1180 (no. 135).

The sculptural compactness and linear precision differ from those of comparable standing figures produced in early thirteenth-century Limoges workshops (Gauthier, 1950, pl. 33). A

connection with an atelier active in late twelfth-century Grandmont, the monastery outside Limoges, is proposed by Verdier.

BIBLIOGRAPHY: P. Verdier, "Limoges Enamels from the Order of Grandmont," *The Bulletin of the Walters Art Gallery*, May, 1965

139. Ox and lion

France
1190–1200
Copper gilt, champlevé enamel
9.5 x 7.4 cm. (3¾ x 2⅞ in.)
New York, The Metropolitan Museum of Art,
The Michael Friedsam Collection,
32.100.290–291

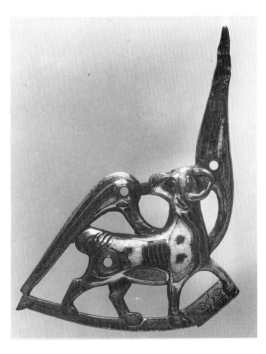

These winged symbols of the evangelists Luke and Mark are in pierced repoussé with champlevé attached in blue, white, yellow, and green. The bands beneath their feet and the three perforations for attachment visible on each animal suggest that they were originally fixed on a flat background, perhaps surrounding a figure of Christ in Majesty. M. C. Ross suggested that the pieces originally were placed on a book cover now in the Cluny Museum (Inv. no. 353), a Limoges work of the late twelfth century. Indeed, the ox and lion are missing from the lower corners of this Majesty composition. The eagle of St. John on the Cluny book cover, as in many other Limoges pieces, stands on a similar band, meant to be his scroll (for a later example, Rupin, p. 498, figs. 552–554). Whether or not the connection proposed by Ross is valid, the technical and stylistic characteristics of our fragments indicate a dating toward the end of the twelfth century. Corroboration comes from the close similarities of our plaques to the Majesty of Christ on the Mozac châsse (see no. 135), convincingly dated around 1180 by G. Souchal; the same expressive pattern formed by the animals' wings is to be noted in both cycles.

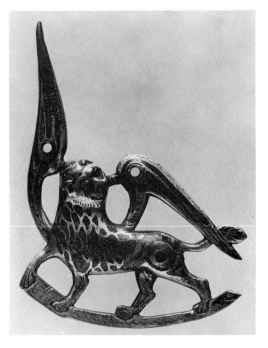

BIBLIOGRAPHY: M. C. Ross, "Two fragments from a Limoges book cover," *Revue Archéologique*, 1935, pp. 73–77

140. Châsse

Southern France or Spain
Late 12th century
Copper gilt, champlevé enamel
12.4 x 19.1 x 7.9 cm. (4⅞ x 7 x 3⅛ in.)
New York, The Metropolitan Museum of Art,
 Gift of J. Pierpont Morgan, 17.190.685–
 687, 695, 710, 711

The two front plaques of this reliquary contain the animalia flanking two floral arabesques. The lower back plaque shows the blessing Christ between saints Mary Magdalene and Martial; on the roof, the hand of God appears flanked and venerated by two censer-bearing angels. The narrow ends of the reliquary show Peter and Paul. The iconographical scheme as a whole follows a widespread tradition, but the representation of Mary Magdalene and Martial seems to point specifically to Limoges, where both saints had a special cult

(for that of Mary, V. Saxer, *Le culte de Marie Madeleine en Occident,* Auxerre Paris, 1959). The provenance of our châsse from Champagnat (Creuse) near Limoges, where it is known to have been in the mid-nineteenth century, may also indicate a Limousin origin. Hildburgh, however, attributed the enamels to a Spanish atelier in Silos and assumed that the reliquary was brought to the Limoges church of St. Martial as a pilgrim's gift. More conclusive for a Spanish origin is his comparison of the floral ornament on our châsse to that on a cover plaque of the St. Dominic casket from Silos in the Burgos museum (Hildburgh, pl. VII, fig. 7c). Beside the ornament, the type of hovering half-length figure, broadening decoratively at its base, has no analogy among Limoges pieces. Our châsse indicates the exchange in the late twelfth century between Spanish and southern French art. Whether

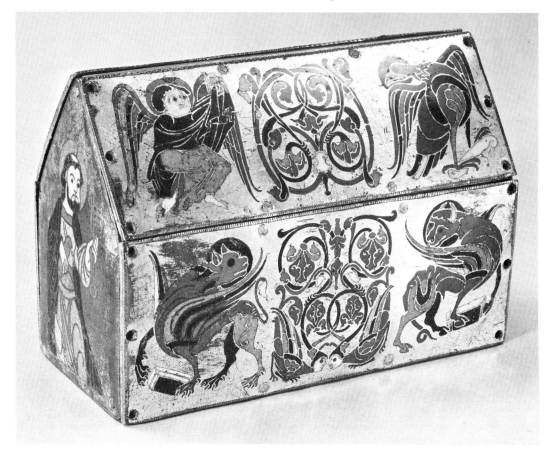

there were comparable Spanish pieces available in Limoges, or whether the artists themselves traveled, is unknown. (G. Troescher, *Künstlerwanderungen in Mitteleuropa, 800–1800,* Baden-Baden, 1953–1954).

BIBLIOGRAPHY: Hildburgh, 1936

141. Adoration of the Magi

France, Limoges
About 1190
Copper gilt, champlevé enamel
26.4 x 18.2 cm. (10⅜ x 7⅛ in.)
Paris, Musée de Cluny

The framing arch of this plaque is surmounted by walls and five round towers, indicating that the scene is an interior one, yet the second king points to the star engraved inside the arch above Mary, beside a burning lamp that hangs from the ceiling. The first king kneels on a hassock formed by stylized plants. Mary holds a scepter with her right hand (compare Christ holding a globe or host in many French representations of the Majesty: Schapiro, 1954); her left hand supports the Child as he sits obliquely on her mantled left knee. Christ's body is in reserve, his head in appliqué relief, the only such treatment on the entire plaque.

An expressive rhythm is seen in the punctuated lines surrounding the figures and articulating their draperies. Also notable is the change from the angular zigzag decoration of the supporting columns to the superbly swinging band in the arch. The intimate gesture of the last king, the meditative expressions, and the elongation of the figures and their dense grouping connect the plaque to stylistic conventions of twelfth-century French art. G. Souchal has shown that a companion plaque, also in the Cluny, represents the hermit monk Hugo Lacerta (d. 1157) with Etienne de Muret, who was canonized in 1189, and that both plaques were originally part of two cycles on the retable of Grandmont Abbey's main altar, depicting scenes from the life of Christ.

Our plaque, accordingly, can be dated to 1189 or shortly after. Its original placement in an altar retable allows two aspects of its iconography to be understood in the light of its liturgical function: the building refers to the concept of Ecclesia, which became first visible, according to traditional exegesis, on Christ's epiphany (RDK, IV, 1950, col. 476); and the similarity of the vessels carried by the Magi to contemporary chalices and ciboria illustrates the parallelism drawn in theological writings between the kings' offer to Christ and the Eucharist taking place on the altar immediately in front of the plaque (U. Nilgen, "Eucharist and Epiphany," *The Art Bulletin,* 49, 1967, pp. 311–316).

BIBLIOGRAPHY: Souchal, 1962

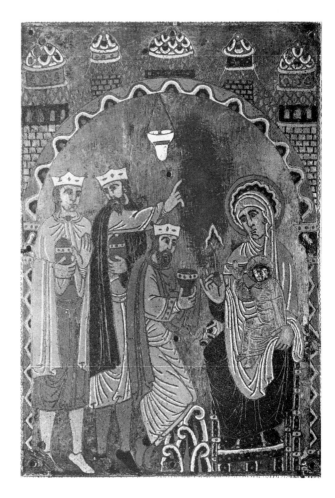

142. Châsse

France, Limoges
1200–1220
Copper gilt, champlevé enamel
20 x 28 cm. (7 7/8 x 11 in.)
Nantouillet, Church

Following a rather widespread type in Limoges production, this casket is decorated with figural scenes on the front only, the back being filled with decorative patterns, the gabled ends showing single standing figures of saints. The iconographical cycle of the piece is dedicated to scenes of the Resurrection. On the front, left to right, are the Harrowing of Hell, the Descent from the Cross, and the Apparition to the Disciples (probably on the way to Emmaus). On the lid, the Three Marys at the Tomb is followed by the "Noli me Tangere" and Mary Magdalene announcing the Resurrec-

tion to the apostles (for this rarely represented scene, Deuchler, 1967, p. 60). No chronological sequence of these scenes is evident but there appears to be a vertical relationship between the Harrowing scene and the three Marys, both referring to the Resurrection. The different scenes are not framed separately, but set continuously before an ornamented background. By this arrangement, typical of a certain group of Limoges caskets (the châsse of St. Stephen, Gauthier, 1950, pl. 10), the parallels between the three figures of Christ are especially emphasized. The motif of the figure turned to the right, while at the same time looking back, is applied even to the dead Christ in the Descent.

The type of overall ornamented background, reminiscent of Islamic metalwork, originated in the late twelfth century among Limoges pieces. The individual figures show a strong sense of

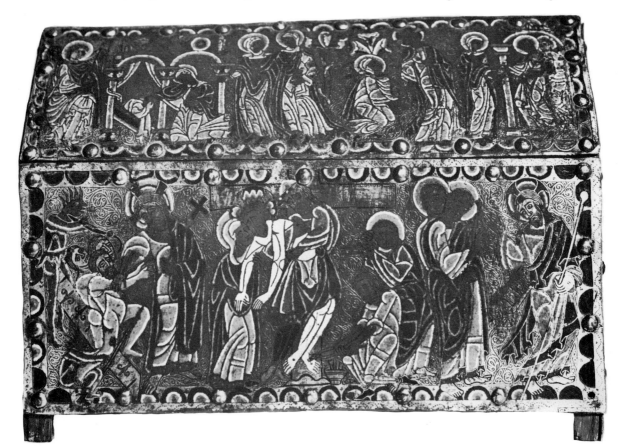

compartmentalization, achieved by simple subdividing lines. This schematic device (also found on the St. Stephen châsse referred to above), contributes to the moving tenderness in the figures of Christ and enriches the composition graphically. In the scene of the three Marys the rendering deviates from the version common in Limoges enamels by two motifs: the unusual columnar arcade representing Christ's tomb is expanded so as to form a double-arcaded structure, and the first of the three holy women is depicted in a kneeling position, grasping Christ's winding sheet (for a representation of Christ shown in a similar action on a Mosan bracelet, see no. 174). Probably inspired by the pictorial type of the Adoration of the Magi with the first king kneeling, the artist assimilated the first Mary to the kneeling Mary Magdalene in the adjacent "Noli me Tangere" and thereby enhanced the compositional unity of the lid plaque.

BIBLIOGRAPHY: Rupin, p. 367; Gauthier, 1950, pl. 11; Paris, 1965, p. 53, no. 112

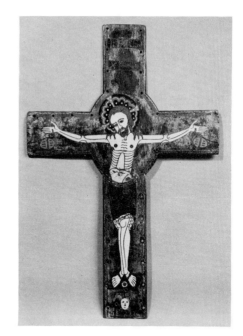

143. Crucifix

France, Limoges
1190–1200
Copper, champlevé enamel
37.5 cm. (14 13/16 in.)
Baltimore, The Walters Art Gallery, 44.83

This plaque originally formed the central part of an enamel cross; the censers visible beneath Christ's hands suggest that angels appeared on the adjoining plaques. The oval center, a typical feature of Limoges crosses, indicates that a Christ in Majesty appeared on the opposite side of the original crucifix. A fully preserved Limoges cross with a similar arrangement is in the Poldi Pezzoli Museum, Milan (Souchal, 1967, fig. 32). The drawing of Christ's chest is a reduced version of elaborate Byzantine prototypes. The concentration on a few major lines, the slight contrapposto movement, the delicate drapery of the loincloth, and the contrast of the dense articulation of

Christ's hair all contribute to the impressive graphic effect. The mentioned features and the vigorous nimbus indicate the dating. Iconographically, the four nail attachment and the open eyes are conservative motifs. The stylistic features, motifs, and technique of this crucifix appear on a group of enameled crosses assembled by G. Souchal and attributed by her to a workshop in the monastery of Grandmont, outside Limoges.

BIBLIOGRAPHY: Thoby, 1953, no. 5, pl. IV; Souchal, 1967, pp. 61–63, fig. 30

144. Crucifix

France, Limoges
1190–1200
Champlevé enamel
67 x 28 (26⅜ x 11 in.)
Cleveland Museum of Art, 23.1051

Busts of Mary and John appear on the terminal plaques of the horizontal bar. Above the titulus

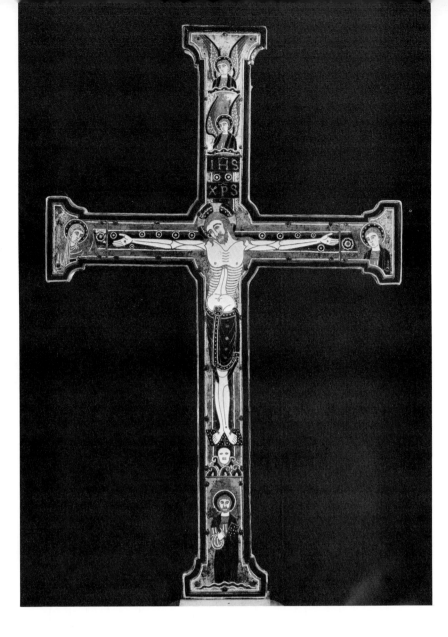

two half-figures of angels appear one above the other (this plaque, perhaps from a similar piece, was installed here in 1890). Beneath Christ's feet and the skull of Adam is the figure of St. Peter, perhaps explicable by the dedication of the church to which the Crucifix was given. The stylized anatomy of Christ's body, along with the drawing of the hair and loincloth, is masterly. Both the clear organization of the cross into separate fields and the fluid outline and balanced posture of the central figure suggest the dating given above. In shape and technique the head of the Virgin close-ly resembles that on no. 141, which is allegedly from the main altar of Grandmont Abbey (Souchal). The figure of St. Peter is similar to that of Etienne de Muret on the Cluny Museum's counter piece to no. 141 (no. 136), foreshadowing a slightly later, more classicizing phase of northern French art, as seen in no. 80. A number of closely related crosses have been grouped around the exhibited piece by Thoby and Souchal.

BIBLIOGRAPHY: Thoby, p. 97 f., no. 14, pl. X; Souchal, 1967, p. 28 f.

145. Corpus from a cross

France, Limoges
1200–1220
Gilt bronze, champlevé enamel
19 x 14.6 (7½ x 5¾ in.)
New Haven, Yale University Art Gallery,
Maitland F. Griggs Fund, 1956.17.6

The head, slightly bent, is framed by long hair. An impression of movement is achieved by the raised arms and the forward position of the left leg overlapping the right. A gentle fluidity marks the rhythm of arms, hair, and the refined modeling of the enamel loincloth. The schematic drawing of the upper body follows a widespread Byzantine convention that became the standard in twelfth- and thirteenth-century Limoges crosses. The dating of the corpus is predicated on its vigorous sculptural modeling and the expressive movement. The unusual band around Christ's neck, decorated by three diamond-shaped enamel "gems," is similar to ornamented collars seen on clothing (Gauthier, 1950, pls. 9, 17). The corpus has been ascribed to a Sienese artist by Verdier, who, overlooking iconographical parallels in Limoges crosses, "with the type of Christ dead on the cross preserving, through the assistance of the Holy Spirit, His dignity and His beauty in death itself" (Schnitzler-Bloch, pl. 50), also could not point to any Italian characteristics in the style of our object. The existence of an Italian variant of Limoges products in the twelfth and thirteenth century might be proved by other material or arguments. The iconographical type of our cross was rare, it is true, in Limoges, compared with the countless examples showing Christ with open eyes and a crown. The Limoges origin of this corpus can, however, be assumed from its style, which is met in a slightly more developed phase of Limoges works, for example the Madonna statuette in the Kofler-Truniger collection (Schnitzler-Bloch, pl. 1).

BIBLIOGRAPHY: P. Verdier, "An Italian Enameled Christ of about 1200," *Yale Bulletin*, 23, 1957, pp. 9–11

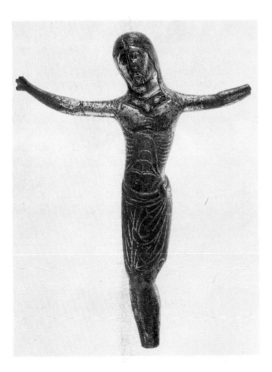

146. Book cover: Crucifixion

France, Limoges
About 1200–1210
Champlevé enamel
32.4 x 21.3 cm. (12¾ x 8⅜ in.)
New York, The Pierpont Morgan Library

This plaque is connected to a large group of similar Limoges plaques and book covers in its iconographical scheme of the Crucifixion with the Virgin, St. John, the rising Adam, the blessing hand of God, and two three-quarter figures of angels. The reserved and engraved figures, the applied heads and the pyramidal supports of the cross and the bystanders are details that are also paralleled in this Limoges group. For another example, a book cover in the Louvre (Gauthier, 1968, fig. 2). Although the present book cover was dated by Gauthier to the last decade of

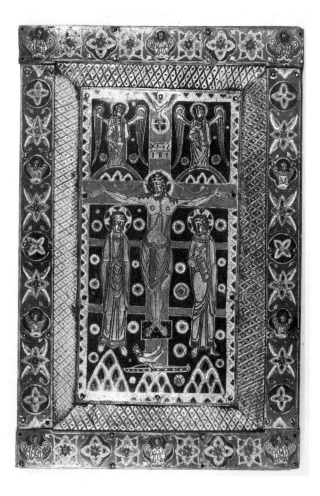

codex no. 216 a similar plaque on the front cover is a counterpiece to a Christ in Majesty on the back cover (Steenbock 1965, no. 122, pls. 168–169). This placement can be assumed for many Limoges plaques of the Crucifixion and Majesty (for a general survey, Gauthier, 1968; Steenbock, 1965, no. 127, pl. 174).

147. Christ in Majesty

France
1200–1210
Champlevé enamel
17.5 x 14.9 cm. (6⅞ x 5⅞ in.)
Cambridge, Mass., Fogg Art Museum,
1957.212

Christ is shown seated on a rainbow between alpha and omega. His head is appliqué, his body chased and engraved. His mandorla is divided horizontally by a wave pattern that is repeated in enameled variations on the rainbow throne, the borders of the mandorla, and the plaque's edge. Christ's feet rest on a curving footstool with foliate terminals that correspond to the rinceaux with enameled fleurons that fill the plaque's corners. This floral motif also appears on a Majesty plaque in the Limoges Museum (Gauthier, 1950, pl. 34) and on a book cover in the British Museum (Steenbock, 1965, no. 124, pl. 171). Although the motif is associated by Riefstahl with the Tree of Jesse imagery, a popular subject in contemporary French art, it appears more likely that it follows the widespread contemporary interest in floral patterns seen in all media (Nordenfalk, 1935). The dynamc interrelation between the figure and its geometric and floral surrounding, Christ's broad gesture, as well as the energetic drawing of the folds indicate the plaque's high quality and also its date. Although precise localization of enamels called "Limoges" is difficult, a definite northern French influence is seen in the style of the present plaque. In the form of the mandorla and the style of drapery, as well as technique, our plaque is closely related to

the twelfth century, the stereotyped appearance and the simple modeling of the figures would suggest a dating at the beginning of the thirteenth century. A close indebtedness to Byzantine sources is apparent in the noble and restrained pathos of Christ's head, surrounded by the delicate ornamental pattern of his hair as well as his raised arms and the floral tendrils on the horizontal bar of the cross. The angular curve of Adam's body is in harmony with the artist's predilection for pointed forms. An earlier version of Adam rising is seen on an almost identical Crucifixion plaque in the Kofler-Truniger Collection (Schnitzler-Bloch, pl. 15). On the St. Gallen

no. 149, attributed by Gauthier to Master G. Alpais.

BIBLIOGRAPHY: R. N. Riefstahl, "Two Medieval French Enamels," *Annual Report, Fogg Art Museum,* 1957–58, pp. 22–28

148. Book cover: Crucifixion

France, Limoges
About 1200
Bronze, copper champlevé enamel
Paris, Petit Palais

On a blue and green ground the bodies of the figures (two angels flanking the cross above, Mary and John below, Adam rising from his tomb at the foot of the cross) are reserved in copper, with the heads in bronze appliqué. The plaque is set in a deep recess, the sloping sides of which are decorated with a diaper pattern. The outer border contains rectangular fields with enameled floral designs. This book cover is typical of work produced in Limoges ateliers from 1190 on; it should be compared with no. 146 and with plaques in Detroit (no. 62.96, unpublished). On a St. Gallen

book cover (Steenbock, 1965, no. 122) the entire body of Christ is in appliqué relief. An earlier version is represented by a *vermiculé* plaque in Nevers (Gauthier, 1950, pl. 16), while a plaque in Manchester (Steenbock, no. 127) of the early thirteenth century differs slightly in the decoration of the outer frame. On our plaque, the drawing of John's gesture and the left side outline of Christ's body are weak.

BIBLIOGRAPHY: G. Cain, *La Collection Dutuit*, Paris. 1903

149. Eucharistic coffret

France
1200–1210
Copper gilt, champlevé enamel
13 x 20.2 x 12.5 cm. (5 3/16 x 8 x 4 15/16 in.)
Limoges, Musée Municipale de Limoges, 267

On the front of the coffret, Christ is flanked by St. Peter and the Virgin, enthroned, like the apostles on the other plaques, on a rainbow in a mandorla-shape; only the Virgin sits on a stool. Half-figures of angels fill the spandrels between the mandorlas; the four lid medallions contain angels in three-quarter length. The figures are re-

served and chiseled and set against an enameled background decorated with circular patterns; the heads of all the figures are applied in low relief. These technical devices became common in Limoges workshops only in the early thirteenth century. Stylistically, the coffret balances the three-dimensionally conceived figures against the ornamental rhythm of the overall pattern of enameled flowers and discs. The type of enthroned figure with energetically drawn drapery folds that suggest modeling of the body is indebted to a phase already reached in Mosan art in the third quarter of the twelfth century (Swarzenski, 1967, figs. 481–484). Indicative of the object's early thirteenth-century origin is the tendency toward systematization and unification, active both in the organization of the single figures and in the composition of the ensemble (for a broad discussion of this trend in different media of early thirteenth-century art, Panofsky, 1951). The perpetuation of this tendency resulted in the deteriorating uniformity of the later Limoges productions. The color range, technique, style, and quality of our piece led M. M. Gauthier to attribute it to Master G. Alpais, known from his signature on the famous ciborium in the Louvre (II, ill. 141; Gauthier, 1950, frontispiece). From the ring at the top it is evident that the coffret originally served as an eucharisic container hung over an altar (Sedlmayr, 1950, p. 32 f.).

Iconographically, our coffret is a major representative in Limoges art of the transition of the mandorla and rainbow from the scheme of Christ in Majesty to the apostles (Swarzenski, 1932, p. 287, n. 230). Some antecedents for this are to be found earlier in medieval art (K. Hoffmann, "Die Evangelistenbilder des Münchener Otto-Evangeliars," *Zeitschrift des Deutschen Vereins für Kunstwissenschaft*, 30, 1966, pp. 17–46). In the Limoges pieces, this transfer may be explained both by the concept of Christomimesis, characteristic of the subjective piety emerging in the twelfth century, and by the general trend toward systematization.

BIBLIOGRAPHY: Gauthier, 1950, pl. 20; Gauthier, 1964, pp. 81–83; Cleveland, 1967, IV, 35; Paris, 1968, no. 381

150. Christ in Majesty

France
1200–1210
Copper gilt, champlevé enamel
17.2 x 12 cm. (6¾ x 4¾ in.)
New York, The Metropolitan Museum of Art,
 Gift of J. Pierpont Morgan, 17.190.759

Seated on a rainbow, on which a cushion repeats the curved outline, Christ raises his right hand in blessing. His left, covered by a mantle, holds a book. The mandorla-shaped plaque combines the strict geometrical patterns seen in the shirt, book cover, and suppedaneum with the sensitive rhythm of swinging curves of the drapery and

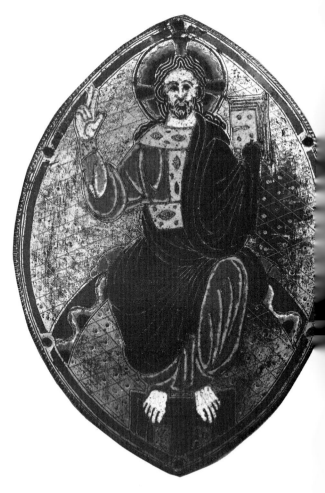

the undulating line within the rainbow. The ground of the plaque is filled with lozenges, each containing a circle motif.

This plaque may have originally been installed at the center back of a cross, but as no precise counterpiece is known, a reconstruction is not possible. Souchal connects this piece with a group of enamel plaques attributed by her to an atelier in the Grandmont abbey and dated in the last two decades of the twelfth century. But compared with the enamels in the Cluny Museum, for which a Grandmont provenance is Souchal's starting point and main argument, our plaque is definitely later. The strong Byzantinism, apparent in Christ's symmetrically framed, icon-like head, and the continuously flowing drapery, are characteristic of the first decades of the thirteenth century. Christ's arm raising the book close to his upper body probably derives from the type of half-length Christ in Byzantine art. The impressive parallelism of Christ's raised arms has an analogy in a stylistically related plaque, formerly in the Martin Le Roy Collection (Souchal, p. 54, no. XIV, fig. 21), with a half-figure of the Pantocrator. In the Le Roy piece, the wavy outline of the clouds below Christ may be compared to the undulating contour inside the rainbow-throne of our plaque.

BIBLIOGRAPHY: Souchal, 1967, pp. 30, 57, fig. 26

151. Shrine fronts of the Quattuor Coronati

France, Limoges
1200–1225
Champlevé enamel
24 x 18 cm. (9 1/16 x 7 1/16 in.)
Cambridge, Fitzwilliam Museum
24 x 18 cm. (9 1/16 x 7 1/16 in.)
Lucerne, Coll. Kofler-Truniger

Both objects originally belonged to a shrine of the legendary so-called Quattuor Coronati, four Early Christian Roman martyrs. No other part of the reliquary is known. On each of the gabled plaques two nimbused, crowned saints are shown enthroned above their tombs with bones depicted on the lid, similar to representations of Kings David and Solomon rising from their tombs in Byzantine Anastasis compositions. The accompanying inscriptions are taken from Psalm 50:10: "Exultabunt Domino ossa humiliata" and Psalm 34:21: "Custodit Dominus omnia ossa sanctorum."

A vigorously patterned floral ornament fills the ground of both plaques. Both the extended color range and the narrow drapery folds have analogies in early thirteenth-century Limoges production, suggesting this date for the pieces. In relation to other Limoges examples, even the similar shrine of St.-Viance (Gauthier, 1950, pls. 48, 49), the exceptionally high quality of our plaques is evident. The drapery style suggests a northern French model, like the (Anchin) Hrabanus Maurus (Schnitzler-Bloch, p. 21). The stylization of the sarcophagi is reminiscent of Roman late antique models, imitated occasionally in medieval representations, as the entombment of Christ in the fresco cycle of St. Angelo in Formis (Pächt-Wormald-Dodwell, pl. 112 f.).

The emphasis on God's protection of the saintly bodies in both of the inscribed Psalm verses seems to have no special connection with the Quattuor Coronati, but refers generally to the resurrection of the dead. The choice of the Quattuor Coronati might have been advanced by contemporary interest in cyclical representations of rulers, mostly from the Old Testament, in the portals and galleries of French cathedrals. On the plaque, the two seated figures were conceived as a dialogue pair, as evidenced by the direction of their heads and gestures (Saxl, 1923). A similarity in style, iconography, and function can be seen with the series of enthroned rulers on the St. Oswald reliquary in Hildesheim (II, ills. 145–148; Swarzenski, 1967, fig. 484). The martyr to the right on the Cambridge plaque (to the left on the Lucerne piece) holds the palm in a similar way to the scepter, often seen in ruler images, held by St. Sigismund on thte Oswald reliquary.

BIBLIOGRAPHY: Dalton, 1912, no. 52; Schnitzler-Bloch, pl. 39

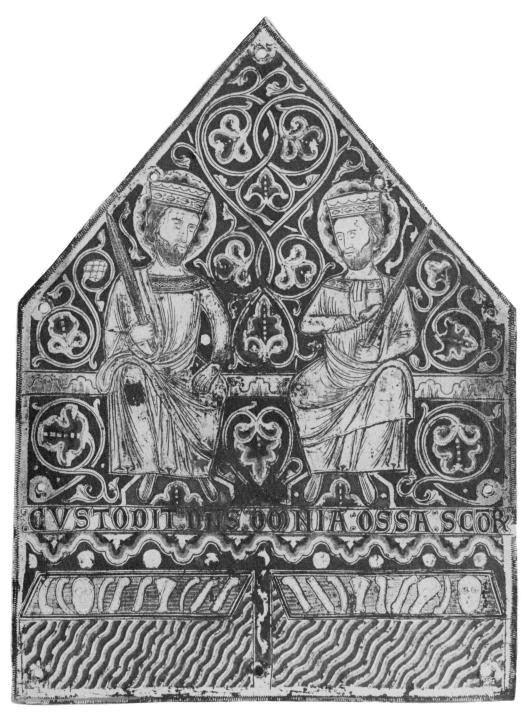

151. Shrine fronts of the Quattuor Coronati

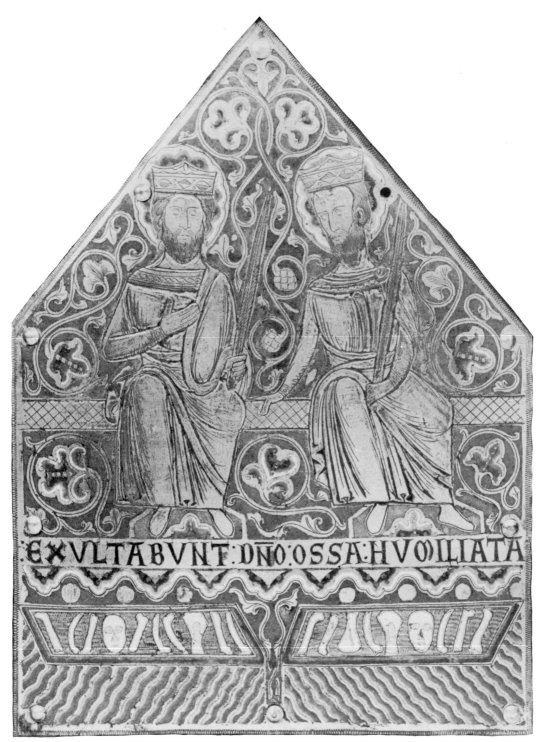

152. Seated apostle

France
About 1210
Champlevé enamel
13 x 10.2 cm. (5¼ x 4 in.)
New York, The Metropolitan Museum of Art,
 Gift of J. Pierpont Morgan, 17.190.756

This plaque was probably originally part of the decoration on a reliquary casket. The figure points to his left, perhaps to a corresponding counterpiece; both pieces probably flanked a central Christ plaque. The motif of the apostle sitting on a rainbow, together with the mandorla-shape of the plaque, was adapted from traditional representations of Christ in Majesty varying, however, the usual frontal pose and cruciform halo. Antecedents for this rare transposition are to be found in some German Ottonian images of Evangelists (Munich, Bayerische Staatsbibliothek, cod. lat. 4453, fol. 139). The metal ground, filled with a star pattern, the sideways glance, and the color choice correlate our plaque to the group of similar pieces assembled by Stohlman as the "star

group," in which two plaques with Christ in Majesty sitting on a rainbow may be found (Stohlman, figs. 12, 21).

Our seated apostle is distinguished by a vivid animation both in gesture and drapery style. The mantle's folds running in broadly swinging curves suggest a spatial encircling of the figure. This type of drapery organization, as well as the comparable one of the Hamburg Christ plaque (Stohlman, fig. 12; for the fragment in Neufchâtel-en-Bray, Musée Mathon, see Rupin, 1890, p. 146, fig. 220, pl. XXV, figs. 344, 345), presuppose a knowledge of some northern French or Mosan work of the beginning of the thirteenth century, prior to the work of Hugo of Oignies. Although the "star group" lacks a precise chronology, this connection would indicate a date prior to 1225 for our plaque. As to the localization, Stohlman accepts the traditional Limoges nomination.

BIBLIOGRAPHY: Stohlman, 1950, no. 14, fig. 11

153. Annunciation

France, Limoges(?)
1200–1230
Copper gilt, champlevé enamel
23.2 x 28 cm. (13½ x 12⅛ in.)
New York, The Metropolitan Museum of Art,
 Gift of George Blumenthal, 41.100.180

The enameled figures appear on a ground filled with stars of different shapes. The angel, approaching from the left and carrying a scroll inscribed AVE MARIA GRASI[A], addresses Mary, whose hands are raised in a gesture of surprise and defense, and who looks modestly at the messenger. The staring eyes turned to the side, and lively gestures of both figures, concentrate the action.

Whereas the ornamental star-motif connects our piece to a group of related works (Stohlman's "star group"), it is unequaled in its wide color range, as seen in the Virgin's green tunic, the angel's turquoise tunic, and their dark blue cloaks. The chronology of the group assembled by Stohl-

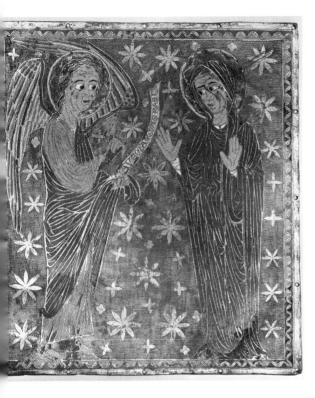

154. Châsse

France, Limoges
Early 13th century
Copper gilt, champlevé enamel
25 x 23.5 cm. (9¾ x 9½ in.)
Brussels, Musées Royaux d'Art et d'Histoire,
2065

The rectangular casket, surmounted by an arcaded crest with three knobs, shows, on the principal plaque, Christ between the saints Peter and Paul. Each one sits on a rainbow in a circular medallion. Above, corresponding medallions contain three-quarter-length figures of angels emerging from clouds. The two narrow gabled ends each show a standing saint while the back plaques are limited to ornamental decoration of interlacing diagonal patterns and starlike forms. The coherent geometrical composition of circles, flowers, and appliqué rosettes connecting the medallions on the main plaques corresponds aesthetically to those of the back. While stylized plants of tender linear rhythm accompany the seated figures, the decoration of the back plaques emphasize dynamic inventiveness and vigorous compactness.

This châsse is similar in style, technique, and ornament to the coffret in the Limoges Museum attributed by M.-M. Gauthier (Gauthier, 1964)

man has not yet been established. In our piece, the dense sequence of fine folds, and the iconographical scheme, clearly point to a Byzantine prototype. On the other hand, some details such as the undulating folds over Mary's belt and feet indicate a knowledge of early thirteenth-century Ile-de-France art. These similarities would limit the chronological position of the plaque to the period before about 1230. Another Annunciation from the "star group" occurs on the back of a reliquary chest in the National Museum, Copenhagen (no. 9109; Stohlman, fig. 1), and shows the deterioration of the type, probably at a slightly later date. Doubts occasionally voiced against the authenticity of the present plaque would not appear convincing in view of its art historical connections pointed out by Stohlman.

BIBLIOGRAPHY: O. Falke, "Romanische Emailarbeiten von Limoges," *Pantheon*, 1931, pp. 282–285; Stohlman, 1950, pp. 327–330

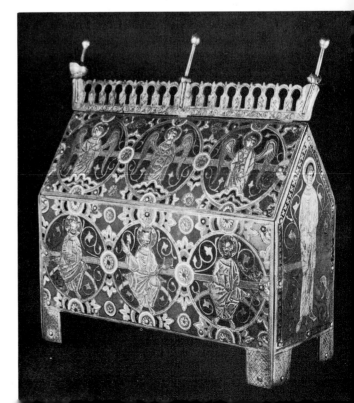

to Master G. Alpais. In spite of some differences (no continuous cycle of enthroned figures on all four sides, more floral than geometrical patterns, instead of St. Paul, Mary combined with Christ and St. Peter on the main front), the same attribution could be advanced for the Brussels châsse, which is of equally high quality.

The motif of Christ raising his right hand, offering a book and flanked by Peter and Paul stems from the Early Christian composition of the *Traditio Legis*. Notwithstanding a possible iconographical significance, the diagonal cross pattern predominant on the back plaques descends from a late antique and early medieval tradition, in which specific meanings were attached to these geometrical configurations (Elbern, 1955/1956).

BIBLIOGRAPHY: Brussels, 1964, no. 106, pls. XLVI–XLVII

155. Two medallions

France, Limoges
Early 13th century
Champlevé enamel
D. 7.3 cm. (2⅞ in.)
Copenhagen, National Museum

A jongleur dances in front of a seated harpist on one plaque; on the other, a violinist plays for a dancing girl. The ground of both plaques is filled with a variety of enameled circles: the figures are reserved, the heads in relief. The figures are drawn with a few firm strokes. The interplay between ornament and figure, and the delicate, rhythmic, curved outline of the harp are distinctive. The imagery suggests that the medallions had a secular use. The technique, style, proportion, and iconography indicate a date in the third decade of the thirteenth century. An early instance of comparable secular scenes appears on a Reims tympanum of the end of the twelfth century (*Kunstchronik*, II, 1958, p. 49, fig. 4). The emphasis on musical activities is also to be seen on two contemporary caskets, one in London (no.

173), the other in Varenne (Paris, 1965, pls. 100, 101). The grouping of harpist and jongleur succeeds earlier medieval representations of the dancing David (Heimann, 1964), which in turn succeeded the antique formula of a jongleur dancing upon his hands. These medallions probably originally decorated a secular casket.

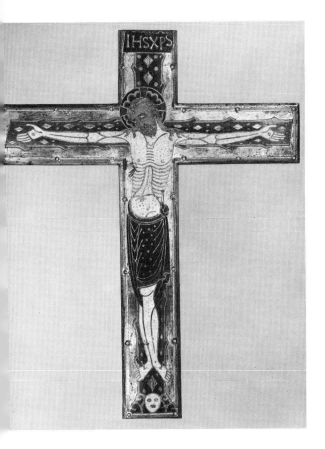

156. Crucifix

France
About 1200
Copper, champlevé enamel
56.5 x 30 cm. (22⅜ x 11¾ in.)
New York, The Metropolitan Museum of Art,
 Gift of J. Pierpont Morgan, 17.190.409

A particularly expressive Christ is represented on a tree-cross that is studded with lozenge and circular patterns indicating jewels. His arms are stretched out in a slightly curved horizontal line; the structure of his body is evoked by parallel lines and is shown in a slightly swinging posture. Although the legs overlap, the feet are attached separately, contrary to the usual contemporary one-nail fastening. Similar examples exist in museums in Cleveland, Saumur, Bordeaux, and Paris (Cluny) (Souchal, figs. 4, 6–9). With our example these crosses constitute the main portion of a group assembled by Geneviève Souchal and attributed by her, on grounds of style and tech-

nique, to the monastery of Grandmont, a suburb of Limoges. Combining Byzantine and northern French influences, our crucifix is characterized by calm nobility and restraint. While lacking the mandorla-shaped protrusion at the intersection used in the related crosses, our crucifix emphasizes the concept of the cross as the Tree of Life, even framing Adam's skull with stylized plants at the base. For a passage from the writings of Stephen of Muret, founder of the order of Grandmont, about the meaning of Adam's skull beneath the cross, see Souchal, p. 41.

BIBLIOGRAPHY: M.-M. Gauthier, "Le goût Plantagenet," *Stil und Uberlieferung, Akten des Internationalen Kunsthistorischen Kongresses* (Bonn, 1964), Berlin, 1967, I, p. 148, no. 27; Souchal, 1967

157. Crosier

France, Limoges
About 1210–1220
Copper, champlevé enamel
27.5 x 10 cm. (10 13/16 x 3 15/16 in.)
Carpentras, Musée d'art Sacré

The cylindrical staff is covered by a system of lozenges showing alternating dragons, engraved in an upright heraldic position, and enameled scrolls. The low, broad knob is divided into four medallions with half-length figures of apostles, the heads applied in relief. The small circular plaques that connect the medallions contain half-figures of angels. The spandrels are filled with floral motifs. In the center of the volute, representing a winged monster's tail, is a large floral form of multicolored enamel, ending in five petals. The motif of the dragon facing downward is derived from twelfth-century Mosan chandelier feet. During the thirteenth century Limoges ateliers produced some thirty crosiers with volutes of stylized petals. The shafts, knobs, and volutes, vary in form, technique, and ornamental details, testifying to the artist's inventiveness. According to Marquet de Vasselot, who rejected local tradition that dated the crosier to the tenth century, the dominating floral pattern is derived

from the tradition of decorative initials in French twelfth-century illuminated manuscripts, particularly illuminations from Limoges ateliers early in the century. Despite the difficulty in establishing an exact chronology, our crosier is probably one of the earliest in the series. It is certainly one of the best in quality. A particular clarity and order is apparent not only in the geometrical disposition of the individual parts, but in the proportion of the whole as well. The craftsmanship, system of lozenges, ornamentation of the medallions at the knob, and the harmonious and vigorous spirit of the whole are reminiscent of the artistic achievements of Master G. Alpais.

BIBLIOGRAPHY: de Vasselot, 1941, pp. 186–188, no. 9

158. Crosier

France, Limoges
Early 13th century
Copper, silver, enamel
Poitiers, Musée Municipal, 3897

This object is decorated entirely with floral motifs, the lozenges on the staff and the medallions of the solid knob ending in intertwining branches (for a similar treatment on an English crosier in the Bargello: Swarzenski, 1967, figs. 451, 452). The upper staff and volute are decorated with alternating bands of silver and copper. A large five-petaled flower is affixed to the volute (compare no. 157 as well as a dragon aquamanile, Falke-Meyer, pls. 106, 107). All crosiers with large

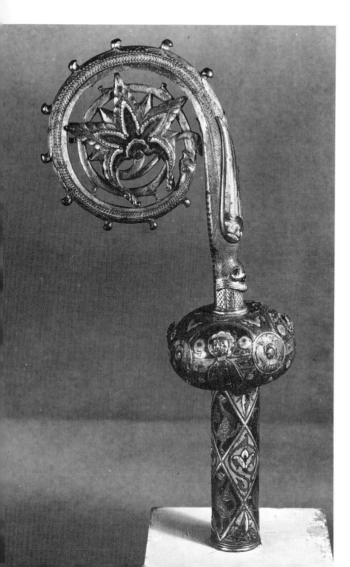

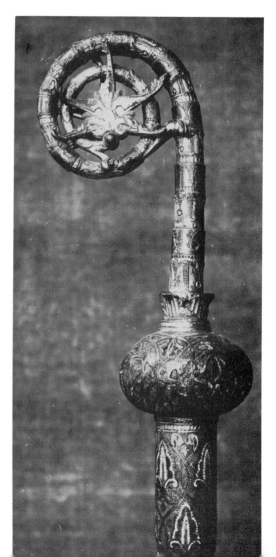

flowers attached to the volutes are products of the early thirteenth century, testifying to the preference for floral ornament in this period (Behling, 1962; Nordenfalk, 1935). The meaning of the decoration of volutes in this manner was recognized in the mid-nineteenth century as a symbolical association of the floral motif with the biblical concept of Aaron's Rod (de Vasselot, pp. 23–25). The type of solid knob derives from Mosan art (the precentor's staff in Cologne: Swarzenski, 1967, fig. 455); in some later Limoges crosiers it was divided vertically and figures were applied, in others the knob was worked *à jour*.

BIBLIOGRAPHY: de Vasselot, 1941, p. 185 f., no. 8; Vatican, 1963, no. 108

159. Tabernacle

France, Limoges
Early 13th century
Copper gilt, champlevé enamel
36.2 x 15.5 cm. (14¼ x 6¼ in.)
New York, The Metropolitan Museum of Art,
 Gift of George Blumenthal, 41.100.184

The lower front and back plaques represent the Crucifixion and St. Peter; the ends show the three Marys at the Tomb and the enthroned Virgin. Three of the four roof plaques contain medallions with half-figures of angels holding books, the fourth, above the Crucifixion scene, shows the blessing Christ with two angels flanking his feet. The heads of the figures in the plaques depicting the Crucifixion and Christ blessing are, unlike the rest, in appliqué relief. Iconographically, the correlation of St. Peter and Christ crucified is rare. The grouping of the two other main scenes is emphasized by the lily-scepter held by the angel at the tomb and Mary. The rare analogy of Mary sitting within a mandorla is mainly found in French art of the twelfth century (A. Grabar, "The Virgin in a Mandorla of Light," *Late Classical and Medieval Studies in Honor of Albert Mathias Friend, Jr.*, Princeton, 1955, pp. 305–311). All

examples except ours show Mary with her child. While the disposition of the accompanying three medallions with angels, and the rainbow as Mary's throne, are transferred from representations of Christ in Majesty, analogous images of St. Peter enthroned are found on other Limoges caskets (Gauthier, 1950, pl. 51). On the famous eucharistic tabernacle in the Limoges museum (no. 149), Mary and St. Peter are enthroned on either side of Christ, encircled, as he is, by a mandorla. The Virgin with St. Peter probably refers to the

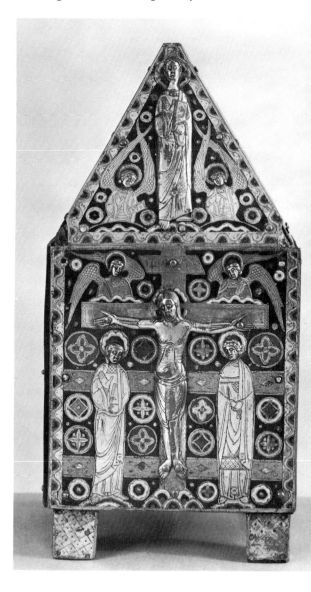

concept of the Church. The prominence of scenes from the Passion would indicate that our casket was not a reliquary but a tabernacle for the eucharist (compare example from Schloss Tussling, Munich, 1960, no. 111, p. 98). The exuberant ornamental design and certain details, such as the movement and drapery of the angel on the tomb, indicate the dating given.

BIBLIOGRAPHY: Rubinstein-Bloch, 1926, pl. XIV (left)

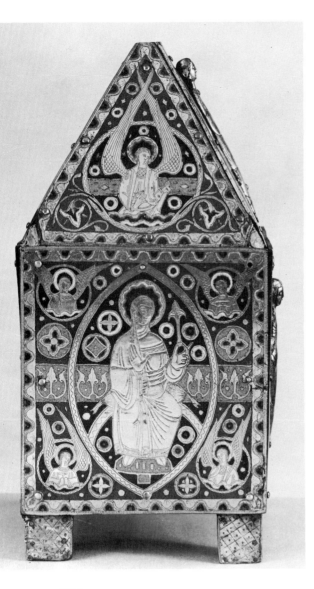

160. Casket

France
About 1220–1230
Wood, enamel, copper gilt
18.7 x 45 x 22 cm. (7⅜ x 17¾ x 8⅝ in.)
New York, The Metropolitan Museum of Art, Gift of J. Pierpont Morgan, 17.190.511

This object is ornamented with thirty enameled circular plaques with designs of scrolls, mythical beasts, warriors, and rosettes, in various colors on a blue ground, and is studded with nails. The copper-gilt hinges are chased with rinceaux. An enameled band with floral ornament is on the cover; the gilt clasp is in the form of a dragon. Lacking heraldic significance, the beasts and warriors may be interpreted as guardians of the jewels originally preserved in the casket. In function, shape, and decoration, this casket, a secular reliquary (for a comparable late thirteenth-century coffret: Paris, 1965, no. 95), may be derived from classical *scrinia,* or more directly, from Byzantine caskets decorated with similar assemblies of warriors, animals, and genre scenes. The type and composition of the plaques have antecedents in an early twelfth-century coffret at Conques (Paris, 1965, no. 545, pl. 51). A comparable grouping of mostly secular scenes is seen as early as the ninth century in a St. Stephen reliquary in Vienna (for its interpretation: M. Schapiro, 1963).

Historically significant as a rare, early example of a casket designed for the private use of a feudal

people, this object belongs to a sizable group as yet not fully studied. A later group of medieval marriage caskets has been assembled and analyzed by Heinrich Kohlhaussen (1926). The possible literary (chivalry romance), iconographical (calendar illustrations), and visual (Oriental art) sources of our casket have yet to be defined. The technique and the energetic mobility and succinct draping of the figures suggest the date indicated above.

BIBLIOGRAPHY: Marquet de Vasselot, *Les Crosses Limousines,* Paris, 1942, p. 130; Luigi Mallé, "Antichi smalti cloisonnés et champlevés dei secoli XI–XIII in raccolte e mn sei del Piemonte," *Società Piemontese di Archeologia e di Belle Arti, Bolletino,* IV–V, 1950–51, pp. 54–136

161. Four apostles (?)

France, Limoges
About 1210
Bronze gilt, appliqué reliefs
H. 10.5, 10.5, 9.5, 9 cm. (4⅛, 4⅛, 3¾,
 3 9/16 in.)
Baltimore, The Walters Art Gallery, 53.44–47

Varying slightly in size, proportion, and gesture, these four standing saints were once fastened to a metal plaque, with a ground of floral engravings, a characteristic background for Limoges appliqué relief figures (Gauthier, 1950, pl. 33). The heads were cast separately and attached to head-shaped bosses. Three of the figures hold jeweled books, the fourth carries a scroll inscribed DEVS MEVS, and from this scroll an identification with the apostles is probable. The fine linear swing of drapery suggests figural volume. A rather advanced chronological position is suggested for the cycle from the elongated proportions of the figures, the vivid sculptural treatment, and the standardization resulting from the uniformity of drapery formulas and heads. A standing appliqué saint in the Cluny Museum (Gauthier, 1950, pl. 33), with its rigidly vertical outline and hieratic frontality, may, despite dissimilarities, have been produced at about the same period,

attesting to the simultaneous presence in Limoges ateliers of conservative and progressive artists. Closer to our group is an angel in the Kofler-Truniger Collection (Schnitzler-Bloch, pl. 54).

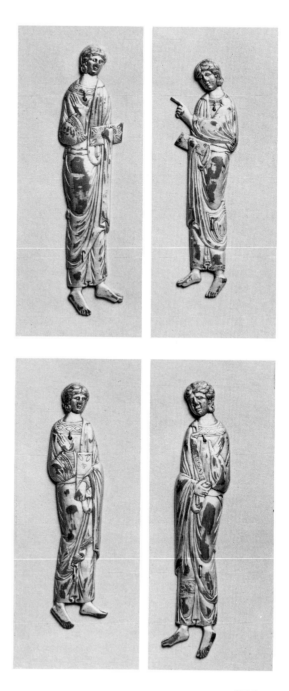

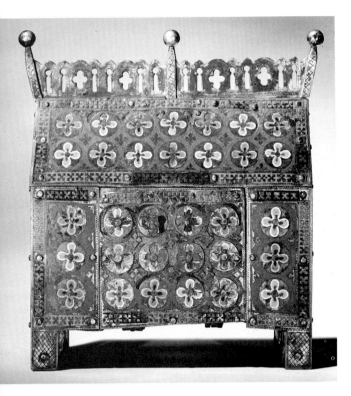

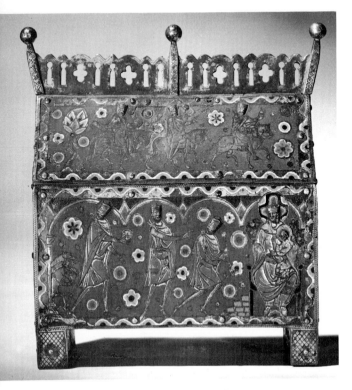

162. Châsse

France, Limoges
1220–1230
Bronze gilt, champlevé enamel
22.6 x 24 x 8.1 cm. (8⅞ x 9½ x 3⅜ in.)
Philadelphia, Museum of Art, Gift of
 Henry P. McIlhenny

The three Magi are represented as horsemen on the front roof plaque and in adoration on the plaque beneath, from which program the use of this container for the kings' relics can be concluded. The back plaques contain quatrefoil ornaments enclosed in medallions, the end plaques show standing saints under an arcade crowned by a tower. The well-preserved crest is decorated with a series of two arcades, or keyholes, alternating with a large quatrefoil that corresponds to the principal motif of the back plaques. Only the heads are applied in relief. The engraved figures are suggested by a few firmly drawn strokes; the high development of this technique is seen in the elegant, triangular stylization of the third king's mantle. Seated frontally, the Virgin embraces the blessing Child in a rare gesture that causes a swinging outline of her mantle on both sides. Another unusual motif is the low stair of bricks placed between the first king and the throne (for the St. Sabina door relief of the Adoration with an elevated throne: W. F. Volbach, *Early Christian Art,* 1961, pl. 103). The broad, undulating ornamental waves at the edges, and the tree at the upper left, indicate the artist's adherence to motifs characteristic of late twelfth-century Limoges production (for the tree on the Malval chasse: Gauthier, 1950, pl. 10, as opposed to the later type of tree on the St. Sernin coffret: *ibid.,* pl. 28). A more pointed version of the quatrefoil motif of the back plaques, probably of slightly later date, occurs on a casket in the Louvre (Gauthier, 1950, pl. 32). For a comparison of the standing saints, see a châsse in the Kofler-Truniger Collection (Schnitzler-Bloch, pl. 30, E 6). The subject of the Magi's journey became especially popular in the period 1220–1230 (Swarzenski, 1967, figs. 502–503); for the differing "High Gothic" rendering of the subject, see a plaque of about 1260–1270 in the Kofler-

Truniger Collection (Schnitzler-Bloch, pl. 18, E 44). Apparently the horseman motif appealed to the chivalric taste. Similar riders surrounded by identical circular ornaments were produced at the same period from the same ateliers. For a secular example: Gauthier, 1950, pl. 24.

163. Châsse

France, Limoges
1220–1230
Copper, champlevé enamel
21.9 x 7.9 x 18.4 cm.
 (8 11/16 x 3⅛ x 7¼ in.)
Baltimore, The Walters Art Gallery, 44.288

The lower front plaque presents Mary and the Child enthroned on a rainbow and the three Magi, each in a columned arch. The front roof plaque shows the Magi riding. The back plaques are filled with floral designs enclosed in squares. On each gabled end plaque is a standing saint, probably an apostle, enclosed in a mandorla that interrupts a rainbow. The kings' postures and Mary enthroned with her feet suspended suggest a manneristic type of instability and fragility. The type of saints in mandorlas and the vigorous floral ornament are associated with Master G. Alpais, (compare no. 149, also a contemporary casket from the Kofler-Truniger Collection: Schnitzler-Bloch, pl. 30). The present châsse is similar to no. 162 in shape, technique, and program (except that the riding figures are not repeated). The drapery treatment and the ornament of the back plaques point to a somewhat later date for this piece.

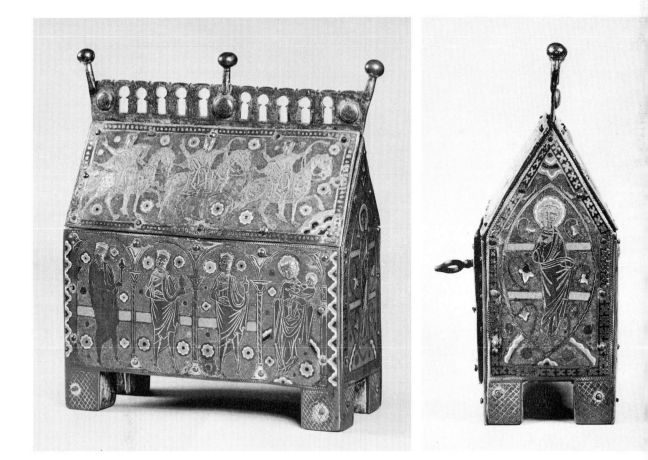

164. Thomas Becket reliquary

France, Limoges
1230
Copper gilt, champlevé enamel
17.8 x 20.8 x 7.7 cm. (7 x 8 3/16 x 3⅛ in.)
Oberlin, Oberlin College, Allen Memorial
 Art Museum, 52.20

The murder of St. Thomas Becket appears on the lower front plaque and his burial is represented on the roof. Following the usual program of Limoges châsses, the back plaque and roof are decorated with a simple star motif. Two unidentified standing female saints occupy the reliquary's gabled sides. Typical of early thirteenth-century Limoges pieces, the figures' heads are in appliqué, and the front and roof plaques are bordered by a broad, undulating ornamental wave. The remarkable freedom in the subtle compositional arrangement of the two executioners handling the sword

and ax is not repeated in the burial scene, where the kneeling figures symmetrically flank the tomb and the blessing bishop behind it. Becket scenes were very popular on contemporary Limoges châsses (Rupin, p. 396 f.; Gauthier, 1960, pl. 29; Cleveland, 1967, p. 116), prompted by the dispersal of his relics after his exhumation in 1220 (T. Borenius, *St. Thomas Becket in Art,* London, 1932, pp. 88–92). The nervous lines of the drapery folds and the active postures of the two murderers, together with the mass production character of the back plaques, would seem to date this piece to the third decade of the thirteenth century. A late thirteenth-century version of the subject illustrates the succeeding stylistic changes (Gauthier, 1950, pl. 57).

BIBLIOGRAPHY: C. Parkhurst, "Preliminary Notes on Three Early Limoges Enamels at Oberlin," *Allen Memorial Art Museum Bulletin,* IX, 1952, p. 92 f., pp. 96–105, figs. 4–8

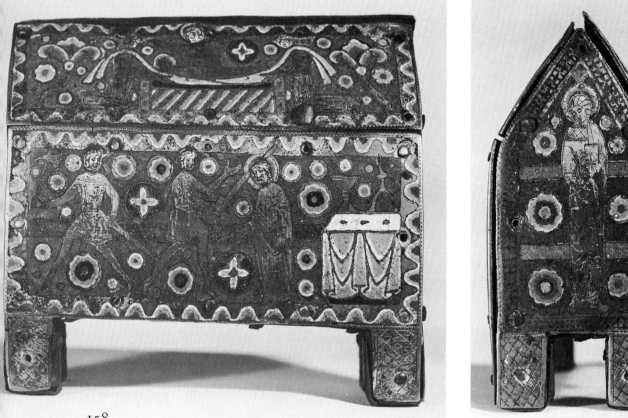

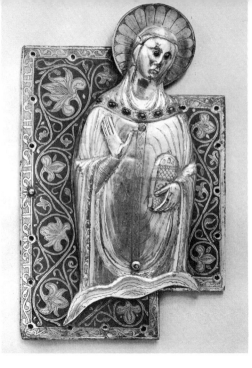

may well be of the same date, testifying to the diversity of stylistic phases practiced side by side in a Limoges workshop of the early thirteenth century.

EXHIBITION: *An Exhibition of Treasures of the Walters Art Gallery, Baltimore, Md.*, Wildenstein, New York, 1967, no. 91

166. Eucharistic dove

France, Limoges
Early 13th century
Bronze gilt, champlevé enamel
17.8 x 22.8 cm. (7 x 9 in.)
Buffalo, Albright-Knox Art Gallery

A magnificent example of a type of container often made in twelfth- and thirteenth-century Limoges ateliers, this was originally suspended

165. Virgin

France, Limoges
About 1210–1220
Copper gilt, appliqué, champlevé enamel, jewels
26.4 x 16.4 cm. (10 5/16 x 6 7/16 in.)
Baltimore, The Walters Art Gallery, 44.22

Originally attached to the left arm of a large cross, this applied half-length figure of the mourning Virgin emerges from a wavy band of clouds and overlaps the upper border with her large nimbus. She wears a chasuble, the folds forming a large elliptic design, and holds a book resembling a pyx or tablet. Stones in glass paste decorate her collar, and she is surrounded by a magnificent pattern of rinceaux and fleurons. The slightly oblique position of her head harmonizes with the noble melancholy of her expression. The cross arm is bordered with an engraved vinelike plant that is transformed, at the left, into a pseudo-Kufic script. A similar half-figure of the Virgin, of not so high a quality, is to be seen on plaque E 64 in the Kofler-Truniger Collection (Schnitzler-Bloch, pl. 41). A similar elliptic organization of drapery occurs on the Mary of the Annunciation plaque in the Cluny Museum (Gauthier, 1950, pl. 17). Despite their other differences, this Annunciation plaque and the exhibited piece

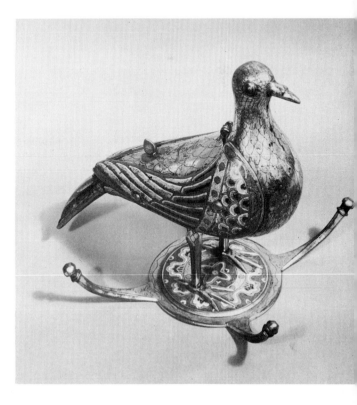

above an altar with chains attached to the four curved arms of the base. A plate, hinged at the back of the bird's neck, opens for insertion of the wafers. The body is reserved and engraved, the wings and tail enameled. Although the feathers are indicated only schematically, the lively conception testifies to the increasing inclination toward naturalism. The complex, enameled rosette, centered on a four-pointed star on the base, is seen in Limoges productions of the thirteenth century. Differing from earlier stylized doves (symbolizing the third person of the Trinity), this piece is a sculptural monument in miniature and invites comparison with eagle lecterns, as recorded by Villard de Honnecourt (*Villard de Honnecourt,* New York, 1959, fig. 52). The use of doves as eucharistic containers, symbolizing the transubstantiation according to the liturgical epiclesis prayer, is documented from Early Christian times (for the tradition of the custom in twelfth-century France, G. Bandmann, "Ein Fassadenprogramm des 12. Jahrhunderts und seine Stellung in der christlichen Ikonographie," *Munster,* V, 1952, pp. 1–21). According to Georg Swarzenski (G. Swarzenski, "A Masterpiece of Limoges," *Boston Museum of Fine Arts Bulletin,* XLIX, 1951, pp. 17–18) "a fine eucharistic dove and a Limoges dove are in fact almost synonymous. In creating this type Limoges was in free accord with the general mood for objects in shape of animals. One cannot help thinking of the contemporary northern aquamanilia; but one realizes that no aquamanile is found in Limoges. On the other hand, birds are exceptionally rare among aquamanilia, but are a favorite motive for Islamic objects. The outstanding merit of a Limoges dove is the combination of engraved gilded copper with variegated enamels and the unification of the two heterogeneous media is a work of plastic corporeality and insinuating realism."

BIBLIOGRAPHY: Rupin, II, pp. 228–230, fig. 295

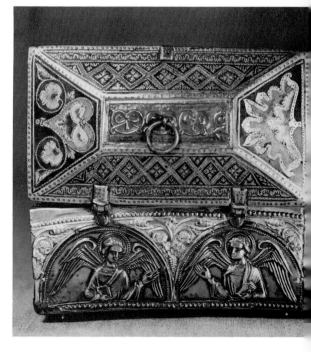

167. Casket

English or Mosan
1180
Embossed silver, champlevé enamel
5.7 x 5.8 cm. (2¼ x 2 5/16 in.)
Cambridge, Fitzwilliam Museum,
McClean Bequest, 58

From the similarity in shape to the Limoges eucharistic coffret (no. 149) and the presence of a ring, it is likely that this casket also served as a eucharistic container and that it hung over an altar. The four sloping fields of the flattened pyramidal roof are decorated with geometrical and floral motifs. The sides of the casket show half-figures of angels in semicircles, stemming from Byzantine prototypes. The motif of a half-figure in a semicircular field was very popular in Mosan goldsmiths' work of the third quarter of the twelfth century (arm reliquary of Charlemagne: Deér, 1961, figs. 3–4; Swarzenski, 1967, 498). An idea of the Byzantine prototype is provided by no. 76. A lower-Saxon plaque (no. 114)

testifies to the widespread use of this composition toward the end of the twelfth century. The possibility of an English origin for our casket is suggested by the striking similarity of the foliage ornament in the spandrel with that on a lead font at Walton-on-the-Hill, Surrey, and the leaves of the enamel decoration to English metalwork like that seen on the Balfour ciborium (Zarnecki, 1957, p. 30, pls. 16–17). Whether these connections are to be explained by Mosan influence on English artists or by an actual English origin of the piece is not known. The books held by the angels are perhaps traceable to the traditional representation of the symbol of St. Matthew, an angel, carrying a book. The choice of the angels for the decoration of an eucharistic coffret can be understood iconographically as a reference to the eucharist as the food of angels.

BIBLIOGRAPHY: Manchester, 1959, no. 95; Swarzenski, 1967, fig. 499

168. Plaques with Saints Peter and Paul

England (?)
Late 12th century
Champlevé enamel
8.6 x 12.7 cm. (3½ x 5 in.)
I. New York, The Metropolitan Museum of Art, Gift of J. Pierpont Morgan, 17.190.445
II. Lyon Museum, 188
III, IV. London, Victoria and Albert Museum, M. 312–1926, 223–1874
V, VI. Dijon Museum, 1249, 1250

These six plaques together with one in Nuremberg (Chamot, pl. 10) once decorated an altar or reliquary probably destined for a church of the saints' patronage. The English origin traditionally claimed is not conclusive. The source of their style is in Mosan enamel production of the third quarter of the twelfth century, where a close interrelation existed in Mosan, northern French,

and English enamel work and miniature painting (Swarzenski, 1932). Swarzenski's dating of the plaques to 1160 would seem to be too early. The common Mosan inspiration of both media allies our series to contemporary objects of lower Saxon origin. The seated figures of a Greek, Plaque IV, and Paul, Plaque I, closely resemble an enthroned physician in a manuscript of unknown provenance in Harley, British Museum, Ms. 1585 (Swarzenski, 1967, fig. 483), which figure in turn has been compared to the figure of St. Sigismund from the Hildesheim Oswald reliquary and connected to England (Swarzenski, 1932). Our group of plaques has similarities to later English works. The freely undulating drapery and movement, particularly of Paul on Plaque IV and the right-hand man on Plaque V, would seem to anticipate the spirit of figures seen on an enameled English casket generally dated around 1200 (Swarzenski, 1967, fig. 489) and on a related plaque with the Baptism of Christ (ibid. fig. 491). The short stature of St. Peter on Plaque VI and the tense faces of both Peter and Paul recall the York statues, no. 30, and the standing figures of the lavabo in the priory of Much Wenlock, Shropshire (Zarnecki, 1953, fig. 113). The posture of the kneeling blinded Saul, Plaque II, has the impressive touch of a pathos formula. Pointing to the half-figure of Christ appearing from a cloud, the man nearest Saul turns back in a manner similar to that of the middle king in a contemporary Adoration scene (no. 141). The modeling of the faces, except for the pointed omega-shaped beards, is much reduced, contrasting curiously with the agitated posture of the man grasping Paul's arm on Plaque III. On three plaques, IV, VI, and the Nuremberg example, the formula of a speaking man is repeated at the left. This is not a compositional weakness, but rather a correlating device.

The scene of the apostles disputing Nero, Plaque VI, resembles an illustration of the same episode in a late twelfth-century drawing (Boeckler, 1924, fig. 49). An eleventh-century Regensburg manuscript, Clm. 18128 (E. F. Bange, *Eine bayerische Malerschule des 11. und 12. Jahrhunderts,* Munich, 1923, p. 18, fig. 44), offers an ear-

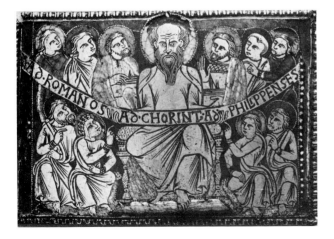

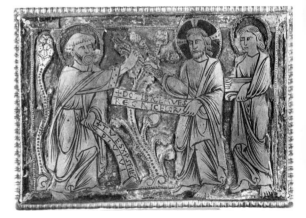

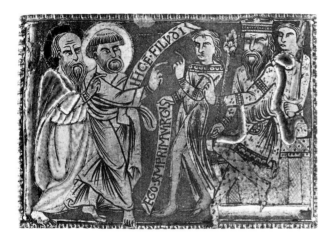

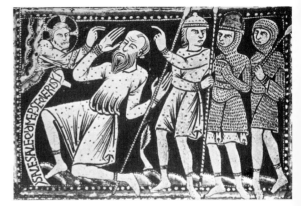

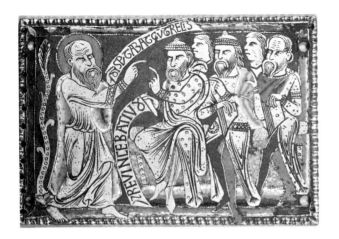

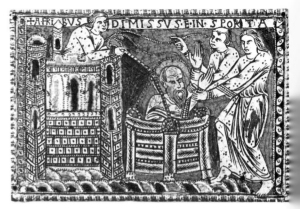

lier version of Paul seated among the recipients of his letters (Plaque I), while the motif of a scroll running in front of several persons seems to have been a specialty of English art more than a hundred years before these plaques were made (Wormald, 1952, pls. 23, 34; see also A. Merton, *Die Buchmalerei in St. Gallen vom neunten bis zum elften Jahrhundert,* Leipzig, 1912, pl. LXVIII, no. 1). The relaxed posture of the first Philippian sitting to the left of Paul and bending his right arm on his knee, Plaque I, is reminiscent of a somewhat later Mosan bronze statuette in Oxford (Swarzenski, 1967, fig. 539). For early medieval and Byzantine cycles concentrating on episodes emphasizing the teaching and disputes of the apostles as well as the aspect of danger and salvation, see H. Buchtal, "Some representations from the life of Paul in Byzantine and Carolingian art," *Tortulae: Studien zu altchristlichen und byzantinischen Monumenten,* Freiburg, 1966, pp. 43–48.

BIBLIOGRAPHY: Chamot, 1930, pp. 10, 35 f., no. 18, pls. 10–134; Swarzenski, 1967, figs. 443–445; Dinkler-Schubert; Festschrift K. H. Usener, Marburg, 1967; Lenzen-Buschausen, p. 43, n. 112

169. Ciborium bowl

England
1180–1190
Silver gilt, niello
H. 82, D. 177 cm. (33¼, 69¾ in.)
New York, The Metropolitan Museum of Art,
The Cloisters Collection, 47.101.31

This vaulted bowl with curving sides is articulated by a system of niello lines and points and crowned by a continuous palmette frieze. The decoration appears in three rows of four compartments. The bottom compartments, forming a quatrefoil, each contain a basilisk. The principal compartments, diamond shaped, each contain a nude young man climbing in foliage. The triangular top compartments contain confronted basilisks. The heads of the human figures and the fantastic animals are in relief. The foliage and conventionalized designs derive from the ornamental repertoire and stylistic achievement of northern French and English art. Similar beasts and the motif of a clambering figure in foliage occur in English miniature painting (Oxford, Bodleian Library, Ms. Auct. E. infra. 1, fol. 304; also Boase, 1953, fig. 29).

The system of compartmented decoration resembles that of the Warwick ciborium (see no. 172) whereas other characteristic details (relief bands, palmette frieze, leaf decoration of the divided bands) connect our piece to a silver cup, most probably of English origin, in the National Museum, Stockholm (Swarzenski, 1967, figs. 458, 459). The decorative system and floral design, as well as the niello technique, relate our

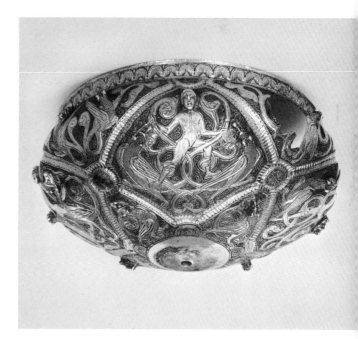

piece to a third cup, found, like ours, in Russia, and now in The Hermitage (Lapkovskaya, *Trudy,* VIII, n.d., pp. 124–133). These three pieces testify to the export of English metalwork to eastern Europe during the Middle Ages.

In contrast to the Warwick ciborium the program of decoration on our bowl does not adhere to the tradition of theologically refined iconography. It strongly suggests, in fact, that the bowl

may have been intended for secular use. Like the related cups, it probably originally rested on a conical foot.

BIBLIOGRAPHY: Darcel-Basilewski, p. 51, no. 139; Swarzenski, 1932, pp. 388–389; Bossert, 1932, p. 304; Boston, 1940, no. 216; Darkevitch, 1966, pp. 38–39, no. 68, pl. 19; Rorimer, 1963, pp. 136–137; Swarzenski, 1967, fig. 457

170. Casket

England
Late 12th century
Copper gilt, champlevé enamel
5.8 cm. (2¼ in.)
Boston, Museum of Fine Arts, 52.1381

A magnificent decoration of floral stems entwines to form medallions on the four lower plaques. In each medallion heraldically conceived animals appear singly or in pairs. On the sloping roof

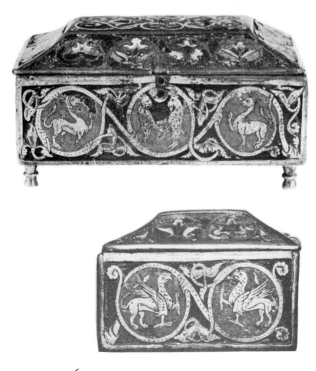

plaques similar stems form half-circles filled with petal-like designs. On the center roof plaque a superb rhythmical pattern is formed by interlaced stems and flowers. The dark blue ground is seen also in later Limoges works and in Rhenish works of the end of the century. Medallions formed by interlaced floral branches are English in derivation (for examples on ciboria and architectural sculpture, Swarzenski, 1932, p. 335 f.; for a similar contemporary casket of English origin, Chamot, 1930, pl. 4). Enamel caskets with circular medallions must have been popular in thirteenth-century England, as demonstrated by written records in contemporary sources (Chamot, 1930, p. 9). Similarities of color can also be noted in Mosan and English goldsmiths' work of the twelfth century (Mütherich, 1940). The animal imagery parallels that seen in English bestiaries of the period (no. 259). The animals may be understood as allusions to the function of the beasts as guardians of the jewelry that was perhaps originally enclosed in the casket. Although resembling a reliquary, this casket is presumed to have had a secular use in view of the imagery and the fact that only English secular caskets are preserved from this period (no. 173, a lid fragment, Swarzenski, 1932, fig. 305).

BIBLIOGRAPHY: *Boston Museum of Fine Arts Bulletin,* 55, 1957, p. 78, fig. 28

171. Ciborium

England
Late 12th century
Enamel
H. 19 cm., D. 16.2 cm. (7½, 6⅜ in.)
New York, The Pierpont Morgan Library

Resting on a low conical foot, the broad bowl is surmounted by a high cover crowned by a solid knob. The colors are, on the bowl, turquoise-blue ground; in the medallions, lapis blue border and turquoise center with a white line between; on

the lid, lapis ground; medallions: green border, gray-blue center with white line between. The figures on the bowl are mainly reserved, on the lid partly enameled; all the figures of Christ are filled with a pinkish flesh tone. Other colors used are red, yellow, gray, and white. Whereas the foot and the knob are decorated by floral spirals only, a continuous stem encloses six scenes from the Old Testament on the body and six scenes from the life of Christ on the cover. The stem, which branches out into dynamically drawn flowers in the spandrels, bears inscriptions relating to each subject.

The six typological pairs of scenes are:

Bowl: Aaron with the Ark and the Rod that Budded; inscribed in the medallion: VIRGA; outer edge: VIRGO. DVCEM. FERT. VIRGA. NVCEM. NATV-RA. STVPESCIT. Cover: the Nativity: VIRGO. MA-RIA. FVIT. QVE. DOMINVM. GENVIT.

Bowl: the Sacrifice of Abel: AGNVS. ABEL. MVNVS. AGNVM. PRIV[S]. OBTVLIT. VNVS. Cover: the Circumcision: OFFERTVR. MAGNVS. NVNC. A. POPVLIS. DEVS. AGNVS. SIMEON. I. T.

Bowl: the Rite of Circumcision: PRECESSIT. LAVACRVM. SACRA. CIRCVMCISIO. SACRVM. Cover: the Baptism of Christ: BAPTIZAT. MILES. REGEM. NOVA. GRATIA. LEGEM.

Bowl: the Sacrifice of Isaac: LIGNA. PVER. GESTAT. CRVCIS. VNDE. TIPV. MANIFESTAT. Cover: the Carrying of the Cross: SIC. A. LAPIS. CESVS. PI A. DVCITVR HOSTIA IHESVS.

Bowl: the Brazen Serpent: SERPENS. SERPEN-TES. XPC. NECAT. IGNIPOTENTES. Cover: the Cru-cifixion: VT VIVAS MECVM FELIX HOMO DORMIO TECVM.

Bowl: Samson fighting the Philistines: PHI-LISTIM. INIMICI. SAMSONIS. GAZA CIVITAS. in the medallion: SAMSON. DE. GAZA. CONCLVSVS. AB. HOSTIBVS. EXIT. Cover: the Resurrection: SURGIT DE TVMVLO PETRA XPC QVEM PETRA TEXIT.

The sequence of scenes is continuous only in the life of Christ on the cover, comprising three scenes from his childhood and three from the Passion. The choice of the Old Testament scenes is not logical in itself, but depends on the Christ scenes, for which they are the basis in a historical as well as a physical sense on the ciborium. Inside

the lid and the bowl a half-length figure of Christ blessing and an Agnus Dei complement the iconographical program of the object.

The agitated style of the ornament and the vivid treatment of the figures are developed from the English and northern French tradition of goldsmiths' work and miniature painting. The vital design of the whole is typical of late twelfth-century English art. The branching stem corre-

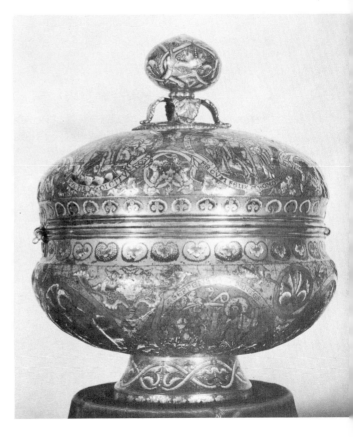

sponds to the analogous voussoir decoration of Malmesbury Abbey, the alleged provenance of the ciborium. The statement that "neither the porch nor the ciborium is linked with the name of any historical personality who might have been responsible for the programme of the two monuments" (Saxl, 1954, p. 63) is still valid.

BIBLIOGRAPHY: Chamot, 1930, no. 12; Swarzenski, 1932; Saxl, 1954, p. 63; Swarzenski, 1967, fig. 453

172. Ciborium bowl

England
Late 12th century
Bronze gilt, champlevé enamel
H. 12, D. 20 cm. (4¾, 7⅞ in.)
London, Victoria and Albert Museum,
M 159–1919

As the result of a fire in 1871 this object (known as the Warwick ciborium) lost most of its enamel, and now only the low conical foot gives an idea of the richly colored original surface (lapis, turquoise, green, red, white, yellow, purple, black). Both foot and bowl (the cover of the bowl is missing) show a decoration of interlaced ornament; on the bowl six medallions are enclosed by a stem that branches out into floral motifs in the spandrels. The six Old Testament scenes in the medallions are identified by an inscription running around the rim below a wavelike border of petals:

Moses and the Burning Bush. Inscription: QUI VELVD ARDEBAT RUBUS ET NO IGNE CALEBAT

The Sacrifice of Cain and Abel. Inscription: AGN' ABEL MVN' AGNV PRIV' OPTVLIT VN'

The Circumcision of Isaac. Inscription: PRECESSIT LAVACRV SACRA CIRCVCISIO SACRVM

Isaac Bearing the Wood for His Sacrifice. Inscription: LIGNA PVER GESTAT CRVCIS VDE TIPV MANIFESTAT

The Sacrifice of Isaac. Inscription: TEPTAS TEPTAT' ISAAC ARIESTQ' PARATVS

Jonah Issuing from the Whale. Inscription: REDITVR VT SALVVS QVECETI CLAVSERA TALVVS

In iconography, as well as in shape and system of decoration, the Warwick ciborium is closely related to the Kennet and Malmesbury ciboria (Chamot pls. 5, 7; see also the Master G. Alpais ciborium, Gauthier, 1950, frontispiece, and the Ste. coupe, Paris, 1965, no. 817). The representation of the Circumcision occurs with the identical inscription on all three pieces; the Sacrifice of Cain and Abel and the accompanying inscription is common to both the Warwick and Malmesbury ciboria (Swarzenski 1967, fig. 453), and the same inscription that accompanies the scene of the woodbearing Isaac on the Kennet and Warwick

ciboria is repeated in the sacrifice of Isaac medallion on the Malmesbury piece. From these similarities, a christological cycle of six scenes may be reconstructed for the missing lid of the Warwick ciborium. The three ciboria are unified stylistically as well by the use of exuberant floral motifs covering the entire surface. This type of ornamentation, foreign to Mosan and Limoges goldsmiths' work, along with the English provenance of the pieces, has been considered an indication of the group's English origin.

BIBLIOGRAPHY: Chamot, 1930, p. 30, no. 13, pl. 8; Swarzenski, 1932, p. 336 f.

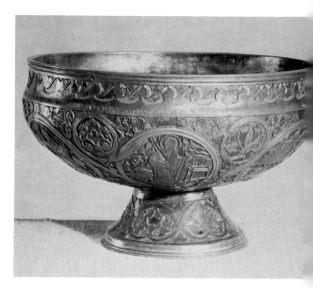

173. Casket

Limoges
1200–1210
Enamel
London, British Museum

This casket, like reliquaries from Malval (Gauthier, 1950, pl. 10) and Nantouillet (no. 142), has an overall application of *fond vermiculé* with the figures left in reserve. This may be interpreted as a reaction against the strict geometrical com-

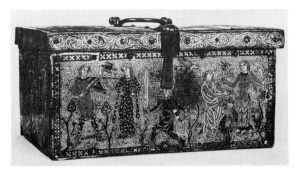

174. Bracelet: the Resurrection

Mosan
1170–1180
Champlevé enamel
Paris, Musée du Louvre

The companion piece to this bracelet, representing the Crucifixion, is in the Hirsch Collection, Basel (Swarzenski, 1967, fig. 405). On the exhibited piece two angels flank Christ and two soldiers sleep beneath the shallow sarcophagus. The axial symmetry of the composition and, more specifically, the disposition of soldiers in the lower area, occur also in the companion piece. Rising from his sarcophagus, Christ, a magnificently draped, nimbused, three-quarter figure, holds a cross-banner in his left hand and his shroud with his right. The latter motif, apparently unique in the iconography of the Resurrection, may be connected with a cult of shroud relics, understood historically in the light of the twelfth-century tendency toward visualization of relics, formerly enclosed inaccessibly in tombs (Sedlmayr, 1950, pp. 311–313; E. Meyer, 1950). The movement of Christ, slightly toward the left,

positions in mid-twelfth-century Romanesque art. Well known to Limoges workshops from Mosan metalwork, this casket's geometrical type of composition is also seen in contemporary French stained-glass windows. The unrestricted interaction between ornament and figures is reminiscent of Islamic art and is probably indebted to this source (Buchthal, 1945). This casket is especially interesting as one of the earliest instances of secular imagery. Compared by de Vasselot with the contemporary genre of courtly romance, and seen by her as a predecessor of late thirteenth- and fourteenth-century ivory caskets with corresponding illustrations, our object has so far not had any literary explanation. On the front plaque, a sword-bearing man appearing between two couples: at the left, a girl, hand on hip, listening to a violinist, at the right, a man, half kneeling before a girl who holds a bird on her hand and has placed a strap around her lover's neck. The central figure carries a key placed directly below the actual keyhole of the casket. A bird flies toward the standing woman at the left, apparently in a secularized adaptation of the scheme used in representations of the Annunciation. The three male figures are represented in motion, the two female figures more or less at rest. (Compare the similarly conceived, but more elongated figure of a wise Virgin: de Vasselot, pl. 7). A similar group of a violinist standing before a girl with one hand on her hip occurs on a roughly contemporary casket in Vannes (Paris, 1965, fig. 100).

BIBLIOGRAPHY: de Vasselot, 1906, p. 31, pl. 7

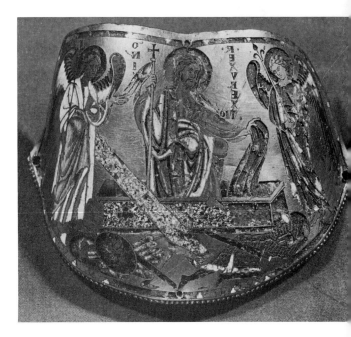

together with the long diagonal formed by the lid of the sarcophagus, enlivens the composition. Dramatically portrayed as he actually leaves the tomb, this Christ differs from the static earlier renditions of the subject, originating with an Ottonian miniature (F. Rademacher, "Zu den frühesten Darstellungen der Auferstehung Christi," *Zeitschrift für Kunstgeschichte*, 1965, p. 195 f.). The richly varied drapery and the free ornamental rhythm to be seen in Christ's flowing hair suggest an advanced position among the Mosan works in the succession of Godefroid de Claire. On the other hand, the stiff posture of the sleeping soldiers is of an earlier style.

Mosan artists are known to have worked for the German emperor Frederick I Barbarossa (Deér, 1961). Taking into consideration the imperial destination of these pieces, the replacement of the letter s with an x in the inscription REXURREXTIO DNI, emphasizing the word REX for king, appears to be meaningful. Possibly the artist wished to allude to the royal connotations traditionally associated with the Resurrection and therefore appropriate for imperial wear (Heitz, 1963; P. Verdier, *Zeitschrift für Schweirerische Archeologie und Kunstgeschichte*, 22, 1962, pp. 3–9).

BIBLIOGRAPHY: Demus, 1965, p. 637; Swarzenski, 1967, fig. 406; Schramm-Mütherich, no. 175

175. Samson carrying the gates of Gaza

Mosan
1170–1180
Champlevé enamel
10.2 x 10.2 cm. (4 x 4 in.)
London, Trustees of the British Museum

From the plaque's small size, as well as from the typological interpretation of the subject, regarded as a prefiguration of Christ's Harrowing of Hell and Resurrection, it is evident that our object

originally formed part of a cross or portable altar. The obliquely placed, high-walled city of Gaza is conceived as a compact unit dominated by a group of three towers. This scheme of representing a city stems from contemporary seals (Deér, 1961). In the multicolored layers and the formal brick wall one notes a remarkable precision. The apparent elongation of the city wall harmonizes with the tall figure of Samson. While the two door wings carried under his arms correspond to the geometrical design of the city, they contrast with Samson's unstable posture, the outline of his bent right leg and the sweeping curve of his mantle and long hair. The crowding of the city and the man inside the narrow frame, comparable to other compositions by Mosan artists (Aaron writing the letter tau on the front of a house, Verdier, 1961), produces a dynamic effect.

The moving facial expression of the suffering, blind Samson and the emphasis on the loneliness of the figure departing from the city are achieved by a delicate articulation pervading the whole as well as every single stroke. Note, for example, the subtle correspondence between the top of the

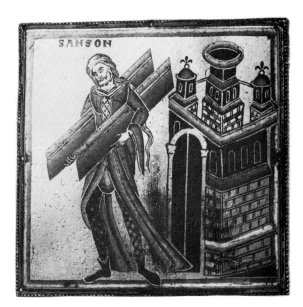

wall and Samson's collar, both of diamond shape. From these characteristics the dating of the plaque becomes evident; perhaps it had as a counterpiece a plaque of Samson wrestling with the lion (Swarzenski, 1967, fig. 403), where the same devices in the treatment of hair and face can be observed, together with almost identical proportions and dimensions. The elongation, tenderness and melancholy are characteristic of Mosan enamel production prior to Nicholas of Verdun's new concept of dynamically active figures. Further ramifications of this Mosan phase of enamelwork are discussed by Lenzen-Buschhausen.

BIBLIOGRAPHY: Falke-Frauberger, p. 79, fig. 27

176. Investiture of a bishop

Mosan or Cologne
About 1180
Champlevé enamel
10.2 x 7.7 cm. (4 x 3 in.)
Hamburg, Museum für Kunst und Gewerbe

An enthroned ruler, wearing a crown and holding an orb, is shown investing a nimbused monk who stands to his right with a cross-standard. The arcades above them lack supports, a minor artistic shortcoming. The inscription on the plaque's upper edge—E–P·FIT· (Episcopus fit) —emphasizes the saintly monk as the protagonist; the inscription at the bottom edge—PVEROS DOCET—suggests another scene, now lost, showing the saint teaching. From this sequence, and the possibly Cologne style of the plaque, Weisgerber, in 1937, identified the saint with the canonized Bishop Anno of Cologne being designated by Henry III, the German emperor. Weisgerber suggests that our plaque is a fragment of a St. Anno cycle, originally installed in a predella, depicting Anno's teaching in Bamberg. Hanns

Swarzenski (Swarzenski, 1952, p. 301) points out the lack of evidence for such an interpretation. Stylistically the plaque represents the impact of Mosan tradition in a Cologne workshop prior to the advent of Nicholas of Verdun. The investiture of the bishop by the miter corresponds to the investiture struggle of Anno.

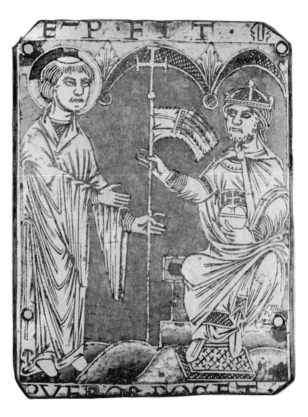

For both the compositional scene and stylistic provenance of the plaque, compare the scene at the upper left of the Remaclus retable in Stavelot, known to us through a seventeenth-century drawing (Dinkler-Schubert, 1964, pl. 8).

BIBLIOGRAPHY: A. Weisgerber, "Die Niello-Kelchkuppe des Kölner Diözesanmuseums und der Rest eines Siegburger Anno-Zyklus," *Kunstgabe des Vereins für christliche Kunst im Erzbistum Köln und Bistum* Aachen, 1937, p. 15 f.; Cologne, 1964, no. 20

177. Reliquary in form of a gabled front

Mosan
About 1180
Wood, copper repoussé, enamel
56 x 33 cm. (22 x 13 in.)
Brussels, Musées Royaux d'Art et d'Histoire,
1038

This is one of four reliquaries from the main altar of St. Servatius church, Maastricht (Brussels, 1964, no. 110, a–d). Their identical size and shape indicate that they were conceived as companion pieces. An anonymous bishop saint is represented *en buste* on two of the reliquaries. On one he looks up at a crown held by angels and blessed by the hand of God, on the other, he looks at a crown pointed to by angels and held by the hand of God. The third reliquary shows St. Candidus enthroned. On our piece the embossed half-figure of St. Gondolphus fills the triangular gable; the rectangular plaque below shows four engraved angels framing a quatrefoil phylactery. Here five more angels, in half-length, are identified by inscriptions and attributed as personifications of virtues. The armed figure of St. Michael at the center represents Veritas. He is surrounded by Justitia (with a pair of scales), Fides (carrying a baptismal font), Caritas (with bread and chalice, referring to two of the seven works of mercy), and Spes (holding a cross-inscribed disc and a branch). The arrangement emphasizes St. Gondolphus as the embodiment of all virtues. Perhaps the number of angels represented refers to the traditional concept of the nine choirs of angels.

This reliquary is similar in form and iconography to contemporary Mosan goldsmiths' work. The disposition of a half-length figure in a gable above a cross flanked by angels (the quatrefoil being considered a type of cross), was adopted by the artist from the numerous cross reliquaries produced around 1180 in the Mosan region (Swarzenski, 1967, figs. 375–376). The composition of the rising saint, occurring on two of the companion reliquaries, is also derived from these Mosan cross reliquaries. These objects also supply the models for the angels that are characterized by inscriptions as personifications of virtues. An exact parallel for the representation of Fides carrying a baptismal font occurs on a Mosan enamel, a fragment of the Stavelot retable of Godefroid de Claire (Swarzenski, 1967, fig. 366). In the whole Mosan production there is a marked predilection for allegorical representations of virtues in different combinations (Verdier, 1961). On our piece three theological virtues (Fides, Spes, Caritas), or *virtutes infusae* (for this scholastic concept, Kantorowicz, 1957, p. 451 f.), appear with Justitia and Veritas, mentioned in conjunction in Psalms 84 and 88. A coherent source for the whole program of our piece, however, has not yet been found.

Stylistically, the delicately stranded drapery to be noticed in the three techniques (engraving, repoussé, enamel) as well as the modeling of the saint's figure are similar to those of the shrine of St. Servatius in the Maastricht church, where the reliquary was originally placed.

The type of quatrefoil phylactery can be traced as a theme in twelfth-century Mosan goldsmiths' work, starting with the Stavelot altar (Brussels, 1964, no. 39, pl. XXIV). A phylactery in the Namur Museum (Swarzenski, 1967, fig. 426) differs in the centripetal arrangement of the accompanying half-figure angels, conceived as virtues. Like the similarly shaped plaques with the Beatitudes from the Aachen chandelier (Swarzenski, 1967, fig. 427), the Namur phylactery may be dated around 1165–1170, slightly preceding the exhibited reliquary.

BIBLIOGRAPHY: Collon-Gevaert, 1961; Verdier, 1961; H. v. Einem, *Das Stützengeschoss der Pisaner Domkanzel,* Cologne-Opladen, 1962; Brussels, 1964, no. 110b

178. Reliquary of the true cross

Mosan
About 1180
Copper, champlevé enamel
28.5 x 22 cm. (11½ x 8¾ in.)
Tongres, Basilique Notre Dame

The recessed central plaque, covered by two movable wings, is framed by alternating engraved oblong and enameled squares. The iconographical program is rich on this plaque. The witnesses of the Crucifixion, Mary and St. John, are here, as are personifications of church and synagogue, a bust of Christ, and in the corners, the animalia. Angels bearing censers appear on the outside of the wings, while inside Empress Helena is shown recovering the Cross. The engraved plaques of the frame display Old Testament prefigurations of the Crucifixion (widow

of Sarepta, Sacrifice of Isaac, Brazen Serpent, Moses marking the Israelite houses with the letter Tau), and post-biblical episodes relating to the Cross (Constantine's dream, Chosroe). Ten Early Christian Tongres bishops are represented as half-length figures on the enameled plaques. The moldings between the frame and the wings bear inscriptions. The outer one, PONTIFICES MERUIT HOS INCLITA TONGRIS HABERE DONEC ENIM POTUIT HUMMORUM GENS ABOLERE, refers to the bishops residing in Tongres before the Huns' invasion. The inner one, HOC SALVATORIS TIBI TONGRIS PIGNUS AMORIS LEGIA DAT LIGNUM CUNCTIS VENERABILE SIGNUM, concerns the donation of the cross relics by Liège to Tongres in 1180 when the church was rebuilt after a fire. The inscriptions testify to the blending of ecclesiastical and communal pride, typical of the urban culture of medieval Flanders. Stylistically the reliquary can be placed among the followers of Godefroid de Claire, seen in a comparison with the cover of the St. Trond lectionary in Düsseldorf (Swarzenski, 1967, fig. 378).

BIBLIOGRAPHY: Collon-Gevaert, 1961, no. 59; Swarzenski, 1967, figs. 424, 425 (with erroneous title "Annunciation" given to the two angels)

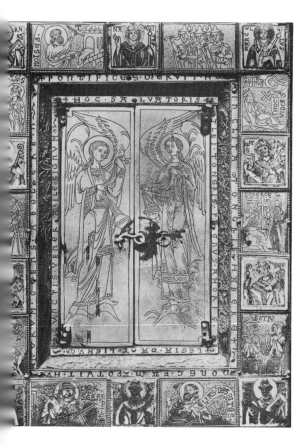

179. Plaques

Mosan, Nicholas of Verdun
1181
Champlevé enamel
20.5 x 16.5 cm. (8 x 6 7/16 in.)
Klosterneuburg, Chorherrenstift

These three plaques comprise the twelfth of seventeen vertical rows of the Klosterneuburg altarpiece. In a rare formula, each vertical row combines two Old Testament prefigurations (rather than one) with one christological episode. Represented here are: the Letter Tau, the Harrowing of Hell, and Samson and the Lion. These three subjects were often linked together in earlier theological writing. Prior to its reassembly after a fire in 1331 the Klosterneuburg cycle of fifty-one

plaques decorated the ambo of the abbey church (for its present appearance, *Art Mosan,* 1961, fig. 8). Signed by the artist and dated by inscription, the cycle is the earliest documented work of Nicholas of Verdun. Nicholas apparently worked directly on this project in the church. A revealing glimpse into his working method was provided by the discovery of an incomplete and discarded

preliminary engraving of the Three Marys at the Tomb on the back of the fifty-first plaque, the Mouth of Hell (Demus, 1951). All the plaques are numbered on the back, indicating the scheme of their original placement on the ambo. Nicholas' stylistic development can be followed in the overall sequence of the plaques on the altarpiece, from left to right. Characterized by an increase of

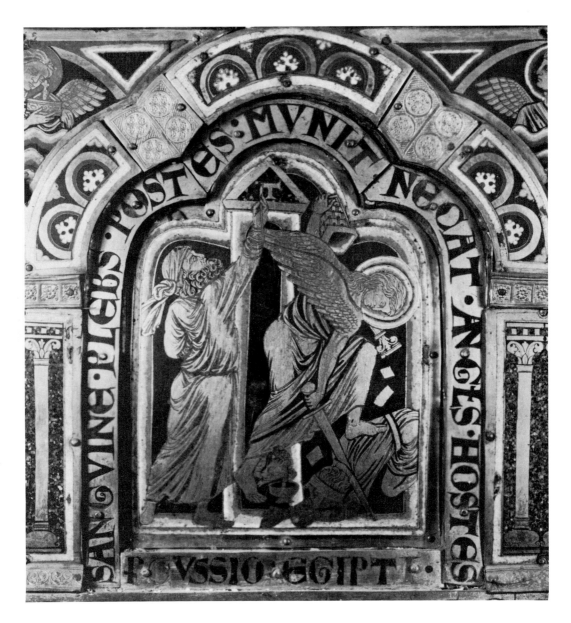

172

movement, the dynamic gestures and expressive faces contribute to a more and more classicizing impression. Iconographically, the cycle reflects the mid-twelfth century revival of typological programs. More specifically the imagery derived from the writings of Honorius Augustodunensis. Earlier Mosan and northern French book illumination and goldsmiths' work as well as Sicilian

mosaics have been suggested as possible sources of Nicholas' style (Kitzinger, 1966).

On the Tau plaque, the priest, seen from the back, represents an expressive adaptation of a classical device (E. Koch, *Die Rückenfigur im Bild von der Antike bis zu Giotto,* Recklinghausen, 1966), while the scene of the angel killing the king under a column appears to stem from

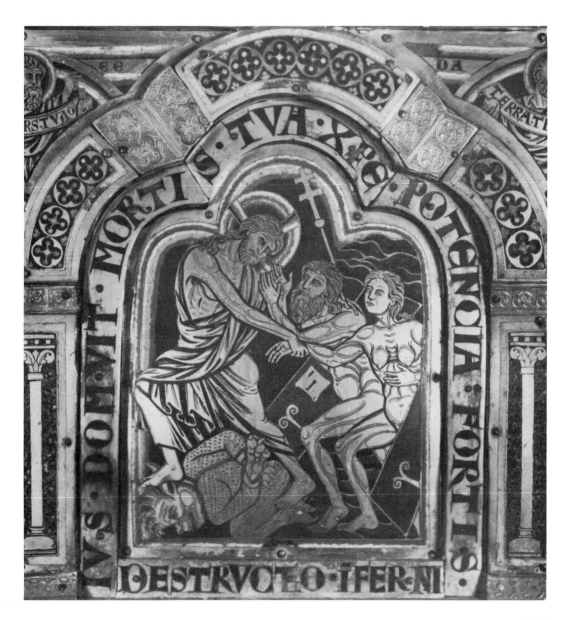

late antique triumphal imagery. In the Harrowing plaque, Nicholas adopted the middle Byzantine scheme with the ascending Christ pulling Adam and Eve out of hell, derived in turn from the classical representations of Hercules drawing Cerberus out of the underworld (K. Weitzmann, "Das Evangelion im Skevoplylakion zu Lawra," *Seminarium Kondakovianrum,* 1936). In two apparently unique motifs Christ places his hand on Adam's shoulder while grasping Eve's hand, and Adam is shown in a gesture of adoration and thanks, indicative of Nicholas' attempt at a psychological interpretation of the episode.

The Samson plaque is distinguished by a superb rhythm emphasized in the swinging edge of the hero's loincloth (for the pictorial tradition:

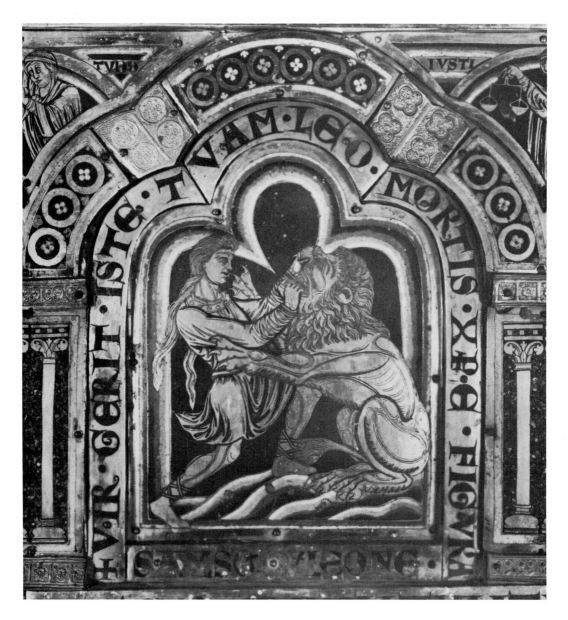

Swarzenski, 1940). The contrast between the intensity of artistic imagination and emotion, and the abstract surrounding space and the flatness characteristic of the entire cycle is particularly strong in this plaque. In comparing the figures of the kneeling angel, Christ, and Samson, one notes a consistent zig-zag pattern created by the position of their legs. In the Samson plaque the pointed trefoil arch echoes the compositional tension of the figures; the personification of strength in the left spandrel echoes Samson's action of opening the lion's mouth.

BIBLIOGRAPHY: Cologne, 1964, no. 7; Röhrig, 1955

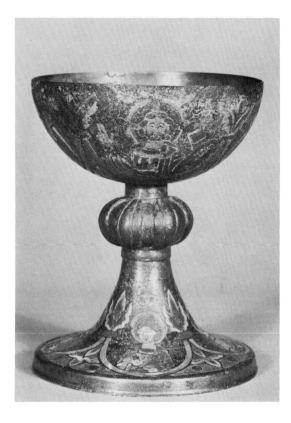

180. Two chalices

A. Mosan
1180–1190
Copper gilt, champlevé enamel
H. 13.2 cm. (5¼ in.)
London, Trustees of the British Museum

B. Mosan
1180–1190
Copper gilt, champlevé enamel
H. 10.5 cm. (4¼ in.)
Brussels, Coll. Stoclet

The first chalice, from a tomb at Rusper Priory, Sussex, is decorated on the foot with half-figures of angels enclosed by half-circles, two of which end in a common flower motif. Half-figures of Christ and the evangelists are placed under arcades on the bowl. In spite of its bad state of preservation, the chalice is still impressive in its well-balanced proportion, its vigorously ribbed knob, and the dynamic conception of the figures. While the decoration apparently follows the style of Godefroid de Claire and the Master of the Stavelot Altarpiece (this stylistic phase is represented also by the plaques of Henry of Blois, which were taken to England, Chamot, 1930, no. 17), the half-figure of the blessing Christ, inspired by the Byzantine Pantocrator type, invites comparison with Nicholas of Verdun's transfor-

mation of this subject on a plaque from the shrine of the Three Kings (Cologne, 1964, no. 1, fig. 48). The drawing of the figures on the Rusper chalice shows a tendency toward simplification. With regard to the shape and type of the object, the transformation of the chalice in the hands of early Gothic craftsmen may be illustrated by a comparison with Hugo of Oignies' Namur chalice for Gilles de Walcourt (*Art Mosan*, 1961, no. 62, p. 279).

The second chalice recalls the first in shape, decoration, and technique. The half-figure of the blessing Christ, the busts of angels holding crosses, and the stylized trees might represent a repetitive version produced slightly later in the same workshop.

BIBLIOGRAPHY: C. Oman, "Influences mosanes dans les émaux Anglais," *Art Mosan*, 1952, p. 156; *Adolphe Stoclet Collection*, pt. I, Brussels, 1956, p. 184

181. Plaque (fragment) with dogs

Mosan
1200–1210
Enamel
Cleveland, Museum of Art, 52.327

Edged with a beaded band and pierced with four holes for attachment, this fragment is decorated with leafy tendrils that curl to form two medallions, each containing a seated, confronting dog. The spirited composition, undoubtedly inspired by late classical ornamental prototypes, the rhythmical intertwining of plants and animals, and technical and artistic peculiarities relate this plaque to the workshop of Nicholas of Verdun. The alert posture of the dogs calls to mind drolleries of later thirteenth-century art. The linear elegance of the floral medallions is indebted to late twelfth-century English enamels, such as a casket with fantastic animals (Boston, *Museum of Fine Arts Bulletin,* LV, 1957, p. 78, fig. 28). Compared with this piece our plaque represents

the step from heraldically conceived, isolated animals to their intertwining in a dynamic tension. The common Mosan vocabulary of the motifs can be seen on a phylactery of around 1200 (ibid., p. 76, fig. 23). The variations and the development of this classicizing decoration, imagery, and style in English, Mosan, and Rhenish art of the late twelfth century have been traced by Swarzenski (1932) and Mütherich (1940).

182. Châsse of St. Mark

France
1210–1230
Champlevé enamel
52 x 22 x 46 cm. (20½ x 8¾ x 18 in.)
Huy, Notre-Dame Church

The plaques of this reliquary, ten in number, combine scenes from the life of Christ, on front and back, on the ends, an Old Testament theme, the Sacrifice of Abraham, and a hagiographical analogy of Christ's death, the martyrdom of Stephen. Some of the scenes (the Nativity, Adoration of the Magi, Flight into Egypt) represent Christ's childhood, others (the Resurrection of Lazarus, Communion of the Apostles, Washing of the Feet, Descent from the Cross) treat of the Passion. The artistic style seems as mixed as the iconography. No comparable example can be found among Mosan works of the time. The compositional schemes and iconographical details indicate a direct or indirect Eastern inspiration. An attempt has been made (Devigne) to narrow the sources to Cappodocian art, but influences from Early Christian art are also evident. The retardatory iconographical character apparently prompted an attempted dating (Crooy) in the ninth century, but the marked linear stylization and graceful composition place the work in the second decade of the thirteenth century or later. As to localization, the apparent borrowings from Sicilian mosaic style are not helpful since they might then have occurred anywhere in Europe. (See nos. 238 and 268 for the geographical range of the Sicilian impact.) A French origin is plausible in view of certain similarities with Limoges products (Devigne). The Flight into Egypt plaque, for example, shows much the same linear "Gothic" interpretation of the early thirteenth-century classicizing trend that one finds in a Limoges plaque of the Flight (Gauthier, 1950, pls. 22–23). Another Limoges plaque (ibid., pl. 18) is also comparable, particularly in its figure of Joseph. These Limoges variants seem to have originated in the last decades of the twelfth century, as suggested by the engravings of another châsse, no. 135. In light of this the present châsse

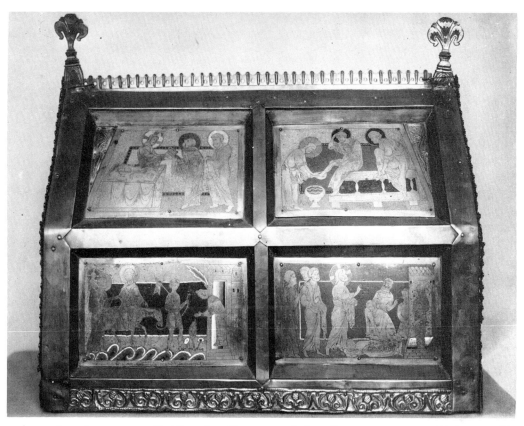

may be attributed to an unspecified French atelier active in the second or third decade of the thirteenth century. As to individual plaques, it may be noted that the image of Lazarus in the arched door of his tomb is a formula apparently deriving from late classical adventus scenes (Kantorowicz, 1965), while the Communion of the Apostles, a rare motif, is revived here from Early Christian prototypes and forms part of a sacramental allegory connecting the Communion with the Baptism of the Apostles, as the episode of the Washing of the Feet traditionally was understood (Kantorowicz, "The Baptism of the Apostles," *Dumbarton Oaks Papers,* 1956, pp. 203–251).

BIBLIOGRAPHY: M. Crooy, *Les émaux carolingiens de la châsse de Saint Marc à Huy-sur-Meuse,* Paris, 1948; M. Devigne, "Notes sur des émaux conservés à Notre-Dame de Huy," *Association Française pour l'avancement des sciences,* Liège, 1937, pp. 1392–1416; J. de Borchgrave d'Altena, "Nouvelles notes au sujet des émaux champlevés de la châsse dite de Saint-Marc à Huy," *Bulletin de la societé royale archéologie de Bruxelles,* 1949, pp. 24–41; Kitzinger, 1966, p. 131 f.; Deuchler, 1967, p. 40; Haussherr, 1969, p. 62

183. Four prophet plaques

Germany
About 1180
Copper, champlevé enamel
Cleveland, Museum of Art, 50574–7

These plaques, showing Isaiah (Esaias), Elisha (Heliseus), Obadiah (Achapias), and Hosea (Osea), are part of a cycle; the Jeremiah plaque is in Dijon, the Ezekiel plaque in Düsseldorf. Seated frontally on a three-storied throne, holding an inscribed scroll, each figure is framed by a recessed arch. Stylistic sources are found in Mosan work (the blessing Jacob plaque, Swarzenski, 1967, fig. 418). The energetically drawn, diagonal drapery folds are inventively varied on all the figures; particularly impressive is their culmination in a "whirlpool" on the Hosea plaque. While

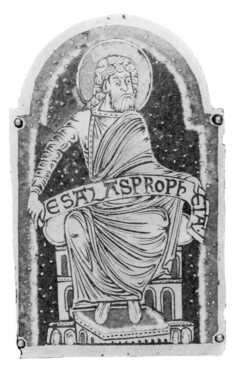

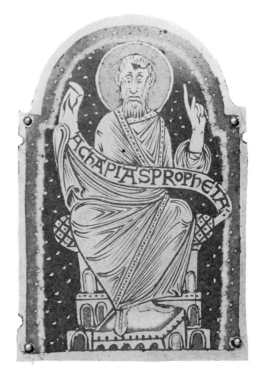

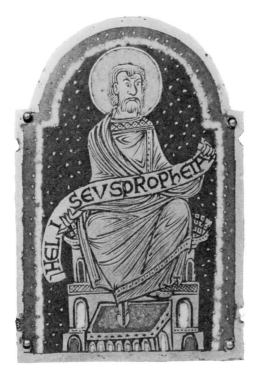

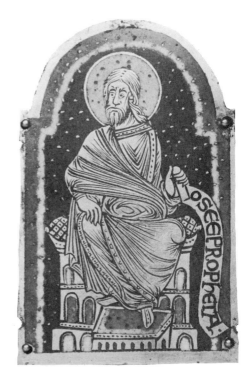

similar variations of Mosan models are seen in the output of different workshops during the third quarter of the twelfth century (from Cologne, the Darmstadt tower reliquary; Swarzenski, 1967, fig. 421), the characteristic *horror vacui* seen in the drapery is most closely matched by works convincingly attributed to lower Saxon ateliers (while juxtaposing the Hosea plaque with the English St. Paul's cycle, no. 168, Swarzenski, 1967, p. 76, questions its lower Saxon origin). Other similarities can be seen in the lid plaque of the Vorau reliquary (Swarzenski, 1932, fig. 224; Corvey, 1966, no. 267) and the quatrefoil reliquary of Henry II (Swarzenski, 1932, figs. 292–293). The apostle plaques in Bamberg and Hannover (Swarzenski, 1932, figs. 202–205; Dinkler-Schubert, 1964, figs. 87–90) represent an intermediary stage between the Eilbertus portable altar (Dinkler-Schubert, 1964, fig. 91) and our series. This comparison elucidates the iconographical peculiarity seen in our plaques, where the artist has adapted the traditional seated apostles seen on the Eilbertus altar to prophets who, in twelfth-century art, were normally shown standing (Swarzenski, 1967, figs. 412, 416, 421). The curved scroll held in front of Elisha and Obadiah stems from the early medieval portrayals of the Evangelists that was also occasionally applied to depictions of Christ in Majesty (Cologne, 1968, no. 20).

BIBLIOGRAPHY: Milliken, *Cleveland Museum of Art Bulletin*, 1951, p. 77 f.; Swarzenski, 1967, fig. 440

184. Three plaques

Germany, Cologne
1185
Enamel
2.7 x 2.7 cm. (1⅛ in.)
Baltimore, The Walters Art Gallery, 44.603–5

Two of these plaques show youthful heads, the third presents a majestic old man with an omega-shaped beard — apparently a representation of Christ even though it lacks a nimb. All three have symmetrically falling long hair. The faces are nearly identical with some to be seen among the technically similar plaques decorating the Siegburg shrine of St. Anno, which had at least the collaboration of Nicholas of Verdun (Demus, 1951), if indeed it was not wholly his work (Schnitzler, 1959). A comparable series of medallion heads appears on Nicholas' Shrine of the Three Kings in Cologne (Dinkler-Schubert, fig. 184), which, in the great variety of the positions of the heads, clearly illustrates a later stage in the development of his style. The relationship to the plaques of the Siegburg shrine establishes the date given above. Whereas the Christ face among our plaques reflects the middle Byzantine Pantocrator type, the Cologne plaques apparently depend on classical sources.

BIBLIOGRAPHY: Mütherich, 1940; Dinkler-Schubert, 1965, p. 140 f.

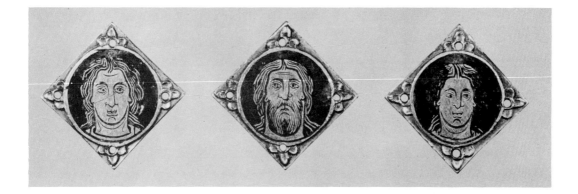

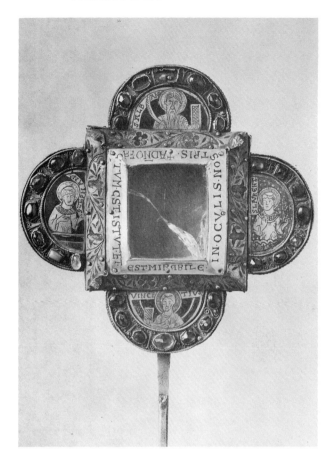

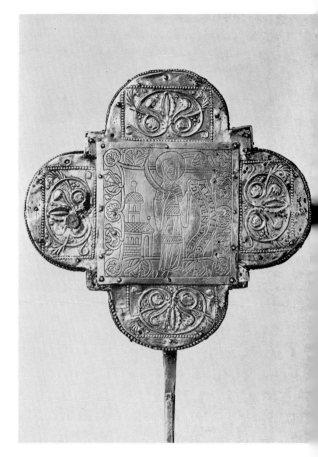

185. Reliquary

German
About 1180–1190
Champlevé enamel, copper gilt, rock crystal
17.5 x 18.2 cm. (6⅞ x 7⅛ in.)
Munich, Bayerisches Nationalmuseum, 56.103

The square center of the quatrefoil object originally contained relics; framed by an oblique molding with engraved floral ornament, added or replaced in the fourteenth century, it is surrounded by four half-circle medallions. On the inner frame of the reliquary Psalm 118:23 is inscribed: A DNO FACTUM EST ISTUD ET EST MIRABILE IN OCULIS NOSTRIS. The four half-figures of saints are identified by inscriptions as Vincentius, Stephanus, Albanus, and Laurentius. On the back,

a female saint standing beside a church building with a high tower holds a martyr's palm and a scroll with the quotation from the Psalm 118:18 DEXTERA DNI EXALTAVIT ME. The medallions are filled by a stylized palmette pattern. The choice of saints indicates a destination for St. Alban's church in Mayence, where altars were dedicated not only to the patron saint, but to Vincent and Stephen as well. No sure identification of the female saint is possible; Usener suggests St. Justina.

Quatrefoil reliquaries were especially popular in twelfth-century Mosan art; the obliquely framed square center has a close parallel on the reliquary of St. Gondulphus (no. 177), which also contains half-figures in the four circle-segments. Judging from the simple filigree and the style of the engraving, however, a Mosan origin for the

present object is improbable. A middle-Rhenish origin was suggested by Usener, who discussed the blending of Mosan and Cologne influences seen in the two pieces of goldsmiths' work attributed to Mayence workshops of the late twelfth century: two book covers in Berlin and Mayence. Close contacts between middle-Rhenish illuminated manuscripts and Mosan models have been observed by Rosy Schilling (1950). For the latest contribution on the subject of middle Rhenish late twelfth-century goldsmiths' work see D. Kötzsche's article on the Berlin book cover from Bleidenstadt ("Eine romanische Grubenschmelzplatte des Berliner Kunstgewerbemuseums," *Festschrift für Peter Metz,* Berlin, 1965, pp. 154–169).

Iconographically, the quatrefoil form was conceived in the Middle Ages as a specific type of the cross (Dinkler-Schubert, 1965). By applying this form to reliquaries, a parallelism was established between Christ's death and the death of the saints.

BIBLIOGRAPHY: Braun, 1946, p. 295, n. 54; K. H. Usener, "Ein Mainzer Reliquiar im Bayerischen Nationalmuseum," *Münchener Jahrbuch,* 1957, pp. 57–64

Elbern, "Dar Adelhausener Tragaltar," *Wallraf Richartz Jahrbuch,* 1955). For their use in other twelfth-century works see the Heribert shrine (Schnitzler, 1959, pl. 85), the shrine of the Three Kings (ibid, pl. 121; II, ill. 111), and the Klosterneuburg altarpiece (Röhrig, 1955, pl. 49; II, ills. 100–104).

186. Plaque

Rhineland
1180–1190
Enamel
Cleveland, Museum of Art, 53.275

This plaque, edged with a beaded band (incomplete on one side), and the four holes of its original (unknown) attachment preserved, shows two rows of half-circles. Rosettes fill the center of the half-circles as well as the spaces between them. The multilobed edging of the circles is reminiscent of the decoration of contemporary patens. Combinations of half-circles occur often in medieval art (for the late classical background and the significance of this repertory of forms: V. H.

187. Two columns

Germany, Cologne
1180–1190
Copper gilt, enamel
Baltimore, The Walters Art Gallery,
44.597–598

That these columns come from a late twelfth-century Cologne shrine is evident in their similarity to the decoration of the Anno shrine in Siegburg (Schnitzler, 1959, pls. 144–151). Both columns are decorated with diagonal bands of trellis design filled with tiny crosses and quatre-

188. St. Nicholas

German, Cologne?
1180–1190
Copper, champlevé enamel
8 x 7 cm. (3 5/16 x 2¾ in.)
New York, Coll. George E. Seligman

The mandorla, with a serrated edge, contains the nimbused standing figure of St. Nicholas in bishop's garment, although without miter. His right hand holds a crosier, his left supports an open book inscribed PAX VOBIS. The inscription AR-CHIEPISCOPVS SCS NICHOLAVS runs along the inside of the plaque's edge. The choice of the mandorla form, as well as the inscription in the book, alludes to the parallel drawn between St. Nicholas and Christ (for Christ addressing the apostles—Pax vobis: John 20:19). The original context of the plaque is not known but it probably formed part of a reliquary. The twelfth-century dating, based on stylistic reasons, coincides with the cult of St. Nicholas, which was particularly widespread during this period (see the crosier with scenes from the life of St. Nicholas, no. 59). In the simply outlined draperies with inscribed angular lines, there is a similarity with the standing figures of bishops in the roof medallions of the Cologne shrine of St. Anno (Schnitzler, 1959, pls. 90–95).

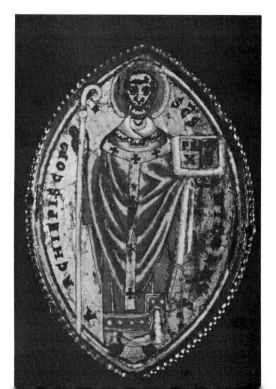

foils. On one of the capitals symmetrically arranged leaves flank palmettes. On the other, eagles with downward curled wings formally correspond to the broad swing of the first column's floral volutes, resulting in a common oval pattern. The base volutes differ in shape only slightly. For a closely related capital see A. Peraté, *Collection G. Hoentschel,* Paris, 1911, Vol. 2, pl. XI, no. 24. The eagle motif recurs on capitals of the Anno shrine columns (Schnitzler, 1959, pl. 149). Compare, as a counterpiece from architectural sculpture, no. 46.

189. Plaques

Rhenish
Late 12th century
Copper gilt, champlevé enamel
New York, The Metropolitan Museum of Art,
 Gift of J. Pierpont Morgan
I. Circular motifs, L. 8, H. 2.8 cm. (3⅛, 1⅛
 in.), 17.190.2147
II. Stem with flowers, L. 11.8, H. 3.4 cm.
 4⅝, 1 5/16 in.), 17.190.2139
III. Eagle between birds, L. 8.2, H. 2.8 cm.
 (3⅜, 1⅛ in.), 17.190.2142
IV. Two dragons, L. 8.2, H. 2.8 cm. (3⅜, 1⅛
 in.), 17.190.2143

These plaques probably are fragments of late twelfth-century Rhenish shrines. Plaque I is decorated with two rows of circles containing flower-like designs in alternating colors. Plaque II shows five flowers with intertwining stalks springing from a continuous stem with a vigorous linear treatment in the calyxes. The animals and birds on Plaques III and IV are vividly rendered, the curving lines of their bodies playfully exaggerated. A close resemblance in style, technique, and imagery is evident in several of the plaques deco-

rating the Innocentius-and-Mauritius shrine in Siegburg (Mütherich, 1940, p. 16 f. fig. 2) and a date of about 1190–1200 is deduced for our plaques from this similarity. The delicate wavy lines, the jagged strokes, the sharpness of contour, and the gracious ornamental rhythm, are more developed in our plaques and anticipate, in some respects, the Cologne Passion medallions (no. 198). Whereas the man attacked by the dragons on the Siegburg plaque mentioned above relates iconographically to a contemporary aquamanile (no. 121), the type of confronted dragons on our plaques stems from classical and Eastern proto-types. Early medieval instances—for example in Ottonian Reichenau Gospel books—offer a great variety of demoniac images that are also to be seen on Romanesque capitals, initials, textiles, and goldsmiths' work (Schrade, 1900; Schapiro, 1948, à propos the famous criticism of this imagery by Bernhard of Clairvaux). The erect eagle of Plaque III closely resembles a medallion on the knob of the precentor's staff in the Cologne Cathedral treasury (Swarzenski, 1967, fig. 455).

190. Plaques

Rhenish, Mosan
1180–1200
Champlevé and cloisonné enamel
Ds. 5.3 cm. (2¼ in.), Ls. from 8 to 3 cm.
 (3⅛ to 1¼ in.)
New York, Coll. Mrs. Ernest Brummer

The two circular plaques, decorated with floral motifs, once served as nimbs of figures of the type seen on the Aetherius shrine and other works of the Fridericus group (Falke-Frauberger, pl. II).

Similar pieces are in the Kofler-Truniger Collection (Schnitzler-Bloch, II, E.17, E.23). One of the plaques is inscribed S IPOLITUS MART. The oblong plaques show a great variety of floral decoration. Goldsmiths' marks are present on the backs of two.

BIBLIOGRAPHY: F. Mütherich, *Die Ornamentik der rheinischen Goldschmiedekunst in der Stauferzeit*, Würzburg, 1940, p. 54; *Kunst des frühen Mittelalters*, Bern, 1949, no. 345; "Kölner Zwickelplatte," *Ars Sacra*, Munich, 1950, no. 295; *Die Sammlungen des Baron von Hüpsch*, Cologne, 1964

191. Four plaques

Rhenish
1180
Cloisonné and champlevé enamel
A: 7.8 x 4.0 cm. (3 1/16 x 1 9/16 in.)
B: 8.2 x 4.2 cm. (¼ x 1 11/16 in.)
C: D. 5.0 cm. (2 in.)
D: D. 5.5 cm. (2⅛ in.)
New York, Coll. Mr. and Mrs. Germain
 Seligman

Plaques A and B, beveled with a beaded lower edge, each show three quatrefoil designs of red and white on blue set in a gold disc, on a deep blue background. At the bottom of C and D an arc is cut out. While C presents a centralized geometrical composition of eight gold circles, D shows vine and leaf designs on its gold background. The geometrical and floral decorations of these plaques are variations of patterns common in Mosan and Rhenish goldsmiths' work of the third quarter of the twelfth century (Mütherich, 1940, pp. 74–89). The plaques have been tenta-

tively attributed to the Cologne Fredericus group by Steingraber (oral information). Comparative material includes medallions in the Kofler-Truniger Collection (Schnitzler-Bloch, pl. 34) and two circular plaques, no. 190).

192. Two arches

Cologne
About 1190
Champlevé enamel, copper gilt
11.4 x 27.9 cm. (4½ x 11 in.)
New York, The Metropolitan Museum of Art,
 Gift of George Blumenthal, 41.100.147,
 148

A row of small circles with quatrefoil centers decorates the dark blue background of these arches. The crest is of copper-gilt openwork in a dart and pierced heart design. The ends of each arch are missing. The shape and size, the distinctive style, the sensitive rhythm of the cresting indicate our fragments originally formed part of Nicholas

193. Finial

German
Late 12th century
Copper, champlevé enamel
H. 13.8 cm. (5⅜ in.)
New York, The Metropolitan Museum of Art,
 Gift of J. Pierpont Morgan, 17.190.347

The spherical knob, divided horizontally by a central band, rests on a short column that ends in a floral volute. The crowning pine cone is supported by an inverted volute. The upper and lower registers each contain four fields filled with facing animals flanking trees, floral arabesques, or a lamb attacking a bird. The crowning pine cone suggests that the finial once decorated a shrine. The shape and disposition of our piece remind one of the finials of the Anno shrine, produced in the late twelfth century by a Cologne workshop and based on Mosan prototypes (Schnitzler, 1959, pl. 142). Similar knobs occur on the Cologne St. Albinus shrine (ibid., pl. 101) and the Aachen shrine of Charlemagne (ibid., pl.

of Verdun's shrine of the Three Magi in Cologne Cathedral. A comparison with the enameled arches still on the shrine bears out this assertion. Our fragments were probably dismantled in the early nineteenth century, before the shrine had to be shortened by the width of one arcade (Schnitzler, 1959, p. 36 f.; Cologne, 1964, pp. 15–18). The ornamental repetition and the color sophistication apparent in our piece testify to Nicholas's inexhaustable inventiveness. The triple arch motif, occurring in Western art since the tenth century, was used by him as a framing device on all three of his great reliquary shrines, Klosterneuburg, Cologne, and Tournai (no. 179, II, ill. 111, no. 100). Employing the varied solutions of earlier Mosan art, Nicholas transformed the traditional vocabulary, partly inspired from Byzantine sources, into his own idiom. By his example, he inspired a great production of enamel and goldsmith work in Cologne and Aachen, superseding the radiation of earlier Mosan art via the Cologne shrine of St. Heribert.

On the back of one of the arches (41.100.147) is a crudely incised head of a woman and an unfinished head of a man, both in profile, apparently sketches worked out later for a head on the *émail brun* strip of the Cologne shrine. Examples of this working procedure of Nicholas were observed also on the back of plaques from the Klosterneuburg altarpiece (see no. 179; Demus, 1952, figs. 21–22).

BIBLIOGRAPHY: Rubenstein-Bloch, 1926, III, pl. IX; Mütherich, 1940, p. 39 f., Paris, 1968, no. 371, p. 238

28), which, like ours, are Rhenish goldsmiths' work of around 1185–1200. A similar division of the fields of the knob is seen as early as the tenth-century staff of St. Peter in Cologne (V. Elbern, *Das erste Jahrtausend, Düsseldorf,* 1962, fig. 335). The motif of facing pairs of animals stems from Eastern models and was widespread in Romanesque architectural sculpture (Bernheimer, 1931).

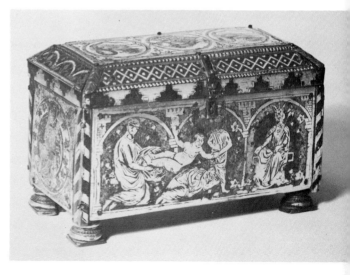

194. Casket

Lower Saxony
12th–13th century
Champlevé enamel
9.4 x 15.7 cm. (3¾ x 6¼ in.)
Hannover, Museum, W.M. XXI a 9

The plaques of this casket were made at different times and assembled in their present form around 1220, the date of the *émail brun* back and left end plaques. The back plaque is filled with floral ornament, the left end plaque shows an enthroned woman. The earliest plaque, that of the right end, has been tentatively identified by Swarzenski as representing Jacob annointing the altar in Bethel (compare with the scene of the circumcision of Isaac on the Kennet ciborium, Swarzenski, 1967, fig. 448). The geometrical background and starry frame beneath which Jacob is shown are typical of Mosan work of around 1180. The general stylistic milieu, according to Swarzenski, is indicated by the small roof plaques of the Cologne shrine of St. Heribert. A slightly later date is suggested for the lid plaque of the exhibited casket; judging from its shape, it probably originally ornamented a casket of identical shape. On this plaque three medallions enclose (center) a peacock and (flanking) herons carrying serpents in their beaks. Because of the predilection for illustrated bestiaries with groups similar to those of the three medallions, and the similarity of caskets occurring in English art of this time only, Swarzenski, 1932, suggested both English and Mosan sources for this plaque and for a similar plaque with almost identical

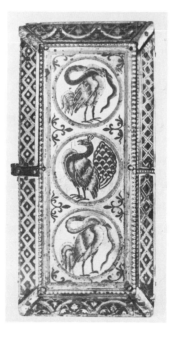

decoration (fig. 305). Although not of such high quality, the remaining plaques of the exhibited casket illustrate the adaptation of more advanced Western models and techniques by lower Saxon artists of around 1220.

BIBLIOGRAPHY: Swarzenski, 1932, p. 360 f.; Lenzen-Buchausen, 1965, fig. 51; Hannover, 1966, no. 72

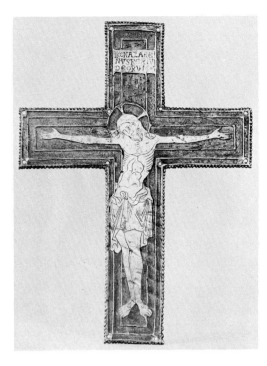

195. Two crucifixes

Lower Saxony
Beginning of the 13th century
Champlevé enamel
23.3 x 17.2 cm. (9⅛ x 6¾ in.)
Frankfurt am Main, Museum für
 Kunsthandwerk
22.5 x 17.5 cm. (8⅞ x 6⅞ in.)
Cologne, Schnütgen Museum

In both examples the body of Christ shows a slight swinging motion. The arms are outstretched almost horizontally and the thumbs stand out at an angle. The nailed feet are placed in a way that reflects the contrapposto posture. The zigzag folds of the loincloth and the nervous hatchings between them add to the impression of motion. On the Frankfurt example the dark and light blue, turquoise green, yellow, white, and iron-oxide red on the background of the cross stand side by side, not separated by cloisons. Along the outer edge of the cross runs a band of beading. The space between the ridge of the outer margin of the cross and the inner design of the engraved figure of Christ is filled with frag-

mentary remainders of a varicolored wavy band. On the Cologne example the original enamel decoration is lost. Georg Swarzenski compared both crosses with an enameled box and a panel reliquary from the Guelph Treasure, and attributed the whole group to Braunschweig. Hermann Schnitzler (Cologne, 1968) prefers to localize the origin to Hildesheim, and indicates the niello chalice from Iber (no. 116) and the St. Lawrence reliquary from the Guelph Treasure as comparisons.

The crucifixes represent the intensive interpretation of Byzantine models that took place in lower Saxony in the beginning of the thirteenth century (Steingraber, 1956, p. 26, fig. 18). A possible Byzantine prototype is supplied by the reliquary cross in the Dumbarton Oaks Collection, Washington, D.C. (Dumbarton Oaks, 1967, no. 261). On the other hand, stylistically, in its nervous lines, the crucifixes are more reminiscent of Constantinopolitan works, such as the enamel plaque of the Crucifixion on the Pala d'Oro in San Marco, Venice (Wessel, 1964, pl. 46g). The indication of sculptural modeling of Christ's ribs differentiates the body type used in lower Saxon workmanship from that of the Byzantine models cited above. Viewed in the history of style, both crucifixes combine the organically soft tendency of Mosan origin with the incipient jagged, broken drapery design that developed simultaneously in the Thuringian-Saxon school of painting. Furthermore, these crucifixes owe their characteristic wavy, varicolored bands to the Limoges school of enamels.

BIBLIOGRAPHY: Swarzenski, 1932, pp. 366 f., fig. 316

196. Crucifixion

Germany
1200–1210
Copper, champlevé enamel
22.9 x 19.8 cm. (9 x 7¾ in.)
New York, The Metropolitan Museum of Art,
 Gift of J. Pierpont Morgan, 17.190.448

This plaque telescopes the actions of the two soldiers moments before (giving of sponge) and

after (opening of the side-wound) the death of Christ. Two figures above the arms of the cross hold discs of the sun and moon, the shapes of which seem to be a variation of the circular floral ornaments filling the field of the plaque. While the geometrical organization of the field recalls a Romanesque tradition, the vividly active soldiers, the modeling and swinging curve of Christ's body, and the sharply contrasting folds of the drapery point to an early thirteenth-century date.

The head of Christ, added in relief, presupposes the artist's knowledge of contemporary Limoges technique, as does the overall pattern of ornament. Pointing to the same Limoges element in the Stephanus and Laurentius reliquary, ascribed by him to Fritzlar, Ross also assigned this origin to our piece. An idea of Fritzlar enamel production of the end of the twelfth century is given by the book cover with a Crucifixion, in the treasury of Fritzlar Collegiate Church (Steenbock, 1965, no. 102, fig. 141). In the 1940 Boston catalogue, G. Swarzenski preferred to localize our piece to Braunschweig. As an indication of its German origin, Ross cites the iconography of the crucifixion with Stephaton and Longinus, Mary and John are usually represented in French

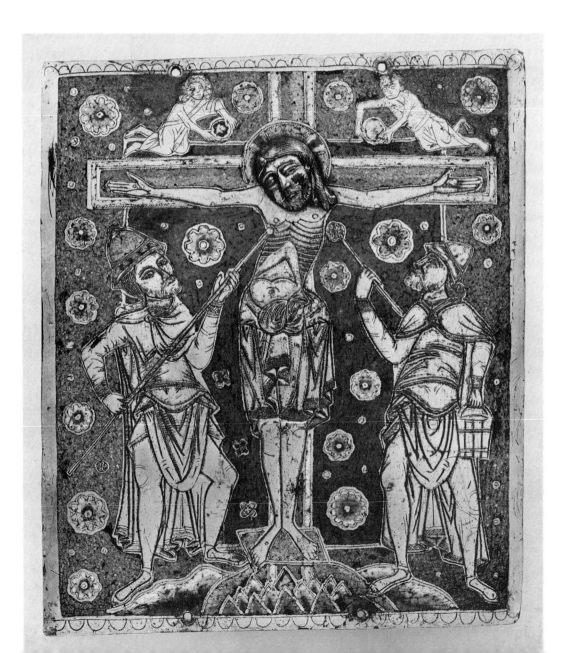

examples. Another rare motif is that of the figures carrying discs of the sun and moon. Lacking haloes, they do not appear to be angels. In spite of the hasty execution, their complicated postures presuppose a prototype of the early thirteenth century.

BIBLIOGRAPHY: Ross, M. C. "Ein Emailbild der fritzlarer Werkstatt," *Pantheon*, XII, 1933, pp. 278–279; Boston, 1940, no. 256

197. Standing bishop

Rhenish-Mosan, circle of Nicholas of Verdun
1200–1210
Copper gilt, champlevé enamel
15.2 x 5.7 cm. (6 x 2¼ in.)
Chicago, The Art Institute, 43.38

The shape of this plaque shows that it formed the right half of a cusped and gabled arch, probably from the wall of a shrine. Technically, the plaque is of interest for the subtle handling of the blue enamel, which is given a special vibrance through the introduction of a green edging in the larger fields, and an underlay of red in the filling of the engraving.

The monumental conception of the standing figure and the dynamic composition seen in the diagonal of the crosier, the juxtaposition of deeply molded drapery folds, and sharply drawn angular forms all point to a date in the early thirteenth century. Schnitzler attributes the piece to the workshop of Nicholas of Verdun and suggests that it represents Archbishop Bruno of Cologne (921–965), the founder of the church of St. Pantaleon. The bishop seems to look at the model of the church he is carrying. This iconographical type (for a late eleventh-century Lotharingian tombstone of a secular donor with a church model, see Muller-Dietrich, 1968, p. 28, fig. 14), harking back to devotional scenes of classical art, occurs in Rhenish-Lotharingian goldsmiths' work of the early twelfth century, as on the engravings on the book cover of the Liber Aureus of Prüm (Schnitzler, 1959, pl. 15:

compare the upper left figure of Pippinus Rex beside the enthroned Christ). Compare, in later developments of Rhenish-Mosan goldsmiths' work, similar standing figures of bishops, not holding models of a church, on the reliquary plaques of the Holy Cross in the St. Matthias monastery at Trier (II, ills. 133, 134; Schnitzler, 1959, pl. 10; lower row, two similar figures), and St. Lutwinus on the right wing of the Cross reliquary triptych in Mettlach (II, ills. 136, 137; Schnitzler, 1959, pl. 16). A parallel in book illumination can be seen in Cologne, 1964, no. 47, fig. 44.

BIBLIOGRAPHY: Schnitzler, 1939, p. 56 f.; Swarzenski, 1942; Rogers-Goetz, no. 29; Demus, 1965; Swarzenski, 1967, no. 521; Paris, 1968, no. 369

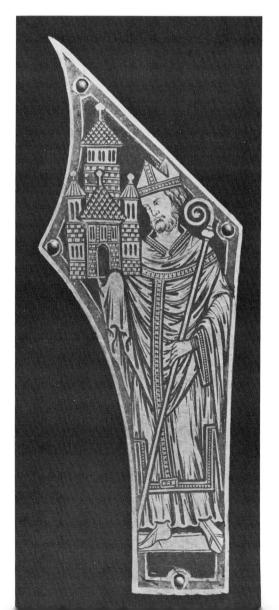

198. Descent into Limbo, resurrected Christ

Germany, Cologne
1210–1220
Copper, champlevé enamel
13.7 cm. (5⅜ in.)
Cologne, Schnütgen Museum, G. 49

These plaques are part of a group of four, the other two (II, ills. 159–162) representing the Three Marys at the Tomb and the Coronation of the Virgin. The lobes of the Limbo and Three Marys plaques show similar floral ornament, while the Resurrected Christ and Coronation lobes have half-figures of angels emerging from clouds. All the spandrels are filled with stylized plants. Compositionally, the scenes are sharply reduced, the Descent into Limbo consisting only of Christ and two youths with the head of one just visible and Christ's right foot omitted. The Three Marys at the Tomb may be compared with the more complete scenes of the Klosterneuburg altarpiece and the Tournai shrine (Swarzenski, 1967, figs. 517–518). The combination of a standing Christ, carrying book and cross-banner, and two acclaiming apostles in three-quarter length who appear on clouds like the surrounding angels, probably derives from a representation of Christ's ascension with accompanying angels hovering on clouds.

Stylistically, the plaques developed from the workshop of the shrine of the Magi in Cologne. This relationship can be seen in both the floral ornament, and the type and modeling of the standing figures, on our Limbo plaque and on an ornamental band from the shrine (Swarzenski, 1967, fig. 523). A common indebtedness to Nicholas of Verdun is seen in the Mettlach cross reliquary (Schnitzler, 1959, pl. 10); the work of Hugo of Oignies has a more advanced Gothic stylization, especially the foot of his Namur chalice (Swarzenski, 1967, fig. 533). From this comparison a date in the second decade of the thirteenth century may be suggested for our plaques.

The Resurrection plaque (compare the head of Christ on the back of the Cloisters St. Stephen reliquary, no. 106) varies the interpretation of

a common Byzantine model. Influences from French sculpture are particularly evident in the Coronation of the Virgin plaque, in style as well as iconography. The formal disposition of the plaques, combining a central medallion with smaller ones at the periphery, is derived from the decoration of eucharistic patens (the Bernward paten: Swarzenski, 1967, fig. 482; Elbern, 1963; related circular compositions and objects in twelfth century art: Weitzmann-Fielder, 1956). The treatment of the plants foreshadows the naturalistic achievements seen in the thirteenth-century Reims capitals (Nordenfalk, 1935).

BIBLIOGRAPHY: Cologne, 1968, no. 61

199. Two Spandrels

Germany, Cologne
About 1200
Copper gilt, enamel
Darmstadt, Rheinisches Landesmuseum,
54.265a.b

These objects are decorated with a dragon whose tail becomes a graceful floral arabesque, filling the triangular space; their counterpieces, differing slightly in design, are in Cologne (Cologne, 1964, no. 86). The serenity of classical grotesques, perhaps available to the artist through provincial Roman examples, harmonizes with the tradition of abstract geometrical interlaces in early medieval art. Meeting the demands of secular patrons in their genre-like decoration, these plaques were nonetheless integrated into a complex theological imagery, perhaps of a shrine. Although Mütherich's (1940) suggestion that the four plaques originally came from the Shrine of the Three Kings is improbable because of differing measurements, the closest parallels for the decoration of the plaques are found on that Cologne masterpiece (II, ill. 111). While the floral grammar and the dragon motif of our spandrels are derived from Mosan sources, the subtle jaggedness of the dragon's tail is characteristic of Nicholas of Verdun.

An immediate antecedent for the spandrels may be seen in a late twelfth-century enamel plaque from a Cologne workshop (Cologne, 1964, no. 34, fig. 36). This plaque, unlike our examples, has a circular frame and a subdivision of the spiral pattern, testifying to the lingering Romanesque geometrical conception as opposed to the continuous fluidity and floral naturalism of the transitional period to which our plaques belong. Certain similarities can also be seen in contemporary Limoges pieces, explained by the common Mosan inspiration of both Limoges and Rhenish production of the early thirteenth century (Gauthier, 1953).

BIBLIOGRAPHY: Cologne-Hüpsch, 1964, no. 42, figs. 46–47; Cologne, 1964, no. 9a

STAINED GLASS

200. God speaking to Noah

France, Poitiers Cathedral
About 1190
Pot metal
76.4 x 37.5 cm. (30 x 14¾ in.)
New York, The Metropolitan Museum of Art,
 The Cloisters Collection, 25.120.394

This piece is part of a roundel, the other half of which is lost. Before Steinheil reorganized the stained glass of Poitiers Cathedral in 1884, it had been used as a stopgap in the St. Peter window in the chevet of the church. The most obvious restorations include parts of the drapery of the figure and the head, a modern copy of the original, which was known from photographs made when the glass was still *in situ.* The scene is the sealing of Noah's ark by God (Gen. 7:16), here shown as Christ incarnate. Both in type and in pose, the figure recalls the corresponding figure in the deluge fresco in the vault of the neighboring church of St.-Savin, painted about 1130. Thus this panel may be seen to exemplify the general archaizing tendencies in west French art of the late twelfth century. Even though the slender figure, with its large head, heavy features, and expressive gesture, is a type stemming from a long-standing local tradition of glass painting, certain individualities of drawing and color indicate a shift in style. The predominance of cool tonalities, including subtle gradations of blues and greens, the soft, clinging drapery, and a new concern with form are observable in glass produced in all the major centers of western France in the last decade of the twelfth century. Among the closest comparative pieces are the scenes from the life of St. Ambrose at Le Mans (no. 203), dated about

1190, and the work of the St. Martin Master at Angers, from the beginning of the thirteenth century (Hayward-Grodecki, pp. 25–26). All of this glass is representative of a stylistic development peculiar to western France around 1200: a style that had not completely discarded tradition but that was, nevertheless, in a stage of transition toward new visual concepts. The place of the Noah fragment in the iconographic program of Poitiers can be determined from the existing windows in the cathedral. On the north wall of the church are remains of an extensive cycle of Old Testament histories, beginning with the story of Abraham in the second bay of the choir. The first bay, now lacking colored glass, must once have contained the history of Noah, and probably a creation cycle, now lost. The program was completed by the New Testament windows still in place on the south side of the church (Grodecki, 1951, pp. 160–162).

BIBLIOGRAPHY: Grodecki, 1948, pp. 87–111; Grodecki, 1951, pp. 160–162; *Vitrail,* 1958, p. 98

201. St. Martial and St. Fabian

France, Poitiers Cathedral
About 1210–1220
Pot metal
78.7 x 39.4 cm. (31 x 15½ in.)
New York, The Metropolitan Museum of Art,
The Cloisters Collection, 25.120.394

Half of a roundel, the other portion of which is lost, this piece was once joined to no. 200. Before 1884, it was used as a stopgap in the St. Lawrence window on the north side of the east wall of the choir of Poitiers Cathedral. Its original location in the cathedral is unknown, but it is thought to have come from a window devoted to the legend of St. Martial or St. Fabian (Auber, I, 1849, p. 346). St. Martial (*Anal. Boll.,* I, pp. 411–446) was the traditional founder of the cathedral, which as early as 1161 had been in possession of his miraculous cross. A chapel dedicated to him

occupied the first bay on the south side of the choir (Auber, II, 1850, pp. 14, 232). It is probable, therefore, that the window from which this panel came recorded the history of St. Martial rather than that of Pope Fabian. Furthermore, this window may well have occupied one of the two lights above the chapel in the first bay of the choir in the same relationship as the St. Lawrence

window had to his chapel in the north apsidiole. This bay, like its pendant on the north wall, where the history of Noah (no. 223) was originally situated, now contains white glass. In all probability the stained glass was removed from both these bays at the same time, perhaps during the renovations of 1775, when white glass was set in many of the window openings to admit more light into the cathedral. The remains of the stained glass were later used to patch the east windows. Although other fragments leaded into the St. Lawrence window were described by Auber in 1848, they are difficult to identify as to subject. This scene, as suggested by Auber, is probably Pope Fabian sending St. Martial on his mission to Christianize Gaul. The dating of this panel is a problem since it appears on stylistic grounds to be considerably later than the Noah scene. The iconographic program at Poitiers offers little help, since only one window other than those on the east wall has been positively identified as depicting the life of a saint, this being the St. Blaise window in the north transept. The rest of the windows on the north side of the church are devoted exclusively to Old Testament subjects, while those on the south include the life of Christ, his miracles, and additional Old Testament histories. The dating of this piece, therefore, must rest on stylistic grounds alone. The glazing of the side walls at Poitiers has been divided into two campaigns (Grodecki, 1951, pp. 160–163), the windows of the north side of the choir and transept dating from the first fifteen years of the thirteenth century, and those of the south wall and nave from 1230–1240. The St. Martial fragment, however, relates most closely to the former group, particularly to the first window, whose subject is the story of Lot. Such peculiarities of drawing in the Lot window as the double lining of the eyebrow and the folds of the drapery delineated by a heavy and a light stroke are shared by the figures on the left of the St. Martial panel. These features gradually disappear in the later windows. In addition, the detailing of the costumes and patterned floor of this piece are particulars not found in the later glass. On this basis, therefore, the St. Martial window was probably installed soon after the

beginning of the glazing program of the nave, perhaps as early as 1210 and certainly before 1220. This panel has been restored many times, and much of the background, as well as the head on the right, has been replaced. It is the work of a provincial atelier, observing the traditions of the western school of glass painting—traditions that would produce such an accomplished artist as the Good Samaritan Master at Bourges (no. 211).

BIBLIOGRAPHY: Abbé Auber, "Histoire de la Cathédrale de Poitiers," *Mémoires de la Société des Antiquaires de l'Ouest,* Poitiers, I, 1849, pp. 344–346, II 1850, pp. 14, 232; Grodecki, 1949, pp. 51–54; Grodecki, 1951, pp. 138–163; A. Mussat, *Le Style Gothique de l'Ouest de la France,* Paris, 1963, pp. 247–263

202. Abiud

France, probably St.-Remi-de-Reims
About 1190
Pot metal
63.5 x 87 cm. (25 x 34¼ in.)
New York, The Metropolitan Museum of Art, Rogers Fund, 14.47a

This pointed arched panel with the bust of a male figure comes from the upper part of a window. The piece is well preserved except for parts of the neck, background, and border. The original inscription AB . . . IVD in Roman capitals is the name of the ancestor of Christ in the thirtieth generation after Abraham (Matt. 1:13). A series of windows depicting the ancestors of Christ is known to have existed in the clerestory lights of St.-Remi-de-Reims before 1855. Guilhermy (Bib. Nat., Ms. fr. n. acq. 6106, fol. 42) described one of them as Abiud. The figure of Abiud now in bay G at St.-Remi is a product of the 1875 restoration, in which the original location of the various windows was confused and much of the old glass destroyed or lost. As it appears today, the body of this figure is in part old, but the head and upper part of the window are modern. The head on exhibition, conversely, was formerly attached

to a body made of modern glass, from which it has since been removed. It is tempting to believe, though unprovable, that the head of Abiud was that originally noted by Guilhermy. There is, however, additional evidence for associating this glass with St.-Remi. Both the shape of the arched top and the dimensions of the panel correspond to the upper apertures of the choir of the church as noted by Grodecki (letter in Metropolitan Museum, Sept. 6, 1953), and not to the openings in the clerestory of the nave, as believed by Kingsley Porter (letter in Metropolitan Museum, June 3, 1918). Such stylistic features of the drawing as the expressive demarcation of the brows and the curled lock of the beard indicating the chin are found in other figures at St.-Remi. This powerful, classicizing figure style with its emphasis upon volume also appeared in the work of the contemporary master goldsmith Nicholas of

Verdun (no. 100) and somewhat later in the style of the architect Villard d'Honnecourt. This was the style that would dominate glass painting in northeast France for the next quarter century. The highly complex iconographic program, including the precursors of Christ as well as the evangelists and apostles, bishops of the diocese, kings, and patron saints, was first developed at St.-Remi-de-Reims—a development as important for future programs as was the style of the glass. The theme of the holy genealogy was repeated only a decade later at Canterbury (no. 225), and the kings and bishops and the apostles and evangelists as superposed figures at Reims Cathedral as late as 1240.

BIBLIOGRAPHY: Grodecki, 1953, pp. 46–47; Grodecki, 1958, p. 108; J. Simon, "Restauration des vitraux de Saint-Remi-de-Reims," *Monuments historiques de la France,* 1959, pp. 14–25

203. Scene from the life of St. Ambrose

France, Le Mans Cathedral
About 1190
Pot metal
66 x 48 cm. (26 x 19 in.)
Paris, Monuments Historiques

This vesica-shaped panel, which has been leaded into the south window of the west wall of the nave of Le Mans Cathedral, together with another scene from the same window, was restored by Steinheil in 1898. The incidents depicted in these two scenes relate to the discovery of the relics of SS. Gervaise and Protaise by St. Ambrose, as recorded by St. Augustine (*Confessions*, IX, vii). The location of the graves of the two martyrs was revealed to St. Ambrose by St. Paul in a dream. This scene is shown in the exhibited panel, while the subsequent discovery of the remains of the martyrs is depicted in the other panel. Le Mans Cathedral possessed relics of SS. Gervaise and Protaise, which accounts for there being originally at least three windows relating to them. The earliest of these three illustrates the martyrdom of the two saints, while the two later ones are devoted to the lives of their parents, SS. Valerie and Vitalus, and to St. Ambrose. It is possible that the St. Ambrose window was not a life but rather the account of his discovery of the relics. It has been suggested that the two later windows may have come originally from another church in the area, since there is no record of any building activity at the cathedral in the last decades of the twelfth century (Grodecki, 1961, pp. 60–61). Stylistically this panel and those related to it exhibit the distinct changes notable in all western French centers during precisely the same period — the last decade of the twelfth century. At Angers, in the Dormition of the Virgin window, this style is robust and vigorous. At Poitiers, in the panels from the history of Noah (no. 200), it is somewhat reserved. At Le Mans, in the St. Ambrose series, it reaches its apogee: in the subtle balance of the diagonal compositions, in the elegance of the figures, and in the exquisiteness of the drawing. Here is foreshad-

owed the style of the early thirteenth century, exemplified by the splendid head of the Virgin from Vendôme (no. 208). Though still retaining certain traits of the Romanesque school of glass painting that produced it, this Vision of St. Ambrose panel indicates a turning point in the stained glass of western France and a trend toward the Gothic style of the north.

BIBLIOGRAPHY: E. Hucher, *Calques des vitraux de la cathédrale du Mans*, Le Mans, 1862, pp. v–viii; A. Echivard, "Les vitraux de la cathédrale du Mans," *Revue historique et archéologique du Maine*, 1913, pp. 7–17; Grodecki, 1958, pp. 96–98; Grodecki, 1961, pp. 59–76

204. Three scenes from the Temptation of Christ

France, Troyes Cathedral
1190–1200
Pot metal
A: 45 x 47.5 cm. (17¾ x 18¾ in.)
B: 43.5 x 47.5 cm. (17⅛ x 18¾ in.)
London, Victoria and Albert Museum, Gift of
 J. Pierpont Morgan, C. 107–1919,
 C. 108–1919
C: 43.3 x 31 cm. (17 x 12¼ in.)
Paris, Coll. Jacques Bacri

Panels A and B were first mentioned and reproduced as engravings by Arnaud (1837, pp. 179, 242), who noted them as being in the window next to the altar of Troyes Cathedral. In 1863, according to Guilhermy (Bib. Nat., ms. naf. 6111, fols. 117, 119), they were in the first window of the chapel of Notre-Dame. Scene A illustrate the first Temptation, in which the devil commands Christ to change stones into bread (Matt. 4:3; Luke 4:3). Arnaud's engraving shows that the inscription DIE VT LAPIDES ISTI PANES FIANT formerly ran across the top of the panel. Similarly, in scene B, the lost inscription ASSVMPSIT CVM DIABOLVS IN SEAM CIVIT described the second Temptation, in which the devil, who has taken Christ to the pinnacle of the temple, commands him to hurl himself down and tempt God to res-

cue him (Matt. 4:5; Luke 4:9). Scene C shows Christ consoled by angels (Matt. 4:11). This panel was combined with the two Bacri panels in no. 205 to form a window. The Temptation panels and others of the same series have been dated between 1190 (Grodecki, 1963, p. 140) and 1223, when the choir of Troyes Cathedral was completed. Stylistic comparisons with other glass of the Champagne region, such as the Passion window at Orbais, 1210–1215, or the life of the Virgin in Troyes Cathedral itself, about 1235, make the earlier date seem more plausible. However, the tenth-century cathedral was destroyed by fire in 1188, and the present structure, built on its foundations, was not begun until 1208. It seems unlikely, therefore, that Troyes Cathedral was the original location of these windows. Furthermore, the panels are too narrow to fit the ample lancet windows of the present choir. All of the panels of the series have lateral strips of ornament framing the scenes, a type of decoration employed during the second half of the twelfth century throughout France. In panel C and in all of the scenes from the St. Nicholas window (no. 205) this frame has been augmented by a foliate border of later date (masked in the exhibition). It is possible, therefore, that these windows were originally made for one of the parish churches of Troyes and were later transferred to the cathedral. Judging by the style of the border, the transfer took place in the second quarter of the thirteenth century, when the choir was glazed. The master of these windows employed few colors in his compositions, but the interrelationships are exceptional. Combinations of two shades of blue are rare in windows of the twelfth century but common in later glass. In these examples both sapphire and a blue of a light greenish cast are employed, and the deep ruby red, pink, and light yellow are equally unusual. The backgrounds of this series of windows are particularly noteworthy for the variety of their treatment. In the Temptation scenes, the position of the blue half and the red half of the ground alternates in the vertical sequence of the window. Only the incidents from the life of St. Nicholas window are set against plain-colored fields. The remains of another win-

dow of the series, illustrating the public life of Christ (fragments of three scenes), have a background of a painted lozenge design, while those of still another, the Dormition of the Virgin (two scenes) have a damascened ground (New York, 1968, nos. 179–182). All of these devices are common to manuscript illumination. It is tempting, in this respect, to add to this series still other panels, now lost, which were noted by Arnaud in the choir of the cathedral in 1837. These include the Sacrifice of Isaac, the Burning Bush, and the Brazen Serpent, described by him as having damascened grounds, and another triad of scenes, the Creation of Man, the Chastisement of Adam and Eve, and the Expulsion. The Temptation of Christ is unknown elsewhere in stained glass of the twelfth century, as is so extensive a rendering of his miracles. The Dormition of the Virgin was an iconographic type that was first introduced toward the end of the twelfth century. From the subjects represented, it seems logical to postulate that the glass belonged to an extensive iconographic program—a program that combined the historical and philosophical aspects of theology in a manner quite exceptional for its time. In no case do there appear to be more than three scenes from a single window. The illumination-like style of the painter, moreover, with its concentration upon detail, is further evidence for supposing that these windows came originally from the lower apertures of a small church. Their high quality and uniqueness of style may very well have led to their being reused in the newly constructed choir of the cathedral.

BIBLIOGRAPHY: Grodecki, 1955, p. 127; J. Lafond, 1957, p. 45; B. Rackham, *A Guide to the Collections of Stained Glass,* Victoria and Albert Museum, London, 1936, p. 28, no. C107-1919; Grodecki, 1963, p. 135, pl. xlvii, no. 6

205. Three scenes from the legend of St. Nicholas

France, Troyes Cathedral
1190–1200
Pot metal
A: 43 x 30.2 cm. (16⅞ x 11⅞ in.)
C: 43.5 x 30.5 cm. (17⅛ x 12 in.)
Paris, Coll. Jacques Bacri
B: 42 x 30.5 cm. (16⅝ x 12 in.)
London, Victoria and Albert Museum, Gift of
J. Pierpont Morgan, C. 106-1919

The frames of ornament and foliate borders (the latter on the left only in panel B and masked on all three panels as exhibited), similar to those of the panel showing the second Temptation of Christ in no. 204, are later in date than the scenes themselves. Panel B was described and reproduced as an engraving by Arnaud and noted by Guilhermy (see no. 204). Panels A and C were not recorded by Arnaud, and it is possible that they were removed from the cathedral during a particularly drastic renovation and reorganization of the stained glass that was begun in 1836. Panels A and C record two of the most frequently illustrated incidents from the legend of St. Nicholas (*Anal. Boll.,* II, pp. 143–151): his gift of gold to the destitute father to provide a dowry for his three daughters, which occurred before Nicholas was selected bishop of Myra; and the posthumous miracle of the Jew who placed a statue of St. Nicholas in his house in order to protect his goods from thieves. In the Bacri collection these two panels are joined to one from the Temptation of Christ window (no. 204). The incident depicted in panel B is probably St. Nicholas being chosen bishop of Myra. While most of the great cathedrals of the thirteenth century included a window illustrating the life of St. Nicholas in their glazing programs, the subject is rare in stained glass of the twelfth century, and the panels from Troyes Cathedral may have served as a prototype for the more extensive series of the succeeding century. The selection of the saint as bishop of Myra is depicted in both Chartres and Bourges, but the iconography is different. The panel illustrating the charity of St. Nicholas is,

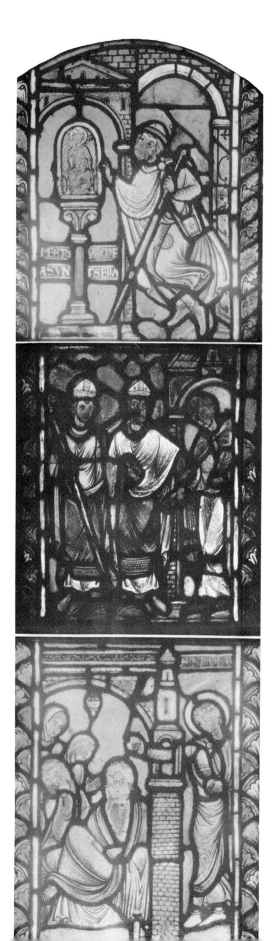

on the contrary, remarkably similar to those in both Chartres and Bourges. The small turret representing the wall of the house, with its arched window opening through which the saint extends his hand, appears in all three examples, and the poses and positioning of the figures agree. The miracle of the Jew does not appear at Bourges but is included at Chartres, Le Mans, and Auxerre. At Chartres the small statue in its arched niche placed atop a columnar base with a foliate capital is almost identical to that shown in the Troyes panel. The glass from Troyes belongs to a group, now widely dispersed in collections in Europe and America, that on the basis of style can be attributed to a single master (Grodecki, 1963, pp. 135–136). His work is distinctive both for the harmonious color relationships of the compositions and for the painting method. While most stained glass of the end of the twelfth century shows a thinness in mat tones and a contrast between tone and sharply defined outline, this master applied the paint in thick, successive layers, like the overpainting in manuscript illumination. His brushwork is extremely fine and delicate both in the drawing of features and in the delineation of folds. Strands of hair are painted in soft, wavy lines, and the drapery is given a diaphanous quality by carefully graded strokes of the brush. His use of painted ornament is profuse. It appears as decorative bands on costumes and as detail in landscape and in architecture. His is a style richly embellished with painted detail. This master is thought to have been an illuminator rather than a glass painter, which would account for his predilection for minutiae and detail (Grodecki, 1963, pp. 135–137). Close similarities of style exist between this glass and a group of manuscripts, all by the same hand, that originated probably in the scriptorium of Clairvaux in the diocese of Troyes and that dates from the last decades of the twelfth century. It is not inconceivable that a single master was the painter both of the manuscripts and of these windows. The question has been raised as to how to term the "intermediary" style represented by the windows (Grodecki, 1963, p. 141), and "proto-Gothic" has been suggested. Certainly the artistic

changes that they demonstrate indicate a new
mode of expression—a manner that is very close
to Gothic.

BIBLIOGRAPHY: Grodecki, 1955, p. 127; Lafond,
1957, p. 45; Rackham, 1936, p. 28, no. C107–1919;
Grodecki, 1963, p. 135, pl. xlvii

206. Fragment of a border

France, St.-Remi-de-Reims
About 1200–1210
Pot metal
63 x 16.5 (24¾ x 6½ in.)
Lent anonymously

This fragment comes from one of the side win-
dows of the tribune of the choir. These windows,
filled with ornament made of grisaille and col-
ored glass, were drastically restored and in many
cases entirely remade in the third quarter of the
nineteenth century. Part of one of the windows,
including a piece of the border, was published by
Cahier and Martin (II, pl. supp. E, 6) prior to
the restoration. The glazing of the choir of St.-
Remi was begun as early as 1180 and continued
into the first decade of the thirteenth century
(Grodecki, 1958, pp. 108–109). Conceivably,
the clerestory windows were executed first, fol-
lowed by those in the tribune below. The dating
in the first decade of the thirteenth century is
substantiated by the style of this border. The
elegance of the design, the delicacy of the painted
ornament, and the verticality of the composition
are all characteristic of the period. Only the nar-
rowness of the border prefigures those of a later
time. Unlike the large figural windows of the
upper lights at St.-Remi, the glazing of the side
bays of the tribune was composed exclusively of
ornament. The borders, therefore, were merely a
termination of the field of ornament rather than
a separate decorative element enclosing a figural
representation. The piece is in a remarkably good
state of preservation with only the topmost amber
leaves replaced. Much, if not all, of the leading is

old. This border is representative of the high point in the development of early Gothic ornament at St.-Remi—a point at which the glass painter achieved a balance between figure and decoration combined with a technical perfection that would be equaled only in the glazing of the great cathedrals a decade later.

BIBLIOGRAPHY: Cahier-Martin, II, pl. supp. E, 6; Simon, 1959, pp. 14–25

207. Four scenes from the legend of the Seven Sleepers of Ephesus

France, Rouen Cathedral
About 1210–1220
Pot metal
A: 62 x 58 cm. (23⅜ x 22⅞ in.)
Worcester, Art Museum, 1921.60
B, C, and D: 63 x 58.5 cm. (24¾ x 23 in.)
 each piece
Lent anonymously

Each panel is surrounded by a patterned background and pearled border of modern glass. The strip at the base of panel A has been added, and the original shape of the scene altered. The skirt of the figure on the left in panel B is a replacement, and panel D includes numerous insertions of both ancient and modern glass. There are some distortions in all four scenes due to careless releading in the nineteenth century. The popular legend of the Seven Sleepers of Ephesus was recorded by Gregory of Tours (*Anal. Boll.,* XII, pp. 371–387). Of particular interest for this glass is the occurrence of the legend in an Anglo-Norman poem, *Li Set Dormanz,* written by a certain Chardry (ed. Koch, Leipzig, 1879), testifying to the story's especial favor in Normandy. The legend of the Seven Sleepers concerns the fate of seven Christian men who suffered persecution under the emperor Decius. The young men were accused by their relatives, the subject of panel A, of refusing to sacrifice to pagan gods. As punishment, they were sealed in a cave to die, but

through divine intervention, they fell asleep instead. Some two hundred years later they awakened and were released. Panel B shows one of them, Malchus, being apprehended by the people of Ephesus because of the antiquity of the coins with which he attempted to buy bread to feed his companions. In panel C Malchus is brought by the baker before the consul Antipater and Martin, bishop of Ephesus, to account for his possession of the coins. (The inscription at the top of the panel probably explained the scene, but it has been restored and disordered.) Panel D depicts the martyrs praying in the cave after their release. It is impossible to determine the placement of these panels in the original window, which was part of the first glazing program of Rouen Cathedral, but the window itself was one of a series designed for the aisles of the new nave, built after the fire of 1200. Presumably these windows were of the multiform medallion type common in France during the first half of the thirteenth century, which would account for the unconventional shapes of the scenes in their present state. A century later the addition of side chapels to the nave necessitated the removal of the glass. Since it was apparently highly regarded—fourteenth-century records mention these windows as *belles verrières*—it was used, probably recut, in the narrow lancets of the new chapels. A number of scenes are still in place in two chapels of the north aisle. The style of all the panels is free and strong in execution, and the design is distinctive. The drapery is complex in its fold patterns. The artist has concentrated upon the figures, placing them so that the scenes do not appear overcrowded and excluding everything but the most essential elements of setting. Uniformly light tonalities are employed for the figures, which thus appear in bold silhouette against the deep blue of the background. The emphasis is upon narrative, expressed through the lively gestures and tension of the poses, continuing a tradition in western French glass painting that extends back into the twelfth century. These panels are probably the work of the St. John the Baptist Master, to whom the earliest and finest windows in the nave of Rouen have been ascribed. His

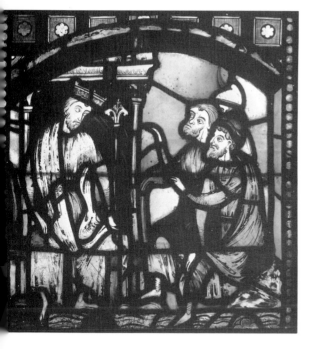

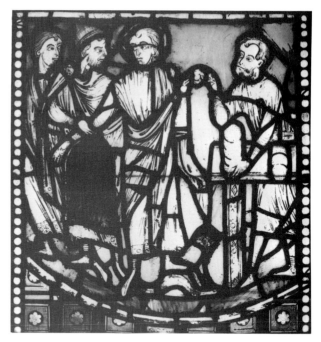

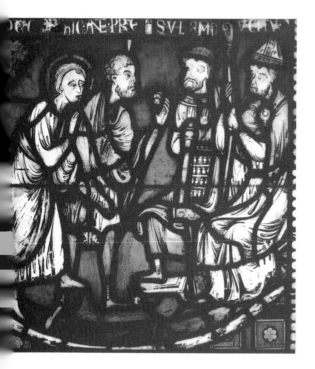

origins are obscure, but it is possible that he also worked at Chartres as a member of the atelier responsible for the history of Joseph window in the nave. In any case, he was an accomplished artist who had completely emancipated himself from the Romanesque traditions that had lingered overly long in many of the other centers of western French glass painting.

BIBLIOGRAPHY: American Art Gallery sale catalogue of the Henry C. Lawrence Collection, New York, January 28, 1921, pp. 36–38, no. 374, ill., nos. 375–377; J. Lafond in A. Loisel, *La Cathédrale de Rouen,* Paris, 1924, pp. 111–112; Grodecki, 1956, no. 2, pp. 101–103; New York, 1968, nos. 183–185

western France that are comparable in style. It has been suggested that this piece is related to the Virgin in the central window of the apse at Chartres (Grodecki, 1953, p. 50), but the latter example, austere and majestic, does not duplicate, even on larger scale, the aforementioned qualities that distinguish this piece.

BIBLIOGRAPHY: L. Magne, II, 1887, p. 6, no. 34; J. Roussel, *Album des vitraux extraits des archives du Ministère de l'instruction publique,* Paris, 1905, II, pl. 6; A. K. Porter in *Art in America,* 1918, V, pp. 264–266; Rotterdam, 1952, no. C; Grodecki, 1953, no. 11, pp. 47–48

208. Head of Virgin in glory

France, La Trinité de Vendôme
About 1215
Pot metal
37 x 28 cm. (14½ x 11 in.)
Vendôme, church of La Trinité

The only surviving panel of a window, this was removed from the church of La Trinité at Vendôme about 1875, but following World War II it was returned and installed in the east window of the north transept. The fragment was originally part of a large figure of an enthroned Virgin and Child adored by two censing angels. The type became popular in the early years of the thirteenth century, and similar examples can be seen in the central windows of the apses at Bourges and Chartres and in the nave of Angers, all of roughly the same date. Certain iconographic features, such as the type of the crown and flowering scepter, are common to all of these representations. There is, however, a softness and subtlety in the painting of this figure that is not present in other examples. It is apparent in the elegant turn of the wimple about the Virgin's neck, in the pensiveness of her face, and in the graceful gestures of the angels. Unhappily, this fragment is all that remains at Vendôme from its period, and there are no other contemporary examples from

209. Scenes from the life of St. Eustace

France, Dreux, church of St.-Pierre
About 1215
Pot metal
57 x 63 cm. (22½ x 24¾ in.) including mounts
Paris, Monuments Historiques

These two roundels were set in frames of modern glass by the restorer R. Lorin. Before 1937 they were in the tracery lights of the windows on the south side of the nave of the church of St.-Pierre. The panels have been deformed through restoration and have lost their original borders. The paint is worn and some of the glass, particularly the heads, has become heavily patinated. The scenes represent two incidents from the legend of St. Eustace (*Act. S.S.,* Sept. 6, pp. 123–135). One of the roundels illustrates the conversion of St. Eustace: when he was known as Placidus and was master of the cavalry under Trajan, he hunted down a stag only to find a crucifix attached to its horns. In this version a bust of Christ takes the place of the cross, but this particular iconographic type also occurs in the St. Eustace window in the clerestory of the transept at Chartres (Grodecki, 1953, p. 54). The other roundel shows St. Eustace after his conversion going into exile with his family. The boat is similar to that shown in a more complete version of the legend in the nave

at Chartres dating from about 1210. The style of the Dreux roundels, their color, and their design suggest a relationship with this window (Grodecki, 1953, pp. 54–55), which may be the work of the same atelier. These two small scenes echo the Chartrain atelier's work in their calm, harmonious compositions, their elongated figure style, and their drapery composed of small, tightly bunched folds. This is a style of purity and elegance, a style similar to that of the ateliers of Soissons and Laon.

BIBLIOGRAPHY: Delaporte, 1938, pp. 425–428; Exposition Universelle de New York, 1939; Grodecki, 1953, pp. 54–55; Grodecki, 1958, p. 129; Aubert, 1946, p. 32; L. Grodecki, "Le maitre de Saint-Eustache de la Cathédrale de Chartres," *Gedenkschrift Ernst Gall,* Munich, 1965, pp. 171–194

210. Two panels from a Tree of Jesse

France, abbey of Gercy
About 1215
Pot metal
Top panel, 45.5 x 55.5 cm. (18 x 21⅞ in.);
 lower panel, 43 x 55.5 cm. (17 x 21⅞ in.)
Paris, Cluny Museum, cl. 44

These panels come from the destroyed abbey of Gercy, not far from Melun in Ile-de-France. The abbey, founded in the parish church of Gercy in 1269 by Alphonse de Poitiers and his wife Jeanne de Toulouse, probably gave the existing windows to a new church built for the parish in 1270 in the neighboring town of Varennes (Magne, II, 1887, pp. 75–98). This would explain why the glass predates the foundation of the abbey. The condition of the glass is excellent, with only a few insertions of replacement glass in the background and the white edge fillet. The two panels follow the traditional iconography of the Jesse Tree as first expressed in stained glass at St.-Denis. At the top of the tree, in a mandorla formed by the branches, is Christ, who holds the orb and blesses mankind. He is surrounded by the seven doves, representing the gifts of the Holy Spirit. Occu-

pying her place below him in the genealogy is the Virgin, flanked by two unidentified prophets. The missing panels below doubtless contained the royal ancestors of Christ, with the sleeping Jesse in the lowest. The iconography (A. Watson, *The Early Iconography of the Tree of Jesse,* London, 1934) is based on Isaiah 11:1. One of the few remaining examples from its geographic area and period, it provides evidence of the character of the Parisian style of glass painting in the first decades of the thirteenth century. The great ease and suppleness of the design (Grodecki,

1953, p. 51), shorn of all ornamental stylization in the patterning of folds or drawing of the heads, and the relatively short proportions of the figures as well as their type relate this window to later examples in Ile-de-France—to other panels from Gercy and to glass at St.-Jean-aux-Bois and St.-Germain-lès Corbeil (no. 219).

BIBLIOGRAPHY: Magne, II, 1887, pp. 75–98; Merson, 1895, pp. 39–40; Roussel, I, 1905, pl. 6; Magne, 1912, pp. 1, 6, no. 47; Rotterdam, 1952, no. 6; Grodecki, 1953, pp. 50–51; Grodecki, 1958, pp. 140, 144.

211. Meal in the house of Simon

France, Bourges Cathedral
About 1215
Pot metal
54.5 x 105.5 cm. (21½ x 41½ in.)
Bourges, Cathedral St.-Etienne

These three panels, which make up one scene from the life of Mary Magdalene, come from the fourth register of the right-hand window in the first chapel on the north side of the choir of Bourges Cathedral. This remarkable window has been attributed to the Good Samaritan Master, so named after his principal work at Bourges (Grodecki, 1948, pp. 87–111). He used white sparingly, blues sometimes matted to make them appear deeper, and a vibrant red, which in this example is offset by an unusual light olive green. This tendency toward variety of palette is also to be noted in the backgrounds of his scenes. The broad red frame of this particular scene separates each panel into three separate medallions, while the scene itself is continuous, stretching across the entire field of the window. The multicolored trellis background is richly painted. The figure type is distinctive, the large heads with heavy features presenting a quite melancholy appearance. The small, slender limbs are defined by lines that indicate the skeletal structure beneath. The drapery style is restless, with folds looped over belts and falling in wavy patterns irrespective of the forms of the bodies they clothe. The work of the Good Samaritan Master shows certain resemblances to the earlier windows of the side aisles of the choir at Poitiers, but this style can be traced

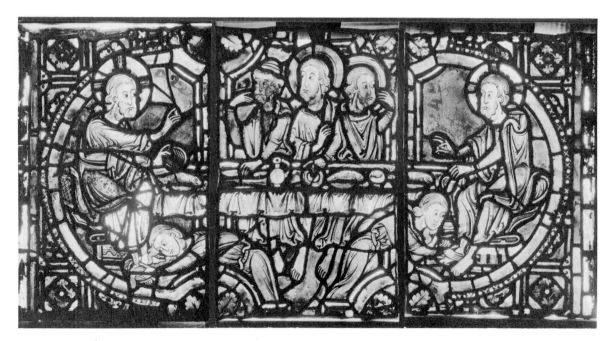

back even further, to its origin in the Dormition of the Virgin Atelier at Angers. The scene of the meal in the house of Simon the Pharisee (Luke 7:37–39) is beautifully designed as a perfectly symmetrical composition, but this results in a curious iconography. Christ sits simultaneously at each end of the table, and the Magdalene is also shown twice, kneeling at his feet while performing her act of penitence. In the left-hand panel Christ holds a morsel of bread in one hand, a loaf in the other. His attention is focused upon Simon, who is seated at the left of the central panel. In the right-hand panel Christ admonishes his followers and points at the kneeling Magdalene. This is clearly an illustration of the accompanying parable (Luke 7:39–50) in which Christ discourses on the forgiveness of sin. The Good Samaritan Master rarely used the star-shaped composite medallion common at Chartres and in other glazing of the period. Instead, as in this example, his scenes are joined by continuous framing strips that extend from register to register. Another feature that links this window with Poiters is the sequence in which it is read, from top to bottom rather than upward, as is usual in narrative cycles of stained glass. The work of the creator of this window marks the high point in a style of French glass painting.

BIBLIOGRAPHY: Cahier-Martin, II, pp. 245–248; Grodecki, 1948, pp. 87–111; Grodecki, 1951, pp. 138–163; Hayward-Grodecki, 1966, pp. 20–21

212. Fragment of the martyrdom of St. George

France, Chartres Cathedral
1215–1220
Pot metal
70 x 65 cm. (27½ x 25½ in.)
Princeton, University Art Museum, 71

This fragment was until 1788 on the south side (bay CVIII) of the choir clerestory of Chartres Cathedral (Stohlman, 1927, pp. 39). Another part of this same scene, identified as a martyrdom

of St. George (Delaporte, 1926, pp. 450–452), still exists in bay LVII on the east wall of the north transept. The original aspect of this window is well documented, both from a drawing by Gaignières (H. Buchot, *Bibliothèque Nationale, Inventaire des dessins exécutés pour R. de Gaignières et conservés aux départements des estampes et des manuscrits,* Paris, 1891, no. 100) and from a description by the Chartrain historian Pintard (Bib. Chartres, ms. 1012, fol. 425). In the nineteenth century the exhibited panel was restored and other glass joined to it to make up a complete scene, but these incongruous additions have here been deleted. Originally the piece formed the central panel of a nine-part medallion, which showed the martyr pinned by his arms and legs to the sword-studded wheels of torture. According to Pintard's description, the scene included the figure of a king directing the torture. This iconography is similar to that in the St. Blasien Psalter (no. 278). Below this medallion was another, the subject of which, now unknown, was probably from the same legend, and at the base of the window was the donor portrait, depicting a member of the Courtenay family, who also gave the glass in the other window of the bay. The martyrdom of St. George (*Act*

S.S., Apr. 3, p. 101) as it appears in this panel differs only slightly in iconography from a somewhat earlier version of the scene in one of the nave clerestory windows at Chartres in that in this scene the martyr is stretched horizontally upon the wheels while in the earlier panel his body is vertical. The style reflects that of the principal atelier of the choir of the cathedral. It is a style of great tranquility and elegance, a style that depends for its effect upon delicate modeling of form and linear accent. There is in the head of this saint nothing of the boldness or robustness of accent that characterizes the earlier style of St.-Remi (no. 202). The developed Chartrain style, which would have wide and long-lasting effects upon French glass painting, evolved very quickly from the various local traditions that marked the glazing of the nave a decade earlier. At this stage individual hands or ateliers, though recognizable, are less evident than the homogeneous approach.

BIBLIOGRAPHY: W. F. Stohlman, "A Stained Glass Window of the Thirteenth Century," *Art and Archeology,* XX, 1925, p. 135; Delaporte, 1926, pp. 450–452; Stohlman, "A Stained Glass Window from Chartres Cathedral," *Bulletin of the Department of Art and Archeology of Princeton University,* Oct., 1927, pp. 3–9; Stohlman, "A Window from Chartres," *The Arts,* Nov., 1927, pp. 271–274; Grodecki, 1958, pp. 130–131; H. B. Graham, "A Reappraisal of the Princeton Window from Chartres," *Record of the Art Museum, Princeton University,* XXI, no. 2, 1962, pp. 30–45; Grodecki, 1963, pp. 192–196

213. Scenes from the legends of SS. Crispin, Crispinian, and Blaise

France, Soissons Cathedral
About 1215–1220
Pot metal
D. 69.8 cm. (27½ in.) each piece
Washington, D.C., The Corcoran Gallery of
 Art, W. A. Clark Collection, 26.793

These three roundels are framed in modern glass. Their subjects indicate that they are remains of two different windows. The central panel, identified by the inscription s CRISPINVS:CRI/SPINANVS on the scroll held by the angel, is the announcement of the martyrdom of the two saints (Verdier, 1958, pp. 5–10). The upper panel, according to Verdier, continues the legend and is composed of fragments of two scenes. The figure on the right is Rictiovarus, Roman governor of Gaul, who ordered SS. Crispin and Crispinian thrown into a caldron of boiling lead, but who was himself hit in the eye by a drop of the hot metal, which caused him such pain that he went mad. The group of people on the left are witnesses to a miracle involving a crippled child who was brought to the coffins of the two martyrs as they were being transported to Soissons, whereupon he was instantly healed. Attribution of this glass to Soissons is made on the basis of a scene showing the martyrdom of the two saints, which is still in place in one of the windows of the ambulatory. The lower roundel is from a different legend. Verdier has suggested that it depicts the education of Médard and Gildard, local saints venerated in Soissons. In the 1962 restoration of the panel, however, the previously disordered inscription was discovered to read s:BL/AS/IVS. Moreover, three panels now in the Marmottan Museum in Paris, which are stylistically related to this one, have been identified (Grodecki, 1960, pp. 173–175) as coming from a life of St. Blaise. The lower Corcoran roundel, therefore, can now be established as another scene from the same window. It shows St. Blaise receiving the two sons of a widow who were to be martyred with him. The best preserved of the Marmottan panels records an incident from the legend of St. Blaise involving seven Christian women, one of them the mother of the two boys. That there are exactly seven women in the group at the left in the upper Corcoran panel strongly suggests that they too have been extracted from the St. Blaise window, and do not belong to the St. Crispin window. Furthermore, the water at their feet and the bent pose of the one in the foreground present the possibility that the scene is that in which the women cast the pagan gods into a pond (*Act. S.S.,* Feb. 1, p. 337). The Corcoran panels are also related to the glass in the

Marmottan Museum by similarities of style and composition. Arcaded backgrounds occur in both sets, but the most distinctive feature is the figure style. The slender, elongated figures have a particular grace of movement and gesture. Large eyes, long slender noses, and small, drooping lips impart a peculiarly melancholy appearance to the faces, while the soft clinging draperies that wrap loosely around the body or fall in tiny folds relate the glass not only to other glass from Soissons but to a whole school (Grodecki, 1960, pp. 163–178; Verdier, 1958, pp. 5–22). It was an influential school that flourished between 1200 and 1220 in northeast France, having its roots in such earlier monuments as the glass of St.-Remi-de-Reims, but receiving its classicizing tendencies from other media — from manuscript illuminations, such as those in the Ingeborg Psalter (Deuchler, 1967, pp. 180–182), and from works by the goldsmith Nicholas of Verdun (Cologne, 1964, pp. 7–14), whose son was a glass painter.

BIBLIOGRAPHY: Grodecki, 1953, pp. 169–176; Grodecki, 1958, pp. 118–124; Verdier, 1958, pp. 5–22; Grodecki, 1960, pp. 163–178

214. Fragment of a border

France, Lyon Cathedral
About 1215–1220
Pot metal
40.5 x 65.5 cm. (16 x 25¾ in.)
Lent anonymously

This fragment is part of the original lower edge of the border of the Redemption window that fills the central aperture of the choir of Lyon Cathedral. A copy of the original in which the colors, especially the blue, are much darker, was inserted during a restoration of the windows begun in 1842 by Alfred Gérente. According to Cahier and Martin (I, pl. viii, opp. p. 127), who published the Redemption window in 1841, just prior to its restoration, this portion of the border had been replaced, probably in the eigh-

209

teenth century, by a section of ornament enclosing a blank medallion, an arrangement similar to that of the border on the sides of the lancet. The cornerpieces were also missing. The border of this window is one of the richest and most elegant of its period, since it includes not only ornament but figural subjects as well. The central portion of the window contains a history of the Redemption from the Annunciation to the Ascension, while opposite each scene in the border are antitypes. Though the border dates from the second decade of the thirteenth century, its exceptional width, richness, and delicacy relate it to ornament found in stained-glass windows of the end of the twelfth century. The proliferations of the vine motif bring to mind borders in the cahedral of Angers, dating from the last decades of the twelfth century. The closest analogies of style are, however, with the window of the Three Magi on the north side of the apse at Lyon. The border of this window also includes figural medallions enclosed by ornament, though the design of the latter is not so elegant as this. The Byzantine emphasis of the iconography of the glass at Lyon has been noted many times. The Eastern tradition is not, however, responsible for the ornament. The borders of Lyon, particularly this example, lie in the Western tradition, recalling the richest of all ornamental stained-glass—the borders of French windows of the twelfth century.

BIBLIOGRAPHY: Cahier-Martin, I, pp. 127–132; Bégule, 1880, pp. 99–131; Grodecki, 1958, pp. 116–117

215. Scenes from the life of St. John the Baptist

Switzerland, Lausanne Cathedral
After 1210–1220
Pot metal
D. 76–66 cm. (30–26 in.)
Lausanne, Cathedral

The precise date of these four roundels is difficult to determine. Beer (1956, p. 25) believes that they were made for one of the windows of the choir soon after the fire of 1219. Lafond (1953, p. 129) considers that on stylistic grounds they are closer to 1210. At one time employed as stopgaps in the south rose, these pieces were restored in 1898 by Hosch and placed in the three windows on the south wall of the transept. In 1934 they were removed and put into storage. They have since been placed on exhibition in the cathedral museum. The history of the Baptist as illustrated in these panels begins with St. John's recognition of Christ as the Lamb of God (John 1:29). This scene is inscribed: ECCE.AGNVS.DEI. The glass is well preserved, all of the heads being original, but the shape of the panel had been changed. A portion of its original polylobed format can be seen at the bottom of the scene. The second panel depicts the arrest of the Baptist by Herod after John had accused the king of an unlawful marriage. The accusation is lettered on John's banderole: NO[N] LICET TI[BI] HABE[RE] UXOREM FRATRIS (Mark 6:18). Portions of the scene are well preserved, including the polylobed frame and architecture at the top of the panel and the figure of the saint. In the succeeding panel, showing the beheading of the Baptist, only the figures are original. The concluding panel, which illustrates the feast of Herod, is least well preserved. Only fragments of the original glass remain, and the composition is largely a reconstruction by Hosch. Beer (p. 60) has drawn attention to the iconographic similarities between the beheading panel and the panel of the same subject at Clermont-Ferrand. Lafond (1953, pp. 130–132) has connected the mantle of camel skin, shown in an original portion of the Agnus Dei panel, with similar representations at Vézelay, Strasbourg (no. 233), and Lausanne itself. For the same author, the polylobed framing of the panels is typical of Lyon and persistent in German stained glass, while the form of the capitals of the arcades is also reminiscent of Rhenish glass. These observations lead Lafond to postulate that the sources of style for this glass should be found in Lyonnais and in Burgundy. Unfortunately, there is little early glass left in these regions to serve as comparative material. Beer, on the contrary, sees this glass as tardive in style and

related to the work of the Good Samaritan Master at Bourges (no. 211). Both masters employed an active figure type, complicated drapery style, and broad range of color in their compositions, but there is little actual resemblance in style. Relationships with Lyon and Clermont-Ferrand seem closer. Perhaps this glass was the product of a local workshop under the influence of both Burgundian and Rhenish art.

BIBLIOGRAPHY: Lafond, 1953, pp. 116–132; Beer, 1956, pp. 58–60, 71–72

216. Ornament panel

France, Angers, abbey of St.-Serge
About 1220
Grisaille
About 54 x 56 cm. (21¼ x 22 in.)
Angers, church of St.-Serge

This panel is from the third register of the second of three windows on the south wall of the choir. The design consists of concentric circles of strapwork and foliate ornament on a background of cross-hatching. Painted colorless glass, or grisaille, is as old a medium as colored glass, if not older, but its development as a significant art form began in 1132 with the ban on color and figural subjects in windows in the Cistercian churches. The type soon came into use in other churches by virtue of its economy. Embellished with insertions of color, our piece is one of the rare examples of grisaille glass from the first quarter of the thirteenth century in France. The date of the three windows coincides with the building of the choir between 1215 and 1225 (Mussat, 1963, p. 231). But it is possible to arrive at a more precise date by means of a stylistic comparison with the Virgin and Child win-

dow in the nave of Angers Cathedral. Here the figures of the Virgin and Child are surrounded by a broad strip of grisaille glass so similar in design to the St.-Serge fragment that it must be by the same hand. This window has been dated on the basis of the donor portraits at the Virgin's feet to shortly after 1220. Its grisaille border seems a little more developed, considering the grace with which the vine leaves are drawn and the skill with which they are worked into the composition of the strapwork. It is probable, therefore, that the windows at St.-Serge preceded the Virgin and Child window at the cathedral. The problem of why the Benedictines, an order known to have had a preference for colored windows since the time of Suger, chose to have their abbey at Angers glazed in grisaille is difficult to resolve. No expense seems to have been spared in the sculptural decoration of the choir. Nor was this type of window, with the single exception of the border of the cathedral window, used in other churches of Anjou at that time. The windows of St.-Serge are, therefore, unique in that they represent a stage in the development of a type that would be important in French stained glass some twenty-five years later.

BIBLIOGRAPHY: Mussat, 1963, p. 231; Hayward-Grodecki, 1966, pp. 27–29

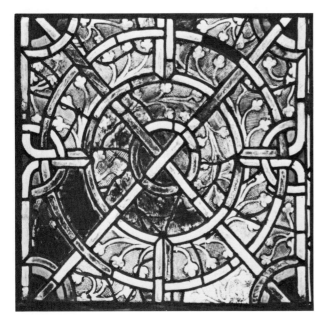

217. Fragment of a border

French, Soissons Cathedral
About 1220–1225
Pot metal
57 x 30.5 cm. (22½ x 12 in.)
Lent anonymously

The central leaf in each trefoil was wrongly placed when this piece was restored in the nineteenth century. In the original arrangement, as published in Cahier-Martin (pl. supp. M, 1), each yellow central leaf was paired with blue outer leaves and each white central sprig with green. The simplicity of the border's design, the

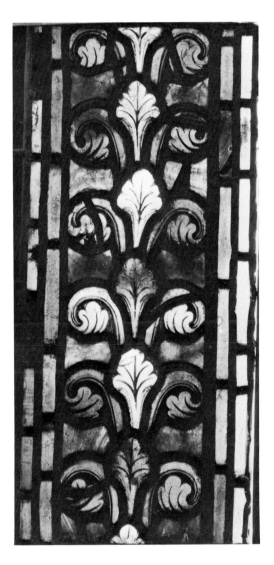

into the 1180s were derived from Romanesque prototypes in metalwork and sculpture. During this stage of development, window-border designs consisted of a series of centralized and repeated units that, whether horizontally or vertically oriented, were highly stylized and formalized. Nos. 222 and 223, though of English origin, are examples of this type of decoration. In the 1190s a change occurred toward a more naturalistic type of foliage and a more loosely conceived composition. Intricately entwined vine tendrils with small clusters of leaves proliferated on the broad field of the frame. Though later in date, no. 214 is characteristic of the type. The decade that followed the turn of the century witnessed a reorganization of the window as a whole with a corresponding reordering of its ornament. Still richly elaborated with painted detail, the design became a continuous band of decoration, as in no. 206, that enclosed the figural panels and background of the central field. The perfect balance between image and ornament achieved during this period deteriorated through repetition in the years that followed. From this point onward the border, as an element in window design, would play an increasingly unimportant role, finally to disappear altogether.

BIBLIOGRAPHY: Cahier-Martin, II, pl. supp. M, 1

coarseness of its style, and the unimaginativeness of its composition indicate that it dates from the end of the first quarter of the thirteenth century. The design is uncompromisingly vertical in direction, and the forms of the leaves stocky and lacking in grace. It represents a late period in the development of early Gothic ornament—a period when motifs had become stereotyped through reuse. Between 1180 and 1220 French ornament, seen at its richest in stained glass, had undergone significant changes. The tightly organized, lavishly painted borders that persisted

218. Fragment of a border

France, Chartres Cathedral
About 1220
Pot metal
73.5 x 34 cm. (29 x 13½ in.)
Lent anonymously

This section of a border, with some restoration at the top, is identical in design to the border of the Pilgrims of St. James window in the first bay on the north side of the choir clerestory at Chartres Cathedral. The original border of this window was removed in 1757 to permit more

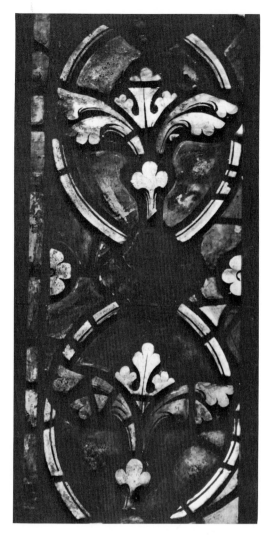

when viewed from the pavement of the choir aisle. In its general character, this design is similar to borders of many other clerestory windows in the choir at Chartres, notably in bays 105 and 123. These borders, while still retaining their individuality of design, are markedly less rich in detail than those of the nave clerestory at Chartres, executed some ten years earlier. The elements that compose this particular piece are designed with a strong vertical accent. This tendency toward verticality and a corresponding reduction of detail is characteristic not only of glass at Chartres but also throughout France in the second decade of the thirteenth century.

BIBLIOGRAPHY: Delaporte, 1926, pp. 58, 485; Grodecki, 1963, p. 123

219. Panels from a Tree of Jesse

France, St.-Germain-lès-Corbeil
About 1220–1230
Pot metal
198 x 102 cm. (78 x 40⅛ in.)
St.-Germain-lès-Corbeil, parish church

These nine panels are from the northeast window of the chevet. The window was restored in 1896 and modern glass substituted for the missing parts, including the lowest register showing the patriarch Jesse and two flanking prophets, and portions of the figure of Christ and the gifts of the Holy Spirit at the top of the tree. Part of the glass was again restored in 1968 prior to its exhibition in Paris (Paris, 1968, no. 195). As a representation of the ancestry of Christ, this tree follows the type initiated at St.-Denis in the middle of the twelfth century. Of the pieces shown, the three central panels contain the Virgin and two of the royal ancestors, who are without any identifying attributes but have been thought to represent King David and King Solomon (Vol-

light to penetrate the choir (Delaporte, 1926, pp. 58, 485). The present border, made in 1920 when the window was restored, reproduces the original design, known from a drawing in the collection of R. de Gaignières (J. Guibert, *Les dessins d'archéologie de Roger de Gaignières,* Paris, 1911, pl. 73). The piece on exhibition may be the only existing remnant of the original border. On the back it is marked 25 A, probably a notation of its position in the window frame. The design is simple and boldly executed, and its modern counterpart is therefore quite legible

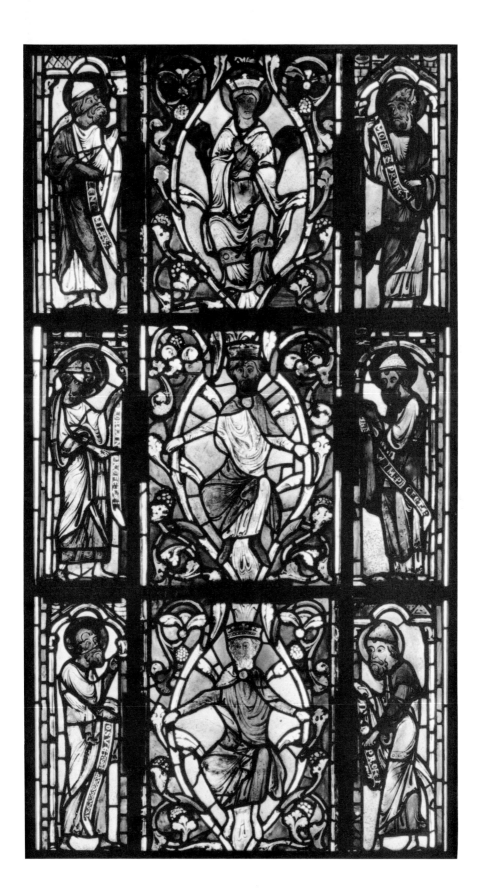

lant, pl. XI). The prophets, who occupy the outer panels, are identified by the names inscribed on the scrolls they hold: IOSVE and ARON PROFETA in the lowest register; ROBOAN PROFETA and ABRAAM PROFETA on the second level; and GENEMIAS and MOSES PROFET flanking the Virgin at the top. In contrast to the earlier Jesse Trees of Chartres and St.-Denis, the one at St.-Germain shows an increased emphasis on the human figure and a corresponding reduction in the role of ornament. The rich borders of the earlier examples have been omitted, and the older, elaborately delineated palmette foliage of the tree itself has here been reduced to a simple flowering vine. The style, however, is one of considerable elegance, particularly notable in the complex rhythms of the drapery. These panels and the two other windows of the chevet at St.-Germain (Paris, 1968, no. 194; Vollant, pls. X–XII) are among the few examples remaining of the important school of Paris of the first third of the thirteenth century. Together with the window from St.-Jean-aux-Bois, the earlier Jessee Tree from Gercy (no. 210), and the remains of the west rose of Notre-Dame in Paris, the three windows from St.-Germain-lès-Corbeil constitute all that is left of the most influential school of glass painting of its time. This group of windows, with the exception of the one at Notre-Dame, which is the subject of an admirable study (Lafond, 1959, pp. 19–34), has received little attention. The glass at St.-Germain-lès-Corbeil constitutes the most extensive of these remains. The style is vigorous and expressive. The proportions of the figures are short and their gestures decisive. The themes are literal translations of prevailing types rather than innovations. The first decades of the thirteenth century mark the youth of this style, prefiguring its full flowering in the middle of the century, when it would take its place as the first example of what may be termed a national style of glass painting.

BIBLIOGRAPHY: Vollant, 1897, pp. 1–34; Paris, 1968, nos. 194, 195; J. Lafond in *Corpus Vitrearum Medii Aevi, France, I, Les Vitraux de Notre-Dame et de la Sainte-Chapelle de Paris*, Paris, 1959, pp. 23–26

220. Redemption window

France, church of Montreuil-sur-Loir
About 1220
Pot metal
259 x 30.5 cm. (102 x 12 in.)
St. Louis, City Art Museum, 6–3:35

This round-arched window is composed of four panels, each containing a separate scene. It has been restored at least twice: once extensively in the nineteenth century and once following its removal from the church shortly after 1925. In the lowest panel the three Marys (partially restored) are confronted by the angel, who points to the empty sepulcher. The Crucifixion with Mary and St. John, in the panel above, has replacement pieces only in the loincloth and left knee of Christ, the bare feet of the Virgin, and the lower part of John's robe. Only the upper half of the scene above, excluding the head of Christ, is original. The lower part is entirely the creation of the nineteenth-century restorer, who completely altered the appearance of the panel to represent a Christ in Gethsemane. It was, in all probability, originally a Resurrection. The uppermost scene, showing Christ in Glory surrounded by the symbols of the four evangelists, is original with the exception of the right side of Christ's robe. A Resurrection scene, surmounted by Christ with the symbols of the Evangelists, also occurs in a stylistically related fragment of slightly earlier date in the chapel of the Hôpital St.-Jean at Angers. Both the windows belong to a group made around the year 1200 in the region of Anjou. All probably inspired by the great Crucifixion window of Poitiers, the windows in the group have as their central theme the Crucifixion, though each differs in the other scenes included. None of these windows can be read as a narrative sequence. Rather they are symbolic, stressing the theme of redemption. In the window on exhibition, the Resurrection is in fact represented twice: in the scene of the Marys at the tomb and in the other scene showing the actual event. Both the human and divine aspects of redemption are thus emphasized. Curiously, St. John appears tonsured in the Crucifixion scene. Is he, therefore,

to be considered here as Christ's deacon, stressing the liturgical significance of the Crucifixion? Christ triumphs not as the spiritual ruler with book and scepter as in earlier Angevin examples (Bib. Angers, Ms. 4, fol. 208), but rather as man's redeemer blessing the world. Provincial and archaic though this window may seem in style when compared with other French glass of its period, its creator was nevertheless an artist of considerable accomplishments. Also from his atelier are the large Virgin and Child in the cathedral of Angers and very probably the grisaille windows of St.-Serge (no. 216). The Virgin and Child has been dated shortly after 1220 (Hayward-Grodecki, p. 29), while the choir of St.-Serge was completed between 1210 and 1220 (A. Mussat, *Le style gothique de l'ouest de la France,* Paris, 1963, p. 223). Since the execution of the Montreuil window is less accomplished than that of these other examples, it is probably an earlier work of the master, completed before 1220, at which time the atelier appears to have been engaged in Angers itself. The window is an example of the school of the west in French glass painting—a school that had not yet cast off its Romanesque heritage. The traditional character of this style persisted until well into the third decade of the thirteenth century.

BIBLIOGRAPHY: F. M. Biebel, "XII Century French Window," *Bulletin of the City Art Museum of St. Louis,* XX, 4, 1935, pp. 48–52; J. Hayward, "Identification of the 'Crucifixion' Window," *Bulletin of the City Art Museum of St. Louis,* XLII, 2, 1957, pp. 19–22; Hayward-Grodecki, pp. 28–29

221. Fragment of a border

France
About 1220
Pot metal
65 x 16 cm. (25½ x 6¼ in.)
Lent anonymously

This piece, with the corner motif included, is from the lower part of a window. In spite of the rubbed state of the paint, the fragment is remark-

ably well preserved. Only the lowest piece of the green fillet on the left side of the border is modern, and the leading, if not original, is very old. It is impossible without further study to attribute the piece, either to a known monument or even a region of France, much less to a school of glass painting. The design is a repeated series of palmettes joined by quatrefoils. The palmette motif made its first appearance in stained-glass border designs at St.-Denis (1140–1144). Unlike other designs that are so highly individualized in character they can be attributed to a particular school (no. 214), the palmette border is found in windows in every region of France from the mid-twelfth to the mid-thirteenth century. Moreover, because it is a horizontally conceived design, it did not undergo the transformation to a vertical emphasis notable in ornamental window frames (no. 206) in the early thirteenth century. Further, the ovoid shape of the enclosing loop mitigates any drastic reduction in width, another tendency of stained-glass borders after the second decade of the thirteenth century. The changes that occurred in the motif, notable in this example, were in the representation of the elements of which it is composed and in the detail of its painting. A simplicity of design is here apparent, a single line serving as an indication of form in the enclosing ribbon. In earlier examples this element is elaborately detailed. The foliage, with its coarse, heavy leaves and bulbous central stalk, echoes the delicate, graceful bouquets of the twelfth century. As the Gothic style progressed in the first quarter of the thirteenth century ornament became less significant as an enriching

element in the design of the window and more important as a neutral field for enclosing or separating the figural portions of the design. It is this latter aspect of Gothic design that is exemplified by this piece.

BIBLIOGRAPHY: *Vitrail*, 1958, pp. 23–29

222. Fragment of a border

England, York Minster
About 1180
Pot metal and grisaille
67 x 26 cm. (26½ x 10¼ in.)
York, Dean and Chapter of York Minster,
 C. 34 W, no. 14

This fragment was recently removed from the nave clerestory of York Minster. Though a number of fragments of this border and others of similar design still exist in the upper windows of the nave, their original location can only be surmised. Westlake (p. 44) believed that they were remains of the glazing of the Norman cathedral constructed during the administration of Archbishop Thomas (1070–1100). In his opinion the fragments were removed from the Norman choir when it was rebuilt by Archbishop Roger (1154–1181) between 1170 and 1178 and were reused in the old nave, which had been damaged by a fire in 1137. On the basis of style he believed that these borders must have been remains of a glazing program dating from around 1150–1160.

Lethaby (p. 45) attributed the fragments to the new choir of Archbishop Roger and suggested a date around 1180. He concluded, moreover, basing his argument on the observation that the floral ornament in these borders and in the fragment of the Jesse Tree from York was later than the ornament at St.-Denis and Chartres, that these borders are remains of the choir of Archbishop Roger, which should have been ready for glazing at that time. No less than a dozen different designs still exist, indicating that the glazing program to which they belonged must have been extensive. This choir was replaced by the present one in 1380. It is likely, therefore, that fragments of the original glazing, including the Jesse Tree panel and these borders, were used as stopgaps in the Gothic nave already nearly a hundred years old at that time. The strongest support for this theory lies in the style of these borders—in the

luxuriance of the foliage and in the delicacy of the painted ornament. In a general sense, this ornament most closely resembles the richly decorated borders of St.-Denis and Le Mans, but its style, as discussed with its companion piece (no. 223), is different.

BIBLIOGRAPHY: Westlake, I, 1881, pp. 41–44; Benson, 1915, pp. 1–7; Lethaby, 1915, pp. 37–48

223. Fragment of a border

England, York Minster
About 1180
Pot metal and grisaille
67 x 26 cm. (26½ x 10¼ in.)
York, Dean and Chapter of York Minster,
 C. 33 W, no. 7

This fragment, like no. 222, was recently removed from the clerestory of the nave of York Minster, where it had been used as a stopgap in one of the tracery lights. Both fragments have since been restored and releaded. Nineteenth-century restorations have been removed, and twelfth-century pieces of suitable color from the cathedral stores have been substituted. This piece is also probably a remnant of the glazing of Archbishop Roger's choir of about 1180. In style it closely resembles the profusely decorated examples of mid-twelfth-century French ornament. Lethaby (pp. 37–48) has postulated a relationship on historical grounds between the style of this glass and the ornament style of western France, centered at Angers. An examination of the remains makes the thesis of Westlake (p. 42)—that the style is English—more reasonable. While almost all twelfth-century French borders do incoporate white glass in their compositions, they employ it either as a frame or a surround for a design of colored glass. At York, on the contrary, painted grisaille is used so extensively that it becomes the dominant feature of the design and, in fact, controls the composition. The black paint, which forms the design on the white glass, covers the

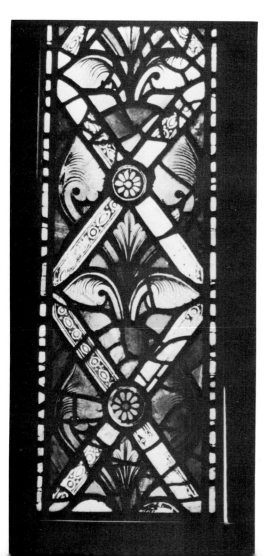

224. Scene from the legend of St. Nicholas

England, York Minster
About 1190
Pot metal
74 x 75 cm. (29 x 29½ in.)
York, Dean and Chapter of York Minster,
 C. 31 W, 1L 2P

This panel, recently removed from the south nave clerestory of York Minster, has been reordered, cleaned, and releaded. Its subject (P. Newton, letter to J. Hayward, 1969) is one of the posthumous miracles attributed to St. Nicholas (*Anal. Boll.,* II, pp. 143–151). According to the legend, a man was run over by a cart after he had falsely sworn to have paid a debt. His creditor, a Jew, vowed that he would become a Christian if the man were restored to life, which was accomplished through the intervention of St. Nicholas. The panel and others related to it bear little relationship to the glass made for Archbishop Roger's choir at York about 1180 (nos. 222, 223). Rather, its more sophisticated style indicates a date closer to 1200. Unfortunately, the only other isolated example of figural glass, the Daniel in the Lions' Den, now glazed into the north transept of the cathedral, seems earlier in style. The *fermaillets* that have been leaded into the corners of the St. Nicholas panel are doubtless from the earlier glazing program. Certain work at Le Mans (no. 203) shows similarities in head types, subtle relationships of color, and softness of fold patterns, which gives credence to Lethaby's belief (pp. 41–47) that the glass at York is related to western French glass of the end of the twelfth century. Based on these similarities, this panel can be dated about 1190. Nothing is known about work at York Minster between 1181, when Archbishop Roger's choir was completed, and about 1220, when the south transept was built. It is conceivable, therefore, that after the glazing of the choir was finished, a new series of windows was made for the old Norman nave, completed under Archbishop Thomas in 1100. This nave continued in use until 1291, when the foundation stone of the present one was laid. What remained of the old windows could, therefore, have been

glowing white far less densely than in French examples. The edging of white between the paint and the lead, moreover, is wider (compare no. 235). The white fillets seem to restrict and compartmentalize the colored foliage, which is in general far less brilliant in hue than that of France. The York borders are distinctive both in their design and color. Since no other contemporary English examples of this type of border design exist, it is impossible to determine the influence of York on other centers of English glass painting.

BIBLIOGRAPHY: Westlake, I, 1881, pp. 41–44; Benson, 1915, pp. 1–7; Lethaby, 1915, pp. 37–48

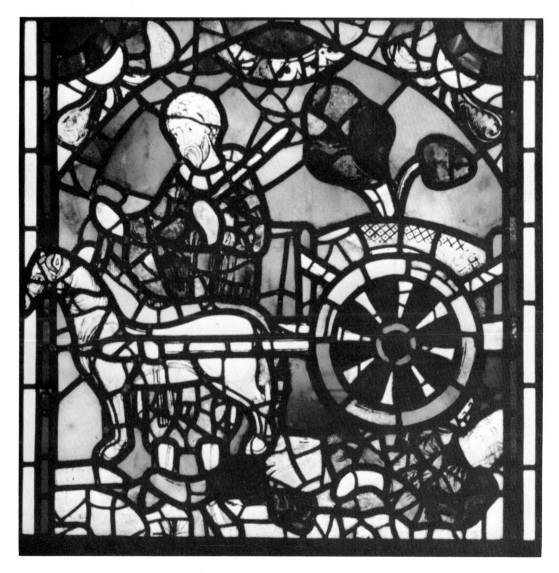

inserted at that time or later in the upper windows of the new building. Excavations indicate that the bays of the older nave were only slightly smaller than those of the present structure; the old glass could, therefore, have been accommodated in the new apertures (P. Newton, letter to J. Hayward, 1969). This panel and the others of the series were first recorded in their present location in the mid-seventeenth century (Torre, Mss. notes, Minster Library).

BIBLIOGRAPHY: Benson, 1915, pp. 46–55; Lethaby, 1915, pp. 37–48

225. Head of a patriarch

England, Canterbury Cathedral
About 1190
Pot metal
36.2 x 25 cm. (14¼ x 9¾ in.)
London, Victoria and Albert Museum, Gift of the Rev. T. Wheatley, C.854–1920

This head is set in a panel made up of fragments of old glass. The face, part of the neck, and the hair are original. The figure of the patriarch Semei (wrongly restored as Seth), now in the

partly repainted (Caviness, letter to J. Hayward, 1969), are conventionalized. The painting style is insistently calligraphic, not only recalling in its effect earlier creations of the school of Canterbury, such as the psalter of about 1150 preserved in Cambridge (Trinity College, Ms. R. 17.1), but also exemplifying the elegance and sophistication of later windows from the cathedral (no. 226). This linear style represents an approach to the problem of the glazing of the upper apertures of the Gothic building that contrasts sharply with the modeled, classical treatment of figures in the choir clerestory at St.-Remi.

BIBLIOGRAPHY: Rackham, 1949, p. 32; Rackham, 1957, pp. 17–20; C. Woodforde, *English Stained and Painted Glass,* Oxford, 1958, p. 2; Baker, 1960, p. 60

226. Fragment from a life of St. Alphege

England, Canterbury Cathedral
About 1220
Pot metal
68.5 x 22 cm. (27 x 8¾ in.)
Dublin, Coll. John Hunt

This portion of a roundel is said to have come from a window from Canterbury Cathedral. Three scenes from the saint's life are now in one of the apertures in the triforium of the north choir aisle, placed there during the restoration by Samuel Caldwell following the bombing of 1942. Caldwell has suggested that in all probability the St. Alphege window was originally in the first bay east of the northeast transept near the tomb and altar of the saint. The history of St. Alphege was first recorded by Osbern, monk of Canterbury, who had heard it recounted by one of the saint's pupils (*Act. S.S.,* Apr. 2, p. 630). The scenes remaining from the window concern the siege of Canterbury by the Danes, their capture of the archbishop Alphege, and his subsequent murder at their hands. It is impossible, considering the present condition of the fragment, to de-

west window at Canterbury, includes a modern copy of its original head (Rackham, letter in the Victoria and Albert Museum, 1959). The head on exhibition, previously thought to have come from Rochester Cathedral, closely resembles this copy (Baker, 1960, p. 60) and is now believed to belong to the Semei figure. Semei is recorded (Luke 3:26) as belonging to the fifteenth generation before Christ. It was planned that representations of the ancestors of Christ, of which some forty-five survive at Canterbury, fill the lights of the clerestory of the new choir, begun after the fire in 1174. This group of windows must have been among the first in the new glazing program to be installed and may even have predated the genealogical series at St.-Remi-de-Reims (no. 202), the only other early one (Rackham, 1949, p. 16, dates the clerestory windows at Canterbury as early as 1178). Although the head of Semei is the only one of the series that appears in profile and is beardless, it is closely related to the other heads in style. The features,

termine its place in the sequence. The static poses of the figures, however, and their apprehensive attitude are in sharp contrast to the activity present in the scenes still *in situ,* making it possible that the scene of which this piece was a part showed an event that took place after the murder of the saint. Certain features of the piece's iconography, however, relate it directly to the other scenes from the window. The conical helmets, the chain mail represented by rows of small curved strokes, and the boots defined by horizontal lines are the same as those worn by the figures in the cathedral glass. The weapons carried by the figures are also the same, with the exception of the shield, which is here flat rather than curved at the top. The figures stand upon a bridge parapet, a feature common to all the scenes, logical or not. The panel is also similar in style to the other scenes. Elongated figures with small clawlike hands and deep-set eyes are of the type found in other panels of the series. In spite of restorations (though only the lower portion of the shield has been made with modern glass) these figures manifest the elegance of style that is a hallmark of the Canterbury workshops of the first quarter of the thirteenth century. A concentration upon line both as a defining element and as a means of rendering ornamental detail characterizes not only this particular example but also the style of Canterbury in general.

BIBLIOGRAPHY: Rackham, 1949, pp. 68–71; Rackham, 1957, pp. 34–36; Lafond, 1947, pp. 151–156; M. H. Caviness, "A panel of thirteenth-century stained glass from Canterbury in America," *The Antiquaries Journal,* 1965, XLV, pt. II, p. 195

227. Fragment of a border

England, Canterbury Cathedral
About 1220
Pot metal
30 x 87.5 cm. (11¾ x 34½ in.)
Dublin, Coll. Mr. and Mrs. John Hunt

The other remaining portions of the border from which this fragment comes were placed in the east window of the crypt of Canterbury Cathedral in 1945, together with the topmost scene, a Virgin and Child enthroned, from the same original window. Parts of the border are modern, and it seems certain that this piece is one of the missing original sections. The unusual width of the border led Rackham (1949, pp. 65–67) to suggest that it is very early in date. S. Caldwell (*Seventeenth Annual Report of the Friends of Canterbury Cathedral,* Canterbury, 1944, p. 15) concluded on the basis of subject that it was originally intended for its present location in the Lady Chapel in the crypt. Rackham agrees and states that this portion of the cathedral would have been one of the first areas to be glazed in the rebuilding program following the fire of 1174. In style, however, this border is similar to

those of the Trinity Chapel dating from about 1220. Details of the foliage are emphasized by fine, closely placed brushstrokes strengthened by tonal modeling. The scalloped edges of leaves are rendered as color silhouettes against black. The forms are crisply and decisively painted in a manner that is unlike the softer style common to borders in France. The piece is remarkably well preserved, the only restored section being the center of the right-hand roundel.

BIBLIOGRAPHY: Rackham, 1949, pp. 65–67; Rackham, 1957, pp. 37–38; Baker, 1960, pp. 50–51; Caviness, 1965, p. 195

228. Panel with rinceau design

England, Canterbury Cathedral
About 1220
Pot metal
80.5 x 45 cm. (31¾ x 17¼ in.)
London, Victoria and Albert Museum,
 Gift of John Hunt, C.2–1958

This panel of rinceau ornament encircling a palmette is from the background of a medallion window and includes part of the framing of a scene. A modern copy of the design, made in 1852 by the restorer George Austin, exists in St. Gregory's Chapel in the southeast transept of Canterbury Cathedral (M. Caviness, letter to J. Hayward, 1969). In addition, the background, in part old, of the window in St. Martin's Chapel in the northeast transept (Rackham, 1949, p. 111) repeats the design exactly. The spindly, widely spread leaves of the palmette, which curl about the encircling vine tendrils, recall similar motifs

in the illuminated initials of a group of manuscripts produced at Canterbury, or by an artist trained there, in the second half of the twelfth century (Cambridge, Trinity College, Ms. B.3.11; Oxford, Bodley Ms. Auct. E. Infra 6 and Auct. E. Infra 7). An association closer in time can be seen in the similarity between this type of ornament and backgrounds of certain windows at Sens, including that of the life of St. Thomas Becket. Historical relationships between Sens and Canterbury in the twelfth century are documented, explaining the continuing artistic relationships of these two centers, but the origin of this distinguished style of ornament has yet to be determined. One of the most remarkable features of this piece is its color. In the luminous red background, a thin flash of ruby is apparent. Lafond

224

has suggested that this particular type of red was produced by the "cylinder" method of blowing rather than by the "crown" type generally employed in France. The latter method produced a striated effect in the coloration of the glass rather than the evenness of tone that is distinguishable at Canterbury.

BIBLIOGRAPHY: Rackham, 1949, p. 111; Rackham, 1957, pp. 46–47; Caviness, 1965, pp. 193–196

229. Fragment of a border

England, Canterbury Cathedral
About 1220
Pot metal
37 x 28 cm. (14½ x 11 in.)
London, Victoria and Albert Museum,
C.7–1959

This fragment is believed, on the basis of style, to have come from one of the windows of the clerestory of the Trinity Chapel (M. Caviness, letter to J. Hayward, 1969). It would thus be from one of the forty-two windows of the genealogical series, only sixteen of which retain their original ornament, even though none of these remnants reproduces the design of this piece. The genealogical series was apparently planned from the beginning to fill the clerestory apertures of the new choir. There seems to have been a break in the actual glazing of the windows between the choir proper, including the eastern transept, and the Trinity Chapel. This break involved not only a change in design but also a change in style. The borders of the earlier windows are precise in draftsmanship and richly painted. Those of the later series are looser and freer in style and less accomplished in design. The repetitive nature of the motif and the schematic rendering of the foliage in this example indicate that it belonged originally to the second group of windows in the series. The white edge fillets and lowest pair of leaves are restorations.

BIBLIOGRAPHY: Westlake, I, 1881, pp. 67–70; Rackham, 1949, pp. 29–46; Rackham, 1957, pp. 17–21

230. Two fragments of a border

England, Canterbury Cathedral
About 1220
Pot metal
18.5 x 44 cm. (7¼ x 17¼ in.)
London, Victoria and Albert Museum,
C.8–1959
23.5 x 78.8 cm. (9¼ x 30⅞ in.)
Dublin, Coll. John Hunt

Both of these fragments show a design of palmettes and foliage with berries. The Victoria and Albert fragment has been filled out by replacement glass on both edges and in the center of the blue background. The Hunt fragment is in remarkably good condition; the paint is well preserved, and only the base of the green bouquet between the two white ribbons on the left has been replaced. Other fragments of this border have been leaded into the south window of the southwest transept of the cathedral. The comparative narrowness of the border and the deli-

231. Ornamental boss

England, Canterbury Cathedral
About 1220
Pot metal
D. 28.5 cm. (11¼ in.)
Detroit, Institute of Arts, Gift of Mrs. Lillian
 Henkle Haass, 58.190

This circular panel with foliate quatrefoil and another roundel of the same design presently glazed into a window in the cathedral library were probably part of the foliate background ornament of Window XI in the Trinity Chapel, restored in 1906 by Samuel Caldwell, Sr. One of the distinctive features of Canterbury glass is its infinitely rich vocabulary of ornament. The foliate boss as an element in the design of the

cacy of its painting suggest that its probable original location was in one of the lower windows. Certain motifs, such as the central trefoil-shaped leaves springing from the small leaf buds, and particulars of drawing, like the veining of the lateral leaves, recall the borders of the aisle windows of the Trinity Chapel. It is probable, therefore, that this border is from a lost window produced by the same workshop, active at the cathedral from about 1220.

BIBLIOGRAPHY: Rackham, 1949, pp. 81–111; Rackham, 1957, pp. 47–68; Baker, 1960, pp. 50–51; Caviness, 1965, pp. 193–195

window achieved a prominence at Canterbury that is unique. Its origins lie in the *fermiel* of twelfth-century windows—the traditional means of filling the corners of circular scenes before the invention of the curved iron frame. When inserted in the ironwork, these corner decorations formed bosses of ornament. This motif became less and less important in thirteenth-century windows in France. At Canterbury, however, the motif was retained and assumed added importance in the design by being encircled by its own iron frame. This isolated it as a decorative element on the foliate field of the background.

BIBLIOGRAPHY: Rackham, 1949, pp. 61, 78, 113, 103; Rackham, 1957, pp. 47–68

foliate trefoil curls over the arch. The arches themselves have foliate forms at their springing, and in the spandrels the foliate trefoil is bound by a band of contrasting color. All of these characteristics, which are essentially linear in treatment, occur in borders of the Trinity Chapel.

BIBLIOGRAPHY: Westlake, I, 1881, pp. 101–119; Baker, 1960, pp. 50–51

232. Fragment of a border

England, Canterbury Cathedral (?)
About 1220
Pot metal
59 x 29 cm. (23¼ x 11½ in.)
Lent anonymously

In this fragment with geometrical and foliate designs, the enclosing fillets and the topmost amber leaf are replacements. This border has not been identified, but certain elements in its design and its style relate it to borders of the Trinity Chapel in Canterbury Cathedral. Its distinguishing features include a marked horizontality in design, in contrast to the insistently vertical emphasis of thirteenth-century French borders (no. 217), and a decidedly geometric character in the nonfoliate elements, such as the arches. In French borders of the period these elements are frequently so modified in shape that they often become the stem from which the foliage springs. The present foliage, moreover, differs from French examples both in type and in its curvilinear terminations. The leaf edges are painted as spiky loops, each of which is defined by a broad vein. The terminations of the leaves curl back over themselves, and the central member of each

233. St. John the Baptist and St. John the Evangelist

Rhineland, Strasbourg Cathedral
After 1190
Pot metal
115 x 105 cm. (45¼ x 41⅜ in.)
Strasbourg, Cathedral of Notre-Dame

This rectangular panel was originally two separate pieces. In the middle of the nineteenth century it was inserted in the left window of the north wall of the north transept of Strasbourg Cathedral. The central part of the panel, including the two colonettes and the ornament above them, and portions of the drapery of the two figures have been restored (C. Block, letter to J. Hayward, 1969). According to Zschokke (pp. 29–35), these two figures were originally made for the chapel of St. John the Baptist, situated on the east wall of the north transept. The chapel was remade in the thirteenth century. The two figures stand under arcades and hold phylacteries. That held by St. John the Baptist is inscribed: JOHAN/ BAPTI/STA. E/GO. VOX./CLAMA/NTIS. IN/

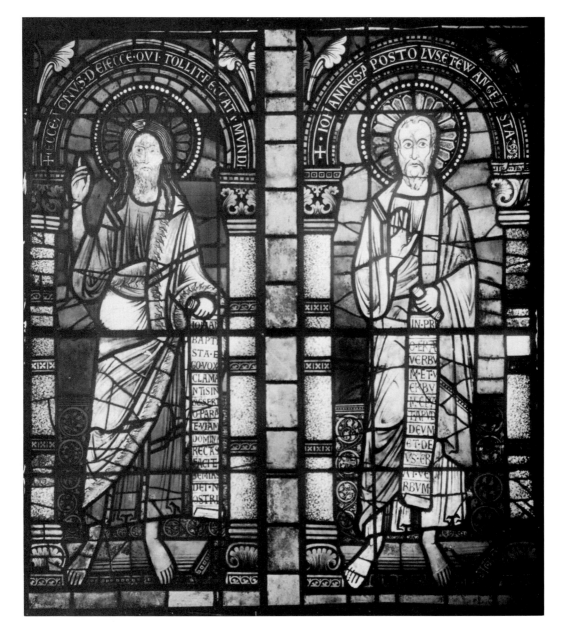

DESERT/O. PARA/TE. VIAM/DOMINI/RECTAS/
FACITE/SEMIAS/DEI. N/OSTRI., and in the arcade
above him is lettered: +.ECCE. AGNVS. DEI. ECCE.
QVI. TOLLIT. PECCATA. The inscriptions appear-
ing in the St. John the Evangelist panel are: in
the banderole, IN. PRI/[ncipi]/O. ERA/VERBV/

M. ET. V/ERBV/M. ERA/T. APVD/DEVM/ET. DE/
VS. ER/AT. VE/RBVM, and in the arcade, +.JO-
HANNES. APOSTOLVS. ET. No doubt the figures
originally came from the same window or from
neighboring windows and were meant to be re-
lated in meaning. As indicated by the inscrip-

228

tions, St. John the Baptist appears as the prodomos while St. John the Evangelist is represented as the theologos (C. Block, letter to J. Hayward, 1969). The frontality of the poses, the scrolls that the saints hold, and the arches under which they stand are of Byzantine origin. Zschokke has noted a strong Byzantine influence on the style of the early glass at Strasbourg that is exceptionally apparent in these two figures. He has also called attention to similarities between the two saints and comparable types in the miniatures from the *Hortus Deliciarum* of Herrade of Landsberg. The two saints are related, in a broader sense, to a Byzantinizing tradition in stained glass of the second half of the twelfth century that extended throughout the east of France and the Rhineland (Grodecki, 1953, pp. 241–258). But their style also owes its origin to a local tradition stemming from the Meuse valley. The classicizing tendencies in the work of Nicholas of Verdun (no. 100) are indicative of a trend at the end of the twelfth century toward a new figure type that would prevail in northeastern France for more than a quarter of a century.

BIBLIOGRAPHY: Zschokke, 1942, pp. 29–35; Grodecki, 1953, pp. 241–258; Beyer, 1957, pp. 96–97

234. Fragment of a border

Rhineland, Strasbourg Cathedral
About 1200
Pot metal
105.5 x 36 cm. (41½ x 14¼ in.)
Strasbourg, Musée de l'Oeuvre Notre-Dame

This piece was probably part of one of the borders of the windows of the old Romanesque nave, built in 1015 and razed in 1253 to make way for the present structure. Its design, preserved in a drawing (Zschokke, p. 108, no. 22) made in 1854 when the stained glass of the cathedral was restored, involves a series of circles, like no. 235, but in this case the focus is eccentrically placed

as a result of the inclusion of small lion masks from the mouths of which spring the circular forms as well as leaf tendrils. These masks are unique to the borders of Strasbourg and occur in eight of the forty-one border designs that have been preserved. Equally characteristic of these borders is the richness of painted detail, such as the pearled pattern of the veins of the leaves and the delicate scalloping of their edges. The ornament as well as the figural portions of the Strasbourg windows is more varied in color than French glass and is closer to German glass of the twelfth century. The source of this style of ornament has, however, been traced to the Meuse valley (Grodecki, 1953, pp. 241–248), where a tradition of superbly rich ornamental detail, seen particularly in metalwork and enamels, developed in the second half of the twelfth century. Many facets of this ornament are discernible not only in the glass of Strasbourg and the Rhineland but in that of eastern France as well. It is a Romanesque style of ornament that reached its point of perfection about 1200, but persisted well into the thirteenth century.

BIBLIOGRAPHY: Zschokke, 1942, pp. 107–112; Grodecki, 1953, pp. 241–248; Grodecki, 1958, pp. 109–110; Beyer, 1965, p. 14

235. Fragment of a border

Rhineland, Strasbourg Cathedral
About 1200
Pot metal
105.5 x 22 cm. (41½ x 8⅝ in.)
Strasbourg, Musée de l'Oeuvre Notre-Dame

According to Zschokke (pp. 107–112), there were forty-one different border designs in the stained glass at Strasbourg in 1854, when drawings were made of them by Haas. These drawings are preserved in the cathedral archives. While all of these borders can be assigned to the former Romanesque cathedral on the basis of style, it is

impossible to determine from what part of the building they came. Undoubtedly, many of them were in the forty-eight bays of the old nave. Zschokke has divided these fragments into groups based upon similarities of motif. This particular example (Zschokke, p. 109, no. 33), whose dominant motif is the circle surrounding a painted quatrefoil and enclosed by pearl fillets, has been placed in a group of five fragments, all based on the circle motif and all in a style that is especially Rhenish. Like other examples from Strasbourg, this border is rich in its painted detail. While the Strasbourg borders vary slightly in width, none are less intricately painted or bolder in design. Unlike French borders, these Rhenish examples seem not to vary either in scale or in detail with their position in the church. The motifs of which they are composed are found in French glass, but the style of their composition is very different.

BIBLIOGRAPHY: Zschokke, 1942, pp. 107–112; Beyer, 1965, p. 14

236. Emperor in Majesty

Rhineland, Strasbourg Cathedral
About 1200
Pot metal
118.5 x 93.5 cm. (86 x 36⅞ in.)
Strasbourg, Musée de l'Oeuvre Notre-Dame

In this glass, consisting of two panels, an emperor is shown seated on a throne in a frontal pose and holding an orb and scepter, symbols of his power. Behind the throne are two attendants, one of whom bears a sword. It has been proposed (Zschokke, pp. 186–188) that this glass was originally situated in the central window of the tribune gallery above the main portal of the destroyed Romanesque nave. A long-standing tradition begun at Aachen accorded the emperor an official place in the western loggia or tribune in churches of imperial foundation. His spiritual presence (for his actual visits were infrequent) was signified by his painted or sculptured image placed in the imperial gallery (Beyer, 1957, p. 98). The hieratic character of the present image seems to indicate that it served such a purpose at Strasbourg. Zschokke has also suggested that the figure may be intended as Charlemagne, portrayed as the ideal Christian ruler. Unfortunately, the arcade under which the figure was placed and its identifying inscription (a tradition in the windows at Strasbourg) are lost, but Charlemagne's canonization was recorded in the calendar of the cathedral in 1165. The figure type recalls the official ruler portraits in Carolingian miniatures, such as that of the emperor Lothair I from the Gospels of Lothair (Paris, Bibliothèque Nationale, Ms. lat. 266, fol. 4). The significant difference between the glass and the ruler portraits, however, is in the nimbus that surrounds the head in the emperor window. Zschokke has suggested that the figure was the central focus of an iconographic program for the nave windows that included a series of Holy Roman emperors (several of which are still extant) in the apertures of the north wall and a series of prophets on the south. A similar arrangement including the kings of France was planned for the somewhat earlier church of St.-Remi-de-Reims. With regard to style, Zschokke has noted strong Byzantine elements in these windows. Beyer indicates affinities with Rhenish art in general and with Master Gerlacus, who worked in the area of Mainz, in particular. Grodecki (1953, pp. 241–248) has pointed to relationships between the art of the Rhine and that of the Meuse throughout the second half of the twelfth century. It is probable that all of these sources had their effect upon the glass of the cathedral. To attribute all the early windows, including no. 233 and the present one, to a single atelier is hardly possible, since there are differences in style among them that must be taken into account. These variations may well have resulted from the model type employed as much as from the personal styles of the several masters who created the windows. The archaic character of the early emperor series, of

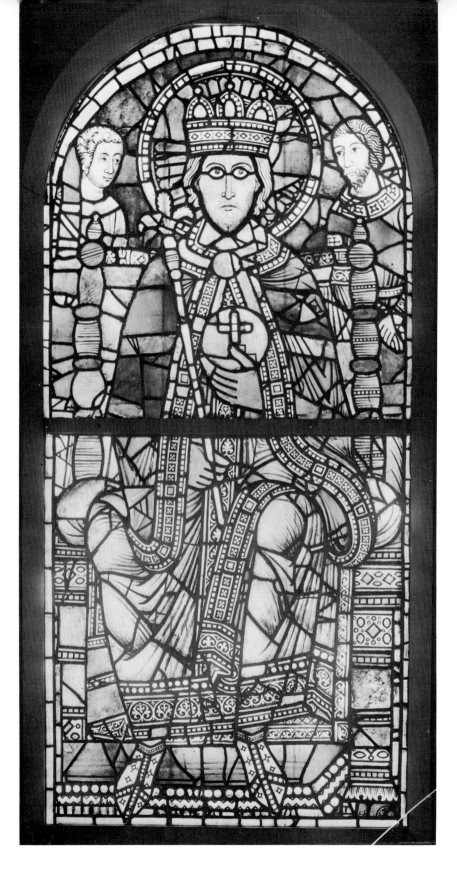

232

which this example is undoubtedly the oldest, is essentially a product of the Romanesque tradition.

BIBLIOGRAPHY: Zschokke, 1942, pp. 186–199; Wentzel, 1951, pp. 14–23; Beyer, 1957, pp. 98–100; Beyer, 1960, pp. 7–8; Beyer, 1965, pp. 12–13; Grodecki, 1953, pp. 241–248; Grodecki, 1958, pp. 109–110; Aachen, 1965, no. 671

237. Jacob with the ladder

Germany, Freiburg Minster
Before 1218
Pot metal
D. 55 cm. (21¾ in.)
Freiburg im Breisgau, Minster

With eight others, this roundel came originally from a Tree of Jesse window in the former Romanesque choir of Freiburg Minster, begun in 1200. All of these panels are now in the south transept of the cathedral (Geiges, 1931, pp. 1–13). Their dating is based on a 1218 record of the interment of Prince Berthold V in the choir. The Freiburg Jesse Tree is iconographically unusual, differing from its counterparts both in France and elsewhere in Germany. In the French type, derived from St.-Denis and represented in its developed form at Gercy (no. 210) and St.-Germain-lès-Corbeil (no. 219), the ancestors are seated upon the branches of the tree that springs from the loins of Jesse, and the prophets, unidentified by attribute, appear at the sides of the window. The early German type, as exemplified at Arnstein (Becksmann, 1966, pp. 34–44) and Soest, is similar, except that the prophets are not included. Remains of the Freiburg Jesse Tree as reconstructed (Becksmann, 1969) indicate that the medallions were arranged in three vertical rows with the ancestors in the center and the prophets at the sides. The most unusual feature, however, is the inclusion of attributes as well as name bands to identify the figures. Jacob's attribute is the celestial ladder (Gen. 28:10–17). As Becksmann has remarked, the Freiburg Jesse Tree may be a link between the earlier and later types

of German stained glass, even though it does not enlarge the content or modify the original theme of the Tree, as do later examples, beginning with that at St. Cunibert in Cologne. The present glass stands as a unique example of its kind in the upper Rhineland. It has been compared with the oldest stained glass from Strasbourg (Wentzel, 1954, p. 89), but this relationship, according to Becksmann, is limited to details such as ornament. The connection with the school surrounding the *Hortus Deliciarum* is equally tenuous. The statuesque representation and plastic realization of this figure are important characteristics for the derivation of its style. In spite of their small scale, the figures in the entire group of roundels are amazingly monumental. The treatment of the drapery, with its swelling folds and sweeping lines, is not unlike that of the Klosterneuburg altarpiece (no. 179) by Nicholas of Verdun. It is possible, therefore, that this style may have originated to the south, perhaps at Basel in the stylistic area of Lake Constance.

BIBLIOGRAPHY: F. Geiges, 1931, pp. 1–13; Wentzel, 1954, p. 89; Becksmann, 1966, pp. 34–44; I. Krummer-Schroth, *Glasmalereien aus dem Freiburger Münster,* Freiburg im Breisgau, 1967, pp. 26–31; Becksmann, 1969 (in press)

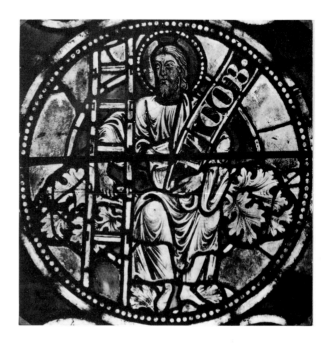

238. Seven Prophets from the chapter house of Sigena

Spain
About 1200
Fresco
Barcelona, Museo del Arte, Cataluña

Prior to a fire in 1936 the chapter house of the Sigena monastery in the province of Huesca, Aragon, contained a fresco cycle of twelve to fourteen New Testament scenes on its walls and an Old Testament cycle of twenty scenes on the facings of five transverse arches, the soffits of which were covered with life-size fresco busts of seventy ancestors of Christ. The New Testament cycle was entirely destroyed in the fire; the remains of the arch paintings were transferred to the Barcelona museum. Once thought to date no earlier than the fourteenth century, the cycle has been properly dated by Pächt, who also established the English origin of the painter from iconographical and stylistic analysis. The close connections of the frescoes to Byzantine art are matched strikingly in the later parts of the Winchester Bible initials (II, ill. 166), especially in the work of the Masters of the Genesis initial and of the Malachi. The relationship of the frescoes to the miniatures of the Master of the Morgan leaf (no. 256) has been discussed by Pächt; they agree in pictorial details and in the characteristic mobility and freedom of the figures. Blending a deep understanding of classical art, transmitted by Byzantine models, with the ornamental fantasy of northern tradition, the Sigena cycle may be understood as epitomizing the English contribution to the climactic phase of art around 1200. In view of the close connections between England and Sicily in the second half of the twelfth century, one may imagine the English artist painting in Sigena on his return journey from Sicily, then the center of Byzantine infiltration. (For information on such wandering artists, G. Troescher, *Kunstlerwanderungen,* Baden-Baden, 1953).

BIBLIOGRAPHY: Pächt, 1961; Barcelona, 1961, p. 120; Demus, 1968, p. 166 f.

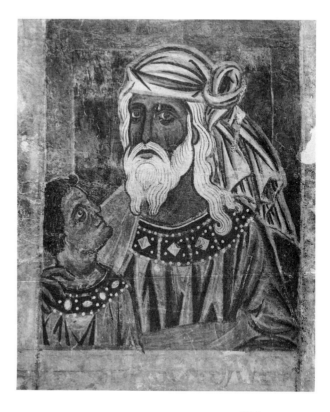

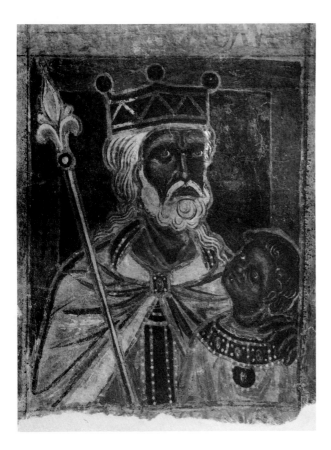

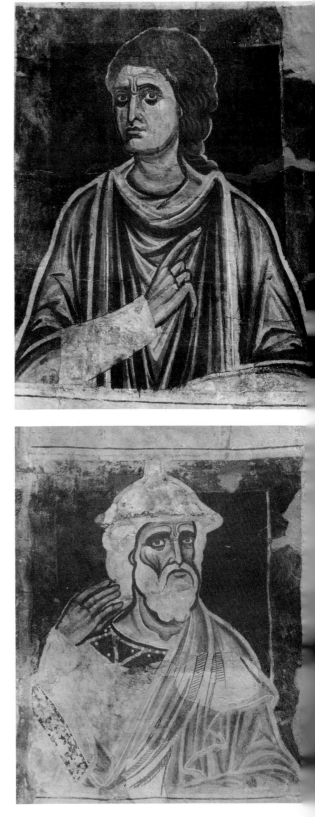

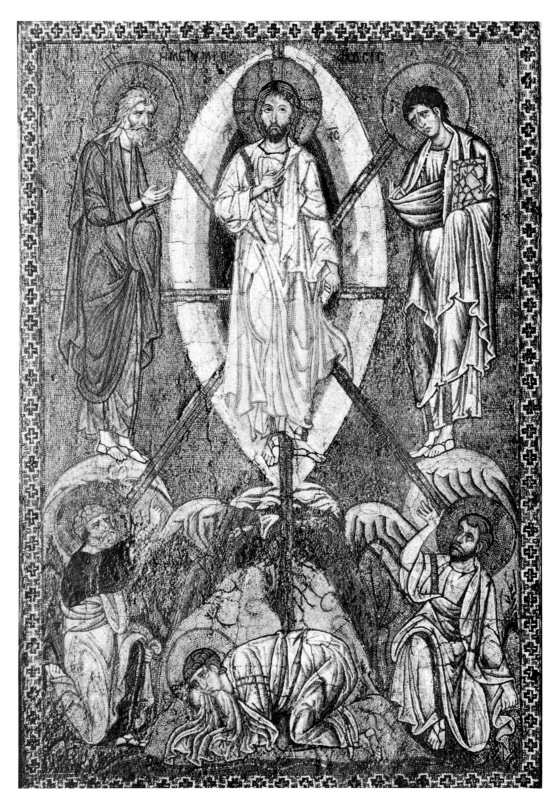

238

239. Icon: Transfiguration

Byzantium
About 1180–1190
Mosaic
52 x 36 cm. (20½ x 14⅛ in.)
Paris, Louvre, ML 145

Christ, in a mandorla, holds a scroll in his left hand and raises his right in blessing (the awkward position of his right thigh is the result of a nineteenth-century restoration). Eight rays emanate from Christ, and he is flanked by Elijah and Moses, the latter represented in the Byzantine manner as a young man. The two prophets and Christ appear above mountain peaks with Peter, James, and John below. This composition follows the traditional Byzantine iconography of the Transfiguration as seen at Daphni, Cappella Palatina (Palermo), and Monreale (Diez and Demus, 1931, fig. 91; Demus, 1949, figs. 19B, 67A; Millet, 1916, p. 216 f.; Schiller, I, 1966, p. 155 f.; W. Krönig, "Zur Transfiguration der Cappella Palatina," *Zeitschrift für Kunstgeschichte,* 1956, pp. 162–179). The plaque carried by Moses is generally identified as a book; however, the veined design on its front and sides indicates that it is probably meant to be the tablet of the Law (for a similar veined rectangular tablet as Moses receives the Law, *Handbook of the Byzantine Collection,* Dumbarton Oaks, Washington, D.C., 1967, no. 385). The calm, well-ordered draperies, the clear-cut mountain crags on the right, and the relatively round mandorla are all reminiscent of the mosaics in the Cappella Palatina of around 1150–1170, but the agitated drapery covering John's hands and the impressionistic contours of the central mountain top suggest a dating closer to the later Monreale mosaics, as given in the heading.

The artistic genre of the mosaic icon seems to have been created in the eleventh century. It found increasing favor under the Comnenians and reached its maturity under the Paleologan emperors. The icons derive their technique from wall mosaics, although the stone and glass-paste tesserae are set in wax rather than plaster. Their size and use, however, stem from painted icons. A mosaic icon as large as the present one may have been used as an altarpiece or mounted on a wall in a chapel or church; smaller mosaics may have served as portable icons. While recently published early small mosaic icons may modify Demus' theory of an evolution from large to continually smaller icons and tesserae, the Louvre Transfiguration (Athens, 1964, pp. 161–162; Demus 1947) conforms. Like an icon of Christ of about 1150 in Florence (Rice, 1959, pl. 169), it is a large panel, yet its tesserae are smaller than those of an early twelfth-century icon of Christ in Berlin (Rice, 1959, pl. 168).

BIBLIOGRAPHY: Bettini, S., "Appunti per lo studio dei Mosaici portatili Bizantini," *Felix Ravenna,* XLVI, 1938, p. 17 f.; Demus, O., "Byzantinische Mosaikminiaturen," *Phaidros,* III, 1947, pp. 190–94; E. Coche de la Ferté, *L'Antiquité chrétienne au Musée du Louvre,* Paris, 1958, no. 74; H. Skrobucha, *Meisterwerke der Ikonenmalerei,* Recklinghausen, 1961, 65–66; Athens, 1964, p. 163

240. Old Testament books:
Proverbs, Ecclesiastes, Songs

Northern France
Around 1170
Parchment
34.3 x 23.2 cm. (13½ x 9⅛ in.)
Colorado Springs, Colorado College

This manuscript belongs to a group of books commissioned by Thomas Becket and his friends during his exile in the monasteries of Pontigny and St. Columba in the archdiocese of Sens between 1164 and 1170. Tentatively identified as the codex given by Ralph of Reims, Thomas' friend, to Christ Church, Canterbury (M. R. James, *The Ancient Libraries of Canterbury and Dover,* Cambridge, 1903, p. 86), the manuscript was thought by Dodwell to have been ordered by Becket himself, who later passed it on to Ralph, whose other Canterbury gifts have been recognized as Pembroke College, Cambridge, Ms. 210 and, tentatively, Corpus Christi College, Cambridge, Ms. 345. The organization of the pages, the script, and the decorative coloring agree with other Becket manuscripts, such as Trinity Mss. B55 and B311. It is in these codices that the closest analogies are to be found for the initials of the present manuscript. The magnificent initial on fol. 61 v., set against a blue background within a gold frame, with a gold ground inside the initial, has an exact counterpiece in Trinity College, Ms. B311, fol. 2 (Dodwell, 1954, pl. 65a). Dodwell ascribes these two manuscripts to the same atelier. The geometrical clarity of the initial's structure, the color scheme, and the ornamental stylization of its elongated animals all indicate northern French miniature painting of the third quarter of the twelfth century. Puzzling as a Cistercian manuscript with a richness of decorative imagery that seems to belie Bernhard

of Clairvaux's *Apologia ad Guillelmum* (Schapiro, 1947; for the preserved Cistercian manuscripts and this apparent difficulty, Dodwell, 1954, p. 107 f., who suggests that the Cistercian monks produced deluxe manuscripts for outside patrons only), our codex may be compared with

of contemporary Gospel books (C. Nordenfalk, *Die Spaetantiken Kanontofeln,* Göteborg, 1938; Sedlmayr, 1950, p. 294 f.), this decoration is distinguished by the striking elongation of the columns and the wealth of ornamental motifs freely curling on the bases and capitals, as opposed to the geometrical, textile-like patterns filling the shafts. On the other side of the leaf an exuberant initial Q is framed by a geometrical scheme subdivided into two rectangular fields. A dense pattern of floral forms and interlacing branches is set against a unicolored background. Tentatively attributed to the Cistercian scriptorium of Pontigny abbey, a Burgundian house under the jurisdiction of the Sens archbishop, this leaf may be compared to no. 240. Apparently more closely connected with preceding Burgundian illumination (compare the propor-

northern French manuscripts around 1170, such as the Bible from St. André-au-Bois (Dodwell, pl. 65d) and the slightly later Bible written by the Canterbury scribe Manerius (Paris, Bibliothèque Ste. Geneviève, Swarzenski, 1967, fig. 506).

BIBLIOGRAPHY: Dodwell, 1954, p. 107 f.; Dodwell, letter to M. Lansburgh, June 6, 1958

241. Leaf from *Decretum Gratiani*

France, Burgundy
1170–1190
Vellum, tempera
43.5 x 33.5 cm. (17¼ x 13¼ in.)
Cleveland, Museum of Art, 54.598

The *Decretum Gratiani,* a body of canon law, was composed around 1140 by a Bolognese monk, Gratian, and the work spread quickly (A. M. Stickler, *Historia Juris Canonici Latini, I: Historia Fontium,* Turin, 1950). On one side of the exhibited leaf four flat arcaded columns contain a list of the chapters in Roman and Greek numerals and letters, with explanatory transcriptions. Clearly derived from the usual canon tables

tions of the columns) than no. 240, our leaf nevertheless may be a contemporary product of a related scriptorium. The columnar structure may be compared with the canon tables in a French Bible (J. Kirchner, *Die Phillipps-Handschriften,* Leipzig, 1926, p. 48, fig. 52), and an illustrated Italian decretum of the early thirteenth century (Kirchner, p. 63 f.).

BIBLIOGRAPHY: R. Schilling, "The Decretum Gratiani Formerly in the C. W. Dyson Perrins Collection," *Journal of the British Archaeological Association,* XXVI, 1963, p. 27 f. Cleveland, 1967, p. 47

242. Scenes from the life of Christ

France
Late 12th century
Parchment
33.8 x 21.8 cm. (13¼ x 8⅝ in.)
New York, The Pierpont Morgan Library,
 Ms. M. 44

This codex contains thirty full-page miniatures illustrating the life of Christ. Although picture cycles such as this were often prefixed to psalters, there is no evidence that this manuscript was ever accompanied by a text. At least three other picture Bibles of this type are preserved (for the most similar, G. Warner, *A Descriptive Catalogue of Illuminated Manuscripts in the Library of C. Dyson-Perrins,* Oxford, 1920, II, no. 1). The codex has been thought to be of Limoges origin

but this is not supported by documentary evidence or by stylistic parallels in known Limoges work. The two kneeling figures in the miniature of Christ enthroned (fol. 16 v.), who hold up a lance and a miter, perhaps represent the donor and a local saint.

Several iconographic peculiarities suggest diverse sources. Crosses in the shape of processional crucifixes with thin, spike-like bases and widening arms such as the one on fol. 9 v. are found in late Carolingian and Ottonian art (Goldschmidt, *German Illustration,* II, Florence/Paris, 1928, pls. 68, 81, 88, 102). The seraphim appearing in the Christ in Majesty and the Coronation of the Virgin miniatures, and the cross beside the enthroned Christ in the miniature depicting the displaying of his wounds appear in French cathedral sculpture of the mid-twelfth century (Percy-les-Forges, Senlis, and Beaulieu). The style

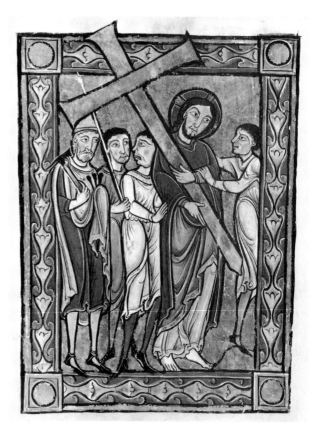

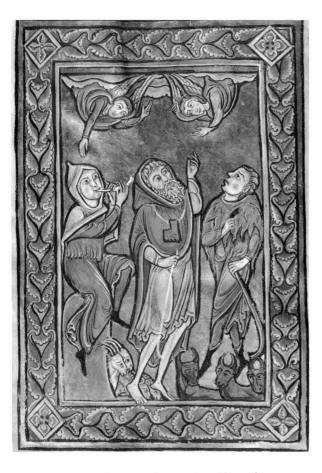

seems also to reflect such mid-twelfth-century models as the western lancet windows at Chartres (E. Houvet, *Les vitraux de la Cathédrale de Chartres,* I, Chartres, 1926, pls. I, color, VI). However, late twelfth-century contact with the Mosan influenced areas of north or west France is discernible in the soft, plastic quality of some of the figures. The colorful border pattern, unusual in French illumination, occurs in Alsatian or German works of the late twelfth century that were influenced by earlier English and Flemish models (Swarzenski, 1943, figs. 10–13, 24–26). Probably provincial work, the miniatures have a light-hearted quality that modifies both the gravity of their content and the drama of their often monumental compositions. The plain, open manner, the warm colors, and calm slackness of form create a charm rare in medieval religious art.

BIBLIOGRAPHY: New York, 1933, no. 35; Paris, 1954, no. 328

244

243. Psalter

Northern France, probably Tournai
Late 12th century
Parchment
22.6 x 32.9 cm. (10¼ x 13 in.)
New York, The Pierpont Morgan Library,
 Ms. M. 338

This manuscript contains the first fifty psalms in Latin with a commentary in French. Its numerous historiated and decorative initials are painted in a style close to that of the Ingeborg Psalter (Chantilly, Musée Condé, ms. 1695). The sequence of initials represents Old Testament scenes from Genesis to the Sacrifice of Isaac. It was customary to introduce the psalter text with illustrations from the Old Testament and the life of Christ. Deuchler attributes the scenes in the initials to the Older Painter of the Ingeborg Psalter, noting that they lack the intensified Byzantine quality of his later work. The iconographic and stylistic similarity demonstrated by Deuchler leaves no doubt that the two manuscripts were produced in the same atelier. Furthermore, both manuscripts are connected with the entourage of Eleanor of Vermandois. According to Liebman, the psalter commentary was composed by Simon of Tournai, after 1163, for Laurette, daughter of Thierry of Alsace and stepmother of Eleanor. The psalter was altered to include both Eleanor's and

Laurette's names but it is unlikely that it was made for either one of them. Laurette's name must have belonged to an early edition of the text; it appears over erasures as part of the script line. Reference to Eleanor was added interlinearly and by a different hand, which also made numerous corrections in the text. The reference may have been made in commemoration or because the manuscript had passed into her possession. Citing Danish paleographic elements in the manuscript, Liebman suggests a connection with the Danish entourage of Stephen, Bishop of Tournai, who was Ingeborg's principal defender before Philippe Auguste, as well as Eleanor's companion and Simon's protector.

BIBLIOGRAPHY: Deuchler, 1967, pp. 168–179; Liebman, 1955

244. Psalter with additional texts

North France or Flanders
End of the 12th century
Parchment
8.3 x 13.5 cm. (3¼ x 5¼ in.)
Paris, Bibliothèque Nationale, ms. lat. 238

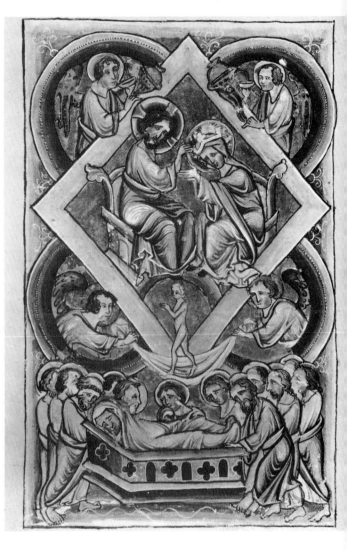

This manuscript contains the psalms, the usual liturgical calendar, canticles or songs, the litany or invocation of saints, readings, and—exceptionally—fragments from three gospels, the relatively rare epistle of St. Stephen, and a sermon in French verse with musical notation. The additional texts precede the matter for Sunday vespers and thereby interrupt the sequence of the psalms. Flemish and female saints predominate in the calendar and litany and point to the old diocese of Cambrai. The psalms are illustrated with miniatures that mark the first psalm to be read at each daily devotion during a seven-day cycle of the divine office. The initials of the psalms facing these illustrations contain seated apostles. In standard psalter cycles the scenes usually show David, the psalmist, in an episode related to the text that follows. Here the themes are primarily Marian and related to the psalms only in a general way. Psalm 97, beginning "The Lord reigneth" is illustrated by Christ in Majesty. Psalm 81, containing the verse "Thou calledst in trouble, and I delivered thee" is illustrated by a miracle of the Virgin. Even less direct is the relationship between Psalm 52 and its illustrations of the Entombment, Ascension, and Coronation of the Virgin, or between Psalm 68 and its illustration of the Miracle of Theophilus and the Virgin. David himself is seen only once, facing Goliath, this illustration accompanying the canticle that reads in part, "And hath raised up an horn of sal-

vation for us in the house of his servant David ..
that we should be saved from our enemies" (Luke
1:68–71). This is the only known illustration of
this canticle from this period.

The scheme of illustration relates this psalter
to a small group of northern French and Flemish
psalters in which the divisions are marked by
seated apostles. Closest in attitudes and gestures
is Arras ms. 527, of about 1200. In a psalter of
about 1250 with a Bruges calendar (Paris, Bib-
liothèque de l'Arsenal, ms. 604) apostles point
to full-page illustrations of which two repeat
themes in our manuscript. The style of the pres-
ent work suggests a provincial atelier near the
center which produced the contemporary Inge-
borg Psalter. Byzantinizing characteristics are
discernible in the muscular bodies, stepping with
a new torsion; the heavily underpainted, brightly
colored figures lightened and articulated with
white pen lining; the tight, almost wound-up
quality of the drawing.

BIBLIOGRAPHY: V. Leroquais, *Les Psautiers manu-
scrits latins des bibliothèques publiques de France,*
Mâcon, II, 1940–41, p. 38; P. Grossjean, "Notes d'ha-
giographie celtique," *Analecta Bollandiana,* LXXV,
1957, p. 378; Deuchler, 1967, p. 67 f.

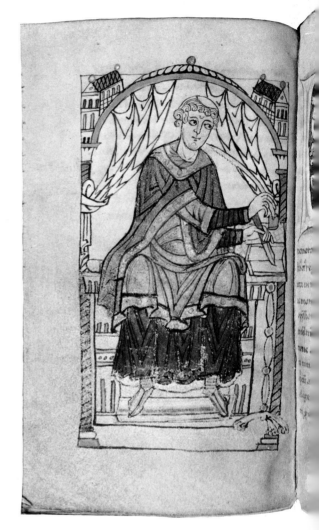

245. Eadmer, *Life of Anselm of Canterbury*

French, perhaps Tournai
Third quarter of 12th century
Parchment, 96 folios
18 x 11 cm. (7 1/16 x 4 5/16 in.)
New York, Coll. H. P. Kraus

This manuscript preserves the only version with
miniatures of Eadmer's famous biography of St.
Anselm. Eadmer was a monk at Canterbury when
Anselm was made archbishop in 1093. Eadmer
completed the basic text about 1100, against
Anselm's wishes, and used it after Anselm's death
to promote his canonization. The text was imme-
diately controversial and was widely propagated

on the Continent where the archbishop was espe-
cially well known.

Each of the two main textual divisions is pre-
ceded by a portrait of Eadmer seated, writing.
The manuscript contains a fourteenth-century
signature of St. Martin of Tournai, and is gener-
ally regarded as from Tournai. In 1142 Herman
of Tournai mentioned an Eadmer text in the
Tournai library; Schmitz associates the present
manuscript with this reference. A date before
1142 would appear to be too early paleographi-
cally and Herman's remark probably refers to
another manuscript, perhaps the one from which

the present manuscript was copied. The model, in any event, may not have been from Tournai or even illustrated. Boutemy suggests that the miniatures were copied from a St. Amand manuscript of about 1150 that illustrates another Eadmer text.

BIBLIOGRAPHY: P. Schmitz, "Un manuscrit retrouvé de la *Vita Anselmi* par Eadmer," *Revue Bénédictine*, XL, 1928, pp. 225–234; A. Boutemy, "Les miniatures de la *Vita Anselmi* de St. Martin de Tournai et leurs origines," *Revue belge d'archéologie et d'histoire de l'art*, XIII, 1943, pp. 117–122; R. N. Southern, *The Life of St. Anselm, Archbishop of Canterbury, by Eadmer*, London, 1962

246. Bible

Champagne or Ile-de-France
Early 13th century
Parchment
33 x 34.8 cm. (13 x 13¾ in.)
Paris, Bibliothèque Nationale, ms. lat. 11535, 4

The end of the twelfth century witnessed an important increase in the production of large multi-volume Bibles. They normally contained the complete Old Testament and New Testament, many prefaces (usually taken from the commentaries of St. Jerome), and a concordance of the gospels. The first letter of each book and preface is enlarged and decorated. When painted, the initials usually represent an event in the following text, or the author or subject of the particular book. The present manuscript belongs to a group of Bibles or Bible fragments with similar iconography and style, notably a manuscript written in France by the Canterbury scribe Manerius (Paris, Bibliothèque Ste. Geneviève, mss. 8–10), which has more than twenty-five initials identical in composition and iconography. The Manerius Bible probably precedes the present work by a few years and may have issued from the same scriptorium. It exhibits two trends: the first, unique to the Manerius Bible, is an echo of the Byzantinizing style found after 1180 in England, north France, and Flanders (Leyden, University Library, ms. 26A; Boulougne-sur-Mer, ms. 2). In

the third volume of the Manerius Bible, however, an artist appears who paints in the softer, less robust style found throughout our Bible. The same artist may have worked on both. In the Manerius manuscript he attempts to graft onto his usual style the harder, more expressive forms of the main artist (compare fol. 365 to fol. 247v); in our Bible his style is looser, less detailed and youthful. This latter style may be compared to painting influenced by Ile-de-France or Champagne, such as the stained glass at Orbais or the

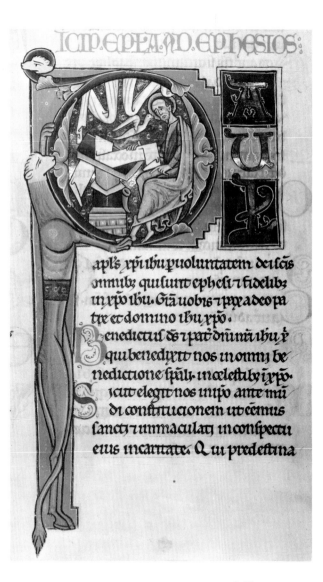

St. John the Evangelist window at Chartres. The same style is evident in the Genesis initial of no. 248. The Genesis initial of the present manuscript contains unusual scenes of Christ shaping Eve from Adam's rib, the clothing of Adam and Eve, and Christ (rather than the angel) expelling Adam and Eve from Eden. These scenes, like their contemporary parallels in the *Hortus Deliciarum,* follow the scheme in the Cotton Genesis recension (Green). In addition, the tympana of the canon tables contain unusual New Testament scenes. Although historiated canon tables are known from the sixth and ninth centuries, their illustration was primarily limited to scenes of the life of Christ. In the present manuscript there are rare scenes such as Christ with Mary and Martha as well as scenes from the Old Testament, non-canonical sources, parables, and Last Judgment iconography. Other scenes, such as the goat standing on the altar in the initial to Psalm 52, appear to be without parallel.

BIBLIOGRAPHY: Dodwell, 1954; R. B. Green, "The Adam and Eve Cycle in the *Hortus Deliciarium*," *Late Classical and Medieval Studies in Honor of Albert Mathias Friend, Jr.,* Princeton, 1955, pp. 340–347; H. Swarzenski, "Fragments of a Romanesque Bible," *Gazette des Beaux-Arts,* LXII, 1963, pp. 71–80; W. Cahn, *The Souvigny Bible, A Study in Romanesque Manuscript Illumination,* dissertation, New York University, 1967, pp. 458–462; R. Branner, "The Manerius Signatures," *The Art Bulletin,* L, 1968, p. 183

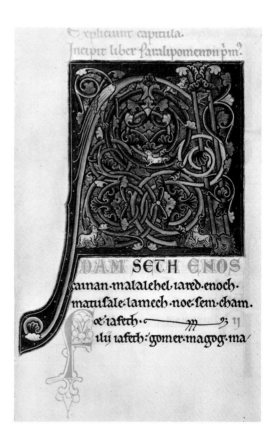

247. Bible

France, perhaps Troyes
About 1190
Parchment
45 x 35.3 cm. (17¾ x 13⅞ in.)
Paris, Bibliothèque Nationale, ms. lat. 16743–6

Two artists painted this four-volume Bible. Haseloff recognized the hand of one in a psalter in Cambridge (St. John's College, Ms. C. 18), attributed by him to an atelier in St. Bertin on the basis of its calendar commemorating the Depositio St. Bertini. Grodecki identified the second hand in Vols. I and III to which he also attributed the paintings in a Clairvaux manu-

script in Troyes (Bib. Mun. ms. 92), several stained glass panels (nos. 204, 205) from a series of lost windows originally in the cathedral at Troyes, and the painting of a seated physician (British Museum, Harley Ms. 1585, fol. 13). Since the style appears in works in two media,

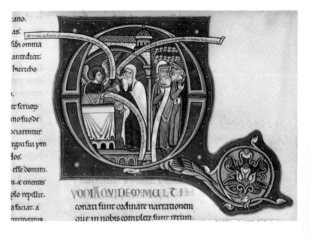

both associated with Troyes, Grodecki suggests that the Bible was executed in Troyes by a local artist and that the other artist came there from St. Bertin.

Although the affiliation of one artist with Troyes seems likely, the origin of the other remains uncertain. The Cambridge Psalter's calendar compares poorly with those in known St. Bertin manuscripts. Similar initials may be found in St. Albans manuscripts executed for Abbot Simon (1163–1183), particularly a Bible at Cambridge, Corpus Christi College, Ms. 48 (Cahn). Accordingly, it seems likely that the guest artist at Troyes was from England. Although his faces betray a new psychological awareness, his drapery folds are rendered in hard, schematic patterns, and his bodies twist in excited, stylized gestures. In contrast, the figures of the Troyes artist are painted with the firm roundness and authority that is paralleled in the Westminster Psalter (London, British Museum, Roy. Ms. 2 A. XXII) and work by the Winchester Master of the Gothic Majesty (no. 256). The suppleness and ease of the Troyes artist's work in the present manuscript reflects the marked Mosan influence in southern Champagne.

BIBLIOGRAPHY: Grodecki, 1963, I. pp. 129–141; W. Cahn, *The Souvigny Bible*, 1967, p. 464 (unpublished dissertation, New York, The Institute of Fine Arts); J. Porcher, *Les manuscrits à peintures en France du VIIe au XIIe siècle*, Paris, 1954, p. 58; no. 130

248. Bible folios

France, Champagne (?)
Late 12th century
Parchment
37.6 x 53.2 cm. (14¾ x 20⅞ in.)
Paris, Bibliothèque Nationale, ms. lat. 8823

This manuscript consists of nine folios, fragments of a multivolume Bible. The first folio, pasted backward into the present binding, contains the initial beginning the Book of Genesis.

The first folio differs from folios 2–9 in both its script and style of painting; its Genesis initial belongs stylistically and iconographically to the group of the Manerius Bible (Paris, Bibliothèque Ste. Geneviève, Ms. 9–12) and no. 246. Folios 2–9 are probably the first pages of a later volume; the quality of the parchment, the method of lining, and the page and script dimensions are the same. The higher, thinner script is that of northern France. The paintings, which have a strong Romanesque flavor, can be compared to those of Bibliothèque Nationale, ms. lat. 11576, a manuscript painted somewhat earlier at Corbie.

BIBLIOGRAPHY: Boase, 1953, p. 187 f.

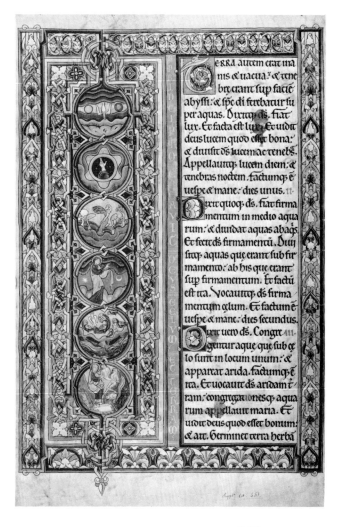

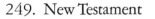

249. New Testament

Northern France
1205–1210
Vellum, 78 fols.
43 x 31.8 cm. (17 x 12½ in.)
Baltimore, The Walters Art Gallery, W. 67

The decoration of this manuscript, produced by several artists, includes ten pages of ornamented canon tables, eight historiated, and thirty-three ornamented initials. Particularly impressive is the letter I with the apostle James. In an elongated field, the slender figure of the saint supports with his left hand a diagonally placed book, hidden under his mantle, while pointing to the adjacent text with his right. This image is strikingly similar to sculptural figures in Chartres Cathedral's north transept (especially the jamb figure of St. Andrew: Sauerländer, 1966, fig. 96). Besides

250

representing a heuristic parallel, the relationship between painted initials and columnar statues reveals a concrete historical connection insofar as this sculptural invention of the mid-twelfth century apparently was partly indebted to earlier Cistercian initial figures (Sedlmayr, 1950, p. 300 f.). In the particular initial discussed, no sculptural suggestion is implied in the flat ground of the figure. The refined linear rhythm, the noble appearance, and the simplified omega-type beard relate the figure to Byzantine ivories, which had their impact on contemporary sculpture (Sauerländer, 1959).

BIBLIOGRAPHY: De Ricci, 1935, I, p. 766, no. 58; Baltimore, 1949, no. 23 (dated to 1200)

250. Missal

France, Anchin (?)
Early 13th century
Parchment
14.5 x 23.5 cm. (5¾ x 9¼ in.)
Douai, Bibliothèque Municipale, ms. 90, II

Vol. I contains feasts from December to March, Vol. II contains feasts from April to November. A crucifixion miniature, removed from Vol. I, originally faced, in both volumes, the prayers "Per omnia" and "Vere Dignum" whose initials are painted with scenes from the life of Abraham and the life of Moses; two pages later, in both volumes, a full-page Christ in Majesty introduces the canon of the mass.

The style and scale of the missal's paintings approach those of the Ingeborg Psalter and their apparent localization at Anchin seems to support the theory of a northern French origin of the Ingeborg style. The Anchin origin of the present manuscript is based both on a sixteenth-century note indicating that it was then in the possession of the Anchin Library, and on the dedicatory feast associated with Anchin included in the calendar. However, the identification of this feast has never been confirmed and manuscripts foreign to Anchin are known to have entered its library by the sixteenth century. A more conclusive attribution to Anchin is provided by two manuscripts definitely made there, Douai mss. 372 and 392, that are comparable in script, parchment quality, lining, and collation. The developing Anchin script traceable in the three volumes of ms. 372 begins in its third volume to approximate that of the missal.

The painter of the missal's miniatures appears not to have come from Anchin, since the miniatures and the historiated initials are not comparable in style or quality to known or suspected Anchin works, and the unpainted parts of the manuscript—the penned filigree and decorative

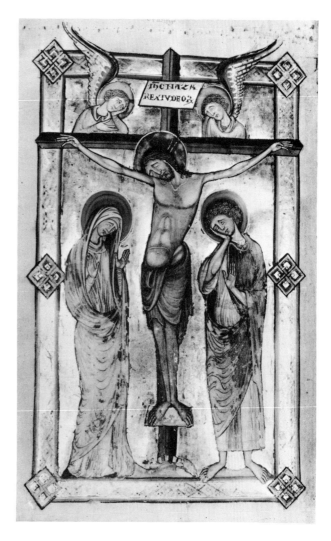

initials—are of pedestrian quality by Anchin standards. It seems likely that the miniatures were painted by a guest artist, untrained in the Anchin tradition and commissioned to paint only specific parts of the manuscript. Byzantine influence is seen in the Crucifixion miniature (G. Sotiriou, *Icones du Mont Sinai,* Athens, 1956, II, pl. 64).

BIBLIOGRAPHY: V. Leroquais, *Les Sacrementaires et les missels manuscrits des bibliothèques publiques de France,* II, Paris, 1924, p. 6 f.; J. Porcher, *L'Enluminure française,* Paris, 1959, p. 85; Swarzenski, 1967, figs. 540, 543

251. Bible

France
1200–1210
Vellum, 462 fols.
21 x 14 cm. (8¼ x 5¾ in.)
London, British Museum, Add. Ms. 15452

This Bible contains more than 120 delicately drawn initials. From the representation of the Tree of Jesse, filling half a column at the begin-

ning of Matthew, fol. 331 verso (Deuchler, 1967, fig. 170), a similarly lavish illustration can be reconstructed for the first leaf of Genesis. Labeled "probably French" (British Museum, 1850) and "English late thirteenth century" (Warner), the codex was first connected with the scriptorium of the Ingeborg Psalter by Millar. The resemblance is most evident in the purely ornamental initials. Two different artists worked on the historiated initials (Deuchler). A conservative graphic treatment of thinly drawn drapery folds occurs in some of the initials, such as the one showing Luke writing, fol. 340 verso (Deuchler, fig. 181). Painterly modeling, the work of the second miniaturist, occurs in others, for example fol. 149 recto (Deuchler, fig. 173). The harmoniously composed floral patterns of the ornamental initials may be compared to earlier northern French initials, for example, those in the Becket manuscript (no. 240); these patterns illustrate both the continuation of a basic decorative vocabulary and the new compositional discipline achieved toward the turn of the twelfth century. The dating of the Bible results from its relationship to the Ingeborg Psalter.

BIBLIOGRAPHY: *Catalogue of Additions to the Manuscripts in the British Museum in the Years 1841–1845,* London, 1850, section 1845, p. 6; Warner, 1903, pl. XXI; Millar, IV, 1928, p. 10; Boase, 1953, p. 285; Deuchler, 1967, pp. 180–182, figs. 169–192

252. Works of Vergil and others

North France
Beginning of the 13th century
Parchment
31 x 22 cm. (12¼ x 8⅝ in.)
Paris, Bibliothèque Nationale, ms. lat. 7936

Although the original owner of this manuscript is unknown, we know that it comes from a collection of books assembled by the clerk of Jean Lebègue, one of the most prominent figures in Parisian prehumanism at the beginning of the fifteenth century; despite some later scratchings, the anagram of the clerk's name, A bele viegne, is decipherable on folios 12, 80 v., 140 v., and

221. The illustrations, consisting of nineteen historiated initials, represent only part of the original, since the beginnings of certain books have been cut out. The repeated occurrence in the margin, opposite these initials, of marks consisting of one or two horizontal lines seems to indicate the collaboration of at least two artists. In addition, initials on folios 12, 130, 152 v., and 165 v. are accompanied by penciled inscriptions in French; these cannot be deciphered completely. Stylistically, the closest comparison for these initials, all of which are of excellent workmanship, is to be found in the group of manuscripts related to the Ingeborg Psalter, notably the latest one, a Latin Bible in the British Museum (no. 251). However, certain details in the present manuscript indicate that it came from another workshop. The initials are more interesting stylistically than iconographically. Certain ones make use of existing designs, especially in the *Georgics*, where themes depicting the work characteristic for the month have been taken from calendars. Others, in the *Aeneid*, and *Thebaid*, and the *Pharsalus*, are original compositions, for which there was no established iconographic tradition. Illustrated manuscripts of all these works are rare. As a matter of fact, for the period between the sixth and the fifteenth century only two illustrated manuscripts of the *Aeneid* are known (no. 271; E. Panofsky, *Studies in Iconology,* New York, 1939, p. 24, n. 20; M. R. Scherer, *The Legends of Troy in Art and Literature,* London, New York, 1964, pp. 238–239).

253. Missal, usage of St. Remi

France, Reims
Beginning of the 13th century
Parchment
21.5 x 30.5 cm. (8½ x 10⅞ in.)
Reims, Bibliothèque Municipale, ms. 229

One of a series of missals made around 1200 for churches of Reims. Although its usage for the church of St. Remi is evident from the calendar, which includes a votive mass for the saint and a special feast of the church's dedication, it is not certain that the manuscript was made there. The closest parallels in script and decoration occur in missals made for the cathedral of Reims, beginning about the third quarter of the twelfth century with Reims, ms. 216. In another cathedral missal, Reims, ms. 219, the crucifixion miniature was probably executed by the same artists who painted our manuscript. A related St. Remi missal, Reims, ms. 228, contains a crucifixion miniature exactly like the one in our manuscript and of about the same date. Although the figural style of these works has no immediate parallels in contemporary Reims sculpture, they share a Mosan component. The crucifixion miniature of the present manuscripts lacks the expressiveness and pathos of the same scene in the approximately

contemporary Anchin missal (no. 250). Indeed, the schematic disposition of details around the large, wide cross and the rather neutral roles played by Mary, John, and the angels holding the sun and moon all contribute to a severe image, with loss of narrative power. This type of crucifixion became standard in later Parisian missals such as Paris, B.N., ms. lat. 15615.

BIBLIOGRAPHY: *Les plus beaux manuscrits de la Bibliothèque Municipale de Reims,* Reims, 1967, no. 48

254. Pontifical

France, Chartres
Early 13th century
Parchment
19 x 29.7 cm. (7½ x 11¾ in.)
Orléans, Bibliothèque Municipale, ms. 144

Numerous ceremonial instructions indicate that this manuscript was made for the cathedral of Chartres. It is the only surviving early thirteenth-century Chartrian manuscript with important illustrations. In the mid-thirteenth century it was altered to conform to the usage of Orleans. As in a missal, full-page miniatures of Christ in Majesty and the Crucifixion introduce the canon of the mass; throughout the manuscript, numerous historiated initials illustrate events from the life of Christ. The script is of fine quality, contrasting sharply with the unpracticed initial and filigree ornamentation and the awkward, provincial miniatures. The figures have flat, narrow bodies clothed in loosely undulating folds, and both individual details and overall compositions lack tight definition. However, the deep coloring of the folds give the figures a harder more robust aspect which, against the heavy gold background sustains an impression of sumptousness. The present manuscript may be a provincial adaptation of the style of the Pontigny Bible fragment and related manuscripts (nos. 248, 246).

BIBLIOGRAPHY: W. Cahn, *The Souvigny Bible: A Study in Romanesque Manuscript Illumination,* diss. New York University (June, 1967), pp. 459–462

255. Miscellaneous codex

Northern France
1210–1220
Vellum
23 x 16.5 cm. (9 x 6½ in.)
Princeton University Library, Ms. Garrett 114

This illustrated Seneca text, though apparently the only one of this period, testifies to the intensity of humanistic concern in early thirteenth-century France. Interest in the stoicism of Seneca started in the twelfth century (K. D. Nothdurft, *Der Einfluss Senecas auf die Theologie und Philosophie des zwölften Jahrhunderts,* Leiden, 1963), during which time his letters were considered models for humanistic letter writing (Kantorowicz, 1965, p. 194 f.). In this codex, his *Liber moralium* is introduced by a large initial R. As in many B (*beatus vir*) initials of the first psalm in contemporary psalters, the letter is divided into two parts: in the upper half, the

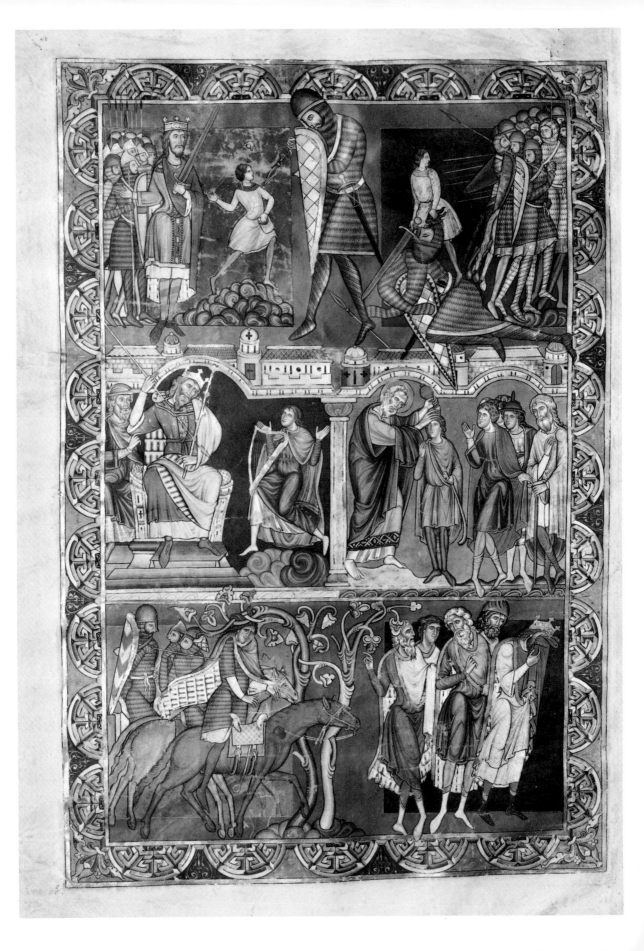

emperor Nero is enthroned on a faldistorium with lion-head terminals, presiding over the martyrdom of the philosopher below. The representation of this martyrdom is similar to contemporary illustrations of St. John the Evangelist's martyrdom (Boeckler, 1923). The main shaft of the letter is extended between two opened lions' mouths (another lion's mask marks the intersection of the R's two curved parts). At the center of the shaft a lozenge-shaped field contains the face of a young man, perhaps the dying Seneca's anima (for animas on contemporary tombstones, Panofsky, 1964; for the type of frontal youthful heads, Bober, 1963, pl. XVII).

BIBLIOGRAPHY: *Illustrations from One Hundred Manuscripts in the Library of H. Y. Thompson*, IV, London, 1914, pp. 9–10, pls. XVI–XVII; L. D. Reynolds, *The Medieval Tradition of Seneca's Letters*, Oxford, 1965 (discusses fols. 104–164)

256. Bible leaf scenes from Kings I and II

England, Winchester
1175–1200
Parchment
57.5 x 38.8 cm. (22¾ x 15¼ in.)
New York, The Pierpont Morgan Library, Ms. M. 619

This leaf is of the same style and dimensions as the leaves of the Winchester Bible, written and illustrated before 1185 for the St. Swithum's Priory, Winchester. The format would suggest that the leaf was intended to serve as a frontispiece to the Book of Kings. The corresponding page of the Winchester Bible has the same chapter heading and is illustrated by a simple historiated initial by the same painter as the present leaf's verso—suggesting either that the leaf is the only known fragment of a related Bible painted at Winchester, or, more probably, that it was intended for the Winchester Bible and was for some reason discarded.

The recto illustrates the early life of Samuel. Oakeshott identifies the underdrawing as by the Winchester Bible's Master of the Apocryphal Drawings; the final painting may be by another

hand. Rendered in a style of the mid-twelfth century, the exaggerated gestures and flowing drapery of the figure fit into a patterned format to which the drama remains subordinate. The verso illustrates episodes from the life of David. The underdrawings were ignored by a later artist, called by Oakeshott the Master of the Morgan Leaf; he perhaps completed this page after the leaf had been discarded. His figures, softly painted and dressed in classicizing drapery, suggest a new psychological awareness, already "early Gothic" in character. The influence of Byzantine art can be seen both in the iconographic schemes, such as David anointed in the presence of his brothers, and in stylistic details. The face of the young man in the lower right corner resembles that of a Byzantine archangel. The old man to the right resembles Simeon in the Presentation scene at Monreale. The same Winchester artist may also have worked on the frescoes in Sigena, Spain (no. 238).

BIBLIOGRAPHY: W. Oakeshott, *The Artists of the Winchester Bible*, London, 1945, p. 18 f.

257. Psalter

English
About 1200
Parchment
Paris, Bibliothèque Nationale, ms. lat. 8846

All three of Jerome's translations of the psalter are written here: Gallicanum, Romanum, and Hebraicum, the column of the Gallicanum or Vulgate version twice the width of the others (Panofsky). The text breaks off after the sixth verse of Psalm 98. The page layout and the texts (save for the missing Anglo-Saxon) are nearly identical with those of the Canterbury Psalter by Eadwine (Cambridge, Trinity College, R. 17.1). Yet the differences in the French version (F. Michel, *Le livre des psaumes, ancienne traduction francaise*, Paris, 1876) and in the Anglo-Saxon fragments (H. Hargreaves, C. Clark "An unpublished Old English Psalter-Gloss fragment," *Notes and Queries*, n.s., 12, 1965, pp. 443–446), along with some divergencies in the illustrations, make it certain that this psalter was copied neither from

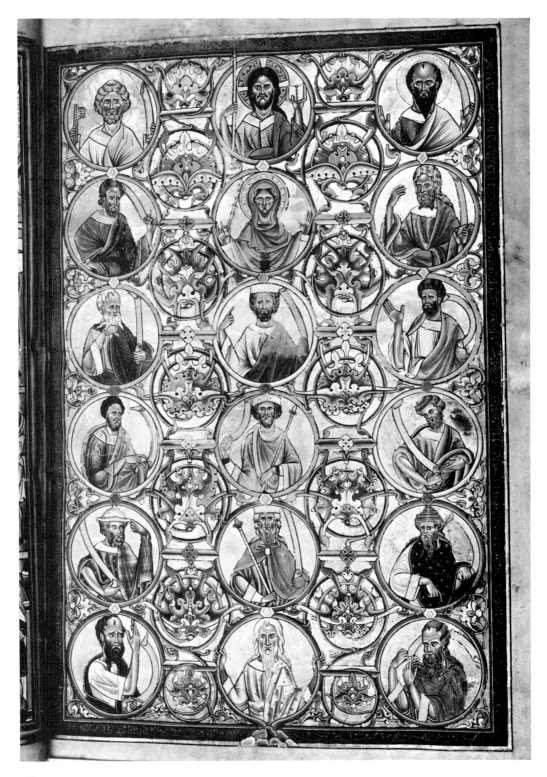

258

the Canterbury Psalter (despite the common supposition that it was) nor from the Utrecht Psalter but from a lost intermediate copy.

Four folios of Bible scenes precede the psalter, starting with the Creation and ending with the Tree of Jesse. The first three folios are divided into twelve compartments; the last is a full-page illustration. The Old Testament cycle finishes with David crowned, followed immediately by John's baptism and beheading. The life of Christ starts with the Annunciation, includes a number of miracles and parables, but omits the Passion (for a complete list of the scenes, H. Omont, *Psautier illustré,* Paris, n.d., pp. 5–10). These four folios, as James pointed out, resemble four leaves from the first half of the twelfth century, now divided among the Morgan Library (Mss. 521, 724), the British Museum (Add. 37472), and the Victoria and Albert Museum (Ms. 661). C. R. Dodwell's suggestion that these leaves may once have been part of the Canterbury Psalter is not convincing; rather, they may have belonged to the now lost intermediary copy.

The illustrations of the exhibited psalter follow the system of the Utrecht Psalter through fol. 95, and seven of them (fols. 72 v., 73 v., 80 v., 82 v., 93) were painted on underdrawings after the Utrecht model by the same Catalan hand that illuminated the subsequent psalms after a different prototype. Although there are no comparable Canterbury manuscripts of this period, sumptuous codices on this scale existed in England at the time, notably the Westminster Psalter (British Museum, Roy. Ms. 2. A. XXII) and a Bible in Oxford (Bodleian, Auct. E. infra 1, 2). In Canterbury the images closest in style are the Old Testament figures in the earlier windows of the cathedral, especially those belonging to the genealogy of Christ.

BIBLIOGRAPHY: V. Leroquais, *Les Psautiers manuscrits des bibliothèques publiques de France,* Mâcon, 1940/41, II, pp. 78–91; D. Panofsky, "The Textual Basis of the Utrecht Psalter Illustrations," *Art Bulletin,* XXV, 1943, pp. 50–58; D. Tselos, "English Manuscript Illustration and the Utrecht Psalter" *Art Bulletin,* XLI, 1959, pp. 137–49; Barcelona, 1961, no. 171; Paris, 1968, no. 234

258. Psalter

England, London (?)
1200–1225
Parchment
22 x 32.5 cm. (8⅝ x 12 13/16 in.)
New York, Pierpont Morgan Library, Glazier Ms. 25

In addition to a fine Beatus frontispiece, the psalter's principal decoration is a unique series of six full-page illuminations arranged in three groups of two facing miniatures. The Virgin, Christ, and David are the subjects of each pair. On the right they are enthroned, on the left they appear in narrative scenes: the Virgin in the Annunciation, Christ crucified, and David playing before Saul. Noting that David is shown being crowned by two men in contemporary ecclesiastical dress, traditional in English coronations (Brieger, pls. 47a, b), Schapiro maintains that the miniature represents a historical controversy over the ecclesiastical power of the king when consecrated by anointment. Wormald, on the other hand, suggests the facing miniatures contrast humility with triumph and are not associated with a historical event. Introductory miniatures devoted to the Virgin, Christ, and David, both hieratic and narrative in type, occur in the Westminister Psalter (British Museum, Roy. Ms. 2. A. XXII), which, according to Schapiro, was the type on which the present psalter was based.

The size of the manuscript is unusual. Twenty years earlier than the Amesbury Psalter (Oxford, All Souls College, Ms. 6), with which it shares almost identical dimensions, the present psalter employs the same closeness of drama and surface adherence of the fold pattern that cause the narrative action to seem physically to fill up the page. Stylistically, the manuscript is comparable to the Cambridge, University Library, Ms. KK. IV. 25 (Brieger, pls. 41b, 50; Schapiro, 1960, pls. 19a, 21b) and other manuscripts related to the St. Albans-London sphere and generally assigned to the 1220s. However, the most advanced paintings in the present psalter, the two David scenes, show an

organic contouring and a soft fluency in drapery folds suggestive of a slightly later date.

BIBLIOGRAPHY: Brieger, 1957; M. Schapiro, "An Illuminated English Psalter of the Thirteenth Century," *The Journal of the Warburg and Courtauld Institutes,* XXIII, 1960, pp. 179–189; F. Wormald, "Notes on the Glazier Psalter," *The Journal of the Warburg and Courtauld Institutes,* XXIII, 1960, pp. 307–308; J. Plummer, *The Glazier Collection of Illuminated Manuscripts,* New York, 1968, p. 22

259. Bestiary

English
About 1185
Vellum, 106 miniatures, 120 leaves
21.6 x 15.5 cm. (8½ x 6⅛ in.)
New York, Pierpont Morgan Library, Ms. M. 81

The manuscript reveals a manner of drawing and painting that seems to have been developed especially for the representation of animals. Complementing the descriptive details found in the text, it also captures the salient physical characteristics of each animal. The elephant (fol. 23), for instance, is painted in broad monochrome strokes and shown with three mailed figures on its back. It is contained in a sturdy frame that, with the coloring, emphasizes the beast's size, cumbersomeness of movement, and ability to carry loads. The yale (fol. 39), represented in a wispy drawing style, seems too fast and wiry to be enclosed, and indeed it overlaps its frame. These characterizing features are duplicated in a bestiary in Leningrad (Leningrad, State Library, Ms. QV. V. I). The present manuscript is one of the earliest bestiaries to have encyclopedia intentions. Portions of its Latin text derive from the *Physiologus (Naturalist)*, the Greek work of the second to third century that was standard for bestiaries, but it also incorporates later material, notably the *Etymologies* of Isidore of Seville (d. 636), which give meticulous attention to the natural aspects of animals. It also expands the conventional format to include 106 illustrated lessons arranged according to beasts, fish, birds, and reptiles. Portions of the text are known in only one other bestiary (British Museum, Royal 12 C. XIX); these in-

clude extracts from the *De imagine mundi,* attributed to Honorius Augustodunensis, the book of Genesis, Isidore's *De pecoribus et iumentis* and *De aribus,* and a seemingly irrelevant sermon. Finally, three items occur that are known in no other bestiary: Isidore's *De aquis* and *De terra* and a sermon on Joseph ascribed to Augustine (*Patrologia Latina,* XXXIX, col. 1765).

The precise purpose of a bestiary is not known. These books may be viewed as part of the encyclopedic tradition of the twelfth and thirteenth centuries, with their particular focus corresponding to the increased interest around this time in the natural world. This interest is also evident in the medieval concern with the writings of Pliny, Isidore, Solinus, and Aristotle (whose *History of Animals* was translated into Latin by Michael Scot in the thirteenth century). Alexander Neckam's twelfth-century work *On the Nature of Things* is another indication of the trend. As well as identifying foreign and domestic animals and offering moral and religious teaching, the bestiary may have delighted royal courts, many of which began to maintain menageries.

BIBLIOGRAPHY: M. R. James, *The Bestiary,* Oxford, 1928; A. Konstantinowa, *Ein englisches Bestiar des zwölfen Jahrhunderts in der Staatsbibliothek zu Leningrad,* Berlin, 1929; F. McCulloch, *Medieval Latin and French Bestiaries,* North Carolina, 1960

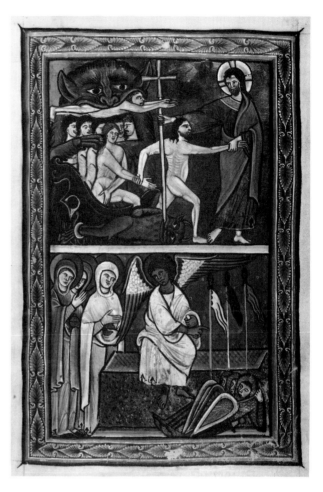

260. Psalter

England, Oxford (?)
About 1220
Vellum, 185 fols.
30.5 x 22.8 cm. (12 x 9 in.)
London, British Museum, Ms. Arundel 157

One of a closely related group of English illustrated psalters produced in the early thirteenth century, apparently all from the same workshop, for the private use of prominent feudal patrons. Others are no. 261, the Westminster Psalter (British Museum, Roy. Ms. 2 A. XXII), and the Munich Gloucester Psalter (Boeckler, 1930, pl. 92). They use variations of a common stock of iconographical models and their style evolves

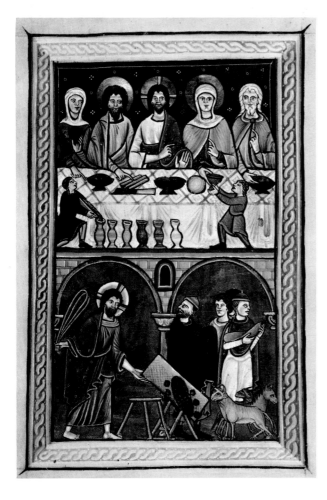

dense renderings of the B initial can be seen in manuscripts from other European scriptoria of the period: from Weingarten, no. 275, from the Thuringian-Saxon school, the Stuttgart Landgrafenpsalter (Boeckler, 1930, pl. 86).

BIBLIOGRAPHY: *Schools of Illumination, British Museum*, II, London, 1915, p. 7, pl. 8; *Reproductions from Illuminated MSS., British Museum,* 3rd series, London, 1925, p. 10, pl. XVI; E. G. Millar, *English Illuminated Mss., X–XIII Century,* London, 1926, p. 45, pl. 66; Boeckler, 1930, p. 93 f.; Haseloff, 1938; T. S. R. Boase, *English Art, 1100–1216,* London, 1953, pp. 280–82, 290–91, pl. 91 a; Schapiro, 1960; M. Rickert, *Painting in Britain,* London, 1965, pp. 98–102; Deuchler, 1967

261. Psalter

England
1210–1220
Vellum
35 x 24 cm. (13¾ x 9½ in.)
London, British Museum, Royal Ms. I.D.X.

The English origin of this manuscript is evident in the choice of saints mentioned in the calendar. As was usual in English psalters, starting in the twelfth century, an illustrated cycle of Christ's life precedes the text: here it consists of sixteen miniatures. With the exception of the Majesty, each illustrated page is divided into two compartments, with backgrounds alternately of gold and color. Stylistically, the summary outlines of the more or less isolated figures, and the flatness and ornamental linearization, are striking deviations from slightly earlier northern French book illuminations, such as those of the Ingeborg Psalter. These characteristics also appear in the illustrations of the Westminster Psalter, British Museum, Royal Ms. 2 A. XXII, which shortly antedates the present codex, as well as in related psalter manuscripts such as no. 260 and Munich Bayerische Staatsbibliothek clm. 835. All these codices use a broad iconographical repertory of christological scenes that surpasses the scope of preceding English twelfth-century cycles. While the present manuscript is thought to have origi-

from a complex interchange of French and English sources. The B initial of Psalm 1 (*Beatus vir*) is brilliantly ornamented. A rich pattern of intertwining floral circles is enclosed by the roundels of the initial's outline. At the center is a frontal lion's mask, a motif traditional in English medieval art. The background is covered by a diamond pattern. Historiated medallions with David scenes appear at each corner of the frame. Six elongated monsters extend beyond the confines of the initial. These animals are missing in the corresponding page of the Munich Psalter which furthermore differs in the more complex interlacing of the ornamental circles, reminiscent of cosmological schemata or representations of Ezekiel's vision of the four wheels. Similarly

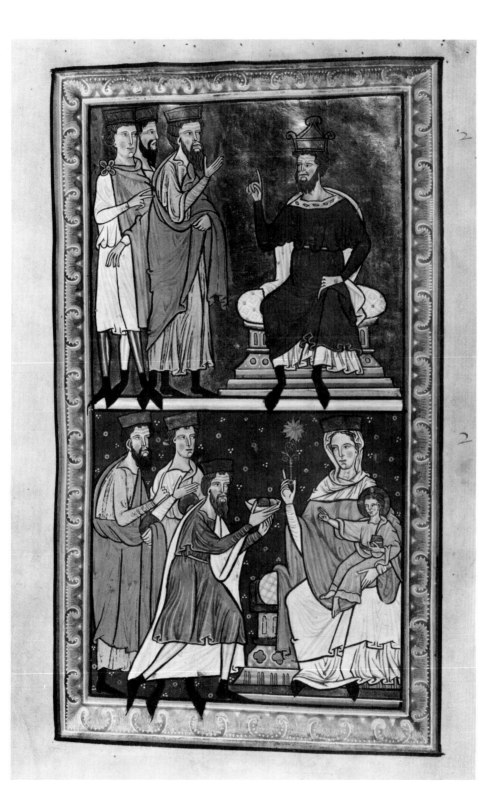

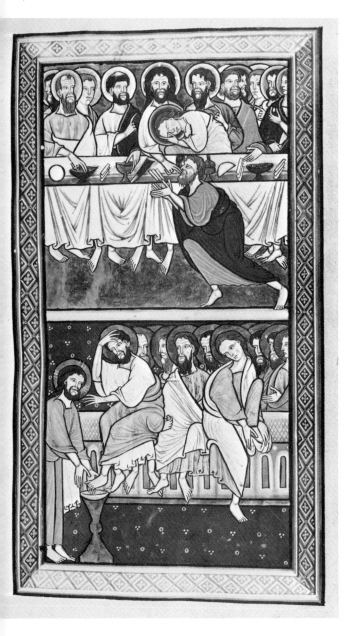

considered the missing reference to the transposition of Thomas Becket's body a cogent *terminus ante.*

BIBLIOGRAPHY: E. G. Millar, 1926, p. 45, pls. 64, 65; Boeckler, 1930, p. 93 f; Boase, 1953, pp. 380, 385, 391, pl. 91 b, c; Rickert, 1965, pp. 98–102; Deuchler, 1967

262. Bible ("Lothian")

England, probably St. Alban's
About 1220
Parchment
47 x 32.5 cm. (18½ x 12¾ in.)
New York, The Pierpont Morgan Library,
Ms. M. 791

There are numerous historiated initials in this extensively illustrated manuscript. The upper portion of the miniature preceding Genesis depicts the Creator as the Trinity enthroned among the angelic host. The center portion shows the fall of the rebel angels, with the dove or Holy Spirit hovering over the deep on one side and the four rivers of Paradise on the other. Beneath, six roundels of the days of Creation began with the creation of the angels and conclude with the shaping of Eve. The detailed representation in this manuscript extends to infrequently illustrated books such as Esther, whose initial contains nine scenes. Henderson suggests that the model for the illustrations may have been an Anglo-Saxon copy of an Early Christian cycle. Although his comparisons with the Caedmon and Aelfric manuscripts are convincing, the absence of this iconographic type from the great English Romanesque Bibles and its sudden appearance about 1210 may reflect the new scholastic and literary interest in the Old Testament then current in England and France. Stylistically, the manuscript is related to the Huntingfield Psalter, Morgan Ms. 43, and probably slightly precedes Oxford, New College, Ms. 322, attributed to W. de Brailles, with whose work this Bible shares many iconographic details. Plummer has convincingly argued for a St. Albans provenance on the basis of

nated in a scriptorium at Westminster Abbey, the alleged provenance of no. 260 (Oxford) and that of the Munich Psalter (Gloucester) would seem to localize the whole group in the area between London and Gloucester. While certainly later than the Westminster Psalter, this manuscript has been dated before 1220 by Millar, who

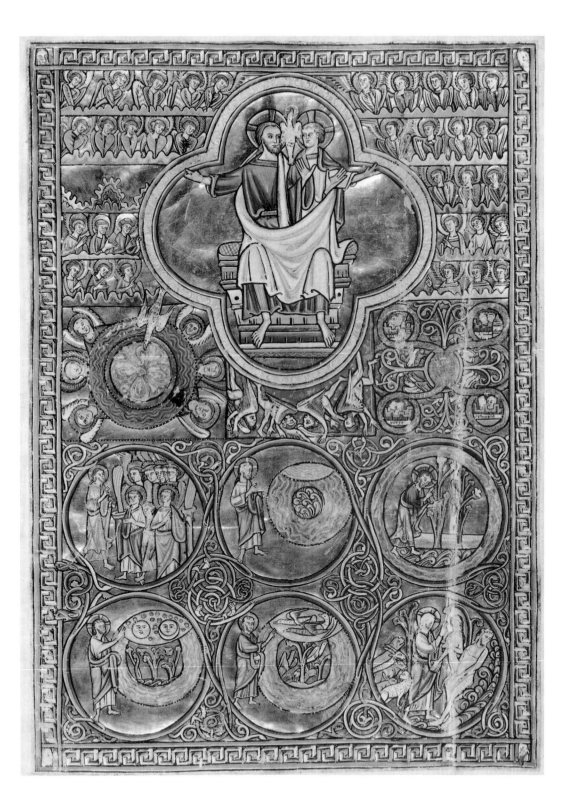

agreement in variant text readings and chapter order with known St. Albans works. In addition, he identifies a fourteenth-century pressmark on fol. 6 as belonging to St. Albans. The Bible's relation to works originally thought to be from St. Bertin but recently attributed to St. Albans, such as no. 247, strengthens the argument for a St. Albans origin.

BIBLIOGRAPHY: J. Plummer, *The Morgan Lothian Bible* (unpublished dissertation, Columbia University, 1953); J. Plummer, *Liturgical Manuscripts for the Mass and Divine Office,* New York, 1964, no. 45; G. Henderson, "Studies in English Manuscript Illumination," *Journal of The Warburg and Courtauld Institutes,* XXX, 1967, p. 128 n. 65

263. Epistles of St. Paul, Glosses

Lower Saxony, Halberstadt
1180–1190
Parchment, 186 folios
31 x 21 cm. (12¼ x 8¼ in.)
Berlin-Dahlem, Preussischer Staatsbibliothek,
Theol. lat. fol. 192

Besides gold initials at the beginning of each letter, which include half-length figures of St. Paul (Galatians), Timothy (Timothy II) and He-

brews (Hebrews), the main decoration of this codex consists of a full-page miniature of the enthroned Paul among the recipients of his letters. Like the similar images in the eleventh-century Regensburg cod. lat. 18128 in Munich, Bayerische Staatsbibliothek (E. F. Bange, *Eine bayerische Malerschule des 11. und 12. Jahrhunderts,* Munich, 1923, fig. 44) and on a late twelfth-century English enamel plaque, no. 168, this representation emphasizes Paul as teacher. The impressive figure of the saint, like the earlier Regensburg one, is indebted to Byzantine models, not only in physiognomy but painterly technique. Parallel to the development in the Helmarshausen workshop, represented by nos. 264, 265, this miniature testifies to the adaptation of Eastern style in another lower Saxon center, Halberstadt. The same characteristics are also observable in the highly developed contemporary sculpture of this region. The intense sculptural conception of the heavily seated St. Paul is comparable to stucco figures of the Halberstadt and Hildesheim churches.

Stylistically, a close relationship exists between the exhibited manuscript and one in Berlin, theol. lat. fol. 193. Preserved on the inside of the book cover are the fragments of a late tenth-century

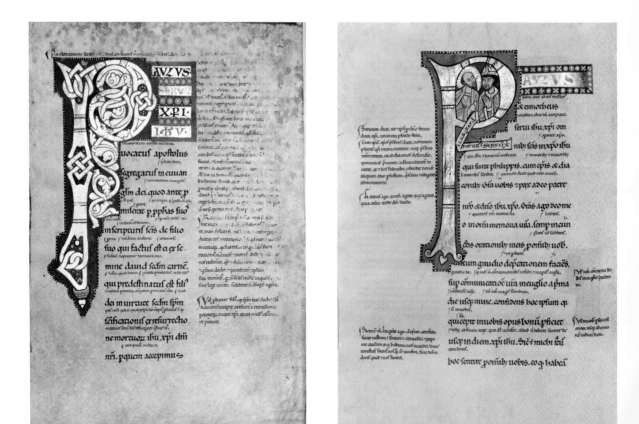

Fulda sacramentary representing saints Gregory and Gelase, and an allegory of Annus surrounded by personifications of the twelve months.

BIBLIOGRAPHY: Munich, 1950, no. 268; Barcelona, 1961, no. 44

264. Evangelistary

Lower Saxony, Helmarshausen
About 1190
Parchment, 195 fols.
34.7 x 24 cm. (13⅜ x 9½ in.)
Trier, Dombibliothek, Ms. 142

The decoration of this codex consists of twenty-four initials of varying size marking major divisions and pericopes; in each gospel text one pericope is distinguished by a figural representation. Each frontispiece of a gospel text is introduced by an illuminated page facing the author's portrait (Mark: Baptism of Christ, with the Ark of Noah between Sponsus and Sponsa; Luke: Crucifixion; John: Last Judgment). Canon tables, prologues, and a miniature of Matthew (no. 265) are missing from the beginning of this codex. Many technical and artistic details in manuscripts of assured Helmarshausen origin (decorative gold majuscules on purple, small two-line initials), suggest the origin for this one. The illuminations have been attributed to three different artists. Master I, responsible for the Matthew and Mark pages, and the majority of the initials, continues the style of Herimann (Swarzenski, 1932, p. 261 f. for an appraisal of this personality). The work of Masters II and III reflect northern French, English, and Byzantine influences. The style of Master II has been compared to that of the Wolfenbüttel codex of 1194, and called an anticipation of thirteenth-century achievements in book illumination. Influences from English models, for example nos. 256 and 257, can be seen in the contributions of Master III. A Helmarshausen origin has also been convincingly claimed for the cover of this book, which repre-

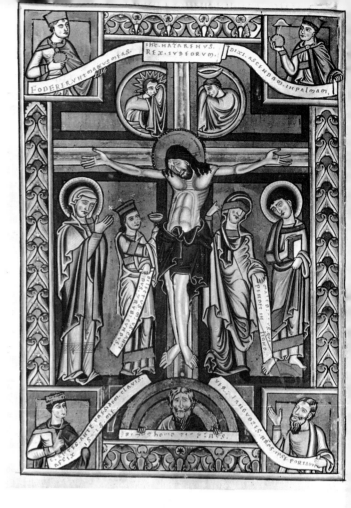

sents Christ enthroned, surrounded by the animalia and flanked by Peter and Paul (Steenbock, 1965, no. 108).

BIBLIOGRAPHY: Swarzenski, 1932, p. 301 f.; Corvey, 1966, no. 183

265. Nativity: St. Matthew

Germany, Helmarshausen
1180–1190
Vellum
34.5 x 23.8 cm. (13½ x 9⅜ in.)
Cleveland, Museum of Arts, 33.445

This leaf, discovered and identified by Georg Swarzenski, was cut from codex 142 in the Trier Domschatz library at an unknown date and preserved, prior to its acquisition by the Cleveland Museum, in a Westphalian castle. The geometri-

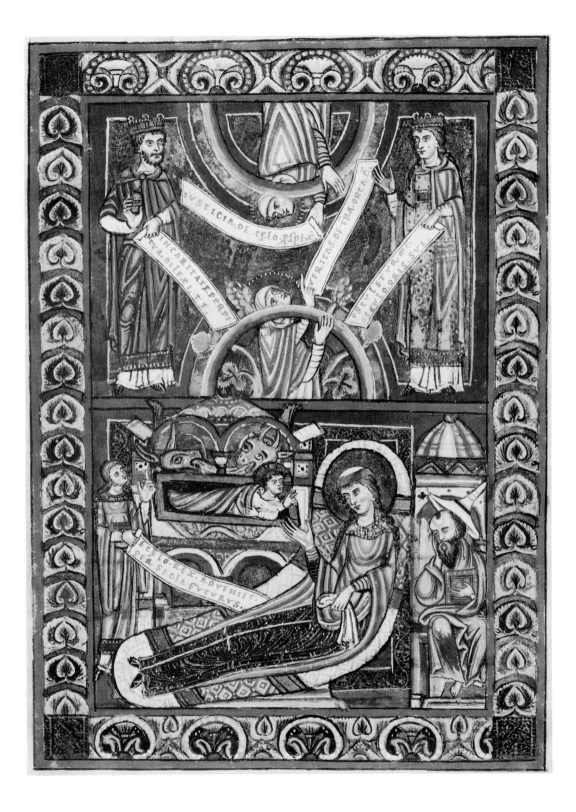

cal composition, the floral ornamentation, and the iconographical peculiarities of this leaf and, consequently, of the Trier codex, are developed from the Helmarshausen workshop of miniature painters active in the services of Duke Henry the Lion. Accordingly, the type of Nativity seen here has its closest precedent in the corresponding miniature of the famous Gospel book formerly preserved in Gmunden (Swarzenski, 1932, fig. 209). Mary reclining, as a type, was borrowed from Byzantine models, and was especially popular in contemporary north German representations (Dinkler-Schubert, figs. 21–38). Byzantine inspiration is noticeable also in the sharply broken drapery folds and the physiogonomy of Joseph. The elongation of the figures, their ornamentally swinging drapery folds, and details of the floral motifs, on the other hand, were linked to English models, due to the close dynastic and cultural connections of Duke Henry with the English court. The type of ornamentation seen in Mary's drapery and in the filling of the background is also seen on a northern French cross of the late twelfth century (no. 78), a demonstration of the Helmarshausen miniature's deep trans-Mosan infiltration.

The artist's ornamental inventiveness is evident in the verso illumination with the floral integration of the letter L enclosing a bust of the Evangelist Matthew. This type of bust in a medallion often recurs in the Gmunden and Trier codices (Swarzenski, 1932, figs. 215–216). The extent of the artist's indebtedness to English sources is also seen in a figure of St. Mark set in a quatrefoil frame of the Trier codex (Swarzenski, 1932, fig. 214) and in one of the prophet busts framed by quatrefoils in the library of Canterbury Cathedral, dated around 1190 by Zarnecki (1953, fig. 111).

A feature of the Cleveland leaf (and some of the related leafs) is the thorough theological interpretation of a biblical episode by means of accompanying allegorical figures. In the Nativity the female figure with the inscription E CELO REX ADVENIET PER SECLA FUTURUS, which points to the explicit allegories in the upper field, is without precedent in the pictorial tradition of

the scene. The personifications of Truth and Justice emerging from the earth and sky, according to Psalm 85:11 ("Truth shall spring out of the earth; and righteousness shall look down from heaven"), are flanked by King Solomon and the Sponsa, carrying inscriptions from the Song of Songs, with the motif of the kiss emphasized. In the Gmunden codex the same composition of Truth and Justice is combined with an Annunciation and Visitation, accompanied by a verse of Psalm 84: IUSTITIA ET PAX OSCULATAE SUNT (Swarzenski, fig. 219).

BIBLIOGRAPHY: Swarzenski, 1932; W. M. Milliken, "A Manuscript Leaf from the Time of Duke Henry the Lion," *Cleveland Museum of Art Bulletin,* 21, 1934, pp. 25–39; Jansen, 1933, p. 119, note 186b; Corvey, 1966, no. 194

266. Three leaves from a *Speculum Virginum*

Germany, middle Rhineland
About 1190
Parchment
33.5 x 23.5 cm. (13¼ x 9¼ in.)
Bonn, Rheinisches Landesmuseums, 15.326–8

These leaves were removed, probably in the nineteenth century, from the allegorical treatise *Speculum Virginum,* Ms. 132 of the Treves Cathedral library. They served as frontispiece illustrations to the first (Genealogy of Christ), sixth (Parable of the Wise and Foolish Virgins), and seventh (Three Christian Professions: Virginity, Marriage, Widowhood) books. (Another leaf, now in the Kestner Museum, Hannover, introduced the fourth book.) The complex literary sources of the *Speculum* and the choice of its illustrations have been studied by Bernards and Greenhill. The earliest *Speculum* (British Museum, Arundel

44) shows the three Christian professions as an allegorical scheme modeled after the Tree of Jesse and the Arbor Virtutum. In the present version this has become a realistic rendering of genre activities, reminiscent of calendar illustrations. Both the provenance and the stylistic relationship of the leaves to the illustrations of the so-called prayerbook of St. Hildegard of Bingen (Bayerische Staatsbibliothek, cod. lat. 935) suggest a middle Rhenish origin for this manuscript. Mosan influences may be assumed, as they are for other contemporary works of this region (Schilling, 1951).

BIBLIOGRAPHY: A. Watson, *The Early Iconography of the Tree of Jesse,* London, 1934, p. 131 f., pl. XXX; M. Strube, *Die Illustrationen des Speculum Virginum,* Bonn, 1937; Boeckler, 1952, no. 51; M. Bernards, *Speculum Virginum, Geistigkeit und Seelenleben der Frau im Hochmittelalter,* Cologne-Graz, 1955, pls. 5–6; B. Bernards, "Die verlorenen Miniaturen des Trierer Jungfrauenspiegels," *Kunstchronik,* IX, 1956, pp. 76–99; Barcelona, 1961, no. 45; Greenhill, 1962; Cologne, 1964, no. 51

267. Miniature: St. Gregory (recto), celebration of the Mass (verso)

Southern Germany, scriptorium of Weingarten
 Abbey
1190–1200
Vellum
29.8 x 23 cm. (11¾ x 9⅛ in.)
Chicago, The Art Institute, Buckingham Fund,
 44.704

The miniatures of this leaf appear in rectangular frames made up of a great variety of ornamental motifs. The recto is dominated by the enthroned figure of a haloed scribe, identified as St. Gregory by the inspiring dove perched on his right shoulder. Of the accompanying four roundels in the corners, only the lower two, presenting a dialogue between a Christian and a Jew, have a definite iconographic content. In earlier medieval art there occur representations of St. Gregory dictating to his secretaries disposed in similar arrangement below his throne.

The verso shows a bishop-saint celebrating Mass at an altar. His identity and the identities of the four heads at the corners of the frame are uncertain. The architectural background, a church roof resting on three arcades, is a pictorial formula lacking sufficient individual features to point to any identifiable building.

H. Swarzenski's theory that the leaf belongs to a lost codex of the life of St. Gregory, written by the monk Konradus in the scriptorium of Weingarten Abbey during the time of Abbots Wernher and Meingoz (1181–1200), is improbable in view of the iconography of the verso miniature, which has no connection with the later representations of the Mass of St. Gregory (Swarzenski, 1943, p. 15, himself inconsistently proposes the Mass of St. Martin at Albenga as a possible subject). His stylistic attribution to Weingarten and the reference to Anglo-Saxon models, however, remain highly convincing (for the comparison in Swarzenski, 1943, figs. 8, 10). Therefore, the various exuberant ornaments, the manneristic linearism, and the archaistic flat combination of figure and ground can be explained in terms of a concrete historical situation. The anonymity of

the bishop is perhaps intentional and may emphasize the general liturgical aspect of Mass celebration; one could imagine a missal instead of a Vita Gregorii as the original setting of this single leaf. Corroborative evidence for this suggestion comes from the fact that the image of the writing St. Gregory belongs to the repertory of earlier medieval illustrated missals and sacramentaries. The motif of the bishop elevating the Host reflects the change in liturgical practice during the twelfth century, leading up to the participation of the congregation in the eucharistic act. Along with Swarzenski's suggestion of English sources for the writing Gregory, we see a similarity of the verso to representations of the murder of St. Thomas Becket (1173) in the Canterbury cathedral, notably in the figure of the nobleman with a sword upon his shoulder.

BIBLIOGRAPHY: Swarzenski, 1943, p. 77 f.; Baltimore, 1949, no. 26

268. Christ and Zacchaeus; St. Theodore and companion riding

Upper Rhenish
1210–1220
36.1 x 22.8 cm. (14 1/16 x 9 in.)
Vellum
Freiburg, Augustiner Museum

The leaf shows two superimposed scenes: at the top, Christ, followed by St. Peter, addresses Zacchaeus, standing in a tree (Luke 19: 1–10); at the bottom, two saints ride upon horses. Whereas the upper scene appears in outline only, the horsemen are distinguished by vivid coloring. The number LXXV is visible to the right of the lower group. This refers to a listing of seventy-five scenes preserved on two correlated leaves, the only remnants, along with the present leaf, of a lost codex with miscellaneous contents. The unconventional sequence of items, not fitting any traditional type of book, suggests that the miniatures formed part of a richly illustrated artist's model book (Scheller, 1963, for a general survey of the medieval material). Demus has pointed out the close similarity of the Christ in the upper scene to figures in various scenes of the Palermo and Monreale mosaics. From the hand of Christ holding the scroll, drawn in outline only, without division into fingers, Demus concludes that this figure is a direct copy from a Byzantine drawing, probably in one of the model books used by the Sicilian mosaicists (for thirteenth-century miniatures that copy scenes from the Sicilian mosaic cycles, H. Buchthal, "Some Sicilian Miniatures of the Thirteenth Century," *Miscellanea Pro Arte, Festschrift H. Schnitzler,* Düsseldorf 1965, pp. 185 f.).

The close stylistic relationship of the drawings to the illustrations of the *Hortus Deliciarum* and the 1197 Speyer Gospels in the Karlsruhe Library (Homburger-Preisendanz) has long been recognized. For stylistic comparison Homburger also refers to the reliefs of the so-called Böcklin-Kreuz in the Freiburg cathedral. This group of monuments bears testimony to the dominant role played by Siculo-Byzantine models in upper Rhenish art of the late twelfth century. An im-portant transmission of forms and motifs was supplied by sketchbooks such as the one from which our leaf comes.

BIBLIOGRAPHY: Flamm, 1914, pp. 123–126; Demus, 1950, pp. 445–448; Homburger, 1959, pp. 16–23; Bober, 1963, pp. 37, 103; Scheller, 1963, p. 73 f., no. 7; K. Weitzmann, "Icon Painting in the Crusader Kingdom," *Dumbarton Oaks Papers,* 20, 1966, p. 78 f.; Deuchler, 1967, p. 138

269. Bible

Germany, Regensburg
1190–1210
Vellum, 239 fols.
71.2 x 47.7 cm. (28 1/16 x 18¾ in.)
Munich, Bayerische Staatsbibliothek,
 Cod. lat. 3901

An entry on fol. 2 states that this Bible was given in 1241 to the cathedral of Augsburg. The decoration, confined to colored linear drawings, indicates that it was produced in the scriptorium of Regensburg, where this style was practiced from about 1135. The beginning of each book is marked by a full-page initial; other initials appear throughout the text. While the drawings represent the author, or a major episode from the text, the initials are decorated with branching stems, animals, and human figures. The work of three artists (Boeckler, 1924), the decoration of this Bible is similar throughout in the smooth fluidity of the drapery. The tendency toward voluminous bodies, not found in earlier products of the scriptorium (Munich Mss. lat. 13002, 13074, 14399, and 14159), is emphasized by the coloring of the drapery. Emphasizing the sculptural modeling of the figures, this coloring (occurring earlier in clm. 27204; Boeckler, 1924) contributes to the impression of restlessness. In describing these qualities Boeckler labeled our codex "Romanesque baroque" and contrasted it with Vienna cod. 12600, the first instance of *Zackenstil* in the scriptorium. The style of our codex is to be seen in a slightly later phase in no. 271.

BIBLIOGRAPHY: Boeckler, 1922; Boeckler, 1924, p. 67 f., p. 110 f.; Boeckler, 1930, p. 84

270. Abraham with Lazarus

Germany, Thuringia
About 1230
Vellum
23 x 15.5 cm. (9⅛ x 6⅛ in.)
Washington, National Gallery of Art,
 Rosenwald Collection

This leaf is from a psalter supposed to have been completed before 1239; another leaf from it is now in the Art Institute in Chicago. The patriarch Abraham, clad in a yellowish-white tunic and a tan mantle, sits enthroned, holding on his lap a small, beardless man with a cruciform halo, who distributes apples to the Blessed of Paradise. Around these figures a mandorla-shaped frame is intersected by four roundels with symbolic representations of the four Rivers of Paradise.

The miniature represents Lazarus in Abraham's Bosom, illustrating the parable of Dives and Lazarus (Luke 16:19–31). Rosenthal has shown how, in the twelfth and thirteenth centuries, the pictorial representation of this parable as Abraham's Bosom was used as an image of Paradise. On the other hand, compare the earlier representation of Abraham enthroned in a quatrefoil mandorla, in a mid-eleventh-century English psalter, Vat. Reg. lat. 12, fol. 72 r. (F. Wormald, *English Drawings of the 10th and 11th Centuries,* London, 1952, pl. 266). The earliest representations of the composition with the Rivers of Paradise occur in the *Hortus Deliciarum* and in a Regensburg manuscript (Boeckler, 1924, pl. LXXIV). Our miniature differs from comparable compositions in that its Lazarus has a cruciform halo, and is thus identified with Christ (Rosenthal). Abraham with only one soul, that of Lazarus, on his lap is to be considered as deriving from the Byzantine image of paternity: God the Father enthroned, with the Christ Child seated on his knee (H. Gerstinger, *Festschrif W. Sas-Zalloziecky zum 60 Geburtstage,* Graz, 1956, pp. 79–85). The same type of composition can also be seen in a contemporary stained-glass window in the St. Elisabeth church in Marburg (Heimann, 1932, p. 43, fig. 28) and in Ms. 711 in the Pierpont Morgan Library, New York (no. 277).

The dependence on Byzantine sources is evident both in the iconography and the style. The hieratic dignity of the design, the angular stylization of the drapery, and the intensity of expression are all characteristic of Thuringian painting of the period, particularly of the school associated with Würzburg.

BIBLIOGRAPHY: H. Swarzenski, 1936, p. 79; p. 155, no. 2; p. 157, no. 3; p. 161, no. 2; Rosenthal, 1945–46, pp. 7–23; Baltimore, 1949, no. 33; Kantorowicz, 1965, p. 119, pl. 27, fig. 11

271. Heinrich von Veldeke: *Eneit*

South Germany
1210–1220
Parchment
25.5 x 17 cm. (10⅛ x 16¾ in.)
Berlin, Dahlem, Preussischer Staatsbibliothek,
 Mgf.282

Written between 1170 and 1180, Heinrich von Veldeke's *Eneit* is based on Benôit de St. Maure's *Roman d'Eneas* of about 1160, a chivalric interpretation of Vergil's *Aeneid.* One of the earliest copies of von Veldeke's poem, this codex displays a full pictorial cycle of seventy-one colored drawings, each corresponding to a page of the middle High German text. Taking into consideration figure style, color, and the technique of the drawings, the codex is connected with the Regensburg school of miniature painting, particularly in its similarities to codex lat. 3901 in the Bayerische Staatsbibliothek, Munich (Boeckler, 1924, figs. 116–137). Given the expansion of the Regensburg style of book illumination to other Bavarian scriptoria of the early thirteenth century, no precise localization of the manuscript, the provenance of which also points to Bavaria, is possible. The striking asymmetry seen in many of its compositions not only agrees with other Regensburg representations (Boeckler, 1939, p. 29 f.) but follows the literary style of narrative adopted in Veldeke's poem (Frey, 1929, p. 170 f.). In spite of Vergil's importance in medieval literature, no illustrated copies of his *Aeneid* appear after the late antique period. An isolated example, with a

very few reduced, initial-like illustrations, produced toward the end of the twelfth century, testifies to the fading pictorial tradition (Weitzmann, p. 61, fig. 70). Lacking a tradition of illustrated *Aeneid* manuscripts, the artist had to assimilate pictorial types and inspiration from a great variety of sources and contexts (Boeckler, 1939, pp. 37–39). In its wealth of lively illustrations of chivalric life—battles, armor, heraldry, courtly love episodes, and genre objects—the present codex is a mine of antiquarian information. By adapting the classical subject matter to his contemporary representational modes, the artist followed the "principle of disjunction" observed by Panofsky (1960, p. 84 f.) in other medieval renderings of antique themes. Although probably originating from an ecclesiastical scriptorium, the codex may have been ordered by a secular patron.

BIBLIOGRAPHY: M. Hudig-Frey, "Die älteste Illustration der Eneide des Heinrich von Veldeke," *Studien zur deutschen Kunstgeschichte,* Strasbourg, 1921; A. Boeckler, "Zur Heimat der Berliner Eneit-Handschrift," *Monatshelfte für Kunstwissenschaft,* 1922, pp. 249–257; A. Boeckler, 1939; Saxl, 1957, p. 128 f.; Weitzmann, *Ancient Book Illumination,* Cambridge, 1959, p. 61 f.; Stammler, 1962, p. 140 f.

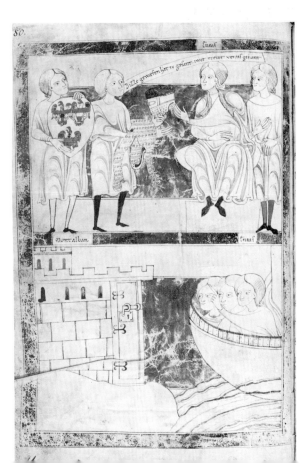

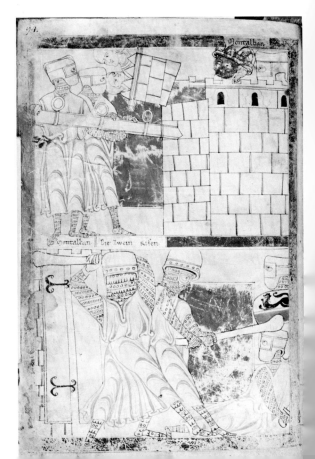

272. Crucifixion

Westphalia
1200–1210
Vellum leaf
33.6 x 23 cm. (13¼ x 9 1/16 in.)
Paderborn, Erzbischöfliches Diözesanmuseum

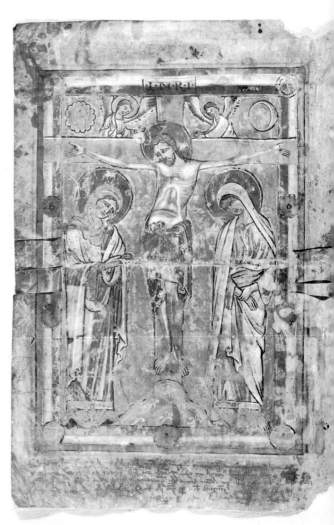

His outstretched arms filling the width of the painting, Christ is flanked by two half-figures of angels while two mourning women stand beneath. Christ's features and the characteristic painterly modeling of his body follow a Byzantine prototype. The rhythmical linearism of Christ's posture, the drapery of the loincloth, the outline of the hill supporting the cross, and the garment of the woman at the left are adaptations from a northern French miniature, similar to the Crucifixion page in the Anchin Missal (Swarzenski, 1967, fig. 543). A single leaf with the Crucifixion in the Cologne Wallraf-Richartz-Museum (Cologne, 1964, no. 44, fig. 41) was executed by a Belgian or Rhenish artist in imitation of a very similar prototype. In the Cologne miniature the verticalism and elegant mobility of posture point to a close connection with French sources. In our leaf the broad figure and the slightly undulating drapery of the woman at the right testify to the influence of the immediately preceding Westphalian art, seen in the Virgin in the Soest antependium (Barcelona, 1961, no. 1119). Slightly later Byzantine models were interpreted by Westphalian and lower Saxon artists in quite a different manner, stressing the angular sharpness of folds and features. Iconographically, the replacement of St. John by a second woman is without parallel in the artistic tradition of the Crucifixion. But, already in a Crucifixion miniature from the Helmarshausen atelier, active in Westphalia from the middle of the twelfth century (Baltimore, Walters Art Gallery, Psalter: Corvey, 1966, fig. 184), St. John may hardly be identified as male and is recognized only by his traditional book. Furthermore, with regard to his chastity, St. John was thought of as "virgo" in the Middle Ages; perhaps the representation of a second woman under the cross in our miniature was facilitated by this terminological ambiguity.

Around 1200, a great variety of interpretations was given to the subject of the mourning Virgin (no. 80). Apparently this theme had a strong emotional appeal to the contemporary artist and beholder (for a discussion of the feeling of sorrow in the literature of the time, F. Maurer, *Leid*, Munich, 1960).

BIBLIOGRAPHY: Corvey, 1966, no. 212, fig. 195

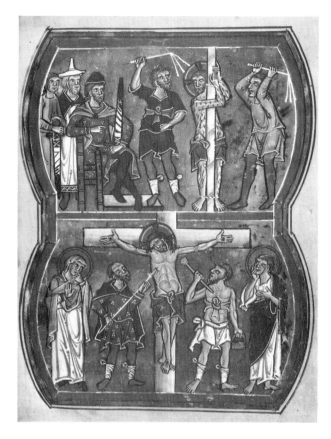

273. Miniature: Flagellation and Crucifixion

Germany
About 1225–1230
Vellum
21.3 x 15.1 cm. (8½ x 6 in.)
Chicago, The Art Institute, 24.671

In the upper scene, Pilate sits crosslegged, the traditional position of judges, and, with the high priest and a sword bearer, observes the Flagellation. Christ's body is covered with wavy lines of blood; the sharply angled position of his arms is unusual. In the lower scene, Christ's closed eyes and the schematic rendering of his chest point to a contemporary Byzantine prototype. The concentrated expressions of the figures and the sharp angles of the drapery outlines are characteristic of Saxon miniature painting of 1230–1250. The knotted band on the chests of the flagellator and

the sponge-bearer became common in later works of this school. In both style and conception these scenes may be compared to an ivory medallion of the Flagellation, no. 64, and a miniature of the Crucifixion, no. 272. This leaf may have come from the same codex as no. 270.

274. Minor prophets and lives of saints

South Germany (Bavaria), Weingarten Abbey
1215–1232
Parchment
30 x 42.8 cm. (11¾ x 16¾ in.)
New York, Public Library, Spencer Ms. 1

This manuscript was illuminated in Weingarten Abbey for Abbot Berthold (1200–1232). A contemporary description of manuscripts commissioned by the abbot lists a book containing twelve

minor prophets and another with the lives of saints. These two manuscripts were rebound in the sixteenth century; six of the minor prophets were then combined with the lives of the saints to form the present manuscript. The remaining books of minor prophets, in addition to Ezekiel and Daniel, are today in Leningrad (State Library, Ms. F. V. I. 133). Variations in style and archaic Romanesque script suggest that parts of both manuscripts were made to replace sections damaged in the fire of 1215 that destroyed the monastery.

The present manuscript contains the work of the Master of the Berthold Missal (no. 275), his style here slightly less developed than in the missal, and also work by artists who apparently did not participate in the painting of the missal. Byzantine influence appears in both manuscripts, here in the Pantocrator (fol. 44) and Christ giving the Byzantine blessing (fol. 14), but the style is here more schematic and flat and the anatomy less well understood than in no. 275. An unusual feature in the present manuscript is the depiction of the prophet Nahum seated on the ground, his face in his hands; the vivid color and constricted forms suggest the fury and indignation he prophesies.

BIBLIOGRAPHY: Swarzenski, 1943; The Walters Art Gallery, *Illuminated Books of the Middle Ages and Renaissance,* Baltimore, 1949, p. 15, no. 32

275. The Berthold Missal

South Germany (Bavaria), Weingarten Abbey
1215–1232
Parchment; silver gilt, jewels
29.2 x 20.3 cm. (11½ x 8 in.)
New York, The Pierpont Morgan Library,
 Ms. M. 710

This missal was commissioned by Berthold, Abbot of Weingarten (1200–1232), probably not long after the destruction of the monastery by fire in 1215. The cover of silver gilt repoussé plaques is composed of a rectangular center section superimposed on the arms of a cross. In the center, the enthroned Virgin and Child appear; in the corners, the four evangelists with their symbols; and, flanking the arms of the cross, eight standing figures, one of them Abbot Berthold. The cover once contained relics and represents a variant on a type of panel reliquary of the True Cross appearing in the Rhineland at the beginning of the thirteenth century (H. Schnitzler, *Rheinisches Schatzkammer,* Düsseldorf, 1957–1959, II, pls. 11–13, 16–19).

The miniatures of this missal are unparalleled in German Romanesque painting or in Weingarten production either before or after Berthold (nos. 267, 277). The missal's unique combination of northern and Byzantine elements with local German traditions is due to the historical position of the abbey, the active patronage of Berthold, and the individual genius of the Master of the Berthold Missal. Under the patronage of the House of Guelph, with its connections to both England and Flanders, the abbey received northern illuminated manuscripts. These were copied throughout the twelfth century and may have been a factor in the abbey's continued receptiveness to northern styles. Swarzenski has shown how, in script and decorative details, the missal refers back to these Romanesque traditions. After the fire of 1215, according to documents, a period of intense activity began in metalwork and stained glass as well as in manuscript production. Of the eleven manuscripts preserved from this period four show the hand of the Master of the Berthold Missal. These are distinguished by an unusually antiquarian spirit, especially in their repeated use of iconographic types and conventions from much earlier art, for example the antique Spinario figure (fol. 37 v.) and "assembly" picture (fol. 64 v.), the Carolingian Evangelist portrait type (Leningrad, State Library, Ms. F. V. I. 135, fol. 105), or Byzantine formulas of the Koimesis (fol. 107) and the Virgin Orans (fol. 112). Swarzenski has pointed out that all these recur in late twelfth-century art from both sides of the Channel. In work such as no. 257, the Klosterneuburg plaques (no. 179), or the Manerius Bible (Bibliothèque Ste. Gene-

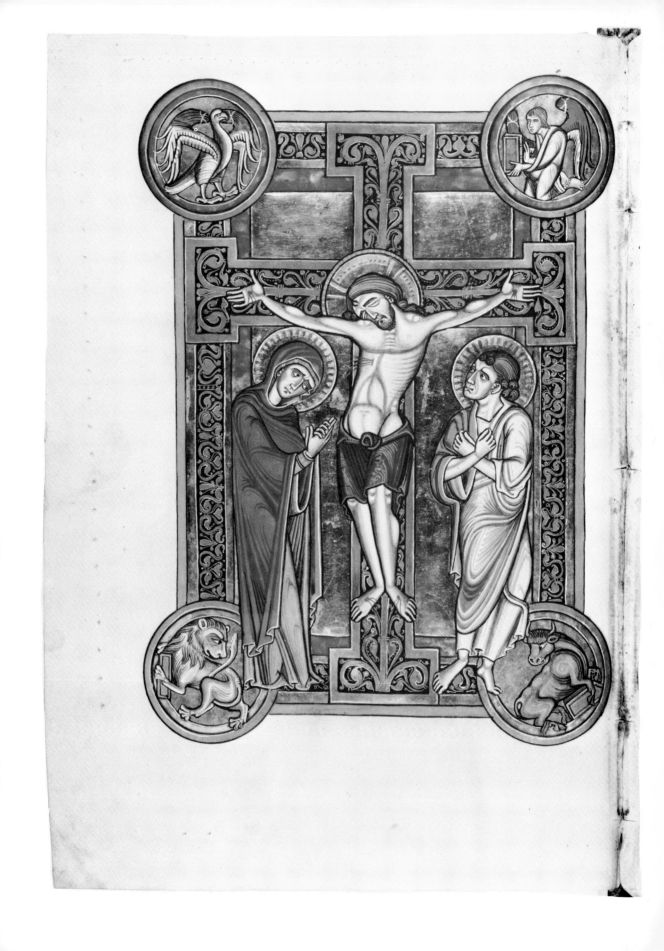

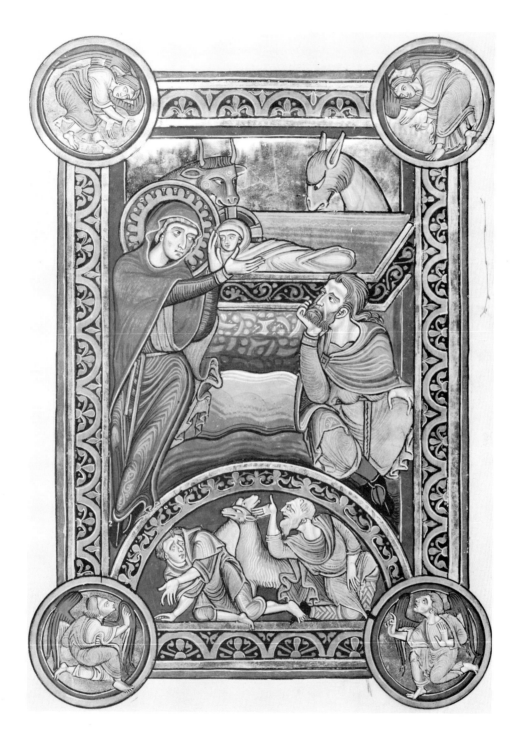

viève, Mss. 8–10), one finds similar spatial and figural development. Unique in the present manuscript is the Berthold Master's fondness for dynamic rotating movement, for stately decorative splendor, and for a stern, menacing intensity. Similar assimilations of Byzantine and northern influences occurred elsewhere in Germany in works sponsored by Duke Henry the Lion (no. 264), but the Berthold Missal's combination of individual artistic talent with an intense spirit of research into new forms and motifs allies it with the broadest trends shaping European art around 1200.

BIBLIOGRAPHY: Swarzenski, 1943; M. Harrsen, *Central European Manuscripts in the Pierpont Morgan Library,* New York, 1958, p. 31, no. 20; Steenbock, 1965, no. 116, pp. 215–217

276. Gospels of St. Matthew and St. Mark

Saxony, Halberstadt-Magdeburg (?)
About 1210–1220
Parchment
32.4 x 19.7 cm. (12¾ x 7⅞ in.)
New York, The Pierpont Morgan Library, Ms. M. 565

Each gospel is preceded by a miniature of the Evangelist writing. He sits beside a large ornamental initial and writes the first phrases of his gospel in an open book. The codex is preserved in a modern case carrying a silver gilt plaque representing Christ enthroned. The plaque may be original, but the surrounding medallions are almost all of late thirteenth century, perhaps of Freiburg origin. The binding also probably dates from this time. According to a fourteenth-century inscription the manuscript belonged to an Augustinian monastery at Theningen, a few miles from Freiburg. Swarzenski has related the style of both the cover and the miniatures to lower Saxon works under the patronage of Duke Henry the Lion. Saxon manuscripts of this time

(no. 265), all display Byzantine and English influence, but whereas this tended in most works to become stylized into zigzag drapery folds, here the figures maintain a corporeal fullness softened by light coloring. The artist may be among the several who painted the evangelistary produced for the Premonstrateneusian Abbey at Brandenburg (J. Gülden, *Das Brandenburger Evangelistar,* Düsseldorf, 1962). The Brandenburg figures of Isaiah (fol. 97 v.) and Paul (fol. 95) are closely comparable to those in the present manuscript; similarities can also be seen in the floral motifs of both manuscripts. As the evangelistary was probably produced at Magdeburg, it is likely that the

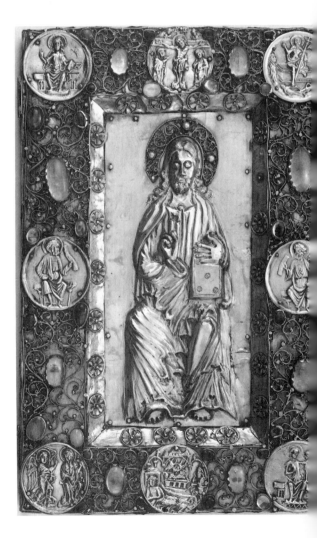

present manuscript was also painted there or painted by an artist from Magdeburg (Harrsen).

BIBLIOGRAPHY: A. Stange, "Beiträge zur sächsischen Buchmalerei des 13 Jahrhunderts," *Munchener Jahrbuch der Bildenden Kunst,* VI, 1929, pp. 302–344; Swarzenski, 1943; M. Harrsen, *Central European Manuscripts in the Pierpont Morgan Library,* New York, 1958, p. 39 f.

277. Gradual and sacramentary of Hainricus Sacrista

South Germany, Weingarten
1225–1250
Parchment
12.7 x 18.0 cm. (5 x 7 1/16 in.)
New York, The Pierpont Morgan Library,
 Ms. 711

The manuscript contains five full-page miniatures and thirty-five historiated initials that are related both stylistically and iconographically to no. 275. The manuscript was apparently made for one Hainricus, who appears beneath in three full miniatures and on the frontispiece, where he is called *sacrista* (priest). He has not been identified: three monks by his name are known, two of them associated with book production.

There are several manuscripts of similar style and iconography. Harrsen dates the present manuscript, and presumably the whole group, to the abbacy of Meingoz (1188–1200) largely on the basis of the calendar that includes the dedication of the chapel of the Virgin, which she dates about 1100. The calendar also contains the November 12 feast of the *dedicatio,* connected with either the monastery's dedication in 1187 (Harrsen) or its rededication in 1216 (Swarzenski, 1943). Arguing for a late dating, Swarzenski assumes a thirteenth-century dating for the chapel and includes in the group a manuscript with a portrait of Innocent III which could not date before his pontificate (1198–1216).

The iconographic relationship of these manuscripts with the Berthold Missal (no. 275) sug-

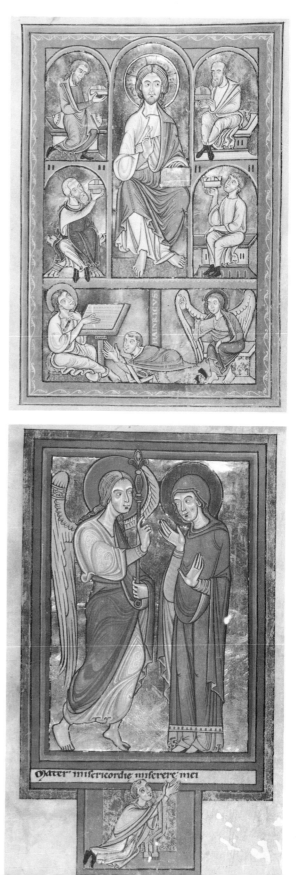

gests that they either influenced its production or show the effects of it. Stylistic comparisons suggest the latter. In contrast to the Berthold Missal's expansive and robust figures, those of the Hainricus manuscript appear delicate and feminine, a quality that did not appear in the earlier work of the Berthold manuscripts (no. 274). Although the Berthold Missal's dynamism seems to have influenced the Hainricus angel of the Annunciation, this miniature is exceptional. Without a definite date for the dedication of the Virgin Chapel or supportive paleographic evidence, a firm dating must remain an open question.

BIBLIOGRAPHY: Swarzenski, 1943; M. Harrsen, *Central European Manuscripts in the Pierpont Morgan Library,* New York, 1958, pl. 27, no. 17, with bibliography; Swarzenski, 1956

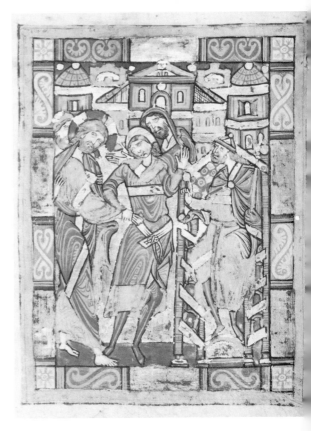

278. Psalter

Southern Germany
1225–1235
Parchment
22.4 x 16 cm. (8⅞ x 6¼ in.)
New York, Coll. H. P. Kraus

Extensively illustrated, the psalter contains a three-part textual division, each part preceded by a series of miniatures that illustrate, not always chronologically, the life of Christ. The cycle also includes five frontispieces, the Wheel of St. George, two Evangelist portraits, and numerous marginal scenes. Miniatures such as the Transfiguration (fol. 9 v.) and the Descent from the Cross (fol. 93 v.) reflect Byzantine iconographic formulas. The style also shows distant Byzantine influences. Fold patterns found in the Berthold Missal (no. 275) are flattened but still fill monumental silhouettes, which, being enlarged and crowded, give the scenes an extraordinary energy and drama.

The psalter is part of a group of manuscripts from the western diocese of Constance (today southern Germany and Switzerland). Bober suggests that the manuscript was made for the usage of St. Blasien and that it was produced in a scrip-

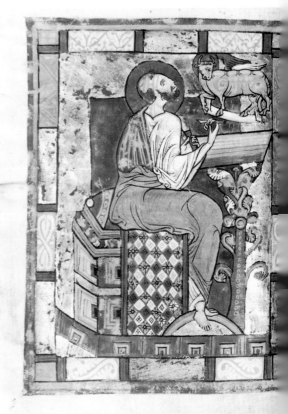

torium there. Irtenkauf, on the other hand, finds the psalter to be of the usage of nearby Bernau and places the two manuscripts most closely comparable to our psalter (Paris, Bibliothèque Nationale, n. a. ms. lat. 187 and Liverpool, City Museum, Ms. 12004) at a third nearby monastery at Ochsenhausen. Although their liturgical destinations remain problematic, all the manuscripts appear to have been influenced by the same scriptorium and (as pointed out by Bober) by an influence from the earlier Engelberg scriptorium.

BIBLIOGRAPHY: Swarzenski, 1936; Swarzenski, 1943; Bober, 1963; W. Irtenkauf, "Über die Herkunft des sogenannten St. Blasien Psalters," *Bibliothek und Wissenschaft,* I, 1964, pp. 23–49; II, 1965, pp. 59–84; Deuchler, 1967, pp. 55, 144

279. Christ in Majesty

Austria, Salzburg
1180–1190
Vellum
29 x 20.6 cm. (11⅜ x 8⅛ in.)
Vienna, Oesterrichische Nationalbibliothek,
Ms. 953

This drawing, dated in earlier literature to the middle of the twelfth century, was compared with the Monreale mosaics and dated not before 1180 by Kitzinger (1966). The vigorous linear rhythm and the sculptural effects of the drapery folds are impressive, while the commanding gesture of Christ's raised right hand and the oblique positioning of the large book on his left thigh add to the figure's dynamic effect. The sideways glance indicates the attention to psychological interpretations characteristic of late twelfth-century Byzantine art. W. Koehler (1943), commenting on the preceding phase of Western art and the adaptation of the "damp-fold" style, refers to the contemporary emphasis on the interaction of body and soul. The wave of the Siculo-Byzantine "dynamic style" (Kitzinger, 1966) may be traced throughout Europe. It is seen not only in the present drawing but in another adaptation of a Maj-

esty, done at about the same time in Regensburg (Boeckler, 1924, pl. XXIV), an imitation of a similar if not the identical model (Demus, 1952). Stylistically, the agitation of our drawing, seen in the position of the eyes, contrasts with the calmness of the Regensburg majesty, which is similar in its mood to treatments in the *Hortus Deliciarum.*

BIBLIOGRAPHY: Swarzenski, 1913, pp. 96, 153, fig. 404; C. Altgraf zu Salm, *Münchener Jahrbuch,* XIII, 1962, pp. 49–62; Krems, 1964, no. 19; Kitzinger, 1966, p. 38 f., fig. 11

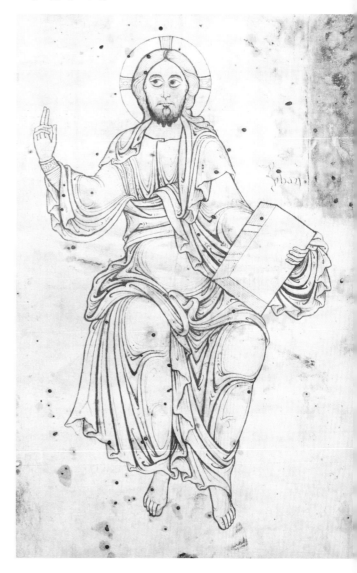

280. Honorius Augustodunensis: Treatises

Austria, Salzburg
1190–1200
Vellum, 150 fols.
26.6 x 18 cm. (10⅜ x 7⅛ in.)
Baltimore, The Walters Art Gallery, Ms. W. 29

The codex contains Honorius' *Expositio super Cantica Canticorum* (fols. 1–220 v.), *Sigillum Sanctae Mariae* (fols. 123–140 v.), and *Neocosmos* (fols. 140 v. to 149 v.). The illustrations consist of an initial and three half-page scenes referring to the allegorical explanation of the Song of Songs. Each of the latter representations is dedicated to one of the brides, who represent, according to Honorius, a different stage in the salvation of mankind as well as one of the cardinal points. On fol. 10 v. an angel brings a message to the crowned and haloed Sponsa orientis (or filia Pharaonic); the iconographical scheme is comparable to that of an Annunciation. On fol. 43 v. the Sponsa orientis (or filia Babylonis), riding on camels, is led by philosophers and followed by apostles and martyrs. On fol. 89 v. Sponsa occidentis (or Sunamitis) rides in the Quadriga Aminadab, whose wheels, according to Ezekiel's vision, contain symbols of the Evangelists, while the trappings of the horses bear the heads of apostles and prophets; compositionally similar to the preceding illustration, the Quadriga is led by the priest Aminadab and followed by Jews. On fol. 103 v. Christ replaces the head of Antichrist on the nude body of Sponsa aquilonis (or Mandragora) with a replica of his own head. Following an Austrian tradition, these illustrations are outline pen drawings in brown, red, and lilac against backgrounds of solid horizontal areas of red, blue, and green. Iconographically, the cycle is noteworthy as an example of twelfth-century allegorical imagery. In the organization of the picture fields there is a survival of mid-century geometry that was adequate to the scholastic spirit of the allegorical commentary (for its position in the tra-

286

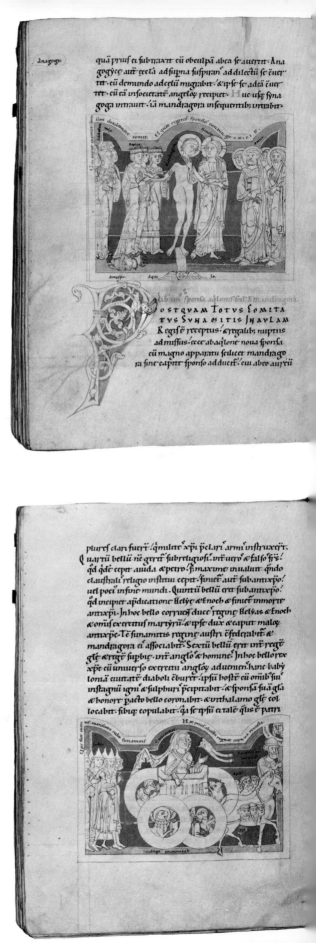

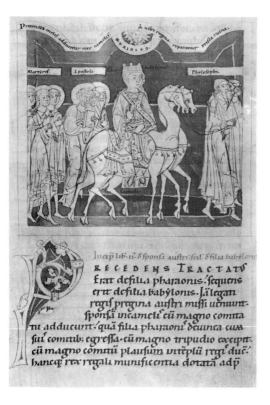

281. Evangelistary

Austria, St. Lambrecht Monastery
1200–1210
Parchment, 157 fols.
26 x 18 cm. (10¼ x 7 1/16 in.)
Graz, Universitätsbibliothek, cod. 185

This codex contains the canon tables and four evangelist portraits, the rectos of which each show scenes from the life of Christ: fol. 13: Nativity, Annunciation to the Shepherds; fol. 53: Adoration of the Magi, Baptism; fol. 83: Crucifixion, Resurrection; fol. 126: Pentecost, Trinity. A deep indebtedness to Byzantine models is evident in both iconography and style. The excellent quality of these models appears most clearly in the head of Christ in the Baptism, which is comparable to other adaptations from Eastern sources in contemporary art, such as those seen in the

dition of Canticum exegesis: F. Ohly, *Hohelied-Studien,* Wiesbaden, 1958). The codex was probably produced in Salzburg, since it compares with Salzburg illuminations of the third quarter of the twelfth century; its origin in Lambach, as suggested by Holter, seems improbable in view of the low quality in other productions of the Lambach scriptorium. The writings of Honorius were popular in Bavaria and Austria at this period, and four more illustrated manuscripts of these treatises are known: Munich, Bayerische Staatsbibliothek, clms. 5118, 4550, 18125; Vienna Nationalbibliothek, cod. lat. 942 (Krems, 1964, no. 20).

BIBLIOGRAPHY: G. Swarzenski, 1913, p. 95, n. 1; H. J. Hermann, *Die deutschen romanischen Handschriften,* Leipzig, 1926, p. 138; de Ricci, I, 1935, p. 821, n. 387; de Ricci, II, 1937, p. 2292; Baltimore, 1949, pp. 12–13, no. 27 (ascribed to Seitenstetten), pl. XVIII; K. Holter, "Die romanische Buchmalerei in Oberösterreich," *Jahrbuch des Oberösterreichischen Musealvereines,* CI, 1956, no. 5

 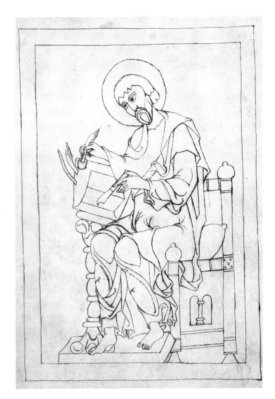

Hortus Deliciarum (Deuchler, 1967, pls. LVIII, LIX). Throughout the codex a tendency to linear mannerisms is apparent in the exaggerated gestures and distorted movements seen especially in the figure of the angel in the Annunciation to the Shepherds (for the wider historical context of this phenomenon, Weisbach, 1942). Technically, the predilection for linear drawing, as opposed to full-scale book illumination, is rooted in the tradition of southern and southeastern scriptoria (Swabia, Regensburg, Salzburg; see also no. 280). The high standard of Austrian drawing in the late twelfth and early thirteenth centuries is documented by such works as Graz UB cod. 1202; compare the Virgin and Child (Unterkircher, fig. 32) with those in the Adoration of our codex, the brilliant Reuner Musterbuch (Krems, 1964, no. 26) and the Millstatt Genesis (Voss, 1962). Compared with these the drawings of our evangelistary are striking in the fewness of the strokes used to articulate the bodies.

BIBLIOGRAPHY: B. Binder, "Spätromanische Federzeichnungen aus St. Lambrecht, Obersteier," *Graphische Kunste*, 6, 1941, pp. 1–6; Unterkircher, 1954, pls. 29–30; Krems, 1964, no. 25; *Die Handschriften der Universitatsbibliothek Graz; bearb. v.a. Kern*, II, 1942, p. 93 f.

282. Missal

Austria
About 1200
Vellum, 287 fols.
27.6 x 16.5 cm. (10⅞ x 6½ in.)
Baltimore, The Walters Art Gallery, W. 33

This volume, containing the summer part of the liturgical year only, was made for a church in upper Austria, following the usage of Melk. Decorated by two full-page miniatures, six historiated, and eleven ornamented initials, the manuscript represents a type of Austrian outline drawing closely connected with the stylistic development of the nearby Salzburg scriptoria. A light coloring in red and lavender appears against a background of pale blue and green. In the gentle flow of outline and the ornamentally conceived combination of floral branches, animals, and human figures, for example in the R initial (Resurrexi et

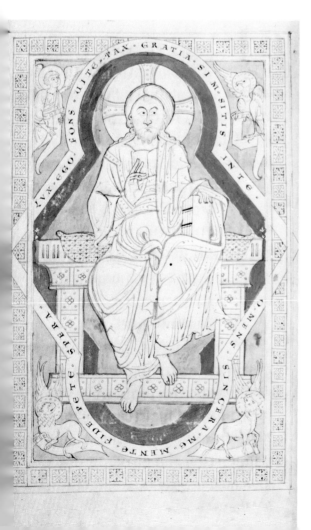

adhuc tecum sum) and in the half-figure of Jonah emerging from the mouth of the whale, one observes a serenity characteristic of the period around 1200.

BIBLIOGRAPHY: Swarzenski, 1913, pp. 153, 165, figs. 406–07; Baltimore, 1949, no. 30, pl. XVIII; K. Holter, "Die romanische Buchmalerei in Oberösterreich," Jahrbuch des Oberösterreichischen Musealvereines, 1956, pp. 221–250

283. Bible (Devil's Bible)

Bohemia
1204–1227
Vellum, 309 fols.
90 x 50 cm. (35⅜ x 19 11/16 in.)
Stockholm, Royal Library, A 148

This book contains the Old Testament and New Testament in a Latin version prior to the Vulgate, as well as Isidore of Seville's *Etymologies,* Josephus' *History of the Jews,* and Cosmas of Prague's *Chronicle of Bohemia.* Written in the Bohemian Benedictine monastery of Podlacize, it is known both as a "codex gigas" (similar to the common designation of a group of contemporary Italian Bibles as "giant Bibles") and as a "Devil's Bible." For this is one of a number of Bibles popularly supposed to have been completed in a single night by a monk who summoned the Devil to help him. A further clue to the name is found in the impressive representation of the Devil on fol. 290 r. The image of the Devil writing in a book was not foreign to medieval artists, as evidenced by the sculpture in Bonn by the Samson Master. At the time our manuscript was produced, book illumination in Bohemia closely depended on scriptoria in adjacent southeastern Germany and Austria (A. Boeckler, "Zur bohemischen Buch-Kunst des 12. Jahrhunderts," *Kunsthistorisk Tidskrift,* 22, 1953, pp. 61–74.

BIBLIOGRAPHY: A. Friedl, *Kodex Gigas. Cesky ilominovary vukopis romansky v Kralovski Vuikovn ve Stockholm,* Stockholm, 1929; Stockholm, 1952, p. 32, no. 27; S. G. Lindberg, "Codex Gigas," *Biblis,* 1957, pp. 9–29

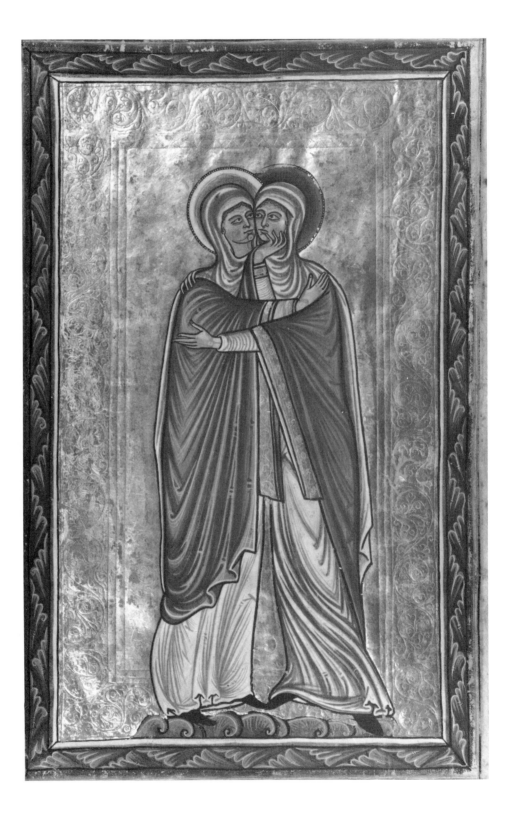

284. Miniatures: scenes from the life of Christ

Germany (?), Anglo-Danish (?), Flemish (?)
Late twelfth century
Vellum
40.7 x 31 cm. (16 x 12¼ in.)
London, British Museum, Cotton Ms.
Caligula A .VII

This incomplete cycle of eight miniatures, depicting the life of Christ from the Annunciation to the Baptism, probably came from a psalter, to which christological cycles were sometimes added in twelfth-century manuscripts. Byzantine influence is seen in the placing of the figures against a background of burnished gold with an overall ornament of fine scrolls and other patterns, as well as in the elongated proportions, details of physiognomy, gesture, and technique. The Annunciation (fol. 3), is comparable to similar scenes in a Helmarshausen manuscript (cod. Helmstedt 65), dated 1194, and its Byzantine prototypes (Weitzmann, 1965, pl. 71). Whereas the pathos in the conception of figures and scenes suggests Eastern inspiration, the elegant linearism of the ornamental patterns reflects Mosan and northern French art (for other Helmarshausen adaptations of such ornamental motifs, nos. 264, 265). Kitzinger used the Visitation page of our cycle as a basis for a general analysis of late twelfth-century illumination, commenting (p. 88): "Even with the double barrier of the architectural system and a consistent ornamentalism figures of the twelfth century often surprise us by a humanity which has been absent in many earlier works. The two Holy Women greeting each other ... have all the qualities of pure ornament, and they stand like pillars in the centre of a sheet of gold. Nevertheless there is real human pathos in the gentleness of their embrace."

BIBLIOGRAPHY: Warner, 1903, pl. XVIII; Pächt, 1961, p. 172, n. 43, Kitzinger, 1964

285. Joachim of Fiore: *Liber Figurarum*

South Italy
1200–1220
Vellum, 14 fols.
33.5 x 28 cm. (13½ x 9 in.)
Oxford, Corpus Christi College, Ms. 255 A

The oldest extant copy of this work by the Calabrese abbot and visionary, this contains, on fols. 222–235, a set of explanatory diagrams pertaining to his major writings, the *Expositio in Apocalypsim, Concordia Veteris et Novi Testamenti,* and *Psaltesrium decem Cordarum.* The manuscript also contains twenty-four full-page illustrations, the only complete version of Joachim's cycle. Some schemata are missing in a slightly earlier copy in Reggio, Emilia (Library of the Episcopal Seminary). The manuscript is important both for its text and pictorial treatment. Despite the highly personal and complex character of Joachim's writing, it represents the type of scholastic schemata that summarized longstanding traditions (Bober, 1956) and also influenced later developments of encyclopedia imagery (Saxl, 1942). One of the main sources of its variegated visual imagery, combining apocalyptic motifs, concordances of Old Testament and New Testament, Trinitarian symbols, and animal allegories, is the encyclopedic interest of the twelfth century; the oft-used scheme of the tree shape, for example, has close precedents in Lambert of St. Omer's *Liber Floridus* and the *Speculum Virginum* (Saxl, 1942; Behling, 1960; Greenhill, 1962). While the illuminations most probably are the work of one artist, the technique and color scheme vary in different parts of the manuscript, changing from the use of black and red ink only to a great wealth of colors. The few tiny heads inserted in the Trinitarian tree on fol. 4, as well as the freely intertwining floral ornament throughout the codex, suggest the date given above. The manuscript is the closest approximation of the archetype written around the turn of the century. The striking Gothic styliza-

tion in the pair of trees on fol. 5, clearly indicating the influence of a northern scriptorium, prompted the assumption of a French origin (Saxl). French connections are, however, demonstrable in contemporary Sicilian book illumination (no. 286), and a southern Italian provenance, close to Joachim himself, is more persuasive.

BIBLIOGRAPHY: M. W. Bloomfield, "Joachim of Fiora. A critical survey of his canon teachings, sources, biography and influence," *Traditio,* XIII, 1957, pp. 249–311

286. New Testament

Sicily
1200–1225
Parchment
24.5 x 15.5 cm. (9⅝ x 6⅛ in.)
New York, Coll. H. P. Kraus

In this manuscript the calendar feasts are particular to the chapel of the Lateran in Rome, the papal residence at this time. The text contains several historiated initials and a full-page miniature inserted between the Book of the Apocalypse and the *Constituta Romanum Pontificum,* a series of notes on early church history drawn chiefly from the *Liber Pontificalis.* The inserted leaf, which originally preceded Acts, shows the Crucifixion in the upper register, the Descent into Hell in the lower. The broad ornamental frame includes four corner roundels of the evangelists writing and two side roundels of figures holding Old Testament predictions of the Harrowing of Hell. Although this manuscript was destined for Roman usage and displays early Italianate elements (compare the crucifixion in the Pierpont Morgan Library, Ms. 379, fol. 6; Garrison, fig. 118) circumstantial evidence points to a Sicilian origin. The provincial, Byzantinizing style of our manuscript recurs in a Madrid Bible (Biblioteca Nacional, Ms. 217 A 49) once in the collection formed by the fourth duke of Uceda from con-

fiscated Sicilian libraries in Messina and elsewhere. A sacramentary in the Vatican Library (Fondo S. Pietro F. 18) likewise combines a Sicilian style with a calendar of papal usage; neither this manuscript nor the one exhibited shows paleographic or stylistic similarities to known Roman manuscripts. The ornamental style of the Madrid and Vatican manuscripts is typical of late twelfth-century Sicilian work, whereas our codex is decorated with northern European motifs. In the horizontal border of the miniature and in almost all the initials a sharply defined floral interlace curls out from regular nodal points and twines firmly around a trellis— a late English Romanesque form that had spread throughout northern Europe by 1200. Four manuscripts with this type of ornament form part of the same Uceda legacy to the Madrid library (Mss. 206, 216, 218, 253), suggesting the existence of a scriptorium influenced by northern art and under the patronage of the pope who was overlord of Sicily after 1216.

BIBLIOGRAPHY: Swarzenski, 1943, p. 58; Buchthal, 1955; Garrison, 1962, IV, p. 441 f.; Lattanzi, 1966, p. 46 f.

287. *Beatus* of Liebana, Commentary on the Apocalypse

Spain, Burgos
1220
Parchment
36.4 x 52 cm. (14⅛ x 20½ in.)
New York, The Pierpont Morgan Library,
Ms. M. 429

According to an inscription, this manuscript was made at the royal Cistercian convent of Las Huelgas near Burgos for a lady donor, that "God may save her from her present tribulations." It was copied after another manuscript painted in 970 in San Salvadore de Tavara (Madrid, Archivo Historico Nacional, cod. 1240). The donor may have been Berenguela, Queen of Castile, whose

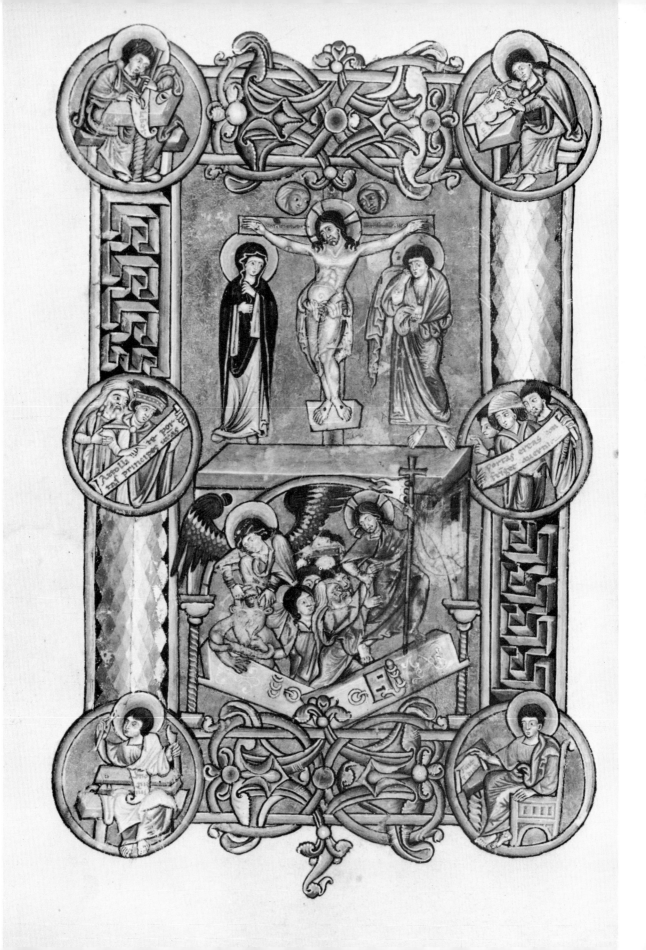

father, Alfonso VIII, built the convent where she was buried in 1246. The manuscript contains a series of full-page miniatures arranged in pairs. The first of each depicts an evangelist presenting his gospel to a second figure; the second represents two angels with the Gospel book. The portrait tradition of the Evangelists with witnesses has been traced to Byzantine sources, perhaps of pre-Iconoclastic origin; the type may have come to the *Beatus* text from an illustrated gospel of the tenth century (Williams). The main group of miniatures illustrates the Apocalypse text, particularly the calamitous events after the opening of each of the Seven Seals. They lack the horrific content of later English Apocalypses, but the coloristic effects of these nearly mural-size paintings—horizontally banded in bright, sharp areas of red, orange, yellow, and green—create in

other ways a sense of the prodigious and fabulous. Late twelfth-century French influence can be seen in the figure style, seen also in the *Liber feudorum Major* (Barcelona, Archives of the Crown of Aragon), where the architectural settings are similar to those in the Evangelists portraits of the present manuscript. The figure facing Matthew (fol. 2) indicates, in the tension of its drapery as it shifts its weight, contact with French art around 1200 such as the sculpture at Laon (no. 10). A still more contemporary influence may have come from England; the scene of the Adoration of the Magi may be compared with that of no. 261.

BIBLIOGRAPHY: New York, 1934, no. 64; P. Bohigas, "La Ilustración y la Decoración del libro manuscrito en Cataluña," *Periodo Romanico,* Barcelona, 1960, I, p. 103; J. W. Williams, "A Castilian Tradition of Bible Illustration," *Journal of the Warburg and Courtauld Institutes,* XXVIII, 1965, pp. 66–85

288. Four Gospels

Cilicia, Poghoskan Monastery
1193
Parchment, 316 leaves, 2 cols., 19–21 lines
26 x 18 cm. (10¼ x 7 1/16 in.)
Baltimore, The Walters Art Gallery, Ms. 528

The manuscript contains elaborately ornamented interlace initials, the letter of Eusebius, and canon tables set in flat arcades surmounted by rectangular pediments. The fragmentary colophon on fols. 311 and 313 states that the manuscript was made in the Poghoskan monastery in 1193 for Bishop Karapet and describes Saladin's advances in the Middle East and Frederick Barbarossa's death in the Third Crusade. The manuscript is closely related to two similarly decorated gospels at Venice and Lwow, written and illustrated in 1193 and 1197–1198 in the diocese of Hromkla in Cilicia (Der Nersessian, 1936, p. 50 f.). The present gospels are imaginatively decorated with multicolored birds, trees, floral, and geometric ornament, characteristic of Armenian illumination of the period. The decoration relies in part on earlier illumination from Greater Armenia (Der Nersessian, 1936) and a type of ornament traditional in earlier Byzantine and Eastern art. The position of the addossed birds on the capitals of fol. 8 v. and the geometric abstraction of their feathers derive from Moslem and Byzantine textiles (Falke, 1922, figs. 116–117, 122, 164, 182); they also recall earlier Byzantine capitals and other architectural ornaments (L. Bégulé, E. Bertaux, *Les chapiteaux byzantins à figures d'animaux,* Caen, 1911; R. M. Harrison, N. Firatle, "Excavations at Saraçhane in Istanbul," *Dumbarton Oaks Papers,* XX, 1966, figs. 6–8; Grabar, 1951). The rich, carpetlike decoration of the canon table pediments, also characteristic of Armenian architectural sculpture (Strzygowski, 1918, II, p. 524 f.), resembles the embellishment of architectural motifs in many Byzantine twelfth-century manuscripts (*Homilies of Gregory Nazianus,* Paris, B. N. ms. gr. 550, Paris, 1958, no. 40; *Homilies of Jacob Kokkinobaphos,* Stornajuolo, 1910). Other pages in the manuscript contain perspec-

tive geometric friezes derived from antique sources, probably via ninth- and tenth-century works (Weitzmann, 1935, pp. 6, 8 f., 26; Frantz, 1934; C. Nordenfalk, *Die Spätantiken Kanontafeln,* I, II, Göteborg, 1938). The border of crenelated half-lozenges is characteristic of late twelfth- and early thirteenth-century Byzantine manuscripts (no. 293).

BIBLIOGRAPHY: de Ricci, 1935, I, p. 761, no. 2; Der Nersessian, 1936; Baltimore, 1947, no. 747; S. Der Nersessian, *Armenian Illuminated manuscripts in The Walters Art Gallery,* no. 2 (in preparation)

289. Four Gospels

Constantinople
1200–1220
Parchment, 309 leaves, 1 col., 18 lines
18.7 x 13.3 cm. (7¼ x 5 in.)
New York, The Pierpont Morgan Library,
 Ms. 340

The manuscript contains three standing Evangelist portraits: St. Matthew (fol. 5 v.), St. Mark

(fol. 89 v.), and St. Luke (fol. 145 v.). Matthew and Luke are portrayed in three-quarter view, turning right, holding an open codex in their left hands and indicating with the pen in their right hands the first words of their gospels. St. Mark stands frontally holding out his open book to the right and raising his right hand with his pen over his chest. A narrow blue band decorated with palmettes along the outer sides frames the figures.

The standing type of Evangelist portrait derives from portrayals of ancient authors created for the illustration of scrolls where the slender format of the figures suited the columnar arrangement of the text (Friend, 1927, p. 129 f.; Weitzmann, 1947, p. 77 f.). The Evangelists' presentation of their books to the right may come from an early composition of the four Evangelists arranged on the verso of one page facing Christ on the recto of the opposite page (Rome, Vatican,

Ms. gr. 756, Friend, 1927, figs. 84–85, p. 133; Buchthal, 1957, pls. 40, 142).

The himation and chiton, draped loosely over the bodies of the Evangelists and articulated by broad highlighting, gives them the heavy, wide form characteristic of early thirteenth-century figures (the Crucifixion at Studenica, II, ill. 248; Millet-Frolow, I, pls. 31–47; Demus, 1958, p. 24 f.). The cloth gives the impression of being made of a stiff material, especially where the himation falls in cardboard-like folds over the left arms. A slightly earlier example of this style occurs in the standing Evangelists and apostles in a Gospel book in the Vatican (cod. gr. 1208; II, ill. 258; Weitzmann, 1944, p. 208 f.) in which, although the drapery adheres more to the surface of the body, the mass of material wrapped around the waists and the cascades of stiff drapery over the shoulders resemble the costuming of the present figures. St. Mark in a gospel of the Philotheu monastery at Mt. Athos (cod. 5; II, ill. 261; Weitzmann, 1944, p. 205 f.) is contemporary with our miniatures. The distribution of his drapery, in a thick gather about his waist, is similar in both codices. The swag of drapery arching from the small house to the lectern is very similar to the himation of the present Evangelists. In light of this, the exhibited gospels may be attributed to a Constantinopolitan workshop at the beginning of the period of the Latin occupation.

BIBLIOGRAPHY: de Ricci, 1935, II, pp. 1429–30; New York, 1934, no. 61; Clark, 1937, p. 149 f.; Baltimore, 1947, no. 72

290. New Testament

Constantinople
1200–1220
Parchment, 352 leaves, 1 col., 36 lines
16 x 11.3 cm. (6¼ x 4⅜ in.)
Baltimore, The Walters Art Gallery, Ms. 525

The manuscript contains portraits of the four Evangelists (fols. 10 r., 57 r., 88 r., 139 v.), seated, writing their gospels on books, or in one case (Mark) on a scroll. There is no architectural

background and the furniture is merely outlined in black on the gold ground. A wash of paint across the bottom of the miniatures serves as groundline. Two of the figures (Matthew and Luke) have been repainted.

The compositional scheme of the seated Evangelist derives from antique representations of seated philosophers, whose position in profile or three-quarter view suited the wide format of the square book page (Friend, 1927, pp. 134 f., 141 f., figs. 155 f.). The younger Evangelists, Mark and Luke, generally were portrayed applying themselves actively to their tasks, while John and Matthew were shown in a more contemplative approach. These portrayals were, however, interchangeable, and in the present manuscript Matthew writes while Luke pauses in his work. The lack of background architecture—it is usually present in seated Evangelist portraits—may be due to the influence of the empty backgrounds of standing Evangelist illustrations. The outlining

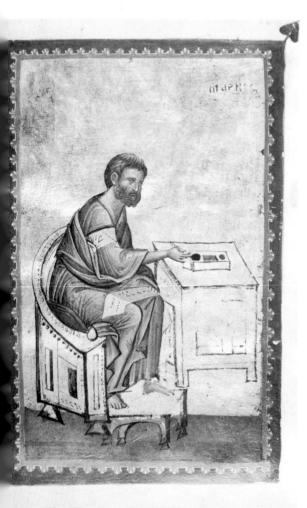

of the furniture may correspond to the etching of the architectural setting on the gold backgrounds of some tenth- and eleventh-century manuscripts (Friend, pp. 135–136, figs. 99–106). The portrait of St. John closely resembles that of St. Luke in a Gospel book in Venice (Biblioteca Marciana, Ms. 541) which may have been a later product of the same workshop. The frames of the miniatures are identical and the furniture is indicated in the same abbreviated fashion. John's himation in the present manuscript falls in a roll of material down his back and ends in flat pointed folds between his legs in the same way as Luke's in the Venice manuscript (H. Pierce, R. Tyler, *Byzantine Art,* London, 1926, pl. 90). The high crown of Luke's head and the deep shadow of his cheeks in both manuscripts indicate knowledge of Constantinopolitan work of the early thirteenth century, such as the apostle miniatures in a Gospel book in the Vatican (cod. gr. 1208; Weitzmann, 1944, p. 205 f.; II, ill. 261); the Vatican miniatures also have similar frames. The drapery of Matthew and Mark in the present manuscript also resembles that of early thirteenth-century manuscripts, for example the Philotheu gospels (Weitzmann, 1944, p. 205 f.; II, ill. 261) and no. 289.

BIBLIOGRAPHY: de Ricci, 1935, I, p. 759, no. 10; Clark, 1937, pp. 252–255; Boston, 1940, no. 9; Baltimore, 1947, no. 723

291. New Testament

Constantinople
Before 1219
Parchment, 241 leaves, 1 col., 21 lines
22.4 x 16 cm. (8⅞ x 6¼ in.)
Berlin, Staatsbibliothek, cod. gr. quarto 66 q.

The manuscript contains thirty-three illustrations of the text, five Evangelist portraits (St. Matthew, fol. 5 v., and St. John, fol. 262 v. are interleaved from a slightly earlier manuscript; Mark is missing), marginal figures, decorative canon tables, and headpieces. A contemporary Arabic inscription on fol. 2 r. records the gift of

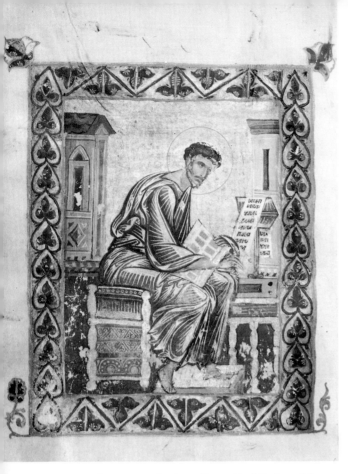

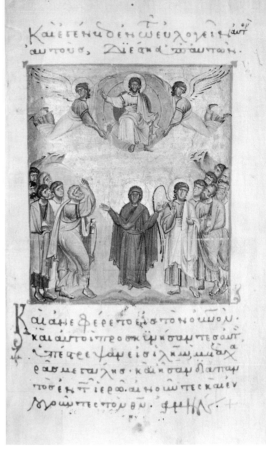

the manuscript by a Copt, Abul-Badr, to his son, the deacon Sayyid-ad-Dar, in 1219. A later colophon indicates that the manuscript belonged to a church of the Koimesis, perhaps that of the monastery of Mega Spelaion near Kalabryta in Peloponnesus (Hamann-MacLean, p. 244 f.).

The manuscript's importance depends in part on its wealth of illustrations, including such detailed textual illustrations as Moses receiving the Law (fol. 264 v.) and the Two Marys at the Tomb (fol. 96 r.), and in part on the unusual combination of Early Christian and Byzantine iconographic motifs. The illustrations also reveal a variety of iconographic and stylistic ideas, some retrospective, some contemporary, some anticipating the Palaeologan style. The Ascension and Deposition (fol. 261 r., 256 v.) derive their monumental compositions from church decoration, a practice seen in ninth-century manuscripts (Weitzmann, 1955), while the mourning Peter or the Washing of the Feet (fols. 251 r., 314 r.) are in the narrative tradition of illustrative texts. Stylistically, Gabriel and Mary of the Annun-

ciation (fol. 165 r.) also adhere to the earlier formula of a late Comnenian icon of the Annunciation from Mt. Sinai and the frescoes at Kurbinovo (Weitzmann, 1965; Hamann-MacLean, p. 232 f.). The Evangelist portraits in their slender, elongated form, and splintered gold drapery highlights, are more typical of a group of contemporary manuscripts of the second decade of the thirteenth century (Krakau, Ms. gr. Czartoryski, 1801; Osieczkowska, 1940; Hamann-MacLean, p. 233 f.), as are the small, active figures of the narrative illustrations (the Washing of the Feet, fol. 314 r.; compare a New Testament, British Museum, Harley Ms. 4, the Mt. Athos Dionysiou, Hamann-MacLean, p. 234, and the Annunciation at Kurbinovo). The Entry into Jerusalem (fol. 65 v.), on the other hand, which itself combines two scenes, the bringing of the ass and the foal to Christ and the Entry, includes not only the prophet Zacharias, who was thought to predict the event but also numerous children and adults welcoming Christ to the city. Such genre elements foreshadow the populated scenes

of Palaeologan cycles, for example the Multiplication of the Loaves in the mosaics of the Kariye Djami in Istanbul (Underwood, 1966, no. 118). Similarly, the sweeping drapery and smooth, full forms of Thomas in the Doubting of Thomas (fol. 336 v.) or Peter and Paul in the Ascension look forward to the stylistic mode that reached its full maturity in the frescoes at Sopocani in 1265 (Millet-Frolow, II, pls. 1–48).

BIBLIOGRAPHY: C. De Boor, *Verzeichnis der griechischen Handschriften der Königlichen Bibliothek zu Berlin,* II, Berlin, 1897, no. 368; Millet, 1916; Paris, 1931, no. 650; Colwell-Willoughby; Goodspeed-Riddle-Willoughby; J. J. Tikkanen, 1933; Athens, 1964, no. 323; R. Hamann-MacLean, 1967

292. Gospels of Luke and John

Byzantium
1220–1240
22.5 x 17 cm. (8 1/16 x 6¾ in.)
Vellum, 253 leaves, 1 col., 18 lines
New York, Coll. H. P. Kraus

Author portraits occur on fols. 4 v. and 150 v. The evangelists sit on a cushioned wooden stool in front of a small two-story building and lean forward to dip their pens in the inkwells on the desks at their left. In their laps they hold the open codex or scroll on which they will copy their gospels. The wide frames are decorated with trefoils in rondels or rinceaux and, along the bottom, with small quatrefoils and trefoils. Although St. John is painted on a leaf inserted into a complete quire of the manuscript, his page was probably originally part of the decoration. His himation, however, has been retouched with gray-green paint.

The evangelists conform to the types of Byzantine iconography, except that John is usually a more contemplative figure (no. 290; Friend, 1927, p. 134 f.). The style of the two portraits, however, is distinctive. St. John's carefully delineated, elaborate drapery folds and rippling hemline suggest a derivation from late Comnenian art (frescoes at Kurbinovo, Weitzmann, 1966). A later, more fancifully exaggerated ex-

ample of the style of his portrait may be seen in the St. Luke of a Gospel book in Baltimore (The Walters Art Gallery, Ms. 528; Demus, 1960, fig. 2). Luke's drapery, on the other hand, covers the body in smoother, softer folds, that flow over his back, around his waist, and fall to his ankles. The elongation of his body and the drapery wrapped around his thigh may derive from the type of the evangelist of St. Luke in a late twelfth-century lectionary in Athens (National Library, Ms. 2645, fol. 67 v.; Athens, 1966, no. 738). It is possible that the type was inspired through the study of such tenth-century Byzantine manuscripts as the gospels in the Stauronikita monastery on Mt. Athos (Ms. 43, Friend, 1927, fig. 97). Some uncertainty in the technique of the two figures in the present manuscript, seen especially in the painting of St. Luke's face, suggests their production outside the most advanced workshops of Constantinople in the third or fourth decade of the thirteenth century.

BIBLIOGRAPHY: G. Warner, *Descriptive Catalogue of Illuminated Manuscripts in the Library of C. W. Dyson Perrins,* Oxford, 1920, I, p. 309, no. 131; H. P. Kraus, *Medieval and Renaissance Manuscripts, Catalogue 117,* New York, 1967, no. 1

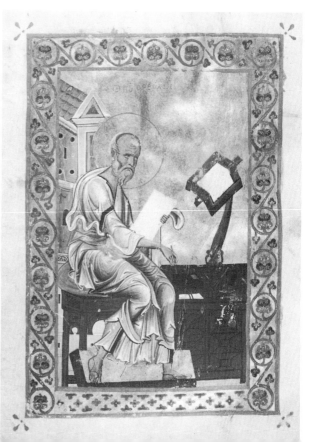

293. Book of Prophets

Byzantium, Constantinople
1220–1240
Parchment, 233 pages, 1 col., 45–46 lines
30 x 20.5 cm. (11¾ x 8 1/16 in.)
Oxford, New College, Ms. 44

This manuscript contains eighteen portraits of standing prophets, the majority portrayed as nimbed half-figures looking out at the beholder, holding a furled scroll in their left hand and raising their right in blessing. Frames, decorated with crenelated half-lozenges, appear only on the lateral sides. The type of standing prophet portrait, like that of the standing Evangelist, derives from antique scroll decoration (no. 289; Friend, 1927, p. 128 f.). An early series of standing prophets occurs in a Syriac manuscript of the seventh or eighth century (H. Omont, "Peintures de l'Ancien Testament dans un manuscrit Syriaque du VIIᵉ ou du VIIIᵉ siècle," *Monuments Piot,* XVII, 1909, pp. 85–98) and as full-page miniatures in a book of the prophets in the Vatican (cod. Chis. R. VIII. 54), where the prophets hold open scrolls inscribed with their prophecies (A. Muñoz, *I codici greci miniati delle minori biblioteche di Roma,* Florence, 1905; Weitzmann, 1935, p. 12 f.; Weitzmann, 1947, p. 104 f.). A mid-thirteenth-century commentary on the Psalms in Istanbul (Serail, Ms. 13) contains a series of half-figure prophets very like those in the present manuscript (A. Muñoz, "Tre codici miniati della Biblioteca del Seraglio a Costantinopoli," *Studi Bizantini e Neoellenici,* I, 1924, pp. 202–205; Hamann-Mac-Lean, p. 237 f.). Standing figures of prophets also appear frequently in monumental art in groups or individually in their role as forecasters of the events of Christ's life pictured on the walls around them (Daphni; Diez-Demus, figs. 54–63).

The halos and the gesture of blessing of the prophets in the present manuscript reflect their assimilation as Christian saints. The prophets resemble those of the Istanbul Psalm Commentary not only iconographically but also stylistically. Jeremiah's himation (fol. 68) falls in the same flat fold over the chest, the same angular bands over the right arm, and the same rolls of material over the foreshortened left arm as that of Jesajas in the Istanbul Commentary (Hamann-MacLean, fig. 39). A similar treatment of the himation can be seen in the frescoes at Zica (1219–1235) and Sopocani (about 1256) (Millet-Frolow, I, pl. 162; Millet-Frolow, II, pl. 4). The exhibited manuscript, however, is probably somewhat earlier than the Istanbul Commentary, which has been dated around the middle of the thirteenth century. The faces of such figures as Baruch (fol. 106 v.) resemble the apostles in the Washing of the Feet in the Berlin New Testament (no. 291). The figures also are less imposing in the smaller space alloted to them, and the crenelated half-lozenges of the unusual lateral frame, which is characteristic of the present manuscript and the Istanbul manuscript (Buchthal, 1957, p. 11) are simpler and more rectilinear.

BIBLIOGRAPHY: O. Pächt, *Byzantine Illumination,* Oxford, 1952; *Bodleian Library, Greek Manuscripts, Catalogue of an Exhibition,* Oxford, 1966, no. 82; Hamann-MacLean, 1967

THE BOOK BY ANDREW WATSON

The intention of this part of the exhibition is to indicate the principal intellectual interests of the period around 1200 by showing several types of manuscripts that were written then. The interest and importance of the period lie in the extent, variety, and depth of the intellectual changes that were taking place. Limited in scope though this group of works is, it confirms the aptness of the phrase "twelfth-century renaissance" for the years around 1200. In western Europe a bridge was then being built back across the centuries to recover the knowledge of the ancient world. Some of the manuscripts shown here represent this recovery; others represent medieval adaptations of ancient works. In Latin and in the vernacular, drama was beginning to free itself from the church services in which it had originated and was starting on an independent existence in churchyard and street. Lyric poetry was being written in Latin and several vernaculars, much of it of a freshness and beauty that has an eternal appeal, and many other types of literature flourished. This age saw the peak of development of the great cathedral schools of northern France and the birth of the earliest universities, the recovery of a great part of the writings of Aristotle, the codification of common law, the recovery of lost parts of Roman law, and the arrival of Arabic science in the West. Different aspects of this renaissance developed, of course, at different speeds and no chronological bounds can be set. The years around 1200 saw some of the developments completed and others with some way yet to go. In the history of Western civilization they are years equally full of achievement and promise.

I The Survival of the Latin Classics

294. Florilegium Gallicum

France
13th century
Paris, Bibliothèque Nationale, ms. lat. 17903

The Middle Ages depended greatly on anthologies as a help in coping with classical literature, some of which survived adequately in manuscripts, but not always accessibly. The principal florilegia (anthologies) originated in France, probably in the north, perhaps in the twelfth century, from which period comes the earliest known example. Authors who drew from these works often give an impression of great learning and of having used the resources of a large library. An example is Vincent of Beauvais, the thirteenth-century encyclopedist. Vincent cites about 450 authors, but it has been shown that much of his quotation comes from the *Florilegium Gallicum,* which contains all the well-known classical Latin writers as well as Petronius, Calpurnius, Nemesianus, Boethius, Martianus Capella, Priscian, and others.

BIBLIOGRAPHY: B. L. Ullman, "Tibullus in the Mediaeval *Florilegia*," *Classical Philology,* XXIV, 1929, pp. 128–362; B. L. Ullman, "Petronius in the Mediaeval *Florilegia*," *Classical Philology,* XXV, 1930, pp. 11–127; B. L. Ullman, "Classical Authors in Mediaeval *Florilegia*," *Classical Philology,* XXVII, 1932, pp. 1–50; A. Gagner, *Florilegium Gallicum: Untersuchungen und Texte zur Geschichte der mittelateinischen Florilegienliteratur,* Lund, 1936

II *Contemporary Latin Literature*

295. Play of the Magi

France, Strasbourg
Late 12th century
London, British Museum, Ms. Add. 23922

Medieval drama grew out of the liturgy of the church. A ninth-century manuscript, probably of St. Gall, provides a trope containing four lines of dialogue beween the angels and the Marys visiting the tomb of Christ; this trope has been called the earliest germ of religious drama. By the twelfth century elaborate liturgical plays for Easter, Christmas, and Epiphany had developed. The present manuscript contains one of several versions of a play, based on the Gospel of St. Matthew, chapter 2, in which the Magi come to Jerusalem seeking the infant Christ. It has parts for the Magi, Herod, an armed man, shepherds, and others, and music is provided for the words.

BIBLIOGRAPHY: A. Wilmart, *L'ancien cantatorium de l'Eglise de Strasbourg du Musée Britannique,* Colmar, 1928; K. Young, *The Drama of the Medieval Church,* Oxford, 1933, II, pp. 64–68, pl. XV

296. Secular lyric poetry

England
Early 13th century
Oxford, Bodleian Library, Ms. Add. A. 44

The twelfth and thirteenth centuries were one of the great periods of religious and also secular lyric verse. The latter, the work of wandering scholars—Goliards, vagantes—circulated widely. It often parodied sacred poems, and the Church was scandalized by its themes of wine, women, and song. The principal collection of this poetry is the *Carmina Burana* (II, ills. 207–209). The present anthology (once owned by Thomas Bekynton, bishop of Bath and Wells, 1443–1465), when open at folios 71 v.–72 r., shows on the left a drinking song beginning "O potores exquisiti / licet sitis sine siti..."

BIBLIOGRAPHY: A. Wilmart, "Le *Florilege* mixte de Thomas Bekynton," *Medieval and Renaissance Studies,* I, 1943, pp. 41–84

297. Matthieu de Vendôme, *Ars Versificatoria* Geoffroy de Vinsauf, *Poetria Nova*

England (?)
Early 13th century
Glasgow, University Library, Hunterian Ms. 511

Late in the twelfth century and early in the thirteenth several works on the art of poetry appeared, the majority in Orléans or Paris, based on Cicero's *De Inventione Rhetorica* and Horace's *Ars Poetica*. The two most important ones are found in this manuscript. Matthieu de Vendôme's

prose *Ars Versificatoria,* written about 1175, and Geoffroy de Vinsauf's *Poetria Nova,* probably written between 1208 and 1213, deal with similar subjects, among them how to begin one's poem, faults to avoid, figures of speech, and amplification and abbreviation of subject matter. Matthieu's treatise quotes freely from Horace, Ovid, Statius, Lucan, Cato, Claudian, Juvenal, and Prudentius. Geoffroy's work, soon itself the subject of expository commentaries, was known as the *Poetria Nova* to distinguish it from the *Poetria Vetus* of Horace.

BIBLIOGRAPHY: E. Faral, *Les arts poétiques du xii^e et du xiii^e siècle,* Paris, 1924

298. John of Salisbury, *Policraticus*

England, Malmesbury
1187–1205
Oxford, Bodleian Library, Ms. Barlow 6

John of Salisbury, who was born in Salisbury and studied in Paris and Chartres, has been called the finest representative of the harmonious and balanced type of culture in which both literature and logic had their place. An elegant Latinist, he was unrivaled by any contemporary in the range of his classical reading, and to this he added an extensive knowledge of the Bible and the Latin fathers. This manuscript contains one of his chief works, the *Policraticus (Statesman's Guide),* which deals partly with church and state, partly with learning in general. At the end of the manuscript is a statement that it was written by one Solomon in the time of Abbot Robert II of Malmesbury, hence the dating given above. The exhibited initial, showing sailors in a ship, refers to the opening words of chapter VIII, "Solent qui mare enavigant illis habere gratiam et referre quorum beneficium pericula evaserunt."

BIBLIOGRAPHY: C. C. J. Webb, *Ioannes Saresburiensis Episcopi Carnotensis Policraticus,* Oxford, 1909

299. Radulphus de Diceto, *Abbreviationes Chronicorum, Ymagines Historiarum*

England, London
About 1200
London, Lambeth Palace Library, Ms. 8

The twelfth century's interest in historical writing reveals little influence of classical historians, even though Livy, Caesar, Sallust, and Suetonius were known. The philosophical content of its history derived from St. Augustine, and its chronology from Eusebius of Caesarea. In the latter, classical and Old Testament systems were reconciled and from this there developed the chronicle or universal history, extending from Adam through Noah and Abraham to Christ, each chronicle being based on existing ones and becoming original only when the writer reached his own time. Nota-

ble chroniclers of the twelfth century were, in Germany, Otto of Freising, in France, Robert of Torigni and Ordericus Vitalis, in England, William of Newburgh (about 1198), Roger of Hoveden (about 1200), Joscelyn of Brakelonde (1173–1202), and the author of the present work, also known as Ralph of Diss (in Norfolk), dean of St. Paul's cathedral, London, from 1180 or 1181 to about 1200. On this manuscript, written after the last date in the chronicle, 1198, is a fifteenth-century inscription indicating that the book belonged to St. Paul's. Probably it was written there and presented to or left to the cathedral by the author himself. One of several fine copies of the work, it is written in an advanced proto-Gothic script with a number of Gothic elements.

BIBLIOGRAPHY: *The Historical Works of Master Ralph de Diceto,* Rolls Series, London, 1876

III *Vernacular Literature*

300. Homilies in early Middle English

England
Late 12th century
London, Lambeth Palace Library, Ms. 487

The twenty sermons in this manuscript, perhaps written in the West Midlands, perhaps in the London area, are based in part on pre-Norman Conquest English material. Although some of them may be post-Conquest in origin, all are entirely in the Old English homiletic tradition. What the manuscript demonstrates is the continuance of this tradition into the period when French influences, introduced by the Anglo-Norman ruling class, were beginning a process of refreshing and softening. The change from Old English to Middle English—seen here in an early

stage—took place in the twelfth century, at the very end of which the spirit in England was forward-looking, as it was in other parts of Europe.

BIBLIOGRAPHY: R. Morris, *Old English Homilies,* Early English Text Society, 1st ser., 34, London, 1868

IV *Laws*

301. The "Frankfurt" collection of decretals

England (?)
Late 12th century
London, British Museum, Egerton Ms. 2901

After the publication of Gratian's *Decretum,* about 1140, canon lawyers turned to expounding on it, and notable schools of decretalists arose in England and on the Continent, especially in Bologna. Canon law continued to grow in quantity as a result of new legislation, and during and after the pontificate of Alexander III (1159–1181) many of his decretals (letters having the force of law within the papal jurisdiction) were formed into collections. Collections from various parts of Europe can be distinguished. The present manuscript is one of three that contain the "Frankfurt" collection, which probably originated in Germany. A seventeenth-century inscription on fol. 1 indicates that the manuscript then belonged to the Benedictine Abbey of St. Maximin in Trier, but if it was not written in England, some of its glosses and additions, which are perhaps the work of professional canonists, indicate that it was in England in the thirteenth century. The exhibited pages deal with betrothal and marriage.

BIBLIOGRAPHY: C. Duggan, *Twelfth-century Decretal collections and their importance in English history,* London, 1963

302. Treatise on the laws and customs of England ("Glanville")

England
About 1200
Oxford, Balliol College, Ms. 350

The twelfth-century revival of jurisprudence showed itself not only in Roman and canon law but in feudal or common law, which was influenced by Roman law and was subjected to a process of codification. The earliest monuments of feudal law date from the eleventh century; the twelfth century saw the growth of maritime and commercial law and the written law of the Italian city-states. The work shown here, the treatise on English law usually ascribed to Ranulf Glanville, Justiciar of England, but perhaps written by a lesser member of the king's household, dates from between 1187 and 1189. The first textbook of the English common law, the law of the king's court common to all free men, it is concerned mainly with civil litigation before the royal justices. Used as a source by Bracton, an English lawyer of the thirteenth century, it was eventually outdated by Bracton's work and went out of fashion, not to be rediscovered until the sixteenth century. The treatise, at the beginning of Book VII, on marriage portions, deals with a wife's rights. According to G. D. G. Hall, "The courage and mastery which produced Glanvill's Book VII are unsurpassed in our legal history."

BIBLIOGRAPHY: G. D. G. Hall, *The Treatise on the Laws and Customs of England Commonly Called Glanvill,* London-Edinburgh, 1965; R. W. Southern, "A note on the text of 'Glanville' 'De legibus et consuetudinibus regni Angliae'," *English Historical Review,* LXV, 1950, pp. 81–89

V *Philosophy and Science*

The twelfth and thirteenth centuries mark a turning point in these disciplines. The philosophy and science of Aristotle, hitherto known only in fragments, were almost fully recovered, there was a revival of Platonism, and the dialectical methods of Abelard, Gratian, and Peter Lombard laid the foundations for the great philosophers of the following century. Of Aristotle's works the early Middle Ages knew only parts of the *Organon* in the translation of Boethius. The rest was recovered by enterprising scholars who sought out Greek and Arabic versions and translated them into Latin. The chief centers for the diffusion of this new knowledge were Sicily and Spain, especially Toledo. By the end of the twelfth century almost all of Aristotle's

scientific works and all the *New Logic* were known, soon to be followed by the more difficult *Metaphysics,* and, about 1260–1270, by the rest of the corpus, the ethical, political, and literary works. In addition, numerous translations of mathematical, medical, astronomical, astrological, and philosophical works by other writers had appeared. One translator, Gerard of Cremona, who died in Toledo in 1187, appears to have translated over seventy works, including Euclid's *Elements,* Ptolemy's *Almagest,* Aristotle's *Posterior Analytics,* and medical works ascribed to Galen and Hippocrates.

303. Works of Aristotle

France (?)
Early 13th century
Glasgow, University Library, Hunterian M. 292

The most important element in the transformation of European thought in the mid-twelfth century was the arrival of Aristotle's *New Logic,* the *Analytica priora, Analytica posteriora,* the *Topica,* and the *De elenchis sophisticis,* all concerned with syllogisms, methods for argument, propositions, and the detection of fallacies. Of these the last two and probably the first were rediscovered in the translation of Boethius, but the *Analytica posteriora* appeared in several translations. That of Gerard of Cremona eventually became standard. In the present manuscript the translation is that of James of Venice, while the translation of the *Priora* is that of Boethius.

BIBLIOGRAPHY: L. Minio-Paluello, "Iacobus Veneticus Grecus, Canonist and Translator of Aristotle," *Traditio,* VIII, 1952, pp. 265–304; G. Lacombe, *Aristotelis Latinus Pars prior,* Bruges-Paris, 1957, pp. 370–71; D. Knowles, "The rediscovery of Aristotle," *The Evolution of Medieval Thought,* London, 1962

304. Aristotle, *Metaphysics*

England or France
12th–13th century
Oxford, Bodleian Library, Ms. Selden supra 24

Aristotle's *Metaphysics* came to western Europe in the second wave of translation, about 1200. Neither the translation of James of Venice in the mid-twelfth century nor other translations from the Greek later in the century were satisfactory, and it was not until the appearance of Michael Scot's translation from the Arabic, about 1210, that the work made its full impact. Minio-Paluello suggests that the present copy of the *Metaphysics,* in a composite volume of philosophical works, may have come in part from northern France, where there seems to have been a center of interest in the new Aristotle and whence perhaps his influence spread to students of philosophy and theology. Two portions of the manuscript, including that which contains the *Metaphysics,* bear the medieval ex libris inscription of St. Alban's Abbey in Hertfordshire, and the entire volume presumably spent the Middle Ages there. The translation of the *Metaphysics* is by James of Venice.

BIBLIOGRAPHY: L. Minio-Paluello, "Iacobus Veneticus Grecus, Canonist and Translator of Aristotle," *Traditio,* VIII, 1952, pp. 265–304; G. Lacombe, *Aristotelis Latinus Pars prior,* Bruges-Paris, 1957, pp. 398–99; D. Knowles, *The Evolution of Medieval Thought,* London, 1962; M.-T. d'Alverny, "Avicenna Latinus," *Archives d'histoire doctrinale et littéraire du moyen âge* XXXII, 1965, pp. 280–282

305. Euclid, *Elements*

England, Canterbury
Late 12th century
Oxford, Bodleian Library, Ms. Digby 174

Adelard of Bath, the pioneer student of Arabic science and philosophy in the twelfth century, was born in England but studied at Tours and

taught at Laon. He later traveled in the Near East, Sicily, and perhaps Spain. He is thought to have died in England in the 1140s. His interests included trigonometry, Platonic philosophy, astrology, falconry, and perhaps even chemistry. Western Europe was indebted to him for the introduction of the new Euclid. Later in the century other translations of the *Elements* were made by Hermann of Carinthia and Gerard of Cremona. The exhibited manuscript, from St. Augustine's Abbey, Canterbury, contains Adelard's translation. It is open at the beginning of Book VI, which deals with the application of the theory of proportion to establishing the properties of geometrical figures. The heavily abbreviated, closely written text is characteristic of texts of this type.

BIBLIOGRAPHY: C. H. Haskins, "Adelard of Bath," *Studies in the History of Mediaeval Science,* Cambridge, Mass., 1924, pp. 20–42; A. C. Crombie, "The Reception of Greco-Arabic Science in Western Christendom," *Augustine to Galileo,* London, 1952

306. Medical illustrations

England
12th–13th century
Oxford, Bodleian Library, Ms. Ashmole 1462

Medicine was another branch of science that recovered much in the twelfth century. Hippocrates and Galen were recovered partly from the Greek but mainly from the Arabic in translations by Gerard of Cremona. To these were added certain original Arabic and Jewish works, the greatest being Avicenna's chief medical work, the *Canon medicinae,* also translated by Gerard. This was still being printed in the sixteenth century. By the twelfth century Europe had seen its leading medical school established at Salerno in southern Italy, and before long another had arisen at Montpellier in the south of France. The illustrations in the exhibited manuscript are part of a medical mis-

cellany preceding the *Herbarium* of the Pseudo-Apuleius. Included are examples of illustrations used by physicians to achieve accuracy in cauterizing. They indicate points at which to cauterize for elephantiasis, asthma, tertian fever and toothache. Other illustrations with captions indicate "Cataracts of the eye are cut out thus," and "Polyps are cut from the nose thus."

BIBLIOGRAPHY: K. Sudhoff, *Beitrage zur Geschichte der Chirurgerie im Mittelalter, Studien zur Geschichte der Medizin,* X, 1914, pp. 81–90, 94–95, pl. 1; R. Mackinney, *Medical Illustrations in Medieval Manuscripts,* London, 1965, pp. 49–50, 70, figs. 43, 69

307. Map of Europe

England
About 1200
Dublin, National Library of Ireland, Ms. 700

Although much scientific knowledge was received by twelfth-century Europeans from the Arabs, this did not include the work of their leading geographers, which remained unknown during the rest of the Middle Ages. European cartographic tradition derived instead from late Roman maps based on Roman itineraries. The exhibited map is in a copy of the *Topography of Ireland* by Giraldus Cambrensis (Gerald of Wales), the entertaining, inaccurate, yet informative author of two similar works on Wales, both, like the one on Ireland, written in the last years of the twelfth century. Once one perceives that Rome is at the top, Ireland at the bottom, Bavaria, Bohemia, and Hungary on the left, and Spain and Gascony at bottom right, and that the sea is green, rivers are blue, and town symbols black, the layout begins to make sense. The map seems intended for travelers from Britain to Rome, via Winchester, Paris, Lyon, Pavia, and Piacenza. Four towns are marked: in Ireland, Dublin, Wa-

308

terford, Wexford, and Limerick; and four in England: Winchester, London, Lincoln, and York (Ebora). The river Severn divides England and Wales and the Thames also appears.

BIBLIOGRAPHY: G. R. Crone, *Early Maps of the British Isles A.D. 1000–A.D. 1579,* London, 1961, p. 14, pl. 2

VI *The Medieval Library*

At the turn of the twelfth century libraries still existed only in monasteries and cathedrals. Over half a century was to elapse before the earliest university collection was available at the Sorbonne, and many more years before anything like a private library was known. The look of these collections can be reconstructed, since books of the twelfth century survive in considerable numbers, some of them in their original bindings. Some books, those required for services, were kept in the choir, some bound in elaborate gold, jeweled, enameled, or ivory bindings; others, those required for reading during meals, were kept in the refectory; the majority, those needed for study, were kept in cupboards in the cloister or, more rarely, in a special book room. These would be bound much more simply—at most in wooden boards covered with stamped or tooled leather, sometimes just in boards or in plain parchment or leather covers—or sometimes not bound at all. They would be stored, not in modern fashion, but lying on their sides on sloping desks, or in chests.

308. Library Catalogue of Rochester

England, Rochester
1202
London, British Museum, Royal Ms. 5 B. XII

The few catalogues of the early medieval collections are mostly simple lists written in books containing other works. This one has the date 1202 at the beginning, and is written at the front of a manuscript containing Augustine's *De doctrina Christiana.* Additions have been made by several later hands. As was usual at this time, the entries are quite summary, giving titles but often no author, and very often only the first item in a composite volume is mentioned. Many of the manuscripts listed in this catalogue still exist. About fifty of them are among the royal manuscripts in the British Museum, having been seized by Henry VIII in 1539, along with others in the library, and incorporated into his own library. The Rochester catalogue contains a fair representation of the classical authors who were widely read in the twelfth and thirteenth centuries, among them Virgil, Ovid, Horace, Statius, Suetonius, Cicero, Lucan, Persius, Sallust, and Macrobius. Gratian's ubiquitous *Decretum* is listed, also Aristotle's *Topica, Analytica,* and *Elenchi,* and the *Polycraticus* of John of Salisbury. Most of the classical works are catalogued in the lower half of the left-hand column on the right-hand page.

BIBLIOGRAPHY: "Catalogue of the Library of the Priory of St. Andrew, Rochester, A.D. 1202," *Archaeologia Cantiana,* III, 1860, pp. 47–64

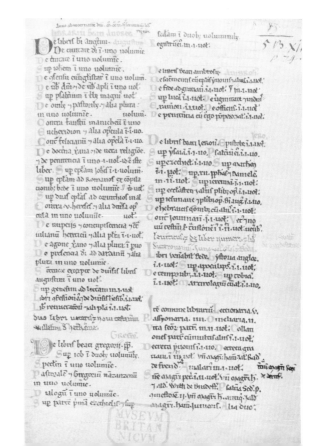

VII *Book binding*

The binding of books in wood and leather was invented by the Copts, probably in the second century A.D. The earliest English bindings known, on the seventh-century Gospels of St. Cuthbert now at Stonyhurst and on three manuscripts once owned by St. Boniface (d. 687), now at Fulda, are constructed in Coptic style. That is, each quire is sown to its neighbor, not onto horizontal bands. It would seem that the later practice was not invented in western Europe until about the late eighth or early ninth century. The skins of many animals were used to cover the boards: goat, deer, seal, horse, dog. Three processes of preparation can be distinguished. First, tanning (used for the two bindings shown here), in which the brown dye of oak bark penetrated the leather and provided a smooth surface for the impression of stamps. Second, whittawing, curing in a bath with lime, alum, and salt, which produced a skin with a suede finish, off-white or cream-colored. Third, whittawed skin could be stained puce with kermes, but as the color tended to be lost through rubbing, stained skin was not often used for covers. Fastenings, used to keep the book shut, were at first a single strap and pin, then a double strap and pin, later still, leather clasps with a metal hook, and lastly, all-metal clasps.

BIBLIOGRAPHY: B. van Regemorter, "Evolution de la technique de la reliure du xiii^e siècle," *Scriptorium,* II, 1948, pp. 275–85; B. van Regemorter, "Le codex relié depuis son origine jusqu'au Haut Moyen-Age," *Le Moyen Age,* 4^e sér., X, 1955, pp. 1–26; G. Pollard, "The construction of English twelfth-century bindings," *The Library,* 5th ser., XVII, 1962, pp. 1–22, with illustrations, diagrams, and information applicable to Continental bindings

309. Stamped leather binding

France
Late 12th century
Hereford, Cathedral Library, Ms. o.6.iii

Formerly thought to be English, this is one of a group of bindings that probably originated in Paris. Bindings bearing these stamps are scattered in England, Spain, Germany, France, and Switzerland. In addition to animal grotesques, this cover shows a mounted king bearing a palm leaf, and an unusual stamp representing either the Last Supper or the Marriage at Cana. Hobson has remarked of the grotesques that they "are well engraved and extremely interesting, as they seem to make the transition from Romanesque to Gothic art. Unlike the earlier tools, they are not based on motifs used in a more ancient art or another medium . . . but spring direct from the creative imagination of the engraver." The manuscript in this binding contains the *De coelestihierarchia* of the Pseudo-Dionysius and other writings.

BIBLIOGRAPHY: G. D. Hobson, *English binding before 1500,* Cambridge, 1929; G. D. Hobson, "Further notes on Romanesque bindings," *The Library,* 4th ser., XV, pp. 160–211

310. Stamped leather binding

France
Early 13th century
London, British Museum, Ms. Add. 24076

A copy of the *Liber Sapientiae,* bound in wooden boards covered with tanned leather, blind tooled. Like 309, this was once thought to be English but is now attributed to Paris. The stamps, pictorial and nonpictorial, include a church, a crowned king on horseback, centaurs shooting stags, a nimbed and winged lion, and rosettes. Two clasps have been lost from the upper cover.

BIBLIOGRAPHY: W. Y. Fletcher, *English bookbindings in the British Museum,* London, 1895, pl. I; G. D. Hobson, *English binding before 1500,* Cambridge, 1929, p. 29; G. D. Hobson, "Further notes on Romanesque bindings," *The Library,* 4th ser., XV, 1960, pp. 160–211

311. Penny: John

England
1199–1216
Silver
New York, The American Numismatic Society

Obverse: in the center medallion, a conical face with straightforward look and open mouth. Regular strokes indicate the beard, and heavy volutes represent the hair. The head is abstractly combined with a hand holding a scepter. The highly advanced sculptural technique seems unusual in relation to the small value of the coin. Inscription: HENRICUS REX. Reverse: a small square cross in a medallion, the quadrants containing quatrefoil ornaments. For similar pieces, known as "short cross coinage," see J. J. North, *English Hammered Coinage,* London, 1963, pl. XVI.

BIBLIOGRAPHY: G. C. Brook, *English Coins from the Seventh Century to the Present Day,* London, 1950, p. 111

312. Halfpenny: John

Ireland, Dublin
1177–1199
Silver
New York, The American Numismatic Society

Obverse: a triangle encloses a full-face crowned head; small stars appear in the angles. Inscription: IOHAN REX. Reverse: a triangle encloses a cross and a crescent; dots appear in the angles. The fragmentary encircling inscription is indecipherable.

BIBLIOGRAPHY: J. Lindsay, *A View of the Coinage of Ireland from the Invasion of the Danes to the Reign of George IV . . .,* Dublin–London, 1939

313. Bracteate: John I

Germany, Arnstadt, Mint of Hersfeld Abbey
1201–1213
Silver
New York, The American Numismatic Society

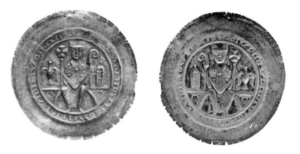

Obverse: Abbot John I sits frontally on a wall, his legs hanging over an arch in a composition reminiscent of Christ in Majesty on a rainbow. The abbot holds a voluted crosier in his left hand, a cross-standard in his right. He wears a bishop's garments and a pectoral cross; his miter has two widely separated horns. A conventional crenelated tower appears at his left side and an eagle at his right. The closely folded drapery is traditional in twelfth-century seated figures. The script at the edge of the coin is unidentifiable.

BIBLIOGRAPHY: *Sammlung Arthur Löbbecke, Deutsche Brakteaten,* Halle, 1925, no. 653

314. Bracteate: Philip of Swabia

Germany, Saalfeld, Imperial Mint
1198–1208
Silver
New York, The American Numismatic Society

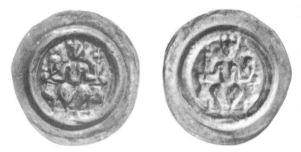

Obverse: the crowned emperor sits frontally on a rectangular throne with decorative knobs at each end. He holds an orb surmounted by a smaller orb in his right hand and a scepter in his left. Thus seated, the ruler carries on a Carolingian tradition.

BIBLIOGRAPHY: *Sammlung Arthur Löbbecke, Deutsche Brakteaten,* Halle, 1925, no. 743

315. Bracteate: Otto I

Germany, Brandenburg
1170–1184
Silver
New York, The American Numismatic Society

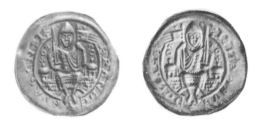

Obverse: Otto I, Count of Brandenburg, dressed in a coat of mail, sits frontally on a wall flanked by two small towers. He holds a sword upright in his right hand, a standard in his left. One of the towers is crowned by a fleur-de-lis. The letters of his name appear at either side of his head. The detailed, punched treatment of his mail coat anticipates achievements of twelfth-century lower Saxon sculpture. The upright position of the attributes and the stare of the ruler produce a striking impression. Inscription: BRANDENBURG-ENSIS.

BIBLIOGRAPHY: M. Bahrfeldt, *Sammlung Römischer Münzen der Republik und des West-Kaiserreichs,* Halle-Saale, 1922, no. 39

316. Denier: Sobeslaw II

Bohemia
1173–1197
Silver
New York, The American Numismatic Society

Obverse: holding a standard and shield, the ruler appears in a cross-legged position combining a dancing movement with a tradition of the cross-legged stance of judges. The image probably derives from a prototype showing a seated emperor, the support having been omitted in the process of copying. Inscription: + DUX SOBEZIA. Reverse: the profile bust of an expressively bearded old man holding a cross in his exaggerated left hand. He is identified by the fragmentary inscription, + SCS WE. C. ZIAUS, as St. Wencezlaus.

BIBLIOGRAPHY: M. Donebauer, *Beschreibung der Sammlung Böhmischer Münzen und Medaillen,* Prague, 1888, p. 53, pl. XII, no. 519

317. Bracteate

Sweden: Province of Westgothland
Around 1200
Silver
New York, The American Numismatic Society

Obverse: a crowned frontal head, the crown and curls of hair combined in an ornamental pattern. This tiny coin illustrates a close adherence to lower Saxon prototypes.

BIBLIOGRAPHY: *Sammlung des Herrn. L. E. Bruun in Kopenhagen: Schwedische Münzen,* Frankfurt am Main, 1914, no. 58

318. Half Grosso: Frederico I

Italy, Como
1178–1186
Silver
New York, The American Numismatic Society

Obverse: a profile bust of the crowned emperor, Frederick Barbarossa, holding a fleur-de-lis scepter. Inscription: FREDERICV IMPERT. Reverse: an eagle with spread wings, the heraldic symbol of Como, identified as CIVITAS CUMANA in the accompanying circular inscription.

BIBLIOGRAPHY: *Corpus Nummorum Italicorum,* IV, Rome, 1913, p. 180, no. 39

319. Grosso: Enrico Dandolo

Italy, Venice
1192–1205
Silver
New York, The American Numismatic Society

Obverse: the doge, Enrico Dandolo, stands beside St. Mark, the patron saint of Venice. Reverse: Christ seated, with the letters IC XC on either side of his head. The combination of the seated Christ and the two standing figures illustrates the close Byzantine connections of Venice. The finely drawn parallel drapery of the Christ figure and the spiral arrangement of the doge's arm drapery represent the fluid style of the period around 1200.

BIBLIOGRAPHY: *Corpus Nummorum Italicorum,* VII, Rome, 1915, pl. I, no. 23

320. Fiorino

Italy, Florence
About 1182–1257
Silver
New York, The American Numismatic Society

An early example of a Florentine coin. Obverse: a half-length figure of John the Baptist, the patron saint of Florence, holding a thin cross-staff in his left hand while raising his right. Byzantine derivation is apparent in the alert rendering of the head and the physiognomic details. Inscription: IOHANNE B in broad, protruding letters. Reverse: a fleur-de-lis set into a medallion surrounded by the inscription FLORENTINA. On both sides a cross is placed at the upper center of the coin. Stylistic peculiarities in the treatment of the saint and the heraldic perfection of the fleur-de-lis suggest a date in the latter part of the period 1182–1257.

BIBLIOGRAPHY: *Corpus Nummorum Italicorum*, XII, Rome, 1930, pl. XV, nos. 4–10

321. Grosso: Otto IV

Italy, Lucca
From 1209
Silver
New York, The American Numismatic Society

Obverse: the crowned head of the German emperor Otto IV in an impressively stylized version, the head framed by long, falling hair, the mouth deeply incised. Inscription: DE LUCCA. Reverse: inscription OTTO REX encircles the central medallion, which contains a pair of stylized T's linked by a crossbar, standing for the middle letters of Otto's name; the edge of the medallion represents the O's.

BIBLIOGRAPHY: *Corpus Nummorum Italicorum*, XI, Rome, 1929, pl. IV, nos. 39–45

322. Trifollaro AE: William II

Sicily
1166–1189
Bronze
New York, The American Numismatic Society

Obverse: the head of a lion, three-quarters facing, with open mouth, executed in a broad, flat design emphasized in the flattened outline of the nose. Reverse: a palm tree, rendered in a manner that follows the Near Eastern tradition of symmetrically designed trees. Both sides of the coin are encircled by a row of beading. For the antecedents of the association between tree and ruler, G. Widengren, *The King and the Tree of Life*, Upsala, 1950. For the widespread lion imagery in twelfth-century Sicilian court art, of which this coin forms a part, Deér, 1959.

BIBLIOGRAPHY: A. Sambon, *Normannia*, Caen, 1928, p. 51, no. 9

323. Denier: Bohemund IV

Antioch
1201–1232
Silver
New York, The American Numismatic Society

Obverse: a profile head wearing a nasal casque. To the left is a crescent, to the right a star. Inscription: BOAMUNDUS. Reverse: a cross pattée in a medallion, a crescent in the second quarter. Inscription: ANTIOCHIA.

BIBLIOGRAPHY: G. Schlumberger, *Sigillographie de l'Orient Latin,* Paris, 1943, p. 53, pl. III, nos. 4–6

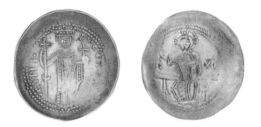

Obverse: the standing figure of Hugo I. Apparently copied from a Byzantine model, the king holds a cross-staff in his right hand and supports a cross surmounted orb in his left. A double row of studs encircles the king, identified by the inscription HUGO REX CYPRI. Reverse: a seated figure of Christ holding a book on his left knee while extending his right in a gesture of address. Inscription: IC XC.

BIBLIOGRAPHY: G. Schlumberger, *Sigillographie de l'Orient Latin,* Paris, 1943, p. 185, pl. VI, no. 3

324. Tari: Tancred

Sicily
1190–1194
Gold
New York, The American Numismatic Society

Obverse: a central point surrounded by an inscription in Arabic that reads: "King Tancred, Victorious in God." The fragmentary outer inscription, also in Arabic, contains the mint data formula. Reverse: the letters IC XC NI KA ("Christus vincit") appear between the arms of a patriarchal cross. A fragmentary inscription in Arabic encircles the cross and contains part of the mint date formula. For the history of the motto "Christus vincit" (an abbreviation of "Christus vincit, Christus regnat, Christus imperat"), E. H. Kantorowicz, *Laudes Regiae,* University of California, Berkeley, 1958.

BIBLIOGRAPHY: A. Sambon, *Normannia,* Caen, 1928, pp. 57–58, no. 2

326. AE: Seljuk Sultanate of Rum, Sulayman II

Anatolia
1196–1204; 595 A. H. (1198)
Bronze
New York, The American Numismatic Society

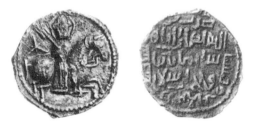

Obverse: a nimbed horseman faces front holding a mace over his right shoulder; a six-pointed star appears below the mace. Reverse: a three-line inscription in Arabic, "Al-Sultan al-Qahir Sulayman b. Qilij-Arslan," encircled by "struck in the

325. Besant blanc: Hugo I

Cyprus
1205–1218
Gold
New York, The American Numismatic Society

year five and ninety and five hundred." The horse-man motif stems from classical art and was transmitted from late antiquity far into Asia Minor. (A. Grabar, *L'Empereur dans l'Art Byzantin,* Paris, 1936).

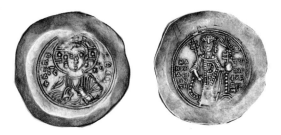

Obverse: a bust of Christ with youthful features holding a scroll and distinguished by a lively sculptural treatment. Inscription: IC XC. Reverse: Manuel I in the Byzantine loros holding a scepter and an orb surmounted by a patriarchal cross while the hand of God blesses him from the arc of heaven. A double row of beads encircles the figure.

BIBLIOGRAPHY: W. Wroth, *British Museum Catalogue of the Imperial Byzantine Coins,* II, London, 1908, p. 566

327. Nomisma AR: Theodore I

Nicaea
1204–1222
Silver
New York, The American Numismatic Society

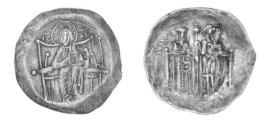

Resembling no. 325, this coin was issued in Nicaea during the reign of Theodore I. Obverse: a traditional representation of Christ in Majesty with an elaborate architectural shaping of the throne. Reverse: Theodore accompanied by his patron saint, Hugo, represented in short soldier's dress. They jointly hold an implement and Hugo presents a long thin staff ending in the Chi-Rho, the Christ monogram of the labarum. Apparently the head of St. Theodore was misstruck and then corrected, leaving an impression of two heads.

BIBLIOGRAPHY: W. Wroth, *Catalogue of the Coins of the Vandals . . . in the British Museum,* London, 1911, p. 206, no. 1

328. Nomisma AV: Manuel I

Turkey, Constantinople
1143–1180
Gold
New York, The American Numismatic Society

329. Nomisma AV: Andronicus I

Turkey, Constantinople
1183–1185
Gold
New York, The American Numismatic Society

Obverse: the Virgin and Child sitting on a broad throne with supporting arcades. The throne's spiral cushion ends in a trefoil ornament that reappears on the upper corners of the throne. Mary's halo is placed above the outer edge of the throne. Inscription: MP ØU. Reverse: the standing emperor Andronicus in full regalia being crowned by Christ, who carries a book to his

right. The figure of Christ is distinguished by the fluidity of movement and drapery. The compositional scheme of this group recalls the pictorial tradition of the Baptism of Christ, which in twelfth-century Byzantine court rhetorics was often adduced as the prototype of the emperor's coronation (for the ideological background, Hoffmann, *Taufsymbolik im mittelalterichen Herrscherbild,* Düsseldorf, 1968).

BIBLIOGRAPHY: W. Wroth, *British Museum Catalogue of the Imperial Byzantine Coins,* II, London, 1908, p. 583, no. 1

330. Nomisma AV: Alexius III Comnenus

Turkey, Constantinople
1195–1203
Gold
New York, The American Numismatic Society

Obverse: Christ stands frontally on a circular pedestal, a traditional scheme in Byzantine ivories. Inscription: XC IC. Reverse: Alexius III stands holding a scroll and jointly holding a cross-staff with St. Constantine, the first Eastern Christian emperor. The representation of Constantine with the living emperor apparently is adapted from the popular image of Constantine and his mother, Helena, who often were represented holding the patriarchal cross.

BIBLIOGRAPHY: W. Wroth, *British Museum Catalogue of the Imperial Byzantine Coins,* II, London, 1908, p. 599, no. 1

331. Dinar: Shams al-Din Iltutmish

India, Delhi
614 A. H. (1217)
Gold
New York, The American Numismatic Society

Obverse: a charging horseman carrying a mace is encircled by an inscription in Arabic of a declaration of faith followed by the words "date fourteen and six hundred." Reverse: a five-line Arabic inscription "Al Sultan al-Mu' azzam Shams al-Dunya wa-al-Din abu-al-Muzaffar Iltutmish al-Qutubi . . . of the Commander of the Believers." The agitated rendering of the horse and rider reveal a baroque pathos stemming from late antique triumphal imagery. (For the transmission of this pictorial type to India, H. Buchthal, *The Classical Sources of Gandhara Sculpture,* New York, 1945.)

BIBLIOGRAPHY: H. N. Wright, *The Coinage and Metrology of the Sultans of Delhi,* Delhi, 1936, p. 15, no. 49G

332. Seal Matrix: Isabella (Elizabeth) of Hainault

France
1180–1182
Silver
9.6 x 5.4 cm. (3¾ x 2⅛ in.)
Switzerland, Sursee, Coll. Dr. Wicki

Of mandorla shape, the object's center shows the standing figure of the crowned queen, holding a scepter in her left hand and a fleur-de-lis in her right. The inscription ELIZABEZ DEI GRACIA FRANCORUM REGINA identifies the figure as Isabella of Hainault, first wife of Philip II Augustus,

the twelfth-century French King. As the couple was married in 1180 and Isabel died in 1190, the seal can be dated around 1180 and could have been used for less than 10 years. The seal is distinguished by precise modeling, subtle interplay between the body and finely stranded drapery, and the delicately executed fleur-de-lis. A compositional refinement is apparent in the way the figure's outline intersects the inner beaded band of the inscription frame.

BIBLIOGRAPHY: L. de la Marche, *Les Sceaux*, Paris, 1889; M. Battifol, *Mémoires des Antiquaires de France*, V, Paris, 1918; R. Johnes, "The Seal of Queen Isabel of Hainault and some Related Seals," *The Antiquaries Journal*, XL, 1960, pp. 73–76

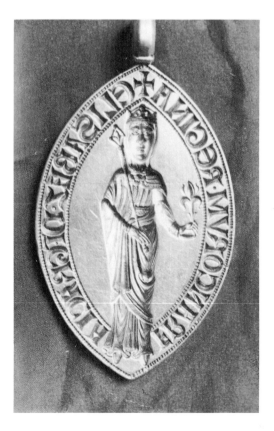

333. Seal of Robert Fitzwalter (1198–1234)

England
1210–1220
Silver
D. 7.3 cm. (2⅞ in.)
London, Trustees of the British Museum, Seal XXXVII.I

The decorated circular seal was a royal privilege in the eleventh and twelfth centuries. This, one of the earliest specimens of a nobleman's private seal, is historically significant for its representation of a heraldic coat of arms (placed in front of the horse) corresponding to the rider's shield. The verticality of the image is emphasized by the erect position of the rider and the placement above his helmet of the traditional cross that marks the beginning and end of the inscription: SIGILLUM ROBERTI FILII WALTERI. The rider's

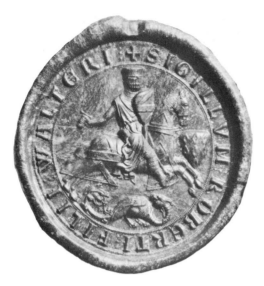

extended arm, the diagonally raised sword, and the intricately curling dragon beneath the horse's feet contribute to the richness of the composition. The superb sculptural treatment of the dragon, especially the exuberant floral ornamentation of its tail, as well as the vigorous modeling of the rider's drapery, indicate the high quality of the piece and its indebtedness to northern French and Mosan prototypes for the rider, a medallion from the shrine of the Three Kings: Swarzenski, 1967, fig. 526). The motif of a rider fighting a dragon, originating in Bellerophon representations of classical art and continued in imperial iconography (the so-called Einhardus Arch of the early ninth century, Elbern, 1962), and medieval and Renaissance images of St. George, apparently refers to the concept of the struggle between good and evil (Simson, "The Bamberg Rider," *Review of Religion,* 4, 1939–1940, pp. 257–282). The horseman motif also appears on an English seal of Duke John (1199–1216) in a stylistically simpler and probably slightly earlier version. A vivid and convincing adaptation of the latest northern French stylistic achievements is first seen in the counterseal of St. Augustine's abbey, Canterbury, dated 1199.

BIBLIOGRAPHY: Panofsky, 1964, fig. 383

334. Seal: Bulla of Baldwin IV

Jerusalem
1173–1183
Lead
New York, The American Numismatic Society

The king, frontally enthroned, holds a cross-surmounted orb in his elevated left hand, a cross-staff in his right. Inscription: BALDVINUS DEI GRACIA REX JERUSALEM. A cross fills the uppermost center. The elaborate structure that supports the throne is perhaps derived from the more detailed rendering of city walls seen in earlier ruler coins (Deér, 1961). The king's garment appears to derive from Byzantine prototypes whereas the fleur-de-lis decorating his crown has a French derivation. Inscription reverse: CIVITAS REGIS REGUM OMNIUM, referring to the designation of Christ in Revelations (Rev. 19:16). The central image shows a high portaled structure representing the Tower of David with, on the left, the Temple of Jerusalem, and, on the right, the Holy Sepulcher, thus assembling the three principal monuments of the Jewish capital.

BIBLIOGRAPHY: G. Schlumberger, *Sigillographie de l'Orient Latin,* Paris, 1943, p. 8, no. 16

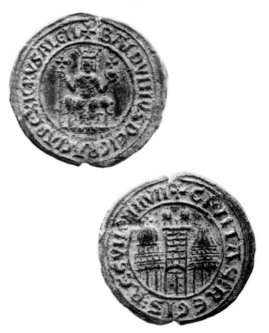

335. Cameo: Frederick II

Sicily
1225–1230
Sardonyx
Baltimore, The Walters Art Gallery, 42.1428

This drop-shaped cameo presents a full-face bust of the emperor, carved in high relief, wearing laurel and armor. A close resemblance to imperial gems of classical Roman art is seen in the choice of stone, portrait type, and style. The cameo's period is revealed in the charming fluidity of the drapery, for here the artist displays his knowledge of contemporary northern French *Muldenfalten-stil* achievements (see no. 12 for a French monumental adaptation of a classical imperial bust). The localization of the cameo to a Sicilian workshop and its dating are the work of Wentzel.

BIBLIOGRAPHY: Baltimore, 1947, no. 553; H. Wentzel, "Die vier Kameen im Aachener Domschatz," *Zeitschrift für Kunstwissenschaft,* VIII, 1954, p. 9, fig. 26; G. Kaschnitz-Weinberg, "Bildnisse Friedrichs II von Hohenstaufen," *Mitteilungen des Deutschen Archäologischen Instituts,* 62, 1955, p. 50 f., pls. 21, 22; W. R. Valentiner, *The Bamberg Rider,* Los Angeles, 1956, figs. 41, 43

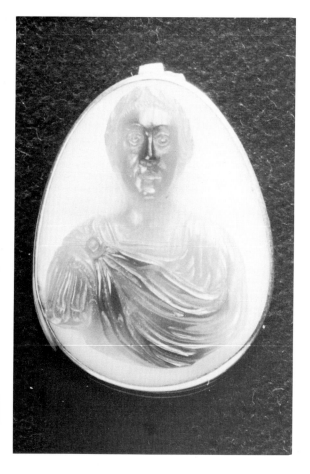

336. Cameo: the Virgin Mary

Constantinople
1230
Bloodstone
4.9 x 2.8 cm. (1 5/16 x 1⅛ in.)
Baltimore, The Walters Art Gallery, 42.5

The gold mounting is modern. The relief carving shows the Virgin, standing on a simple square pedestal, her hands extended to the right. She is the Virgin of Intercession, either the Hagiosoritissa, a term drawn from the precious reliquary containing her girdle in the church of the Chalcoprateia in Constantinope (Der Nersessian), or the Virgin of a Deesis. As the Hagiosoritissa she would have been accompanied by a plaque with Christ (compare a jasper cameo of Christ in the Victoria and Albert Museum, Beckwith, 1961, fig. 102; H. Wentzel, "Datierte und datierbare byzantinische Kameen," *Festschrift Friedrich Winkler,* Berlin, 1959, pp. 9–21) and,

as a Deesis, by a third plaque with John the Baptist. The plaques would have folded together to reveal the cross carved on the back of the Virgin's cameo in a way similar to a triptych in the British Museum (Goldschmidt-Weitzmann, II, no. 38, pl. LXIII). The Hagiosoritissa and the Deesis Virgin interceded with Christ for the salvation of souls and were often accompanied by the prophets, fathers of the church, apostles, and saints in a scheme based on the liturgy of the Greek church (the lost mosaics of the fifth or sixth century at La Daurade, Der Nersessian, p. 79 f.; an ivory book cover in Bamberg, K. Weitzmann, "Die byzantinischen Elfenbeine eines Bamberger Gradduale und ihre ursprungliche Verwendung," *Festschrift für Karl Hermann Usener,* Marburg, 1967, pp. 11–20; and the Harbaville Triptych in the Louvre, E. H. Kantorowitz, "Ivories and Litanies," *Journal of the Warburg and Courtauld Institutes,*

V, 1942, p. 56 f.). Previously attributed to the eleventh or early twelfth century, the exhibited cameo may be dated around 1230. The fullness of the Virgin's body and the maphorion draped in loose, broad folds resemble the style of the figures and drapery of the apostles in a fresco of the Dormition of the Virgin at Milesevo, dated 1234 (Millet-Frolow, I, pl. 72) and of Sophia and Prophetia in the mid-thirteenth-century psalter illustrations at Leningrad (State Library, cod. 269, fol. 3; Weitzmann, 1957, fig. 4, p. 136 f.; Demus, 1958, p. 24 f.).

BIBLIOGRAPHY: Baltimore, 1947, no. 555; S. Der Nersessian, "Two Images of the Virgin in the Dumbarton Oaks Collection," *Dumbarton Oaks Papers,* XIV, 1960, pp. 71–86; M. C. Ross, "Three Byzantine Cameos," *Greek, Roman and Byzantine Studies,* III, 1960, pp. 43–45, fig. 4; P. Verdier, "Gem Carving: The Virgin of Intercession," *The Walters Art Gallery Bulletin,* 1961

337. Antependium

Germany, Rupertsberg
1210–1220
Red silk, embroidered with gold, silver, silk
102 x 235 cm. (40¼ x 92½ in.)
Brussels, Musées Royaux d'Art et d'Histoire,
 1784

The embroidery is dominated by a figure of Christ enthroned in a mandorla with a starry ground and the apocalyptic letters alpha and omega. Mary and St. Peter stand at his right, St. Rupert and St. Hildegard of Bingen at his left. The outer edges of the antependium are filled by monumental figures of St. John the Baptist (left) and St. Martin (right). Beneath the central figures the Bishop of Mayence and Agnes, and the Duchess of Nancy, both benefactors of Rupertsberg Abbey, lie prostrate. The smaller figures standing high up in the center are linked to the flanking saints of the wings, who stand in the foreground and form a continuous niche enclosing the figure of Christ. The lower border of the antependium is filled with figures of praying nuns.

This antependium testifies to the connection of early thirteenth-century middle Rhenish art with contemporary achievements of French and Mosan sculpture and goldsmiths' work. The connection is especially evident in the fluid drapery that covers and at the same time closely follows the movements of the bodies. Another connect-

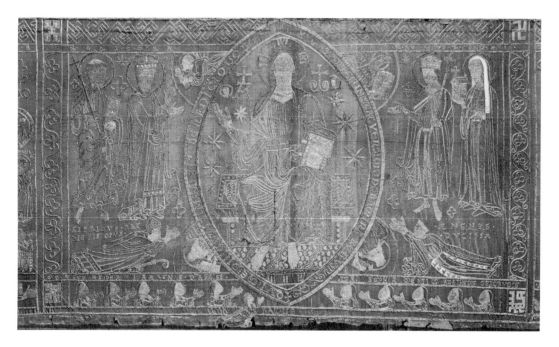

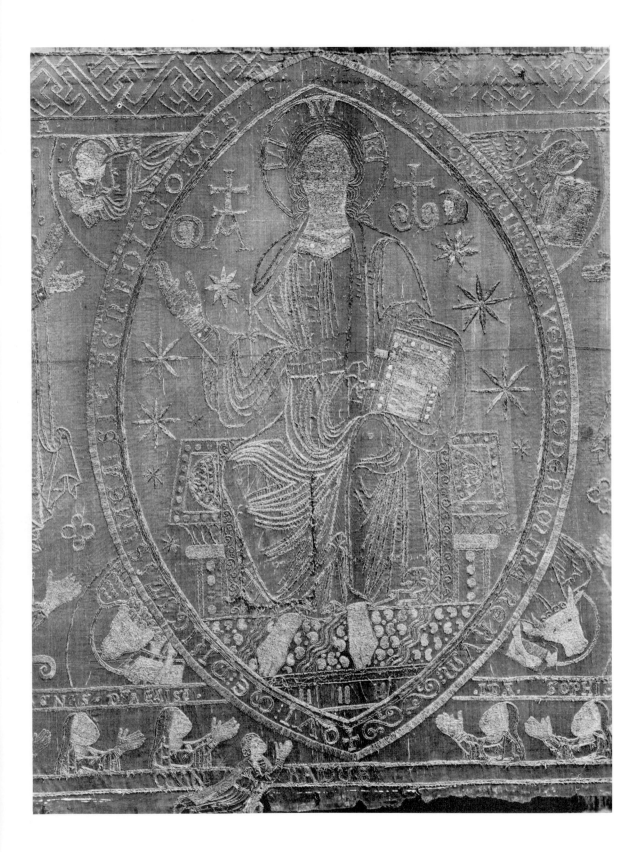

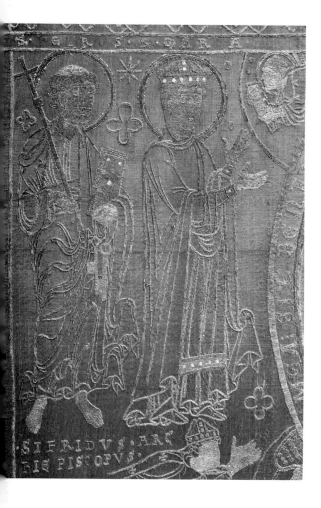

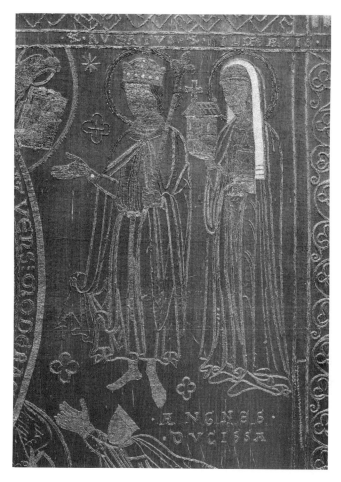

ing detail is the articulation of the body, obtained by the belt's placement, in the figure of St. Rupert. The starry ground of the mandorla suggests comparison with the so-called star group of Limousine enamels (Stohlman, 1950). A Byzantine inspiration is clearly evident in the features and the agitated drapery of Christ and John the Baptist; the model imitated must have been a work of the late twelfth century, representing the characteristically spirited style that strongly appealed to Western artists. Although the antependium follows the Rhenish Byzantinism seen in the *Hortus Deliciarum* and the Speyer Gospels of 1197, it represents a more advanced phase than these works, exploiting the later Western de-

velopments; its significance is greatly enhanced by the rarity of analogous pieces preserved. A comparable representation of local patron saints interceding before Christ occurs on the early eleventh-century antependium from the Basel cathedral in the Cluny Museum (Buddensieg, 1957). More closely related is the miniature on fol. 322 v. in the *Hortus Deliciarum* representing the foundation of Hohenbourg monastery. Here, Christ, flanked by Peter and Mary and by John the Baptist and St. Odilia, turns to the kneeling donor, shown in the lower register in the presence of nuns.

BIBLIOGRAPHY: Baum, 1930, p. 257, fig. 251; Brussels, 1964, no. 210 (with earlier literature)

338. Miter

England
1180–1210
Silk, embroidered
Anagni, Cathedral Treasury

On one side, against a ground of lilies and crescents, are figures of St. Thomas of Canterbury and St. Nicholas, on the other, St. John the Evangelist and an unidentified female figure holding a book. The vertical bands once held ornaments, probably enamels or gems. The lower border has an applied band embroidered with a key pattern. Between the horns of the miter are crescents and stars. Although this miter has been attributed to Byzantium or to Eastern craftsmen working in Venice (Mortari), it is of English origin (Christie), and related to a group of four miters now in Munich (from Seligenstadt), Sens, Tarragona, and Namur; this group has been called (Geijer) "the remains of an extensive serial production intended for distribution as propaganda for the cult of St. Thomas." Rather than the isolated standing figures seen here, these other miters bear representations of the martyrdoms of St. Thomas and St. Stephen. Geijer suggests a connection between the embroidered version of St. Thomas's death and a Canterbury miniature of this subject of about 1180. The presence of the exhibited miter in Anagni is possibly related to the cult for St. Thomas established there after his canonization in 1173.

BIBLIOGRAPHY: A. Christie, *English Medieval Embroidery*, Oxford, 1938; L. Mortari, *Il tresoro della Cattedrale di Anagni*, Rome, 1963; A. Geijer, *Textile Treasures of Upsala Cathedral*, Stockholm, 1964

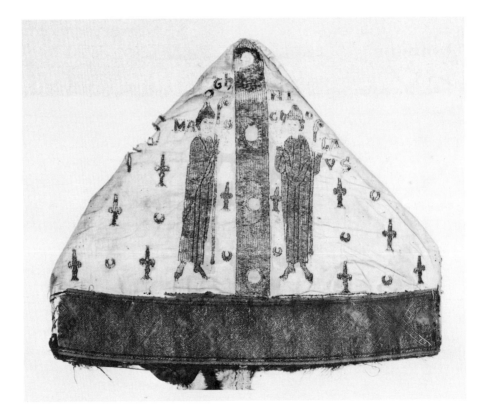

ADDENDA

339. Cupola reliquary

Germany, Cologne
1180–1190
Wood, copper gilt, champlevé enamel, ivory,
 walrus ivory
54.5 x 50.8 (21½ x 20 in.)
London, Victoria and Albert Museum

Resting on four griffins, the reliquary has the cross shape of a centralized church and is surmounted by a "folded" cupola. Each aisle of the reliquary is covered by a roof bearing rich enamel ornamentation (Mütherich, 1940, p. 38 f.). The façades contain bronze male heads in the triangular gables above ivory carvings of the Nativity, Adoration, Crucifixion, and Holy Women at the Tomb (the first two are nineteenth-century restorations). Sixteen walrus-ivory figures of prophets, identified by their scrolls, stand under arcades in the lower tier; Christ and eleven apostles are represented seated in the tambour zone of the cupola. The cupola, crowned by a pierced metal knob, appears as a sequence of small baldachincs above figures of Christ and the apostles.

In form and program this reliquary follows models that were brought home to the Rhineland by crusaders, for example, the Anastasius reliquary in Aachen (Schnitzler, 1959, pl. 62). The griffins, like those in many Crucifixions and candlesticks of the same workshops, represent evil subdued. Around the lower floor the prophets predict Christ's earthly life, and the major events of this life are illustrated by the ivory carvings at the four façades. The assembly of the apostles around Christ, who is placed axially above the Crucifixion, evokes the second advent. (The meaning of the bronze heads in the gables is unknown). The presence of standing prophets and seated apostles is a meaningful contrast based both on antique courtly and pictorial custom and on specific biblical passages; similar differentiations are often found in medieval cycles. The integration of a complex theological program within a small-sized object of liturgical function has been called a peculiarity of German twelfth-century art as opposed to the French predilection for a monumental context in cathedrals (Wallrath, 1953).

A closely related cupola reliquary in Berlin (Goldschmidt, III, no. 47), ordered in 1172 by Duke Henry the Lion to enshrine the head of St. Gregory Naziauzums (Rückert, 1957), is dated slightly earlier than the present example and has been attributed to the atelier of the master of the Siegburg St. Gregory portatile (Schnitzler, 1959, pls. 156–158). The present example is thought to be a work of the so-called younger Fridericus group, according to the classification established by Falke-Frauberger. Similar detailed forms of floral ornament occur here in different media, testifying to the close interaction of artists practicing different techniques in a given atelier. Both in the carving of the ivory statuettes and their compositions one can see an organization traceable back to Rhenish-Belgian ivory work of the ninth century. Clearly differing in conception and technique from the so-called "gestichete Gruppe" (Goldschmidt), these ivories have a

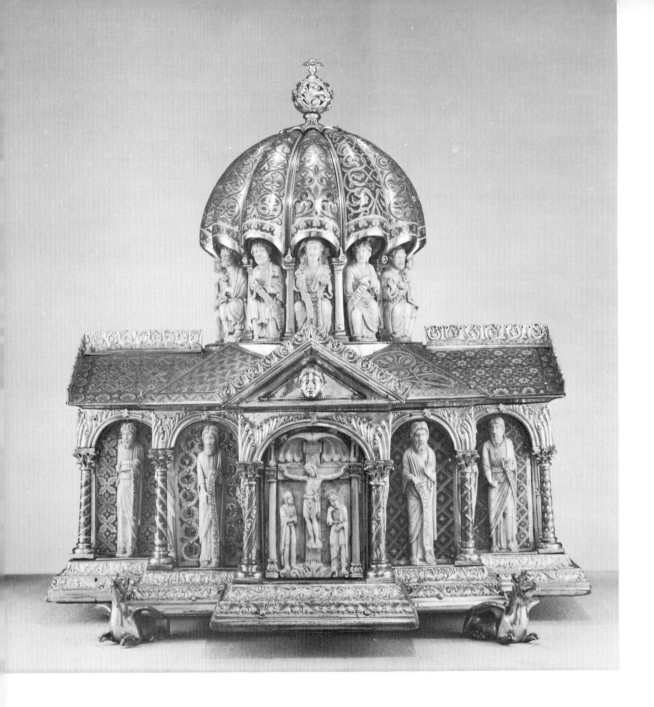

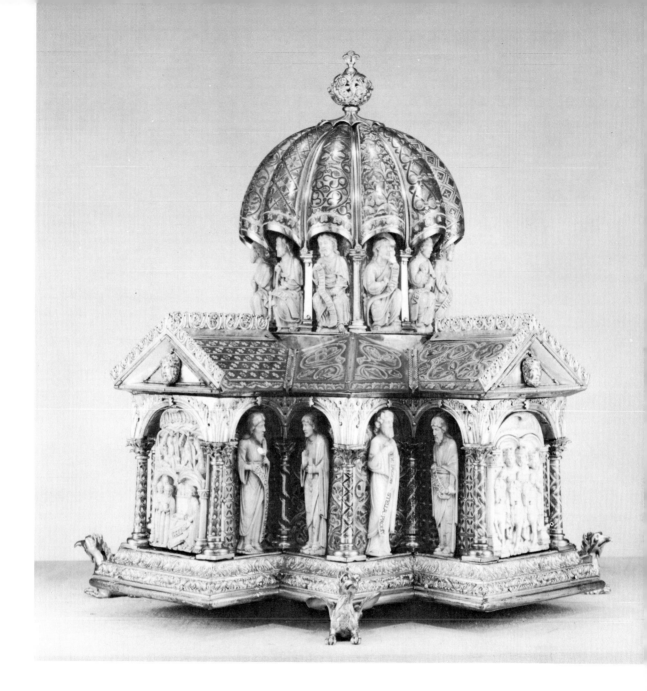

freshness and individuality that was to be lost in the course of development leading to the Cologne mass production in this medium during the first half of the thirteenth century. The variety and subtlety of the goldsmith's and enameler's work epitomize the local tradition in these techniques that culminated in the production of the great reliquary shrines. The Mosan connections of the ornamental vocabulary have been pointed out by Rosy Schilling (1950).

BIBLIOGRAPHY: Goldschmidt, III; Longhurst, 1926; Beenken, 1924; Mühlberg, 1963; Swarzenski, 1967, figs. 500–502; Mütherich, 1940; Meyer, 1942; Schilling, 1950

340. Casket

Rhineland
About 1200
Wood, silver
Anagni, Cathedral Treasury

The casket, its lid in the form of a truncated pyramid, was originally covered with silver repoussé plaques; later, some of these were replaced with pieces of textile or embroidery, the most outstanding being fragments of a superb embroidery representing pairs of birds enclosed in circles with scrolls and leafy decorations. The remaining silver plaques represent: on the lid, Hercules with a club and the back of a dancing maenad; on the lid sides, a putto riding on a pair of dolphins and another standing with a wreath in his left hand and leaning on a spear; Hyppolitus offering up a sacrifice; two putti playing and two lovers; sleep-

ing Silenus or Hercules with two putti binding him to a vine tree. On the sides of the casket only one complete plaque remains; it represents a man bringing an offering on veiled hands. A fragmentary plaque shows a figure holding a sword over his head. The casket's other silver ornaments, consisting of bands with stamped leafy motifs and tiny spiral palmettes on the lid top, have been compared by Weitzmann to decorations on the Honoratis arch in Sieburg, a work of the Rhine region. The pattern of large palmettes dominant on the body of the casket has been compared by Toesca (1927) to a silver book cover in Zara, a Dalmatian work imitating Rhenish models. The silver handle, in the form of two intertwined dragons, is certainly contemporary with the plaques, even though it has often been considered a later addition. The niello silver lock, also thought to be later, seems consistent with a Rhenish origin of the early thirteenth century. Graeven (1927)

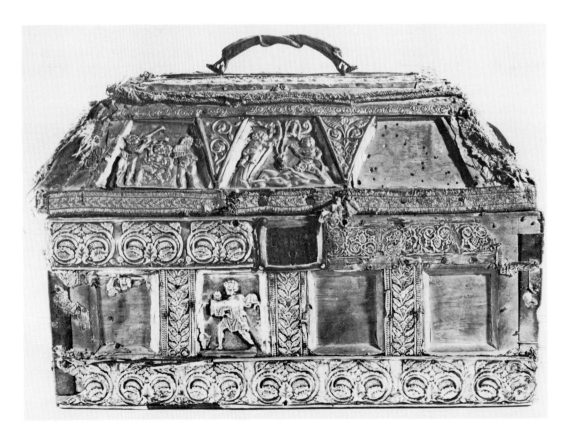

published the casket as a Byzantine work, classing it as a "rosette" ivory casket. Toesca was the first to notice that the figure reliefs are not original creations but are hammered over Byzantine reliefs. Despite this, considering the Western character as a whole, Toesca (1927) attributed it to the Rhine-Meuse regions. Mortari (1963) maintains that the casket was made in Dalmatia. The intricate history of the casket has been clarified by Weitzmann. Though the general shape recalls similar Byzantine ivory caskets, the trapezoidal shape of the plaques on the lid is unusual. The plaques in fact were copied from an octagonal Byzantine rosette casket once in Halle and now known only in an early sixteenth-century drawing. The blocks used for making these two caskets were used to make still another, once in Bamberg, and known in an accurate seventeenth-century drawing. Weitzmann has traced the influence of

the Byzantine models even into the realm of illuminated manuscripts, as in the miniatures of an evangeliary from Speyer now in the Karlsruhe library.

BIBLIOGRAPHY: H. Graeven, "Typen der Wiener Genesis auf byzantinischen Elfenbeinrelief," *Jahrbuch der Kunsthistorischen Sammlungen des allerhöchsten Kaiserhauses,* XXI, 1900, p. 98; P. Toesca, "Cimeli bizantini, il calamaio di un calligrafo, il cofanetto della cattedrale di Anagni," *L'Arte,* IX, 1906, p. 35 f.; C. M. Dalton, *Byzantine Art and Archaeology,* Oxford, 1911, p. 557; Toesca, 1927, pp. 437, 1112, 1145; Goldschmidt-Weitzmann, II, p. 84; K. Weitzman, "Abendländische Kopien byzantinischer Rosettenkästen," *Zeitschrift für Kunstgeschichte,* 1934, p. 89 f.; H. Hermanin, *L'arte in Roma del sec. VIII al XIV,* Rome, 1945, p. 359, L. Mortari, *Mostra di Bonifacio VIII e del primo Giubileo,* Rome, 1950, p. 108; C. Cecchelli, *La vita di Rome nel Mediaevo,* I, Rome, 1952 and 1960, pp. 47, 708; L. Mortari, *Il tesoro della cattedrale di Anagni,* Rome, 1963, p. 40

BIBLIOGRAPHY

A

Aachen, 1965. *Karl der Grosse, Werk und Wirkung*

Abdul-hak, S. *La sculpture des porches du transept de la cathédrale de Chartres,* Paris, 1942

Acta sanctorum quotquot toto orbe coluntur, 69 vols., Brussels, 1863–1931

Adhémar, J. *Influences antiques dans l'art du moyen âge français; recherches sur les sources et les thèmes d'inspiration,* London, 1939

Ainaud de Lasarte, J. *Pintura romanica Catalana,* Barcelona, 1962

d'Alverny, M.-T. *Alain de Lille: Textes inédits avec une introduction sur la vie et sur les œuvres,* Paris, 1965

———. "Les mystères de l'église, d'après Pierre de Roissy," *Mélanges Crozet,* II, Poitiers, 1966, pp. 1085–1104

———. "Un sermon d'Alain de Lille sur la misère de l'homme," *The Classical Tradition: Literary and Historical Studies in Honor of Harry Caplan,* New York, 1966, pp. 513–535

Amsterdam, 1952. *Catalogus van der goud end Zilverwerken,* Rijksmuseum

Analecta Bollandiana, vols. I–LXXXII, Paris-Brussels, 1882–1964

Anastos, M. V. "Some Aspects of Byzantine Influence on Latin Thought," *Twelfth-Century Europe and the Foundations of Modern Society,* Madison, 1957, pp. 131–187

Andersson, A. *English Influence in Norwegian and Swedish Figuresculpture in Wood, 1220–1270,* Stockholm, 1949

Anthony, E. W. *Romanesque Frescoes,* Princeton, 1951

Appleby, J. T. "The Ecclesiastical Foundations of Henry II," *Catholic Historical Review,* XLVIII, 1962, pp. 205–215

Arnaud, A. F. *Voyage archéologique et pittoresque dans le départment de l'Aube . . . ,* Troyes, 1837

Athens, 1964. *Byzantine Art an European Art*

Aubert, M. *La sculpture française du moyen âge et de la renaissance,* Paris, 1926

———. *La sculpture française au début de l'époque gothique, 1140–1225,* Paris, 1929

———. *L'art français à l'époque romane,* 4 vols., Paris, 1929–1950

———. *Vitraux des cathédrales de France, XIIe et XIIIe siècles,* Paris, 1937

———. "Têtes gothiques de Senlis et de Mantes," *Bulletin monumental,* 1938, pp. 5–12

———. "Les statues du Choeur de Saint-Martin d'Angers, aujourd'hui au Musée d'Art de l'Université Yale," Medieval Studies in Memory of A. Kingsley-Porter, II, Cambridge, 1939, pp. 405–412

Aubert, M. *La sculpture française au moyen âge,* Paris, 1946

———. *Le Vitrail en France,* Paris, 1946

———. "Sur les origines de Notre-Dame de Paris," *Scritti di Storia dell'Arte in onore di Mario Salmi,* I, Rome, 1961, pp. 305–307

Aubert, M.—Beaulieu, M. *Description raisonnée des sculptures du moyen âge, Musée National du Louvre,* Paris, 1950

———. "Nouvelles hypothèses sur les 'têtes de Senlis,'" *Mélange L. Blondel,* Geneva, 1963, pp. 257–260

Avery, M. *The Exultet Rolls of South Italy,* II, Princeton, 1936

B

Baker, J. *English Stained Glass,* London, 1960

Baldwin, J. "The Intellectual Preparation for the Canon of 1215 Against Ordeals," *Speculum,* XXXVI, 1961, pp. 613–636

Baltimore, 1947. *Early Christian and Byzantine Art,* The Walters Art Gallery

Baltimore, 1949. *Illuminated Books of the Middle Ages and Renaissance,* The Walters Art Gallery

Baltrusaitis, J. *Le moyen âge fantastique: antiquités et exotismes dans l'art gothique,* Paris, 1955

———. *Réveils et prodiges; le gothique fantastique,* Paris, 1960

Bandmann, G. *Mittelalterliche Architektur als Bedeutungsträger,* Berlin, 1951

Barcelona, 1961. *L'Art Roman*

Baum, J. "Die Malerei und Plastik des Mittelalters in Deutschland, Frankreich und Britannien," *Handbuch der Kunstwissenschaft,* 1930, pp. 288–294

Becksmann, R. *Meisterwerke mittelalterlicher Glasmalerei aus der Sammlung des Reichsfreiherrn vom Stein,* Hamburg, 1966

———. "Das Jesse Fenster aus dem spätromanischen Chor des Freiburger Münsters. Ein Beitrag zur Kunst um 1200," *Zeitschrift des Deutschen Vereins für Kunstwissenschaft,* XXIII, 1969

Beckwith, J. "An ivory relief of the Ascension," *The Burlington Magazine,* XCVIII, 1956, pp. 118–120

———. *The Art of Constantinople,* London, 1961

———. *Early Medieval Art,* New York, 1964

Beech, G. T. *A Rural Society in Medieval France: The bâtine of Poitou in the Eleventh and Twelfth Centuries,* The Johns Hopkins University Studies in Historical and Political Science, LXXXII, Baltimore, 1964

Beenken, H. *Romanische Skulptur in Deutschland,* Leipzig, 1924

———. "Die Mittelstellung der Mitteralterlichen Kunst zwischen Antike und Renaissance," *Medieval Studies in Memory of A. Kingsley Porter,* I, Cambridge, 1939, pp. 47–77

Beer, E. J. *Die Rose der Kathedrale von Lausanne,* Bern, 1952

———. *Die Glasmalereien der Schweiz vom 12. bis zum Beginn des 14. Jahrhunderts,* Corpus Vitrearum Medii Aevi, Basel, 1956

———. *Das Evangelistar aus St. Peter,* Basel, 1961

———. "Gotische Buchmalerei, Literatur von 1945 bis 1961," *Zeitschrift für Kunstgeschichte,* 28, 1965, pp. 134–158

Bégule, L. *Monographie de la cathédrale de Lyon,* Paris, 1880

Behling, L. "Ecclesia als Arbor bona. Zum Sinngchalt einige Pflanzendarstellungen des 12. und frühen 13. Jahrhunderts," *Zeitschrift für Kunstwissenschaft,* XIII, 1959

———. *Die Pflanzenwelt der mittelalterlichen Kathedralen,* Cologne-Graz, 1964

Benson, G. *The Ancient Painted Glass Windows in the Minster and Churches of the City of York,* York, 1915

Benton, J. F. "The Court of Champagne as a Literary Center," *Speculum,* XXXVI, 1961, pp. 551–591

Berg, K. *Studies in Tuscan 12th-Century Painting,* Oslo, 1968

Berlin, 1966. *Bildwerke der christlichen Epochen von der Spatnaike bis zum Klassizismus*

Bernheimer, R. *Romanische Tierplastik und die Ursprünge ihrer Motive,* Munich, 1931

Bertaux, E. *L'art dans l'Italie Meridionale,* Paris, 1904

Beutler, C. "Die Aachener Madonna und der Kruzifixus von Nideggen," *Aachener Kunstblätter,* 17–18, 1958–59, pp. 42–46

Beyer, V. "Le Vitrail," *La cathédrale de Strasbourg,* Strasbourg, 1957, pp. 95–130

———. "Rosaces et roues de fortune à la fin de l'art roman et au début de l'art gothique," *Zeitschrift für Schweizerische Archäologie und Kunstgeschichte,* XXII, 1962, pp. 34–43

———. *Les vitraux des musées de Strasbourg,* Strasbourg, 1966

Biebel, F. M. "XII Century French Window," *Bulletin of the City Art Museum of St. Louis,* XX, 1935, pp. 48–52

Bingen, H. v. *Wisse die Wege. Scivias,* Salzburg, 1954

Blindheim, M. *Norwegian Romanesque Decorative Sculpture,* 1090–1210, London, 1965

Bloch, M. *Feudal Society,* 2 vols., Chicago, 1964

Bloch, P. "Das Steinfeld-Missale," *Aachener Kunstblätter,* 22, 1961, pp. 37–60

Blumenkranz, B. *Le juif médiéval au miroir de l'art chrétien,* Paris, 1966

Boase, T. S. R. *English Romanesque Illumination,* Oxford, 1951

———. *English Art, 1100–1216,* Oxford, 1953

———. *Castles and Churches of the Crusading Kingdom,* Oxford, 1967

Bober, H. "An illustrated medieval schoolbook of Bede's *De natura rerum*," *Journal of the Walters Art Gallery,* 19–20, 1956–57, pp. 64–97

———. *The St. Blasien Psalter,* New York, 1963

Boeckler, A. *Das Stuttgarter Passionale,* Augsberg, 1923

———. *Die Regensburg-Prüfeninger Buchmalerei des XII und XIII Jahrhunderts,* Munich, 1924

———. *Abendländische Miniaturen bis zum Ausgang der Romanischen Zeit,* Berlin-Leipzig, 1930

———. *Die Bronzetür von Verona,* Marburg-Lahn, 1931

———. *Deutsche Buchmalerei vorgotischer Zeit,* Königstein im Taunus, 1952

———. *Die Bronzetüren des Bonanus von Pisa und des Barisanus von Trani,* Berlin, 1953

Bony, J. "La collégiale de Mantes," *Congrès archéologique de France,* CVI, 1947, pp. 163–220

———. *Transition from Romanesque to Gothic,* Studies in Western Art: Acts of the Twentieth International Congress of the History of Art, New York, 1963, 1, pp. 81–84

Borchgrave d'Altena, J. D. *Art Mosan,* Brussels, 1951

———. "Madones en Majesté, A propos de Notre-Dame d'Eprave," *Revue belge d'archéologie et d'histoire de l'art,* XXX, 1961, pp. 3–114

———. *Madones anciennes conservées en Belgique, 1025–1425,* Brussels, 1963

———. "A propos de l'art en pays mosan," *Miscellanea pro Arte Medii Aevi: Festschrift H. Schnitzler,* Düsseldorf, 1965, pp. 144–148

———. "Apports et influences des ateliers mosans et d'entre Sambre et Meuse," *Les monuments historiques de la France,* 1966, pp. 93–112

Borenius, T. *St. Thomas Beckett in Art,* London, 1932

Borenius, T.—Chamot, M. "On a Group of Early Enamels Possibly English," *The Burlington Magazine,* LIII, 1948, pp. 276–287

Boston, 1940. *Arts of the Middle Ages, 1000–1400,* Museum of Fine Arts

Boussard, J. "Influences insulaires dans la formation de l'écriture gothique," *Scriptorium,* V, 1951, pp. 238–264

Brachmann, H. "Zwei gravierte Metallschüsseln aus Dabrun, Kr. Wittenberg," *Wissenschaftliche Zeitschrift der Martin Luther Universität,* II, 1962, pp. 1085–1090

Brand, C. M. "The Byzantine and Saladin, 1185–1192: Opponents of the Third Crusade," *Speculum,* XXXVII, 1962, pp. 167–181

———. "A Byzantine Plan for the Fourth Crusade," *Speculum,* LXIII, 1968, pp. 462–475

———. *Byzantium Confronts the West 1180–1204,* Cambridge, 1968

Branner, R. "Une statue gothique inconnue de Sens," *Bulletin monumental,* CXVIII, 1960, pp. 207–209

———. *Gothic Architecture,* New York, 1961

———. "Historical Aspects of the Reconstruction of Reims Cathedral, 1210–1241," *Speculum,* XXXVI, 1961, pp. 23–37

———. "Keystones and Kings," *Gazette des Beaux-Arts,* LVII, 1961, pp. 65–82

———. *La cathédrale de Bourges,* Paris-Bourges, 1962

Branner, R. "Paris and the Origins of Rayonnant Gothic Architecture Down to 1240," *The Art Bulletin*, LIV, 1962, pp. 39–51

———. "The Manerius Signatures," *The Art Bulletin*, L, 1968, p. 183

Braun, J. *Das Christliche Altargerät, in seinem Sein und in seiner Entwicklung,* Munich, 1932

———. *Die Reliquiare des christlichen Kultes und ihre Entwicklung,* Freiburg, 1940

Brentano, R. *Two Churches: England and Italy in the Thirteenth Century,* Princeton, 1968

Brieger, P. *English Art 1216–1307,* Oxford, 1957

Broutte, E. "Une influence byzantine dans les sceaux épiscopaux lotharingiens du XIIᵉ siècles," *Revue belge de numismatique,* LVIII, 1962, pp. 225–234

Brussels, 1964. *Art Chrétien jusqu'à la fin du moyen âge,* Musées Royaux d'art et d'histoire

Bucher, F. *The Pamplona Bibles, 1197–1200 A.D. Reasons for Changes in Iconography,* Akten des 21. Internationalen Kongress für Kunstgeschichte in Bonn, 1964, I, Berlin, 1967, pp. 131–139

Buchthal, H. "A School of Miniature Painting in Norman Sicily," *Late Classical and Medieval Studies in Honor of A. M. Friend, Jr.,* Princeton, 1955, pp. 312–339

———. "The Beginnings of Manuscript Illumination in Norman Sicily," *Studies in Italian Medieval History presented to Miss E. M. Jamison,* London, 1956, pp. 78–85

———. *Miniature Painting in the Latin Kingdom of Jerusalem,* Oxford, 1957

———. "A Byzantine Miniature of the fourth Evangelist and its relatives," *Dumbarton Oaks Papers,* 15, 1961, pp. 129–139

———. "An Unknown Byzantine Manuscript of the Thirteenth Century," *The Connoisseur,* 155, 1964, pp. 217–224

Buchwald, H. "The Carved Stone Ornament of the High Middle Ages in San Marco, Venice," *Jahrbuch der Österreichischen Byzantinischen Gesellschaft,* XI–XII, 1962–3, pp. 169–210

———. "The Carved Stone Ornament of the High Middle Ages in San Marco, Venice," *Jahrbuch der Österreichischen Byzantinischen Gesellschaft,* XIII, 1964, pp. 137–170

Buddensieg, T. "Die Basler Altarafel Heinrichs II," *Wallraf-Richartz-Jahrbuch,* XIX, 1957, p. 133 f.

Byzantine Art an European Art: Lectures, Athens, 1966

C

Cahier, A.–Martin, C. *Monographie de la cathédrale de Bourges,* 2 vols., Paris, 1841–1844

Caiger-Smith, A. *English Medieval Mural Painting,* London, 1963

Cames, G. "Un nouveau fleuron de l'enluminure romane en Alsace: L'Evangelistaire de Saint-Pierre, Pergament 7 à Karlsruhe," *Cahiers alsaciens d'archéologie d'art et d'histoire,* VII, 1963, pp. 43–72

Cames, G. "Les plus anciens vitraux de la cathedrale de Strasbourg," *Cahiers alsaciens d'archéologie d'art et d'histoire,* VIII, 1964, pp. 101–126

Cantor, N. F. *The Medieval World,* New York, 1968

———. *Medieval History. The Life and Death of a Civilization,* New York, 1969

Cassart, J. "Les madones anciennes du diocèse de Tournai," *La Revue diocésaine de Tournai,* IX, 1954, pp. 497–506

Caviness, M. "A Panel of Thirteenth-Century Stained Glass, from Canterbury Cathedral, in America," *The Antiquaries Journal,* XLV, 1965, pp. 192–199

Chamot, M. *English Medieval Enamels,* London, 1930

Chenu, M. D. *Nature, Man, and Society in the Twelfth Century: Essays on New Theological Perspectives in the Latin West,* Chicago, 1968

Clagett, M. *The Science of Mechanics in the Middle Ages,* London, 1967

Clark, K. W. *A Descriptive Catalogue of Greek New Testament Manuscripts in America,* Chicago, 1937

Clemen, P. *Die romanische Monumentalmalerei in den Rheinlanden,* Düsseldorf, 1916

Cleveland Museum of Art. *Handbook of The Cleveland Museum of Art,* Cleveland, 1967

Cleveland, 1967. *Treasures from Medieval France,* The Cleveland Museum of Art

Colby, A. M. *The Portrait in Twelfth-Century French Literature: An Example of the Stylistic Originality of Chrétien de Troyes,* Geneva, 1965

Collas, J. P. "The Romantic Hero of the Twelfth Century," *Medieval Miscellany Presented to Eugène Vinaver,* New York, 1965, pp. 80–96

Collon-Gevaert, S. *Histoire des arts du métal en Belgique,* Brussels, 1951

Collon-Gevaert, S.–Lejeune, R.–Stiennan, J. *Art Mosan aux XIᵉ et XIIᵉ siècles,* Brussels, 1961

Cologne, 1960. *Grosse Kunst des Mittelalters aus Privatbesitz,* Schnütgen Museum

Cologne, 1964. *Der Meister des Dreikönigenschreins,* Diözesan-Museum

Cologne, 1968. *Eine Auswahl,* Schnütgen Museum

Cologne-Hüpsch, 1964. *Sammlungen des Baron von Hüpsch. Ein Kölner Kunstkabinett um 1800,* Schnütgen Museum

Colwell, E. C.–Willoughby, H. R. *The Four Gospels of Karahissar,* 2 vols., Chicago, 1936

Copleston, F. S. J. *A History of Philosophy,* III, New York, 1962

Coppier, A. C. "Le rôle artistique et social des orfèvres-graveurs français au Moyen Age," *Gazette des Beaux-Arts,* XVII, 1937, pp. 261–282

Corvey, 1966. *Kunst und Kultur im Weserraum*

Cott, P. B. *Siculo-Arabic Ivories,* Princeton, 1939

Courajod, L. *Leçons professées à l'Ecole du Louvre (1887–1896): Origines de l'art roman et gothique,* I, Paris, 1899

Couteur, J. D. *English Mediaeval Painted Glass,* London, 1932

Courtoy, F. *Trésor du prieuré d'Oignies,* Brussels, 1953

Crichton, G. H. *Romanesque Sculpture in Italy,* London, 1954

Crombie, A. C. *Medieval and Early Modern Science,* 2 vols., New York, 1959

Crooy, F. *Les émaux carolingiens de la châsse de Saint Marc à Huy-sur-Meuse,* Paris-Brussels, 1948

D

Dale, W. S. A. "An English Crosier of the Transitional Period," *The Art Bulletin,* XXXVIII, 1956, pp. 137–141

Dalton, O. M. *Catalogue of the Ivory Carvings of the Christian era . . . ,* London, 1909

————. *Byzantine Art and Archaeology,* Oxford, 1911

————. *Catalogue of the Medieval Ivories, Enamels, Jewelery, Gems and Miscellaneous Objects Bequeathed to the Museum by Frank McClean . . . , Fitzwilliam Museum,* Cambridge, 1912

Daly, L. *Benedictine Monasticism, its Formation and Development Through the 12th Century,* New York, 1965

Darcel, A.—Basilewski, A. *Collection Basilewski,* Paris, 1874

Darkevitch, V. P. "Objects of Western Workmanship found in Eastern Europe (X–XIV centuries)," *Arkheologia of USSR,* E1–57, Moscow, 1966

Davidsohn, R. *Philipp II. August von Frankreich und Ingeborg,* Stuttgart, 1888

Davy, M.-M. *Essai sur la symbolique romane,* Paris, 1955

————. *Initiation à la symbolique romane,* Paris, 1964

Debidour, V.-H. *Le bestiaire sculpté du moyen âge en France,* Grenoble, 1961

Decker, H. *Romanesque Art in Italy,* New York, 1959

Deér, J. *Der Kaisernornat Friedrichs II,* Berne, 1952

————. "Die Baseler Löwenkamee und der Süditalienische Gemmenschnitt des 12. und 13. Jahrhunderts. Ein Beitrag zur Geschichte der abendländischen Protorenaissance," *Zeitschrift für Schweizerische Archäologie und Kunstgeschichte,* XIV, 1953, pp. 129–158

————. *The Dynastic Porphyry Tombs of the Norman Period in Sicily,* Cambridge, 1959

————. "Die Siegel Kaiser Friedrichs I Barbarossa und Heinrichs VI in der Kunst und Politik ihrer Zeit," *Festschrift H. R. Hahnloser,* Basel-Stuttgart, 1961, pp. 47–102

————. *Die heilige Krone Ungarns,* Österreich. Akademie der Wissenschaften Philologischhistorische klasse Denkschriften, 91, Vienna, 1966

Degenhart, B. "Autonome Zeichnungen bei mittelalterlichen Künstlern," *Münchener Jahrbuch der bildenden Kunst,* 1, 1950, pp. 93–158

Delaporte, Y. *Les vitraux de la cathédrale de Chartres,* Chartres, 1926

————. "Vitraux anciens récemment découverts dans l'eglise Saint-Pierre de Dreux," *Bulletin monumental,* 4, 1938, pp. 425–428

Demelius, U. *Das Orationale von St. Ehrentrud. Das Salzburger Lektionar Untersuchung zweier Salzburger Handschriften des 13. Jahrhunderts unter Berücksichtigung ihres Verhältnisses zu Byzanz,* Vienna, 1965

Demus, O. *Die Mosaiken von San Marco in Venedig 1100–1300,* Vienna, 1935

————. "Studies among the Torcello Mosaics," *The Burlington Magazine,* LXXXII, 1943, pp. 136–141

————. "Studies among the Torcello Mosaics," *The Burlington Magazine,* LXXXIII, 1944, pp. 41–44, pp. 195–200

————. "Byzantinische Mosaikminiaturen," *Phaidros,* III, 1947, pp. 190–194

————. *The Mosaics of Norman Sicily,* London, 1950

————. "Regensburg, Sizilien und Venedig. Zur Frage des Byzantinischen Einflusses in der Romanischen Wandmalerei," *Jahrbuch der Österreichischen Byzantinischen Gesellschaft,* II, 1952, pp. 95–104

————. "A Renascence of Early Christian Art in Thirteenth-Century Venice," *Late Classical and Medieval Studies in Honor of A. M. Friend, Jr.,* Princeton, 1954, pp. 348–361

————. "Die Reliefikonen der Westfassade von San Marco," *Jahrbuch der Österreichischen Byzantinischen Gesellschaft,* III, 1954, pp. 87–108

————. *Die Entstehung des Paläologenstils in der Malerei,* Akten des Internationalen Byzantinisten Kongresses, IV, 2, Munich, 1958

————. "Salzburg, Venedig und Aquileia," *Festschrift Karl Maria Swoboda,* Vienna, 1959, pp. 75–82

————. "Studien zur byzantinischen Buchmalerei des 13. Jahrhunderts," *Jahrbuch der Österreichischen Byzantinischen Gesellschaft,* IX, 1960, pp. 77–89

————. "The Church of San Marco in Venice: History, Architecture, Sculpture," *Dumbarton Oaks Studies,* VI, 1960

————. "The Role of Byzantine Art in Europe," *Byzantine Art an European Art,* Athens, 1964, pp. 89–110

————. "Ein Madonnenrelief in Seckau," *Miscellanea pro Arte Medii Aevi: Festschrift H. Schnitzler,* Düsseldorf, 1965, pp. 158–162

————. *Romanische Wandmalerei,* Munich, 1968

Dept, G. G. *Les influences anglaises et françaises dans le comté de Flandre,* Ghent, 1928

Der Nersessian, S. *Manuscrits Arméniens illuminés,* Paris, 1936

————. "Two Images of the Virgin in the Dumbarton Oaks Collection," *Dumbarton Oaks Papers,* 14, 1960, pp. 69–86

————. *Agth'amar. Church of the Holy Cross,* Harvard Armenian Texts and Studies, 1, Cambridge, 1965

Deschamps, P.—Thibout, M. *La peinture murale en France. Le haut moyen âge et l'époque romane,* Paris, 1951

————. *La peinture murale en France au début de l'époque Gothique de Philippe-Auguste à la fin du règne de Charles V (1180–1380),* Paris, 1963

Destrée, J. "La Vierge et l'enfant: groupe en bois provenant d'Oignies," *La Revue d'art,* 3–4, 1925

Deuchler, F. *Zur Kunsttopographischen Einordung des Ingeborgpsalters, Der englische Anteil,* Actes du XIXᵉ congrès international d'histoire de l'art, Paris, 1958, pp. 180–182

————. *Der Ingeborgpsalter,* Berlin, 1967

Deus, W. H. *Das Scheibenkreuze in Soest auf Gotland und Anderswo,* Soest, 1967

Devigne, M. *La sculpture mosane du XIIe au XVIe siècle*, Paris-Brussels, 1932

―――― . *Note sur des émaux conservés à Notre Dame de Huy*, Actes du congrès de l'association française pour l'avancement des sciences, Liége, 1939

Diehl, C. *Manuel d'art byzantin*, Paris, 1925

―――― . *La peinture byzantine*, Paris, 1933

Diez, E.―Demus, O. *Byzantine Mosaics in Greece. Hosios Lucas and Daphni*, Cambridge, 1931

Dinkler-Schubert, E. *Der Schrein der Hl. Elisabeth zu Marburg, Studien zur Schrein-Ikonographie*, Marburg-Lahn, 1964

Dodwell, C. R. *The Canterbury School of Illumination, 1066-1200*, Cambridge, 1954

―――― . *The Great Lambeth Bible*, London, 1959

Dominguez Bordona, J. *Manuscritos con pinturas*, 2 vols., Madrid, 1933

Donnelly, M. C.―Smith, C. S. "Notes on a Romanesque Reliquary," *Gazette des Beaux-Arts*, LVIII, 1961, pp. 109-118

Drexler, K.―Stromer, T. *Der Verduner Altar im Stifte Klosterneuburg*, Vienna, 1903

Dronke, P. *Medieval Latin and the Rise of European Love-Lyric*, Oxford, 1966

Duby, G. *L'économie rurale et la vie des campagnes dans l'occident médiéval*, 2 vols., Paris, 1962

―――― . *L'Europe des cathédrales, 1140-1280*, Geneva, 1966

Duby, G.―Mandrou, R. *History of French Civilization*, New York, 1964

Dufrenne, S. "Les copies anglaises du Psautier d'Utrecht," *Scriptorium*, XVIII, 1964, pp. 185-97

Duggan, C. *Twelfth-Century Decretal Collections and their Importance in English History*, University of London Historical Studies, XII, London, 1963

Dumbarton Oaks. *Handbook of the Byzantine Collection*, Washington, D.C., 1967

Dunlop, D. M. *Arabic Science in the West*, Karachi, 1958

Durham, 1967. *Sculpture and Decorative Art, a loan exhibition of selected art works from the Brummer Collection of Duke University*

Durliat, M. *L'art dans le royaume de Majorque. Les débuts de l'art gothique en Roussillon, en Cerdagne, et aux Baléaren*, Paris, 1962

Dürst, H. *Rittertum. Schweizerische Dokumente: Hochadel im Argau. Kantonale Historische Sammlung*, Lenzburg, 1962

E

Echivard, A. "Les Vitraux de la Cathédrale du Mans," *Revue historique et archéologique du Maine*, 1913, pp. 7-17

Einem, H. v. "Die Monumental plastik des Mittelalters und ihr Verhältnis zur Antike," *Antike und Abendland*, III, 1948, pp. 120-151

―――― . *Das Stüzengeschoss der Pisaner Dom Kanzel*, Cologne-Opleden, 1962

Elbern, V. H. "Der eucharistische Kelch im frühen Mittelalter, Teil II: Ikonographie und Symbolik," *Zeitschrift des Deutschen Vereins für Kunstwissenschaft*, 17, 1963, pp. 117-188

Ericsson, T. "L'échelle de la perfection. Une nouvelle interprétation de la peinture murale de Chaldon," *Cahiers de civilisation médiévale*, VII, 1964, pp. 439-449

Erlande-Brandenburg, A. "Le cimetière des rois à Fontevrault," *Congrès archéologique de France*, 122, 1964, pp. 482-492

―――― . "Une tête de style sénonais," *Bulletin monumental*, CXXV, 1967, pp. 415-418

Evans, J. *Art in Mediaeval France, 987-1498. A Study in Patronage*, Oxford, 1948

―――― . *A History of Jewellery, 1100-1870*, New York, 1953

―――― . *Life in Medieval France*, New York, 1957

F

Falke, O. *Sammlung alter goldschmiedewerke im Zürcher Kunsthaus*, Zurich, 1926

―――― . "Der bronzeleuchter des Mailander Doms," *Pantheon*, VII, 1931

―――― . "Romanische Emailarbeiten von Limoges," *Pantheon*, VIII, 1931, pp. 282-285

―――― . "Die Inkunbeln der romanischen Kupferschmelz Kunst," *Pantheon*, XVII, 1936, pp. 166-169

Falke, O.―Frauberger, H. *Deutsche Schmelzarbeiten des Mittelalters*, Frankfurt am Main, 1904

Falke, O.―Meyer, E. *Romanische Leuchter und Gefässe, Giessgefässe der Gotik*, Berlin, 1935

Falke, O.―Schmidt, R.―Swarzenski, G. *Der Welfenschatz*, Frankfurt, 1930

Faral, E. *Les arts poétiques du XIIe et du XIIIe siècle*, Paris, 1958

Fischer, J. L. *Handbuch der Glasmalerei*, Leipzig, 1937

Flamm, H. "Eine Miniatur aus dem Kreise der Herrad von Landsberg," *Repertorium für Kunstwissenschaft*, XXXVII, 1914, pp. 123-162

Forrer, R. *Unedierte Federzeichnungen un Italialen des Mittelalters*, II, Strasbourg, 1907

Forsyth, G. H., Jr. *The Church of St. Martin of Angers*, Princeton, 1953

Forsyth, W. H. "Around Godefroid de Claire," *The Metropolitan Museum of Art Bulletin*, 24, 1966, pp. 304-315

Francastel, P. *L'Art Mosan*, Paris, 1953

Francovich, G. *Benedetto Antelami*, Milan-Florence, 1953

Frankfurt am Main, 1962. *Bildwerke aus dem Liebieghaus*, Museum alter Plastik

Frankl, P. *The Gothic: Literary Sources and Interpretations Through Eight Centuries*, Princeton, 1960

―――― . "The Chronology of the Stained Glass in Chartres Cathedral," *The Art Bulletin*, XLV, 1963, pp. 301-322

Frantz, M. A. "Byzantine Illuminated Ornament," *The Art Bulletin*, XVI, 1934, pp. 43–76

Freeman, M. B. "A Saint to Treasure," *The Metropolitan Museum of Art Bulletin*, 14, 1956, pp. 237–245

Frey, D. *Gotik und Renaissance als Grundlagen der modernen Weltanschauung*, Augsburg, 1929

_____. *Kunstwissenschaftliche Grundfragen, Prolegomena zu einer Kunstphilosophie*, Vienna, 1946

Friend, A. M. "Portraits of the Evangelists in Greek and Latin Manuscripts, Part I," *Art Studies*, V, 1927, pp. 115–147

_____. "Portraits of the Evangelists in Greek and Latin Manuscripts, Part II," *Art Studies*, VII, 1929, pp. 3–29

Frisch, T. G. "The Twelve Choir Statues of the Cathedral at Reims," *The Art Bulletin*, XLII, 1960, pp. 1–24

Fritz, R. "Der Kruzifixus von Cappenberg, ein Meisterwerk französischer Bildhauerkunst," *Westfalen*, 31, 1953, pp. 204–218

Frolow, A. *La relique de la vraie croix*, Paris, 1961

_____. "L'origine des personnages hanchés dans l'art gothique," *Revue archéologique*, I, 1965, pp. 65–82

_____. *Les reliquaires de la vraie croix*, Paris, 1965

Fuchs, A. *Kunstgabe des Vereins für Christliche Kunst im Erzbistum*, Cologne, 1938

Fugmann, M. *Frühgotische Reliquiare*, Düsseldorf-Bonn, 1931

Fuss, K. *Der frühgotische Roman*, Studien zur Geistesgeschichte des ausgehenden 12. Jahrhunderts, Würzburg, 1941

G

Gaillard, G. "De la diversité des styles dans la sculpture romane des pélerinages," *Revue des arts*, 1, 1951, pp. 77–87

_____. *Sculptures espagnoles de la deuxième moitié du XIIe siècle*, Acts of the Twentieth International Congress of the History of Art, I, Princeton, 1963

Ganshof, F. L. *Feudalism*, New York, 1964

Gantner, J. *Romanische Plastik. Inhalt und form in der Kunst des XI. und XII. Jahrhunderts*, Vienna, 1948

_____. *Gallia Romanica; Die hohe Kunst der romanischen Epoche in Frankreich*, Vienna, 1955

Gardner, A. *Medieval Sculpture in France*, Cambridge, 1931

_____. *English Medieval Sculpture*, Cambridge, 1951

Garrison, E. B. *Italian Romanesque Panel Painting*, Florence, 1949

_____. *Studies in the History of Mediaeval Italian Painting*, 4 vols., Florence, 1953–1962

Gauthier, M.-M. *Emaux limousins champlevés des XIIe, XIIIe, XIVe siècles*, Paris, 1950

_____. "Emaillerie mosane et émaillerie limousine au XIIe et XIIIe siècles," *L'Art Mosan*, Paris, 1953

_____. "Les émaux champlevés limousins et l'œuvre de Limoges," *Cahiers de la céramique*, VIII, 1957, pp. 146–167

_____. "Les décors Vermiculés dans les émaux champlevés limousins et méridionaux," *Cahiers de civilization médiévale*, I, 1958, pp. 349–369

Gauthier, M.-M. "Les émaux limousins champlevés," *L'Information d'histoire de l'art*, III, 1958, pp. 67–78

_____. *Emaux champlevés méridionaux d'après l'exposition internationale d'art roman*, Actes du 87e congrès national des sociétés savantes, Poitiers, 1962, pp. 371–381

_____. "Dossiers: Coffret eucharistique provenant du tresor de l'abbaye de Grandmont," *L'Information d'histoire de l'art*, IX, 1964, pp. 81–83

_____. "Emaillerie champlevée méridionale, maîtres et ateliers, note sur les méthodes de recherche," *Bulletin de la Société archéologique et historique du Limousin*, 91, 1964, pp. 68–69

_____. "Croix d'émail champlevé de Limoges à Hanovre Kestner Museum, et à Reykjavik, Thjodminjasain (Musée national)," *Bulletin de la Société archéologique et historique du Limousin*, 92, 1965, pp. 97–105

_____. "Une châsse limousine du dernier quart du XIIe siècle: thèmes iconographiques, composition et essai de chronologie," *Mélanges Crozet*, II, Poitiers, 1966, pp. 937–952

_____. *Le goût Plantagenet*, Akten des 21. International Kunst Kongresses für Kunstgeschichte in Bonn, 1964, 1, Berlin, 1967, pp. 139–155

_____. "Les reliures en émail de Limoges conservées en France, recensement raisonné," *Mélanges d'art et de littérature offerts à Julien Cain*, Paris, 1968

_____. "Une croix émaillée à double traverse au Musée Municipal de Limoges," *Revue de l'Art*, 3, 1969, pp. 9–17

Geiges, F. *Der mittelalterliche Fensterschmuck des Freiburger Münsters*, Freiburg im Breisgau, 1931

Gillen, O. *Ikonographische Studien zum Hortus Deliciarum der Herrad von Landsberg*, Kunstwissenschaftliche Studien, IX, 1931

Gimpel, J. *The Cathedral Builders*, New York, 1961

Godwin, F. G. "The Judith Illustration of the Hortus Deliciarum," *Gazette des Beaux-Arts*, XXXVI, 1949, pp. 25–46

Goetz, O. "Medieval enamels and metalwork in the Buckingham Collection," *Bulletin of the Art Institute of Chicago*, 38, 1944, pp. 106–112

Goldschmidt, A. "Die Stilentwicklung der romanischen Skulptur in Sachsen," *Jahrbuch der Königlich Preussischen Kunstsammlungen*, XXI, 1900, pp. 225–241

_____. *Das Evangeliar im Rathaus zu Goslar*, Berlin, 1910

_____. *Die Elfenbeinskulpturen aus der Zeit der karolingischen und sächsischen Kaiser*, 4 vols., Berlin, 1914–1926

_____. "Das Naumburger Lettnerkreuz im Kaiser-Friedrich-Museum in Berlin," *Jahrbuch der Königlich Preussischen Kunstsammlungen*, 36, 1915, pp. 137–152

_____. *Die Skulpturen in Freiberg und Wechselburg*, Berlin, 1924

_____. "English Influence on Medieval Art of the Continent," *Mediaeval Studies in Memory of A. Kingsley Porter*, Cambridge, 1939, pp. 709–720

Goldschmidt, A.—Weitzmann, K. *Die byzantinischen Elfenbeinskulpturen des X.-XIII. Jahrhunderts*, 2 vols., Berlin, 1931–1934

Gonzalez, M. J. J. "Arte español de Transición al Gótico," *Goya*, 43–45, 1961, pp. 168–178

Goodspeed, E. J.—Riddle, D. W.—Willoughby, H. R. *The Rockefeller McCormick New Testament*, 3 vols., Chicago, 1932

Grabar, A. "Une décoration murale byzantine au monastère de Batchkovo en Bulgarie," *Bulletin de l'Institut archéologique Bulgare*, II, 1923–1924, pp. 1–68

———. "Quelques reliquaires de Saint Démétrios et le martyrium du Saint à Salonique," *Dumbarton Oaks Papers*, 5, 1950, pp. 1–28

———. "Le succès des arts orientaux à la cour Byzantine sous les Macédoniens," *Münchener Jahrbuch der Bildenden Kunst*, II, 1951, p. 76 f.

———. "Orfèvrerie mosane, orfèvrerie byzantine," *Art mosan*, Paris, 1953, pp. 119–126

Grabar, A.—Nordenfalk, C. *Die romanische Malerei von 11. bis zum 13. Jahrhundert*, Geneva, 1958

Graham, H. B. "A Reappraisal of the Princeton Window from Chartres," *Record of the Art Museum, Princeton University*, XXI, 1962, pp. 30–45

Grandgent, C. H. *From Latin to Italian*, Cambridge, 1933

Grayzel, S. *The Church and the Jews in the XIII Century: A Study of their Relations during the Years 1198–1254*, New York, 1966

Green, R. B. "The Flabellum of Hohenbourg," *The Art Bulletin*, XXXIII, 1951, pp. 135–155

———. "The Adam and Eve Cycle in the Hortus Deliciarum," *Late Classical and Medieval Studies in Honor of Albert Mathias Friend, Jr.*, Princeton, 1955, pp. 340–347

Greenhill, E. S. *Die geistigen Voraussetzungen der Bilderreihe des Speculum Virginum*, Münster, 1962

———. "The Provenance of a Gothic Head," *The Art Bulletin*, XLIX, 1967, pp. 101–110

Grillmeier, A. *Der Logos am Kreuz*, Munich, 1956

Grimme, E. G. "Das heilige Kreuz von Engelberg," *Aachener Kunstblätter*, 35, 1968, pp. 21–105

Grodecki, L. *Ivoires français*, Paris, 1947

———. *Vitraux des églises de France*, Paris, 1947

———. "A Stained Glass 'Atelier' of the Thirteenth Century," *Journal of the Warburg and Courtauld Institutes*, 1948, pp. 87–111

———. "Le vitrail et l'architecture au XIIe et au XIIIe siècles," *Gazette des Beaux-Arts*, 1949, pp. 5–24

———. "The transept portals of Chartres cathedral," *The Art Bulletin*, XXXIII, 1951, pp. 156–164

———. "Les Vitraux de la Cathédrale de Poitiers," *Congrès archéologique de France*, CIX, 1951, pp. 138–163

———. "Quelques Observations sur le vitrail au XIIe siècle en Rhénanie et en France," *Memorial de la Société Nationale des Antiquaires de France*, Paris, 1953, pp. 241–248

———. *Vitraux de France du XIe au XVIe siècle*, Paris, 1953

Grodecki, L. "Rapport du 23 Mars," *Bulletin de la Société Nationale des Antiquaires de France*, Paris, 1954–1955, p. 127

———. "A propos de la sculpture française autour de 1200," *Bulletin monumental*, 115, 1957, pp. 119–126

———. "La première sculpture gothique: Wilhelm Vöge et l'état actuel des problèmes," *Bulletin monumental*, 117, 1959, pp. 265–289

———. "Les vitraux soissonnais de Louvre, du Musée Marmottan et des collections américaines," *Revue des Arts*, 10, 1960, pp. 163–178

———. "Les vitraux de Saint-Denis. L'enfance du Christ," *De Artibus opuscula: Essays in Honor of Erwin Panofsky*, New York, 1961, pp. 170–186

———. "Les vitraux de la cathédrale du Mans," *Congrès archéologique de France*, CXIX, 1961, pp. 59–99

———. "Vitraux de la fin du XIIe siècle ou du debut du XIIIe siècle à la cathédrale de Troyes," *Bulletin de la société nationale des antiquaires de France*, 1961, pp. 57–58

———. *Chartres*, Paris, 1963

———. *Problèmes de la peinture en Champagne pendant la seconde moitié du XIIe siècle*, Studies in Western Art: Romanesque and Gothic, Acts of the Twentieth International Congress of the History of Art, Princeton, 1963, pp. 129–141

———. "Le maître de la châsse des Rois Mages," *Bulletin monumental*, 123, 1965, pp. 135–138

———. "Le maître de Saint-Eustache de la cathédrale de Chartres," *Gedenkschrift E. Gall*, Berlin, 1965, pp. 171–194

———. "Les vitraux du XIIe siècle de St. Germer-de-Fly," *Miscellanea Pro Arte Medii Aevi: Festschrift H. Schnitzler*, Düsseldorf, 1965, pp. 149–157

———. "Le psautier de la reine Ingeburge et ses problèmes," *Revue de l'Art*, 5, 1969, pp. 73–78

Grodecki, L.—Lafond, J. *Les vitraux de Notre-Dame et de la Sainte-Chapelle de Paris*, Corpus Vitrearum Medii Aevi, 1, Paris, 1959

Grosset, C. "Les sculptures du portail sud de Notre-Dame d'Etampes," *Cahiers de civilization médiévale*, VII, 1964, pp. 53–61

Gsodam, G. "Die Fresken von Nerezi, Ein Beitrag zum Problem ihrer Datierung," *Festschrift W. Sas-Zaloziecky zum 60. Geburtstag*, Graz, 1956, pp. 86–89

Guignard, J. "La miniature gothique. Le psautier d'Ingeburge," *Art de France*, I, 1961, pp. 278–280

Guilmain, J. "The Forgotten Medieval Artist," *Art Journal*, XXV, 1965, pp. 33–42

Guldan, E. *Eva und Maria: Eine Antithese als Bildmotiv*, Graz-Cologne, 1966

Gülden, J.—Rothe, E.—Opfermann, B. *Brandenburger Evangelistar*, Düsseldorf, 1962

H

Hackenbroch, Y. *Italienisches Email des Frühen Mittelalters*, Basel-Leipzig, 1938

Hadermann-Misguich, L. "Tendances expressives et recherches ornementales dans la peinture Byzantine de la seconde moitié du XIIe siècle," *Byzantion*, XXXV, 1965, pp. 429–448

Hager, H. *Die Anfänge des italienischen Altarbildes*, Römische Forschungen der Bibliotheca Hertziana, XVII, Munich, 1962

Hahnloser, H. R. *Villard de Honnecourt, Kritische Gesamtausgabe des Bauhüttenbuches, MS. fr. 19093 der Pariser Nationalbibliothek*, Vienna, 1935

_____. "Der Schrein der Unschuldigen Kindlein im Kölner Domschatz und Magister Gerardus," *Miscellanea pro Arte Medii Aevi: Festschrift H. Schnitzler*, Düsseldorf, 1965, pp. 218–223

Hamann, R. *Die Abteikirche von St. Gilles und ihre Künstlerische Nachfolge*, Berlin, 1955

Hamann-MacLean, R. "Antikenstudium in der Kunst des Mittelalters," *Marburger Jahrbuch für Kunstwissenschaft*, 15, 1949–50, pp. 157–250

_____. "Zur Zeitstellung und Herkunft des Cappenberger Kruzifixus," *Westfalen*, 33, 1955, pp. 113–124

_____. "Reims als Kunstzentrum im 12. und 13. Jahrhunderts," *Kunstchronik*, 9, 1956, pp. 287–289

_____. "Les origines des portails et façades sculptes gothiques," *Cahiers de civilisation médiévale*, 1959, pp. 157–175

_____. "Stilwandel und Persönlichkeit Der Reimser 'Priester'-Meister," *Sbornik Navodnog Museja Beograd*, 4, 1964, pp. 243–253

_____. "Zur Baugeschichte der Kathedrale von Reims," *Gedenkschrift E. Gall*, Munich-Berlin, 1965

_____. "Der Berliner codex Graecus Quarto 46 und seine nächsten Verwandten als Beispiele des Stilwandels im frühen 13. Jahrhundert," *Festschrift für Karl Hermann Usener*, Marburg-Lahn, 1967, pp. 225–250

Hannover, 1966. *Mittelalter I: Bronze, Email, Elfenbein*, Kestner-Museum

Harvey, J. H. *The Gothic World, 1100–1600, A Survey of Architecture and Art*, London, 1950

Haseloff, A. *Eine Thüringische-Sächsische Malerschule des XIII. Jahrhunderts*, Strasbourg, 1897

Haseloff, G. *Die Psalterillustration im 13. Jahrhundert. Studien zur Geschichte der Buchmalerei in England, Frankreich und Südlichen Niederlanden*, Kiel, 1938

Haskins, C. H. *The Renaissance of the 12th Century*, New York, 1957

_____. *The Rise of the Universities*, New York, 1957

_____. *Studies in the History of Mediaeval Science*, New York, 1960

Haussherr, R. "Besprechung F. Deuchler, Der Ingeborgpsalter," *Zeitschrift für Kunstgeschichte*, 1969, pp. 51–68

_____. "Sauerländer, W. *Von Sens bis Strassburg*," *Kunstchronik*, 1968, pp. 302–321

Hayward, J. "Identification of the 'Crucifixion' Window," *Bulletin of the City Art Museum of St. Louis*, XLII, no. 2, 1957, pp. 19–22

Hayward, J.—Grodecki, L. "Les vitraux de la cathédrale d'Angers," *Bulletin monumental*, CXXIV, 1966, pp. 7–67

Heer, F. *Aufgang Europas. Eine Studie zu den Zusammenhängen zwischen politischer Religiosität, Frömmigkeitsstil und dem Werden Europas im 12. Jahrhundert*, Vienna, n.d.

_____. *The Medieval World*, London, 1962

Heitz, C. *Recherches sur les rapports entre architecture et liturgie a l'époque Carolingienne*, Paris, 1963

Henderson, G. "Giraldus Cambrensis; A note on his account of a painting in the King's chamber at Winchester," *Archaeological Journal*, CXVIII, 1961, pp. 175–179

_____. *Gothic "Style and Civilization*," London, 1967

Herbert, J. A. *Illuminated Manuscripts*, New York, 1959

Hildburgh, W. L. *Medieval Spanish Enamels and their Relation to the Origin and the Development of Copper Champlevé Enamels of the 12th and 13th Centuries*, Oxford, 1936

_____. "Concerning a questionable identification of medieval Catalan champlevé enamels," *The Art Bulletin*, XXVII, 1945, pp. 248–259

_____. "Medieval Copper Champlevé Enamelled Images of the Virgin and Child," *Archaeologia*, XCVI, 1955, pp. 115–158

Hinkle, W. M. *The Portal of the Saints of Reims Cathedral. A Study in Medieval Iconography*, New York, 1965

_____. "The King and the Pope on the Virgin Portal of Notre Dame," *The Art Bulletin*, XLVIII, 1966, pp. 1–13

Hirsch, H. "Gotik und Renaissance in der Entwicklung unserer Schrift," *Forschungen und Fortschritte*, 1932, pp. 343–344

Hobson, G. D. *English Bindings Before 1500*, Cambridge, 1929

Holmes, U. T. "The Idea of a Twelfth-Century Renaissance," *Speculum*, XXVI, 1951, pp. 643–657

_____. *Daily Living in the Twelfth Century*, Madison, 1962

Holmes, U. T.—Schutz, A. H. *A History of the French Language*, New York, 1967

Holt, J. C. *The Making of Magna Carta*, Charlottesville, 1965

Holter, K. "Die romanische Buchmalerei in Oberösterreich," *Jahrbuch des Oberösterreichischen Musealvereins*, 1956, pp. 221–250

Homburger, O. "Eine lotharingische Kunstschule um das Jahr 1200," *Oberrheinische Kunst* I, 1924–1926, pp. 5–13

_____. "Eine unveröffentlichte Evangelienhandschrift aus der Zeit Karls des Grossen," *Zeitschrift für Schweizerische Archäologie und Kunstgeschichte*, 5, 1943, pp. 149–163

_____. *Der Trivulzio-Kandelaber. Eine Meisterwerk Frühgotischer Plastik*, Zurich, 1949

_____. "Zur Stilbestimmung der figürlichen Kunst Deutschlands und des westlichen Europas im Zeitraum zwischen 1190 und 1250," *Formositas Romanica: Festschrift J. Gantner*, Frauenfeld, 1958, pp. 29–45

_____. "Das Freiburger Einzelblatt . . . ," *Festschrift für Werner Noack*, Freiburg, 1959, pp. 16–23

Hörmann, W. "Probleme einer Aldersbacher Handschrift (Clm. 2599)," *Festschrift Gustav Hofmann,* Wiesbaden, 1965, pp. 335–389

Hoster, J. "Zur Form der Stirnseite der Dreikönigen Shreines," *Miscellanea pro Arte Medii Aevi: Festschrift H. Schnitzler,* Düsseldorf, 1965, pp. 194–217

Hoving, T. P. F. "A Long-Lost Romanesque Annunciation," *The Metropolitan Museum of Art Bulletin,* 20, 1961, pp. 117–126

———. "Italian Romanesque Sculpture," *The Metropolitan Museum of Art Bulletin,* 23, 1965, pp. 345–348

———. "A Newly Discovered Reliquary of St. Thomas Beckett," *Gesta,* 4, 1965, p. 28 f.

Hucher, E. *Calques des vitraux de la cathédrale du Mans,* Le Mans, 1862

Hudig-Frey, M. *Die älteste Illustration der Eneide des Heinrich von Veldeke,* Strasbourg, 1921

Hughes, P. *A History of the Catholic Church,* New York, 1954

I

Ilg, A. *Beiträge zur Geschichte der Kunst und der Kunsttechnik aus Mittelhochdeutschen Dichtungen,* Vienna, 1892

J

Jackson, W. T. H. *Medieval Literature,* New York, 1966

Jacobs, F. *Die Kathedrale S. Maria Icona Vetere in Foggia. Studien zur Architektur und Plastik des 11.–13. Jahrhunderts in Süditalien,* Hamburg, 1968

Jahn, J. "Die Stellung des Künstlers im Mittelalter," *Festschrift Eduard Trautscholdt,* Hamburg, 1965, pp. 38–54

Jalabert, D. *La flore sculptée des monuments du moyen âge en France,* Paris, 1965

James, M. R. "Four Leaves of an English Psalter," *The Walpole Society,* XXV, 1936–1937, pp. 18–21

———. *The Canterbury Psalter,* London, 1935

Jansen, F. *Die Helmarshausener Buchmalerei zur Zeit Heinrichs des Löwen,* Hildesheim-Leipzig, 1933

Jauss, H. R. *Genèse de la poésie allégorique française au moyen âge,* Heidelberg, 1962

Jerphanion, G. *Une nouvelle province de l'art byzantin; Les églises rupestres de Cappadoce,* 3 vols., Paris, 1925–1942

Johnson, J. R. *The Radiance of Chartres. Studies in the Early Stained Glass of the Cathedral,* Columbia University Studies in Art, History and Archaeology, IV, New York, 1965

Jolliffe, J. E. *Angevin Kingship,* New York, 1955

Jullian, R. *L'éveil de la sculpture italienne,* Paris, 1945–49

———. "Les persistances romanes dans la sculpture gothique italienne," *Cahiers de civilisation médiévale,* III, 1960, pp. 295–305

———. *La sculpture gothique,* Paris, 1966

K

Kantorowicz, E. H. *Kaiser Friedrich der Zweite,* Berlin, 1931

———. *The King's Two Bodies: A Study In Medieval Political Theology,* Princeton, 1957

———. "Kingship under the Impact of Scientific Jurisprudence," *Twelfth-Century Europe and the Foundations of Modern Society,* Madison, 1961, pp. 89–111

———. *Selected Studies,* Locust Valley, New York, 1965

Katzenellenbogen, A. *Allegories of the Virtues and Vices in Mediaeval Art,* London, 1939

———. *The Sculptural Programs of Chartres Cathedral: Christ, Mary, Ecclesia,* Baltimore, 1959

———. "The Representation of The Seven Liberal Arts," *Twelfth-Century Europe and the Foundation of Modern Society,* Madison, 1961, pp. 39–55

———. *Iconographic Novelties and Transformations in the Sculpture of French Church Façades,* Studies in Western Art; Acts of the Twentieth International Congress of the History of Art, Princeton, 1963, pp. 108–118

———. *Varianten in der Darstellung des Apostelkollegiums um 1200,* Akten des 21. Internationalen Kongresses für Kunstgeschichte in Bonn, 1964, 1, Berlin, 1967, pp. 163–169

Kauffmann, C. M. *The Baths of Pozzuoli.* Oxford, 1959

———. "The Bury Bible," *Journal of the Warburg and Courtauld Institutes,* XXIX, 1966, pp. 60–81

Keck, A. "A Group of Italo-Byzantine Ivories," *The Art Bulletin,* XII, 1930, pp. 147–162

Keller, H. "Zur Entstehung der sakralon Vollskulptur in der ottonischen Zeit," *Festschrift für Hans Jantzen,* Berlin, 1951

Kelly, A. *Eleanor of Aquitaine and the Four Kings,* Cambridge, 1950

Kelly, D. "The Scope of the Treatment of Composition in the Twelfth- and Thirteenth-Century Arts of Poetry," *Speculum,* XLI, 1966, pp. 261–278

Ker, N. *Medieval Manuscripts in British Libraries,* Oxford, 1968

Kerber, B. *Burgund und die Entwicklung der französischen Kathedralskulptur im 12. Jahrhundert,* Münstersche Studien zur Kunstgeschichte, IV, Recklinghausen, 1966

Kessler, C. H. "A Problematic Illumination of the Heidelberg Liber Scivias," *Marsyas,* VIII, 1957–1959, pp. 7–21

Kidson, P. *Sculpture at Chartres,* London, 1958

Kitzinger, E. "The Mosaics of the Cappella Palatina in Palermo. An Essay on the Choice and Arrangement of Subjects," *The Art Bulletin,* XXXI, 1949, pp. 269–292

———. *I mosaici di Monreale,* Palermo, 1960

———. "Some Reflections on Byzantine Portraiture," *Festschrift Ostrogorsky,* Belgrade, 1963, pp. 185–193

———. *Early Medieval art, with illustrations from the British Museum Collection,* Bloomington, 1964

Kitzinger, E. "The Byzantine Contribution to Western Art of the Twelfth and Thirteenth Centuries," *Dumbarton Oaks Papers, 20,* 1966, pp. 25–47

———. "Norman Sicily as a Source of Byzantine Influence on Western Art in the Twelfth Century," *Byzantine Art an European Art, Lectures,* Athens, 1966, pp. 121–147

Knowles, D. *The Evolution of Medieval Thought,* New York, 1962

Koechlin, R. *Les ivoires gothiques français,* Paris, 1924

Koehler, W. "Byzantine Art in the West," *Dumbarton Oaks Papers,* 1, 1941, pp. 61–87

Kohlhaussen, H. *Minnekästchen im Mittelalter,* Berlin, 1928

———. "Das Paar von Bussen," *Festschrift Friedrich Winkler,* Berlin, 1959, pp. 29–48

Köhn, H. *Romanisches Drachenornament in Bronze und Architekturplastik,* Studien zur deutschen Kunstgeschichte, 275, Strasbourg, 1930

Korn, U. D. *Die romanische Farbverglasung von St. Patrokli in Soest,* Münster, 1967

Kötzsche, D. "Eine romanische Grubenschmelzplatte des Berliner Kunstgewerbemuseums," *Festschrift für Peter Metz,* Berlin, 1965, pp. 154–169

Kovács, E. "Le chef de saint Maurice à la cathédrale de Vienne," *Cahiers de civilization médiévale,* VII, 1964, 19–26

———. *Kopfreliquiare des Mittelalters,* Budapest, 1964

Krems, 1964. *Ausstellung Romanische Kunst in Österreich*

Kroos, R. "Drei Niedersächsische Bildhandschriften des 13. Jahrhunderts in Wien," *Abhandlungen der Akademie der Wissenschaften in Göttingen Philologisch-Historische Klasse,* Göttingen, 1964

Krummer-Schroth, I. *Glasmalereien aus dem Freiburger Münster,* Freiburg im Breisgau, 1957

L

Labrousse, M. "Etude iconographique et stylistique des initiales historiées de la Bible de Souvigny," *Cahiers de civilisation médiévale,* VII, 1965, pp. 397–412

Ladner, G. B. *Ad Imaginem Dei: The Image of Man in Medieval Art,* Latrobe, 1965

Lafond, J. "The Stained Glass Decoration of Lincoln Cathedral in the Thirteenth Century," *The Archaeological Journal,* CII, 1947, pp. 119–156

———. "Les vitraux anciens de la cathédrale de Lausanne," *Congrès archéologique de France,* CX, 1953, pp. 116–132

———. "Les vitraux de la cathédrale Saint-Pierre de Troyes," *Congrès Archéologique de France,* CXIII, 1957, pp. 29–62

Lafontaine-Dosogne, J. "Byzanz und der christliche Osten," *Propyläen Kunstgeschichte,* II, 1968

Lake, K. *Dated Greek Miniscule Manuscripts to the Year 1200,* 10 vols., Boston, 1934–1939

Lange, R. *Die byzantinische Reliefikone,* Recklinghausen, 1964

Lapeyre, A. *Des façades occidentales de Saint-Denis et de Chartres aux portails de Laon,* Etudes sur la sculpture monumentale dans l'Ile-de-France et les régions voisines au XIIe siècle, Meudon, 1960

Lasareff, V. N. "The Mosaics of Cefalù," *The Art Bulletin,* XVII, 1935, pp. 184–232

———. *Freski staroi Ladogi,* Moscow, 1960

de Lasteyrie, F. *Histoire de la peinture sur verre,* 2 vols., Paris, 1852–1856

Lattanzi, A. Daneu *Lineamenti di storia della miniatura in Sicilia,* Florence, 1966

Laurent, V. *Le corpus des sceaux de l'empire byzantin,* Paris, 1965

Lazareff, E. V. N. *Istoria Vizantijskoi Zivopisi,* Moscow, 1947

Lehmann-Brockhaus, O. "Lateinische Schriftquellen zur Kunst in England, Wales und Schottland vom Jahre 901 bis zum Jahre 1307," *Veröffentlichungen des Zentralinstituts für Kunstgeschichte in München,* I, Munich, 1956

Lejeune, R.–Stiennon, J. *La légende de Roland dans l'art du moyen âge,* Brussels, 1966

Lenzen, H.–Buschhausen, E. "Ein neues Reichsportatile des 12. Jahrhunderts," *Wiener Jahrbuch für Kunstgeschichte,* XXIV, 1965, pp. 21–73

Leroquais, V. *Les sacramentaires des bibliothèques de France,* Paris, 1924

———. *Les pontificaux manuscrits des bibliothèques publiques de France,* I, Paris, 1937, pp. 252–260

———. *Les psautiers manuscrits latins des bibliothèques publiques de France,* Mâcon, 1940–1941

Lethaby, W. R. "Archbishop Roger's Cathedral at York and its Stained Glass," *The Archaeological Journal,* LXXII, 1915, pp. 37–48

Lichtenberg, H. *Die Architekturdarstellungen in der mittelhochdeutschen Dichtung,* Münster, 1931

Liebeschütz, H. *Fulgentius Metaforalis. Ein Beitrag zur Geschichte der antiken Mythologie im Mittelalter,* Leipzig-Berlin, 1926

———. *Das allegorische Weltbild der Heiligen Hildegard von Bingen,* Leipzig-Berlin, 1930

———. *Medieval Humanism in the Life and Writings of John of Salisbury,* London, 1950

———. "Das 12. Jahrhundert und die Antike," *Archiv für Kulturgeschichte,* 35, 1953, p. 247 f.

Liebman, C. J. "Le Commentaire français du Psautier et le ms. Morgan 338, pour l'attribution à Simon de Tournai," *Romania,* LXXVI, 1955, pp. 433–476

———. "Remarks on the Manuscript Tradition of the French Psalter Commentary," *Scriptorium,* XIII, 1959

Lapinsky, A. "Le aquile gemmigte di Federico II ed altre aquile sveve," *Scritti di storia dell'arte in onore di Mario Salmi,* I, Rome, 1961, pp. 325–349

———. *Oreficerie bizantine dimenticate in Italia,* Atti del I Congresso Nazionale di Studi Bizantini, Ravenna, 1966, pp. 73–137

Loisel, A. *La cathédrale de Rouen,* Paris, 1924

London, 1930. *English Medieval Art,* The Victoria and Albert Museum

Longhurst, M. *English Ivories,* London, 1926

Loomis, R. S. *Arthurian Literature in the Middle Ages,* Oxford, 1959

Lopez, R. S. *The Birth of Europe,* New York, 1967

Lottin, O. D. *Psychologie et morale aux XII^e et XIII^e siècles,* VI: Problèmes d'histoire littéraire de 1160 à 1300, Gembloux, 1960

Ljubinsković, R. "Stara crkva sela Kurbinova," *Starinar,* XV, 1940, pp. 101–123

——. *La Peinture murale en Serbie et en Macédoine aux XII^e et XIII^e siècles,* IX: Corsodi cultura Sull'-arte ravennate e bizantina, Ravenna, 1962

M

McCulloch, F. *Medieval Latin and French Bestiaries,* University of North Carolina Studies in the Romance Languages and Literature, 33, Chapel Hill, 1962

Magne, L. *Palais du Trocadéro. Musée de la sculpture comparée. Galerie des vitraux,* Paris, 1912

Mâle, E. *Religious Art in France, XIII century . . . ,* New York, 1913

——. *L'art religieux de XII^e siècle en France,* Paris, 1947

Mallé, L. "Antichi smalti cloisonnés et champlevés dei secoli XI-XIII in raccolte e musei del Piemonte," *Società Piemontese di Archeologia e di Belle Arti,* IV-V, 1950–1951, pp. 54–136

Mallion, J. *Le jubé de la cathédrale de Chartres,* Chartres, 1964

Manchester, 1959. *Romanesque Art, 1050–1200, from Collections in Great Britain and Eire*

Mango, C. "Antique Statuary and the Byzantine Beholder," *Dumbarton Oaks Papers,* 18, 1963, pp. 53–75

Mango, C.–Hawkins, E. J. W. "The Hermitage of St. Neophytos and its Wall Paintings," *Dumbarton Oaks Papers,* 20, 1966, pp. 119–206

Manitius, M. *Geschichte der Lateinischen Literatur des Mittelalters,* Munich, 1931

Marquet de Vasselot, J. J. *Les émaux limousins à fond vermiculé,* Paris, 1906

——. *Les crosses limousines du XIII^e siècle,* Paris, 1941

Martinet, S. "La création de l'école de Laon," *Revue belge d'archéologie et d'histoire de l'art,* 25, 1956, pp. 161–175

Medding, W. *Die Westportale der Kathedrale von Amiens und ihre Meister,* Augsburg, 1930

——. "Sculptures de Saint-Martin d'Angers," *Gazette des Beaux-Arts,* II, 1934, pp. 170–173

Meer, F. van der *Maiestas Domini,* Rome, 1938

Megaw, A. H. S. *Comnenian Frescoes in Cyprus,* Actes du XII^e Congrès international d'études byzantines, Belgrade, p. 257 f.

Megaw, A. H. S.–Hawkins, E. J. W. "The Church of the Holy Apostles at Perachorio, Cyprus, and its Frescoes," *Dumbarton Oaks Papers,* 16, 1962, pp. 277–348

Megaw, A. H. S.–Stylianou, A. *Cyprus: Byzantine Mosaics and Frescoes,* UNESCO World Art Series, New York, 1963

Merson, O. *Les vitraux,* Paris, 1895

Mesplé, P. *Les sculptures romanes,* Paris, 1961

Messerer, W. *Das Relief im Mittelalter,* Berlin, 1959

Messerer, W. *Romanische Plastik in Frankreich,* Cologne, 1964

Meulen, J. van der "Recent Literature on the Chronology of Chartres Cathedral," *The Art Bulletin,* XLIX, 1967, pp. 152–172

Meyer, E. "Spätromanische Abendmahlskelche in Norddeutschland," *Jahrbuch der Preussischen Kunstsammlungen,* 53, 1932, pp. 163–181

——. "Zur Geschichte des hochmittelalterlichen Schmuckes," *Festschrift für A. Goldschmidt,* Berlin, 1935, pp. 19–22

——. "Reliquie und Reliquiar im Mittelalter," *Festschrift für C. G. Heise,* Berlin, 1950, pp. 55–66

——. "Eine mittelalterliche Bronzestatuette," *Kunstwerke aus dem Besitz des Albert-Ludwig Universität Freiburg im Breisgau,* Berlin-Freiburg, 1957, p. 17 f.

——. "Romanische Bronzen der Magdeburger Giesshütte," *Festschrift für F. Winkler,* 1959, pp. 22–28

——. "Mittelalterliche Bronzen," *Bilderhefte des Museums für Kunst und Gewerbe,* II, Hamburg, 1960

Miljkovie-Pepek, P. "La formation d'un nouveau style monumental au XIII^e siècle," Actes de XII^e Congrès international d'etudes byzantines, Belgrade, 1964, pp. 309–313

Millar, E. G. *English Illuminated Manuscripts from the Xth to the XIIIth Century,* London, 1926

——. *Reproductions from Illuminated Manuscripts,* IV, London, 1928

Millet, G. *Recherches sur l'Iconographie de l'Evangile,* Paris, 1916

——. *Monuments de l'Athos,* Paris, 1927

Millet, G.–Frolow, A. *La peinture du moyen âge en Yougoslavie,* 3 vols., Paris, 1954–1962

Mitchell, H. P. "Some works by the goldsmiths of Oignies," *The Burlington Magazine,* XXXIX, 1921, pp. 157–168; pp. 273–285

——. "English Enamels of the Twelfth Century," *The Burlington Magazine,* XLVII, 1925, pp. 163–170

——. "English Enamels of the Twelfth Century," *The Burlington Magazine,* XLIX, 1926, pp. 161–173

Mjasoedov, V. K. *Freski Spasa-Nereditza,* Leningrad, 1925

Montauban, 1961. *Trésors d'art gothique en Languedoc,* Musée Ingres

Montpellier, 1963. *Miniatures médiévales en Languedoc méditerranéen,* Musée Fabre

Morey, C. R. *Medieval Art,* New York, 1942

Mortet, V.–Deschamps, P. *Recueil de textes relatifs à l'histoire de l'architecture et à la condition des architectes en France au moyen âge,* Paris, 1929

Mühlberg, F. "Grab und Grabdenkmal der Plektrudis in St. Maria im Kapitol zu Köln," *Wallraf-Richartz-Jahrbuch,* 24, 1962, pp. 21–96

Müller, W. "Nikolaus von Verdun," *Wissenschaftliche Zeitschrift der Hochschule für Architektur Weimar,* IX, 1962, pp. 425–435

Müller-Dietrich, N. *Die romanische Skulptur in Lothringen,* Munich-Berlin, 1968

Müller-Wulckow, W. "Das goldene Schiff von Uelzen," *Niederdeutsche Beiträge zur Kunstgeschichte,* 2, 1962, pp. 270–281

Mundy, J. H.–Riesenberg, P. *The Medieval Town,* Princeton, 1958

Munich, 1950. *Ars Sacra, Kunst des frühen Mittelalters*

Mussat, A. *Le Style gothique de la France de l'Ouest,* Paris, 1963

Mütherich, F. *Die Ornamentik der rheinischen Goldschmiedekunst in der Stauferzeit,* Würzburg, 1940

N

Nau, E. "Staufer-Adler," *Jahrbuch der Staatlichen Kunstsammlungen in Baden-Württemberg,* V, 1968, pp. 21–56

Naumann, H. "Ritterliche Standeskultur um 1200," *Deutsche Vierteljahreschrift für Literaturwissenschaft und Geistesgeschichte, Buchreihe 17,* 1929

New York, 1934. *The Pierpont Morgan Library Exhibition of Illuminated Manuscripts,* New York Public Library

New York, 1968. *Medieval Art from Private Collections,* The Metropolitan Museum of Art

Nikolovski, A. *The Frescoes of Kurbinovo,* Belgrade, 1961

Noehles, K. "Die Kunst der Cosmaten und die Idee der Renovatio Romae," *Festschrift für W. Hager,* Recklinghausen, 1966, pp. 17–37

Nordenfalk, C. "Bemerkungen zur Entstehung des Akanthusornaments," *Acta Archaeologica,* V, 1935, pp. 257–265

———. *Die spätantiken Kanontafeln,* Göteborg, 1938

———. "Insulare und kontinentale Psalterillustrationen aus dem XIII. Jahrhundert," *Acta archaeologica,* X, 1939, pp. 107–120

Nordström, F. "Peterborough, Lincoln and the Science of Robert Grosseteste. A Study in Thirteenth-Century Iconography," *The Art Bulletin,* XXXVII, 1955, p. 241 f.

Nothdurft, K. D. *Studien zum Einfluss Senecas auf die Philosophie und Theologie des zwölften Jahrhunderts,* Studien & Texte zur Geistesgeschichte des Mittelalters, VII, Leiden 1963

O

Oakeshott, W. *The Artists of the Winchester Bible,* London, 1945

———. *Classical Inspiration in Medieval Art,* New York, 1960

Oidtmann, H. *Die Rheinischen Glasmalereien,* 2 vols., Düsseldorf, 1912–1923

L'Orange, H. *Studies in the Iconography of Cosmic Kingship in the Ancient World,* Oslo, 1953

Osiezkowska, C. "Notes sur la décoration du manuscrit grec Czartoryski 1801 et sur l'ornement byzantin," *Studi Bizantini e Neoellenici,* VI, 1940, pp. 334–339

Otto, S. *Die Funktion des Bildbegriffes in der Theologie des 12. Jahrhunderts,* Beiträge zur Geschichte der Philosophie und Theologie des Mittelalters, XL, Münster, 1963

P

Paatz, W. *Von den Gattungen und vom Sinn der gotischen Rundfigur,* Heidelberg, 1951

Pächt, O. "The Illustrations of St. Anselm's Prayers and Meditations," *Journal of the Warburg and Courtauld Institutes,* XIX, 1956, pp. 68–84

———. "A Cycle of English Frescoes in Spain," *The Burlington Magazine,* CIII, 1961, pp. 166–175

———. *The Rise of Pictorial Narrative in Twelfth-Century England,* Oxford, 1962

Pächt, O.—Wormald, F.—Dodwell, C. R. *The St. Albans Psalter,* London, 1960

Painter, S. "The Family and the Feudal System in Twelfth-Century England," *Speculum,* XXXV, 1960, pp. 1–16

———. *French Chivalry,* New York, 1964

Panofsky, E. *Die deutsche Plastik des 11. bis 13. Jahrhunderts,* Munich, 1924

———. "Review of H. Jantzen, *Deutsche Bildhauer des 13. Jahrhunderts,*" *Repertorium für Kunstwissenschaft,* XLVII, 1926, p. 54 f.

———. "Zur künstlerischen Abkunft des Strassburger Ecclesiameisters," *Oberrheinische Kunst,* IV, 1929–1930, pp. 124–129

———. *Gothic Architecture and Scholasticism,* Latrobe, 1951

———. *Early Netherlandish Painting, Its Origins and Character,* Cambridge, 1953

———. *Renaissance and Renascences in Western Art,* Stockholm, 1960

———. "The Ideological Antecedents of the Rolls Royce Radiator," *Proceedings of the American Philosophical Society,* 107, 1963, pp. 273–288

———. *Tomb Sculpture,* New York, 1964

Panofsky, E.—Saxl, F. "Classical Mythology in Medieval Art," *Metropolitan Museum Studies,* IV, 1933, pp. 228–280

Paré, G.—Brunet, E.—Tremblay, P. *La Renaissance du XIIe siècle: les ecoles et l'enseignement,* Paris, 1933

Paris, 1931. *Exposition Internationale d'art byzantin,* Musée des Arts Décoratifs

Paris, 1954. *Manuscrits à peintures du VIIe au XIIe siècle,* Bibliothèque Nationale

Paris, 1955. *Manuscrits à peintures du XIIIe au XVIe siècle,* Bibliothèque Nationale

Paris, 1958. *Byzance et la France médiévale, manuscrits à peintures du XIe au XVIe siècle,* Bibliothèque Nationale

Paris, 1962. *Cathédrales. Sculptures, vitraux, objets d'art, manuscrits des XIIe et XIIIe siècles,* Musée du Louvre

Paris, 1965. *Les trésors des églises de France,* Musée des Arts Décoratifs

Paris, 1968. *L'Europe gothique, XIIe–XIVe siècles,* Musée du Louvre

Pascal, P. "Medieval Uses of Antiquity," *Classical Journal,* LXI, 1966, pp. 193–197

Pelekanides, S. *Kastoria,* Thessalonike, 1953

Pevsner, N. *The Leaves of Southwell,* Harmondsworth, 1945

Poole, A. L. *From Domesday Book to Magna Carta, 1087–1216,* Oxford, 1951

Porcher, J. *L'enluminure française,* Paris, 1959

Porter, A. K. "Le Roi de Bourges," *Art in America,* VI, 1917–1918, pp. 264–273

——. *Romanesque Sculpture of the Pilgrimage Roads,* 10 vols., Boston, 1923

——. *Spanish Romanesque Sculpture,* 2 vols., Florence-Paris, 1928

Prache, A. "Contribution à l'étude des contacts et des échanges établis entre les sculpteurs du XIIIᵉ siècle: à propos de la cathédrale de Reims," *Gazette des Beaux-Arts,* XLVII, 1961, pp. 129–142

Preisendanz, K.—Homburger, O. *Das Evangelistar des Speyerer Domes,* Leipzig, 1930

Pressouyre, L. "Sculpture du premier art gothique à Notre-Dame-en-Vaux de Châlons-sur-Marne," *Bulletin monumental,* 120, 1962, pp. 359–366

——. "La colonne dite aux trois chevaliers de Châlons-sur-Marne," *Bulletin de la Societé nationale des antiquaires de France,* 1963, pp. 76–81

——. "Un tombeau d'abbé provenant du cloître de Nesle-la-Reposte," *Bulletin monumental,* 1967, pp. 1–20

——. "Sculptures retrouvées de la cathédrale de Sens," *Bulletin monumental,* 127, 1969, pp. 107–118

Providence, 1969. *The Twelfth-Century Renaissance,* Brown University

Q

Quarré, P. "Le visage humain dans la sculpture monumentale du XIIIᵉ siècle en Bourgogne," *Bulletin de la Société de l'histoire de l'art français,* 1967, pp. 7–12

Quintavalle, A. C. *Problemi di romanico emiliano,* Parma, 1965

R

Raby, F. J. E. *A History of Secular Latin Poetry,* 3, Oxford, 1934

——. *A History of Christian-Latin Poetry,* Oxford, 1953

Rackham, B. *Victoria and Albert Museum, A Guide to the Collection of Stained Glass,* London, 1936

——. *The Ancient Glass of Canterbury Cathedral,* London, 1949

——. *The Stained Glass Windows of Canterbury Cathedral,* Canterbury, 1957

Rademacher, F. *Der thronende Christus der Chorschranken aus Gustorf,* Cologne, 1964

Randall, R. H. "The mediæval artist and industrialized art," *Apollo,* LXXXIV, 1966, pp. 434–441

Reinhardt, H. "Sculpture française et sculpture allemande au XIIIᵉ siècle," *L'Information d'histoire de l'art,* VII, 1962, pp. 174–197

Restlé, M. *Byzantine Wall Painting in Asia Minor,* New York, 1968

Reuther, H. "Das Oswaldreliquiar im Hildesheimer Domschatz und seine architektonischen Vorbilder," *Niederdeutsche Beiträge zur Kunstgeschichte,* IV, 1965, pp. 63–76

Rhein, A. *Notre Dame de Mantes,* Paris, 1932

de Ricci, S.—Willson, W. J. *Census of Medieval and Renaissance Manuscripts in the United States and Canada,* 3 vols., New York, 1935–1940

Rice, D. T. *The Art of Byzantium,* London, 1959

——. "The Ivory of the Forty Martyrs at Berlin and the Art of the 12th Century," *Mélanges G. Ostrogorsky,* 1963, pp. 275–279

——. *The Twelfth-century Renaissance in Byzantine Art,* Hull, 1965

Richardson, H. G. *The English Jewry under the Angevin Kingdom,* London, 1960

Rickert, M. *Painting in Britain: The Middle Ages,* London, 1965, pp. 93–95

Ritgen, L. "Die höfische Tracht der Ile-de-France in der ersten Hälfte des 13. Jahrhunderts," Zeitschrift für Waffen und Kostümkunde, IV, 1962, pp. 8–24

Röhrig, F. *Der Verduner Altar,* Vienna, 1959

Rome, 1954. *Mostra storica nazionale della miniatura,* Palazzo di Venezia

Roosen-Runge, H. "Ein Werk englischer Grossplastik des 13. Jahrhunderts und die Antike," *Festschrift Hans R. Hahnloser,* Basel-Stuttgart, 1961, pp. 103–112

Roosval, J. "Proto-Renaissance at the End of the Twelfth Century," *Essays in Honor of Georg Swarzenski,* Chicago, 1951, p. 39 f.

Rorimer, J. J. *The Cloisters, the Building and the Collection of Medieval Art in Fort Tryon Park,* New York, 1963

Rosenthal, E. "Abraham and Lazarus. Iconographical Considerations of a Medieval Book Painting," *Pacific Art Review,* IV, 1945–46, pp. 7–23

Ross, D. J. A. "A late twelfth-century artist's pattern-sheet," *Journal of the Warburg and Courtauld Institutes,* XXV, 1962, pp. 119–129

Ross, J. B. "A Study of Twelfth-Century Interest in the Antiquities of Rome," *Medieval and Historiographical Studies in Honor of J. W. Thompson,* Chicago, 1938, pp. 302–321

Ross, M. C. "Ein Emailbild der Fritzlarer Werkstatt," *Pantheon,* XII, 1933

Rotterdam, 1952. *Kleurenpracht uit Franse Kathedralen,* Museum Boymans

Roussel, J. *Album des vitraux extraits des archives du Ministère de l'Instruction publique,* 2 vols., Paris, 1905

Rubinstein-Bloch, S. *Catalogue of The Collection of George and Florence Blumenthal,* II, Paris, 1926

Rücker, F.—Hahnloser, H. R. "Das Musterbuch von Wolfenbüttel," *Mitteilungen der Gesellschaft für vervielfältigende Kunst,* Vienna, 1929

Rückert, R. "Zur Form der byzantinischen Reliquiare," *Münchener Jahrbuch der bildenden Kunst,* VIII, 1957, pp. 7–36

——. Beiträge zur limousiner Plastik des 13. Jahrhunderts, *Zeitschrift für Kunstgeschichte,* XXII, 1959, pp. 1–16

Rupin, E. *L'œuvre de Limoges,* Paris, 1890

Rushforth, G. McN. "Magister Gregorius de Mirabilibus Urbis Romae," *Journal of Roman Studies,* IX, 1919, p. 44 f.

S

Salm, C. A. "Neue Forschungen über das Gnadenbild der Alten Kapelle in Regensburg," *Münchener Jahrbuch der bildenden Kunst,* 13, 1962, pp. 49–60

Salmi, M. *Romanesque Sculpture in Tuscany,* Florence, 1928

Salvini, R. *The Cloister of Monreale and Romanesque Sculpture in Sicily,* Palermo, 1962

Sanfaçon, R. "La tradition symbolique de la deuxième vision de l'Apocalypse et les débuts de l'art gothique," *Mélanges Crozet,* II, Poitiers, 1966, pp. 993–1002

Sanford, E. M. "The Twelfth-Century Renaissance or Protorenaissance," *Speculum,* XXVI, 1951, pp. 635–642

Sauer, J. *Symbolik des Kirchengebäudes und seiner Ausstattung in der Auffassung des Mittelalters,* Freiburg im Breisgau, 1924

Sauerländer, W. "Beiträge zur Geschichte der frühgotischen Skulptur," *Zeitschrift für Kunstgeschichte,* 19, 1956, pp. 1–34

––––––. "Die Marienkrönungsportale von Senlis und Mantes," *Wallraf-Richartz-Jahrbuch,* 20, 1958, p. 115 f.

––––––. "Sens and York," *Journal of the British Archaeological Association,* XXII, 1959, pp. 53–69

––––––. "Die kunstgeschichtliche Stellung der Westportale von Notre-Dame in Paris," *Marburger Jahrbuch für Kunstwissenschaft,* 17, 1959, pp. 1–12

––––––. "Art antique et sculpture autour de 1200, Saint-Denis, Lisieux, Chartres," *Art de France,* 1, 1961, pp. 47–56

––––––. "Skulpturen des 12. Jahrhunderts in Châlons-sur-Marne," *Zeitschrift für Kunstgeschichte,* 25, 1961, p. 97 f.

––––––. "Cathédrales," *Kunstchronik,* XV, 1962, pp. 225–234

––––––. "Cathédrales," *Art de France,* III, 1963, pp. 210–219

––––––. "Eine Säulenfigur aus Châlons-sur-Marne im Museum in Cleveland (Ohio)," *Pantheon,* XXI, 1963, pp. 143–148

––––––. *Twelfth-Century Sculpture at Châlons-sur-Marne,* Studies in Western Art; Acts of the Twentieth International Congress of the History of Art, Princeton, 1963, pp. 119–128

––––––. "Tombeaux chartrains du premier quart du 13e siècle," *L'information d'histoire de l'art,* 9, 1964, pp. 47–60

––––––. "Uber einen Reimser Bildhauer in Cluny," *Gedenkschrift E. Gall,* Berlin, 1965, pp. 255–268

––––––. *Von Sens bis Strassburg. Beiträge zur kunstgeschichtlichen Stellung der Strassburger Querhausskulpturen,* Berlin, 1966

––––––. "L'Europe gothique, XIIe–XIVe siècles, points de vue critiques à propos d'une exposition," *Revue de l'Art,* 3, 1969, pp. 83–92

Sauerlandt, M. *Deutsche Plastik des Mittelalters,* Düsseldorf, 1911

Saxl, F. *English Sculptures of the Twelfth Century,* London, 1954

––––––. *The Belief in Stars in the Twelfth Century.* Lectures, London, 1957, pp. 85–95

––––––. *Illustrated Medieval Encyclopedias. The Christian Transformation.* Lectures, London, 1957, pp. 242–254

––––––. *Macrocosm and Microcosm in Medieval Pictures.* Lectures, London, 1957, pp. 58–72

Saxl, F.–Wittkower, R. *British Art and the Mediterranean,* London, 1948

Schade, H. *Dämonen und Monstren,* Regensburg, 1962

Schapiro, M. "From Mozarabic to Romanesque in Silos," *The Art Bulletin,* XXI, 1939, pp. 313–374

––––––. "On the Aesthetic Attitude of Romanesque Art and Thought," *Essays in Honor of A. K. Coomaraswamy,* London, 1947, pp. 130–150

––––––. *Two Romanesque Drawings in Auxerre and Some Iconographical Problems,* Studies in Art and Literature for Belle da Costa-Greene, Princeton, 1954, pp. 331–348

––––––. "An Illuminated English Psalter of the Early Thirteenth Century," *Journal of the Warburg and Courtauld Institutes,* 23, 1960, pp. 179–189

––––––. "The Bowman and he Bird on the Ruthwell Cross and Other Works: The Interpretation of Secular Themes in Early Medieval Religious Art," *The Art Bulletin,* 45, 1963, pp. 351–355

Scheller, R. W. *A Survey of Medieval Model Books,* Haarlem, 1963

Schiller, G. *Ikonographie der Christlichen Kunst,* I, Gütersloh, 1966

Schilling, R. "Studien zur deutschen Goldschmiedekunst des 12. und 13. Jahrhunderts," *Kunstgeschichtliche Studien für Otto Schmitt,* Stuttgart, 1950, pp. 73–88

Schipperges, H. "Das Schöne in der Welt Hildegards von Bingen," *Jahrbuch für Asthetik und Allgemeine Kunstwissenschaft,* IV, 1958–59, pp. 83–139

Schirmer, W. F.–Broich, U. *Studien zum literarischen Patronat im England des 12. Jahrhunderts,* Cologne-Opladen, 1962

Schlag, G. "Die Skulpturen des Querhauses der Kathedrale von Chartres," *Wallraf-Richartz-Jahrbuch,* V, 1943, pp. 115–164

Schlosser, F. *Andreas Cappellanus, seine Minnelehre und das christliche Weltbild im 12. Jahrhundert,* Berlin, 1962

Schlumberger, G. *L'Epopée byzantine,* 3 vols., Paris, 1896–1905

Schmarsow, A. *Kompositiongesetze romanischer Glasgemälde,* Leipzig, 1916

––––––. *Kompositiongesetze frühgotischer Glasgemälde,* Leipzig, 1919

Schmoll, J. A. gen Eisenwerth. "Sion-Apokalyptisches Weib-Ecclesia Lactans. Zur ikonographischen Deutung von zwei romanische Mater-Darstellungen in Metz und Pompierre," *Miscellanea Pro Arte Medii Aevi: Festschrift Hermann Schnitzler,* Düsseldorf, 1965, pp. 91–110

Schnitzler, H. *Die Goldschmiedeplastik der Aachener Schreinswerkstatt,* Düren, 1934

———. "Die spätromanische Goldschmiedebildnerei Aachener Schreiner," *Wallraf-Richartz-Jahrbuch,* IX, 1936, pp. 86–107

———. "Nikolaus von Verdun und der Albinusschrein," *Wallraf-Richartz-Jahrbuch,* XI, 1939, pp. 56–80

———. *Rheinische Schatzkammer. Die Romanik,* Düsseldorf, 1959

Schnitzler, H.—Bloch, P. *Email, Goldschmiede- und Metallarbeiten. Europäisches Mittelalter. Sammlung E. u. M. Kofler-Truniger,* Lucerne-Stuttgart, 1965

Schnyder, R. "Das Kopfreliquiar des heiligen Candidus in Saint-Maurice," *Zeitschrift für schweizerische Archäologie und Kunstgeschichte,* 24, 1965–1966, pp. 65–127

———. *Das Kopfreliquiar des heiligen Candidus in St.-Maurice,* Akten des 21. Internationalen Kongresses für Kunstgeschichte in Bonn, 1964, 1, Berlin, 1967, pp. 169–171

Schramm, P. E. *Herrschaftszeichen und Staatssymbolik,* 3 vols., Stuttgart, 1954–1957

———. *Kaiser Friedrichs II. Herrschaftszeichen,* Abhandlungen der Akademie der Wissenschaften in Göttingen, 36, Göttingen, 1955

———. "Ein Gemmenbild des Welfen Otto IV. aus den Jahren 1198–1209, bisher auf Otto I. bezogen," *Mitteilungen des Instituts für österreichische Geschichtsforschung,* 71, 1963, pp. 62–66

Schramm, P. E.—Mütherich, F. *Denkmale der deutschen Könige und Kaiser (760–1250),* Munich, 1962

Schwartz, H. "Anmerkungen zu einer trauernden Maria," *Miscellanea pro Arte Medii Aevi: Festschrift Hermann Schnitzler,* Düsseldorf, 1965, pp. 224–225

Schreiner, L. *Die frühgotische Plastik Südwestfrankreichs. Studien zum Style Plantagenet zwischen 1170 und 1240,* Cologne, 1963

———. *Style Plantagenet: Entwicklung und Deutung, 1180–1220 und die Rezeption in Westfalen,* Akten des 21. Internationalen Kongresses für Kunstgeschichte in Bonn, 1964, 1, Berlin, 1967, pp. 155–163

Schürenberg, L. "Spätromanische und frühgotische Plastik in Dijon und ihre Bedeutung für die Skulpturen des Strassburger Münster Querschiffres," *Jahrbuch der preussischen Kunstsammlungen,* 58, 1937, pp. 13–25

Schwietering, J. *Mystik und höfische Dichtung im Mittelalter,* Tübingen, 1960

Sedlmayr, H. *Die Entstehung der Kathedrale,* Zurich, 1950

———. "Die Entstehung der Gotik und der Fortschritt der Kunstgeschichte," *Zeitschrift für Ganzheitsforschung,* V, 1961, pp. 98–115

Seymour, C. "XIIIth-Century Sculpture at Noyon and the Development of the Gothic Caryatid," *Gazette des Beaux-Arts,* XXVI, 1944, p. 163 f.

Sheppard, C. D. "Romanesque Sculpture in Tuscany," *Gazette des Beaux-Arts,* LIV, 1959, pp. 97–108

Simon, K. "Diesseitsstimmung in spätromanischer Zeit und Kunst," *Deutsche Vierteljahresschrift für Literaturwissenschaft und Geistesgeschichte,* XII, 1934, p. 49 f.

Simon, J. "Restauration des vitraux de Saint-Remi de Reims," *Monuments historiques de la France,* 1959, pp. 14–52

Simson, O. v. *The Gothic Cathedral: Origins of Gothic Architecture and the Medieval Concept of Order,* New York, 1964

Singer, C.—Holmyard, E. J.—Hall, A. R.—Williams, I. *A History of Technology,* II, Oxford, 1951

Skubiszewski, P. "La patène de Kalisz," *Cahiers de civilisation médiévale,* 5, 1962, pp. 183–191

Sommer, J. "Der Niellokelch von Iber. Ein unbekanntes Meisterwerk der Hildesheimer Goldschmiedekunst des späten 12. Jahrhunderts," *Zeitschrift für Kunstwissenschaft,* 21, 1957, p. 109 f.

———. *Das Deckenbild der Michaelskirche zu Hildesheim,* Hildesheim, 1966

Sotiriou, G. & M. *Icones du Mont Sinaï,* 2 vols., Athens, 1956

Souchal, F. "Les bustes reliquaires et la sculpture," *Gazette des Beaux-Arts,* LXVII, 1966, pp. 205–216

Souchal, G. "Les émaux de Grandmont au XIIe siècle," *Bulletin monumental,* CXXI, 1963

———. "L'émail de Guillaume de Treignac, sixième prieur de Grandmont," *Gazette des Beaux-Arts,* LXIII, 1964, pp. 65–80

———. "Autour des plaques de Grandmont: une famille d'émaux limousins champlevés de la fin du XIIe siècle," *Bulletin monumental,* CXXV, 1967, pp. 21–71

Southern, R. W. *The Making of the Middle Ages,* New Haven, 1953

———. "The Place of England in the Twelfth Century Renaissance," *History,* XLV, 1960, pp. 201–216

———. *The Life of St. Anselm, Archbishop of Canterbury, by Eadmer,* London, 1962

Stammler, W. *Wort und Bild,* Studien zu den Wechselbeziehungen zwischen Schriften und Bildkunst im Mittelalter, Berlin, 1962, pp. 136–160

Steenbock, F. *Der kirchliche Prachteinband im frühen Mittelalter,* Berlin, 1965

———. "Das Kreuz von Valasse," *Festschrift Usener,* Marburg, 1967, pp. 45–51

Steiner, R. "Some Monophonic Latin Songs Composed Around 1200," *Musical Quarterly,* LII, 1966, p. 59–70

Steingräber, E. *Antique Jewelry,* New York, 1957

Stiennon, J. "La Pologne et le pays mosan au moyen âge," *Cahiers de civilisation médiévale,* 4, 1961, pp. 457–473

Stockholm, 1952. *Gyllene Böcker, Illuminerade medeltide handskrifter i dansk och svensk ägo*

Stoddard, W. S. *The West Portals of Saint-Denis and Chartres, Sculpture in Ile-de-France, 1140–1190,* Cambridge, 1952

Stohlman, W. F. "A Stained Glass Window of the Thirteenth Century," *Art and Archeology,* XX, 1925, p. 135

———. "A Stained Glass Window from Chartres Cathedral," *Bulletin of the Department of Art and Archeology of Princeton University,* Oct., 1927, pp. 3–9

———. "A Window from Chartres," *The Arts,* Nov., 1927, pp. 271–274

Stohlman, W. F. "Quantity production of Limoges champlevé enamels," *The Art Bulletin,* XVII, 1935, pp. 390–394

———. *Gli smalti del museo sacro Vaticano,* Rome, 1939

———. "The star group of champlevé enamels and its connections," *The Art Bulletin,* XXXII, 1950, pp. 327–330

Stone, L. *Sculpture in Britain in the Middle Ages,* London, 1955

Stornajolo, C. *Miniature delle Omilie di Giacomo Monaco e dell'Evangeliario Urbinato,* gr. 2, Rome, 1910

Straub, A.–Keller, G. *Herrade de Lansberg, Hortus Deliciarum,* Strasbourg, 1879–1899

Strayer, J. R. *Feudalism,* Princeton, 1965

Strzygowski, J. *Die Baukunst der Armenier und Europa,* 2 vols., Vienna, 1918

Stubblebine, J. "Two Byzantine Madonnas from Catalonia, Spain," *The Art Bulletin,* XLVIII, pp. 379–381

Swarzenski, G. *Die Salzburger Malerei,* Leipzig, 1908–1913

———. "Aus dem Kunstkreis Heinrichs des Löwen," *Städel-Jahrbuch,* VII–VIII, 1932, pp. 241–397

———. "Samson killing the Lion, a Medieval Bronze Group," *Boston Museum of Fine Arts Bulletin,* XXXVIII, 1940, pp. 67–74

———. "A Masterpiece from Limoges," *Boston Museum of Fine Arts Bulletin,* XLIX, 1951, pp. 17–25

Swarzenski, H. "Zwei Zeichnungen der Martinslegende aus Tournai," *Festschrift A. Goldschmidt,* Berlin, 1935, pp. 40–42

———. *Die Deutsche Buchmalerei des XIII. Jahrhunderts. Die lateinischen illuminierten handschriften des XIII. Jahrhunderts . . . ,* 2 vols., Berlin, 1936

———. "Recent Literature, Chiefly Periodical, on Medieval Minor Arts," *The Art Bulletin,* XXIV, 1942, pp. 287–304

———. *The Berthold Missal,* New York, 1943

———. "Two Unknown French Romanesque Frescoes," *Boston Museum of Fine Arts Bulletin,* XLVIII, 1950, pp. 21–26

———. *Englisches und flämisches Kunstgut in der romanischen Buchmalerei Weingartens. Festschrift zur 900. Jahrhunderts Feier der Abtei Weingarten.* Ravensburg, 1956

———. "A Vièrge d'Orée," *Boston Museum of Fine Arts Bulletin,* 58, 1960, pp. 64–83

———. "A Chalice and the Book of Kings," *De artibus opuscala XL., Essays in Honor of Erwin Panofsky,* New York, 1961, pp. 437–444

———. *Monuments of Romanesque Art,* Chicago, 1967

T

Thoby, P. *Les croix limousines de la fin du XIIe siècle au début du XIVe siècle,* Paris, 1953

Tikkanen, J. J. *Studien über die Farbengebung in der mittelalterlichen Buchmalerei,* Helsinki, 1933

Toesca, P. *Il Medioevo,* Torino, 1927

Tollenaere, L. *La sculpture sur pierre de l'ancien diocèse de Liège à l'époque romane,* Gembloux, 1957

Tondelli, L. *Il libro delle figure dell'abate Gioacchino,* Torino, 1953

Trier, E. "Die Madonna von Unkelbach," *Miscellanea Pro Arte Medii Aevi: Festschrift H. Schnitzler,* Düsseldorf, 1965, pp. 233–238

———. "Das Triumphkreuz in St. Severin zu Boppard," *Wallraf-Richartz-Jahrbuch,* XXX, 1968, pp. 19–56

Tristram, E. W. *English Medieval Wall Painting. The 12th Century,* Oxford, 1944

———. *English Medieval Wall Painting. The 13th Century,* Oxford, 1950

Troescher, G. *Künstlerwanderungen in Mitteleuropa, 800–1800,* Baden-Baden, 1953

Tselos, D. "English Manuscript Illumination and the Utrecht Psalter," *The Art Bulletin,* XLI, 1959, pp. 137–149

Turner, D. H. *Early Gothic Illuminated Manuscripts in the British Museum,* London, 1965

———. *Romanesque Illuminated Manuscripts in the British Museum,* London, 1966

U

Ullmann, E. "Zum Problem des Stilwandels von der Romanik zur Gotik in Frankreich," *Erbe und Gegenwart: Festschrift J. Jahn,* 1963, pp. 463–471

Underwood, P. A. *The Kariye Djami,* 3 vols., New York, 1966

Unterkircher, F. *La miniatura Austriaca,* Florence, 1954

Usener, K. H. "Kreuzigungs-Darstellungen in der mosanen Miniaturmalerei und Goldschmiedekunst," *Revue belge d'archéologie et d'histoire de l'art,* IV, 1934, pp. 201–209

———. "Ein Mainzer Reliquiar im Bayerischen Nationalmuseum," *Münchener Jahrbuch,* 1957, pp. 57–64

V

Vanuxem, J. "Les portails détruits de la cathédrale de Cambrai et de Saint-Nicolas d'Amiens," *Bulletin monumental,* CIII, 1945, pp. 89–102

———. "La sculpture du XIIe siècle à Cambrai et à Arras," *Bulletin monumental,* CXIII, 1955, pp. 7–35

———. "Fragments de sculpture monumentale du XIIe siècle," *Bulletin de la société nationale des Antiquaires de France,* 1962, pp. 160–163

———. "A propos de la sculpture monumentale dans le nord de la France au XIIe siècle," *Gedenkschrift E. Gall,* Berlin-Munich, 1965, pp. 87–94

Venturi, A. *Storia dell'Arte Italiana,* III, Milan, 1904

Verdier, P. "A Stained Glass from the Cathedral of Soissons," *The Corcoran Gallery of Art Bulletin,* 10, 1958, pp. 4–20

———. "Un monument inédit de l'art mosan du XIIe siècle: la crucifixion symbolique de la Walters Art Gallery," *Revue belge d'archéologie et d'histoire de l'art,* XXX, 1961, pp. 115–175

Verdier, P. "Limoges enamels from the order of Grand-mont," *Bulletin of the Walters Art Gallery*, XVII, 1964–1965, pp. 1–3

Verrier, J. *Vitraux de France aux douzième et treizième siècles,* Paris, 1950

Viarre, S. "La survie d'Ovide dans la littérature scientifique des XIIᵉ et XIIIᵉ siècles, *Cahiers de Civilisation médiévale,* Poitiers, 1966

Vielliard, J. *Le guide du pèlerin de Saint-Jacques de Compostelle,* Mâcon, 1938

Vienna, 1964. *Katalog der Sammlung für Plastik und Kunstgewerbe,* Kunsthistorisches Museum

Le vitrail français, Paris, 1958, Authors: Aubert, M., Chastel, A., Grodecki, L., Gruber, J.-J., Lafond, J., Mathey, F., Taralon, J., Verrier, J.

Vöge, W. *Die Anfänge des monumentalen Stiles im Mittelalter. Eine Untersuchung über die erste Blütezeit der französischen Plastik,* Strasbourg, 1894

————. "Die Bahnbrechter des Naturstudiums um 1200," *Zeitschrift für bildende Kunst,* XXV, 1914, p. 193 f.

————. *Bildhauer des Mittelalters. Gesammelte Schriften,* Berlin, 1958

Volbach, W. F. *Mittelalterliche Bildwerke aus Italien und Byzanz,* Berlin, 1930

————. "Ein antikisierendes Bruchstück von einer kampanischen Kanzel in Berlin," *Jahrbuch der Preussichen Kunstsammlungen,* Berlin, 1932, pp. 183–197

————. "Oriental Influences in the Animal Sculpture of Campania," *The Art Bulletin,* XXIV, 1944, pp. 172–180

————. "Byzanz und sein Einfluss auf Deutschland und Italien," *Byzantine Art an European Art, Lectures,* Athens, 1966, pp. 89–120

Vollant, L. *L'eglise de Saint-Germain-les-Corbeil,* Paris, 1897

Voss, H. *Studien zur illustrierten Millstätter Genesis,* Munich, 1962

Voyce, A. *The Art and Architecture of Medieval Russia,* Norman, 1967

W

Wulf, M. de. *Scholastic Philosophy,* New York, 1956

Wallrath, R. "Kathedrale und Kultgerät als Bildträger," *Münster,* 1953, pp. 1–19

Warner, G. F. *Illuminated Manuscripts in the British Museum,* London, 1903

Weber, G. *Gottfried von Strassburgs Tristan und die Krise des hochmittelalterlichen Weltbildes um 1200,* 2 vols., Munich, 1953

Weisbach, W. *Manierismus in mittelalterlicher Kunst,* Basel, 1942

————. *Religiöse Reform und mittelalterliche Kunst,* Zurich, 1945

Weitzmann, K. *Die byzantinische Buchmalerei des IX. und X. Jahrhunderts,* Berlin, 1935

————. "Constantinopolitan Book Illumination in the Period of the Latin Conquest," *Gazette des Beaux-Arts,* XXV, 1944, pp. 193–214

————. *Illustrations in Roll and Codex,* Princeton, 1947

Weitzmann, K. *The Narrative and Liturgical Gospel Illustrations,* New Testament Manuscript Studies, Chicago, 1950, pp. 151–174

————. "A Late Romanesque Ivory Virgin," *Princeton University Art Museum Record,* 10, 1951, pp. 1–6

————. "Eine Pariser-Psalter-Kopie des 13. Jahrhunderts auf dem Sinai," *Jahrbuch der Österreichischen Byzantinischen Gesellschaft,* VI, 1953, pp. 125–143

————. *Ancient Book Illumination,* Cambridge, 1959

————. "Zur byzantinischen Quelle des Wolfenbüttler Musterbruches," *Festschrift H. R. Hahnloser,* Basel-Stuttgart, 1961, pp. 223–250

————. "Eine spätkommenische Verkündigungikone und die zweite byzantinische Welle des 12. Jahrhunderts," *Festschrift Herbert v. Einem,* Berlin, 1965, pp. 299–312

————. "The Classical in Byzantine Art as a Mode of Individual Expression," *Byzantine Art an European Art, Lectures,* Athens, 1966, pp. 149–177

————. "Icon Painting in the Crusader Kingdom," *Dumbarton Oaks Papers,* 20, 1966, pp. 49–83

————. "Various Aspects of Byzantine Influence on the Latin Countries from the Sixth to the Twelfth Century," *Dumbarton Oaks Papers,* 20, 1966, pp. 1–24

Weitzmann-Fiedler, J. "Romanische Bronzeschalen mit mythologischen Darstellungen," *Zeitschrift für Kuntswissenschaft,* X, 1956, pp. 109–152

————. "Romanische Bronzeschalen mit mythologischen Darstellungen," *Zeitschraft für Kunstwissenschaft,* XI, 1957, pp. 1–34

Wentzel, H. "Review of F. Zschokke, *Die Romanischen Glasgemälde des Strassburger Münsters,*" *Zeitschrift für Kunstgeschichte,* 13, 1949, pp. 131–134

————. "Mittelalter und Antike im Spiegel kleiner Kunstwerke des 13. Jahrhunderts," *Studier tillägnade Henrik Cornell på sextioårsdagen,* Stockholm, 1950, p. 67 f.

————. "Die ikonographischen Voraussetzungen der Christus-Johannes-Gruppe und das Sponsus-Sponsa-Bild," *Heilige Kunst,* Rottenburg, 1952, pp. 7–21

————. "Ein gotisches Kapitell in Troia," *Zeitschrift für Kunstgeschichte,* XVII, 1954, p. 185 f.

————. *Meisterwerke der Glasmalerei,* Berlin, 1954

————. "Antikenimitationen des 12. und 13. Jahrhunderts in Italien," *Zeitschrift für Kunstwissenschaft,* IX, 1955, p. 29

————. "Das Medallion mit dem Hl. Theodor und die venezionischen Glaspdsten im byzantinischen Stil," *Festschrift Erich Meyer,* Hamburg, 1959, pp. 50–67

————. "Datierte und datierbare byzantinische Kameen," *Festschrift Friedrich Winkler,* Berlin, 1959, pp. 9–21

Wentzloff-Eggebert, F. W. *Der Hoftag Jesu Christi 1188 in Mainz,* Wiesbaden, 1962

Wessel, K. *Die byzantinische Emailkunst vom 5. bis 13 Jahrhundert,* Recklinghausen, 1964

Westlake, N. H. J. *A History of Design in Stained and Painted Glass,* London, vols. 1–4, 1881–1884

White, L. *Medieval Technology and Social Change,* Oxford, 1962

Wilhelm, P. *Die Marienkrönung am Westportal der Kathedrale von Senlis,* Hamburg, 1941

Will, R. *Répertoire de la sculpture romane en Alsace,* Strasbourg-Paris, 1951

Willoughby, H. R. "Codex 2400 and its miniatures," *The Art Bulletin,* XV, 1933, pp. 3–74

Woodforde, C. *English Stained and Painted Glass,* Oxford, 1958

Wormald, F. "The Development of English Illumination in the Twelfth century," *The Journal of British Archaeological Association,* VIII, 1943, pp. 31–49

———. *English Drawings of the 10th and 11th Centuries,* London, 1952

X

Xyngopoulos, A. *Thessalonique et la peinture macédonienne,* Athens, 1955

Z

Zarnecki, G. *Later English Romanesque Sculpture 1140–1210,* London, 1953

———. *English Romanesque Lead Sculpture,* London, 1957

———. *The Transition from Romanesque to Gothic in English Sculpture, Studies in Western art,* Acts of the Twentieth International Congress of the History of Art, I, Princeton, 1963, pp. 152–158

———. "A group of English Medieval Door-knockers," *Miscellanea pro Arte Medii Aevi: Festschrift H. Schnitzler,* Düsseldorf, 1965

Zschokke, F. *Die romanischen Glasgemälde des Strassburger Münsters,* Basel, 1942

PHOTOGRAPH CREDITS

Photographs supplied by the lending institutions, with these exceptions: